The Joan Palevsky Imprint in Classical Literature

In honor of beloved Virgil —

"O degli altri poeti onore e lume . . ."

— Dante, *Inferno*

The publisher gratefully acknowledges the generous contribution to this book provided by the Classical Literature Endowment Fund of the University of California Press Foundation, which is supported by a major gift from Joan Palevsky.

ROME AND ENVIRONS

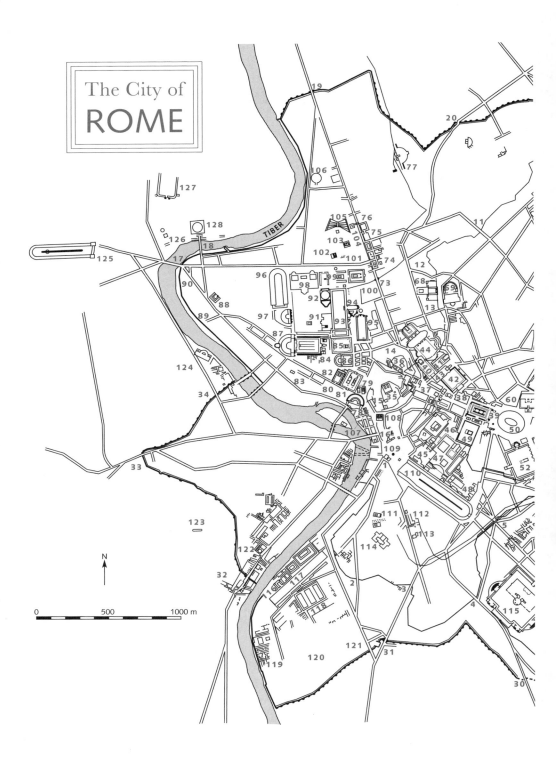

The City of
ROME

TIBER

N

0 500 1000 m

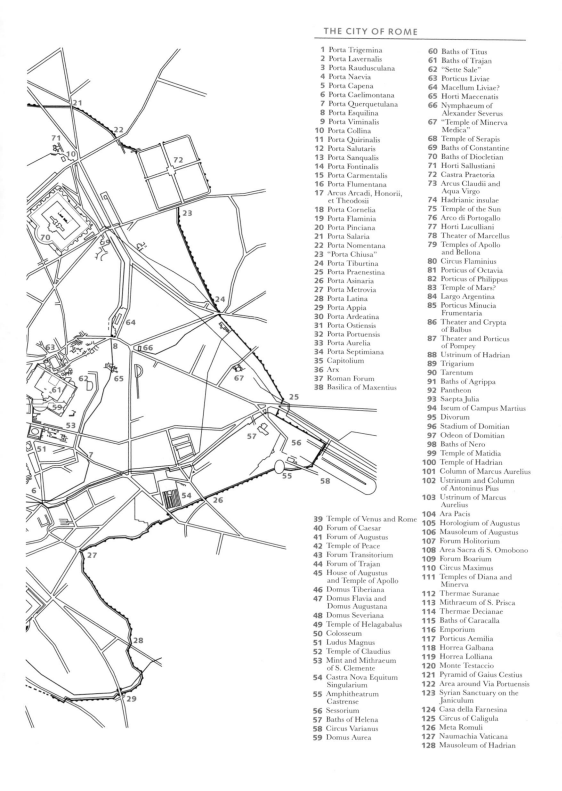

1 Porta Trigemina
2 Porta Lavernalis
3 Porta Raudusculana
4 Porta Naevia
5 Porta Capena
6 Porta Caelimontana
7 Porta Querquetulana
8 Porta Esquilina
9 Porta Viminalis
10 Porta Collina
11 Porta Quirinalis
12 Porta Salutaris
13 Porta Sanqualis
14 Porta Fontinalis
15 Porta Carmentalis
16 Porta Flumentana
17 Arcus Arcadi, Honorii,
 et Theodosii
18 Porta Cornelia
19 Porta Flaminia
20 Porta Pinciana
21 Porta Salaria
22 Porta Nomentana
23 "Porta Chiusa"
24 Porta Tiburtina
25 Porta Praenestina
26 Porta Asinaria
27 Porta Metrovia
28 Porta Latina
29 Porta Appia
30 Porta Ardeatina
31 Porta Ostiensis
32 Porta Portuensis
33 Porta Aurelia
34 Porta Septimiana
35 Capitolium
36 Arx
37 Roman Forum
38 Basilica of Maxentius

60 Baths of Titus
61 Baths of Trajan
62 "Sette Sale"
63 Porticus Liviae
64 Macellum Liviae?
65 Horti Maecenatis
66 Nymphaeum of
 Alexander Severus
67 "Temple of Minerva
 Medica"
68 Temple of Serapis
69 Baths of Constantine
70 Baths of Diocletian
71 Horti Sallustiani
72 Castra Praetoria
73 Arcus Claudii and
 Aqua Virgo
74 Hadrianic insulae
75 Temple of the Sun
76 Arco di Portogallo
77 Horti Luculliani
78 Theater of Marcellus
79 Temples of Apollo
 and Bellona
80 Circus Flaminius
81 Porticus of Octavia
82 Porticus of Philippus
83 Temple of Mars?
84 Largo Argentina
85 Porticus Minucia
 Frumentaria
86 Theater and Crypta
 of Balbus
87 Theater and Porticus
 of Pompey
88 Ustrinum of Hadrian
89 Trigarium
90 Tarentum
91 Baths of Agrippa
92 Pantheon
93 Saepta Julia
94 Iseum of Campus Martius
95 Divorum
96 Stadium of Domitian
97 Odeon of Domitian
98 Baths of Nero
99 Temple of Matidia
100 Temple of Hadrian
101 Column of Marcus Aurelius
102 Ustrinum and Column
 of Antoninus Pius
103 Ustrinum of Marcus
 Aurelius
104 Ara Pacis
105 Horologium of Augustus
106 Mausoleum of Augustus
107 Forum Holitorium
108 Area Sacra di S. Omobono
109 Forum Boarium
110 Circus Maximus
111 Temples of Diana and
 Minerva
112 Thermae Suranae
113 Mithraeum of S. Prisca
114 Thermae Decianae
115 Baths of Caracalla
116 Emporium
117 Porticus Aemilia
118 Horrea Galbana
119 Horrea Lolliana
120 Monte Testaccio
121 Pyramid of Gaius Cestius
122 Area around Via Portuensis
123 Syrian Sanctuary on the
 Janiculum
124 Casa della Farnesina
125 Circus of Caligula
126 Meta Romuli
127 Naumachia Vaticana
128 Mausoleum of Hadrian

39 Temple of Venus and Rome
40 Forum of Caesar
41 Forum of Augustus
42 Temple of Peace
43 Forum Transitorium
44 Forum of Trajan
45 House of Augustus
 and Temple of Apollo
46 Domus Tiberiana
47 Domus Flavia and
 Domus Augustana
48 Domus Severiana
49 Temple of Helagabalus
50 Colosseum
51 Ludus Magnus
52 Temple of Claudius
53 Mint and Mithraeum
 of S. Clemente
54 Castra Nova Equitum
 Singularium
55 Amphitheatrum
 Castrense
56 Sessorium
57 Baths of Helena
58 Circus Varianus
59 Domus Aurea

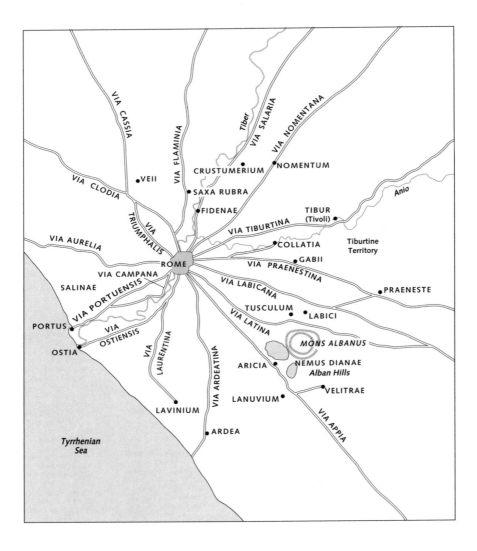

Environs of Rome.

ROME AND ENVIRONS

An Archaeological Guide

FILIPPO COARELLI

Translated by
JAMES J. CLAUSS AND DANIEL P. HARMON

Illustrations adapted by
J ANTHONY CLAUSS AND PIERRE A. MACKAY

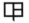

UNIVERSITY OF CALIFORNIA PRESS Berkeley Los Angeles London

University of California Press, one of the most distinguished university presses
in the United States, enriches lives around the world by advancing scholarship
in the humanities, social sciences, and natural sciences. Its activities are
supported by the UC Press Foundation and by philanthropic contributions
from individuals and instutions. For more information, visit www.ucpress.edu.

The text is a translation of an original manuscript provided by Filippo Coarelli
that includes updated and revised chapters from three of his books in
the Guide archeologiche Laterza series (Rome and Bari: Gius. Laterza & Figli
S.p.A): *Roma* (© 1995 and 2003), *Dintorni di Roma* (© 1993), and *Italia Centrale*
(© 1985).

University of California Press
Berkeley and Los Angeles, California

University of California Press, Ltd.
London, England

Library of Congress Cataloging-in-Publication Data

Coarelli, Filippo.
 Rome and environs : an archaeological guide / Filippo Coarelli ; translated
by James J. Clauss and Daniel P. Harmon ; illustrations adapted by J
Anthony Clauss and Pierre A. MacKay.
 p. cm.
 "The text is a translation of an original manuscript provided by Filippo
Coarelli that includes updated and revised chapters from three of his books in
the Guide archeologiche Laterza series (Rome and Bari: Gius. Laterza & Figli
S.p.A): *Roma* (1995 and 2003), *Dintorni di Roma* (1993), and *Italia Centrale* (1985)."
Includes bibliographical references and index.
 ISBN 978-0-520-07960-1 (cloth : alk. paper)
 ISBN 978-0-520-07961-8 (pbk. : alk. paper)
 1. Rome (Italy)—Antiquities—Guidebooks. 2. Rome Region (Italy)—
Antiquities—Guidebooks. I. Title.

DG62.C623 2007
937.6—dc22 2006016234

Manufactured in Singapore

16 15 14 13 12 11 10 09 08 07
10 9 8 7 6 5 4 3 2 1

The paper used in this publication meets the minimum requirements
of ANSI/NISO Z39.48-1992 (R 1997) *(Permanence of Paper)*.

CONTENTS

TRANSLATORS' PREFACE

In the late 1980s, when the Department of Classics at the University of Washington began its Seminar in Rome, we found that the only book that presented a complete guide of the city and could serve as a teaching text on Roman topography was Filippo Coarelli's magisterial *Roma*. The guide not only discussed the major monuments but also offered remarkable detail about the archaeological, architectural, political, religious, and cultural history in a section-by-section survey of the city, including countless minor monuments that lie in basements, under churches, along the side of hard-to-find alleys, or wherever antiquities might lurk in the Eternal City.

The various editions of Coarelli's *Roma* provide tourists, teachers, and students with critical information about the marvels of the Colosseum and Pantheon, while also leading them confidently to such unforgettable remains as the one visible fragment of the Temple of Matidia, the Emperor Hadrian's mother-in-law, that sits inconspicuously in the Vicolo della Spada d'Orlando. On more than a few occasions, when we asked doormen if we could visit archaeological remains in their buildings, they would exclaim, "How did you know it was here? So many who pass by are completely unaware of its existence!" The problem for most people, however, has been the need to read Italian to benefit from the treasures that *Roma* has to offer.

In our initial conversations with Professor Coarelli, during which we worked out plans to develop an English version of his text, he suggested that we expand its scope and include sections of his *Italia Centrale* and *Dintorni di Roma*. Thus, what you have before you is a thoroughly engaging archaeological guide not only of the city of Rome but also of much of its environs, including the important and much-visited sites of Ostia Antica, Hadrian's Villa, Palestrina, the Catacombs, and

many of the fascinating monuments that line the various major roads that led to Rome, such as the historic Appian Way. *Rome and Environs: An Archaeological Guide* gives English-speaking readers the opportunity to visit Rome and its surrounding territory armed with the information and insights of one of the most influential scholars of Roman topography.

For readers who are not familiar with Latin, it will be helpful to note a few spelling conventions that we have followed. When we refer to C. Iulius Caesar, for example, we are using the Latin form of the name, which becomes Gaius Julius Caesar in English. In older Latin the letter C represented the sound indicated by both C and G in later (classical) Latin. Thus the abbreviation of Gaius by C was retained as an archaism even in the classical period. The letter *i* was used not only for the vocalic *i;* it also represented the consonantal (or glide) *i,* which is often made *j* in English.

There are many people whom we would like to thank for their numerous critical contributions to this book. First and foremost, we would like to acknowledge our sincere gratitude to Filippo Coarelli for his willingness to work with us, and to Paolo Bracconi, who assisted us in countless ways. We are also grateful to Dott. Giuseppe Laterza, publisher of the Coarelli volumes represented in this book, for his most gracious assistance.

A large number of people at the University of California Press were involved at different stages in the process: Mary Lamprech worked with Laterza to acquire permission to translate Coarelli's work. She was succeeded by Kate Toll, who offered herculean logistical support along the way. As we drew near to the culmination of the project, we benefited from the critical assistance of UC Press director Lynne Withey, editors Laura Cerruti and Rose Vekony, proofreaders Juliana Froggatt and Lynn Meinhardt, and production manager Anthony Crouch.

We have enjoyed the support of many friends, colleagues, and students. Astra Zarina, former director of the University of Washington Rome Center, and Trina Deines, the current director, gave us much encouragement, as did our former department chairs, Michael Halleran and Stephen Hinds. Our colleague Alain Gowing carefully read the final proofs, and Jackie Murray, a former graduate student, helped in editing the full bibliography. We are especially grateful to Professor James Russell of the University of British Columbia and to Professor Ily Nagy of the University of Puget Sound for extensive help and invaluable advice, and to J Anthony Clauss and our colleague Pierre MacKay for their painstaking enhancement and updating of the illustrations in the text.

James J. Clauss
Daniel P. Harmon
University of Washington, Seattle

ROME AND ENVIRONS

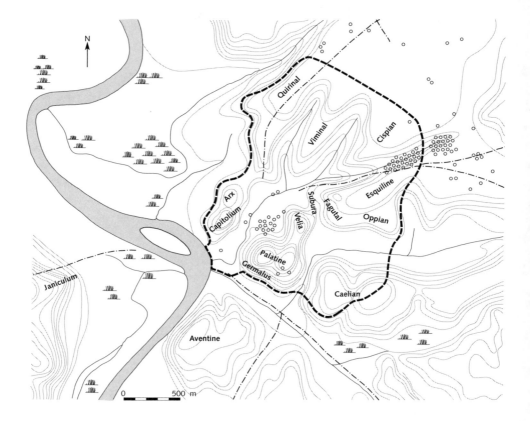

FIGURE 1. The territory of Rome in the archaic period, identifying the major hills. The boundary of the City of the Four Regions is marked by dashes; the lines of dots and dashes identify the principal roads; the small circles indicate archaeological finds, in particular necropolises, dating to the end of the Bronze and Iron Ages.

INTRODUCTION

The importance of Rome's geographical position, situated where river and land routes meet and where Etruria is linked with Latium and Campania by the ford below Tiber Island, is not difficult to understand. To experience the interplay of this geography at first hand, one need only follow Via della Lungaretta, which traces the course of the ancient Via Aurelia originating in southern Etruria, from the slopes of the Janiculum to the Tiber. There the modern Ponte Palatino crosses the river at a short distance from the ancient Pons Sublicius. Leaving the bridge, the traveler enters the Forum Boarium, the ancestral market, which was older than the city itself. Beyond the valley of the Circus Maximus lies the point where Via Appia and Via Latina split off and begin their descent southward toward Campania. This traffic route, preserved in the modern city, accounts clearly enough for the rise of an important settlement in this location.

The Greek writer Strabo, who lived during the Augustan Age, noted the absence of settlements of any importance between Rome and its port, Ostia, at the mouth of the Tiber. But this was not always the case. Between the end of the Bronze Age and the beginning of the Iron Age, villages dotted almost every hill along the river. At the site where Rome would one day rise, a settlement occupied the Capitoline from as early as the fourteenth century BC. Tradition holds that the city was formed from the incorporation of surrounding villages into the most

important settlement in the region, that on the Palatine. This process coincided with the increase in agricultural productivity and with the beginning of Greek colonization, which—not by chance—corresponds to the traditional date of Rome's founding: the middle of the eighth century BC. Almost immediately Rome developed contacts with these first colonies, especially Ischia and Cumae, as eighth-century Greek pottery found in the Forum Boarium attests.

An important phase in the early development of the city occurred in the second half of the seventh century BC. According to tradition, Ancus Marcius built the first wooden bridge over the Tiber, the Pons Sublicius, and protected its bridgehead on the right bank by occupying the Janiculum. At the same time, he founded Ostia and secured its connection with Rome by razing all settlements between the port and the city on the river's left bank. Archaeological evidence appears to confirm this tradition.

At the end of the seventh century, the potential inherent in the new urban center and its favorable setting attracted the Etruscans, for whom Rome had become a key location. During the century in which it was ruled by an Etruscan dynasty, Rome achieved its definitive urban form without losing its ethnic character and Latin culture. The city was divided into four administrative regions or territorial tribes (Palatina, Collina, Esquilina, and Suburana) and constituted an area considerably larger than the original extent of the Palatine, as can be observed in the circuit of the Servian Walls, whose fourth-century BC reconstruction follows almost perfectly the earlier sixth-century course (FIG. 1). The area of the city, though not fully inhabited, was no less than 426 hectares; larger, that is, than any other city on the Italian peninsula. The wealth and power of the "Grand Rome of the Tarquins" are also reflected in the number and size of the sanctuaries constructed at that time. The sanctuary of Capitoline Jupiter is by far the largest known Etruscan temple.

Yet the building activity of the Etruscan rulers was not limited to religious sanctuaries. In addition to the vast circuit of walls, built of cappellaccio blocks in its earliest phase (the middle of the sixth century BC), the Tarquins also installed an impressive system of channels and drainage sewers. Once the unhealthy swamps in the low-lying areas of the valley were cleared, further urban development became possible. The two principal conduits in the system are the Cloaca Maxima and the channel that drained the Vallis Murcia. The former reclaimed the Forum valley, which was first paved at that time, and the latter cleared the way for construction of the Circus Maximus; on that site the Tarquins were supposed to have erected the first formal structure for the games.

The text of the first treaty between Rome and Carthage, passed down to us by Polybius and dated to the early years of the Republic, conveys a sense of the city's territorial expansion during the sixth century. The document reveals that the territory dominated by Rome at that time extended as far as Circeo and Terracina.

In the decades after 509 BC, the year in which the Tarquins were expelled, building activity continued at a remarkable pace. During these years, some of the most important sanctuaries were built, including the temples of Saturn and of the Castors in the Forum, and those of Ceres and Mercury at the foot of the Aventine. The impact of Greek culture, evident in these foundations, is also reflected in the importation of Greek ceramics, which continued, without significant change, until the middle of the fifth century. When the Decemviri assumed control of the government and the Laws of the Twelve Tables were promulgated, a serious crisis emerged, whose effects were felt in the rest of Italy, including Etruria and Magna Graecia. This crisis coincided with the most turbulent phase in the struggle between the patrician and plebeian classes and with the loss of the territories of southern Latium following the invasion of the Volscians. This same period witnessed the foundation of the important Temple of Apollo in the Campus Martius. Among other public buildings erected at this time was the Villa Publica, which housed the newly established office of the censor.

At the beginning of the fourth century, the city recovered from the losses of the preceding century, a time characterized by life-or-death struggles, lost in obscurity, with surrounding peoples. The first sign of this recovery was the destruction of the city's most dangerous rival, the Etruscan city of Veii, after a ten-year siege; the attack and conquest by the Gauls ensued immediately afterward. The Roman annalistic tradition has probably exaggerated the importance of this event by attributing the destruction of a large portion of the city's oldest documents to the fire set by the Gauls; this loss is said to account for the lack of detailed knowledge about Rome's first centuries. Archaeological evidence, however, does not confirm tradition in this case. Other factors, such as the paucity of written documentation at such an early period, would appear to explain the lack of information for the years prior to 390 BC. The irregularity evident in the most ancient regions of the city, which Livy attributes to hasty reconstruction after the Gallic sack, might be explained more plausibly as the result of long and progressive growth, similar to that observed in Athens. A total reconstruction of the city in the fourth century would certainly have resulted in a more methodical organization. Moreover, the buildings whose archaic and fourth-century phases have survived (such as the Regia and a number of temples) show no noteworthy signs of sudden reconstruction or even of changes in plan or orientation.

Evident resumption in building activity occurs in the fourth and third centuries BC. The most impressive undertaking is the complete reconstruction of the walls, which had proved inadequate to withstand the Gallic assault. Construction of this massive defense system built of Grotta Oscura tufa began in 378 BC and was completed around the middle of the century. At the same time, large building projects were undertaken on the Capitoline and Palatine Hills, and numerous temples were built or rebuilt (e.g., Temples A and C in Largo

Argentina). The level of urban planning undertaken at that time can be seen in the construction of several roads, Via Appia in particular, and above all in the erection of the first aqueduct, begun in 312 BC by the censor Appius Claudius Caecus. Artists from Magna Graecia had already been working in Rome by the beginning of the fifth century, but now such activity increased, a sign that the median level of culture had risen and that the Romans valued the products of Greek art. Workshops producing ceramics of high quality begin to appear in the city; their products were exported throughout the western Mediterranean. Bronze statues start showing up in public buildings and spaces: in the second half of the fourth century BC, statues of Pythagoras and Alcibiades, certainly the work of artists from Magna Graecia, are recorded as standing in the Comitium. In 296, the ancient terracotta quadriga that had adorned the peak of the Temple of Jupiter Capitolinus, the work of the Etruscan artist Vulca, was replaced by one in bronze. During the same years, two colossal statues, one of Hercules, the other of Jupiter, were erected in the Area Capitolina; statues of the Roman kings may also have stood nearby. The famous bronze known as the Capitoline Brutus gives an idea of the quality of these works. Increasingly, Greek writers begin to focus on Rome; one author goes so far as to call it a "Greek city." This impressive development coincides with the conquest of Italy—from the Samnite Wars to the war against Tarentum and Pyrrhus—and subsequently of Sicily and Sardinia after the First Punic War.

This era represents the classical phase of the Roman Republic, whose expansion was based primarily on a substantial class of small- and middle-sized landowners that formed the core of the army. Late Republican and Imperial writers would come to idealize this period, creating the fiction that Rome was in those years poor, rustic, and largely unsympathetic to Greek culture. This idea, which endures to this day, is certainly misguided, if not completely erroneous.

Until the Second Punic War, Roman territory was limited to the dimensions of a city-state; it was the center of a confederation. But from the beginning of the second century BC, a crisis emerged that progressively undermined the basic structure of the Republic and resulted in the creation of the empire. Leaving aside Rome's economic and social development, the last two centuries of the Republic were decisive in shaping the city's subsequent growth. On the one hand, the huge increase in Rome's population, resulting from migration that gradually emptied cities throughout Italy, gave rise to large working-class neighborhoods, with rental flats in multistory buildings—the *insulae* that housed many of Rome's inhabitants during the Imperial period as well. On the other hand, the desire to win political support from this mass of citizens led Rome's ruling families to display their power and prestige as a political strategy. In time, the Forum, the Capitoline, and the Campus Martius were strewn with porticoes, gardens, monumental temples, and entertainment complexes. New facilities, including a port, warehouses, and aqueducts, arose to channel supplies into the city. The dual phenomenon of function and propaganda, resulting in the subdivision of

the city into areas with specialized activities, together with the emergence of large residential and commercial quarters, came to characterize the city as early as the Imperial period.

The phenomenon of urban development based on the display of wealth and power is a distinguishing characteristic of the Forum, the Capitoline, and the Campus Martius. The latter in particular gradually assumed a monumental appearance: in the second century BC, a number of temples and porticoes, benefiting from the input of Greek architects and artists, arose in the vicinity of the Circus Flaminius; the building activities of Pompey, Caesar, and Augustus accentuated this development, facilitated by the public character of the region. Strabo provides a lively description of the area at the beginning of the Imperial period: alongside spaces left in their natural state lay an uninterrupted series of public buildings, porticoes, temples, baths, three theaters, and an amphitheater, all constructed by the Republican nobles, whose internecine wars would eventually oust them from power. The greatest developer was the most capable member of this nobility, Augustus, the heir and successor of Divus Julius.

This monumental character informed other areas of the city as well, such as the Forum Holitorium and the Forum Boarium, whose mercantile functions extended to the large commercial district that arose south of the Aventine at the beginning of the second century BC. Monte Testaccio, the "mountain of potsherds," attests to the level of commerce undertaken here.

Along with the evident growth of public projects, we find a parallel expansion in the construction of private dwellings of two types: *insulae,* the large, multistory tenement houses that appear now for the first time but which, though often rebuilt during the Imperial period, disappeared leaving few traces, and *domūs,* the homes of the wealthy, which resemble the more luxurious Hellenistic residences. The *domus* is characterized by the addition of a Greek colonnaded courtyard (peristyle) to the traditional Roman atrium plan and the use of ever more elaborate decorations, such as marble and mosaic pavements, wall paintings, and gilded ceilings. Numerous remains of houses of this sort have been found within the city, especially on the Palatine and Esquiline.

We learn from Cicero that Caesar was planning a complete reconfiguration of the city, involving a large-scale overhaul of various regions, especially the Campus Martius and Trastevere. Among other projects, he planned to alter the course of the Tiber, a move that would have eliminated the large bend that formed the Campus Martius and united it with the *Ager Vaticanus.* The death of the dictator put an end to these works, but Caesar's activities elsewhere shaped the character of the city's center: the destruction of the *Comitium* and the construction of the *Curia Iulia,* the *Basilica Iulia,* and the new *Rostra* defined the new orientation of the ancient Republican forum, while the construction of the Forum of Caesar opened the way for the future Imperial fora.

Augustus's urban program was less grandiose and radical than Caesar's, although this did not prevent him from associating himself directly with his great-

uncle's work. The city was totally restructured and divided into fourteen regions, in a plan that remained intact until late antiquity (FIG. 2). Along with this new organization, Augustus instituted a corps of *vigiles*, who served as nighttime police and firemen; he defined the limits of the Tiber's banks and bed; and he built new aqueducts, the first public bath complex (that of Agrippa), two theaters, an amphitheater, and libraries open to the public. No fewer than 82 sanctuaries were reconstructed or restored during his reign. The Roman Forum, which was losing the political function that it possessed from the city's founding, acquired its definitive character by becoming a monumental plaza. Augustus also situated a new forum, the Forum Augustum, alongside the earlier Forum of Caesar. Above all, the Campus Martius became the focus for most of the activity undertaken by Augustus and members of his court. It was at the edge of the Campus Martius that Augustus erected his dynastic tomb, the resting place for the emperor, his family, and his successors.

The subsequent emperors of the Julio-Claudian dynasty stayed more or less within the lines set by Augustus; only Nero broke out of the mold in the aftermath of the great fire of AD 64, which leveled three of the Augustan regions and severely damaged seven, leaving only four intact. In the years that followed, Nero began construction of the *Domus Aurea*, transforming much of the city center into a kind of gigantic villa, a tangible sign of the emperor's autocratic aims. On the other hand, the crisis resulted in the elaboration of an urban policy that, according to Tacitus, required the renovated areas of the city to be regularized, endowed with larger streets, and flanked by porticoes. Structures employing common walls were forbidden; limits were set on building heights; and the use of flammable material was restricted (the new building code called almost exclusively for stone and brick construction). The market on the Caelian Hill known as the *Macellum Magnum* and the Neronian Baths in the Campus Martius, probably the first example of a bath complex with the symmetrical plan that thereafter became canonical, are among the important public buildings erected in the Neronian period.

Disasters also struck the city during the Flavian period, such as the fire on the Capitoline in AD 69 and another in the Campus Martius and on the Capitoline in AD 80, a little more than ten years later. The first two Flavian emperors rebuilt the temple of Jupiter Capitolinus and repaired other buildings damaged by fire. But they are best known for dismantling the Domus Aurea, whose vast spaces, with the exception of a small section reserved perhaps for the *Domus Titi*, were restored to public use: the villa's pool was drained and in its place an enormous amphitheater, the Colosseum, arose. The Flavians reconstructed the temple of Divus Claudius, which Nero had turned into a nymphaeum. The Baths of Titus went up quickly alongside the Domus Aurea; these were probably nothing more than a modification of Nero's private baths. The statues that Nero had collected, mostly in Greece and Asia Minor, to adorn his residence were set up in a new monumental piazza, the Temple of Peace. If their principate is seen

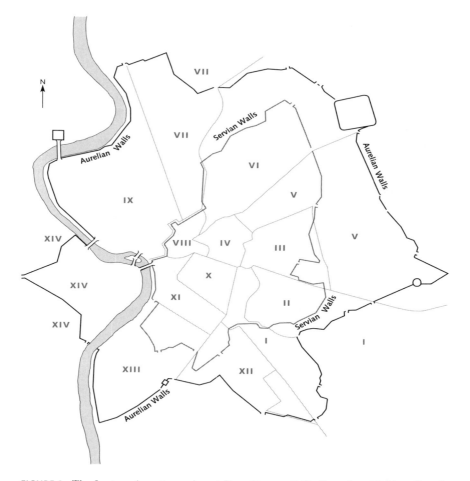

FIGURE 2. The fourteen Augustan regions: **I** Porta Capena. **II** Caelimontium. **III** Isis et Serapis. **IV** Templum Pacis. **V** Esquiliae. **VI** Alta Semita. **VII** Via Lata. **VIII** Forum Romanum. **IX** Circus Flaminius. **X** Palatium. **XI** Circus Maximus. **XII** Piscina Publica. **XIII** Aventinus. **XIV** Transtiberim.

as anti-Neronian, at least in its public building program, in their overall policy of urban development the Flavians found it necessary to follow the earlier plans. Completion of Nero's *nova urbs* was, after all, not feasible in the short period of four years between the fire and the emperor's death. We know that in AD 73 Vespasian and Titus resumed an almost forgotten Republican magistracy, the censorship. They took this extraordinary step to enlarge Rome's sacred boundary—the *pomerium*—an action that was probably essential to a general reconfiguration of the city.

Domitian, the third emperor of the dynasty, vigorously carried on the work begun by his predecessors. The Campus Martius and Capitoline were almost completely rebuilt after the fire of AD 80. Other new buildings also went up at this time: a new forum, the Forum Transitorium (which would later be inaugurated by Nerva, from whom it derived its alternate name, the Forum of Nerva), the Arch of Titus, and the temple dedicated to Vespasian and Titus. In the Campus Martius, Domitian built the Stadium and the nearby *Odeon*, as well as the *Templum Divorum*, another building for the cult and burial of the Imperial family, like the temple of the *Gens Flavia* erected on the Quirinal at the spot where the Flavians had their private home. The new palace, built on the Palatine, was perhaps Domitian's most spectacular building; it remained the official residence of the emperors until the very end of the empire.

The second century AD, from Trajan to the Severans, witnessed Rome's greatest period of expansion, both geographic and demographic. The beginning of the century was signaled by the construction of the largest and most monumental of the Imperial fora, Trajan's Forum. The area was already so overbuilt that it was necessary to cut away the saddle between the Quirinal and Capitoline and tear down various venerable buildings, probably including the old *Atrium Libertatis*. Still more profound changes took place in utilitarian building projects, both public and private. Apollodorus of Damascus, the same architect who designed Trajan's Forum, was also responsible for Trajan's Markets, which were closely integrated with the Forum, and for the large baths on the Oppian Hill where we first encounter the fully articulated classical form of the Imperial bath complex—the model for the Baths of Caracalla and Baths of Diocletian.

Building activity reached a high point with Hadrian and Antoninus Pius. The practice of giving the consular date on bricks begins in 123, a clear indication of the complete retooling of the furnaces for brick manufacture in response to this intense undertaking. The spike in building activity, while evident in individual monuments such as the Pantheon and the Temple of Venus and Rome or in the restorations of the palaces on the Palatine and of the *Horti Sallustiani*, is even more dramatic in the construction of entire neighborhoods with multistory *insulae*, such as the one in Region VII east of Via Lata, which was fully developed at that time. Nor should we forget the creation of Hadrian's suburban palace, the Villa Adriana, and his mausoleum, destined for a new dynasty—that of the Antonines.

A large number of works were undertaken by the Severan emperors after the devastating fire of AD 191, including the reconstruction of the Temple of Peace, the *Horrea Piperataria*, and the Porticus of Octavia. A wing was added to the Imperial palace on the Palatine, which was endowed with a monumental facade, the *Septizodium*, facing Via Appia. But among the most impressive buildings of the period are the baths constructed in Region XII by Caracalla, the best-preserved bathing complex of Imperial Rome. To the same period belongs what is perhaps Rome's largest sanctuary, the Temple of Serapis on the Quirinal.

Fragments of a marble plan, executed during the reign of Septimius Severus, provide a planimetric representation of the city in the years when it had reached its apogee. The plan covered a wall in the restored Temple of Peace. Building activity slowed down noticeably and almost stopped in the third century AD, as the empire encountered a violent economic and social crisis. The cessation of the use of brick stamps after Caracalla's death—the practice was resumed only under Diocletian—is a symptom of the chaos of the times. Among the more important buildings of the third century are the Temple of Elagabalus on the Palatine and the Temple of the Sun erected by Aurelian in the Campus Martius. But the most notable construction of the period—striking testimony to the uneasy character of the age and clear evidence of the empire's military weakness—are the fortification walls that Aurelian had erected around the city.

Building activity resumed in Rome under Diocletian and the Tetrarchy, much as it did elsewhere in an extensive and partly successful attempt to restructure the empire. The Fire of Carinus in AD 283 had destroyed a large part of central Rome; Caesar's Forum, the Curia, the Temple of Saturn, and the porticoes of Pompey were hastily reconstructed, but the emperor wanted to associate his name with a large and entirely new building. To this end Diocletian built his eponymous baths, the largest ever constructed, at the juncture of the Viminal and Quirinal. It is possible that the Regionary Catalogues were compiled during these years. Although the precise function of these lists of buildings, set out region by region, is uncertain, they nonetheless provide precious information about the city at the end of the ancient period.

Even as late as Maxentius, who had chosen Rome for his capital and had clearly intended to refurbish the ancient and now impoverished city, we encounter a notable increase in the number of building projects. These include the reconstruction of the Temple of Venus and Rome, the building of a new Imperial villa with its own circus and dynastic mausoleum on Via Appia, and above all the erection of the great basilica, later named for Constantine, who completed some of Maxentius's works and initiated others, such as the Baths of Constantine on the Quirinal, though these too may well have been begun by Maxentius. But Constantine's attention soon turned to his new capital, Constantinopolis. From this point forward, Roman authorities focused their energies on simply preserving and restoring the old monuments, which, after falling into general disuse, were abandoned and destroyed over the years. In the meantime, a new city emerged alongside and extending beyond the old city: Christian Rome.

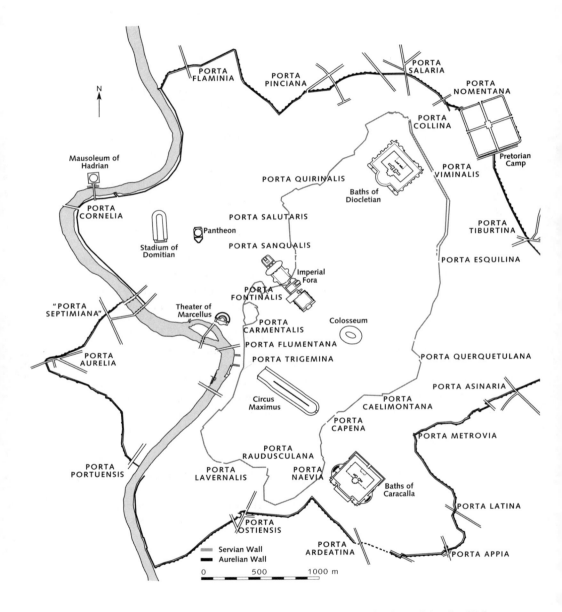

FIGURE 3. The City Walls. Plan of the Servian and Aurelian Walls.

CITY WALLS

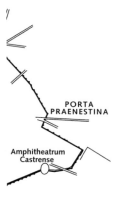

PORTA
PRAENESTINA

Amphitheatrum
Castrense

HISTORICAL NOTES

Literary sources attribute the construction of Rome's earliest walls to the city's penultimate king, Servius Tullius, although, according to some authors, work on this project may well have begun under his predecessor, Tarquinius Priscus. In either instance, the structure can be dated to the first half of the sixth century BC. Records suggest, however, that an earlier defensive system enclosed a narrower area than the Servian city.

With some exceptions, scholars have tended to reject the idea that Rome had a complete defensive system in the sixth century BC. Recent discoveries, however, such as those at Lavinium, have shown that fortification walls in *opus quadratum* were constructed at this time in several cities of Latium. It would be strange indeed if the most important settlement in the region did not have walls, particularly since it possessed no natural defenses toward the east. But the strongest argument in favor of the traditional date comes from portions of the wall that survive and the final disposition of the wall as a whole.

Following the occupation of the city by the Gauls in 390 BC, which exposed the weakness of the older defenses, a wall of Grotta Oscura tufa was erected. Livy (6.32.1) provides the exact date—378 BC—and informs us that the censors contracted to have the new wall constructed "of squared stones" (i.e., in *opus quadratum*). The tufa used was from the

quarry at Grotta Oscura, which became accessible after the conquest of Veii in 396 BC. Restorations were carried out in 353, 217, 212 (during the Second Punic War), and 87 BC (during the civil war between Marius and Sulla).

The construction technique of the fourth-century wall was uniform throughout: rows of blocks, roughly 59 centimeters, or two Roman feet, high, were laid out alternately by headers and stretchers. The structure was approximately 10 meters high and occasionally more than 4 meters thick. Numerous crews worked on the walls simultaneously, as is evident from the points where their sections joined, sometimes imperfectly. The stretch of wall near the train station suggests that an individual segment extended for a length of approximately 36 meters. Even the quarry's excavation was meticulously conducted, as is evident from the many engravings visible on the blocks; these may be inspection marks identifying the work of the individual stone-yards. The wall was about 11 kilometers long, enclosing an area of around 426 hectares. The territory within the walls was not completely occupied, since strategic needs determined the course of the walls.

Between the end of the Republic and the third century AD, Rome essentially had no defensive walls. Nonetheless, various recognized boundaries defined the area of the city, from the ancient *pomerium*, which was enlarged several times by Sulla, Claudius, and Vespasian, to the edges of the Augustan regions and to the customs border established under the Flavian emperors. The possibility that barbarians might actually reach the capital became more imminent in the third century and prompted Aurelian (AD 270–75), fighting wars increasingly distant from the city (in particular against Palmyra), to equip Rome with new walls. The work began in 271 and proceeded quite rapidly; the walls must have been essentially complete by his death. Probus (AD 276–82) finished the project.

The walls were built primarily by the bricklayers' guilds and at first served as a somewhat modest defensive system, strong enough to contain the attacks of peoples technologically incapable of conducting sustained sieges. The wall was constructed of brick and measured 6 meters high and 3.50 meters thick, punctuated every 100 Roman feet (29.60 meters) by a square tower with an upper room for *ballistae*. The most important gates consisted of two identical arched entrances, faced in travertine and framed by two semicircular towers. Some gates had only a single arch, while the most modest gates were simply openings in the center of a section of wall located between two square towers.

The entire course of the fortification was just under 19 kilometers, following a strategic line that took in the hills and, to the extent possible, the larger existing structures. The incorporation of various buildings in the walls attests to the haste in which the work was carried out; in fact, preexisting buildings constitute one tenth of the wall.

The fortification must have seemed inadequate and in need of reinforcement soon after completion. The walls were first restored under Maxentius, and his work is easily distinguished by the manner of construction, primarily *opus vittatum* (horizontal rows of bricks alternating with small tufa blocks). The excavation of

a moat was begun but never completed. In 401–2, during the reigns of Honorius and Arcadius, the walls received their most extensive renovation in the face of attacks by the Goths; the work essentially doubled their height. A covered gallery, outfitted with numerous slit windows, replaced the earlier patrol walkway. Above this ran a new wall walk, furnished with merlons. The inclusion of the Mausoleum of Hadrian during this renovation marked the principal change made in the course of the wall, thus transforming the funerary monument into an outwork on the right bank of the Tiber. The double entrances in some of the gates were reduced to single openings, and the towers were raised and reinforced. With the addition of a second internal gate, connected to the principal entrance by lateral walls, the new gate complexes in effect became independent fortresses.

Other restorations, principally those of Belisarius, were undertaken in the sixth century AD during the Gothic War. The walls were repaired and reconstructed periodically, and they continued to protect the city until 1870, when papal troops defended them for the last time against the Italian army.

ITINERARY 1

The Servian Walls

The following description of the walls begins from the western side of the Capitoline, which was included within the city's fortified area (FIG. 3).

Even during the earliest phase of construction, the walls, built of cappellaccio, ran at a level halfway up the slopes of the hill. A structure in *opus quadratum* whose remains occupy the summit functioned as a terrace wall during the fourth century BC, although it too may have formed part of the defensive complex. The largest surviving fragment in this area can be seen on Via del Teatro di Marcello. It consists of five rows of cappellaccio blocks incorporated within a modern retaining wall. One of the gates, the *Porta Catularia* (not shown on plan), was probably located nearby; this provided access to the summit of the hill and to the Area Capitolina by means of a long flight of stairs. Another gate stood on the opposite side of the hill, facing northwest, at the foot of the Arx. This was the *Porta Fontinalis*, toward which the *Vicus Lautumiarum* ran from the Forum and from which the Via Flaminia began its course. Several blocks of Grotta Oscura tufa from this gate are still visible in the modern pavement in front of the Museo del Risorgimento.

From here the wall must have run along the saddle that connected the Capitoline to the Quirinal. Excavation on this ridge in preparation for the construction of Trajan's Forum removed every trace of the ancient structure. Two short sections of the wall in cappellaccio belonging to the earliest phase of the fortification are visible on the slope of the Quirinal behind Trajan's Markets, along the modern Salita del Grillo.

A little farther ahead, in Largo Magnanapoli, a more important section of the walls extends for about 10 meters, built of Grotta Oscura tufa and now situated on the circular traffic diverter at the center of the piazza. These are probably the remains of the northern side of a gate, which has been identified as the *Porta Sanqualis*.

Another fragment can be found in the main hall of Palazzo Antonelli (Largo Magnanapoli no. 158), consisting of a stone arch made of Monteverde tufa *(saxum rubrum)* set on piers composed partly of the same tufa, partly of Grotta Oscura tufa. The arch was previously thought to be a gate, but the fact that it sits so high on the wall—the original base of the wall is considerably lower—suggests that this was an opening for *ballistae*. It need not be assigned, as some have argued, to a restoration of 87 BC. The technique employed in the construction appears to be older and would tend to indicate a date between the third and second centuries BC; this being the case, the addition was probably occasioned by the Hannibalic War.

From here the walls continue along the crest of the Quirinal, where two gates must have afforded access to the city: the *Porta Salutaris* and the *Porta Quirinalis*, each taking its name from nearby temples, those of Salus and Quirinus, respectively. The first was located near the present-day Via della Dataria, and the second near Via Quattro Fontane. Remains that have come to light on various occasions belong, almost without exception, to the oldest structure in cappellaccio. One short segment can be seen under the Caserma dei Corazzieri on Via XX Settembre, another in Largo S. Susanna inside the traffic divider.

An important stretch of wall in Grotta Oscura tufa, measuring about 12 meters in length, survives on Via Salandra within the Ministero dell'Agricoltura. Here in 1900 a section of the ramparts was excavated, in which a fragment of red figure Attic pottery, dated to the beginning of the fifth century BC, was found. We can thus assign the second phase of the earthwork to this period.

Two important sections in cappellaccio can be seen at the intersection of Via Carducci and Via Salandra, each more than 11 meters long. These are among the finest and most interesting examples of the archaic fortification wall. The presence of *opus caementicium* in the footings has led some to associate this late addition with the very last restoration of the Servian Wall in 87 BC. It appears more likely, however, that the concrete was added somewhat later, albeit still during the late Republic, to support the aging fortification. Inside a store on the other side of Via Salandra lies another section in Grotta Oscura tufa that is aligned with these two segments and originally connected with the wall preserved within the nearby Ministero dell'Agricoltura.

From here, the walls projected outward, forming a large salient, before turning toward the south; nothing of this section is visible at present, although various fragments were observed during the construction of the area around Piazza Sallustio. One of the city's most important gates, the *Porta Collina*, stood just beyond the southern turn. The remains of this gate were seen during

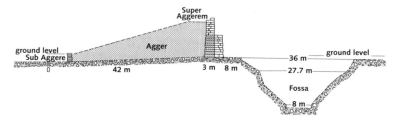

FIGURE 4. Section of the *agger* (rampart) and *fossa* (trench) of the Servian Walls.

construction of the former Ministero delle Finanze under the northern corner of the building. The *Vicus Portae Collinae*—the continuation of the *Alta Semita*, which was the principal axis of the Quirinal—passed through this gate and split off into Via Nomentana and Via Salaria.

The stretch of walls between *Porta Collina* and *Porta Esquilina* (the Arch of Gallienus) flanked the eastern side of the city, the weakest and most exposed section of the enclosed area. For this reason, the walls here were reinforced with an *agger* (rampart) and *fossa* (trench) (**FIG. 4**). Halfway in-between these gates stood *Porta Viminalis*, located at the center of the present-day Piazza dei Cinquecento.

Several ancient writers describe the defensive system; the Augustan author Strabo (5.3.7) reports the following:

> Servius . . . added the Esquiline and Viminal, which could easily be attacked from outside. For this reason, a deep trench was excavated, and the dirt was thrown toward the inner side of the trench, forming an earthwork at the edge of the trench that extended for six stades [1,110 meters]. On top of the earthwork they erected a wall with towers that ran from Porta Collina to Porta Esquilina, at the center of which is a third gate that has the same name as the Viminal Hill.

According to Dionysius of Halicarnassus (9.68.3–4), the length of the *agger* was 7 stades (1,295 meters), a measurement closer, albeit rounded, to the actual length of more than 1,300 meters. Dionysius also records other dimensions, such as the trench's width (100 Roman feet = 29.60 meters) and depth (30 feet = 8.90 meters). The actual measurements are in fact greater (approximately 36 by 17 meters). The discrepancy might be explained by an enlargement of the trench undertaken subsequent to a description of the *fossa* that Dionysius used as his source. A wall about 10 meters high stood at the edge of the trench and supported the earthen rampart that extended 30–40 meters on the city side. The other end of the rampart was in turn supported by a retaining wall.

Some of the most imposing and best-preserved sections of the wall are to be found on Piazza dei Cinquecento, where parallel segments can be seen on

the northern side. The outer section, facing east, is built of Grotta Oscura tufa and Anio tufa, with an inner lining of concrete faced with coarse *opus reticulatum,* a feature that dates this section to the restoration of 87 BC. This work evidently reinforced the section of the earlier wall in Grotta Oscura tufa that can be seen about a meter to the west. To the west of this section (27.50 meters) are two segments in cappellaccio that constituted part of the *agger*'s retaining wall and thus allow us to observe at first hand its thickness at this point. That these segments are part of the archaic wall is clear not only from the material used, but also from the presence of Grotta Oscura tufa in the restoration, which can be dated to the fourth century BC. The wall in this restoration veers toward the east at a right angle, projecting outward in order to respect an earlier cult place. In fact, an altar made of peperino, now preserved in the Capitoline Museums, was found here with a dedication to Verminus, an otherwise unknown divinity but certainly associated with diseases peculiar to livestock. A. Postumius Albinus, probably consul in 151 BC, dedicated this altar, as well as another in Largo Argentina.

Farther south in the square stands a 30-meter-long section of wall, constructed in various types of tufa (Grotta Oscura, Anio, Monteverde, sperone) with four external buttresses, another remnant of the restoration of 87 BC. This is followed by another small stretch of Grotta Oscura tufa. The two walls in sperone located further ahead, perpendicular to the wall and extending outward, are all that remains of the **Porta Viminalis.** There follows, to the left of the facade of the Stazione Termini, perhaps the most impressive extant section of the wall in the entire city. It measures approximately 94 meters long, 10 high, and 4 deep and consists of seventeen courses of Grotta Oscura tufa blocks, many of which still preserve their quarry marks. Above the first eight courses, the typical arrangement of alternating headers and stretchers can be observed. Closer inspection reveals two joins, one 20 meters, the other 36 meters from the southernmost point, each associated with a different construction crew. The irregularity of the blocks facing the interior is explained by the fact that the earthen rampart was built up against the inside of the wall. On the outside are two quadrangular buttresses and the remains of brick walls from buildings of the Imperial period. Excavations have unearthed numerous remains in cappellaccio of the *agger*'s inner retaining wall west of and parallel to this last section; these can now be seen in the subterranean passages of the railroad station. The course of this wall is not exactly parallel to its external counterpart and thus confirms that the two belong to different phases.

Farther to the east, in Piazza Manfredo Fanti, is another important section of the wall constructed in Grotta Oscura tufa, which is 23 meters long and forms an obtuse angle; the remains of a semicircular foundation abut the inside, suggesting the possibility of a buttress or tower. Walls in *opus reticulatum* rest against the outside of the city wall; these clearly belong to a structure built during the last decades of the first century BC, when the walls were no longer needed to defend the city.

A small section of the wall in Grotta Oscura tufa can be seen in Via Carlo Alberto, incorporated at an oblique angle into a modern building. This fragment is aligned with and must originally have reached the nearby Porta Esquilina. This gate, consisting of three entrances, was the terminus of the *agger*. It was entirely rebuilt by Augustus and subsequently dedicated to Gallienus, whence its modern name (FIG. **53**).

From here the course of the walls is less clear. In Largo Leopardi, we find a fragment adjoining the Auditorium of Maecenas, after which a short section of the wall is visible on Via Mecenate, at no. 35a. The walls must have run along the Oppian Hill, down into the valley between it and the Caelian, and then up the Caelian. Of the two gates on the Caelian, the *Porta Querquetulana* must have stood in the vicinity of the Church of the SS. Quattro Coronati; we know the location of the *Porta Caelimontana* because it survives in its Augustan restoration, when it came to be called the Arch of Dolabella and Silanus, near the Church of S. Maria in Domnica. From the Caelian Hill, the walls crossed the valley between it and the Aventine. The *Porta Capena* originally stood not far from the curved end of the Circus Maximus, where a small medieval tower rises and the Passeggiata Archeologica, or "archaeological walk," begins. The Via Appia and the Via Latina left the city from this gate, at first taking the same course but later veering off in different directions. The remains of the gate were excavated in the middle of the nineteenth century.

A section of the wall can be seen inside the Ospizio di S. Margherita, adjacent to the Church of S. Balbina. The concrete core with remnants of its facing in Grotta Oscura tufa would appear to date this fragment to the restoration of 87 BC.

Three segments are visible in Piazza Albania: two in concrete, dressed with blocks of Anio, Monteverde, and Grotta Oscura tufa, dating to the restoration of 87 BC, and another entirely in Grotta Oscura tufa, located in the cellar of the building at Piazza Albania no. 10.

Even more important is the section located nearby on Viale Aventino, the most interesting fragment after that near the Stazione Termini. This surviving portion of the wall measures 42 meters long and as much as 8 meters high; it has a concrete core with facing of Grotta Oscura tufa. Its arch, of Anio tufa on top, resembles the one in Largo Magnanapoli but postdates it; it too functioned as a placement for *ballistae*. Thus this section probably is also a late restoration. There follows another long stretch of wall on Via di S. Anselmo, which is 43 meters long and for the most part constructed of Grotta Oscura tufa, with some blocks of Monteverde and Fidenae tufa. Traces of an earthwork are preserved behind it. The reworking evident here might well date to the third century BC.

A significant fragment can still be seen west of S. Sabina in an underground gallery adjacent to the church. The walls, in cappellaccio, follow the slope of the hill and were subsequently recut to serve as a terrace wall supporting a reconstruction in Grotta Oscura tufa. The discovery of this small portion of the

wall has provided crucial information: not only does it attest to two successive phases in the wall in this area, but it proves that the Aventine had already been included within the city's oldest enclosure, that of the sixth century BC. Three gates punctuated the stretch of wall running east to west between the Small and Large Aventine: the *Porta Naevia* (near S. Balbina), the *Porta Raudusculana* (on viale Aventino), and the *Porta Lavernalis* (south of the Aventine). No remains of these have been found.

One of the most problematic issues regarding the Servian Walls is their course between the Aventine and Capitoline. According to one theory, the side of the city that faced the river would not have been enclosed within the fortification; that is, the walls are believed to have run directly from each hill to the river, leaving the area in between exposed. Thus, the *Porta Trigemina* would have served the wall that stretched from the Aventine to the Tiber, while the section extending from the Capitoline to the Tiber would have contained the *Porta Flumentana* and the *Porta Carmentalis*. Another theory envisages a wall running parallel to the Tiber that descended the Aventine and made its way toward the southwestern corner of the Palatine, from which point it ultimately reached the Capitoline. Recent investigations suggest that a course parallel to the Tiber would appear to be the more likely, although it would have had to run closer to the river than previously thought. Fragments of the wall have been documented at various times near the Church of S. Maria in Cosmedin, the fountain in Piazza Bocca della Verità, and the Temple of Portunus (formerly known as the Temple of Fortuna Virilis). Thus the arches dating to the Augustan period, which were preserved until the fifteenth century near the temple and the Church of S. Maria in Cosmedin, were probably reconstructions of Porta Flumentana and Porta Trigemina. Porta Carmentalis, on the other hand, stood at the foot of the Capitoline near the Area Sacra di S. Omobono.

Toward the end of the third century BC (after 212), this section of the walls was damaged by a fire and successive floods; it was probably reused as a retaining wall for a large embankment erected at that time to control flooding along the Tiber.

ITINERARY 2

The Aurelian Walls

The description of the Aurelian Walls begins from the spot where *Porta Cornelia* (or *Porta Aurelia;* later called Porta di S. Pietro) was located, in front of *Pons Aelius* (now called Ponte S. Angelo), and proceeds clockwise (FIG. 3).

Beginning with the emperor Honorius, the Mausoleum of Hadrian (Castel S. Angelo) was incorporated in the city's fortifications as a redoubt on the right bank. Procopius (*Goth.* 1.22) provides a vivid description of the Goths' attack on

the mausoleum, which the defenders repelled by hurling any available projectile, including the statues that decorated the upper section of the monument.

From here the walls followed the Tiber along the left bank—nothing survives of this segment—and then turned east, running roughly 130 meters up to the point where we find them today; this last-mentioned section, west of the present-day Porta del Popolo, was reconstructed in its new position in 1825. The first remains of the original Aurelian wall begin at the fourth tower west of the *Porta Flaminia*, Porta del Popolo's original name. Via Flaminia left the city from this gate and headed toward the Milvian Bridge, beyond which Via Cassia split off in a different direction.

The present configuration of the Porta Flaminia is the result of a complete overhaul undertaken in the 1500s, with the addition of two side arches in the 1800s. A largely reconstructed stretch of wall, the initial part of which is completely modern, begins from this gate and includes the Pincian Hill, the ancient *Collis Hortulorum*. The modern Via del Muro Torto, which follows the exterior of the walls, owes its name to the large wall in *opus reticulatum* that in antiquity was a retaining wall for the *Horti Aciliorum*. This structure was eventually incorporated within the wall, as Procopius reports (*Goth.* 1.23.4); it had already assumed the pronounced forward slope that gave rise to its modern name.

Porta Pinciana sits at the top of the hill through which ran the oldest part of Via Salaria, *Via Salaria Vetus*. From this point, one of the best-preserved segments of the Aurelian Walls begins; it was fortified with eighteen towers that are well preserved, though largely restored. *Porta Salaria* stood at the southern end of what is now Piazza Fiume. Although the gate was demolished in 1870, its original plan is outlined in the modern pavement. The gate had a single entrance, flanked by two semicircular towers, and through it passed *Via Salaria Nova*, whose route largely coincides with the present-day Via Salaria. Just beyond the gate is a **small latrine,** consisting of a semicylindrical projection resting on two travertine brackets inserted high up into the walls.

The following segment running from here to *Porta Nomentana*, through which *Via Nomentana* passed, is also relatively well preserved (FIG. **5**). The gate lies 75 meters beyond and east of Porta Pia, which replaced it; this gate was erected in 1560 by Pius IV and designed by Nanni di Baccio Bigio, the same architect who designed Porta del Popolo. Although the gate was later walled up, its jambs in *opus latericium* and the semicircular tower to the right of the entrance are still visible; the tower that originally stood on the left was demolished in 1827. A tomb with a concrete core was discovered in the tower; an inscription names its occupant as the praetor Q. Haterius—perhaps the well-known orator who died under Tiberius.

Between Porta Nomentana and the *Castra Praetoria* were two postern gates—one approximately 43 meters from the gate, the other almost adjacent to the *castra*. Both were closed by Honorius. The Pretorian Camp lay completely within

FIGURE 5. Porta Praenestina *(left)*, Porta Nomentana *(right)*.

the walls. The camp's original walls, which measured 4.73 meters high when they were erected under Tiberius, were raised 4.8/5.1 meters (2.5–3 on top and 2.3 at the base, the latter resulting from the exposure of the foundations). Maxentius later added square towers at irregular distances in his restoration of the walls. The gates on the northern and eastern sides were closed; the one on the south probably remained open, although it ultimately disappeared, together with a large part of the southern side. Near the camp, on the south, stood another gate with a travertine facing, whose name is unknown (it is usually referred to as Porta Chiusa because it was closed up and put out of use by a wall erected, undoubtedly, at a considerably later date). The gate can be seen at Via Monzambano nos. 4–6, situated among the modern buildings. It was from here that the road leading from Porta Viminalis in the Servian Wall *(Via Claudia?)* continued to join Via Tiburtina.

From here up to *Porta Tiburtina* the walls are partially preserved. For the most part, only the lower section of the fortification survives, except along those points where openings were pierced to facilitate the continuation of modern streets.

Porta Tiburtina was originally a monumental arch built during the Augustan period (5 BC) to support the three aqueducts *(Aqua Marcia, Tepula,* and *Julia)* that ran above Via Tiburtina (FIG. **6**). The arch was later incorporated into the fortification as a gate, similar to the Claudian arches of Porta Maggiore. Honorius subsequently added a new entrance in front of the older one; this was destroyed by Pius IX in 1869. A well-preserved segment of the walls is still visible on both sides of the gate, facing the outside, although the encroachment of modern houses has all but hidden the ancient structure.

The Augustan arch, built in travertine, is perfectly preserved, including its Tuscan pilasters and keystones decorated with bucrania. It now sits considerably below the modern ground level. The lofty attic, containing the channels of the aqueducts, whose openings are still visible along its sides, carries two inscriptions: one by Augustus dated to 5 BC and the other by Titus dated to AD 79. The latter mentions the restoration of the Aqua Marcia. On the other side, an inscription records Honorius's enlargement of the walls. A tomb was introduced in the tower that lies south of the gate; the name of its occupant, L. Ofilius, son of Gaius, is preserved in an inscription on a travertine slab. For the next 1,275 meters, the walls were built on the arches of the Marcia, Tepula, and Julia aqueducts.

FIGURE 6. Porta Tiburtina *(left)*, Porta Latina *(right)*.

Halfway between *Porta Tiburtina* and *Porta Praenestina*, we find a postern gate, embellished with an architrave, that was already closed in antiquity; this entrance may have provided access to the *Horti Liciniani*, to which the nearby building, known as the Temple of Minerva Medica, belongs. **The facade of a large brick building** was incorporated into the walls between the fifth and sixth towers beyond Porta Tiburtina. It may be the remains of a multistory residence that originally measured some 16 meters high and more than 30 meters long. Two rows of windows (later walled up), the relieving arches above them, and fifteen travertine brackets that originally supported a balcony are still visible. There should have been a tower at the spot where the facade stands, but it was never built.

The next major entrance we encounter is a double gate consisting of *Porta Praenestina* and *Porta Labicana* (today called Porta Maggiore [FIG. 5])—one of the most interesting monuments along the entire course of the wall. The gates were originally two monumental arches of the Aqua Claudia that crossed above *Via Labicana* and *Via Praenestina;* Honorius later added a projecting bastion, inserting two gates into the curtain wall. The **Tomb of Eurysaces** was incorporated within the round central tower. The interior gate, whose remains were discovered during a recent renovation of the square, may date to this second phase. The projecting portion of the fortified gate complex, which we know from prints, was destroyed in 1838. Honorius's inscription, originally affixed to Porta Praenestina, is displayed outside of Porta Maggiore, on the right as you leave the city. The inscriptions on the attic, repeated on both sides, are original: the uppermost was installed by Claudius in AD 52; the lower ones, recording restorations undertaken in AD 71 and 81, were added by Vespasian and Titus, respectively.

The next section of the wall suddenly changes direction and heads east for a good stretch, employing the arches of the Aqua Claudia, which were closed up for this purpose. After reaching the so-called Circus Varianus, of which very little remains, the walls break off from the course of the aqueduct at a sharp angle and head southwest. The resulting salient that was formed at this point included the Imperial palace known as the *Sessorium*, cutting the circus in two.

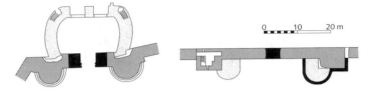

FIGURE 7. Porta Ostiensis *(left)*, Porta Asinaria *(right)*.

One of the most important monuments incorporated in the construction of the wall was the **Amphitheatrum Castrense.** This small structure, built entirely of brick, also constituted part of the Sessorium, predating the wall by only a few decades (it dates, in fact, to the end of the Severan period). Half of the amphitheater's ellipse protrudes beyond the walls; its arches, framed by engaged columns, were closed, and its upper level heightened.

The stretch between the Amphitheatrum Castrense and *Porta Asinaria* is in excellent condition, having been recently restored. At several points along the interior of this section, a second wall walk, rather than a simple gallery, was built on top of the first to compensate for an appreciable drop in ground level. The exterior wall, which collapsed at various times, has been shored up with modern brickwork here and there; the interior wall, on the other hand, is much better preserved, though of difficult access.

Porta Asinaria, restored in the 1950s, lies immediately beyond and at a lower level than Porta S. Giovanni, built in 1574. This was a minor entrance that originally lacked towers **(FIG. 7)**. Honorius added two semicircular towers as part of his restoration, attaching them to the inner side of the preceding rectangular ones. The gate derives its name from *Via Asinaria*, from which *Via Tusculana* branches off further ahead. The stretch of the walls running along S. Giovanni in Laterano is poorly preserved. Another postern gate was excavated in this vicinity in 1868. The large foundations that were incorporated into the walls for a good part of this section (visible behind the sports complex on Via Sannio) were part of the Lateran estate. From here to *Porta Metrovia*, the walls underwent significant reconstruction during medieval and modern times. The gate—today called Porta Metronia—was a simple postern. Numerous openings have been made in the walls at this point to accommodate modern traffic. A nearby tower bears an inscription of 1157 that records a restoration of the walls and gate.

From this point begins what is perhaps the most interesting and best-preserved portion of the Aurelian Walls, forming a large salient that stretches all the way to *Porta Ardeatina*. The Comune di Roma, to which the walls belong, has meticulously restored the entire section and periodically opens the stretch between *Porta Latina* and the Bastion of Sangallo to the public. Examination

of the site gives the visitor a good sense of how the entire defensive structure functioned, as well as providing a lovely setting of gardens and open grounds that are still substantially untouched, despite the recent construction of some pretentious villas.

Porta Latina, through which Via Latina left the city, is one of the most beautiful and best-preserved gates (FIGS. **6** and **8**). The travertine facade is still substantially the one constructed by Aurelian, with only slight modifications added during Honorius's renovations. At that time, the earlier gate, which was considerably larger, was reduced in size, as traces of the original opening clearly reveal. In the upper portion, which may have been raised by Honorius, there are five small arched windows in the portcullis chamber; these were later closed, probably during the Gothic War. The semicircular tower on the left is in large part the one originally built by Aurelian, while the one on the right was reconstructed during the Middle Ages. Constantine's monogram can still be seen on the keystone of the arch. As did many of the walls' principal gates, the entrance featured a double closure: on the outside a door of two leaves, and on the inside a portcullis that ran along slots and could instantaneously cut off access. The vantage court and interior gate, which have completely disappeared, were often represented in prints and sketches from the Renaissance to the eighteenth century.

A small ancient doorway, located behind the western tower of the gate (Tower 1), provides access to the rampart-walk and the portcullis chamber, whose brickwork dates to the seventeenth century (FIG. **8**). The loopholes along the rampart-walk running between the aforementioned tower and the subsequent one (Tower 2), as well as those that follow, were enlarged in the nineteenth century. This second tower is medieval, dating from the twelfth century. From this point, the walls, angling off noticeably toward the southeast, were extensively reconstructed in the fifteenth century, as the coat of arms of Pius II, displayed on the exterior of the walls, reveals. Tower 3 has partially collapsed, and Tower 4 almost completely (the latter has been replaced in part by a modern wall); all of Tower 5 is missing. The exterior wall between Towers 5 and 6, of which little remains as well, was partially restored in 1562—commemorated by the coat of arms of Pius IV—and partially (the upper section) in the eighteenth century. After Tower 7, which still has its lower half, the walls turn toward the west; the walls between Towers 7 and 8 date to the mid-seventeenth century, as the coat of arms and inscription of Alexander VII attest. Even in the stretch between Towers 8 and 9, only the lower section is original, while the upper part of the wall is eighteenth century. The rampart-walk from Tower 9 (of which little remains) to Tower 10 is very well preserved. The restoration of Tower 10 in 1623 is documented by the coat of arms and inscription of Urban VIII. The following stretch up to Tower 11 is also well preserved and, like the previous section, consists of six archways; the lower part of this tower is

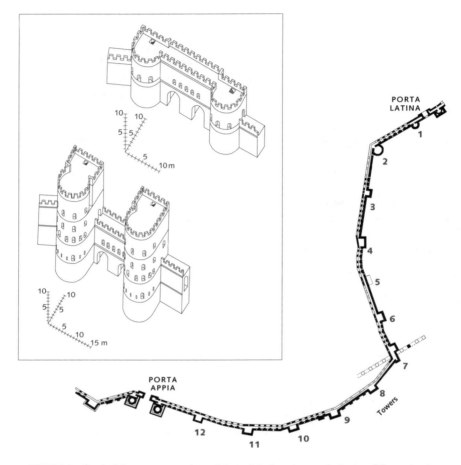

FIGURE 8. *On the left,* a reconstruction of the original and second phases of Porta Appia (S. Sebastiano); *on the right,* the Aurelian Walls between Porta Latina and Porta Appia, with towers.

original, the upper part medieval. The rampart-walk that follows—also well preserved—is slightly longer than the preceding one, spanned by seven arches. The next main gate, Porta S. Sebastiano, is reached by the rampart-walk that extends from the last tower along this section, Tower 12, which is largely reconstructed.

In antiquity, Porta S. Sebastiano was known as *Porta Appia.* This is the largest and best-preserved gate of the Aurelian Walls, equal in importance to the road passing through it—*Via Appia*—that gave its name to the gate. Five distinct phases in its construction can be observed (**FIG. 9**):

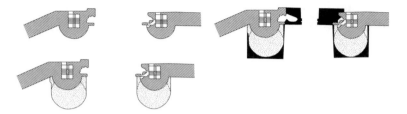

FIGURE 9. The structural phases of Porta Appia (S. Sebastiano). The shaded area indicates the wall of Aurelian, the speckled area the addition of Maxentius, that in black the addition of Honorius.

1. In the first phase—dating to the reign of Aurelian (271–75)—two identical archways were set between two semicircular towers, as was always the case for the major gates of this period; the impost block of one of these arches can still be seen on the inside of the gate on the right as you leave the city. As in Porta Latina, there was a second floor with arched windows.

2. The first reconstruction consisted of an enlargement of the original towers. The new towers, incorporating the earlier structures, were raised by one story and given a horseshoe plan. A vantage court was possibly added at this time, which used as its interior gate a preexisting arch, the so-called Arch of Drusus. The western side of the court still survives.

3. In the third period, the large square bastions with marble facing were added to the towers, probably by Honorius.

4. The fourth period involved nothing more than some internal repairs.

5. Finally, in the fifth period the towers and the main body of the gate in between were raised another story. The projecting bosses left in the marble blocks that dressed the lower part of the monument are particularly interesting. Of the various explanations offered, the most likely identifies these marks as indicators of work completed by the stonecutters. Another interesting feature is the figure of the Archangel Gabriel, engraved on the left doorpost of the gate as one enters. An inscription, written in medieval Latin, records the victory of the Romans in battle against Robert d'Anjou, king of Naples, on 29 September 1327. The gate's opening, like Porta Latina's, was secured by a door of two leaves and a portcullis that was lowered along slots from the chamber above the gate.

The interior of the gate, which was recently restored, underwent many transformations, especially in 1942–43, when the secretary of the Fascist Party, Ettore Muti, turned the monument into his residence. During this renovation, mosaics were installed in several of the rooms, including the portcullis chamber,

where the travertine brackets that supported the portcullis are still visible. The Museo delle Mura is now housed in the same chamber and adjacent towers.

Of particular interest is the next section of wall, between Porta S. Sebastiano and the Bastion of Sangallo, which is open to the public. A late Byzantine Madonna and Child can be seen in the fourth tower from the gate. The original structure of the rampart-walk between the first and sixth towers and between the tenth and eleventh is particularly well preserved. The eleventh tower has its original stairs, allowing access to the upper level of the wall, which offers a panoramic view of the wall complex. Immediately beyond this tower, the walls turn a corner at a well-preserved postern gate that was closed during one of the later reconstructions. At this point, the walls incorporate an **early Imperial tomb.** The tour of the gallery concludes at the fourteenth tower, which was completely destroyed. The great bastion, begun in 1537 by Antonio da Sangallo, begins here. Here, too, stood *Porta Ardeatina*, destroyed together with a section of the walls to facilitate construction of the bastion.

After the Bastion of Sangallo, the walls proceed northwest along a straight line and then turn to the southwest, forming a reentrant to include the far slopes of the Lesser Aventine. There is evidence of many restorations, particularly during the Renaissance; almost all the towers are reconstructed.

The next gate is Porta S. Paolo, the ancient *Porta Ostiensis*, similar to Porta Appia in its excellent state of preservation (FIG. 7). Here, too, various phases of reconstruction can be discerned. In the first phase, the gate had two entrances framed by semicircular towers. During the reign of Maxentius, two walls were added, describing a tong shape, together with an interior gate that, like the main gate, had two travertine arches. This is the only fully preserved example of the vantage courts added at the rear of the principal gates of the Aurelian Walls. At that time the towers received a new facing. As was typical under Honorius, the two external arched entrances were reduced to one (the two openings of the interior gate, however, were preserved in their original state). The towers were raised at this time. Later modifications are also visible. In AD 594, the Goths under Totila entered Rome through this gate.

Via Ostiensis ran from this gate to Ostia, the ancient port of Rome. The gate complex is now occupied by the Museo della Via Ostiense. Here models of Ostia and of the ports of Claudius and Trajan are on display, as well as casts of reliefs and inscriptions that reconstruct the course and monuments of the ancient road. Of special note are three painted lunettes decorated with images of Prometheus, birds, and other subjects displayed in the portcullis chamber between the two towers. These once decorated a Severan tomb that was cut into the rock facing the apse of S. Paolo fuori le Mura (Saint Paul Outside-the-Walls).

Immediately to the west of the gate is one of the most fascinating tombs of the early empire, the **Pyramid of Gaius Cestius,** which, like so many other monuments, was incorporated into the walls. Beyond the pyramid was a postern gate that may have been connected with the oldest Via Ostiensis, whose earliest

course once ran in this direction. This entrance had already been eliminated by the time of Maxentius, as attested by a brick stamp discovered in the wall that closed off the gate. Its remains were demolished in 1888. The following section proceeds in a straight line toward the Tiber and encloses the Emporium and Monte Testaccio; it shows evidence of considerable periodic repairs. After the walls reached the river, they ran north for more than 800 meters, but this section has completely disappeared. They resumed on the opposite bank of the Tiber. During the Middle Ages, two towers were erected at this vulnerable point in the city's defenses; between these a chain was extended across the river, cutting off all river traffic during emergencies. A similar stratagem was undoubtedly employed in ancient times.

The walls on the right bank of the river—now almost completely gone— enclosed a portion of Trastevere; the Vatican hill and valley lay outside of the fortification. The enclosed area described a triangle, with a vertex on the Janiculum where Porta S. Pancrazio is located; the latter replaced the ancient Porta Aurelia, named for *Via Aurelia*, which left the city through this gate.

Two other gates provided access to and from Trastevere. On the south was *Porta Portuensis*, from which *Via Portuensis* led to the ports of Claudius and Trajan; the gate was destroyed in 1643 and replaced by Porta Portese, which lies considerably north of the original gate. The other gate stood opposite Porta Portuensis on the north, at the spot where the present Porta Settimiana (built in 1498) now rises. Only the slightest traces of the Aurelian Walls survive in Trastevere, and little remains of the stretch that ran along the left bank up to Porta Cornelia (modern Porta di S. Pietro) in front of Pons Aelius (where this description of the walls began). The Arch of Gratianus, Valentinianus, and Theodosius, built between AD 379 and 383, was located here. It may have been associated with the contemporary enlargement of the walls, which, as mentioned above, included the Mausoleum of Hadrian.

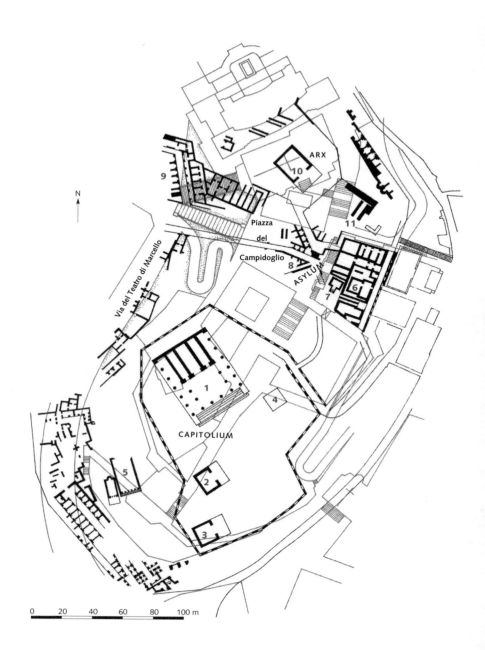

FIGURE 10. Map of the Capitoline in antiquity. **1** Temple of Jupiter Optimus Maximus. **2** Temple of Ops Opifera. **3** Temple of Fides. **4** Ara Gentis Iuliae? **5** Unidentified temples from the Severan Marble Plan. **6** Tabularium. **7** Temple of Veiovis. **8** Buildings of the Imperial period. **9** Insula of the Ara Coeli. **10** Traditional location of the Temple of Juno Moneta. **11** Probable remains of the Temple of Juno Moneta and of the Auguraculum.

CAPITOLINE

HISTORICAL NOTES

The Capitoline is the farthest projection of a group of hills that breaks off from the plateau northeast of Rome and extends almost to the Tiber. Originally a saddle joined the Capitoline to the Quirinal, but this was carved away by Trajan in the construction of his forum. Located at the northwestern end of the area enclosed within the Servian Walls, the hill overlooks Tiber Island and the river's ford. The Capitoline separates the Campus Martius from the Roman Forum and Forum Boarium, two early marketplaces that lie in the valley formed by the watercourse running through the Velabrum. Because of its strategic position and physical characteristics, the hill readily served as a citadel, probably as early as the archaic period. The Capitoline measures only about 460 meters in length (running northeast to southwest) by 180 meters in width, making it the smallest of Rome's hills. The only side affording easy access is the southeastern corner, which faces the Forum and thus the interior of the city. Although the summit ascends to 46 meters above sea level in the area of S. Maria in Aracoeli, what made the Capitoline formidable was not its height but its configuration, with sheer cliffs on each side except that facing the Quirinal. The hill itself actually consists of two peaks, the *Capitolium* and *Arx*, separated by a depression, the *Asylum;* these features can still be observed (FIG. **10**). The Piazza del Campidoglio

occupies the area of the depression. Two stairways by Giacomo da Vignola, ascending the hill to the left and right of the piazza, lead respectively to the Church of S. Maria in Aracoeli (on the Arx) and to the garden alongside Via del Tempio di Giove (on the Capitolium).

According to ancient tradition, it was here that Saturn established the region's first community, which was destined to become Rome. At the foot of the hill, an altar—to which a temple was added at the beginning of the Republic—and a gate were dedicated to the god. Bronze Age pottery (fourteenth to thirteenth centuries BC), discovered at the base of the hill in the Area Sacra di Sant'Omobono, as well as Iron Age ware recently found near the southern entrance of the *Tabularium*, appears to confirm the antiquity of the Capitoline village.

At the time of Romulus, the Sabines are said to have captured the Capitoline as the result of the treachery of a Roman woman named Tarpeia, who, the tale goes, opened the gates to the invading army. As a "reward" for her help, the Sabine soldiers killed the traitor by burying her under their shields. It is very likely that Tarpeia was in fact the name of the tutelary deity of the place, since *Mons Tarpeius* is probably the oldest name of the hill, and one of its precipices bore the title *Saxum Tarpeium*, "the Tarpeian Rock." The statue of the divinity, portrayed rising out of a heap of arms in the manner of a *tropaeum* (trophy), might well have inspired the legend. When Romulus founded the city, tradition has it that he established a place of refuge for deserters from the nearby communities in the depression; this came to be known as the Asylum from the function it served. This small valley, flanked by two summits, was also called *inter duos lucos*, "between the two groves."

One of the most important events in the history of the Capitoline is the building of the great temple dedicated to Jupiter, Juno, and Minerva. Tradition assigns the earliest stages of construction to the first Etruscan king, Tarquinius Priscus, and its completion to Tarquinius Superbus. The inauguration—or possibly its *re*inauguration—did not take place until the beginning of the Republic: 13 September 509 BC. The temple housed the Sibylline Books, collections of prophecies of Greek origin that were brought here by Tarquinius Superbus. Other sanctuaries predated the temple, including the Temple of Jupiter Feretrius, whose founding is traditionally attributed to Romulus; like the later Temple of Jupiter, it was the focal point for the celebration of the Triumph. The older sanctuaries of Terminus and Iuventas, which stood in the area later occupied by the Temple of Jupiter, could not be uprooted and were thus incorporated within the new building. The most famous event that took place on the Capitoline is the defense of the hill when the city was sacked by the Gauls in 390 BC. Within a few years, in 383 BC, the hill was buttressed with an enormous terrace wall, which must also have served as a fortification.

In 133 BC, Tiberius Gracchus was killed near the temple during a meeting of the people. A statue of this revolutionary tribune was later erected at the spot where he died—possibly at the top of the stairway leading down to the

Campus Martius from the vicinity of the Temple of Jupiter. The statue came to be venerated as if that of a god. In 83 BC, the Capitoline was almost completely destroyed in a devastating fire. The Temple of Jupiter went up in flames, and with it, the Sibylline Books. Q. Lutatius Catulus, one of Sulla's followers, assumed the task of reconstruction, which continued until at least 69 BC. Thanks to a recently discovered inscription, we now know the name of the architect, or rather of *one* of the architects, who collaborated on the project: Lucius Cornelius. In AD 69, the tumultuous year that followed the death of Nero, a battle broke out around the hill between the partisans of Vespasian, who had taken refuge there, and those of Vitellius. A terrible fire erupted, destroying the Capitoline for a second time. The new emperor Vespasian had just restored the buildings when fire broke out yet again in AD 80 during the reign of Titus; the conflagration that had ravaged the Campus Martius reached the Capitoline and destroyed buildings that had only recently been reconstructed. The task of reconstruction then fell to Domitian, who became emperor in AD 81 after the death of his brother Titus. Several monuments associated with this last project still survive, including the Porticus of the Dei Consentes and the Temple of Vespasian and Titus, both of which lie on the slope of the hill facing the Forum.

The only carriage road that went up to the Capitoline was the *Clivus Capitolinus*, a continuation of the Sacra Via, that began at the Arch of Septimius Severus. A considerable segment of the road can still be seen immediately beyond the Porticus of the Dei Consentes. Farther ahead, the road collapsed, together with a large section of the southern slope of the hill; the road must originally have continued for a while along a straight line, before veering north until it reached the Area Capitolina in front of the Temple of Jupiter. This was the last stretch of the triumphal procession.

We know of only two other approaches to the Capitoline: the *Scalae Gemoniae* and the so-called *Centum Gradus*. The first went up to the Arx and corresponds approximately with the modern stairway between the *Carcer* and the Temple of Concord. The bodies of criminals executed in the nearby prison were exposed here. Ancient writers also mention the *Gradus Monetae*; quite likely this was an extension of the Scalae Gemoniae that led to the Temple of Juno Moneta, situated on the highest point of the citadel. Another stairway, constituting the second approach, rose toward the Area Capitolina along the side of the hill facing the Area Sacra di Sant'Omobono. Centum Gradus (Hundred Stairs) is the name generally ascribed to this stairway on the basis of a passage in Tacitus (*Hist*. 3.71). Yet the title was neither its formal name nor an accurate designation for this ascent; it more aptly describes the length of a different stairway, the Gradus Monetae that led to the summit of the Saxum Tarpeium. In all probability, the latter formed a part of the Arx, and not of the Capitoline, as is commonly held. In fact, we know that this celebrated peak stood above the Forum. The executions that took place here might well have been closely, and quite naturally,

associated with the Carcer just below and with the nearby tribunals of justice in the Comitium.

Some of the Roman state's most important political functions and formal ceremonies took place on the Capitoline. Here the *Comitia Tributa* met (at least for a certain number of years during the Republic), and here triumphal processions concluded in front of the Temple of Jupiter, where the victorious general offered a sacrifice. It was also here, on 1 January, that the ceremony investing the consuls with *imperium* was celebrated, and from here that governors left for their provinces. A recently discovered document suggests that the military *Aerarium* was located in the vicinity of the Temple of Ops Opifera in the Area Capitolina; Augustus founded the building as an annex to the civil Aerarium located in the Temple of Saturn.

ITINERARY

The Temple of Jupiter Optimus Maximus (Capitolinus)

Of the two peaks on the Capitoline separated by the Asylum saddle, the Capitolium to the south was the more noteworthy because of the political and religious functions that were celebrated on the summit from the sixth century BC onward. It was here that the Roman state established its most important cult center—the Temple of the Capitoline Triad: Jupiter Optimus Maximus, Juno Regina, and Minerva (FIG. 10:1, FIG. 11). The Etruscan dynasty under the Tarquins constructed this sanctuary during the sixth century BC, evidently hoping to draw the political center of the Latin League to Rome and replace the league's traditional cult center on *Mons Albanus* (present-day Monte Cavo), which stood nearby and was associated with Alba Longa, the early regional capital of the Latin peoples. Some of the most important ceremonies of the Roman state took place at the Temple of Jupiter and in the open space in front of it *(Area Capitolina)*, including the taking of auspices by a magistrate setting off on a military campaign and the solemn sacrifices offered by victorious generals at the conclusion of the triumphal procession. The Sibylline Books, housed inside the temple within a stone case, were consulted in times of great peril by a special board of priests, the *quindecemviri sacris faciundis*, whose membership over time increased to fifteen from an original two. Augustus transferred this collection of oracles, reconstructed after the fire that destroyed them in 83 BC, to the Temple of Apollo on the Palatine.

Only a few sections of the temple's foundations survive: the eastern corner of the facade facing south on Via del Tempio di Giove; a section of the rear on the north opposite the garden in Piazzale Caffarelli; and a considerable portion of the central core in the Museo Nuovo Capitolino. The overall dimensions of

FIGURE 11. Temple of Jupiter Capitolinus. Plan and conjectural reconstruction of the facade.

the building—oriented along a roughly north-south axis—are impressive: some 53 by 63 meters. The material (cappellaccio, the highly friable tufa that lies on the surface of the area around Rome) and the construction technique identify these ruins as part of the foundations of the original sixth-century BC temple, and not, as has been supposed, those of a fourth-century BC reconstruction, for which there is no evidence. Thus, this is the largest known Etruscan temple of the archaic period.

Since we lack details about the elevation of the temple, it is difficult to formulate a reconstruction of its overall appearance. A single painted roof tile of the original building survives, preserved in the Capitoline Antiquarium. It is nonetheless clear that the temple differed in several respects from the theoretical model of the Etruscan temple described by Vitruvius. It is likely that the three cellas, one for each of the divinities housed here, did not occupy the entire width of the podium, but only a portion of it, that there were colonnades (possibly comprising six columns) along both sides, and that the back wall was blind, as was common in Italic temples (FIG. **11**). There were probably six columns along the front of the building, and there must have been two other rows of columns between the facade and the front walls of the cella that supported the beams of what was a very deep pronaos. We know that the central cella was dedicated to Jupiter, the one on the right to Minerva, and the one on the left to Juno.

The ridge *(fastigium)* of the earliest building was decorated with a magnificent acroterium: a painted terracotta four-horse chariot (quadriga), attributed to

artists from Veii. The cult statues, also of terracotta, and the rest of the temple's architectural ornamentation came from the same workshop, which was under the direction of the master artist Vulca, as Pliny the Elder (*NH* 35.157) informs us. Although nothing remains of these celebrated works, a fortunate discovery that occurred in Veii at the beginning of the twentieth century suggests their original appearance. The large sculptural acroteria that decorated the peak of the Portonaccio Temple in Veii might well have come from Vulca's workshop. Among these is the famous Apollo housed in the Museo di Villa Giulia in Rome. The original terracotta quadriga was replaced in 296 BC with a bronze one, thanks to the aediles in office that year, the Ogulnius brothers, who were also responsible for a bronze she-wolf erected in the Comitium.

The fires that devastated the Capitoline in 83 BC, AD 69, and 80 consumed the superstructure of the temple. The first reconstruction was probably in marble, as can be inferred from Pliny the Elder (*NH* 36.45), who reports that Sulla appropriated the huge columns of the Temple of Olympian Zeus in Athens for the purpose. Q. Lutatius Catulus, a partisan of Sulla, oversaw this reconstruction, which was probably carried out by the Roman architect Lucius Cornelius. The work dragged on for a long time, either because of fiscal shortfalls during those years or because of political infighting (Caesar tried to have the management of the reconstruction taken away from Lutatius Catulus). The dedication took place in 69 BC, but the cult statues were completed later, around 65, as Cicero remarks in *De Divinatione* (2.46). We even know the name of the sculptor, Apollonius of Athens, possibly the same Apollonius, son of Nestor, who signed the famous Belvedere torso in the Vatican Museums. Moreover, we can reconstruct the huge chryselephantine (gold and ivory) statue of Jupiter on the basis of replicas made for other temples of Jupiter Capitolinus in the colonies and *municipia;* the Jupiter of Otricoli in the Vatican Museums offers a useful example.

The Area Capitolina

The large space that opened up in front of the temple was called the Area Capitolina. Continuous landslides have eaten away at this section of the Capitoline since antiquity. What remains of it is now occupied by the public garden alongside Via del Tempio di Giove. An enormous number of buildings, monuments, and statues once filled the spacious square; most, however, survive only in the records of ancient writers. There came to be so many statues that it was occasionally necessary to remove them from the square, as happened in 179 and 167 BC and later under Augustus, who transferred the statues to the Campus Martius.

All that survives today of the Area Capitolina is the **foundation of a building**—and of this, only its concrete core. This structure was discovered at the end of the nineteenth century during the construction of Via del Tempio di Giove, which bisected the wall at an angle; the flint chips of the concrete can

be seen embedded in the walls on either side of the street. The building to which this belonged, dated to the beginning of the Imperial period, occupied a higher level but followed the same orientation as the Temple of Jupiter Capitolinus, aligned with its right side. A recent hypothesis identifies this as the base of the altar of the *gens Iulia* (FIG. **10:4**), possibly the *Ara Pietatis* that was vowed by the Senate when Livia, the wife of Augustus, was seriously ill in AD 22, and finally dedicated in AD 43 by Claudius. The square plan of the concrete core, its date and dimensions (15 × 15 meters) accord with this monument's function; it likely resembled the *Ara Pacis*, which measures 11.65 × 10.625 meters. Some reliefs, inserted into the rear facade of the villa Medici, as well as fragments found in the vicinity of the Capitoline, are probably remnants of this altar.

The **Temple of Fides** was recorded as one of several sanctuaries in the Area Capitolina; the building probably occupied the southern side of the square (FIG. **10:3**). Architectural and sculptural fragments discovered near the Church of Sant'Omobono, where they came to rest after tumbling from the hill's peak, may be remains of this temple. These include a chunk of a podium in *opus caementicium*, fragments of travertine columns, and a large marble head of a woman, probably that of the cult statue. These ruins are generally assigned to the Temple of Ops Opifera that also stood at the edge of the Area Capitolina, but this shrine was probably located a little farther to the north (FIG. **10:2**). The discovery of bilingual inscriptions contemporary with the fragments mentioned above supports the identification of the building as the Temple of Fides (Fidelity, Trust). These dedications in Latin and Greek were offered by peoples of Asia Minor around the end of the second to the beginning of the first century BC. Originally they would have been displayed near the Temple of Fides, since that divinity guaranteed treaties and diplomatic relations and safeguarded the loyalty of soldiers. Bronze tablets certifying the honorable discharge of legionaries *(tabulae honestae missionis)* were kept here until the reign of Domitian, thus confirming the location of the temple, near which the original documents were housed. A copy of each document was issued to the individuals concerned; these, as one might expect, are the copies that were discovered in various cities of the empire.

Among the material that has tumbled down in landslides from the top of the Capitoline are fragments of a base of black marble, decorated with reliefs depicting Victories, trophies, and weapons (now in the Capitoline Museums). This probably supported a bronze group representing the surrender of Jugurtha to Sulla, offered as a gift to the Romans by King Bocchus of Mauretania. The subject of this monument clearly undercut Marius's part in the Jugurthine War; indeed, the gift, among other causes, provoked the bitter rivalry between Marius and Sulla that ultimately led to civil war.

Among the earliest remains from the Capitolium is the votive deposit that was discovered under the modern Protomoteca; the oldest of these objects dates to the seventh century BC. A three-branched cistern hollowed out of the hill's

tufa is probably contemporaneous; it stood in the area now occupied by the Museo dei Conservatori. A bucchero cup found along the Clivus Capitolinus is particularly important because its inscription confirms the presence of the Etruscans in Rome during the sixth century BC.

The Tabularium

The best preserved of the ancient structures on the Capitoline lie within the depression between the Capitolium and Arx, known as the Asylum. Of these, the most important is the Tabularium (FIG. **10:6,** FIG. **12**), whose imposing substructure still dominates the valley of the Forum. Although textual sources are silent regarding this monument, built to house the archives of the Roman state, an inscription, copied during the Middle Ages and subsequently lost, names the building (as well as its builder) and records the date of its construction:

> Q(uintus) Lutatius Q(uinti) f(ilius) Q(uinti) n(epos) Catulus co(n)s(ul) / substructionem et tabularium / de s(enatus) s(ententia) faciundum coeravit eidemque / probavit. (CIL VI. 1314). (Quintus Lutatius Catulus, son of Quintus, grandson of Quintus, consul, undertook the building and inspection of the foundation and tabularium in accordance with a resolution of the senate.)

The name *tabularium* derives from the documents that were housed there: the *tabulae publicae.* An almost identical inscription, lacking only the name of the building complex, was discovered in the eighteenth century and moved by the archaeologist Luigi Canina to the northeastern side of the monument, where it can still be seen today:

> [Q. Lu]tatius Q(uinti) f(ilius) Q(uinti) n(epos) C[atulus co(n)s(ul) / de s]en(atus) sent(entia) faciundu[m coeravit] / eidemque [p]rob[avit]. (CIL VI. 1313). (Quintus Lutatius Catulus, son of Quintus, grandson of Quintus, consul, undertook the construction in accordance with a resolution of the senate.)

The first inscription was engraved on the blocks of a lintel that certainly belonged to this building, indicating that this must be the *substructio* and *tabularium* mentioned in the text. We can safely assign the building to Quintus Lutatius Catulus, the official charged with the reconstruction of the Capitoline after the fire of 83 BC. Given that Catulus was consul in 78 BC, it is likely that work on the Tabularium began in that year, lasting perhaps until 65, the year he became censor (only to resign immediately thereafter). Accordingly, the Tabularium must have been completed in some haste; work on the Temple of Jupiter Capitolinus took much longer. A recent discovery has brought to light the name of an architect who worked for Lutatius Catulus and who might well have been the principal designer of the building:

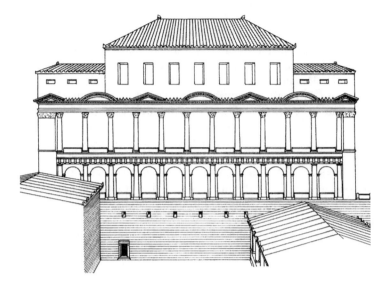

FIGURE 12. Reconstruction of the facade of the Tabularium.

L(ucius) Cornelius L(uci) f(ilius) Vot(uria tribu) / Q(uinti) Catuli co(n)s(ulis) praef(ectus) fabr(um) / censoris architectus. (Lucius Cornelius, son of Lucius, belonging to the Tribus Voturia, prefect of engineers for Q. Lutatius Catulus during his consulship and architect during his censorship.)

Lucius Cornelius, a Roman citizen, perhaps originally from Ostia (to judge from his tribal affiliation), must have worked for Catulus between 78 and 65 BC, evidently on the reconstruction of the Capitoline.

The distinction that the dedicatory inscription makes between the *substructio* and *tabularium* aptly describes what survives of the monument: a large basement complex that hides the Asylum saddle on the side of the hill facing the Forum, on which stood the Tabularium proper, now almost completely gone. The building has a trapezoidal plan, with its shorter sides, northeast and southwest, converging in the direction of Piazza del Campidoglio. The foundation rises on a step cut into the tufa; it supported a large embankment that regularized the level of the hill. The massive retaining wall, 73.60 meters long, is the most conspicuous feature of the building today. Two different tufas were used in its ashlar construction: sperone on the outside and Anio tufa on the inside. The vaults and the substructures of the first floor are of concrete. Six small windows on the first floor of the facade illuminated the long corridor within (**FIG. 12**). The last window on the right was clearly inserted slightly left of its expected position in order to respect the Temple of Concord, an earlier Republican building. Two

entrances, at the opposite end of the building on the southwest, provided access from the Forum. The entrance on the ground level is a large doorway spanned by a lintel surmounted by a relieving arch; of particular interest is the threshold of Pentelic marble, which is among the earliest examples of the use of this marble in Rome. Under Domitian, this entrance was closed to construct the Temple of Vespasian and Titus. Originally, it gave access to the arcaded gallery on the next level through two flights of stairs perpendicular to the facade and from there to the upper level, now completely gone. The barrel vault and sixty-six travertine steps of the first flight survive intact.

Another entrance, topped by a round arch, lies a little to the left of the first, behind the Porticus of the Dei Consentes, but at a considerably higher level. Above this opening, a pier of the upper gallery is distinguished from the others by the absence of a decorative half-column; this indicates that the pier was not originally visible, for it was hidden by a building older than the Tabularium and backing onto it. This structure was probably destroyed in the fire of AD 80 and replaced by the Porticus of the Dei Consentes. The raised doorway provided access to the upper floor and, by way of an obliquely angled entrance, to the corridor that ran the entire length of the building; this barrel-vaulted passageway was illuminated by windows that were originally fitted with grilles. At the opposite end, on the northeastern corner, a flight of stairs rose to the upper gallery and gave access to a series of rooms with communicating passages.

These features may well explain the function of the entire complex. The older building abutting the Tabularium was probably associated with the Aerarium, connected to the nearby Temple of Saturn, where the oldest archives of the Roman state were located. The Tabularium, then, may have been nothing more than an extension of this older building. It is noteworthy that the windowed corridor ran straight from this earlier building to the Arx, which housed the mint. Thus, newly minted coins could be delivered to the Aerarium directly through this hidden and well-protected passageway.

The broad open gallery on the first floor linked the Capitolium and the Arx directly. The gallery, originally paved in basalt (as we know from a section of the pavement still visible in the nineteenth century), was essentially a covered passageway *(via tecta)*. The gallery consists of a series of twelve piers connected to each other and to the rear wall by round arches; the square spaces so formed are spanned by eleven pavilion vaults. Fluted Doric semicolumns with travertine bases and capitals decorated the facade of the piers. The architrave above this, adorned with *regulae* and *guttae*, is also in travertine; the conventional Doric frieze of metopes and triglyphs that must have surmounted the architrave has disappeared. The gallery affords access to several rooms, three on the southwest and two on the northeast, whose function is no longer clear (they may have been shops). Behind these rooms, four vaulted chambers contained within the concrete core were originally inaccessible; these must have corresponded to another set of four halls on the second floor, to which the second flight of

stairs led. On the northeastern side facing the Arx are four large adjoining and interconnected rooms, the first of which could be entered through stairs leading from the corridor below. These may have been part of the *Moneta* (the Republican mint); at any rate, they presume the existence of a second floor, of which traces remain. On the lintel of the door between the first and second of these rooms is the inscription of Lutatius Catulus.

The facade of the Tabularium is better preserved on the opposite end facing the Capitolium. Northwest of the entrance to the gallery lies a large trapezoidal niche, whose opening is spanned by a lintel; its function is unknown. Here remnants of basalt pavement can be seen; these belonged to a side street branching off from the Clivus Capitolinus and heading toward Piazza del Campidoglio, where the building's principal facade must originally have been located. A recess in the western corner of the building, still visible in the basement of Palazzo Senatorio, accommodated the older Temple of Veiovis.

Almost nothing remains of the second floor, the main part of the Tabularium proper. The foundations suggest that this portion of the building, fronting Piazza del Campidoglio, had a monumental facade and contained several large rooms. A large colonnaded porticus, about 13 meters high, on the opposite side of the building just above the gallery looked out on the Forum. Numerous remains of this porticus (capitals, bases, column drums, fragments of travertine cornices) have been found on the ground below. Most of these now lie in the vicinity of the Porticus of the Dei Consentes.

The Tabularium is one of the most interesting surviving examples of late Republican architecture, which, spanning the middle of the second to the middle of the first century BC, spread throughout central Italy and is especially evident in the sanctuaries at Palestrina, Tivoli, and Terracina. The Tabularium bears a particular resemblance to the sanctuary of Hercules in Tivoli, built during the Sullan period, particularly in its systematic use of several architectural novelties such as the pavilion vault and the arch framed by engaged columns, a feature subsequently employed with considerable frequency in Roman architecture.

Two items of particular interest are displayed inside the gallery, which offers an extraordinary view of the Forum: a section of the upper cornice of the Temple of Concord (an Augustan reconstruction) and a cast of the architrave of the Temple of Vespasian and Titus decorated with images of sacrificial instruments. On display in the other rooms are several mosaics from buildings that were demolished to make room for the Tabularium; these are among the oldest mosaics in Rome (not later than the second century BC).

The Temple of Veiovis and the Arx

The southwestern corner of the Tabularium is recessed to accommodate an older building, which was discovered in 1939. This has been identified as the Temple of Veiovis, a young divinity of the underworld (FIG. **10:7**). We know

that the temple was dedicated in 192 BC and that it first underwent renovation in the middle of the second century BC. The surviving structure belongs to a later phase, probably contemporary with the construction of the Tabularium (78 BC); later brickwork suggests a restoration during the reign of Domitian, certainly after the great fire of AD 80. The building has a rather unusual form, similar to that of the Temple of Concord and likewise determined by limitations of space. In *De Architectura* (4.8.4), Vitruvius describes the temple as standing on a travertine podium with a stairway leading to a pronaos, four columns wide, and a cella that was wider than it was deep. A small marble altar occupies the floor of the pronaos, while the large cult statue is now housed in one of the nearby rooms of the Tabularium. Found in the vicinity of the temple, the statue is unfortunately missing its head and hands as well as other distinguishing features.

The Temple of Juno Moneta (the warner), the most important shrine on the Arx, does not appear to have been built before 343 BC, although the cult is certainly older, as can be deduced from the archaic architectural terracottas found in the garden of S. Maria in Aracoeli. Tradition attributes the temple's construction to the son of Camillus, who was supposed to have built it after a victory over the Aurunci. Later on, Rome's mint was established near the sanctuary, which gave its name to the money coined there. *Moneta*, the modern Italian word for "coin," is also the root of the English word "money."

Structures of various periods can be seen in the little garden at the foot of S. Maria in Aracoeli, north of the Tabularium (FIG. **10:10**); their function, however, is difficult to ascertain. The cappellaccio blocks belong to an archaic wall; the ashlar walls constructed of Fidenae tufa, peperino, and concrete would appear to form a large podium. The ashlar walls have been tentatively identified as the ruins of the Temple of Juno Moneta; the older cappellaccio blocks, on the other hand, might belong to the *Auguraculum* (FIG. **10:11**). This sanctuary, located on the Arx and aligned with the Comitium, was the site of very old and important ceremonies, such as the ritual "inauguration" of the king, described in the case of Numa by Livy and Plutarch; the sacrifices performed by the king-priest on the Nones of each month were called the *Sacra Nonalia in Arce*, and the functions were overseen by the college of augurs, which was integral to the political life of the city.

Other Buildings on the Capitoline

Several eastern cults settled on the Capitoline as early as the late Republic and left their mark on the hill. These include the cults of Caelestis, Mithras, and Isis.

The Iseum on the Capitoline was both important and of great age. The sanctuary already existed in 58 BC, when it is mentioned for the first time, and it certainly lasted into the Imperial period, since Domitian took refuge there during the siege of the Capitoline by Vitellius's supporters; the future emperor managed to escape by disguising himself as a priest of Isis. Inscriptions, one of

which is datable to the Republic, provide information about some of the priests of Isis Capitolina. The obelisk of Ramesses II, which once stood on the Arx but was moved to Villa Celimontana in the sixteenth century, may have been associated with this temple. It is also possible, however, that it belonged to the Iseum in the Campus Martius, since an identical obelisk, now erected in Piazza della Rotonda, originally came from that sanctuary. If this is the case, it must have been brought to the Capitoline during the Middle Ages.

Other Imperial ruins came to light during the excavation of an underground passageway below Piazza del Campidoglio, built to connect the two museums. The remains of several **second-century AD residences** can still be seen lying alongside an ancient street; they were constructed in *opus mixtum* (a combination of brick and reticulated tufa) and had balconies supported by travertine brackets (FIG. **10:8**). Between 1931 and 1942, in the course of freeing the Capitoline from encroaching structures, numerous ancient buildings were discovered on the slopes of the hill. The most noteworthy of these is a **large *insula*** (a multistory apartment building), which can be seen between the base of the stairway leading to S. Maria in Aracoeli and the Monument to Victor Emmanuel II, resting against the steep rock of the hill (FIG. **10:9**). In addition to the ground floor and mezzanine, three other floors have survived, as well as traces of a fourth, which may not have been the topmost story. The ground floor comprised tabernae that fronted a courtyard surrounded by a porticus supported by piers. These tabernae, probably boutiques, had direct access to the rooms on the mezzanine level, whose original wooden floor has completely disappeared. A balcony suspended on travertine brackets marks the transition to the rental units, consisting of many rooms lit by rectangular windows. The rooms become progressively smaller in the upper floors. This second-century AD complex offers a good example of the crowded living conditions in the city at the height of the Imperial period, a situation that we know well from Ostia. The apartment building would have housed about 380 tenants, making this a veritable dormitory for the poor. Contemporary Latin writers often bemoaned such habitations, especially the upper floors, which were normally assigned to the poorest tenants. Martial complained about the two hundred steps *(ducentas scalas)* he had to climb to reach his apartment; Juvenal referred to the constant threat of collapse and fire.

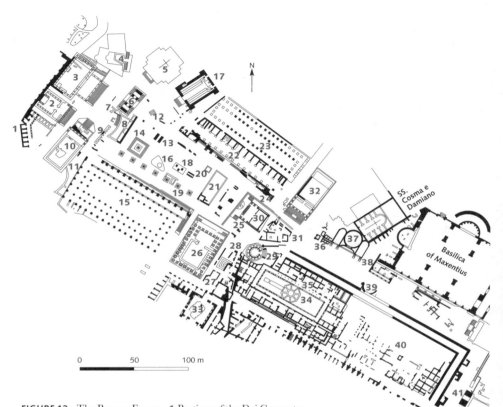

FIGURE 13. The Roman Forum. **1** Porticus of the Dei Consentes. **2** Temple of Vespasian and Titus. **3** Temple of Concord. **4** Carcer. **5** Church of SS. Martina e Luca. **6** Arch of Septimius Severus. **7** Altar of Saturn and the Umbilicus Urbis. **8** Caesarian-Augustan rostra. **9** Republican viaduct. **10** Temple of Saturn. **11** Arch of Tiberius and Vicus Iugarius. **12** Niger Lapis. **13** Trajanic plutei. **14** Column of Phocas. **15** Basilica Iulia. **16** Lacus Curtius. **17** Curia Iulia. **18** "Equus Domitiani." **19** Diocletianic Columns. **20** Equus Constantini. **21** Rostra ad Divi Iulii. **22** Porticus Iulia (Gai et Luci). **23** Basilica Fulvia-Aemilia. **24** Parthian Arch of Augustus. **25** Actian Arch of Augustus. **26** Temple of the Castors. **27** Oratory of the Forty Martyrs. **28** Fountain of Juturna. **29** Temple of Vesta. **30** Temple of Divus Iulius. **31** Regia. **32** Temple of Antoninus and Faustina. **33** Church of S. Maria Antiqua. **34** House of the Vestals. **35** Domus Publica. **36** Republican building. **37** "Temple of Romulus." **38** Medieval Porticus. **39** Sanctuary of Bacchus and Cybele. **40** Imperial buildings. **41** Arch of Titus. **42** Building near the Arch of Titus. **43** Convent of S. Francesca Romana (Forum Antiquarium). **44** Temple of Venus and Roma.

ROMAN FORUM

S. Francesca
Romana

43 44

HISTORICAL NOTES

The valley of the Forum was carved out of the region's compacted volcanic tufa by one of the many rivulets and streams that spill into the Tiber. The depression thus formed lies between the Capitoline and Palatine and extends southwest toward the river through the low-lying Velabrum, the original name of the watercourse in this area.

Ancient writers unanimously emphasize the marshy and inhospitable nature of the valley. In fact, the earliest communities established themselves on the peaks or on the uppermost slopes of the hills—the Palatine and certainly also the Capitoline—whereas the plain was used as a necropolis. Excavations near the Temple of Antoninus and Faustina, however, as well as sporadic discoveries made near the Temple of Divus Iulius and the Arch of Augustus, have shown that the Palatine village extended to part of the valley.

The main section of the surviving necropolis was discovered at the beginning of the twentieth century near the Temple of Antoninus and Faustina and can be dated to the first phase of Latial culture in the area (tenth century BC). Two tombs found in the 1950s near the Arch of Augustus, however, would appear to predate those in the cemetery near the Temple of Antoninus and Faustina; they are contemporary with a tomb found on the Palatine under the House of Livia. The relative

dating of the two burial sites suggests a gradual movement of the Palatine village from west to east, a tendency that characterizes subsequent phases of Rome's development as well. In fact, the cemetery was used for adult burials only until the initial phase of the second Latial period, about the beginning of the eighth century BC. From then on, the cemetery was devoted exclusively to infant burials (children could be buried within the city, although even this custom came to an end at the beginning of the sixth century BC). Burials in the cemetery on the Esquiline began with the abandonment of the necropolis in the Forum; expansion of the Palatine community would appear to explain the change. The evolution from small separate burial groups associated with individual villages to a single unified necropolis—a typical development in the early life of a city—is a phenomenon that has been observed in the most important Etruscan urban settlements.

Around 600 BC or a little before, the Forum was paved for the first time— a pavement consisting solely of beaten earth. The conclusions to be drawn from this are clear: the Forum was no longer at the periphery of its constituent communities, but a city center. The correspondence between the archaeological data and literary tradition regarding this period is striking. At the end of the seventh century BC—the traditional date is 616 BC—the Etruscan Tarquins established their dynasty in Rome; the first king, Tarquinius Priscus, was reported to have begun a series of public works, in particular a large-scale system of sewers built to drain the valleys' swampy lowlands. The most important of these was the *Cloaca Maxima*, which diverted the stream running through the Velabrum into a regular channel and made the area usable from that time forward; its course through the central area of the Forum can still be distinguished today. It is clear, then, that we cannot divorce the literary from the archaeological evidence, which shows that the practice of burial ended at the same time that the Forum received its first pavement. On the other hand, the development of the valley as a city center also presupposes the incorporation of the Capitoline and Quirinal, located at the opposite side of the Forum, into the original Palatine city; this too would have been the work of the Etruscan kings. The construction of the huge Temple of Jupiter Optimus Maximus on the Capitoline—according to tradition, a project begun by Tarquinius Priscus—is the best proof that the two hills lay within the city's compass at this time.

The division of the valley into two distinct parts, each with its own specific function, must also have occurred during the same period. These are the Comitium, the center of political and judicial activity lying at the foot of the Arx (the northern summit of the Capitoline), and the Forum proper, the marketplace of Rome. The antiquity of the Comitium, which means "meeting place," is clear not only from its explicit mention in the early Roman calendar and from its use for the earliest public meetings—those of the Comitia Curiata—but also from the discovery of a group of monuments beneath the *Niger Lapis*, which can be dated to the period of the kings (seventh to sixth century BC).

Recent excavations would appear to confirm the traditional date of 509 BC as the beginning of the Republic, corresponding to the inauguration of the Temple of Jupiter Capitolinus and the initiation of the consular list. At roughly the same time, around the end of the sixth century BC, the old *Regia*, which tradition distinguished as the home of King Numa, was destroyed in a fire and reconstructed along a new architectural plan. The expulsion of the Tarquins, however, did not substantially interrupt the city's development. The most significant change in the Forum's topography occurred just before the middle of the fifth century BC, during the first years of the Republic, when two important sanctuaries were constructed: the Temple of Saturn and the Temple of Castor and Pollux (also called the Temple of the Castors). The Temple of Saturn, possibly begun under the kings, was erected on the spot occupied by an ancient altar consecrated to this god; the cult of Castor and Pollux, on the other hand, was imported from Greece, as the Hellenic names of the dedicatees indicate. The discovery in Lavinium of a sixth-century BC inscription containing a dedication to these deified heroes confirms both the traditional chronology and the cult's Greek provenance.

The second half of the fifth century BC is an obscure period in the history of the Forum, as it is for the rest of the city. Among the various legendary accounts handed down by Roman writers, at least one is historical and of fundamental importance: the creation of a body of written laws, possibly inspired by Greek models, that were inscribed on bronze tablets and affixed to the Rostra in the Comitium around the middle of the century. These were the famous Twelve Tables, which for centuries constituted the foundation of Roman law.

The next significant period of building activity in the Forum occurred in the fourth century BC. Around 390 BC, an army of Gauls sacked and set fire to the city. The extent of the damage inflicted during this attack was probably exaggerated by the ancient tradition, at least to judge from the almost total absence of archaeological evidence attesting to the event. The Comitium was rebuilt for the first time in 338 BC, when the prows of the ships sunk at the battle against the Latins at Antium were affixed to the speaker's platform, which assumed its name, *Rostra*, from these spoils. A second renovation, probably undertaken by the consul in 264, Marcus Valerius Messalla, occurred at the beginning of the First Punic War.

Tradition assigns construction of the Temple of Concord, located at the foot of the Capitoline, to Camillus, who defeated the Gauls in 367. In 305, the aedile C. Flavius—a protégé of the great Appius Claudius, censor in 312—dedicated a shrine to the same divinity near the Volcanal. The fourth and third centuries BC saw various statues erected in the Comitium, while the oldest food market, the *Macellum*, was probably built north of the square in the third century.

Large-scale building projects in the Forum, however, were not undertaken until after the wars against Carthage in the west. Following the wars against the Hellenistic states in the east, Rome extended its rule over the entire Mediterranean. The urban requirements of an empire's capital are reflected in the intense

building program that transformed the appearance of the Forum in only a few decades. During the second century BC, no fewer than four basilicas—the Basilicae Porcia, Fulvia-Aemilia, Sempronia, and Opimia—replaced the single basilica built at the end of the third century, and the temples of Concord and the Castors were entirely reconstructed, to mention only the most ambitious projects.

At the beginning of the first century BC, Sulla's reconstruction of the Capitoline included the building of the *Tabularium*, which provided the Forum with a monumental backdrop to the west. Prior to this, the Basilica Sempronia (the site of the future Basilica Iulia) and the Basilica Fulvia-Aemilia delineated the southern and northern sides of the square. This tendency toward monumentalization set the stage for a complete rethinking and reorganization of the area, culminating in the building projects of Caesar and Augustus. The new configuration responded to a relocation of the political and judicial functions of the cramped Comitium to the Forum, the site of legislative assemblies and law courts as early as the second half of the second century BC. Similarly, many of the mercantile activities that had been concentrated in the Forum relocated to purpose-built facilities, such as the Macellum, which the censors of 179 BC reconstructed on a monumental scale.

At the end of the Republic, when Rome was firmly established as the capital of an empire extending from Gaul to Syria, the old Republican Forum was no longer adequate to the functions of central administration and public relations. The first to address these needs by initiating the construction of a new monumental complex (as early as 54 BC) was Julius Caesar, who presented the project initially as a simple enlargement of the old Forum. Caesar's subsequent alterations of the Republican Forum were more radical, entailing the virtual elimination of the Comitium, replaced in part by the new Forum Iulium (Forum of Caesar), and the reconstruction of the *Curia Hostilia,* the ancient seat of the Roman Senate, in a different location, which essentially transformed the new senate house, the *Curia Iulia,* into an annex of Caesar's Forum. Construction of the Basilica Iulia on a scale much larger than its predecessor, the Basilica Sempronia, and renovation of the Basilica Fulvia-Aemilia completed the total reconfiguration of the Forum's long sides.

Augustus, though more cautious and hesitant than his great-uncle, nonetheless had to take into account the revolutionary development that Julius had begun in his own building program. He thus completed the monumental frame of the Forum with the temple dedicated to the deified Julius that occupied the square's eastern side; the speakers' platform in front of this building was a companion to that on the opposite side of the Forum, which Caesar had built to replace the Republican Rostra. Propagandistic and dynastic needs, developing gradually over time, informed subsequent building projects. A Parthian arch— perhaps subsequently dedicated to Gaius and Lucius Caesar, the grandsons of the *princeps*—may have abutted the northern side of the Temple of Divus Iulius, balancing Augustus's Actian arch, which lay on the opposite side of the building;

the complex subtly prefigured the succession to Imperial power that was planned for the two young men. After their premature death, the new heir, Tiberius, became deeply involved in other building projects: he oversaw the reconstruction of the temples of the Castors and of Concord, and, after becoming emperor, he had an arch erected alongside the facade of the Temple of Saturn. In this, Tiberius not only gave formal, public expression to his respect for tradition, but also clearly signaled his desire to appropriate that tradition for dynastic purposes, as had Augustus in the design and construction of his forum. Now stripped of its original political function, the old Roman Forum was transformed into a celebratory backdrop, intended to exalt the prestige of the dynasty.

Augustus's configuration of the Forum remained unchanged for a long time. New buildings, such as the Temple of Vespasian and Titus and that of Antoninus and Faustina, were designed to complement the Augustan layout without modifying it. Only Domitian, in conjunction with his decidedly monarchical policy, dared intrude upon the Imperial structure of the Forum by erecting a gigantic equestrian statue of himself in the center of the square. The size of the statue reduced the Forum to little more than a frame for a monument intended to exalt the *dominus et deus*.

Not until the beginning of the third century AD was the Forum again encumbered by the intrusion of new constructions—the arch and the equestrian statue of Septimius Severus, the seven commemorative columns on the southern side of the square, the monuments commemorating the tenth anniversary of the Tetrarchy, the new rostra at the Forum's east side; some of these edifices formed part of the massive task of reconstruction after the fire of Carinus in AD 283. The history of the Forum concludes with the Column of Phocas, the "construction" of which in AD 608 probably entailed little more than the rededication to this Byzantine emperor of a preexisting monument. In this we observe evidence of a new age, by then well under way, during which many pagan buildings were transformed into Christian sanctuaries: the Curia Iulia became the Church of S. Adriano in the seventh century, while other churches were installed all around the area, from S. Maria Antiqua to Saints Cosmas and Damian.

ITINERARY 1

The Western End of the Forum

The most complete views of the Forum are from the terrace on the Capitoline, to the right of Palazzo Senatorio, and from the arcade of the Tabularium. The terrace of the Farnese Gardens at the northern corner of the Palatine also offers a sweeping, panoramic vista.

The main entrance to the Forum lies along Via dei Fori Imperiali, near its intersection with Via Cavour. From here, the ancient level of the square is

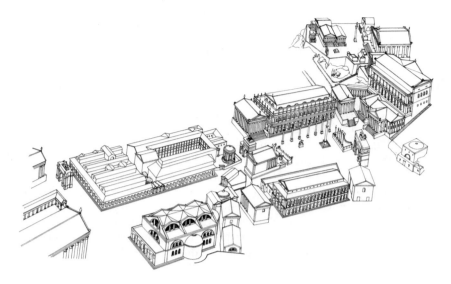

FIGURE 14. The Roman Forum. Reconstruction from the northeast.

reached by a ramp that passes between the Basilica Aemilia and the Temple of Antoninus and Faustina (FIGS. **13:23, 13:32**). Another entrance to the site is located at the Arch of Titus (FIG. **13:41**). For the sake of convenience, the following description of the monuments follows a strictly topographical sequence, starting from the main entrance. A chronological itinerary, although longer and more winding, is possible and even recommended, for it affords a better understanding of the area's historical development. In that case, the tour would begin at the archaic necropolis and proceed to the Regia, the Temple of Vesta, the Fountain of Juturna, and the Temple of the Castors, and subsequently to the Comitium (site of the Niger Lapis) and Curia. Thereafter, the topographical route resumes at the Basilica Fulvia-Aemilia.

THE BASILICA FULVIA-AEMILIA The Basilica Fulvia-Aemilia is the only surviving Republican basilica, the Basilicae Porcia, Sempronia, and Opimia having disappeared completely (FIG. **13:23**). The building, however, was restored several times during the empire, and it is this that we see today. It was erected by the censors of 179 BC, M. Aemilius Lepidus and M. Fulvius Nobilior. Given that Nobilior was responsible for the construction, the building was at first called the Basilica Fulvia; following restorations financed by various members of the *Gens Aemilia* (ca. 80 BC, and thereafter in 54, 34, 14 and in AD 22 under Tiberius), the building was renamed the Basilica Pauli, after Aemilius Paulus. According to a recent hypothesis, however, the Basilica Aemilia should be distinguished from the Basilica Fulvia and identified with another building, erected by Aemilius

Paulus during his censorship in 159 BC, that occupied the short eastern side of
the Forum and whose remains were found beneath the Temple of Divus Iulius.
A final restoration took place after a fire that can be dated to the beginning of
the fifth century AD on the evidence of coins that fused into the floor (the fire
may be associated with the sack of Alaric in AD 410). After the blaze, a new floor
was added at a higher level.

Scholars have attributed the origin of the basilica as a building type to the
large cities of the Hellenistic east. The name, clearly Greek in origin, has been
connected with the Royal Porch *(stoa basileios)* in the Athenian agora; it seems
more likely, however, that the term is a hellenization of the Latin expression
atrium regium, a building in the Forum recorded by ancient sources that seems
to be associated with the nearby *Regia* (house of the king). It is generally held that
the basilica first appeared as a distinct architectural form after the Second Punic
War, but the reference to a basilica in comedies by Plautus that predate the
construction of the Basilica Porcia supports the notion that the latter, far from
being the oldest example of the type, was preceded by another basilica, built
during the second half of the third century BC. Basilicas were little more than
large covered spaces that provided protection from the elements for the activities
that regularly took place in the Forum: the various judicial, political, and
economic activities that were held outside in good weather. In its basic structure,
a basilica covered as large a space as could be managed with a roof supported by
rows of columns or piers, which formed a series of aisles. Lighting was introduced
into the interior by raising the central nave one story higher than the side aisles,
thus making it possible to insert large windows in the elevated section.

The Basilica Fulvia-Aemilia must have been constructed in this form from
the beginning, as an excavated section of the building's oldest phase, still visible
on the western side of the ruins, suggests. The design of the building was not
modified in subsequent restorations; the only significant divergence from the
previous plan was the presence of two smaller aisles on the northern side of the
building, which underscores the desire of the architects to exploit the available
space as fully as possible.

During the Augustan period, a facade of sixteen arches, composed of piers
decorated with engaged columns in two superimposed orders, was constructed
on the basilica's southern side facing the square. The structure, either the *Porticus
Gai et Luci* or the *Porticus Iulia*, probably replaced an earlier porticus that stood
on the same spot (FIG. **13:22**). After the fire of AD 410, it was replaced in
turn by a much more compact colonnade; three of its granite columns, which
stood on white marble bases, have been reerected on the eastern side of the
basilica, facing the Temple of Antoninus and Faustina. Farther to the east
lies the large inscription dedicated to Lucius Caesar, *princeps iuventutis* (leader
of the youth), which, together with the fragments of another dedication to
his brother Gaius, probably belonged to an arch dedicated to Augustus's two
intended heirs (FIG. **13:24**); it may have been built originally to celebrate the

emperor's diplomatic victory over the Parthians. The arch must have stood between the corner of the Basilica Aemilia and the Temple of Divus Iulius, aligned symmetrically with the Actian Arch that was built on the other side of the temple.

Between the porticus and the basilica proper was a **series of shops** constructed of tufa in *opus quadratum;* these were an Imperial reconstruction of the *tabernae novae* (new shops) that served the Forum's bankers and originally stood in front of the Republican basilica. Three entrances lead to the interior of the hall (approximately 70 × 29 meters), which was divided into four aisles by columns of so-called African marble (the stone was in fact imported from Asia Minor). The floor and a large portion of the marble architectural fragments scattered about date to the Augustan restoration. Traces of the fire of AD 410 and remains of the coins that melted into the marble during the blaze can still be seen here and there on the floor.

The cast of a short **segment of a frieze,** decorated with subjects pertaining to the origin of Rome, is on display in the northeastern corner of the building, on the side nearest the entrance to the archaeological site (the Forum Antiquarium houses the original). This long relief in Greek marble must originally have been located inside the building. While the date of the work is debated, its reuse in the Augustan period confirms its Republican provenance. Since we know that older columns were reemployed in the restoration of 54 BC, and since the frieze was likewise reused, it is perhaps not overly rash to suggest that both the columns and the frieze date to a reconstruction undertaken during the reign of Sulla by M. Aemilius Lepidus, consul of 78. What makes this possibility even more attractive is the representation on contemporary coins of the same subjects of legendary Rome we see carved on the frieze.

THE SHRINE OF VENUS CLOACINA Next to the steps of the basilica on the western end sits a circular marble base that supported a small building. As can be inferred from coins depicting the superstructure, the monument was an open-air shrine, consisting of a low fenced enclosure, likewise circular, and two cult images that stood within it; Servius, the author of commentaries on Vergil, speaks of "statues" of Cloacina in the plural; these may have represented two aspects of the divinity, both Cloacina herself and Venus, with whom she was later identified. The monument marked the point where the Cloaca Maxima, with which the divinity is associated, entered the Forum. Two well-known episodes among the legends of Rome's origins took place alongside this small but important shrine: the purification of the Roman and Sabine armies with branches of myrtle following the war provoked by the celebrated rape, and the killing of Verginia by her father to protect her virtue from the designs of one of the decemvirs, Appius Claudius.

THE TEMPLE OF JANUS Alongside the Argiletum—the street that ran between the Basilica Fulvia-Aemilia and the Curia toward the Subura—stood the small building that originally housed the oldest and most important sanctuary of Janus. The double-faced statue of the god, protector of every entrance and every beginning, was located in the center of the shrine. Some have suggested that this monument was an ancient gate of the city, enlarged to include the Capitoline; others maintain that it functioned as a kind of bridge on the Velabrum. A Neronian coin preserves the only image of the building, whose doors were opened in times of war and closed in times of peace. According to a recent hypothesis, the small brick structure on the southwestern corner of the basilica is to be identified as the temple's last reconstruction, following the fire of AD 410.

THE COMITIUM The *Comitium*, the ancient political center of the city, occupied the northern corner of the Forum, between the Basilica Fulvia-Aemilia, the Arch of Septimius Severus, and the Forum of Caesar. Few elements of this ancient meeting place survived the large-scale transformations undertaken by Julius Caesar and Augustus; Caesar's construction of the Curia Iulia even encroached upon its space. Following an ancient rite, augurs defined the area of the Comitium along the cardinal points; evidence of this fact comes not only from the ancient writers, but also from archaeological remains (FIG. **15**). A passage of Pliny the Elder (*NH* 7.60) provides crucial information for reconstructing the topography of the area. Prior to the introduction of the first sundial, which occurred during the course of the First Punic War (in 263 BC, to be precise), the principal hours of the day were announced by the consul's herald. Standing on the steps of the Curia Hostilia, the oldest seat of the Senate, he marked the passage of the sun between the Rostra and Graecostasis (the raised platform on which foreign ambassadors—particularly Greeks, whence the name—attended meetings of the Senate) to announce midday, and between the Columna Maenia and the Carcer to announce sunset. From this account we can deduce that the Curia must have stood north of the Comitium, while the Rostra and Graecostasis were on the south, the latter lying to the west of the former. This configuration is confirmed by the position of the Rostra (as attested by other authors) between the Comitium and the Forum. Moreover, we know the exact location of at least two of the monuments mentioned by Pliny: the Carcer and the Republican Rostra. The latter was identified by a base that was set up between the Niger Lapis and the facade of the Curia Iulia and stood below the surviving travertine pavement of the Augustan period.

The chronology of the Comitium can be reconstructed on the basis of test trenches excavated by Giacomo Boni beginning in 1899. As a result of this work, we are able to identify eight levels that correspond to the same number of pavements. Description of the levels proceeds from bottom to top; that is, from the earliest to the most recent:

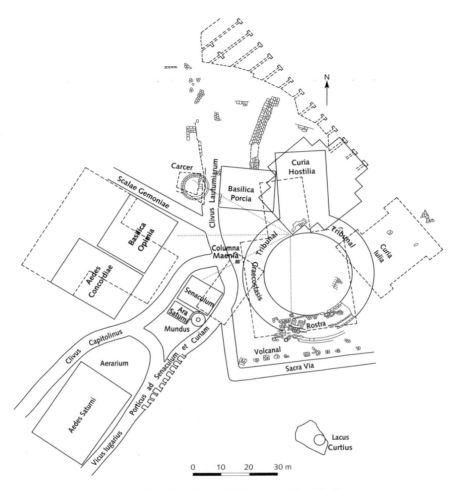

FIGURE 15. The Comitium and the western side of the Forum
in the Republican period (before Sulla).

1. The first level was built at the end of the seventh century BC and thus
 coincides precisely with the date of the Forum's first pavement and of con-
 temporary buildings such as the Regia.
2. Fire destroyed the structures in the Comitium within the first thirty years of
 the sixth century BC, around the same time that a similar disaster struck the
 Regia. The second pavement and some architectural terracottas—possibly

from the Curia Hostilia and similar to those of the Regia of this period—belong to the reconstruction following this fire. The archaic inscription underneath the Niger Lapis, which can be dated ca. 570–550 BC, is contemporaneous.

3. A third pavement was laid around the end of the sixth or beginning of the fifth century BC, at the same time as the earliest speaker's platform (Rostra), rectangular in form. This phase is almost certainly to be associated with the beginning of the Republic in 509 BC, as the construction of the Rostra, intended for public magistrates, strongly suggests.

4. During the second half of the fourth century BC, the Comitium was first paved in stone, as can be inferred from the ruins of the roadbed, the presence of an altar under the Niger Lapis that replaced an older one, and the enlargement of the Rostra. Here too, association with a precise historical event comes to mind: the attachment to the speaker's platform of the prows from the ships captured during the Latin war at Antium in 338 BC; from this time forward, the platform came to be called the *Rostra*.

5. A complete reconstruction of the Comitium took place during the first half of the third century BC, probably at the beginning of the First Punic War. At this time, the area acquired the circular shape and tiered seating that it preserved until the end of the Republic. The configuration, which recalls that of Greek *ekklesiasteria* (places of assembly), was probably introduced from Sicily. In fact, we know that M. Valerius Messalla, the conqueror of Carthage and Syracuse, mounted a painting, commemorating his achievements, on the western side of the Curia and brought the first solar clock to Rome from Catania. The new shape of the Comitium, found also among Roman colonies at Cosa, Paestum, Alba Fucens, Fregellae, and Aquileia, changed the area's orientation and thus ended its use as a large solar clock. The two quarters of the circle on the south corresponded respectively to the Rostra and to the Graecostasis. The northern half was probably occupied by the courts, which were situated on both sides of the Curia Hostilia.

6. The sixth pavement, constructed of tufa slabs, was certainly the one that Sulla installed ca. 80 BC. In this year, the new Curia was built on a larger scale to accommodate the considerably larger senate (six hundred members instead of three hundred) enrolled by the dictator. During this remodeling, the statues of Pythagoras and Alcibiades disappeared; these had been erected along the sides of the older Curia at the beginning of the third century BC. Also on this occasion, the monuments under the Niger Lapis were partly demolished and covered over by a pavement of black marble. The courts were moved out of the Comitium following the construction of the Tribunal Aurelium in another part of the Forum, also around 80 BC. The Rostra and Graecostasis, on the other hand, continued to be used.

7. Between 54 and 44 BC, the entire area was completely transformed by the construction of new buildings under Caesar. The last surviving monuments of the Comitium essentially ceased to exist. The Curia Hostilia, rebuilt by the son of Sulla (Faustus Sulla) after the fire that broke out during the funeral of Clodius in 52 BC, was converted into the Temple of Felicitas; its replacement, the Curia Iulia, was erected in a different location to accommodate Caesar's new forum. The Rostra was moved to the west, in alignment with the Forum's new axis, while the Graecostasis disappeared once and for all. Caesar's new pavement, constructed of regular travertine slabs, incorporated the black marble of the Niger Lapis, which can still be observed today.

8. The last pavement of the Comitium, the same one found throughout the Forum, was installed during the age of Augustus, probably after the fire of 9 BC. The extant inscription near the Column of Phocas identifies the praetor L. Naevius Surdinus as the project's sponsor. This pavement remained in use until late antiquity.

Numerous statues and monuments of various types must have filled the entire expanse of the Comitium: the shrine of Concordia, built of bronze in 304 BC by the curule aedile Cn. Flavius, was erected on the Graecostasis; the statue and well of the augur Attus Navius, which tradition attributes to Tarquinius Priscus, stood next to the Curia, near the Ficus Ruminalis and Column of Maenius erected in 338 BC. Here too were the statues of Marsyas, the symbol of freedom during the Republic, and of Alcibiades and Pythagoras, "the bravest and the wisest of the Greeks," which were erected at the beginning of the third century BC; statues of the three Sibyls (or Parcae), Camillus, and other figures were installed on the Rostra.

The Comitium was the oldest seat of political and judicial activity in the city. Its various components duly reflected the tripartite nature of the Roman constitution: the popular assembly, originally called the *Comitia Curiata* because its earliest structure was based on the old aristocratic *curiae* (wards), corresponds to the central area, which was set up for meetings; the Senate is associated with the Curia Hostilia and the nearby Senaculum; the Rostra calls to mind the magistrates who spoke from this platform. Here was the focal point of the city's political and judicial life from the end of the regal period to the end of the Republic, when a large number of its functions migrated to the Forum.

THE NIGER LAPIS At the end of the nineteenth century—10 January 1899, to be precise—a surprising discovery was made during the excavation of the Comitium: not far from the Curia Iulia, there appeared a section of pavement made of black marble, somewhat trapezoidal in shape and separated from the surrounding Augustan travertine pavement by a partition of white marble slabs (FIG. **13:12**). The discovery immediately brought to mind a passage from the

second-century AD writer Festus (p. 184 Lindsay), which, though considerably
garbled, explicitly defines the site's mystic association with Rome's founder: "the
black stone in the Comitium indicates a place associated with death, because
the death of Romulus was assigned to it." Other traditions identify the Niger
Lapis as the location of the tomb of the shepherd Faustulus or, alternatively, that
of Hostus Hostilius, the grandfather of the third king of Rome. The excavation
beneath the black marble pavement revealed an archaic monumental complex,
which can be reached by means of a short stairway. The monument consists
of the following: a platform on which there stood a **U-shaped altar** that lacked
upper moldings (FIG. **16:A** and **B**); adjacent to this, the truncated shaft of a
column (possibly the base for a statue) **(G)**; and an **inscribed cippus (H)**
whose upper portion is severely damaged. The inscription, in archaic Latin,
was written vertically and in *boustrophedon* (i.e., the lines running alternately from
right to left and left to right); the lack of the upper section makes its original
length difficult to determine. The transcription is as follows:

1) *quoi hon* [- - - / - - -] *sakros es / ed sord*
 [- - -]
2) [- - -]*..a has / recei* ⋮ *i* [- - - / - - -]*euam / quos*
 ⋮ *r* [- - -]
3) [- - -]*m* ⋮ *kalato / rem* ⋮ *ha* [- - - / - - -] *od* ⋮
 iouxment / a ⋮ *kapia* ⋮ *dotau* [- - -]
4) [- - -]*m* ⋮ *i<⋮>te <⋮>r.*[- - - / - - -]*m* ⋮ *quoi*
 ⋮ *ha / uelod* ⋮ *nequ* [- - - / - - -]*od* ⋮ *iouestod*
5) [- - -]*lou <i?> quiod* [- - -]

The only phrase whose sense can be fully grasped is the first, a formulaic curse
that, in the language of the *leges regiae*, was directed at profaners of holy places:
"may the one who will violate this place be consecrated [i.e., condemned] to
the gods of the underworld." Formulas of this type are generally associated with
sanctuaries, and in particular with altars. In fact, the inscription of the Comitium
is located next to an altar, which makes it practically certain that this is a *lex
arae*—a ritual and sacrificial regulation pertaining to the site.

The complex beneath the Niger Lapis is thus a small sanctuary, comprising
an altar, a related inscription, and probably a statue of a god, mounted on the
nearby column. The oldest part of the monument is the inscription, which, from
its position in the second pavement of the Comitium, can be dated to the second
quarter of the sixth century BC. The votive material of the sanctuary—numerous
fragments of Greek pottery datable exclusively within the sixth century BC—not
only confirms this date, but also shows that the cult had particular importance,
primarily before the beginning of the Republic. All of this tends to confirm that
the "king" mentioned in the inscription (*recei*, "to the king") was a real king, and
not the *rex sacrorum*, a pale reflection of the monarch who, during the Republic,

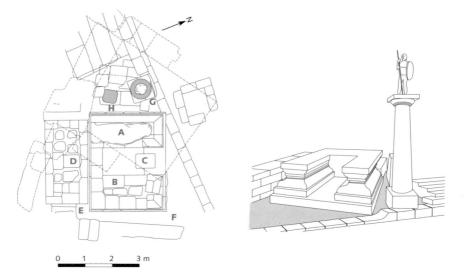

FIGURE 16. *Left,* plan of the Niger Lapis: **A–B** Altar. **C** Block between the side wings of the altar. **D** Platform. **E–F** Republican Rostra. **G** Column drum, or pedestal. **H** Inscribed cippus. *Right,* conjectural reconstruction of the monuments lying beneath the Niger Lapis.

was charged exclusively with priestly tasks. Extant literary sources recount that during the archaic period the king made sacrifices in the Comitium to ensure the successful consummation of the political and judicial tasks associated with this venue. The *calator* (herald) mentioned in the inscription was a functionary responsible for convening meetings *(comitia).*

This group of monuments, in my view, constituted the *Volcanal,* the very ancient sanctuary of Vulcan, which various witnesses situate in the Comitium near the Graecostasis and Rostra. In fact, the Niger Lapis sits precisely between these two Republican platforms. Accordingly, the traditional identification of the Volcanal with the ruins near the *Umbilicus Urbis* may now be discarded. As Festus, the only writer to use the term Niger Lapis, confirms, the Niger Lapis is not the tomb of Romulus—who was supposed to have disappeared miraculously—but the site of his death, according to one tradition, at the hands of the senators. Plutarch's *Life of Romulus* (27.6) informs us that the first king of Rome was supposed to have been assassinated in the Volcanal. Thus, the monuments beneath the Niger Lapis and the Volcanal appear to be one and the same.

The Volcanal, however, survived the destruction of the group of monuments underneath the black pavement, as references in writers of the Imperial period attest (e.g., Pliny the Elder, *NH* 16.236). Therefore, it must have been reconstructed in the immediate vicinity and probably corresponds to the small square area, partially excavated, 5 meters southeast of the Niger Lapis. A large slab

bearing a dedication to Vulcan, dated to the reign of Augustus (9 BC), was found between the Arch of Septimius Severus and the Curia in the sixteenth century.

The description of the Volcanal in Dionysius of Halicarnassus accords perfectly with the extant remains of the earlier shrine: a small open-air sanctuary, with an inscription "in archaic Greek characters." Certainly the letters on the cippus might easily be thus construed, for the script derived from the archaic Chalcidian alphabet brought to Italy by the first Greek colonists.

In sum, the sanctuary beneath the black pavement was intimately linked in function to the Comitium, for it commemorates two potentially complementary aspects of Romulus: the city's heroic founder (Greek cities typically situated their founders' shrines in the center of the agora); and the divinity overseeing the Comitia Curiata, the oldest formal assembly of the Roman people, which met in the Comitium. When Romulus disappeared in the Volcanal, he was believed to have been transformed into the god Quirinus, the eponymous divinity of the Curiae—that is, of the assembled Romans, who called themselves *Quirites*.

THE CURIA The large brick building that occupies the corner between the Argiletum and the Comitium is the tetrarchic reconstruction of the Curia Iulia, the official seat of the Senate (FIG. **13:17**). Julius Caesar began the construction of a new Senate chamber to replace the earlier Curia Hostilia, which had burned down in 52 BC, but it was Augustus who completed and inaugurated the building on 28 August 29 BC. Between 1930 and 1936, the present building, which had been turned into the Church of S. Adriano at the beginning of the seventh century AD, was restored to the form of its reconstruction by Diocletian after the fire of Carinus (AD 283). This blaze had destroyed the entire area between the Forum of Caesar and the Basilica Iulia (the hall had been previously restored by Domitian in AD 94).

Recent studies, largely based on a drawing made by Antonio da Sangallo the Younger, have considerably advanced our understanding of the Curia as a complex of several buildings: the Curia itself, a *Chalcidicum*, the *Secretarium Senatus*, and the *Atrium Minervae*. In fact, the Chalcidicum was nothing more than the Curia's colonnaded porticus, as represented on an Augustan coin. The Secretarium Senatus—not the "secretariat of the senate," as the term is generally translated and interpreted, but a special court convened to judge senators—came into existence only toward the end of the empire; its seat may have been the late antique apsidal building whose remains are still visible at the south of Caesar's Forum, behind the Curia. The Atrium Minervae may have been simply another name for the Chalcidicum in later years.

Recent work behind the Curia has shown that Caesar's Forum extended as far as the building itself, which means that the *Atrium Libertatis* could not have been located in this area, as was once believed. The Curia immediately adjoined the porticus of Caesar's Forum, for which it served, significantly, as a

kind of annex. The present rectangular structure is strengthened by four broad buttresses, aligned with the facades, each of which culminates in a triangular pediment; a stairway in the front left buttress leads to the roof level. The principal facade, which preserves traces of medieval loculi (burial niches) at various levels, was embellished on the lower half by marble slabs and on the upper level by stucco laid down to imitate marble ashlar blocks. The bronze leaves of the central door are replicas of the Diocletianic originals; the latter were reused in the seventeenth century to form the central doorway of S. Giovanni in Laterano.

The spacious interior, spanned by a flat ceiling (the present wood ceiling is modern), is 21 meters high, 18 meters wide, and 27 meters long; this corresponds, more or less, to the proportions suggested by Vitruvius (*De Architectura* 5.2) for *curiae*, whose height, according to the Augustan writer, should be roughly half of the sum of the building's width and length. The marble floor, partly original and partly reconstructed with ancient marbles, dates to the reign of Diocletian, as do the architectural decorations on the walls—niches framed by small columns supported by brackets and designed to hold statues. Paintings in the Byzantine style were added when the Curia was transformed into a church; their remains can be seen on the interior of the facade. The hall is divided into three sections running the length of the building (FIG. **17**). Those on the right and the left consist of three low and wide steps that accommodated the chairs of the senators, who numbered approximately three hundred. The wide platform between the two doors in the rear wall was reserved for the presiding official of the senate. Here too was the pedestal on which the statue of Victory (originally from Tarentum) probably stood, erected by Octavian. At the end of the fourth century AD, St. Ambrose and Aurelius Symmachus, one of the last pagan senators of Rome, argued bitterly over this statue and the altar connected with it; Ambrose won the argument, and the altar was removed.

Currently on display in the Curia are two large reliefs, discovered in the center of the Forum and known as the *plutei*, or **"anaglyphs of Trajan"** (FIG. **13:13**). The reliefs may have originally been part of a small enclosure, possibly surrounding the *ficus ruminalis* (ceremonial fig tree) and the statue of Marsyas. Scenes relating to the principate of Trajan adorn the monument: that on the right, which is incomplete, depicts the burning of financial records in the presence of the emperor—symbolizing the remission of debts owed to the treasury by the citizens; the one on the left depicts the institution of the *alimenta*—low-interest agricultural loans for impoverished youths. The scenes take place in the Forum, providing an important picture of this area in antiquity. The statue of Marsyas standing next to the *ficus ruminalis* appears in both reliefs, and the identical position of the statue and tree in both scenes shows that the *plutei* portray not the two sides of the Forum, but the same side: that on the south. Accordingly, we can identify the buildings as follows: in the relief on the left (from right to left), the Rostra, the Temple of Vespasian and Titus (distinguished by its Corinthian columns), an arched entrance to the Capitoline, the Temple of

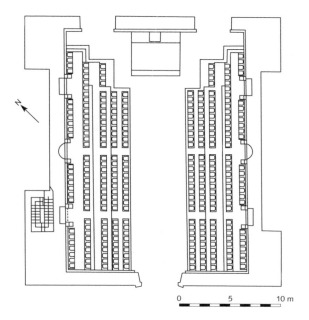

FIGURE 17. Curia Iulia, with conjectural reconstruction of the seating area.

Saturn (distinguished by its Ionic columns), an empty space representing the Vicus Iugarius, and the arcades of the Basilica Iulia; on the other relief (also to be read from right to left) there follows the continuation of the Basilica Iulia, the empty space representing the Vicus Tuscus, the Temple of the Castors, the Arch of Augustus, and the Rostra of the Temple of Divus Iulius. In front of the Basilica Iulia, the emperor (or perhaps his statue) is shown seated on a platform. The reverse sides of the reliefs depict animals—a pig, a sheep, and a bull—offered in the solemn Roman sacrifice known as the *suovetaurilia*.

BASES OF COMMEMORATIVE MONUMENTS The bases of several honorary monuments, most of which are identified by inscriptions, lie at various points in the area between the Curia, the Arch of Septimius Severus, and the open space of the Forum. One such marble base, lying a short distance from the Niger Lapis toward the Curia, was dedicated by Maxentius "To Mars and the Founders of the Eternal City." The association of this monument with Romulus's *heroon* (hero shrine) is obvious. The emperor's name was chiseled out after his defeat and death in AD 312 at the battle of the Milvian Bridge. Alongside the Arch of Septimius Severus stands the base of an equestrian statue, whose inscription to Constantius II dates the monument to AD 352–53.

At the edge of the Forum, not far from the Niger Lapis, a high pedestal with a dedicatory inscription to Arcadius, Honorius, and Theodosius commemorates their victory against Alaric and the Goths in AD 403; the name of Stilicho, the victorious general of the battle, was effaced after his murder in 408. Holes on the sides show that the base was later reused to support an equestrian statue.

Not far from here, toward the Arch of Septimius Severus, sits a marble base, decorated in high relief on all four sides, that supported a commemorative column. On the principal side, the inscription on a shield held up by two Victories records the tenth anniversary of the Caesars of the Tetrarchy *(Caesarum decennalia feliciter)*, the government of the four emperors (the two Augusti and two Caesars) instituted by Diocletian in AD 293. The monument, associated with the emperor's visit to Rome in 303, may have stood behind the Rostra. In fact, a representation of the Rostra, surmounted by five columns, appears in a relief on the Arch of Constantine, which was erected a few years after this visit. We know of two other inscribed bases, similar to the one in question, that probably belong to this group. These were discovered in the Renaissance and subsequently lost; one recorded the twentieth anniversary of the Augusti *(Augustorum vicennalia feliciter)*, and the other, the twentieth anniversary of the Imperatores *(vicennalia Imperatorum)*. The last mentioned base possibly held the central column represented on the Arch of Constantine and would thus have held a statue of Jupiter, while the other four would have supported statues of each of the emperors.

Starting from the right, the reliefs on the other three sides of the base depict the following: (1) The sacrifice of a bull, ram, and pig. (2) The libation of the emperor to Mars as he is being crowned by a Victory, an event evidently taking place at the god's altar in the Campus Martius; alongside the god to his left are the priest (the *flamen Martialis*) with his distinctive headgear, a boy carrying a small box of incense, and a flutist, while on his right, a person dressed in a toga completes the scene; to the left of the emperor stands another figure dressed in a toga, who represents the Senate *(genius senatus);* to his left are two other divinities: the goddess Roma, seated, and the head of the Sun, identified by its rays. (3) The last side depicts a procession of senators.

The southern side of the square is lined by seven large brick bases, each of which supported honorific columns, two of which have been reerected. Brick stamps date these monuments to the time of the Tetrarchy.

THE ARCH OF SEPTIMIUS SEVERUS The imposing structure rising between the Rostra and the Curia is the Arch of Septimius Severus, a triple arch 20.88 meters high, 23.27 meters wide, and 11.20 meters deep (FIG. **13:6,** FIG. **18**). The inscription on the attic dates the building to AD 203. The side arches are approached from the Forum through short flights of stairs; the road that once ran through the central passageway was demolished during excavations at the beginning of the twentieth century, which exposed the Augustan

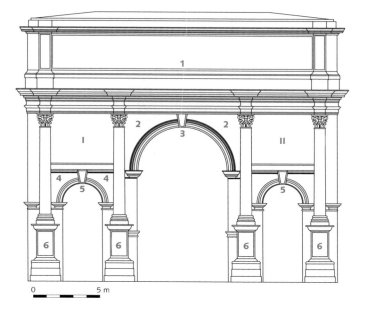

FIGURE 18. Arch of Septimius Severus. **1** Inscription. **2** Victories. **3** Mars. **4** River gods. **5** Divinities. **6** Roman soldiers with Parthian prisoners. **I** (**III** reverse) and **II** (**IV** reverse). Relief panels depicting the Parthian campaign (the triumph is represented in the unnumbered narrow panels below the Parthian campaign).

street beneath it. Contrary to popular belief, the road at the higher level was contemporaneous with the arch; reports of the *Ludi Saeculares* celebrated by Septimius Severus in AD 204 record the passage of a procession below the arch.

The majestic inscription on both sides of the attic **(1)**, which houses four small chambers within, records the dedication of the monument to Septimius Severus and Caracalla:

To the Emperor Caesar Lucius Septimius Severus, son of Marcus, Pius, Pertinax, Augustus, Pater Patriae, Parthicus, Adiabenicus, Pontifex Maximus, granted the Tribunician power for the eleventh time, acclaimed victorious general for the eleventh time, Consul for the third time, Proconsul; and to the Emperor Caesar Marcus Aurelius Antoninus, Son of Lucius, Augustus, Pius, Felix, granted the Tribunician power for the sixth time, consul, proconsul, Pater Patriae; to both men, the best and bravest emperors, for having saved the Republic and expanded the dominion of the Roman people and for their remarkable virtue, at home and abroad, the Senate and the people of Rome make this dedication.

The fourth line shows clear traces of reworking: a series of holes, drilled to accommodate bronze letters, does not coincide with the extant letters. In place of the words of the surviving inscription, *optimis fortissimisque Principibus* (to the best and bravest emperors), the earlier holes spell out the phrase *P. Septimio Getae nobilissimo Caesari*. The original dedication thus included Septimius Severus's other son, Geta, who was killed by his brother Caracalla after the death of their father and whose name was effaced from all public monuments after his *damnatio memoriae*.

The core of the arch is travertine and brick, while its exterior facing is entirely marble. Four columns with composite capitals resting on high bases give depth to the facades on both sides. The elaborate decoration includes the following: two representations of Mars in the keystones of the central arch **(3)**; Victories carrying trophies in the spandrels of the same arch **(2)**, at whose feet are personifications of the four seasons; four divinities, two male and two female, in the keystones of the minor arches **(5)**, of which only the figure of Hercules is identifiable; river gods on the spandrels of the minor arches **(4)**; above the minor arches, a small frieze representing the triumph of the victorious generals. The bases of the columns depict Roman soldiers with Parthian prisoners **(6)**.

The four large panels **(I–IV)**, each measuring 3.92 × 4.72 meters, above the minor arches constitute the most important and original section of the monument's decorative program, portraying decisive incidents in the two campaigns against the Parthians. The story begins with the left panel on the Forum side and moves around the arch from left to right; each panel is read from bottom to top.

I. This panel, in very poor condition, consists of three superimposed sections: (A) the departure of the Roman army from camp (Carrhae or Zeugma); (B) combat; (C) on the left, the speech of Septimius Severus to the army, and, on the right, the liberation of Nisibis, besieged by the Parthians.

II. This panel similarly consists of three superimposed sections: (A) the Roman army, employing siege engines, attacks the city of Edessa, which surrenders; (B) on the right, the submission of the Osroeni and of King Abgar to Septimius Severus, and on the right, a speech by Septimius Severus to the army; (C) on the right, the emperor's council of war in a fortified camp, and on the left, the emperor directing the continuation of the campaign.

The panels on the opposite side consist of two superimposed sections:

III. (A) the Romans' attack on the city of Seleucia on the Tigris and the flight of the Parthians; (B) the surrender of Seleucia and the submission of the Parthians to the emperor.

IV. (A) the Romans' attack on Ctesiphon with siege engines and the fall of the city; (B) the final address of the emperor in front of Ctesiphon.

The similarity of these relief sculptures to those on the Column of Marcus Aurelius has prompted some to speculate that the designs typically found on illustrated columns were adapted for the Arch of Septimius Severus. The use of superimposed scenes to describe narrative, however, is not by any means unique to columns; indeed, the exploits of victorious generals were typically thus represented at least from the middle of the Republic. Moreover, we know that Septimius Severus had pictures of this sort sent to Rome from the east; these may have been the models of the sculptures on the arch.

A coin dated AD 204 shows a bronze quadriga with statues of the emperors on top of the arch.

THE ALTAR OF SATURN, THE *UMBILICUS URBIS,* AND THE *MILIARIUM AUREUM*

If the remains under the Niger Lapis constitute the early sanctuary of Vulcan, then the traditional identification of the remains of the ancient altar behind the Imperial Rostra, near the western corner of the Arch of Septimius Severus, as the Volcanal must be rejected. Instead, this monument can be none other than the Altar of Saturn (FIG. **13:7**). We know that this altar, which remained in use until the last days of the Empire, stood in front of the Temple of Saturn south of the Senaculum and east of the Temple of Concord, and it is within this small area that the remains of an altar have been recovered; their archaic appearance accords with what we know of the altar—a monument that certainly predates the temple dedicated to the divinity in the sixth century BC. According to tradition, the altar was erected by Pelasgians in honor of Saturn, identified with the Greek god Kronos, who was supposed to have founded the earliest settlement on the Capitoline known to Roman tradition; it was named *Saturnia,* in honor of its founder.

Ancient authors record that a shrine to Dis and Proserpina, the gods of the underworld, lay in the immediate vicinity of the Altar of Saturn. This was probably the *Mundus,* the precinct that Plutarch situates near the Comitium in his *Life of Romulus* (11.2). Alongside the Altar of Saturn stands a circular brick structure, 4.45 meters in diameter. This has been identified as the *Umbilicus Urbis* (the navel of the city) mentioned by late sources. The Umbilicus Urbis and the Mundus would have been the same monument. A single trope underlies both the Umbilicus Urbis (a term that appears only in late antiquity) and the Mundus: they mark the heart of the city. A circular trench dug by Romulus at the center of the city during its founding, the Mundus was, according to ancient authors, the site of ceremonies in which future citizens of Rome would offer earth taken from their places of origin, as well as the first fruits of the year. The Mundus was envisaged as a portal to the underworld. Three times a year it was opened (the ritual formula in the Roman calendar is *Mundus patet:* "the *Mundus* is open"). These days were considered particularly unlucky and dangerous because infernal divinities could visit the upper world through this opening. In the second century BC, the Mundus was described as comprising two parts: a

subterranean trench and a surface monument. The latter is the Umbilicus, the central core of which survives. It was built during the Severan period, apparently immediately after the construction of the Arch of Septimius Severus, which must have damaged the earlier monument. The Severan Umbilicus reused elements of the earlier one: remains of a travertine base molding and part of the denticulated cornice of a circular shrine, both dated to the last quarter of the second century BC, are still *in situ* or alongside the extant brick core.

Symmetrically opposite the Umbilicus, at the other end of the Imperial Rostra, was the *Miliarium Aureum* (the golden milestone), a small monument erected by Augustus in 20 BC to mark the central point from which Roman roads issued forth and to indicate the distances between Rome and the principal cities of the empire. Remains of the column, originally clad in gilded bronze, and of its white marble base, decorated with palmettes, can still be seen in front of the Temple of Saturn. The Miliarium Aureum complemented the Umbilicus, defining a symbolic contrast between the center of the Roman world and the center of the city. The Umbilicus, the older of the two monuments, was the model for the Miliarium.

THE IMPERIAL ROSTRA Caesar oversaw the demolition of the monuments of the Comitium and followed this up with the reconstruction of the most important of these—the Curia and the Rostra—in a new location, namely, along the short northwestern side of the Forum (FIG. **13:8**). Both were inaugurated shortly before the death of the dictator in 44 BC; they were probably rededicated under Augustus after the battle of Actium. During the empire, this celebrated tribunal was called the *Rostra Vetera* to distinguish it from the rostra situated at the other end of the Forum in front of the Temple of Divus Iulius.

The remains visible today correspond precisely to the two known phases of construction: a hemicycle with a flight of stairs and a marble facade facing the Forum, and a rectilinear construction that was later added to the eastern side of the hemicycle. The former, inserted into the Caesarian pavement, is contemporary with it, while the later addition sits above both the pavement and the hemicycle. The cornice on the right-hand side of the hemicycle, facing north, was clearly deliberately broken in order to accommodate the lateral cornice of the new construction. The addition, however, predates the Forum's extant pavement, laid by L. Naevius Surdinus after the fire of 9 BC. Archaeological evidence thus appears to confirm that the hemicycle was the rostra built by Caesar and that the rectilinear addition was the enlargement undertaken by Augustus. The concrete structure, the travertine stairs, and the marbles used in the construction (Porta Santa for the facade, Africano for the small piers, and a white Greek marble for the base, in which the masons' marks in Greek characters are still visible) confirm the identification of the Caesarian tribunal; these materials were already in use during the last century of the Republic. The bronze prows must have been attached to the

piers, a detail that seems to be indicated on a coin minted by a partisan of Caesar, Lollius Palicanus, in 44 BC, the same year as the inauguration of the Rostra. The structure's curving form, also visible on the coin, probably reproduces that of the older rostra of the Comitium. The facade of the Augustan rostra—23.80 meters long, equal to 80 feet—is constructed of Anio tufa in *opus quadratum* (the section in conglomerate is a modern restoration). Large holes visible in the front of the monument held the bronze prows in place. The brick piers between the Augustan and Caesarian rostra supported the platform of the tribunal, which probably consisted of a wooden floor. These extant brick supports replaced the original piers, which were probably of travertine.

An extension in brick rests against the original podium on the side facing the Arch of Septimius Severus. An inscription preserved *in situ* attributes the extension to Ulpius Junius Valentinus, the city prefect during the reign of Leo and Antonius (ca. AD 470). The association of this structure with a Roman victory over the Vandals has given rise to the modern name *Rostra Vandalica*.

THE TEMPLE OF SATURN The large Ionic building that rises at the foot of the Capitoline, southwest of the Rostra, can be identified with certainty as the Temple of Saturn (FIG. **13:10**); the much older altar of Saturn, which tradition associates with the god's founding of the city on the Capitoline, was located in front of this temple. Construction of the temple began during the regal period; its inauguration, however, did not take place until the first years of the Republic (perhaps in 498 BC). After the Temple of Jupiter Capitolinus, this is the oldest Republican temple. It was entirely reconstructed by Munatius Plancus in 42 BC and restored after the fire of Carinus (AD 283). What remains of the superstructure—eight columns and the entablature, constructed largely of salvaged material—may date to the third-century restoration, or even to a later one. The still legible inscription on the frieze records a restoration that was undertaken following a fire *(Senatus Populusque Romanus Incendio Consumptum Restituit)*. The magnificent podium, with travertine revetment, dates to the reconstruction overseen by Munatius Plancus. In front of the podium there was an extensive avant-corps, now largely collapsed, whose interior was entirely empty; entrance was on the east through a door, of which only the threshold survives. On the anniversary of the temple's dedication, 17 December, the feast of the year's end, the Saturnalia, was celebrated with unrestrained freedom.

A paved road passes in front of the facade of the temple and connects the *Vicus Iugarius* with the *Clivus Capitolinus*. The Arch of Tiberius (FIG. **13:11**), erected in AD 16 following the victories of Germanicus, stood just before the intersection, spanning the Vicus Iugarius, and not (as it is generally—and erroneously—situated) on the road that runs along the facade of the Basilica Iulia. The two brick piers rising between the temple and basilica must have belonged to this monument. On the other side of the Clivus Capitolinus, of which a long tract of

the ancient pavement survives, a group of buildings on the slope of the Capitoline marks the western end of the Forum: from south to north, these are the Porticus of the Dei Consentes, the Temple of Vespasian and Titus, the Temple of Concord, and the Carcer.

THE PORTICUS OF THE DEI CONSENTES According to Varro (*R.* 1.1.4), near the Forum stood twelve gilded statues of the *dei consentes,* six gods and six goddesses, which may have been a Roman version of the Greek *dodekatheon* (twelve Olympian deities) or possibly a group of gods of Etruscan origin. In 1834, a strange building was discovered above the Temple of Saturn on the slopes of the Capitoline consisting of eight rooms, made of brick, that were laid out on two sides at an obtuse angle; the colonnaded porticus in front of the rooms was reconstructed in 1858 (FIG. **13:1**). The colonnade is situated on a platform in which there were seven other rooms at a lower level and with a different orientation from the upper rooms. The statues of the twelve gods might have been displayed in pairs in six of these rooms. The inscription on the architrave of the porticus records that the statues of the Dei Consentes and the building that housed them were restored by Vettius Agorius Praetextatus, city prefect in AD 367. The rooms, architrave, and capitals (Corinthian, decorated with trophies), however, date to the preceding phase, probably a Flavian reconstruction following the fire of AD 80. The restoration of 367 is one of the last manifestations of the pagan revival of the fourth century AD that owes much to Vettius, whose aversion to Christianity, the dominant religion at that time, is well known.

THE TEMPLE OF VESPASIAN AND TITUS Immediately to the north of the Porticus of the Dei Consentes rises the base of a temple that abuts the large foundation wall of the Tabularium (FIG. **13:2**); in fact, the temple closed off an entrance to the building. Identification of the shrine was made possible by the fragment of an inscription still visible on the architrave: *[r]estituer(unt)* (they restored). A pilgrim of the eighth century AD, who left notes recording his visit to Rome (the so-called Einsiedeln Itinerary), transcribed the inscription when it was still complete and the temple was in all likelihood mostly intact: *Divo Vespasiano Augusto S.P.Q.R. Impp. Caess. Severus Et Antoninus Pii Felices Augg. Restituer.* On that evidence, the building is the temple dedicated to Vespasian, whom the Senate had proclaimed a god, and later restored by Septimius Severus and Caracalla. We know that it was also dedicated to Titus, and thus the original construction would have been completed by Domitian.

The building was 33 meters long and 22 meters wide, prostyle and hexastyle, with a spacious cella in front of which rose six columns, flanked on each side by two lateral columns. A podium within the cella held the statues of the two deified emperors. (The two gigantic marble heads of Vespasian and Titus in the Farnese collection, preserved in the Museo Nazionale in Naples, belonged to

these statues.) Of the colonnade, only three columns of the northeastern cor-
ner survive (Corinthian, 15.20 meters high and 1.57 meters in diameter). They
support a fragment of the architrave on which, in addition to the remnant of
the inscription, there is a frieze representing sacrificial implements. The late
Flavian style of the capitals and the sculptures indicates that what remains of the
building dates to the original construction; the Severan emperors' restoration
of the temple was thus quite limited, as was their restoration of the Pantheon.
The curious arrangement of the temple steps within the colonnade accom-
modates the limited space of the site; the steps, like the podium, were rebuilt
in 1811.

THE TEMPLE OF CONCORD North of the Temple of Vespasian and Titus, and
separated by only a small amount of space, is a large podium that also abuts
the Tabularium. The identification of the building as the Temple of Concord
is certain; it appears, for example, on a fragment of the Severan Marble Plan
(FIG. **13:3**). The temple was popularly believed to have been vowed by Camillus
in 367 BC to celebrate the end of the struggles between the patricians and plebs,
which culminated that year in the passage of the Licinio-Sextian laws, setting
the two classes of the city on an even footing, at least politically. The authenticity
of the episode, however, has been called into question, since the practice of
deifying abstract virtues did not begin until the end of the fourth century BC. It
is possible that the temple was first built in 218 BC by the praetor L. Manlius.
It was restored by L. Opimius after the murder of C. Gracchus and again by
Tiberius between 7 BC and AD 10, the year of its new inauguration.

The present form of the cella, wider than deep (45 × 24 meters), dates to
the last reconstruction, which took maximum advantage of the narrow space
available. At this time it must have expanded into part of the area previously
occupied by the Basilica Opimia, built north of the temple in 121 BC by the same
L. Opimius who restored the temple itself; thereafter, the basilica disappears
from the historical record. The narrow porch in front of the cella featured
a hexastyle colonnade. Nothing of the splendid Tiberian building remains
other than the podium and threshold of the cella. The latter consists of two
enormous blocks of Porta Santa marble engraved with a caduceus, the emblem
of ambassadors and thus a symbol of reconciliation. A segment of the very
ornate entablature is housed in the Tabularium, while a capital from the cella,
composite Corinthian with representation of pairs of rams instead of volutes,
resides in the Forum Antiquarium.

Tiberius transformed the building into a veritable museum. Pliny the Elder
(*NH* 34.73, 77, 80, 89, 90; 35.66, 131, 144ff.) catalogues the works that were
housed there. For the most part, the pieces mentioned are Greek and can be
dated to the post-Lysippean period, corresponding to the emperor's preference
for Hellenistic art. During the Republic, the Senate would occasionally meet
in the temple. It was here that Cicero made his Fourth Catilinarian speech

and, during the early Empire, the Senate convened in the temple to condemn Sejanus, who was subsequently executed in the nearby Carcer.

THE CARCER TULLIANUM Identification of the Carcer as the ancient building at the foot of the Capitoline beneath the Church of S. Giuseppe dei Falegnami is secure (FIG. **13:4**). Pliny records its position as west of the Curia, and we know that it was in the immediate vicinity of the Temple of Concord and near the Forum. The remains beneath the church accord perfectly with the descriptions provided by ancient authors. The extant structure is only one part of the ancient Carcer—probably the innermost and most secret section, called the *Tullianum*. The attribution of the building to Servius Tullius or Tullius Hostilius probably derives from this name; according to Livy (1.33), however, its founder was Ancus Marcius.

A flight of stairs leads to the ancient level. The travertine facade dates from the beginning of the Imperial period, as is indicated by the large inscription with the names of the two consuls, C. Vibius Rufinus and M. Cocceius Nerva, dating to between AD 39 and 42. The present facade covers an older one of Grotta Oscura tufa. An opening, probably modern, leads to a trapezoidal room constructed of Monteverde and Anio tufa blocks and thus datable to the second half of the second century BC. The original entrance possibly consisted of a small door, now walled in, which stood in the wall on the right at a higher level than the current floor.

The other rooms in the prison, called *lautumiae* (stone quarries) because they were fashioned out of ancient tufa quarries, must have stood beyond this entrance along the slope of the Capitoline. The floor has a circular opening that was once the only entrance to the lower room, access to which is now possible by a modern stairway. The lower room, circular in form, is built entirely of unmortared peperino blocks. A wall that cuts through the building on the eastern side is probably associated with the construction of the Basilica Porcia. When the latter was built, the ancient street that passed by the prison, the *Clivus Lautumiarum*, must have shifted to the west; in late antiquity this road appears to have been called *Clivus Argentarius*. We can thus be certain that this section of the Carcer predates the construction of the Basilica Porcia in 184 BC.

What survives of the building is the most secret and terrible part of the prison, known as the Tullianum. The infiltration of water, which can still be observed today, has suggested to some that the original construction was a cistern, but it is more likely that the building served as a prison right from the beginning. State prisoners were incarcerated here and then strangled after being led through the city in the triumphal parades celebrated by victorious generals. This fate was reserved for, among others, Jugurtha and Vercingetorix. Among the Romans, the partisans of Gaius Gracchus, the Catilinarian conspirators, and Sejanus and his children perished here. The medieval legend that Saints Peter and Paul were imprisoned here should be discounted.

Sallust provides the most detailed description of this gloomy place in his account of the execution of the Catilinarian conspirators (*Cat.* 55): "There is a place in the prison called the *Tullianum*, a little to the left as you go down, sunk about twelve feet underground. It is enclosed within thick walls and a vaulted stone ceiling. Its appearance is repugnant, even frightening, because of its neglect, darkness, and smell." The courage that Jugurtha showed in the face of death is memorable: when thrown into the Tullianum, he turned to his executioners and said, jokingly, "By Hercules, see how cold your bath is!"

ITINERARY 2

The Central Area of the Forum

OPEN SPACE OF THE FORUM The Forum's **first pavement** of beaten earth dates from the beginning of the Etruscan period; that is, to the end of the seventh century BC. Stone pavements were laid several times during the course of the Republic, traces of which can be seen in various points in the Forum. Near the Column of Phocas, an inscription in large letters, which has undergone considerable restoration, securely dates the last surviving pavement. It reads: *L. Naevius L. f. Surdinus pr(aetor).* The same text appears complete on a relief discovered in the immediate vicinity, now on display in the Capitoline Museums, which depicts Mettius Curtius hurling himself into a chasm. A reproduction of the original is displayed beside the *Lacus Curtius*.

Surdinus was a *praetor inter cives et peregrinos;* that is, the official in charge of judicial transactions between Romans and foreigners; he probably held the position in 9 BC. It was long believed that the inscription pertained to the nearby tribunal of the praetor, but it has since been shown, on the basis of similar placements in other fora (such as those in Tarracina, Saepinum, and Veleia), that Surdinus had the pavement rebuilt. This pavement was installed following the great fires of 14 and 9 BC, which destroyed a large section of the Forum, extending from the Basilica Fulvia-Aemilia to the temples of Vesta and the Castors and the Basilica Iulia. Most of the buildings were rebuilt immediately afterward. The new pavement covered over another laid during the reign of Julius Caesar, of which traces are visible where the Augustan pavement is missing. Between the Rostra and the Lacus Curtius, various rectangular openings, giving access to vertical shafts, can be seen in the Caesarian level. These were part of a system of **underground passageways,** probably constructed by Caesar, that extended underneath the entire Forum. In conjunction with the vertical openings, nineteenth-century excavators noted the remains of wooden lifts, an indication that these passageways were likely used in the gladiatorial games that took place in the Forum during the Republic, serving the same functions as the subterranean galleries of the Colosseum. Surdinus's pavement, by closing these

apertures, put the passageways out of use; the closure coincides with the cessation of gladiatorial games in the Forum at the beginning of the Augustan period.

The column that rises on a stepped base in front of the Rostra is the last of the commemorative monuments to be erected in the Forum (FIG. **13:14**). The inscription reads as follows:

> *Optimo clementiss[imo piissi]moque / principi domino n(ostro) / F[ocae imperat]ori / perpetuo a d[e]o coronato [t]riumphatori / semper Augusto / Smaragdus ex praepos(ito) sacri palatii / ac patricius et exarchus Italiae / devotus eius clementiae / pro innumerabilibus pietatis eius / beneficiis et pro quiete / procurata Ital(iae) ac conservata libertate / hanc sta[tuam maiesta]tis eius / auri splend[ore fulgen]tem huic / sublimi colu[m]na[e ad] perennem / ipsius gloriam imposuit ac dedicavit / die prima mensis Augusti, indict(ione) und(ecima) / p(ost) c(onsulatum) pietatis eius anno quinto.* (To the best, most clement, and most pious emperor, our lord Phocas, general in perpetuity, crowned by god, triumphator, always Augustus— Smaragdus, former head of the holy palace and patrician and exarch of Italy, devoted to his clemency on account of his innumerable acts of piety and the peace he conferred on Italy and his preservation of liberty, set this statue of his majesty, shining with the splendor of gold, upon this high column that his glory might last forever and dedicated it on the first day of the month of August, in the eleventh indiction, in the fifth year of his service after the consulship.)

The statue was dedicated in AD 608, but the column itself belonged to an older monument, probably of the second century AD; it was rededicated to Phocas after the original inscription was erased. A portion of the steps was removed at the beginning of the twentieth century to expose Surdinus's inscription.

The bombastic praise of the inscription, reiterated in Pope Gregory's letter to the emperor, cannot erase the memory of Phocas's ascension to the throne in 602 by his murder of the emperor Mauritius and his five sons. The new emperor's true legacy in his dealings with Rome was his presentation of the Pantheon to the pope, who transformed it into the Church of S. Maria ad Martyres in 609. As for Phocas, he was deposed and murdered in the year following.

In front of the Rostra lies a **square area** that was left unpaved. This was the site of the fig tree, olive tree, and vine that Pliny the Elder (*NH* 15.78) observed in the center of the Forum near the Lacus Curtius. All three were replanted in 1956.

A little to the east of Surdinus's inscription is a trapezoidal area below the Augustan pavement that has preserved both a segment of the ancient Caesarian paving and, where the latter is missing, a section of the underlying tufa pavement. On the eastern side, a twelve-sided base of friable tufa (cappellaccio) encloses a circular foundation, which is open in the middle; this was probably the base of a well. Farther to the west are two rectangular cuttings, possibly intended to secure bases for altars. The site can be identified with certainty as the **Lacus Curtius,** the subject of several legends (FIG. **13:16**). According to one of these, the site was originally a swamp into which the Sabine leader, Mettius Curtius,

fell while riding his horse during the legendary war between the Romans and Sabines. According to another, it was named for a Roman, Marcus Curtius, who sacrificed himself in response to an oracle by throwing himself into a chasm that opened up at this spot. Varro's account (*L.* 5.150), however, is more plausible; according to him, the name derives from the consul of 445 BC, C. Curtius, who on the order of the senate oversaw the enclosure of a place struck by a thunderbolt.

The relief in Greek marble depicting the legend's climactic episode, discovered nearby in 1553, must have belonged to this monument. The work dates from the Republican period, as is evident from the fact that Surdinus's inscription, engraved on the reverse, shows evidence of having been added afterward by its clear traces of reworking. The sculpture may have been part of the balustrade contemporary with the Caesarian pavement—perhaps crafted by the same workshop of Greek sculptors that created the frieze in the Basilica Fulvia-Aemilia, since it is as similar in style and content as it is in chronology.

A little to the east of the Lacus Curtius is a rectangular depression about a meter deep. On the basis of a contemporaneous description (Statius, *Silvae* 1.1), scholars have generally identified this as the site of the bronze equestrian statue of Domitian *(Equus Domitiani)*, erected in AD 91 (FIG. **13:18**). The monument is depicted as well in a contemporaneous coin. We know that under the raised foreleg of the horse is a representation of the Rhine, commemorating Domitian's victories in Germania. The three hollowed-out travertine blocks inserted into the concrete foundation, some have argued, might have been supports for the metal props that anchored the horse's other three legs. A recent study, however, has demonstrated that the statue lay farther to the north, right in the center of the Forum, where the pavement shows clear signs of reworking. The monument was certainly pulled down immediately after the assassination of Domitian in 96. It has been proposed that the visible remains belonged instead to the *Doliola*, where vessels sacred to Vesta were buried at the time of the Gallic sack. In fact, several vases, datable to the seventh century BC, were found by Giacomo Boni in a stone receptacle *(theca)* inserted into the cement bedding.

THE BASILICA IULIA The Basilica Iulia occupies the whole area between the Temple of Saturn and the Temple of the Castors, bordered by the two principal streets that lead to the Forum from the Tiber: the *Vicus Iugarius* on the west and the *Vicus Tuscus* on the east (FIG. **13:15,** FIG. **19:3**). It is likely that the construction of the basilica in its current size prompted a change in the course and a regularization of the two streets; below the extant pavements, excavators have observed the remains of Republican constructions.

The building, 101 meters long and 49 meters wide, sits on top of one of the oldest basilicas in Rome, the Basilica Sempronia, which the censor Tiberius Sempronius Gracchus, father of the famous tribunes Tiberius and Gaius, built in 169 BC. We know from Livy (44.16) that Gracchus had to demolish the home

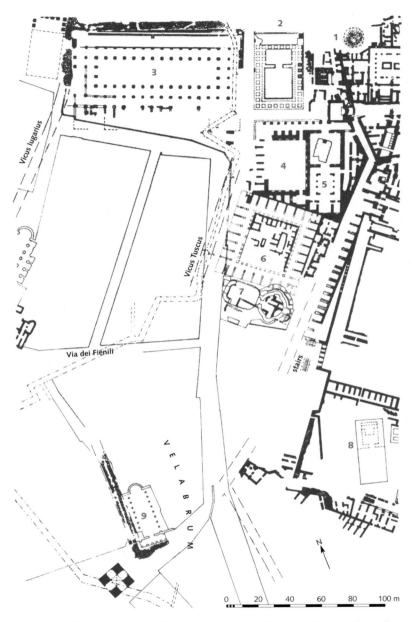

FIGURE 19. The area of the Velabrum. **1** Temple of Vesta. **2** Temple of the Castors. **3** Basilica Iulia. **4** Domitianic hall. **5** Church of S. Maria Antiqua. **6** Horrea Agrippiana. **7** Church of S. Teodoro. **8** Temple of Magna Mater (Cybele). **9** Church of S. Giorgio in Velabro. (After Astolfi, Guidobaldi, and Pronti)

of Scipio Africanus, which stood in this location, as well as nearby shops, to make room for his basilica. The Basilica Iulia was certainly much larger than its predecessor since it took over the space occupied by the group of shops *(tabernae veteres)* that stood in front of the older basilica, balancing the *tabernae novae* located on the other side of the square in front of the Basilica Fulvia-Aemilia.

Caesar probably began construction of the building as early as 54 BC, at the same time he was working on his new forum, as Cicero records in a letter to Atticus. Augustus completed the project, but it was destroyed immediately afterward in the great fire of 9 BC. Following reconstruction, the building was dedicated to the emperor's two adopted sons, Gaius and Lucius, but always kept its original name. Diocletian rebuilt the basilica after it was damaged in the fire of Carinus (AD 283).

Unfortunately, because of continuous pillaging, little survives of the ancient building; in effect all that is left is the podium, which rises on several steps— seven on the eastern corner and one on the west, owing to the slope of the ground. The brick piers visible today are largely a nineteenth-century restoration. Nonetheless, the plan of the basilica can be reconstructed. The imposing building consisted of five aisles. Its large central hall (82 × 18 meters) was surrounded on all four sides by two concentric porticoes; the one on the outside facing the Forum had arcades on two stories, an indication that the central hall must have risen to a height of three stories. The basilica housed the tribunal of the *centumviri*, and its interior was sectioned off by curtains or wooden partitions so that it could be used by four tribunals at the same time. Only particularly important cases would have required use of the whole space; Pliny the Younger (*Ep.* 6.33.3) records that one of the cases in which he was involved drew such a crowd that people were massed not only in the hall but in the upper galleries as well.

On the steps of the basilica facing the Forum and on the floor of the aisles idlers passed the time playing board games *(tabulae lusoriae)* and left graffiti sketches of statues displayed in the area. Toward the center of the facade are two bases inscribed *opus Polycliti* and *opus Timarchi;* these supported two statues—originals, not copies—by the famous Greek sculptors named in the inscriptions, which were probably brought here in the Severan period, at least to judge from the style of the writing. One of these inscriptions now sits on a base that bears the name of the city prefect in AD 416, Gabinius Vettius Probianus, who records his relocation of a statue from another place into the Basilica Iulia. As indicated by similar bases found in the area, Probianus's work was probably undertaken as a result of the sack of Alaric.

Excavations carried out deep in the center of the building have brought to light the remains of a building—the Basilica Sempronia—that sat on top of even older structures, including, among others, the *impluvium* of a private house; this was very likely the house of Scipio Africanus. Two archaic terracotta antefixes, dating to between the end of the sixth and the beginning of the fifth centuries

BC, were among the discoveries and should be ascribed to the oldest phase of the nearby Temple of the Castors.

In the area south of the basilica and communicating with it are **several tabernae** that probably opened onto an ancient street. The Temple of Divus Augustus must have stood beyond this street, in the unexcavated area beneath the former Ospedale della Consolazione; the monument was begun by Tiberius and completed by Caligula. A fragment of the Severan Marble Plan probably contains a plan of this temple, which stood within a square identified by the inscription as the *Graecostadium*, possibly the location of a slave market during the Imperial period. The statue of Vertumnus, a god of Etruscan origin, must have stood on the corner of the street, near the *Vicus Tuscus* (Street of the Etruscans), named, according to legend, for the district's inhabitants, who came to Rome with King Tarquinius Priscus. Ancient tradition held that the statue marked the boundary of the Velabrum marsh prior to the construction of the Cloaca Maxima.

THE TEMPLE OF THE CASTORS The surviving three Corinthian columns of the Temple of the Dioscuri (or of the Castors, as the Romans more frequently called it, privileging one of the two divine twins) rise on a high podium immediately to the east of the Vicus Tuscus (FIG. **13:26**, FIG. **19:2**).

The Greek cult was introduced into Rome quite early, at the beginning of the fifth century BC. The legend states that during the battle near Lake Regillus in 499 BC, in which the Romans fought the Latins allied to Tarquinius Superbus in his attempt to reconquer Rome, two mysterious horsemen appeared and led the Romans to victory. Immediately afterward, the same horsemen were seen watering their horses in the city at the Fountain of Juturna, where they announced the victory and thereafter disappeared. In their honor, the dictator Aulus Postumius Albinus made a vow to erect a temple, which was dedicated by his son in 484 BC.

The discovery at Lavinium (Pratica di Mare) of an archaic inscription of the sixth century BC containing a dedication to Castor and Pollux confirms the early introduction of these two divinities into Latium. The strongly Hellenic tone of the language makes it certain that the cult migrated here from one of the cities of Magna Graecia, probably Tarentum. The patricians must have had a hand in introducing the cult to Rome, given the ease with which this foreign cult was welcomed in the heart of the city and inside the *pomerium*. Just as the Dioscuri were the protectors of the knights (i.e., the aristocracy) in Magna Graecia, they were also the tutelary gods of the nobility in Rome.

Important remains of the archaic temple with three cellae and a podium in cappellaccio, as well as its terracotta decoration, were brought to light during recent excavations, which have definitively confirmed the traditional dating of the temple. It was restored by L. Caecilius Metellus Delmaticus in 117 BC and then again in 73 BC by Verres, the governor of Sicily made famous by Cicero's

brilliant prosecution. Tiberius oversaw the final restoration after the fire of 14 or 9 BC; the new building was dedicated in AD 6; the remains that can be seen today date to this reconstruction. The podium is in large part that of the 117 BC construction, which incorporated the remains of the earlier archaic phase, but only a section in *opus caementicium* survives; the tufa blocks that supported the more important structural parts of the building were removed by pillagers, and a marble block from the temple was used for the base of the equestrian statue of Marcus Aurelius on the Capitoline. The building (32 × 49.50 meters) can be reconstructed as peripteral, Corinthian, and octostyle with eleven columns on its long sides. Some have argued, though the issue cannot be definitively resolved, that the front section of the podium, which was approached by two side stairs, was decorated with ships' prows and that, together with the Imperial Rostra and another located on the podium of the Temple of Divus Iulius, it constituted one of three known speakers' platforms in the Forum (the so-called *Rostra Tria*). As was the case of the rostra of the Temple of Divus Iulius, however, it is likely that the platform was actually the independent structure, possibly built during the reign of Diocletian, that has recently been identified in front of the temple, along the eastern side of the Forum.

Several noteworthy episodes in the history of the Republic occurred in the temple of the Castors: Caesar argued in favor of his agrarian legislation on the platform, and the Senate met from time to time in the temple. The podium might also have served as the presidential tribune of the legislative assemblies that convened in the section of the Forum that faces the temple. We know, moreover, that the temple housed the office of weights and measures as well as bankers' stalls; these are probably the small rooms in the podium situated between the columns, which have been partially preserved on the eastern side.

THE FOUNTAIN OF JUTURNA Before the censorship of Appius Claudius (312 BC), as Frontinus records in his treatise on aqueducts (written at the end of the first century AD), water in Rome was drawn primarily from the Tiber, wells, and the few springs that existed within the city. During the archaic period, the most important spring was located at the foot of the Palatine between the temples of Vesta and of the Castors. As were others in antiquity, the spring was associated with a divinity, the nymph Juturna, sister of King Turnus, and its waters were considered salutary (FIG. **13:28**). An excavation in 1900 uncovered the spring and revealed that it had a monumental appearance as early as the Republican period. In the middle of a roughly square basin, clad in marble, stands a rectangular pedestal, designed to support a statuary group. The level of the basin is about a meter lower than the Augustan pavement; the extant arrangement is thus Republican and not early Imperial, as has often been claimed. The use of *opus quasi reticulatum*, typical of the end of the second and beginning of the first centuries BC, confirms this date. Restorations employing Anio tufa in *opus reticulatum*, which can be assigned with certainty to the beginning

of the empire, can also be observed. The latter were probably contemporary with Tiberius's restoration of the Temple of the Castors, while the construction of the basin in its extant form likely dates back to Metellus's reconstruction in 117 BC. Recent discoveries have led to the identification of an older phase, in *opus incertum,* that can be dated to the middle of the second century BC, probably during the censorship of Aemilius Paulus. Confirmation of this dating can be found in the fragments of the marble statues of the Dioscuri (now in the Forum Antiquarium) discovered in the basin; these evidently once stood on the central pedestal. The statues are not Archaic Greek originals, as has been stated, but are in an archaizing style that is typical of the late Hellenistic era and can thus be ascribed, like the rest of the monument, to the second century BC. The sculptures must have come from a workshop of Greek artists active in Rome during those years. It is possible they were commissioned by Lucius Aemilius Paulus, the general who defeated Perseus of Macedon and who, according to Minucius Felix (*Octavius* 7.3), dedicated the statues of the Dioscuri in the *Lacus Iuturnae.* The statues show traces of fire damage and restorations in Carrara marble (the original marble was Greek). The fire of 14 BC must also have damaged the fountain, and so Tiberius may have also restored the statues afterward. In fact, the temple and the fountain appear to belong to a single complex.

A marble cippus of the Trajanic period also comes from this area; a cast of the original, which is in the Forum Antiquarium, has been set on the edge of the basin. The cippus bears a relief sculpture of the Dioscuri, their parents Jupiter and Leda, and Juturna. **Juturna's shrine,** identified by the dedicatory inscription to the goddess located atop the monument, sits a little to the south of the basin. It too was reconstructed, probably during the Trajanic period. The shrine sits at an oblique angle to the other surrounding buildings, a fact that might be explained by the original orientation of *Nova Via,* which must have passed by here before the Neronian reconstruction in this area following the fire of AD 64.

In front of the shrine is a **marble wellhead** with an inscription, repeated twice, that names M. Barbatius Pollio, a *curule aedile* who lived between the ages of Caesar and Augustus. A Severan altar, with a relief depicting two divinities (probably Mars and Venus), sits in front of the well; the work is a reproduction (the original is on display in the Forum Antiquarium).

Behind the fountain toward the east stands a **building** that gives evidence of various phases, from the late Republic to the high Empire. The rooms, constructed in *opus incertum* and thus of Republican vintage, abut the House of the Vestal Virgins and once supported a ramp that led to the Palatine. The building was completely rebuilt in brick and furnished with a black and white mosaic floor during the late Empire. Its precise function can be identified from two inscriptions on a statue base that is still preserved *in situ* (in the room near the shrine). One of these mentions the dedication of a statue to Constantine

by the curator of aqueducts and grain distribution *(Curator Aquarum et Minuciae),* Fl. Maesius Egnatius Lollianus; the other states that the same person built the *Statio Aquarum* (Office of the Aqueducts) on this spot in AD 328. The administration of the water supply and aqueducts was thus transferred here in that year from the office's original seat, probably within the Area Sacra di Largo Argentina. Another inscription preserved here, dedicated to the *Genius* of the Statio Aquarum, definitively confirms the identification. Various statues decorated the building. One of these was of Aesculapius, the god of medicine, perhaps an allusion to the salutary quality of the waters, and another was an archaizing representation of Apollo (now in the Forum Antiquarium).

Immediately to the south of the Fountain of Juturna is a room that also probably dates from the Trajanic period. With the addition of an apse, it was later transformed into a Christian oratory, called the "Oratory of the Forty Martyrs" (FIG. **13:27**). The martyrdom of forty Christian soldiers in Armenia during the persecutions of Diocletian is represented on the back wall in a fresco that probably dates to the eighth century.

GROUP OF DOMITIANIC BUILDINGS AND S. MARIA ANTIQUA An important complex of buildings south of the Temple of the Castors and Fountain of Juturna forms a structural link between the Forum Romanum and the Palatine. The first building (moving from west to east) is a **large hall,** built entirely of brick, that was originally vaulted; it had a porticus facing the Forum side and shops opening onto the Vicus Tuscus (FIGS. **13:33, 19:14**). The building can be dated to the end of the reign of Domitian on the basis of brick stamps, while the shops are Hadrianic.

The **adjacent complex** on the east consists of an open square room from which three entrances provided access to another room with a central hall surrounded by a *quadriporticus;* at the end of the hall were three other rooms (FIG. **19:5**). Underneath the first (open) room another older structure was discovered, containing a rectangular basin (probably an *impluvium*), dated, on the basis of brick stamps, to the reign of Caligula. This, and another apsidal room discovered under the nearby hall, are oriented on an east-west axis, like the *Horrea Agrippiana,* which stood behind the complex (FIG. **19:6**); the later buildings follow a different orientation. A **covered ramp** that leads to the Imperial palaces on the Palatine forms the third section of the complex.

The identification of this perplexing group of buildings as the Temple of Augustus, a notion advanced at the time of excavation, is no longer tenable and has been largely discarded. The current theory is that the complex was a kind of monumental vestibule for the Imperial palaces. In fact, the construction is contemporary with the *Domus Augustana,* and the earlier phase, dated to the reign of Caligula, coincides with what we know about the building activity of this emperor, who brought the entrance of the *Domus Tiberiana* in contact with the Temple of the Castors. One should not, however, exclude the possibility

that the complex was the *Athenaeum*, the building that Hadrian established as a center for advanced studies (although there are Flavian precedents for this). The adjacent, smaller hall that the church would later come to occupy resembles a library and would accord with such a function. Perhaps, then, this was the library of the Domus Tiberiana, recorded by various ancient authors. The name *Athenaeum* might derive not only from the function that the title suggests, but also from a cult of Minerva that we know existed in the area from the reign of Domitian forward. This would explain the phrase *aedes Castorum et Minervae* that we find in the Regionary Catalogues, associating the Temple of the Castors with an otherwise undocumented cult of Minerva. Moreover, after the fire on the Capitoline in AD 80 and the reconstruction that followed, the military diplomas that were kept in the buildings on the Capitoline next to the Temple of Fides until the reign of Domitian were housed in a place situated *post aedem divi Augusti ad Minervam* (behind the Temple of Divus Augustus near Minerva). We know the approximate location of the Temple of Augustus, which stood in the unexcavated zone south of the Basilica Iulia, but it is uncertain whether the temple's facade faced the Capitoline or the Vicus Tuscus. If the latter, then the Minerva in question could have been located within the monumental hall. In the sixth century AD, the smaller hall was converted into the Church of S. Maria, called *Antiqua* to distinguish it from another (later) sanctuary of the same name founded within the Temple of Venus and Roma. The room lent itself well to this purpose because its porticus was easily transformed into three aisles; an apse was inserted into the back wall at that time. A very important series of paintings decorates the walls of the church; these were arranged on several levels and date from the sixth to the ninth centuries.

Immediately to the south and contiguous with the monument described above, where the Vicus Tuscus enters the Velabrum, there are numerous remains of a significant building that consisted of a large courtyard surrounded by shops, with a smaller room at their center. An inscription, dedicated by three merchants to the Genius of the Horrea Agrippiana, can still be seen in the latter. This is the warehouse built by Agrippa during the reign of Augustus in an area, like the Velabrum, completely occupied by shops and commercial enterprises of every sort. The originally two-story building, containing porticoes, arcades, and travertine semicolumns, was periodically reconstructed until the Middle Ages. The courtyard, originally open, was over time almost entirely filled by a series of rooms.

Alongside the Horrea Agrippiana, whose entrance was located outside the Forum, is the Church of S. Teodoro, the seat of an ancient deaconate documented from the beginning of the ninth century (FIG. **19:7**). Recent investigations have revealed the existence of older structures below the church: a basilical hall with an apse and a mosaic floor, perhaps dating to the fourth century (it is turned slightly southwest with respect to the extant building) and older brick walls that probably belong to buildings associated with the Horrea Agrippiana.

THE TEMPLE OF DIVUS IULIUS After Caesar was assassinated in the Curia of Pompey (located in the Campus Martius, within the Area Sacra di Largo Argentina), his body was brought to the Forum in the vicinity of the Regia. This was in fact the official headquarters of the dictator, who held the religious office of *pontifex maximus*. It was probably here that the body was cremated, and here a marble column was erected with the inscription *parenti patriae* (to the father of the fatherland). The column was later removed and in its place the temple was built and dedicated to "Divus Iulius"—that is, to Julius the God (FIGS. **13:30, 20:3**). This is the first instance of posthumous deification in Rome, following an eastern custom embraced by Hellenistic dynasts.

The temple, erected by Augustus and dedicated on 18 August 29 BC, rises on the eastern side of the Forum, marking one of its borders. After the particularly destructive spoliations of the fifteenth century, only the ruins of a podium in *opus caementicium* survive. The empty spaces correspond to those sections of the structure that supported the colonnade and the walls of the cella; these were originally filled with tufa blocks. The front part of the podium is a hemicycle, within which is the core of a circular altar, probably erected over the spot where the body of Caesar was cremated. Later the hemicycle and altar were closed off by a straight wall. We know from Cassius Dio (47.19) that Augustus himself constructed a wall to block access to the altar in order to put an end to the increasingly popular custom of using the altar as a place of refuge. It is generally believed that the prows of the ships belonging to the armada of Antony and Cleopatra, captured by Octavian at Actium, were affixed to this podium.

The *Rostra ad Divi Iulii*, clear traces of which survive in front of the temple, was probably a structure independent of the temple itself (FIG. **13:21**). This tribunal is represented quite clearly in one of the Trajanic reliefs currently housed in the Curia. The temple, whose podium was approached by two lateral stairs from behind, was probably Corinthian, consisting of a cella and porch with six columns on the front and two on the long sides. Fragments of the marble decoration, in particular the frieze decorated with Victories whose lower extremities emerge from floral shoots, are preserved on site and in the Forum Antiquarium. Within the cella stood the statue of Caesar, its head crowned by a star, the *sidus Iulium*, which was also featured on the pediment, as we can deduce from representations of the temple on coins.

THE ARCH OF AUGUSTUS The scanty remains of an arch with three passageways can be seen next to the right side of the Temple of Divus Iulius (FIGS. **13:25, 20:2**). These undoubtedly belong to the monument erected by the Senate following the battle of Actium (31 BC) and dedicated in 29 BC. A large inscription, 2.67 meters long, found in this area in 1546, bears a dedication to Augustus dated 29 BC. This can only be assigned to Augustus's Actian arch.

The arch can be reconstructed on the basis of the surviving fragments—one of which, a relief with Victories, is in Copenhagen, while others are displayed in

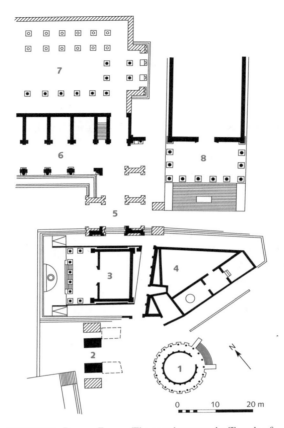

FIGURE 20. Roman Forum. The area between the Temple of
Vesta and the Basilica Aemilia. **1** Temple of Vesta. **2** Actian
Arch of Augustus. **3** Temple of Divus Iulius. **4** Regia. **5** Par-
thian Arch of Augustus. **6** Porticus Iulia. **7** Basilica Fulvia-
Aemilia. **8** Temple of Antoninus and Faustina.

the Forum Antiquarium—and of a coin that depicts it. Only the arch's central
passage was vaulted, while the side passageways had flat ceilings and were
crowned with triangular pediments. According to a commonly held theory,
the consular and triumphal *fasti*—long lists of the consuls and generals from
the beginning of the Republic, which are now on display in the Museo dei
Conservatori on the Capitoline—were located within panels in the minor arches
and not in the walls of the Regia, as was once believed. It is more likely, however,
that these lists were contained in another arch that stood in a symmetrical
position on the opposite (i.e., northern) side of the temple. This monument, the
so-called Parthian Arch (FIGS. **13:24, 20:5**), was erected in 19 BC after the

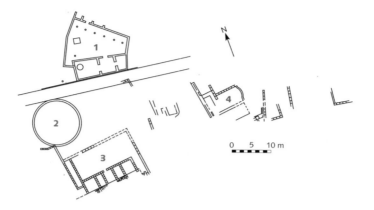

FIGURE 21. Archaic buildings on the eastern side of the Forum. **1** Regia. **2** Temple of Vesta. **3** Atrium Vestae. **4** House of the rex sacrorum.

return of the standards captured by the Parthians from Crassus in the Battle of Carrhae (55 BC). In fact, fragments of the *fasti*, discovered in the sixteenth century, seem to come from the vicinity of the Temple of Antoninus and Faustina.

ITINERARY 3

The Eastern End of the Forum

THE SACRA VIA A precise understanding of the course of the *Sacra Via*, the most important and oldest axial road of the Forum, is indispensable for locating the position of various public and private buildings that were associated with it by the ancient literary tradition and for identifying the extant remains. Contrary to scholarly opinion, the question has not been definitively answered, and numerous problems still remain unresolved. The many, and in some cases profound, transformations that occurred over the centuries in the center of Rome have frequently modified, even radically, the course of various street alignments and the orientation of buildings. It is necessary to take all of this into account.

Varro (*L.* 5.47) and Festus (p. 372 Lindsay) describe with great precision the course of the Sacra Via during the period between the end of the Republic and the beginning of the Empire—before, that is, the destruction and subsequent topographical reconfiguration occasioned by the Neronian fire. Both of these authors distinguish a short stretch, popularly known as the Sacra Via, from a fairly long one, known only by scholars. The first, to which the term *Sacra Via* normally refers, included the section between the Regia and the house of the *rex sacrorum* (which were two separate buildings [FIG. **21**]); that is, the road that

ran between the Forum and the point where the slope of the Velia begins. The second, and longer, Sacra Via ran from the Arx to the Sacellum of Strenia on the *Carinae*—a saddle between the Velia and the Esquiline, behind the apse of the Basilica of Maxentius, that was partially removed for the construction of Via dei Fori Imperiali. The second definition distinguishes the Sacra Via as the road that passes in front of the Basilica Fulvia-Aemilia on its way to the Comitium and from there to the Arx, and not the street that runs between the Regia and the Temple of Vesta, passes the long side of the Basilica Iulia, and proceeds to the Temple of Saturn.

Regarding the topography of the Sacra Via in its narrower sense, we know the exact location of the Regia; various ancient authors tell us that the house of the *rex sacrorum* was a building bordering on the House of the Vestals *(Atrium Vestae)*, inhabited at first by the *rex sacrorum* and then by the *pontifex maximus*. This was the case until Augustus assumed the office of the pontifex and gave the official residence of this priestly official to the Vestals, who incorporated it into their house.

It is thus clear that the other end of the Sacra Via, in its narrow sense, does not lie in the vicinity of the Arch of Titus, but much lower, essentially where the ascent of the Velia begins, in front of the so-called Temple of Romulus and the Basilica of Maxentius.

Accordingly, the upper section of the street—the portion that lies between the house of the *rex sacrorum* and the Sacellum of Strenia—must be the side street, still partially visible immediately behind the so-called Medieval Porticus, that ran toward the *Carinae* but was subsequently cut off by the construction of the Basilica of Maxentius. Such an understanding of the course of the Sacra Via radically changes where we situate several monuments, such as the Porta Mugonia, the Temple of Jupiter Stator, the houses of the kings, and the Temple of the Lares. These must no longer be sought near the Arch of Titus, but rather in the area between the House of the Vestal Virgins and the Basilica of Maxentius. Even the position of the Nova Via, which probably disappeared in the Imperial period, must be modified as a result of this reading. The route that is currently ascribed to this street—at the foot of the Imperial palaces on the Palatine, running between the latter and the House of the Vestal Virgins—is in large part a result of the regularization that took place in this area after the Neronian fire of AD 64. During the Republic, this street, like the Sacra Via, must have passed through the Porta Mugonia, which perhaps should be situated in front of the Medieval Porticus that stands in front of the Basilica of Maxentius. Its original course from the gate toward the Velabrum must have run through the surviving House of the Vestal Virgins at an oblique angle; this complex as well was completely transformed after the Neronian fire. Traces of this older Nova Via may have been discovered to the south of the original Atrium Vestae. The oblique orientation of the shrine of Juturna, here respecting the course of an older street, might provide another indication of the street's ancient alignment.

THE REGIA The building of irregular form, standing between the Temple of Divus Iulius on the west, the Temple of Vesta and the House of the Vestal Virgins on the south, and the Temple of Antoninus and Faustina on the north, has been identified with certainty as the Regia (FIGS. **13:31, 20:4**). The construction of the building was ascribed to the second king of Rome, Numa, whose residence this is believed to have been. The interpretation of the name is obvious: according to Festus (p. 347 Lindsay), "the *Regia* is the house where the king lives." The problem remains of whether we are dealing with an actual king or with his Republican substitute, the *rex sacrorum*, who, at the beginning of the Republic, inherited only the priestly, and not the political or military, functions of his predecessor. The Regia, however, was never the residence of the *rex sacrorum;* he resided in a special house, higher up on the Sacra Via, that later passed into the hands of the *pontifex maximus*. It is likely that the house of the ancient king was in fact a much larger complex, including the Regia proper, the house of the *rex sacrorum*, and the Atrium Vestae.

If we ascribe the oldest remains of these buildings to a single complex, the result is a fairly uniform suite of several pavilions arranged around a central area; we can compare the resulting plan to similar archaic complexes interpreted elsewhere as royal residences, such as the one excavated at Acquarossa (near Viterbo), which can be dated, like the first phase of the Regia, toward the end of the seventh century BC. Using this model, we can identify the building as the residence of kings of the Etruscan dynasty. The larger complex, to which the palace belonged, was subsequently subdivided into its various constituent parts, intended for different functions, after the beginning of the Republic—that is, once its political, religious, and social integrity ceased to exist following the expulsion of the kings. This interpretation is confirmed by the discovery of a fragment of a *bucchero* vase, datable well into the sixth century BC, on which the word *rex* (king) is inscribed. The date of the vase seems to correspond to the end of the Etruscan monarchy, so the term does not necessarily refer to the Republican *rex sacrorum*.

The Regia was thus the place where the *rex sacrorum* and *pontifex maximus* performed their sacred functions. We know that the Regia housed a sanctuary of Mars, the repository for the spears and also for the sacred shields that were carried in procession by the *Salii*, the "jumping" priests, who constituted a very old priestly guild. It also contained a sanctuary dedicated to Ops Consiva, the goddess of the harvest. The important archives of the high priests, the calendar, and the annals of the city were stored here.

Recent excavations have clarified the structural phases of the Regia. Several huts, similar to those that were found on the Palatine, stood on the site before the Regia; they were replaced by a masonry structure toward the end of the seventh century BC. After a fire that struck in the first decades of the sixth century BC and two successive reconstructions, the building assumed its characteristic form, which it preserved up to the Imperial period. This defining change can be

assigned to the last years of the sixth century BC. This event corresponds with remarkable precision to the traditional date of the beginning of the Republic (509 BC).

The building consisted of two parts. The first, on the south, has an elongated rectangular shape oriented along a perfect east-west axis and divided into three rooms. Entrance to the building was through the central room, from which there was access to the two side rooms; the one on the east was probably the sanctuary of Ops and the one on the west, equipped with a circular altar, that of Mars. The building's second part—a large trapezoidal space to the north, with colonnades along two of the sides—was certainly an open courtyard, with a cistern or rather a vaulted silo beneath it; the two laurel trees recorded by ancient writers must also have stood here. On the south, the building faced a street, identified by an inscription as the *Vicus Vestae*, that divided it from the Temple of Vesta, with which it was functionally connected. What survives, then, could not have been a home, but a sanctuary that imitated the form of a home. In addition to contemporaneous examples of Etruscan residences, a tomb in Tuscania, built into the rock, precisely imitates this type of archaic residence. Subsequent reconstructions of the Regia in the third century BC, in 148 BC, and that of Domitius Calvinus in 36 BC, to which the many marble fragments scattered about in the vicinity belong, did not modify the plan in the least, for the building was probably considered sacred.

To the west of the Regia, in the direction of the Temple of Divus Iulius, are the remains of a small room, whose entrance bore an inscribed architrave, preserved *in situ*, stating that it belonged to the heralds of the principal priestly colleges *(calatores pontificum et flaminum)*. The identification is confirmed by the discovery in the same area of another inscription, bearing a list of *calatores*.

One of Rome's oldest triumphal arches, the *Fornix Fabianus*, stood in the vicinity of the Regia. It was erected by Q. Fabius Maximus in 121 BC to commemorate his victory over the Allobroges and restored by his grandson in 56 BC. Fragments of the monument's inscriptions were discovered in the area in the sixteenth century, but the precise site of the arch remains unknown, though it certainly stood on the Sacra Via, probably at the western end of the Regia.

THE TEMPLE OF VESTA AND THE HOUSE OF THE VESTAL VIRGINS On the southern side of the Sacra Via, in front of the Regia, stood one of the oldest and most important sanctuaries of Rome, that of Vesta (FIGS. **13:29, 13:34**). Together with the House of the Vestal Virgins, the temple formed a single complex (Atrium Vestae) that was connected topographically and functionally with the Regia and with the house of the *rex sacrorum* and *pontifex maximus*.

Just as the Regia housed the cults most closely associated in origin with the person of the king, so too the Temple of Vesta probably replaced the most important domestic hearth—that of the king's house—and came to represent

all the other hearths, thus corresponding to the "State Hearth." During the
Republic a group of specialized priestesses, the Vestal Virgins, took the place of
the king's daughters and the queen, who were probably originally charged with
overseeing the hearth; these women would form the only female priesthood in
Rome. The priestesses, six in number, were charged with tending the sacred fire
and overseeing other rites, all closely connected with the domestic cult. Drawn
from patrician families at between six and ten years of age, the Vestal Virgins
had to remain in their priesthood for a period of thirty years, preserving their
virginity. The penalty that awaited a Vestal who failed in this rule was death.
In such a case, she was buried alive—the blood of a Vestal could not be spilled—
in a small subterranean room in the Servian *agger* near the Porta Collina on
the Quirinal. The place was called the *Campus Sceleratus*. Her accomplice faced
death by flogging in the Comitium. In exchange for her commitment, the Vestal
enjoyed considerable privileges: she was not subject to the power of her father,
whose functions were in part assumed by the *pontifex maximus*, and she enjoyed
financial independence and considerable prestige. A Vestal had the right to give
testimony, make a will, ride in a wagon within the city, enjoy reserved seating
at the games, and have a tomb, probably communal, inside the city. A person
condemned to death who had the good fortune of encountering a Vestal on the
day of execution was pardoned.

 In its oldest phase, the Atrium Vestae complex was much smaller than the
one that survives; it also had a different orientation, according to the cardinal
points (FIG. **22**). Traces of the earlier structures can still be seen about one meter
below the Imperial level. The early complex consisted of a courtyard adjacent to
the Temple of Vesta, with six rooms, corresponding to the number of Vestals,
situated on the southern end. Traces of pavement were seen south of these rooms,
which some have argued constitute the oldest course of the Nova Via. Even at
this time, the temple was set within an enclosure that united it closely with the
residence of the Vestal Virgins. Whether the temple originally had its familiar
circular form is unknown, but it is noteworthy that the entry always remained on
the east, maintaining its original orientation. Two wells excavated in front of the
temple have provided material of great interest connected with the cult of Vesta.
The more recent well dates to the fourth century BC, while the older one dates
back to the end of the seventh century BC and is thus contemporary with the
oldest phases of the Regia.

 The extant temple (FIG. **23:1**) belongs to the last restoration, undertaken
by the wife of Septimius Severus, Julia Domna, after the fire of AD 191. The
building's function as the repository of the sacred fire exposed it to the risk
of conflagration, to which in fact it succumbed several times. The temple is
composed of a circular podium, in *opus caementicium* (about 15 meters in diameter)
with a marble revetment, against which the bases that supported the peristyle of
Corinthian columns rested. Within the cella, likewise circular, the sacred fire was
kept burning continuously, while the center of its conical roof must have been

open so that the smoke could escape. One part of the marble superstructure was reerected several decades ago, using original pieces supplemented by restorations in travertine. Identification of the *penus Vestae*, the *sancta sanctorum* of the temple, access to which was prohibited to all except the Vestals, is a complex problem. Here was the repository for the objects, pledges of the universal empire promised to Rome, which legend held that Aeneas brought with him from Troy. Among all of these, the most important was the Palladium, an archaic image of Minerva. The *penus* may be the trapezoidal opening (2.40 × 2.40 meters) in the podium, which could be approached only from the cella.

The entrance of the House of the Vestal Virgins lies east of the temple. To the right of the entrance is a small shrine **(2)**, supported originally by two Ionic columns (only one survives) and bearing an inscription on its frieze that states that the structure was built with public money by a decree of the Senate. Brick stamps date the shrine to the reign of Hadrian.

Because no image of the goddess was displayed in the temple, it has generally been thought that a statue of Vesta was located in the shrine. The shape of the structure, however, similar to a crossroads shrine *(compitum)*, suggests that this was a chapel dedicated to the *Lares Praestites*, the spirits that protected the city. An inscription of Alexander Severus records the reconstruction of the *compitum* of the *Vicus Vestae*, which might be a reference to this shrine.

Here a modern footbridge provides entrance to the central courtyard of the house, a kind of peristyle, below which remains of the oldest building, of the Republican period, can be seen. The earlier structure lay along a different axis and had a mosaic floor in which irregular tiles of colored stone were inserted. The rooms of the later house were laid out around the large courtyard surrounded by a porticus; there were originally several stories, two of which are preserved on the south.

The surviving building, built entirely in brick, is the result of a long series of transformations that have been thoroughly analyzed. Augustus, when he became *pontifex maximus* in 12 BC following the death of Lepidus, transferred the office of this priesthood to his house on the Palatine and then gave the ancient residence of the *pontifex* and *rex sacrorum* to the Vestals; it was subsequently incorporated within the Atrium Vestae. When the Neronian fire of AD 64 destroyed it, together with a large part of the city, including the Temple and the House of the Vestals, the two buildings were replaced at a higher level by the structure we see today. Despite numerous later modifications, the complex preserves the form and dimensions that were established at that time, together with a new orientation that adhered to the prevailing northwest-southeast orientation of the Forum. The complex was completely reconstructed during Trajan's reign, and both the house and the temple were restored under Septimius Severus. Following the formal abolition of pagan cults, enacted for the first time by a decree of Theodosius in AD 391 and again—definitively—following the defeat of the last champions of paganism near Aquileia in 394, the house was abandoned by

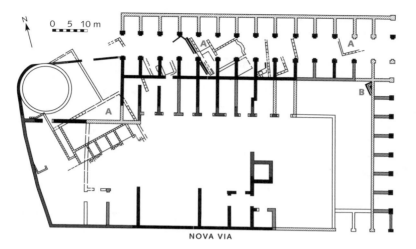

FIGURE 22. Atrium Vestae. Plan of the Neronian phase and of the archaic buildings lying beneath (**A**, **B**).

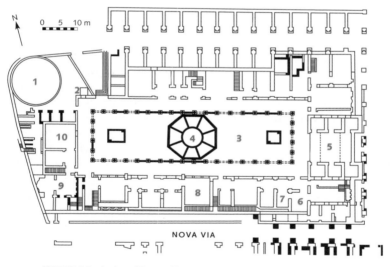

FIGURE 23. Atrium Vestae. Plan of the late phases (from Trajan to Constantine).

the last Vestals and partially reoccupied by functionaries of the imperial court at first and those of the papal court later.

The central part of the building, as it appears to us in its late phase, comprises a huge rectangular courtyard **(3)**, surrounded originally by a porticus with a colonnade of two stories. At the center of the courtyard are three basins: two smaller square ones at the ends and a rectangular one in the middle; the latter was subsequently replaced, perhaps during the Constantinian period, by an octagonal structure made of brick **(4)** that might have served as a garden. Numerous statues of the presiding Vestals (the *virgo vestalis maxima* was the head of the religious college) were displayed beneath the porticus. In fact, many statues and bases were discovered, mostly in a heap, on the western side of the courtyard, evidently to be turned into lime. Some of the most beautiful of these were moved to the Museo delle Terme and the Forum Antiquarium; others remain *in situ* together with their bases, but their present location is entirely random, since their original position is unknown, and the statues do not correspond to the bases. All the inscriptions date from the buildings' last phase, beginning with the reign of Septimius Severus. Statues were erected for the following Vestals: Numisia Maximilla (AD 201), Terentia Flavola (three statues, in 209, 213, and 215), Campia Severina (240), Flavia Mamilia (242), Flavia Publicia (two statues, in 247 and 257), Coelia Claudiana (286), Terentia Rufilla (two statues, in 300 and 301), and Coelia Concordia (380). Some of these bases (those of Campia Severina, Flavia Mamilia, Terentia Rufilla, and Coelia Concordia) are no longer displayed in the atrium. A base, dated to AD 364 and situated to the south near the stairway that leads up to the Nova Via, is noteworthy: while the Vestal's name was erased, the first letter, C, can still be read. She might have been the Claudia who, according to Prudentius, a Christian poet of the end of the fourth century AD, abandoned her priesthood to become a Christian. Her name would thus have been erased by the last followers of paganism as a sign of her disgrace.

On the eastern side there is a large room **(5)**, improperly called a "tablinum," that was originally vaulted and flanked by three smaller rooms on each side; it seems more logical to ascribe each of the smaller rooms to one of the Vestals. In the earlier phase, there was a sanctuary that corresponded to this part of the building, whose remains were excavated in the past. This may have been the place where a marble statue (now displayed in the Forum Antiquarium) once stood, representing Numa—the second king of Rome and, according to tradition, the founder of the cult of Vesta. The rooms on the south, the best preserved in the complex, open onto a long corridor. The first of these is a bakery **(6)**, followed by a mill **(7)**, with a well-preserved grindstone, and probably the kitchen **(8)**. Before this room there is a stairway that leads to the upper floor where the Vestals' private rooms may have been located, as well as numerous baths equipped with heating systems. At the end of the southern wing, two stairways lead to the upper floor. There was also a third floor, as indicated by the beginning of another stairway above the "tablinum." A good

number of these rooms must have accommodated the service staff. Immediately to the west there is an apsidal hall **(9)**, which might have served as a sanctuary. Cicero mentions a grove (the *Lucus Vestae*) above the older house, between the Nova Via and the Palatine, from where in 390 BC a voice had warned the Romans, to no avail, of the imminent attack of the Gauls. Afterward a shrine was dedicated to this mysterious god called Aius Locutius, who is probably to be identified as Faunus. It is not unreasonable to think that the apsidal hall, whose position corresponds to that indicated by Cicero, is a reconstruction of the ancient sanctuary, incorporated later on within the House of the Vestal Virgins. Most of the building's western side is occupied by a large rectangular room that faces the so-called tablinum; it is usually identified as a triclinium **(10)**.

The rooms on the northern side are so poorly preserved as to make their identification purely speculative. On this side of the House of the Vestals lie the ruins of buildings, protected by sheds, that were in use prior to the Neronian fire; they stood, accordingly, at a lower level and along the older orientation. These are the remains of the *domus* of the *rex sacrorum* and subsequently of the *pontifex maximus (Domus Publica)*. Caesar lived here from the day of his election as *pontifex maximus* in 62 until his death in 44 BC.

The oldest surviving remains, in cappellaccio, are clearly archaic. Other walls, built of tufa in *opus quadratum*, date to the Republic. Several structures, in particular the bases of a column and a semicolumn in travertine, are of Caesarian date; a large apsidal room with mosaic flooring, probably part of a bath system, dates to the same period. To the east of this is another small room that preserves a marble floor and the remains of pictorial decoration on one of the walls. The painting, featuring a garden, is Third Style and thus Augustan; a copy of the painting, on display in the Forum Antiquarium, is more legible. Other parts of the same decoration were seen at the time of excavation, at the end of the nineteenth century. The painting must have been part of the restoration that was undertaken immediately after the fire of 12 BC, when Augustus ceded the *domus* of the *rex sacrorum* to the Vestals.

THE "TEMPLE OF ROMULUS" Beyond the Sacra Via, in front of the House of the Vestal Virgins, an important building immediately dominates the view, particularly because of its remarkable state of preservation (FIG. **13:37**). It is a circular domed temple, built entirely in brick; its facade is markedly concave, with four niches intended for as many statues. The doorway is flanked by two porphyry columns with capitals in white marble that support a richly carved white marble cornice. The bronze door is original. Flanking the sides of the central structure stand two deep rooms ending in apses and communicating with the central building; in front of each of these side halls were two cipollino columns set on high plinths; only those on the right are preserved.

In the sixth century AD, when the rectangular room in the Forum of Peace, adjoining the rear side of the rotunda, was transformed into a church dedicated

to Saints Cosmas and Damian, a passageway was opened up between the two buildings, which were originally independent. Later, in 1632, the bronze door and the porphyry columns were reused in a new doorway at a higher level. Only at the end of the nineteenth century were these returned to their original position. The excavations undertaken at that time extended down to the Augustan level and exposed the foundations of the building, which occupies a post-Neronian street level; the openings of two sewers can be seen in the foundations.

The identification of this building is a matter of much debate The general opinion is that this is a temple dedicated to Romulus, son of Maxentius, on the basis of medieval notices that record a "Temple of Romulus" in this area and of a Maxentian coin with the representation of a circular building and the inscription *Aeternae Memoriae*. Sections of an inscription were still extant on the building in the sixteenth century; these record its dedication by Constantine in accordance with a decree of the Senate, but the inscription belongs to a second phase of the building.

A more profitable line of inquiry derives from the topographical context in which the monument is situated: it lies at the end of the Sacra Via *(in summa Sacra Via)* immediately outside the ancient gate of the Palatine, the Porta Mugonia, near the ancient house of the kings later inhabited by the *rex sacrorum*. The building that best corresponds to this context is the Temple of Jupiter Stator. According to tradition, Romulus founded this temple at the spot, immediately outside of the Porta Mugonia, where the Latins finally halted their flight during a battle against the Sabines. The original archaic shrine was probably an open-air sanctuary that was later replaced in 294 BC by a temple built by the consul M. Atilius Regulus following a victory over the Samnites. The identification of the Temple of Jupiter Stator with the so-called Temple of Romulus corresponds with the mention of the building still found in late Imperial inscriptions and literary sources. In particular, the Constantinian Regionary Catalogues, which are more or less contemporary with the temple in its present form, provide us with decisive confirmation. We know from these that the border between Region X *(Palatium)* and IV *(Forum Pacis)* was marked by the course of the Sacra Via and its extension to the Colosseum. In the description of Region IV, the catalogues list the following buildings in succession: the Meta Sudans, the Temple of Venus and Roma, the Temple of Jupiter Stator, the Sacra Via, the Basilica of Constantine, the Temple of Antoninus and Faustina, the Basilica Fulvia-Aemilia—that is, all the buildings that lie on the right side of the street in the ascent from the valley of the Colosseum. The Temple of Jupiter Stator should thus be situated in this area. The only monument mentioned in the Regionary Catalogues' account of the public buildings in Region IV that has not been positively identified is the "Temple of Romulus." There is no room for another building here that might ultimately be identified as the Temple of Jupiter Stator. Accordingly, this and the Temple of Romulus must be one and the same. The building that is commonly identified with the Temple of Jupiter Stator, near the Arch of Titus, is not in

Region IV, but in Region X (FIG. **13:42**). Recent excavations have shown that the structure is probably to be identified as a four-sided arch, not a temple.

The function of the two apsidal rooms that flank the central rotunda remains problematic. A coin of Maxentius that depicts this building, often confused with the tomb of Romulus on the Via Appia, reveals the presence of two statues within the two side halls; these can be readily identified as the Penates, or household gods. We know that the temple dedicated to these divinities was located on the Velia at the top of a flight of stairs in the immediate vicinity of the Forum and Macellum. At the beginning of the fourth century AD, the entire area of the Velia was occupied by the enormous structure of the Basilica of Maxentius (later of Constantine). So, it is likely that the Temple of the Penates disappeared at that time and that it was reconstructed immediately afterward at the nearest available spot—alongside the Temple of Jupiter Stator.

Moreover, it is quite natural that the emperor, who based his political program largely on the prestige of having made Rome his capital and who had for this reason given his son the prestigious name of Romulus, would have paid close attention to these buildings, bound as they are to the memory of the founder of Rome: the Temple of the Penates, the divinities introduced into Latium by Aeneas, and the Temple of Jupiter Stator, personally founded by Romulus. In fact, an inscription dedicated by Maxentius to Mars and the founders of Rome is located near the Niger Lapis.

On the other side of the street, opposite the medieval porticus located at the western corner of the Basilica of Maxentius, sits a **large brick exedra**, built, like the other surrounding buildings, on the level of the street that was constructed following the Neronian fire; this level was removed in the nineteenth century in order to expose the Augustan pavement presently visible. On the basis of a passage from Martial (1.70.9–10), who records the presence of a small sanctuary of Bacchus and Cybele at the point where the side street leading to the Carinae breaks off, these remains have been identified as this temple (FIG. **13:39**). The monument is represented on a medallion of Antoninus Pius as a circular shrine, built within an exedra. A fragment of the curved epistyle from the building was found nearby; it bears a relief representing a Maenad and part of an inscription alluding to restoration done by Antoninus Pius; the original is now in the Forum Antiquarium, while a cast is displayed a little higher up along the street that leads to the Arch of Titus. The discovery nearby of two terracotta antefixes with the figure of Cybele on a boat might confirm the location of the building.

THE ARCHAIC CEMETERY In 1902, a small portion of the cemetery, which at one time must have occupied a large part of the valley of the Forum, was discovered immediately to the right of the Temple of Antoninus and Faustina, in one of the few places in the Forum that was untouched by later constructions. The area was later filled in, but grass beds corresponding to the tombs beneath identify their location. There are forty-one tombs, all of them Iron Age. Of these,

six belong to Latial culture Period I (tenth century BC) and twelve belong to Period II B (ninth century BC).

All burials of the first group were by cremation, consisting of a *dolium* (large earthenware vessel) containing an urn in the shape of a hut as well as other accoutrements. Of the second group, some burials contain cremated remains, while others appear to be inhumations. To explain this change, it is no longer possible, as was once done, to argue for the presence of various peoples with different burial practices (for example, the Latins and the Sabines); rather, it is more appropriate to posit this as an internal change of custom that occurred over time. The interment of adults in the Forum ceases with these graves. Subsequent burials, from now on all by inhumation, sometimes within tree trunks, are of children younger than six years, who we know could be buried within a residential zone. This suggests that, at the beginning of the eighth century BC, the inhabited area extended to this point.

The most recent tombs of children (seventh century BC) are particularly affluent, considering the very young age of the deceased, containing imported and imitation Greek wares, bronzes, and other luxury products, suggesting that families of a high social status lived in this area. The proximity of the Regia and the tradition that places the home of the Valerii nearby, in addition to the discovery of a late seventh-century BC masonry construction near the cemetery, tend to confirm this impression. All the material found in the necropolis during the excavations undertaken by Giacomo Boni is on display in the Forum Antiquarium.

To the east of the cemetery and at the Augustan level of the Sacra Via, below the current pavement, lies a small **Republican building,** containing several small rooms, identified, despite the lack of supporting evidence, as a prison (FIG. **13:36**). It was probably the basement of a shop.

THE TEMPLE OF ANTONINUS AND FAUSTINA The temple north of the Regia, into which the church of S. Lorenzo in Miranda was later incorporated, can easily be identified by the large inscription on the architrave: *Divo Antonino et / Divae Faustinae ex S(enatus) c(onsulto)*. This is the temple that was erected in AD 141 by Antoninus Pius in honor of his wife Faustina, who died and was deified in that year. At the death of the emperor, the temple was also dedicated to him, the first line of the inscription being added on that occasion (FIG. **13:32**; FIG. **20:8**).

The Temple of Antoninus and Faustina rises on a large podium, approached in front by a stairway that has been replaced by a modern reconstruction in brick. At the center of the stairway are the remains of the brick altar. The facade has six large columns of cipollino, the marble from Carystos on Euboea, flanked by two additional columns on each side, all 17 meters high with Corinthian capitals in white marble. The cella is constructed of peperino in *opus quadratum;* a marble frieze runs the length of the two long sides, with facing griffins set amid a vegetal motif in heraldic fashion, a work in the typically cold classicizing manner of the Antonine period. Originally, the exterior wall of the cella was

clad with marble. The statues located on the podium beyond the columns may have belonged to the temple.

The grooves that cut across the high part of the columns at oblique angles were probably carved to fix the ropes that were used in an apparent attempt to pull the building down in order to salvage its materials; the monolithic shafts must have offered greater resistance than was foreseen. The central column on the left has incised drawings representing Hercules and the Nemean Lion, among other subjects; these may have been inspired by statues visible from here.

BETWEEN THE FORUM AND THE PALATINE The stretch of road between the "Temple of Romulus" and the Arch of Titus crosses the saddle that separates the Palatine from the Velia; it was, as noted earlier, the border between Augustan Regions IV and X (FIG. **24**). The Velia does not, as was once thought, correspond to the area occupied by the Arch of Titus, but lies entirely to the left of the ascending road. This area is largely occupied by the massive Basilica of Maxentius. Less clear is the name of the area to the right of the road, lying between it and the Imperial buildings of the Palatine, between the Arch of Titus and the House of the Vestal Virgins. The prevailing denomination *Forum Adiectum* (Adjoining Forum) should be rejected: no such term appears in literary or epigraphal data. In fact, this whole area, which is contained within Region X, is an integral part of the Palatine, forming the outermost slope of the hill facing the Velia. The imposing presence of the Domus Tiberiana gives the impression that the Palatine begins farther south than it actually does.

Accordingly, we should consider situating the numerous buildings that ancient authors describe as *in Palatio* (on the Palatine) within this area. We would locate here, for example, the houses of many Republican luminaries, such as Gnaeus Octavius, Aemilius Scaurus, Clodius, and even Cicero himself. In this way we can understand how it is that many of these houses could be described as lying on the Sacra Via, very close to the Forum, and on the Palatine at the same time. Cicero's home, for instance, which is generally located on the summit of the Palatine, was instead certainly very close to the Forum, as appears to be the case from the fact that it was in the vicinity of Caesar's home, the Domus Publica.

Recent excavations have clarified the topography and character of the area, revealing its development during the period between the origin of the city and the Republic. Remains of a defensive wall with a gate, datable to around 720 BC and aligned along an east-west axis, confirm the existence of an independent settlement on the Palatine approximately coincident with the traditional date of the city's foundation by Romulus and, moreover, in a location that corresponds with the oldest *pomerium*. Sporadic discoveries in the area date back to the aeneolithic period (beginning of the second millennium BC) and as such are the oldest finds to date in Rome. The wall was eliminated around 530 BC and the area was occupied by large archaic residences. The two that have been

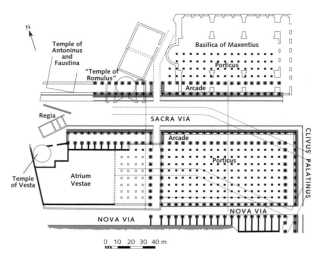

FIGURE 24. Plan of the Imperial buildings between the Atrium Vestae and the Arch of Titus. (After van Deman)

excavated, measuring ca. 400 square meters, certainly belonged to patrician families at the end of the regal period. These houses appear to have survived, notwithstanding occasional rebuilding and restructuring, until the end of the Republic. The discovery is of the greatest importance for the reconstruction of the oldest phases of the city and appears, in broad terms at least, to confirm the ancient tradition.

The whole area changed radically after the fire of 64 AD. It was marginally affected by the construction of the *Domus Aurea*, whose principal atrium was in the area later occupied by the Temple of Venus and Roma. The Sacra Via and its continuation *(Clivus Sacer?)* were regularized when these roads were straightened and their level raised, attested most visibly alongside the stairs of the Temple of Venus and Roma in front of the entrance to the Antiquarium. The extant pavement seen there, which follows an irregular course, is Augustan, corresponding more or less to the Republican street. Unfortunately, the nineteenth-century excavators almost entirely destroyed the post-Neronian pavement, mistaking it for a medieval level; as a result, many buildings—the "Temple of Romulus," the Basilica of Maxentius, and the Arch of Titus—have ended up practically suspended in midair, with their foundations uncovered. Nonetheless, the level of these buildings provides visible evidence that the roads were raised after the fire. At the same time, the ruins of the large buildings between the Sacra Via and the Nova Via were largely demolished. These buildings, of which only some concrete foundation piers survive, are generally identified, incorrectly, as the *Horrea Margaritaria* (the pearl warehouses); these more likely stood in the area

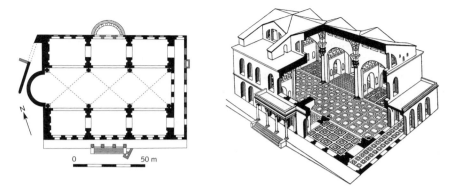

FIGURE 25. The Basilica of Maxentius, plan and reconstruction.

of the Velabrum, since they are situated by the Regionary Catalogues in Region VIII (Forum Romanum) and not Region X (Palatine). All things considered, the most plausible hypothesis is that these were storehouses associated with the palaces, which the catalogues situate in the district of the Palatine.

In these large structures, superimposed on an earlier quarter of opulent Republican residences, we encounter an example of the *nova urbs* (new city) described vividly by Tacitus that was planned after the Neronian fire.

A Republican building was unearthed a short distance from the Arch of Titus. The complex includes numerous independent small rooms, built in *opus quasi reticulatum,* that date to around the beginning of the first century BC. The hypothesis that this is a *lupanar* (brothel) cannot be substantiated. It is more likely the *ergastulum* (slave quarters) of a large aristocratic *domus,* possibly the home of Aemilius Scaurus that was fully described by ancient writers.

THE BASILICA OF MAXENTIUS OR CONSTANTINE A large part of the Velia was occupied at the beginning of the fourth century AD by one of the most impressive buildings of Imperial Rome, the basilica built by Maxentius and subsequently named for Constantine. A fragment of the Severan Marble Plan and excavations in the area have shown that prior to the basilica there existed a large utilitarian complex of the Flavian period. Moreover, we know from ancient writers that the basilica took the place of the *Horrea Piperataria* (warehouses for pepper and other spices), which accounts for at least one part of the older building. This building was also a warehouse for drugs and pharmaceutical products; it is no coincidence, then, that evidence for the presence of doctors is concentrated in this area of the city, beginning with the first of these, the Greek Archagathus, who sometime after 219 BC set up his practice in Rome near the *Compitum Acili,* and extending to Galen, who had his office near the Temple of Peace.

The *Statio Medicorum,* mentioned in an inscription, might also have been located in this area.

The basilica measures 100 × 65 meters. It consisted of a large central nave that runs east-west, 80 meters long and 25 meters wide, originally reaching a height of 35 meters (FIG. 25). At the western end of the nave was an apse, while the entrance, which consisted of a long and narrow atrium with three doors leading to the main hall, would originally have been on the east. The central nave was flanked on the north and south by two side aisles, each divided into three rooms with access to one another and the narrow entrance hall; their barrel-vaulted ceilings were coffered. The central room on the north (the only side preserved) ended in an apse flanked by two columns; around the inside of the walls of the apse were various niches for statues, each framed by small columns standing on carved brackets. On the south side, now razed to the ground, there was an imposing entrance: a porch supported by four large porphyry columns, approached by a stairway, that negotiated the difference in level between the street and the Velia. The creation of this new north-south axis corresponds to a change in the project, datable probably to the end of the fourth century AD, and not to the reign of Constantine, as is generally believed. At the same time, the north apse was put in, cutting across the earlier structures and standing at a higher level than the early fourth-century building, as can be ascertained from its foundations, which rest against the pavement of the road that runs behind the basilica.

The central vault must have been particularly splendid, comprising three immense cross vaults resting on eight columns 14.50 meters high, made of Proconnesian marble. The only surviving column was removed by Paul V in 1613 and set up in the Piazza of S. Maria Maggiore. The mode of construction and the dimensions of the hall are identical to those of the large central halls of the Imperial baths, which in fact were also called "basilicas."

A colossal statue of Constantine on his throne, discovered in 1487, stood in the western apse. The statue was an acrolith, that is, a statue whose head, arms, and legs—the only parts discovered—were in marble, while the rest was probably of gilded bronze. The marble remains are now on display in the courtyard of the Palazzo dei Conservatori. The head and neck alone measure 2.60 meters and the foot, 2 meters. It has recently been shown that the portrait was reworked and that it must originally have represented Maxentius.

The function of the basilica, which is not located in the Forum like the others, but on the Velia, can be explained by its association with the headquarters of the *Praefectura Urbana,* which in late antiquity occupied the portion of the Carinae that lay behind the building. The basilica was the judicial seat of the prefecture, which, from the beginning of the fourth century on, assumed all the administrative functions of the city. The structural transformations that the basilica underwent at the end of the fourth century must be understood in conjunction with the introduction of new procedures. In particular, the insertion of the new apse on the north, which could be cordoned off from the rest of the

building by gates (traces of which are visible on the threshold of the entrance), corresponds to the new type of trial, reserved for the senatorial class, that had to be conducted in a segregated hall and no longer in public. The large apse, with its tribunal still well preserved, can thus be identified as the *Secretarium*.

THE ARCH OF TITUS The course of the upper part of the Sacra Via subsequent to the Neronian fire terminated at the stairs of the Temple of Venus and Roma. A considerable stretch of the road's basalt pavement is still visible here, perfectly aligned with the two large piered structures that flanked it on the north and south, whose foundations emerge here and there. Excavation undertaken during the nineteenth century revealed the outline of the Augustan road, which, much more irregular than its successor, turned toward the south and met up with the street leading to the Palatine. The difference in the levels between the two phases can easily be observed in relation to the Arch of Titus: the foundations of the arch, which sits on the Neronian pavement, are now fully exposed following the excavation that extended all the way to the pre-Neronian level.

The arch owes its partial preservation to the fact that it was incorporated into the medieval fortification erected by the Frangipane family (FIG. **13:41**). The piers are for the most part modern, having been restored in travertine by the Italian architect and archaeologist Giuseppe Valadier in 1822, as the inscription on the attic facing the Forum attests. The original inscription, however, remains intact on the other side and unambiguously identifies the monument, about which ancient writers are entirely silent, with the possible exception of an ambiguous passage in Martial. The arch represented on a relief from the Tomb of the Haterii of the Domitianic or Trajanic period and identified by the inscription as *arcus in Sacra Via summa* (now in the Vatican Museums) is certainly not the Arch of Titus—this does not sit on the Sacra Via—but perhaps the Porta Mugonia of the Imperial age. The text of the inscription on the Arch of Titus, on the east side of the monument, is as follows: *Senatus / populusque Romanus / divo Tito divi Vespasiani f(ilio) / Vespasiano Augusto* (The Senate and People of Rome to the Divine Titus Vespasian Augustus, son of the Divine Vespasian).

The reference to Titus as "divine" attests to the fact that the emperor was already dead when the inscription was carved. The arch can thus be dated after AD 81 and is probably the work of the last emperor of the Flavian dynasty, Domitian, brother of Titus and son of Vespasian. Some date the arch to a later period, at some point during the reign of Trajan, primarily on the basis of the style of the reliefs, which resemble those on Trajanic buildings, and by comparison with the Arch of Trajan at Benevento, which has proportions as well as architectural and decorative details that resemble those of the Arch of Titus. This late dating, however, must be rejected. The continued influence of an architectural model for a period of twenty years is quite normal in the ancient world, and it is very probable that the highly plastic style so typical of Trajanic reliefs had already come into vogue a few years earlier during the late Flavian period.

The facade of the single-passage arch, simple but structurally powerful, is accentuated by four composite semicolumns that project on each side. It is 13.50 meters wide, 15.40 meters high, and 4.75 meters deep. The figures of Rome and the Genius of the Roman people decorate the keystones, while flying Victories on globes carrying standards populate the spandrels above the archivolt. The small surviving frieze (preserved only at the center of the eastern side) encircled the four sides of the arch; it depicted Titus and Vespasian's triumph over the Jews in AD 71, which this monument was intended to commemorate. Two episodes of this triumph are represented in relief on two large panels on the inside walls of the arch. The one on the south shows the procession through the Porta Triumphalis at the beginning of the ceremony: the gate, surmounted by two quadrigae, is on the right; individuals bearing the *fercula* (stretchers), on which the booty is carried, file past from left to right. Included among the objects are the silver trumpets and the menorah—of which this is the earliest known representation—that were taken from the temple at Jerusalem. The names of the conquered cities were probably painted on the placards.

The central episode of the triumph is on the northern side: Titus advances on a quadriga, preceded by the lictors, whose *fasces,* set in the background, tilt at various angles. The goddess Roma holds the horses by the bit, while Victory, standing on the carriage, crowns the emperor. Allegorical representations of the Roman people (a youth with bared torso) and the Senate (an elderly man dressed in a toga) follow. At the center of the vault, decorated with elaborate coffers, Titus is again represented, this time astride an eagle that takes him up into the sky. The scene reflects the apotheosis and deification of the emperor after his death, which has prompted the suggestion that, as in the case of Trajan's Column, the arch also served as the tomb of Titus, whose body, it is argued, would have been placed in the room inside the attic. But such a hypothesis is wholly implausible.

Alongside the arch toward the south are the scanty **remains of a podium** that is generally associated with the Temple of Jupiter Stator (FIG. **13:42**); as we have seen, however, this temple could not have stood here. Recent excavations have shown that the podium does not in fact belong to a temple, but perhaps to the foundation of a quadrifrons arch, subsequently transformed into a tower during the medieval period. This tower, the *Turris Chartularia* that was used as an archive by the popes, stood very close to the *sacrarium* of Augustus. The latter was transformed into an archive of the Imperial administration, providing a notable example of continuity of function in the same place.

THE TEMPLE OF VENUS AND ROMA The huge building that occupies all of the space between the Basilica of Maxentius and the valley of the Colosseum, situated on a podium 145 meters long and 100 meters wide, is the Temple of Venus and Roma, built by Hadrian and dedicated in AD 135 (FIG. **13:44**). The emperor himself supposedly designed the plans, which were harshly criticized

by Trajan's great architect, Apollodorus of Damascus, who was believed to have paid for this audacity with his life. We know that the site of the temple was previously occupied by the atrium of Nero's Domus Aurea, at the center of which stood the colossal bronze statue of this emperor, approximately 35 meters high without the base. When Hadrian began work on the temple, he had to move the statue, which by this time had been transformed into a representation of the sun god, close to the Colosseum, for which task he employed twenty-four elephants.

The temple, which occupied the central part of the large porticus that borders the open square, had two cellae, facing in opposite directions with their rear walls adjoining one another. It has been recently shown that the cellae did not originally have apses and that they were roofed by beams supporting flat ceilings. Their current form, apsidal with vaulted ceilings, can be attributed to the restoration undertaken by Maxentius that was begun in AD 307 after a fire. The best preserved of the two cellae is the one facing the west, in the direction of the Forum, which was incorporated within the former Convent of S. Francesca Romana (now the Forum Antiquarium). Large porphyry columns enliven the walls and flank the apse in which the statue of the divinity stood—Roma in this case (only the brick base remains). Smaller columns, also of porphyry and set on brackets, frame niches intended for statues; this is a typical arrangement employed around AD 300, found, for example, in the Basilica of Maxentius and in Diocletian's reconstruction of the Curia. The rich pavement of polychrome marbles (unfortunately poorly restored without taking into account the remains of the original floor), the stuccoed coffers that decorate the ceiling, and the vault of the apse combine to form a truly splendid complex. Less well preserved is the other cella, devoted to Venus, on the side facing the Colosseum. There remains practically no trace of the colonnade that surrounded the building on four sides. Originally there were ten columns on the short sides, with four other columns between the antae of the pronaoi, and twenty on the long sides.

The temple rose on a stepped stylobate, typical of Greek temple construction and thus well suited to the hellenizing style of the Hadrianic period. Its exceptional dimensions make it, together with the Temple of Serapis on the Quirinal, among the very largest cult buildings of ancient Rome. On the long sides of the podium, two double colonnades enclose the sacred precinct, with a propylaeon at the center of each. Several columns of gray granite still standing belong to this porticus, which was certainly built during the first phase of construction under Hadrian.

Some investigatory work inside the podium has brought to light ruins of an opulent Republican house.

THE FORUM ANTIQUARIUM The Forum Antiquarium is housed in the former Convent of S. Francesca Romana, within the area occupied by the Temple of Venus and Roma (FIG. **13:43**). The most important finds from the Forum are

displayed in several rooms on the first and second floors surrounding the cloister. On display along the walls of the cloister are important inscriptions and several sculptures, including representations of barbarian prisoners in pavonazzetto from the Basilica Fulvia-Aemilia that have recently been reassembled from numerous fragments. The western cella of the Temple of Venus and Roma can be entered from here.

Material from the protohistoric cemetery and the oldest phases of the Forum is displayed in rooms 1–5 on the ground floor.

Room 1. In the center of the room there is a model of the cemetery and the reconstruction of several tombs. Photographs of the excavation, reconstructions, and sections are displayed on the walls around the room. Contents of the graves—both cremations and the older (tenth-century BC) inhumation burials—are displayed in glass cases; these include the hut urns, which reproduce in miniature the shape of the archaic houses of the Palatine city, and personal items (fibulae of various forms, storage jars, and so-called *foculi*, or braziers). The contents of four tombs found near the Temple of Divus Iulius are also on display here.

Room 2. The inhumation burials set within tree trunks, in which infants were placed, are displayed in this room. These tombs date to the most recent phase of the cemetery, when adults were no longer buried here (beginning of the eighth to the beginning of the sixth century BC). Greek pottery, both imported and locally manufactured, appears here for the first time.

Room 3. Material from the excavations around the Temple of Vesta, in particular from archaic wells. One of these wells contained seventh-century BC pottery, which appears to prove that the sanctuary existed already at that time.

Room 4. This room is dedicated to archaic period finds that were recovered from various areas of the Forum, including the Niger Lapis, the Temple of Divus Iulius, the Comitium, the Cloaca Maxima, the Regia, the so-called Equus Domitiani, and the Basilica Fulvia-Aemilia. Of particular interest, in one of the cases are the archaic architectural terracottas, bronze votive statuettes, and pottery from the excavation of the Niger Lapis. The cast of the archaic Niger Lapis inscription is now in the Museo delle Terme.

Room 5. Model of the underground passageways in the Forum constructed in the time of Caesar and materials from the votive pits of the Sacra Via.

Some of the most important inscriptions of the Forum are displayed in the gallery of the cloister on the first floor, including a marble exedra with a dedication to Trajan from the central area of the Forum and a large fragmentary Republican inscription on travertine from the vicinity of the Arch of Septimius Severus. The latter records the contract for the paving of several streets in the area between the Viminal and Aventine.

Room 6. To the left on entering are fragments of historical reliefs, some of which, similar to the great Trajanic friezes, come from the area behind the Basilica Fulvia-Aemilia—probably from the Forum of Caesar. Several sculptures are displayed in the case on the left: a headless statuette of the Aphrodite of Aphrodisias; a small head of a woman in marble from a well on the Sacra Via (a Greek original dating to the first half of the fifth century BC); a terracotta antefix with the head of Silenus and a fragment of an antefix with a woman's head, datable between the end of the sixth and the beginning of the fifth century BC; the latter were recovered during excavations beneath the Basilica Iulia and belong to the oldest decoration of the Temple of the Castors. The case on the right displays Greek pottery from excavations in the Forum. Of particular importance are the fragments of the large Attic black figure crater, datable to ca. 570 BC, depicting the return of Hephaestus to Olympus; these were found under the Niger Lapis.

Room 7. On display here are the fragments of the frieze from the Temple of Divus Iulius, with archaizing Victories emerging from acanthus tendrils, as well as a base and a sculptured capital, with pairs of rams at the corners, reassembled from fragments of various specimens and much restored; the latter belonged to the interior order of columns of the Temple of Concord.

Room 8. Among the noteworthy objects on display here are a torso of Victory from the Basilica Iulia, a neo-Attic base with female dancers from the Basilica Fulvia-Aemilia, and a large marble basin, reconstructed from a small number of fragments and decorated with olive branches, from the Fountain of Juturna.

The fragments of a large marble frieze that illustrated the myths of the origin of Rome and decorated the central nave of the Basilica Fulvia-Aemilia are mounted around the room. Identifiable scenes include the construction of city walls (at Lavinium); the rape of the Sabine Women; the myth of Tarpeia; and combat scenes (possibly representing the Horatii and Curiatii or perhaps the Latins and Sabines). The frieze, clearly inspired by Hellenistic models, belongs to one of the Republican phases of the basilica.

Room 9. This room, formerly the refectory of the convent (fifteenth-century frescos can still be seen on the walls), houses, in addition to medieval paintings removed from the Curia (S. Adriano) and from S. Maria Antiqua, several sculptures from the Basilica Pauli. The Dioscuri group, an archaizing work of the second century BC, restored during the empire, comes from the Fountain of Juturna, as does the archaizing statue of Apollo; the statue of a man dressed in a toga, probably representing King Numa, was found in the House of the Vestals, as were two statues of Vestals.

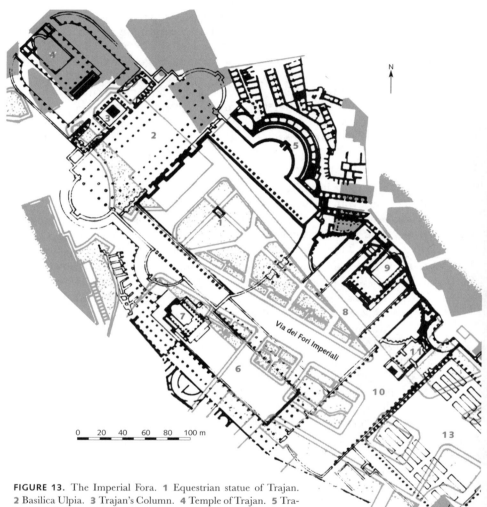

N

FIGURE 13. The Imperial Fora. 1 Equestrian statue of Trajan. 2 Basilica Ulpia. 3 Trajan's Column. 4 Temple of Trajan. 5 Trajan's Markets. 6 Forum of Caesar. 7 Temple of Venus Genetrix. 8 Forum of Augustus. 9 Temple of Mars Ultor. 10 Forum of Nerva. 11 Temple of Minerva. 12 Torre dei Conti. 13 Temple of Peace. 14 Hall of the Severan Marble Plan (Forma Urbis).

IMPERIAL FORA

ITINERARY 1

The Fora of Caesar, Augustus, and Nerva

THE FORUM OF CAESAR (FORUM IULIUM) In a letter to Atticus dated 54 BC (*Att.* 4.16.8), Cicero tells his friend that he has accepted the task of acquiring land, on Caesar's behalf, for construction of a new forum, which subsequently assumed the name of the dictator (FIG. **26:6**). The new complex, which cost 60 million sesterces for the acquisition of the land alone, must have extended all the way to the *Atrium Libertatis,* the old seat of the censors' archives. Reconstructed in grand style by Asinius Pollio at the beginning of the Augustan period but destroyed during the construction of Trajan's Forum, the Atrium was in all probability located on the saddle that joined the Capitoline to the Quirinal, which was later razed to the ground.

The wording of Cicero's letter shows that from the very outset, the Forum was conceived in its current dimensions: the apse of the Temple of Venus Genetrix, at the Forum's western end, abuts the saddle. But there was probably some later enlargement—or at least an increase in the cost of the land—for other ancient writers (Suetonius *Jul.* 26; Pliny *NH* 36.103) give the total price for the purchase of the land from private citizens as 100 million sesterces.

The work must have continued for quite some time, for the Forum and the Temple of Venus Genetrix, vowed by Caesar

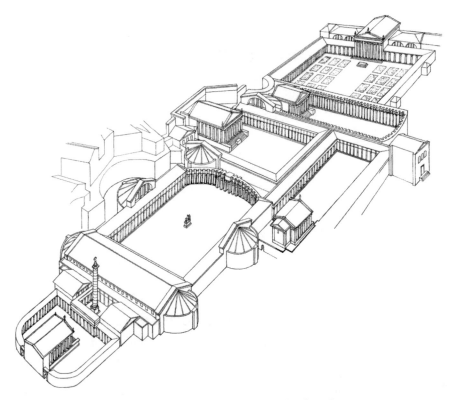

FIGURE 27. The Imperial Fora. Reconstruction from the west.

before the battle against Pompey at Pharsalus, were not dedicated until 46 BC; the work was finished by Octavian only after the death of the dictator. Trajan's complete restoration of the temple and of the Forum itself are attested by an inscription from Ostia (the *Fasti Ostienses*). The new inauguration took place on 12 May AD 113, the same day as the inauguration of Trajan's Column (the project may have started under Domitian). With the construction of the building currently identified as the Basilica Argentaria, the square was then expanded toward the west to include the area previously occupied by the Atrium Libertatis. Diocletian repaired the damage caused by the fire that broke out during the reign of Carinus in 283, which also destroyed the Curia, the Basilica Julia, the Temple of Saturn, and the *Graecostadium*.

Excavation of the Forum took place between 1930 and 1932. Major new excavations in the area, which will modify and substantially expand our knowledge, are currently in progress. The part that has for some time remained visible constitutes about a third of the original area, the southern corner of the square

behind the Curia being considered part of the Roman Forum's archaeological zone. The excavation of the 1930s was never completed, and the eastern half and a good portion of the northern sector were covered over thereafter, so many details of the Forum's plan remain uncertain. All that is visible now are remains of the temple, the entire western corner, and part of the southern side.

The Roman street called the **Clivus Argentarius,** well preserved even now, runs between Caesar's Forum and the slope of the Capitoline; it began at the square in front of the Carcer and passed over the saddle that originally lay between the Capitoline and Quirinal hills. The name is probably from the late Imperial period, although records of it date back only to the Middle Ages; the more ancient name was probably *Clivus Lautumiarum*. Brick structures with decorative niches that served as terracing can still be distinguished on the side of the road running along the foot of the Arx, where the ancient part of the *clivus* comes to an end. Remains of the Servian Wall in blocks of Grotta Oscura tufa, embedded in the modern pavement, show that the change in level at this point resulting from Trajan's building project must have been imperceptible; the surviving blocks probably belong to the Porta Fontinalis. But the change is much more noticeable a little farther on, at the point where the fora of Caesar and Trajan meet.

A **row of tabernae** (shops) built of brick is preserved on the right side of the Clivus Argentarius (traces of others are visible on the left). The last room is occupied by an apsidal nymphaeum with niches for statues. All these structures must date to Trajan's construction.

The entrance to the Forum lies opposite the Carcer Tullianum at the beginning of the Clivus Argentarius. Here we see some remains of walls in cappellaccio and tufa ashlars oriented north-south, like the Comitium, which it appears originally extended this far. Excavation between this point and the facade of the Carcer in 1940 brought to light the presence of a large wall that supported the artificial cut allowing the street to pass and the remains of a colonnaded building that can be identified as the Basilica Porcia.

Descent from the Clivus Argentarius to Caesar's Forum is by way of an ancient travertine stairway. Immediately to the left, at a level above that of the forum and situated on top of its shops, is a **large semicircular hall,** constructed of brick and originally heated, as is evident from the double flooring supported on small piers. The large bench that runs along the curved wall identifies the building, which was erected during the reign of Trajan, as a spacious public latrine.

The area occupied by the Forum originally measured about 160 × 75 meters; it was thus an elongated rectangle, surrounded on three sides by a double colonnaded porticus, with an entrance that opened on the southeastern side, directly onto the *Argiletum*. At the center of the square, as the poet Statius (*Silvae* 1.1) records, was an equestrian statue of the dictator, with the horse's front hooves in the shape of human feet; the rider originally represented was probably Alexander, whose likeness was replaced by that of Caesar. Statius mentions

another statue of the dictator, dressed in armor *(loricata)*, but this may be the same statue.

The southwestern side consists of a **row of tabernae** of various depths, built of tufa and travertine blocks. The facade comprises two superimposed stories, the shop entrances demarcated by flat-arched lintels of tufa and travertine. Some of these doorways, as well as some of the low openings in the second story, were bricked up during the reign of Trajan, probably for structural reasons. Round arches made of tufa blocks were erected above the second story, some of which were rebuilt in brick in Trajan's time. The shops, which evidently date to the earliest (Caesarian) phase, are fronted by a double colonnade, which rises upon a three-stepped platform. In its present form, the colonnade is attributable to a late restoration, certainly the one undertaken by Diocletian after the fire of Carinus. Under the plinths of some columns, traces of older column bases are still visible in the marble pavement, possibly from Trajan's restoration rather than from the original construction. It is not clear how the porticus was roofed and how the roof was joined to the facade of the shops. Some have suggested that the porticus had two stories and that the roof did not cover the space between the colonnade and the back wall, but there is little support for this hypothesis.

Two stairways rise at the back of the colonnade beside the Temple of Venus, giving access to a brick building, currently identified as the **Basilica Argentaria.** The first mention of this building dates from the reign of Constantine, but the basilica certainly dates to Trajan's restoration, for the early Forum ended approximately at the spot marked by the two offset semicircular niches, traces of which are still visible; these abutted the shops on one side and the temple on the other.

The basilica consists of a double series of piers that were set at right angles and roofed with two adjacent vaults. Numerous graffiti have been found on the plaster of the back wall (now protected by glass), including verses of the *Aeneid,* which gave rise to the hypothesis that the facility housed a school; certain areas of the Forum of Augustus and the Forum of Trajan were in fact used for teaching. The porticus continues behind the podium of the temple, which was certainly enlarged during the reign of Trajan. Originally, the foundation of the apse, which one can still make out enclosed within the successive Trajanic structures, rested against the saddle that connected the Capitoline with the Quirinal where the Atrium Libertatis had probably once stood. Both the Servian Wall and the Aqua Marcia, which carried water to the Capitoline, passed over this ridge. At this point we can also see remains of the large southwestern exedra of Trajan's Forum.

The **Temple of Venus Genetrix** occupied the far end of the square and stood in an axial position (FIG. **26:7**; FIG. **28**). In front of the podium are the bases for two fountains, where the statues of the Appiades, works of Stephanus mentioned by Ovid, are mistakenly thought to have stood. In fact, these were displayed in the nearby Atrium Libertatis, as Pliny the Elder (*NH* 36.33) records. Two side-stairways encased within the high podium of *opus caementicium,* orig-

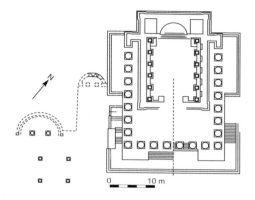

FIGURE 28. Temple of Venus Genetrix in the Forum of Caesar, before the Trajanic reconstruction.

inally faced with marble, provided access to the temple. The building had eight columns on the front and eight on the long sides, while the back wall was blind (according to a model that Vitruvius defines as *peripteros sine postico*). The fragments of three Corinthian columns found in the course of excavation have been reerected, with brick used to fill in missing sections of the marble. Large marble blocks from the architrave and pediment lie in front of the podium.

Columns of giallo antico, engaged to the cella's interior walls on two sides, were surmounted by a sculptured architrave with figures of erotes, a fragment of which is displayed in the Braccio Nuovo of the Capitoline Museums. Other fragments of the rich sculptural decoration, which belong entirely to a Trajanic restoration, are now stored in the tabernae of the Forum. The cella concludes in an apse where the statue of Venus Genetrix, mother of Aeneas and the mythical founder of the *gens Iulia*, was placed, the work of Archelaus. This was certainly one of the earliest apsidal temples (if not the first)—a type that subsequently became widely diffused. A large concrete block, which collapsed onto the podium, shows that the cella was roofed with a vault. Remains of a large brick arch on the temple's left side, probably a reinforcement, may date to the restoration in the time of Diocletian. A similar arch must also have existed on the opposite side.

We know that various works of art were on display in the temple, including a statue of Caesar and another (in gilded bronze) of Cleopatra, as well as two paintings by Timomachus of Byzantium representing Medea and Ajax, purchased by Caesar for 80 talents (Pliny the Elder, *NH* 35.136). Several inscribed bases, supporting statues that have since disappeared, are still visible in the area of the Forum. One of these, near the temple, was dedicated to Sabina, the wife of Hadrian, in AD 138 by the inhabitants of Sabratha in Africa. Another carries a dedication by the urban prefect Virius Nicomachus Flavianus to the emperor Arcadius and can be dated around AD 408. We know that there was a colossal

statue of Tiberius in the Forum, dedicated to the emperor by fourteen cities of Asia Minor in gratitude for the aid furnished after the disasters caused by the earthquakes of AD 17 and 23. Personifications of the cities that had made contributions were represented on the base. Although no traces of the monument remain—perhaps it was located in the unexcavated section of the square—a copy in reduced scale from Pozzuoli is now in the National Museum at Naples.

The Forum of Caesar, then, was a long and narrow square surrounded by a colonnade. The temple, which took up nearly the entire far end facing the entrance, forms the backdrop and unifying element. The rigorously axial plan was fully realized in the construction of the Temple of Venus Genetrix after the Battle of Pharsalus (48 BC), a configuration that was augmented even further by the position of the apse that houses the cult statue—a powerful focal point for the whole complex. The ideological and propagandistic function of this architectural scheme, probably modeled after Hellenistic sanctuaries to deified rulers, seems evident. The Forum and the Temple of Venus were intended to exalt the ancestral goddess of the Julian family, and indirectly the dictator himself, whose equestrian statue occupied the center of the square on the same hallowed axis as the temple and cult statue. We can get a clear idea of the symbolic function that the architectural complex assumed from Suetonius (*Jul.* 78), who recounts how one day the dictator received the Senate—contrary to every norm of Republican etiquette—while seated in the middle of the temple, assuming in so doing the appearance of a living god.

THE FORUM OF AUGUSTUS The second of the Imperial fora, in chronological order, was built by Augustus with money obtained from war booty *(ex manubiis)*, as the emperor himself records in his autobiography (FIG. **26:8**; FIG. **29**). The construction of the square, including the Temple of Mars Ultor (the avenger) at its far end, was vowed before the Battle of Philippi (42 BC), at which Caesar's assassins, Brutus and Cassius, perished. The work took a long time to complete, inasmuch as the inauguration was held forty years later in 2 BC. According to an anecdote handed down by Macrobius (*Sat.* 2.4.9), Augustus was supposed to have joked about the slow pace of the Forum's architect, whose identity is unknown.

We do know that the property was acquired from private citizens, as was the case with Caesar's Forum, and that the square turned out to be smaller than Augustus had planned, because he was unwilling to use strong measures to dispossess reluctant owners (Suetonius *Aug.* 56.2). The function of the new monumental square was to relieve the congestion of the crowds that thronged the two older fora and to create new space for trials and commercial activities. But above all, the rich symbolism of Augustus's Forum served to glorify the emperor, especially in his military and "triumphal" functions. Some restorations were carried out under Hadrian, but of these there remain only slight traces, such as a few capitals, and thus should be considered minor.

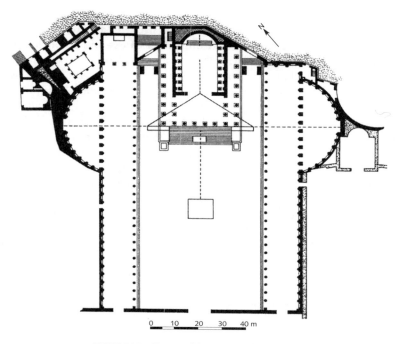

FIGURE 29. Forum of Augustus. (After Zanker)

Excavation has unfortunately been limited to the northeastern sector of the square, including the temple, a portion of the side porticoes, and the two large exedras. The entire front of the complex, including its entrance, was covered over by Via dei Fori Imperiali without being excavated.

A huge wall in *opus quadratum* of peperino and Gabine stone with parts in travertine, about 33 meters high, protected and isolated the Forum from the *Subura* (the valley between the Quirinal and the Esquiline), which lay behind it. Two entrances lead into the square from here, one on either side of the Temple of Mars Ultor. The one farther to the north has three arches, while the southern entrance, known as the Arch of the Pantani, has only one. Two sets of stairs make it possible to negotiate the striking difference in elevation between the old quarter of the Subura and the Forum, which is at a considerably lower level. The entrance through the northern arches leads to the area between the temple podium and the north porticus. Here, at the base of the stairway, was the arch dedicated by Tiberius to Drusus Minor (fragments of the inscription are still on the ground), symmetrical with that of Germanicus, which was set parallel to it on the other side of the temple.

The Forum was originally 125 meters long and 118 wide. Unfortunately, the modern street covers the front part of the square, so what remains appears short and squat. The section of the **colonnade and exedra** on the left of the temple is perfectly symmetrical with that on the opposite side: the remains of the colonnade in cipollino that originally supported a high attic, according to Italo Gismondi's reconstruction, sit on a platform approached by three steps. It seems more probable, to judge from the traces visible on the back wall, that the porticus was two stories high. The large exedras that opened onto the side colonnades represent a new development, later imitated in the Forum of Trajan. It has recently been proposed that the model for this configuration is to be found in the two great hemicycles fronting the first stretch of the Sacred Way in Delphi, which housed the statues of the Argive kings and their successors. The upper part of the porticus was decorated with caryatids, copies of those in the Erechtheum of Athens; between the caryatids were shields that bore the heads of Jupiter Ammon and other gods. The remaining pieces of this decorative material, along with a good part of the other sculptures and inscriptions found in the Forum, are now kept in the small local Antiquarium and in the House of the Knights of Rhodes. According to Gismondi's questionable reconstruction, the front wall of the large semicircular exedra, which opened onto the back of the porticus behind a second row of piers, extended above the roof of the porticus; very likely this wall contained windows to light the exedra.

Along the back walls of the two porticoes and of the exedras, semicolumns of cipollino, which carried an architrave of white marble, framed a series of **niches for marble statues,** of which various fragments have been found. Other statues of gilded bronze may have stood between the intercolumniations of the porticus. The subjects of these statues are known to us in part from ancient authors but above all from the inscriptions found on site. Each statue had two inscriptions: one on the base simply gave the honoree's name and offices *(titulus)*, while the other, inscribed on a slab of marble below the niche, briefly recorded his principal achievements *(elogium)*. Trophies, and not statues, were probably placed in the niches located higher up on the wall.

Altogether, we know the names of twenty-five of the figures honored here. The arrangement of the statues is extremely interesting. The two central niches of the exedras were twice the size of their flanking niches. The statue of Aeneas with Anchises and Ascanius was displayed in the north exedra, while on the south, Romulus was shown in triumph, carrying away the spoils of Acron, king of the Caeninenses, whom he had conquered and killed. The statues of the ancestors of the Julian family, which according to tradition began with Aeneas and his son Iulus, stood in the porticus to the left of the temple, the side dominated by Aeneas. The kings of Alba Longa followed. On the other side, Romulus, the founder of the city, was accompanied by the *summi viri*, the greatest figures of the Republic.

The implicit contrast between the two sides is clear. While the affirmation of monarchic power in the Forum of Caesar was suggested through the potential apotheosis of the dictator, here, in striking contrast and in accord with a model that is typical of Augustan propaganda, we see a compromise between tradition and innovation. Republican history takes on a new life and is at the same time identified with the history of the Julian family. Romulus was descended from Aeneas, and their divine parents—Mars for Romulus and Venus for Aeneas— were brought together in the cult of the Temple of Mars Ultor. In sum, Augustan propaganda conveys the message that the empire constitutes the logical and prov- idential conclusion of the Republic. In this way, the Forum of Augustus becomes a sort of immense patrician atrium with portraits of ancestors. The statue of Au- gustus in his triumphal chariot, which stood at the center of the Forum (probably in the unexcavated part), was placed quite emphatically on the axis of the temple.

At the back of the porticus on the left is a **large square hall,** whose marble decoration is especially rich. A base at the end of this room held a gigantic statue (about 14 meters high)—undoubtedly the colossus of Augustus, which Martial mentions (8.44.7), possibly placed here by the emperor Claudius. Two square spaces on the side walls are undecorated; it was here that the two paintings by Apelles were probably attached to the wall, one representing Alexander the Great with the Dioscuri and Victory, the other showing Alexander in his triumphal chariot and an allegory of war with her hands tied (Pliny *NH* 35.93– 94). Later, Claudius replaced the portraits of Alexander with that of Augustus. These paintings were chosen to exalt the military glory of the first emperor, as the caryatids of the porticus—symbols of the conquered nations—were also probably meant to do. The masks of Jupiter Ammon that the caryatids framed allude to Alexander the Great, who, after his famous visit to the sanctuary in the oasis of Siwa, wished to be considered the son of the god.

The **Temple of Mars Ultor** (FIG. **26:9**) occupies a position similar to that of Venus Genetrix in the Forum of Caesar. The central stairway, constructed in *opus caementicium*, in contrast to the podium built of Anio tufa in *opus quadratum* and veneered with large slabs of Carrara marble, is perhaps a variation introduced while work on the building was in progress. An altar was inserted at the center of the stairs, while two fountains stood at each end of the staircase. Eight gigantic Corinthian columns (17.70 meters high) of Carrara marble lined the facade, and the same number lined the long sides of the temple. Except for some elements reerected after the excavations, only the three terminal columns on the right side, in addition to the terminal pilaster, remain standing. The portion of the cella wall and architrave corresponding to the surviving columns also survives, preserving a segment of the magnificent coffered ceiling that was patterned upon Greek models of the fourth century BC.

The interior space of the temple was accentuated by seven columns on each side, arranged on two levels and placed close to the walls in line with

an equal number of pilasters; niches for statues were inserted between the pilasters. One of the pilaster capitals, with representations of the winged Pegasus replacing the volutes, is now in the Forum Antiquarium. This architectural feature was directly inspired by classical Athenian models, in particular by the Erechtheum.

The cella terminated in an apse, within which stood the base for the cult statues. The length of the base (about 9 meters) suggests that there were not two statues—Venus and Mars, as is usually supposed—but three, with the addition of Divus Iulius. A relief in the Museum of Algiers and other copies give us an idea of these statues: Mars is represented as bearded, fully armed, and leaning on his lance, while Venus, clothed in a light chiton, is accompanied by Eros, who offers her the sword of her divine husband. A colossal copy of the statue of Mars is on display in the Capitoline Museum. The steps in front of the statue base might also have continued along the other sides of the cella. It is thought that these were used for meetings of the Senate, held frequently in the building.

We know that the standards taken from the Romans by the Parthians at the Battle of Carrhae, and later reclaimed by Augustus, were kept in the *penetrale* of the temple, a sort of *sancta sanctorum*. The *penetrale* should probably be identified with the apse itself, rather than with the asymmetrical room to its left. The decoration of the pediment is reproduced in a relief from the age of Claudius, now set into the back wall of Villa Medici, with a representation of a sacrifice in front of the temple.

All aspects of Roman war and triumph were concentrated in the Forum of Augustus. It was here that the Senate met to declare war and to sanction peace. Governors offered sacrifices on the temple's altar before going out to their provinces. It was also here that statues of victorious generals were erected, though in the Imperial period generals no longer had the right to celebrate the triumph, which by then became the exclusive prerogative of the emperor. The Forum provides the clearest illustration of the fact that the princeps had a monopoly on the military triumph.

The **Antiquarium** of the Forum is housed in several ancient tabernae adjacent to a hall with a porticus of piers, now used as a chapel by the Knights of Malta; its original function is unknown. The fragments of inscriptions belonging to the statues of the *summi viri* are preserved in the rooms that open onto the back of this hall, while the few remains of these statues and of the caryatids and the shields depicting Jupiter Ammon (originally displayed on the attic of the porticus) are in the tabernae. Also stored here are fragments of bronze statues, the capital of a pilaster with winged horses from the cella of the temple, various sculptured architectural elements (some are medieval, remnants of the convent and the churches that once occupied the Forum), and finally, in the last room, the plaster model of the Forum of Augustus. In the central hall of the nearby headquarters of the Knights of Malta, one section of the porticus

decoration, a shield with the head of Jupiter Ammon between two caryatids, has been reconstructed from the original fragments.

THE FORUM OF NERVA, OR TRANSITORIUM Today the Forum of Nerva is entered directly from the Forum of Augustus (FIG. **26:10**; FIG. **30**). Construction was begun and all but completed by Domitian, but the inauguration, at which Nerva presided, took place in AD 97, after Domitian's death. The name *Transitorium* alludes to the position of the square, which replaced the first stretch of the Argiletum, the road from the Republican Forum to the Subura, and thus linked the then-existing fora—Caesar's, Augustus's, and the old Forum Romanum—with the Temple of Peace. Thus the square assumed a long narrow shape (120 × 45 meters) and, like the others, was dominated by a temple at its far end. The temple was dedicated to Minerva, a divinity especially venerated by Domitian. The inscription on the frieze of the temple, however, carried the name and titulature of Nerva. Space constraints made the construction of a porticus unfeasible; this in fact was the last space available in the area before Trajan razed the saddle between the Capitoline and the Quirinal. In the absence of a real porticus, a large colonnade was built on the side of the square, at a very short distance from the precinct wall, to which the colonnade was joined by short sections of entablature and attic. The right wall was the original facade of the Temple of Peace. The smaller side facing the Roman Forum, which abuts the back wall of the Basilica Aemilia, is curved. Here, at the western corner, were entrances to the Republican Forum and the Forum of Caesar. According to a late source, Domitian replaced the Arch of Janus, which originally stood at the beginning of the Argiletum, with a quadrifrons arch at the edge of the new square. It is likely that the traces of a structure discovered recently during excavations along the Argiletum, where the four fora intersect (the Republican Forum, Caesar's, Augustus's, and the Transitorium), are the remains of this arch.

All that remains of the Transitorium are the formless nucleus of the **Temple of Minerva,** under which a section of the Cloaca Maxima passes, and the **two famous columns** that survive from the eastern side (called the "Colonnacce"), together with the corresponding segment of the back wall that faces Via Cavour. The temple was well preserved until the beginning of the seventeenth century, when Paul V in 1606 used its materials to construct the Acqua Paola on the Janiculum. The attic contains a sculptured relief of the goddess Minerva, the patron of crafts, while the frieze depicts scenes of women's work; the myth of Arachne has been identified among the scenes. An ancient source mentions gigantic statues of emperors, standing or equestrian, in the square, which Alexander Severus is said to have erected in imitation of the nearby Forum of Augustus (*SHA*, Alexander Sev. 28.6). Under the pavement of the square two early Iron Age tombs have been found, similar to those found in the cemetery of the Forum Romanum.

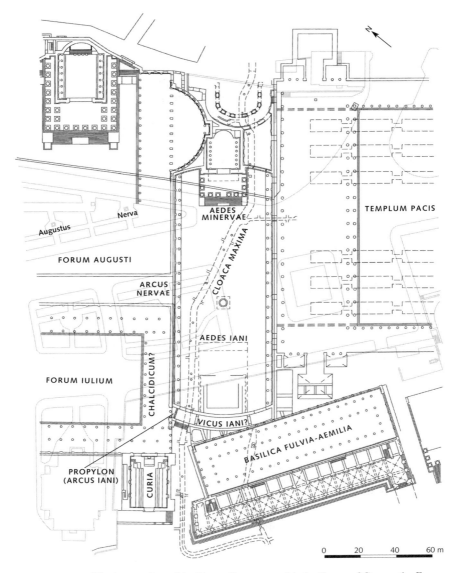

FIGURE 30. The intersection of the Forum Romanum with the Forum of Caesar, the Forum of Augustus, the Transitorium, and the Temple of Peace, including the modern street plan. (After Bauer 1976–77)

Behind the Temple of Minerva is a large **horseshoe-shaped exedra** with a colonnade in front that faces the Subura. This has been identified as the *Porticus Absidata* mentioned in the Regionary Catalogues, which were compiled during the time of Constantine.

ITINERARY 2

The Forum of Trajan and the Temple of Peace

THE FORUM OF TRAJAN The last and most impressive of the Imperial fora was built by Trajan between AD 107 (the year of his triumph over the Dacians) and 113. At that time, the area between the Velia, the Subura, the Quirinal, and the Forum valley was completely occupied by buildings (FIG. **26:1–4**). The only solution to the need for more land was to open additional space in the direction of the Campus Martius by eliminating the saddle between the Capitoline and the Quirinal. Trajan's architect, Apollodorus of Damascus, carried out the massive removal of earth, as attested by the inscription on the base of Trajan's Column and a passage of the historian Dio Cassius (68.16). Existing structures on this saddle were destroyed at that time, such as the Atrium Libertatis and the section of the Servian Wall between the Capitoline and the Quirinal.

The project resulted in the construction of what is perhaps Rome's greatest monumental complex. Two and a half centuries later, the monument was still an object of admiration. When the Emperor Constantius II came to Rome in 357— the city had by then yielded its functions as capital to Constantinople—he was especially struck by Trajan's Forum and so admired the equestrian statue of the emperor, which dominated the center of the square, that he used it as a model for his own statue at Constantinople. His contemporary, the historian Ammianus Marcellinus who records the story (16.10.15), includes the witty remark of a Persian prince in Constantius's retinue, who recommended that the emperor first build a stable large enough to accommodate the immense horse.

The Forum, measuring overall 300 meters in length by 185 meters in width, was inaugurated in January of 112; the column, still unfinished, was inaugurated in May of 113, together with the newly refurbished Forum of Caesar. The monument rested upon a series of terraces rising slightly, one with respect to the other, from south to north. A large arch with a single passageway, located on the side facing the Forum of Augustus, constituted the Forum's main entrance, which lies in the as-yet unexcavated area. Coins of the period give some idea of the entrance: an arch divided vertically into five bays framed by six columns. The main entrance was in the central bay, while the side bays had niches with triangular pediments, each with a statue that probably represented a Dacian prisoner. Above these were the same number of portraits on shields *(imagines clipeatae)*, probably representations of Trajan's generals. The statue of Trajan in

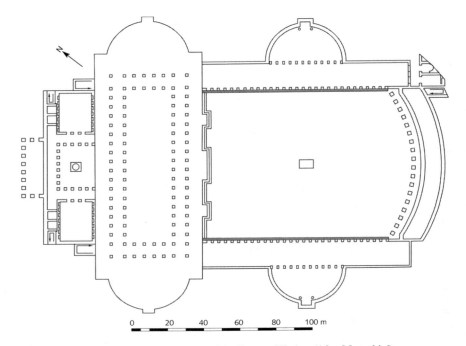

FIGURE 31. Conjectural plan of the Forum of Trajan. (After Meneghini)

his triumphal chariot, drawn by six horses and flanked by trophies and Victories, towered above the high attic.

The main piazza was rectangular, with the wall at the entryway convex toward the outside; at its center, also in the unexcavated zone, was the great equestrian statue of Trajan (FIG. **31**). Here too coins provide us with an idea of the monument's appearance. The two sides of the square were closed by colonnaded porticoes, rising on a platform of two steps, onto the back of which opened two very large semicircular exedras, evidently inspired by the nearby Forum of Augustus. Of these, only the **eastern exedra,** alongside Trajan's Markets, can still be seen. Few remains of this recess survive, as is also true of the other exedra, adjacent to the Temple of Venus Genetrix in the Forum of Caesar. A street paved with basalt separates the Forum from the markets. Abundant remains of the exedra's marble pavement are still in place, with traces of the piers that separated the exedra from the Forum porticus. The front line of this porticus is also preserved for its whole length, elevated two steps above the level of the square. It is easy to recognize the colonnade from the bases remaining *in situ* (mere traces in some instances), while some columns of gray granite lie along the line itself.

The eastern part of the Forum is separated from the center by the modern street, but a tunnel allows access from one section to the other. Only a small section of the square in front of the Basilica Ulpia has been excavated. It is very difficult to envisage the proportions and the original appearance of the monument because it is so broken up and dismembered. Here, too, as was the case in the Forum of Augustus, several portraits must have been on display: two heads of immense size of the emperor Nerva and of Agrippina, the mother of Nero (now displayed in Trajan's Markets), indicate that the gallery focused on the emperors who preceded Trajan and the more important members of their families. The idea, then, was to continue the statue gallery already on display in the Forum of Augustus. Even the attic of the two porticoes was similar to that of the Forum of Augustus: statues of Dacian prisoners in place of the caryatids framed shields with heads, the subject of which is unknown to us, since only fragments of them remain.

The back of the square was blocked off by the massive and imposing Basilica Ulpia. The inclusion of a basilica, which distinguished it from the design of the earlier fora, was an innovation on the part of Trajan's architect. It is thought that the scheme adopted here reproduces that of the Atrium Libertatis. The very fact that Trajan's Column, as the inscription incised on its base attests, was intended to indicate the height of the hill cut away to construct the Forum can be interpreted as a sort of expiatory sacrifice *(piaculum)* for the *sacrilegium* caused by the destruction of such an important part of the city. At the same time, the basilica served to link the old Atrium Libertatis that stood on this hill and the new one annexed to the Forum of Trajan. This type of building complex had already been employed in the case of the Atrium Libertatis, which likewise included a basilica (the *Basilica Asinia*) and two libraries. The Forum of Trajan thus constituted, to a remarkable degree, a replica of the monument of Asinius Pollio.

The basilica, the largest ever built in Rome, measured about 170 meters on its major axis (120 without the apses) and a little less than 60 meters in width. Another coin of Trajan shows us its outer facade, divided vertically into three sections, corresponding to the same number of entrances. A huge frieze in deep relief covered the attic's entire length and must have extended as well to the other three sides of the basilica. At its center is a quadriga, seen from the front, probably the triumphal chariot of Trajan, while trophies stand at the far ends. We cannot dismiss the possibility that this was the original location of the large Trajanic frieze that was later divided into four panels and reused in the Arch of Constantine, though the fact that the Forum was in an excellent state of preservation at the time of Constantius II might argue against such a hypothesis. The standards of the various legions that had taken part in the Dacian wars were probably arranged on the ridge of the facade, as fragments of inscribed architraves recording the names of individual legions appear to confirm. In front of the entrances were three statues of Trajan; one of the bases

with its inscription is still in place. Three steps provide access to the podium of the basilica.

Only the central section of the monument is visible today; the western apse lies below Via dei Fori Imperiali (this has been excavated and is accessible from the nearby library), while the eastern apse lies below the present-day Scalinata di Magnanapoli. The interior was divided into five aisles by four rows of columns that turned and continued along the narrow sides of the basilica. The granite columns surrounding the central nave were larger than the others, which were of cipollino. Only fragments survive of the rich decoration from the frieze, which featured Victories in the act of sacrificing bulls and adorning candelabra with garlands.

Aside from its judiciary and commercial functions, the basilica probably also assumed those that had previously been carried out in the Atrium Libertatis, which was destroyed to make room for Trajan's Forum. So would suggest a fragment of the Severan Marble Plan that represents the eastern apse of the basilica and includes the word *libertatis* (to be completed with the word *atrium*, probably inscribed in the basilica's other apse) and from various references to the use of the hall for manumission ceremonies.

The **two libraries** to the north of the basilica may have belonged originally to the Atrium Libertatis. The one on the western side, visible below the modern street, is the better preserved. It consists of a large rectangular room, furnished with the niches that contained book cabinets. The niches were accessible from a three-stepped platform and were bordered by a rich architectural decor consisting of two orders of columns. At the back of the center wall, a larger niche within an aedicula housed the statue of a divinity, perhaps Minerva. The hall is now used as storage space for architectural fragments from the Forum.

Between the two libraries is Trajan's Column, the only monument of the Forum that has come down to us almost completely intact. The column, made of large blocks of Luna marble, rests upon a large base in the form of a pedestal. Between the socle and cornice, the latter of which has four eagles carrying festoons at its corners, the free surface (or dado) was completely covered with bas-reliefs representing Dacian arms. On the principal side, facing the Basilica Ulpia, is the entrance door, which leads to the inner chamber and to the spiral stairway, cut into the marble, that ascends to the top of the column. Above the door is a panel with an inscription carried by two Victories that reads:

Senatus populusque Romanus / Imp(eratori) Caesari divi Nervae f(ilio) Nervae / Traiano Aug(usto) Germ(anico) Dacico Pontif(ici) / Maximo trib(unicia) pot(estate) XVII Imp(eratori) VI co(n)s(uli) VI p(atri) p(atriae) / ad declarandum quantae altitudinis / mons et locus tan[tis oper]ibus sit egestus. (The Senate and People of Rome to the emperor Caesar Nerva Trajan, son of the Divine Nerva, Germanicus, Dacicus, Pontifex Maximus, invested with Tribunician Power for the seventeenth time, acclaimed imperator

for the sixth time, consul for the sixth time, father of the nation. To indicate the height of the hill that was demolished in the course of these great labors.)

The column, then, served first of all to indicate the original level of the hill at the spot where the hemicycles of the square are located and reveal how much was cut away to free the area needed for the new Forum.

The most important purpose of the monument, however, was quite different: it served as the emperor's tomb. We know that Trajan's ashes, sealed in a golden urn, were placed in the base of the column (Cassius Dio 69.2). A door to the left of the entrance leads to a small room, a sort of antechamber, which is followed by another that takes up the entire northern side of the base; here, on a marble table, the urn once rested. The base's resemblance to a large number of altar-shaped funeral monuments in widespread use from the end of the Republican period strongly suggests that this was the monument's originally intended purpose; the use of columns for funeral monuments, moreover, is hardly unusual. This instance differs, however, in being one of the very few examples of burial within the *pomerium,* which, from the Claudian era forward, included much of the Campus Martius.

A spiraling relief (about 200 meters long) with scenes from the Dacian wars winds its way around the shaft of the column, which is 100 Roman feet high (29.78 meters; including its base, the column measures 39.83 meters). The narrative of the two wars is separated by a figure of Victory in the act of writing on a shield. The reliefs convey not so much a celebratory character as a documentary one. They have been interpreted as a figurative representation of Trajan's *Commentarii,* a prose narrative of the two Dacian wars that unfortunately has not survived but which was surely inspired by the similar work of Caesar. This interpretation seems all the more plausible if we take into account the location of the column between the two libraries (Trajan's commentaries would have been kept in the Latin one) and the very appearance of the relief, which reproduces the form of an ancient book—a scroll *(volumen).*

The frieze recounts in detail the various phases of the war, if only in a schematic way through a series of recurrent operations. The sculptured narrative, proceeding from bottom to top, moves from the crossing of the Danube on a pontoon-bridge, signaling the beginning of the operation, to the deportation of the Dacian population with which the war concludes. In between, we see in succession scenes of camp construction, addresses to the troops, battles, sieges, executions, and submissions of the native chiefs to the emperor. The figure of Trajan reappears no fewer than sixty times.

Viewing the reliefs, which were originally painted, must have been facilitated by the presence of nearby buildings such as the Basilica Ulpia and the libraries, as their terraces, possibly linked with one another, were closer to the high part of the column. Nonetheless, a complete view of the reliefs even in antiquity was

practically impossible. As often happens, a monument of this kind has a certain objectivity or validity in and of itself, apart from whether what is represented upon it can actually be deciphered. Such is the case, for example, with the Parthenon friezes.

The sculptures of the column, like those of the great Trajanic relief now inserted in the Arch of Constantine, which complement them in their celebratory theme, are associated in their conception with a single artist, who has come to be known as the "Maestro delle imprese di Traiano" (Master of Trajan's Achievements). Some have even identified him as the architect of the Forum, Apollodorus of Damascus. Whatever the truth of the matter, we are certainly dealing with one of the most important artistic personalities in the realm of official Roman art. The perfect fusion among formal elements of Hellenistic origin, on the one hand (such as the representation of space and landscape, the intelligently executed gradation and superimposing of levels, the unbroken organic continuity between the various scenes and their constituent elements) and, on the other hand, the narrative content, more typically Roman with its characteristic stress on model situations systematically repeated, the expressive tension that runs without interruption through the entire length of the frieze and finds a consuming poetic intensity in certain key episodes (such as the death of Decebalus and the final deportation of the Dacians)—all of this makes this monument one of the sculptural masterpieces of all time. During the reign of Sixtus V, a statue of Saint Peter replaced that of Trajan, which had crowned the column but disappeared in the Middle Ages.

Until recently, the imposing temple dedicated to Trajan and his wife Plotina, erected by his successor after the death of the emperor in AD 117, was thought to be located to the north behind the column; construction of the temple must, then, have occurred in the years after the death of Plotina, probably in AD 121. Recent exploratory excavations, however, would seem to rule out the temple's traditionally assigned location, for the area was found to be occupied by buildings of a seemingly private nature dating to the first centuries of the empire. Excavations still in progress appear to rule out the alternative hypothesis; namely, that the temple stood on the opposite side of the forum complex to the south. For the time being, the problem remains unsolved. All that survives of the temple is the dedicatory inscription, which resides in the Vatican Museums. A nearby granite column, a little over 2 meters in diameter and thus originally no less than 20 meters high, with a capital of white marble, had long been considered part of the temple but has recently been associated with a northern entrance to the Forum.

The Forum served multiple functions. Laws were promulgated here, some of which, dated between AD 319 and 451, have come down to us. A number of congiaria, distributions of money to the people, were offered by the emperor, probably using the podium of the basilica as his tribune, as in a scene shown on a relief of Marcus Aurelius later inserted in the Arch of Constantine and

perhaps also in a Constantinian relief from the same arch. Finally, the various exedras of the square may have been used as reading rooms and schools.

Despite the plundering carried out here by Constantine to adorn his arch, if in fact the reliefs and statues of the Dacians that were inserted into it came from here, the Forum of Trajan must have remained in good condition until a late period; otherwise, the admiration of Constantius II can hardly be explained, nor can the continuity of its use, which extended at least midway through the fifth century. In addition to the laws that were promulgated here at least until 451, various inscriptions associated with statues, the latest of which is from AD 445, also point to a mid-fifth-century date.

Between the Forum of Trajan and the Forum of Augustus, below the Renaissance loggia of the Knights of Rhodes, is a large construction in brick with a central niche, which can be reached through Campo Carleo, a modern passageway. This is a building dating to the reign of Domitian, whose purpose is unknown.

TRAJAN'S MARKETS Trajan's architect used the space between the eastern limit of the Forum and the lowest slopes of the Quirinal for an intricately organized complex of utilitarian buildings, which, after its discovery, became known as Trajan's Markets (FIG. 26:5). This remarkable complex rises upon a series of successive terraces up to the limit of the hill's excavation. The total height of the mass that was cut away corresponds to that of Trajan's Column, as its inscription records (FIG. 32). Study of the structure's brick stamps dates the complex to the first decade of the second century AD. We can thus conclude that the construction of the markets, which also had the function of hiding the large cut in the Quirinal and retaining the hill's slopes, preceded that of the Forum.

The facade of the markets consists of a large exedra that follows concentrically the curving line of the eastern exedra of the Forum (FIG. 33). Between the two exedras runs a street paved in slabs of basalt. At the ends of the facade are two large semicircular rooms, each roofed with a semidome. The larger of these, the northern room, is illuminated by five large windows, while the one on the south has only three openings, which are offset. These rooms were likely used as schools or auditoriums; we know that in Trajan's Forum as well as in the other fora, at least at a late period, advanced courses of instruction were conducted, which must have made use of the nearby libraries.

The exedra, constructed entirely of brick like the rest of the complex, has eleven shops on the lower level and two entrances, one at each end. These rooms, which are not very deep, rest directly against the rock of the hill. The doors, almost square, have travertine jambs and architraves. The upper part of the shops, with vaulted ceiling, was closed off from the exterior by a projecting wall that was pierced by a transom window. The fourth shop from the left, which has been restored, gives us an idea of their appearance. Inside some of the shops are the remains of plaster with interesting graffiti. The upper part of the facade

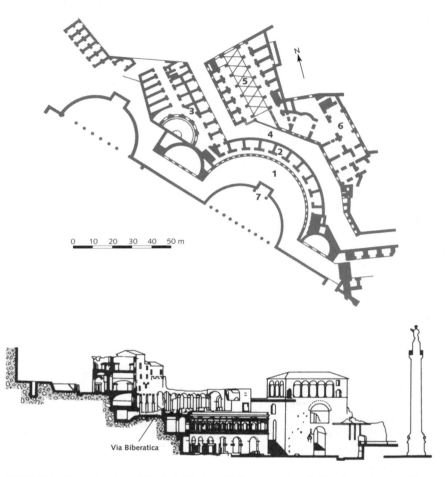

FIGURE 32. *Above,* the plan of Trajan's Markets. **1** Lower exedra. **2** First-floor shops. **3** First-floor corridor and the large exedras (auditoriums?). **4** Via Biberatica. **5** Central hall. **6** Offices? **7** Northeastern exedra of Trajan's Forum. *Below,* section across Trajan's Markets and the cut into the slope of the Quirinal compared with the height of Trajan's Column.

has a series of small arched windows (five for every three shops), framed by brick pilasters with travertine bases and capitals, surmounted by small pediments, complete or broken. The windows lit a vaulted corridor, which stood above the ground-floor rooms. Ten shops opened onto this corridor, which extended northward, where it led to another corridor that was flanked by groups of shops, today only partly accessible. Toward the west there is another semicircular room with a semidomed roof, adjacent to the one on the lower floor.

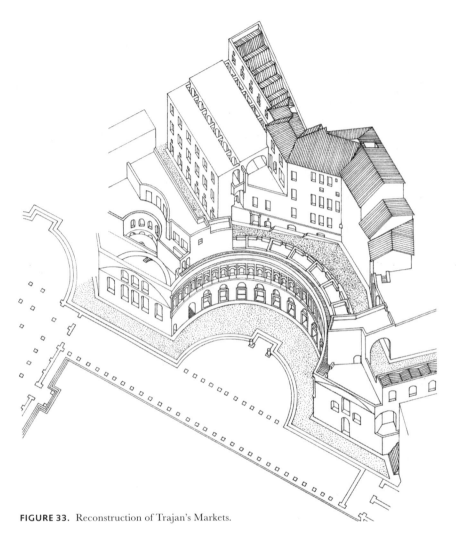

FIGURE 33. Reconstruction of Trajan's Markets.

The third floor of the hemicycle consisted of a terrace, situated above the corridor of the lower floor, and of a group of shops (now razed to the ground) that faced the opposite direction from those below, opening onto an ancient street that is very well preserved. This street, which winds sinuously upward from north to south, was known as Via Biberatica during the Middle Ages. Its name, which might well correspond to the ancient one, is derived from the late Latin noun *biber* (drink), thus providing a clue to the likely purpose of at least some of the shops that flanked the street (i.e., *thermopolia*,

or taverns). The straight section of road that runs from the embankment of the modern Via Quattro Novembre, where the street abruptly ends, toward the hemicycle is bordered on each side by large, well-preserved shops, above which rose balconies that were supported by travertine brackets. As the road continues around the hemicycle, one side of the street complements the smooth curve on the east, while the other assumes the various angles of the buildings that line its course. Then, veering at a right angle, it grazes the Domitianic constructions and the edge of Augustus's Forum before moving off in the direction of the Subura.

A steep stairway leads from Via Biberatica to a **magnificent hall** that constitutes the center of the entire complex. Its main entrance must have opened onto the northern side. The spacious hall is two stories high, spanned by a bold series of six groin vaults resting on travertine supports. There are six shops on each side of the ground floor, whose doors in typical fashion are framed in travertine and surmounted by a transom window. On the upper floor, the shops (almost completely reconstructed after the excavations) give onto a corridor. The space, airy and light, stands as one of the most successful examples of Roman vaulted architecture. Some have erroneously identified the hall as the Basilica Traiana, mentioned by an ancient writer, where the distribution of money to the people *(congiarium)* was supposed to have taken place. In fact, the Basilica Traiana is nothing other than the Basilica Ulpia.

On the southern side of the hall there is an entrance to a **series of rooms** on two floors that seem to have had a different purpose from the others, which are clearly shops. These, it has been suggested, were the offices of the central administration responsible for managing the whole complex. They have been set aside to house the Antiquarium of the Forum of Trajan.

The large complex of buildings was probably used in part as a wholesale market for food supplies, managed by the state, and in part also for retail sales. The creation of such a complex accords perfectly with the large-scale urban restructuring that gradually led to the relocation of the city's commercial and economic functions, formerly undertaken in the Republican Forum and subsequently in the area nearby. The construction of the Imperial fora carried this process forward. We know, for example, that the Temple of Peace was built on the site of the *Macellum,* the Republican market.

The architect was probably Apollodorus of Damascus, the designer of the adjacent Forum of Trajan, as we can deduce from the close connection between the two complexes. The function of each required two completely different solutions. The Forum of Trajan, for all its innovations, was rigidly governed by the principle of axiality, imposed upon it by its official function. But Trajan's Markets were adapted to conditions dictated by their surroundings, gradually passing from the symmetry that was imposed upon the complex by the exedra facing the Forum to an asymmetric articulation that took maximum advantage of the area and employed all its spatial potentialities to the fullest. We are thus

in the presence of one of the finest and most successful creations of utilitarian Roman architecture, which profited from the experience of two centuries of urbanization.

THE TEMPLE OF PEACE The Temple of Peace is a monumental square similar to a forum and is intimately associated with the other Imperial fora, of which it constitutes a kind of appendix to the southeast (FIG. 26:13; FIG. 30). In fact, at the end of the empire it was called, inappropriately, the Forum of Peace. Originally separated from the Forum of Augustus, toward which its facade was oriented, it later came to be connected to this by the Transitorium, which took up the narrow space in between. The back side, where the temple stood, approached the Velia, separated from it by the street that joined the Forum to the Carinae. The Basilica of Maxentius was later erected on the other side of this street, in the area once occupied by the spice market *(Horrea Piperataria)*. The basilica was identified as the Temple of Peace until the beginning of the nineteenth century, when, thanks to the archaeologist Antonio Nibby, the correction was made that prevails to this day.

Vespasian, the first emperor of the Flavian dynasty, was responsible for construction of the facility (completed between AD 71 and 75), which commemorated the victory over the Jews. The temple was destroyed in AD 192 during the reign of Commodus in a great fire and was later restored by Septimius Severus. Further damage sustained in the fifth century led to its eventual abandonment, as the sixth-century AD Byzantine writer Procopius attests. We know that the monument occupied the site of the large Republican public market (the Macellum). It is not improbable that the form assumed by the *Templum Pacis* in part recalls the previous building; it is in fact rather similar to that of several monumental marketplaces, such as the Macellum at Pozzuoli.

Although the monument has for the most part disappeared, we can reconstruct its appearance, principally on the basis of some fragments of the Severan Marble Plan, which was affixed to a wall in one of its rooms; moreover, excavations in progress are now furnishing important new information (FIG. 34). The temple consisted of a simple apsidal hall, which opened onto the back of the porticus, almost in the form of a large exedra. The cult statue stood in the apse at the center of the back wall. A row of columns separated the temple from the porticus in front it of it, while the six columns that formed the front of the temple facing the square actually stood within the colonnade of the porticus, distinguished only by their bases and their larger proportions. When seen from the front, the pediment must also have underscored the presence of the cult building, which was preceded by a rectangular altar (FIG. 35).

Such a schema is found in buildings, both religious and secular, from the Republican age. The oldest thus far documented in Italy is the Temple of Hercules, recently discovered in Alba Fucens, but the example closest in dimension

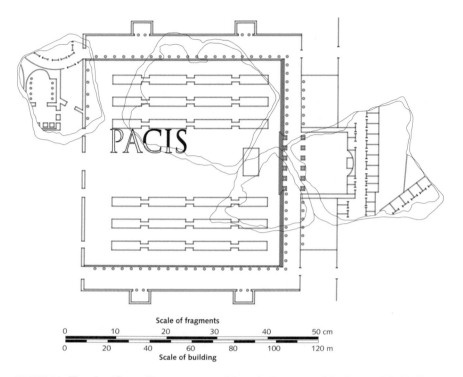

Scale of fragments

0 10 20 30 40 50 cm

0 20 40 60 80 100 120 m

Scale of building

FIGURE 34. Temple of Peace. Plan reconstructed from the fragments of the Severan Marble Plan.

and design to the temple is without a doubt the Library of Hadrian in Athens. Moreover, an important library was housed in the Temple of Peace.

We know that many works of art were kept here; for example, the booty from the Temple in Jerusalem, such as the seven-branched candelabrum (menorah) and the silver trumpets represented on the Arch of Titus. Pliny the Elder (*NH* 34.84) records that numerous statues taken by Nero from their places of origin in Greece and Asia Minor to decorate the *Domus Aurea* were displayed by Vespasian in the Temple of Peace so that they would be available to the public. Among those recorded by ancient authors are the famous cow by Myron, the statue groups featuring Galatians from Pergamum, and other statues by Phidias, Naukydes, Leochares, and Polycleitos, in addition to paintings by Protogenes, Nicomachus, and Helen. The bases of some of these works (the Ganymede of Leochares and the Pythocles of Polycleitos) were found with their inscriptions; these, however, were remade during the Severan age.

Very little of this once splendid complex remains today. A **large column of African marble,** originally belonging to the porticus, and a fragment of architrave in white marble can be seen in the flower bed in front

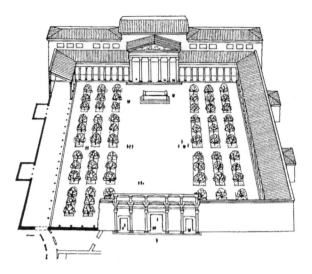

FIGURE 35. Temple of Peace. Reconstruction.

of the entrance to the Roman Forum. The northernmost of the four exedras
of the porticus, built in *opus quadratum*, survives in good condition under the
Torre dei Conti, located at the beginning of Via Cavour. The most impor-
tant segment of the complex to survive, however, is the southern corner, ad-
jacent to the Basilica of Maxentius. That this is preserved (albeit partially)
is due to the fact that at a fairly early period (between 526 and 530) sev-
eral rooms of the complex were transformed into the Church of Saints Cos-
mas and Damian, thus confirming Procopius's reference to the complex's early
abandonment (*Goth.* 4.21).

Remains of the **two halls** situated to the right of the temple are still visible.
The entire southwestern wall of one, constructed all in brick and dating from the
Severan restoration, remains standing between the Basilica of Maxentius and the
entrance to the church. The room's marble flooring, on which a block of masonry
from the Basilica of Maxentius has fallen, is partially preserved; few traces of
the other walls remain. The room communicated with the porticus in front of it
through a large opening, divided by four columns, and measured 34 × 18 meters,
with a height of about 18 meters. A series of small clamp holes inserted at regular
intervals on the brick wall can still be seen. These were part of the support system
for the marble slabs on which the great plan of Rome was engraved; the wall
opposite was likely decorated with a large painted geographical chart probably
representing Italy, fragments of which, painted on marble, have been found.
The *Forma Urbis,* or the **Severan Marble Plan,** as it is often called, was made
during the reign of Septimius Severus, though it almost certainly reproduced

an earlier plan from the Flavian period. This, in turn, was probably based on an Augustan relief fashioned during the urban reorganization that divided the city into fourteen regions. Fragments of the Forma Urbis were found as early as 1562. Originally the map was composed of eleven rows of marble slabs, placed alternately lengthwise and widthwise. In all, there were 151, for a total width of 18.10 meters and height of 13 meters. Of the plan's original 235 square meters (its scale was approximately 1:246), only about a tenth has been preserved. Internal evidence dates it to between AD 203 and 211. The plan was a vertical display of high quality, drawn from a remarkably precise survey that was probably used for property inventory and valuation. The original, perhaps drawn on parchment but more probably engraved on bronze plates, might have been kept in the nearby library. Even though only a small portion of the Forma Urbis survives, it is invaluable documentation for our knowledge of ancient Rome's topography.

The best-preserved section of the Temple of Peace lies behind the wall that bore the Forma Urbis, within which is the Church of Saints Cosmas and Damian. The space seems to have consisted of two rooms divided by a partition, which has since disappeared. The room nearest to the wall of the Forma Urbis was faced with two layers of brick, one from the Flavian period, the other Severan. The so-called Temple of Romulus was later attached to the other room, which was originally apsidal. A door to this hall opened onto the street that ran from the forum to the Carinae in the direction of the Basilica of Maxentius. The impressive exterior wall, built of peperino and travertine ashlars, can be seen from the Forum. Another door, facing northwest, opened onto the porticus of the Temple of Peace. Remains of its wall, still visible in the atrium of the church, show traces of marble decoration.

These two halls were probably associated with the older *Praefectura Urbis*, which was later enlarged in the direction of the Carinae that ran behind it and included the Temple of Tellus. If this is so, we can better understand the location here of the Forma Urbis, a plan that must have originally involved property boundaries as well as a representation of Italy, since the jurisdiction of the Urban Prefect extended to a part of the Italian peninsula.

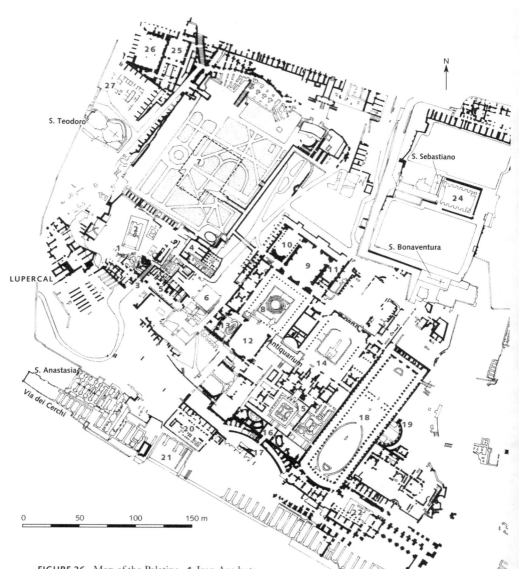

FIGURE 36. Map of the Palatine. **1** Iron Age huts.
2 Temple of the Magna Mater. **3** Scalae Caci. **4** House
of Livia. **5** House of Augustus. **6** Temple of Apollo. **7** Domus
Tiberiana. **8** "Domus Flavia." **9** "Aula Regia." **10** "Basilica."
11 "Lararium." **12** Cenatio Iovis. **13** Nymphaeum. **14** Upper
peristyle of the "Domus Augustana." **15** Lower peristyle of the
"Domus Augustana." **16** Entrance of the "Domus Augustana."
17 Exedra in front of the "Domus Augustana." **18** "Stadium"
(Hippodrome of the "Domus Augustana"). **19** Tribunal of the
"Stadium." **20** Paedagogium. **21** "Domus Praeconum." **22** Do-
mus Severiana. **23** Location of the Septizodium. **24** Temple of
Elagabalus. **25** S. Maria Antiqua. **26** Probably the Athenaeum.
27 Horrea Agrippiana.

PALATINE

/23

HISTORICAL NOTES

The Palatine, which lies at the heart of the system of hills that in time became the city of Rome, is perhaps the best suited of the group for human settlement. It is near the river but not so close as the Capitoline and Aventine. Its maximum height reaches 51 meters above sea level. The hill's central crest—the *Palatium*—slopes downward toward the Forum Boarium and the Tiber along an incline called the *Germalus* (which is not one of the Palatine crests, as it is so often mistakenly thought to be). The Palatine was once joined with the Esquiline, which lies behind it, by a saddle and by a second, less perceptible rise, the *Velia*. Legend tells of a very early settlement of the hill by Greeks from Arcadia under Evander and his son Pallas. These are the Arcadians whom Hercules and later Aeneas were supposed to have found dwelling on the Palatine, as Vergil recounts in the *Aeneid*. When these legends arose is difficult to say. Evander and Pallas are in all likelihood two minor divinities of the Arcadian pantheon. Recent archaeological discoveries, however, have shown that Greek merchants frequented the Forum Boarium and that their presence there predates the Greek colonization of southern Italy.

Romulus was thought to have founded the city around the middle of the eighth century BC (754 BC according to Varro, the famous scholar of Roman antiquities, who lived between

the ages of Caesar and Augustus). The house of Romulus *(Casa Romuli)* was identified with a hut that was periodically reconstructed and restored on the same southwestern corner of the hill later occupied by the House of Augustus (FIG. **36:5**). In fact, it was here that remains of Iron Age huts were excavated, a discovery that seems to confirm Roman tradition, as does the presence of an eighth-century fortification wall on the hill's northern slope.

Religious traditions of great antiquity were associated with the Palatine, especially that of the goddess Pales, whose name may be related etymologically to *Palatium*. The feast of the goddess, the *Palilia* or *Parilia*, was celebrated on 21 April, the day of the city's founding. Another important festival was the *Lupercalia*, whose association with the wolf, Rome's sacred animal, is evident from its name. Starting out from the sanctuary located in a grotto at the foot of the Palatine (the *Lupercal*) and moving in the direction of the Tiber, "wolf-priests"—dressed in goatskins—circled the hill, striking whoever was in their reach, especially women, as they passed by. This was clearly a fertility ritual. The Lupercal and its rites came to be associated with the legend of the mythic twins, Romulus and Remus, who were nursed by the she-wolf.

The boundaries of the city founded by Romulus are described by the historian Tacitus *(Annales* 12.24). It was four-sided, with the points of its angles found at the Ara Maxima of Hercules in the Forum Boarium, the Altar of Consus in the valley of the Circus Maximus, the *Curiae Veteres* in the northeastern corner of the Palatine hill, and at the sanctuary of the Lares (or perhaps Larunda) near the *Lacus Iuturnae* in the Forum. The primitive wall was said to have had three gates: the *Porta Mugonia* (near the temple of Jupiter Stator), the *Porta Romanula* (facing the Velabrum), and perhaps the gate corresponding to the *Scalae Caci* (facing the Forum Boarium).

Various other cults were founded on the Palatine during the course of the Republican and Imperial periods. Among these, worship of the *Magna Mater* (Cybele), imported from Asia Minor during the Second Punic War, is given special attention in Roman literature. Next to this sanctuary were the Temple of Victory, founded by L. Postumius Megellus (294 BC), and the shrine of *Victoria Virgo*, the work of Cato the Censor (193 BC). The location of the temples of Jupiter Invictus (not *Victor*, as it has now come to be called) and of Pales (erected by M. Attilius Regulus in 267 BC) is uncertain. Augustus established the cults of Apollo and Vesta close by his own residence. But during the Republic the hill was transformed above all into a residential quarter for Rome's governing class. Among those who lived on the Palatine, we can name, in more-or-less chronological order, M. Valerius Maximus, consul in 505 BC; Gnaeus Octavius, consul in 165 BC; Tiberius Sempronius Gracchus, the father of the famous tribunes; M. Fulvius Flaccus, consul of 125; the famous orator L. Licinius Crassus, consul of 95; M. Livius Drusus, tribune of the plebs in 91; Cicero and his brother, Quintus; T. Annius Milo, the friend of Cicero and the murderer of Clodius, who also lived on the hill; the other great orator, Q. Hortenius Hortalus, in a house

that was later acquired by Augustus; the triumvir Marc Antony; and Tiberius Claudius Nero, the father of the emperor Tiberius. Many of these personages, to be sure, resided on the slopes of the hill nearer to the Forum (in the area between the Arch of Titus and the House of the Vestals); others lived on the summit. For example, remains of various houses from the Republican period have been discovered around the house of Augustus and under the *Domus Flavia;* among these, the House of the Griffins and the so-called *Aula Isiaca* are among the best known.

The most important development in the history of the Palatine was Augustus's choice to reside on the hill where he was born, at first in the house of Hortensius, which he then enlarged by adding other nearby houses. Excavations eventually led to the discovery of the House of Augustus on the southwestern corner of the hill. Subsequent emperors also chose the Palatine as their residence. Palaces were built here by Tiberius (enlarged by Caligula), Nero (the *Domus Aurea,* which extended to this point), the Flavians (the so-called *Domus Flavia* and *Domus Augustana*), and Septimius Severus. By the end of the Imperial period, the entire hill was covered by one enormous building—the official residence of the emperor (FIG. **37**). The name *Palatium* (Palatine) thus came to stand for the Imperial "palace" par excellence and later became a common noun in all European languages.

ITINERARY 1

The Western Palatine

THE IRON AGE HUTS Some of Rome's oldest traditions are concentrated on the southwestern corner of the Palatine, which is connected by the Germalus to the Forum Boarium. The *Lupercal,* the grotto in which the twins Romulus and Remus were supposed to have been nursed by the she-wolf, stood at the foot of the hill. No trace of this site has ever been found, although we know approximately where the grotto was located. The Scalae Caci, named for the giant Cacus, the monstrous adversary of Hercules, ascended the hill in the immediate vicinity of the Lupercal and linked the area around the Forum Boarium with the Palatine's summit. It is here that Romulus's hut, the Casa Romuli, stood, near which spot Augustus built his house.

Excavations in 1948 uncovered the remains of three Iron Age huts, traces of which had already been seen in 1907 (FIG. **36:1**). The bases of these primitive dwellings were carved into the ground-level tufa and surrounded by a small drainage channel for rainwater. The largest of these huts, whose shape is somewhere between ovoid and rectangular, measures 4.90 meters on the long axis and 3.60 meters on the short. Along the perimeter were six round holes for the stakes that held up the straw walls; the hole for a large central post

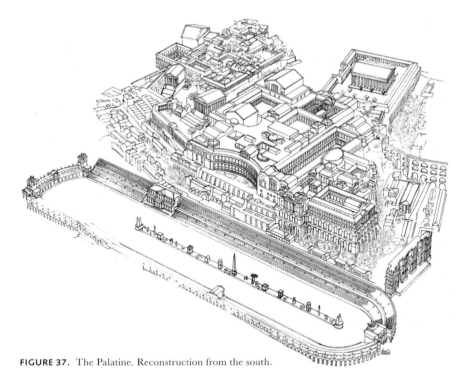

FIGURE 37. The Palatine. Reconstruction from the south.

that supported a mud roof has also been preserved. The entrance door, a little over a meter wide, stood on one of the narrower sides. Two holes, one on each side, clearly served to hold the rough pivots of the door leaves. Two other holes, outside the door, were probably used to secure the supports for a small porch roof. Another opening, on one of the longer sides, must have corresponded to a window.

The excavations have revealed various phases: the first, and oldest, at the level of the floor, dates to the eighth century BC. In the second half of the seventh century BC, the huts were destroyed simultaneously with those of the Forum under the *Regia*. **Several tombs** have also been discovered on the Palatine. One of these, next to the House of Livia and almost certainly connected with a phase earlier than the hut settlement, dates to the first Latial period (tenth century BC), while two others, found under the Domus Flavia, are infant burials of the seventh century BC. The presence of an older burial at such a central point of the hill shows that the villages at this stage were still autonomous entities, not yet definitively integrated within a larger "political" organization.

A series of **tufa walls** in *opus quadratum* sits on levels above the huts. Their purpose is not clear; they might have belonged to the theater constructed by the

censor C. Cassius Longinus in 154 BC in the area between the Lupercal and the Palatine, which P. Scipio Nasica destroyed soon afterward. The position of the theater can be explained by its proximity to the Temple of the Magna Mater, before which theatrical entertainments, the *Ludi Megalenses*, were performed during the goddess's festival.

The **Scalae Caci,** of which only the slightest traces have been found, ran to the east of these walls (FIG. **36:3**). In the area between the huts and the House of Livia, there are remains of **two archaic cisterns,** one of which is particularly well preserved. These were cut into the tufa of the hill, faced with tufa blocks, and then partially covered with a corbeled dome; they date to some point in the sixth century BC. Archaic architectural terracottas found in the same area, together with the cisterns, attest to the presence of a rich sixth-century BC *domus*. It was probably in a house such as this that the *flamen dialis*, the most important priest of the archaic city after the *rex*, lived; his residence, we are told, was on the Palatine.

The whole corner of the Palatine at this point was supported by a **large tufa rampart wall** in *opus quadratum*, mostly visible on the western side. But this cannot be an archaic fortification, contrary to the view sometimes expressed, for it is constructed of materials (Fidene and Grotta Oscura tufa) that came into use only in the fourth century BC. In all likelihood the structure was simply a terrace wall, similar to and contemporary with the one found on the Capitoline.

South of the archaic huts a **group of buildings** is aligned with a street that can be identified as the *Clivus Victoriae*, once thought (mistakenly) to have been located on the opposite side of the hill. The oldest remains, in *opus incertum*, belong to a late Republican porticus supported by piers and arches; the other buildings in brick are Imperial. In recent years, this whole area has been fully excavated, and a complex system of Imperial period structures has come to light.

THE TEMPLE OF THE MAGNA MATER The constant reverses of the Second Punic War put an immense strain not only on the military and political machinery of the city but on its religious institutions as well. Reaction to the crisis was manifested in intense activity in the area of religion and cult, often expressed in novel forms, which was intended to regain the apparently lost favor of the gods. One of the most important of these episodes was the introduction into Rome of the cult of the Magna Mater, the Great Mother Cybele, in 204 BC (FIG. **36:2**). The proposal to do this arose, typically in such crises, after consultation of the *Libri Sibyllini*, a collection of prophecies, probably of Greek origin, which, according to tradition, Tarquinius Superbus brought to Rome.

The goddess was worshiped at Pessinus in central Asia Minor, in the aniconic form of a black stone (probably a meteorite) shaped like an elongated cone. The embassy that was sent to the king of Pergamum, in whose territory the sanctuary lay, arranged to have the cult object brought to Rome by ship. It resided temporarily in the Temple of Victory on the Palatine. The new temple was later

constructed on the same hill within the *pomerium* (the city's sacred boundary)—an exceptional occurrence but perhaps permissible because the goddess was not considered foreign, since she came from the Troad (the legendary homeland of the Romans). Construction began in 204 and was finished only in 191. The dedication took place on 11 April and was the occasion for the first celebration of the Ludi Megalenses, during which some of the best works of Plautus and Terence, among others, were performed. We know that the building burned twice: in 111 BC, when it was restored by a member of the Metellus family (probably C. Caecilius Metellus Caprarius, consul of 113), and again in AD 3, when it was reconstructed by Augustus.

The temple is securely assigned to the impressive remains that lie between the archaic huts and the *Domus Tiberiana*. Its position (at close proximity to the House of Augustus), the statue of the goddess discovered nearby (now displayed in the Palatine Antiquarium), as well as inscriptions with the dedication *M(atri) D(eum) M(agnae) I(daeae)*, identify the temple as that of Cybele. Recent and ongoing excavations have helped clarify various chronological and structural uncertainties regarding the monument. The temple's foundation, in very rough *opus incertum,* is certainly original, dating from the beginning of the second century BC. Restorations in *opus quasi reticulatum* were probably undertaken after the fire of 111. The columns in peperino that lie next to the podium, their Corinthian capitals, and fragments of the pediment, inspired by the earlier Republican structures, have been attributed to the Augustan phase.

Excavation has also allowed us to recover a considerable quantity of votive terracottas associated with the first phase of the temple. These have shed light upon interesting features of the cult, such as the presence of Attis beside Cybele from the sanctuary's earliest phase. A relief from the age of Claudius, now attached to the inner facade of the Villa Medici, probably represents the front of the building, which was thus Corinthian and hexastyle and approached by a steep stairway. The temple, lacking columns on its sides, was accordingly prostyle. Next to the Temple of the Magna Mater are the remains of a shrine in brick from the Hadrianic age. Identification of this structure as the augural temple of the Palatine (the *Auguratorium*) is incorrect; scholars have recently identified the small building as the Shrine of Victoria Virgo, constructed in 193 BC by Cato next to the larger Temple of Victory (FIG. **38**). We also know that there was a sanctuary dedicated to Juno Sospita in the vicinity, which Ovid situates next to the Temple of the Magna Mater (it was already gone by his day). The recent discovery of an archaic antefix representing the goddess may help resolve this difficult problem. Deeper excavation has revealed an archaic *sacellum,* built of cappellaccio in *opus quadratum,* which was followed by a later Republican phase in *opus caementicium.* It would thus seem possible to assign the building to both cults; in other words, Victoria Virgo apparently took the place of an archaic and nearly forgotten cult of Juno Sospita.

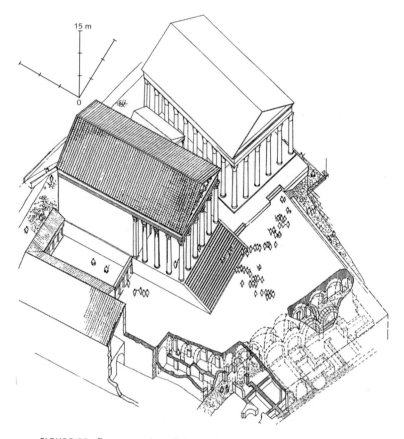

FIGURE 38. Reconstruction of the southwestern corner of the Palatine, with the temples of the Magna Mater *(left)*, Victoria Virgo *(center)*, and Victory *(right)*. (After Pensabene)

The sparse remains of a podium immediately north of the Scalae Caci have been identified as a third sanctuary. Inscriptions with dedications to the goddess Victoria show that this was the temple that L. Postumius Megellus built after 294 BC to celebrate his victory over the Samnites. The discovery has also resolved another difficult topographical problem by clarifying the route of the Clivus Victoriae, which ended in front of this temple. Here, too, we can observe two phases: one, dating to the Middle Republic, built of tufa in *opus quadratum*, and the other, in *opus caementicium*, from either the late Republic or the Augustan period.

The little circular temple of Vesta, constructed by Augustus near his house, must have stood nearby. In fact, when Augustus became *pontifex maximus* in 12 BC, he declined to live in the *domus publica* next to the House of the Vestals,

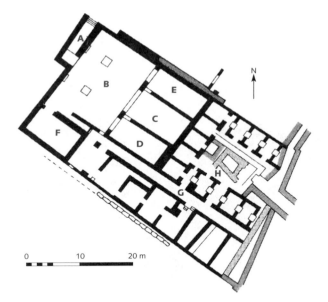

FIGURE 39. House of Livia. **A** Entry corridor. **B** Courtyard. **C** Tab-
linum. **D–E** Lateral rooms. **F** Triclinium. **G** Hall. **H** Atrium?

preferring instead to make a part of his own house on the Palatine public by
creating in it a duplicate of the Vestal cult.

At the foot of the terrace, toward the west, in the area where the Lupercal
must have been, we find a series of brick structures, perhaps private residences.

THE HOUSE OF LIVIA AND THE HOUSE OF AUGUSTUS The remains of three
late Republican houses that survived the construction of the Imperial palaces
lie to the east of the Temple of the Magna Mater; these were to some extent
already known in the nineteenth century but have recently been more fully ex-
plored. These excavations and subsequent research have conclusively resolved
uncertainties posed by the House of Augustus.

One of these, called the House of Livia, was excavated in 1869 by Pietro Rosa
under Napoleon III (FIG. **36:4**). The building, which was constructed on the
slope of the hill, is at a lower level than the terrace that supports the Temple of the
Magna Mater. Entry is through a corridor running along an incline (FIG. **39:A**).
The floor of the entrance still has its original mosaic of isolated black tesserae
arranged in a regular pattern on a white background. The landing, which also
preserves the original black-and-white mosaic, leads to a rectangular courtyard
(B) with squared piers, whose bases survive, that must have held up a sloped
roof. This room is not an atrium, as it is usually described; indeed, the corridor

appears to be a secondary entrance. It is clear that the house was at some point radically modified for some new purpose. Most likely the atrium was originally on the eastern side of the house **(H),** where some structures survive that may have belonged to the *impluvium* around which various rooms were arranged.

The main entrance must originally have been on the eastern side, but it was subsequently closed off. This section of the house, which became secondary when it was remodeled, was entered thereafter from the courtyard **(B)** through a long hall **(G).** The so-called *tablinum* **(C)** probably constituted the original passage between the two parts of the house. This room, like the two at its sides **(D, E),** preserves a very beautiful and deservedly famous Second Style wall painting. The recent detachment of the frescoes has revealed the masonry of the wall, indicating that the wall decoration is not contemporary with the first phase of the house, inasmuch as it covers earlier doorways that were later walled up. The original walls, constructed of a slightly irregular *opus reticulatum,* can be dated to the second quarter of the first century BC (75–50), while the paintings, some of the most interesting examples of a mature phase of the Second Style, can be dated to around 30 BC. The right-hand wall of the *tablinum* is the best preserved. The field is divided into three panels by Corinthian columns resting on high bases, represented as jutting forward from the wall. Above these a coffered ceiling is painted in perspective. The design is obviously inspired by theatrical stage facades. A large door was depicted at the center of each of the three panels; the one in the middle (probably a copy of the famous piece by Nikias, other copies of which we know from Pompeii) presents a mythic scene: Argus guards Io with his intense gaze, while Mercury comes to free her. Through the open doors depicted in the side panels (that on the right is lost), we see in the background various architectural structures in perspective enlivened with human figures. Small pictures with generic scenes are depicted resting on the cornices that spring out halfway up the wall. Minor decorative motifs—sphinxes, winged divinities, grape clusters, candelabra—are distributed here and there over the entire surface. This is precisely the kind of painting that the contemporary Vitruvius (7.5.5) deplores as the expression of that which "neither exists nor can exist." A painting of Polyphemus and Galatea was installed on the wall facing the entrance; although it was still in good condition when it was discovered, it is now faded almost beyond recognition.

The painted decoration of the left wall in the room to the right of the first **(D),** which is quite well preserved and now detached like the others, is organized in a simpler design of panels. Rich garlands of fruit and foliage hang in the lower section, while higher up runs a beautiful frieze with a yellow background, showing scenes of daily life in Egypt, sketched in rough outline with brush strokes and dabs of highlight. The wall paintings in the room on the left have the same decorative organization but without figured scenes. In all three rooms, some of the simple black-and-white mosaic floor survives. The rather large room at

the southern corner of the courtyard (**F**, usually called the "triclinium") also has some of its decorative painting. At the center of the wall opposite the entrance, we can see a landscape scene with an aniconic representation *(baetyl)* of Diana.

A lead pipe that brought water to the house was discovered somewhat to the east. The pipe (now displayed in the *tablinum*) bears a name that must refer to the owner of the house: *Iulia Aug[usta]*. Consequently, some have identified the house's owner as Livia, the wife of Augustus; others, however, and with less support, identify the daughter of Titus as the Julia referred to in the inscription. This cannot, however, have been the house in which Livia resided with her first husband, Tiberius Claudius Nero. Instead, the pipe might belong to an apartment reserved for her in the house of Augustus. We know that the emperor's home consisted of a group of older houses annexed to that of Hortensius, which Augustus had acquired soon after his return from Sicily in 36 BC. In this way, we can better understand the various changes in the house, which after the closure of the atrium was no longer an independent structure. We can date these changes, on the basis of the paintings, to some time around the year 30 BC. If this is the case, the restoration with walls in brick would constitute repairs made after the fire of AD 3, which damaged both the House of Augustus and the nearby Temple of the Magna Mater.

South of the House of Livia lie the remains of a **peristyle** (FIG. **40:A**), which sits atop the mosaic floor of a house that was built at the end of the second or the beginning of the first century BC. This house, recently excavated, extended in the direction of the Scalae Caci. The Augustan structures built over the Republican house partly destroyed but at the same time also protected several rooms of the earlier Republican dwelling. A small pond for breeding fish, one of the earliest known, is one of the striking features of this house. The beautiful mosaic flooring and the early Second Style paintings, similar to those in the House of the Griffins (see below), attest to the affluence of the house's owner. Its decoration probably dates to soon after the fire of 111 BC, which devastated the whole area. It is not implausible to identify this as the house of Lutatius Catulus, consul with Marius in 102 BC. We know that his house was among those acquired by Augustus and incorporated into his residence.

The definitive identification of this complex of buildings as the **House of Augustus** came about as a result of the excavation begun in 1961 between this house and the nearby temple, which, thanks to recent studies, we now know for certain is the Temple of Apollo (FIG. **36:5–6**; FIG. **40**). The house consists of a series of rooms, built of tufa in *opus quadratum*, that were laid out in two rows. One group of smaller secluded rooms to the west was apparently designed as living space; those to the east, which flank a large central room open toward the south **(B)**, seem to have been intended for official functions. Only the latter rooms had marble flooring, of which the impressions of the plundered slabs remain, while the first group of rooms, consistent with what Suetonius says about the simplicity of Augustus's house, had mosaic floors with geometric patterns.

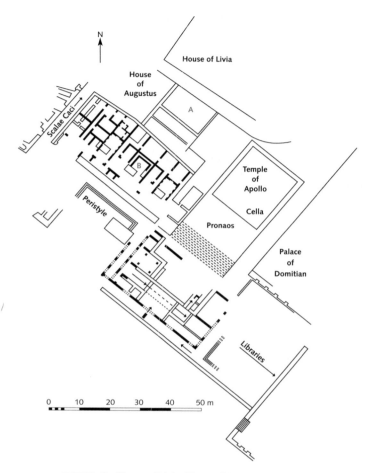

FIGURE 40. House of Livia, House of Augustus, and Temple of Apollo.

The most interesting section of the western wing of the house consists of two small adjacent rooms with rich Second Style painting that is also datable to about 30 BC. The painting in the first room, called the Room of the Masks, has a complex architectural design incorporating theatrical motifs: masks rest on painted cornices halfway up the wall. A painting of a rural sanctuary occupies the center of each wall much like that in the "triclinium" of the House of Livia. Festoons of pine hanging between thin pilasters decorate the second room. This is one of the most remarkable paintings of the Second Style that have come down to us. Other important paintings of the same phase have been

discovered in several recently excavated rooms next to the podium of the Temple of Apollo.

That so much of what we see here corresponds to information about the House of Augustus in ancient sources makes the identification secure. For example, we know that the house was adjacent to the Temple of Apollo, which was built on property that belonged to the emperor but was later given to the state, near the Casa Romuli and the Scalae Caci. The appearance of the ruins coincides with Suetonius's description (*Aug.* 72):

> Augustus lived first near the Roman Forum above the Stairs of the Ringmakers, in a house that the orator Calvus had owned. Later, he lived on the Palatine but in the house of Hortensius, which was again a modest home, not especially large and certainly not luxurious. Indeed, the porticoes built of peperino columns were not very long; and there were rooms that had no marble flooring or mosaic of any artistic quality. For more than forty years, winter and summer, Augustus slept in the same bedroom ... Whenever he needed privacy or wanted to work without interruption, he escaped to a place high up in the house that he called his "Syracuse" and "technyphion" ... Even today we can see the modesty of his dining room furnishings from the still extant tables and couches, many of which would seem barely adequate for ordinary citizens.

A passage from Velleius Paterculus (2.81) informs us that Augustus bought several houses, which he then joined to the first house, that of Hortensius: "On his return to the city after his victory [over Sextus Pompey in 36 BC], Caesar Octavian acquired numerous houses through agents in order to enlarge his own home. But he promised to make them available to the public and to build a temple to Apollo surrounded by porticoes."

Of the private and public sections into which Augustus's house was divided, the surviving ruins are in all likelihood the former. The public area, which would have stood east of the Temple of Apollo, must have been incorporated into the palace of Domitian—a fact that explains the official name assumed by Domitian's palace, the Domus Augustana. If this hypothesis is correct, the excavated remains of the House of Augustus would correspond to the part of the house seen by Suetonius, which must have survived unaltered until Hadrian's reign, and in a condition similar to the remains that can still be seen today. Augustus's bedroom for more than forty years of his life (beginning about 30 BC) could, then, be identified as the Room of the Masks, while the room with pine festoons may be the bedroom of Livia (who might have moved after the emperor's death into the nearby *domus* that today bears her name).

THE TEMPLE OF APOLLO Partially excavated by Pietro Rosa in 1865 and 1870, then again by Alfonso Bartoli in 1937, the building between the House of Augustus and the Domus Flavia was long identified as the Temple of Jupiter

Victor; excavations begun in 1956 have confirmed the hypothesis that it is in fact the Temple of Apollo (FIG. **36:6**; FIG. **40**). Among the important elements that have been found are part of a marble doorjamb with the figure of the Delphic tripod and fragments of a large statue of Apollo in Greek marble now identified not as the cult statue (the work of Scopas), but as the statue recorded by Propertius (2.31) that stood in front of the temple.

Remains of **Republican houses** under the building confirm that this temple was first built during the Augustan period, thus ruling out the possibility that this was the Temple of Jupiter Victor (or more correctly, Jupiter Invictus), which was built in the third century BC. Only the cement nucleus of the temple remains, for the most part devoid of its original revetment of tufa blocks. There are still traces of the marble flooring, as well as column fragments and pieces of Corinthian capitals. These latter are datable stylistically to the beginning of the Augustan period and thus confirm what we know from literary sources: that the building was begun by Augustus in 36 BC, immediately after the Battle of Naulochus against Sextus Pompey, and finished in 28 BC after the Battle of Actium. The temple was incorporated, as seen above, into the public quarters of the House of Augustus, with which it was intimately connected.

We know that the temple was built entirely in Luna marble, as the surviving fragments confirm. The three cult statues of Apollo, Diana, and Latona were the works, respectively, of Scopas, Kephisodotos, and Timotheos. The head of the statue of Diana was remade by Avianus Evander, a sculptor of the Augustan period. The Sibylline books, taken from their original home in the Temple of Jupiter Capitolinus, were kept in golden cases placed within the base of the statue of Apollo.

The building faced a square, surrounded by the Porticus of the Danaids, named for the statues representing the daughters of the mythical Egyptian king that were displayed here. This porticus is probably to be identified with the two peristyles at the sides of the temple podium. In the square and in the temple itself, numerous bricks were found with stamps of a certain Cossutius, who was employed in the brick works that belonged to Asinius Pollio, the famous politician and writer who lived during the last years of the Republic. Ancient authors also situate the mysterious *Roma Quadrata* (commemorating Romulus's founding of the city) and a shrine of four columns (the *Tetrastylum*) in this area. The Auguratorium (perhaps to be identified with Roma Quadrata) must also have been located in the *Area Apollinis;* the monument commemorated the place where Romulus took the auspices under which Rome was founded. We know from an inscription that this structure was restored by Hadrian. Two **libraries** stood on the eastern side of the square (FIG. **40**); the little that has survived dates to Domitian's restoration. The Senate often met in the Temple of Apollo during the Imperial period, another sign of the times and of the fact that what remained of the old Republican governmental structure was subordinate to the *princeps*.

Among the materials discovered in recent excavations are some magnificent terracotta relief panels, of the "Campana" type, that depict archaizing figures (including Perseus and Athena with Medusa, the contest between Hercules and Apollo for the Delphic tripod, and caryatids). The panels, still bearing some of their original paint, must have belonged to a building in the area, perhaps to the Porticus of the Danaids itself, and can be dated to between 36 and 28 BC. They are now on display in the Palatine Antiquarium (Museo Palatino).

THE DOMUS TIBERIANA The House of Augustus, pieced together out of several Republican dwellings, was never a fully integrated complex, even though it was divided into two parts, one private and the other intended for public functions (an arrangement for which there were numerous Republican precedents). The Domus Tiberiana, which took up a large portion of the western side of the hill between the Temple of the Magna Mater and the slope toward the Forum, is more complicated and still not fully understood (FIG. **36:7**). In the 1500s the area was covered by the Farnese Gardens, which still exist in large part today. The presence of the gardens has limited excavation to the margins of the building, mostly on the north and south; the central nucleus is almost completely unknown. Only a few explorations, and these in the middle of the nineteenth century, have ever been carried out.

Tiberius may have chosen this location because it was his father's home and his own birthplace. A large part of the western end of the building, facing the Velabrum, rests on the remains of a large Republican *domus*, rising on a high podium. We know that Tiberius's house was enlarged by Caligula in the direction of the Forum. It was restored first by Domitian, then by Hadrian, and later by Septimius Severus. The complex was reexamined not long ago, and it is now clear that it first assumed its monumental form only under Domitian, at the same time that the larger Imperial palace, the Domus Augustana, was being constructed. The library of the Domus Tiberiana must have been built as part of the project; it is attested by various sources and was probably a replacement for the libraries of Augustus's temple, which were destroyed by fire in AD 80. From this point forward, the double complex comprising the Domus Augustana and Domus Tiberiana achieved its definitive status. The function that each residence served is reflected in their names: the Domus Augustana was the house of the sitting emperor, inasmuch as he was the successor of Augustus; the Domus Tiberiana was for the designated successor (named for Tiberius, insofar as he was Augustus's first successor). We know, for example, that after Marcus Aurelius and Lucius Verus were named by their adoptive father, Antoninus Pius, as his successors, they lived in the Domus Tiberiana.

A large peristyle at the center of the garden, with a number of rooms set around it, was partly excavated by Rosa in 1861–63. A passageway led from the peristyle, emerging at a point east of the rooms that are still visible near the Temple of the Magna Mater. Other corridors must have led into Nero's

cryptoporticus, where we can see entrances to what must have been adjoining passageways. All of the excavated areas have been filled in. The group of eighteen rooms on the south side, mentioned above, was apparently built by Nero after the fire of AD 64; the rooms are still rather well preserved. They are rectangular, roofed with barrel vaults, and constructed entirely of brick. Third-century AD painted panels, depicting a woman, a panther, and birds, are preserved in a section of the vault in the eighth room from the right.

An oval pool with steps, possibly a fish pond, can be seen in the southern corner of the palace. The eastern side of the Domus Tiberiana is bordered by a long **cryptoporticus,** usually assigned to the age of Nero. The passageway serves as the front of the house, as it typically did in ancient villas. The long corridor, with raking windows regularly placed on one side of the vault, still has some of its painted decoration and mosaic flooring. Especially interesting is a fragment of the stucco ceiling, decorated with coffers, floral motifs, and a panel with four cupids (the original has been detached and is now in the Palatine Antiquarium, with a copy inserted in its place). A little farther ahead and on the right, a corridor, added subsequently, branches off in the direction of the Domus Augustana.

The northern side of the Domus Tiberiana, facing the Forum, is the largest part of the house still visible. A road, often mistakenly identified as the Clivus Victoriae, rises alongside. We can make out several phases in this section of the palace. A series of rooms oriented northeast-southwest (dating to the reign of Domitian, when the entire corner overlooking the Forum must have been rebuilt) rests against Hadrianic buildings oriented north-south, the arches of which span the ancient road. Graffiti inscribed in the plaster of these rooms, giving lists of accounts and information regarding coinage, suggest that these rooms were once used as the Imperial treasury, perhaps as the place for distributing newly minted coins. In the last phase, the rooms were used for storage. Recent studies allow us to reconstruct the major lines of the building's design following Domitian's radical reconfiguration.

ITINERARY 2

The Eastern Section of the Palatine

THE PALACE OF DOMITIAN: THE DOMUS FLAVIA AND THE DOMUS AUGUS-TANA The topography of the Palatine was transformed radically and definitively during the last two decades of the first century AD with the erection of Domitian's large palace complex, which covered the entire southeastern part of the hill. The Imperial residence replaced older buildings dating from the Republic to the time of Nero, which have been partly explored by means of deep test trenches. The complex is generally divided into three sections, currently

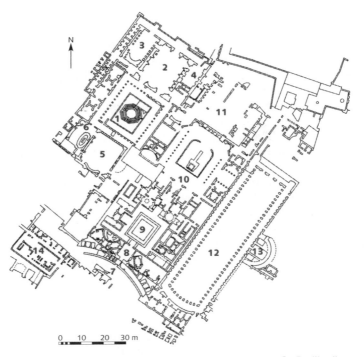

FIGURE 41. "Domus Flavia." **1** Peristyle. **2** "Aula Regia." **3** "Basilica."
4 "Lararium." **5** Cenatio Iovis. **6** Nymphaeum. **7** Entrance of the "Do-
mus Augustana." **8** Atrium. **9** Courtyard. **10** Peristyle. **11** Third Peri-
style? **12** "Stadium." **13** Tribunal. **14** "Paedagogium."

known, from west to east, as the Domus Flavia, the Domus Augustana, and the
Stadium (FIG. **36:8–20**; FIGS. **41, 42**). In fact, the entire complex probably
had a single name: the Domus Augustana—the residence of the Augustus. The
name evoked a sense of continuity with the first princeps, the empire's founder.
Indeed, it is probable that the core of the Imperial palace, in which notable
remains of the Julio-Claudian period have been identified, was originally none
other than the public section of the House of Augustus, the part immediately
to the east of the Temple of Apollo. This, in turn, corresponds to a section of the
so-called Domus Flavia, which was, significantly, the official or public space of
the Domus Augustana.

The courtly praise of the Domitianic poets Martial and Statius gives us some
sense of how the immense structure must have impressed their contemporaries.
So large and magnificent was the palace that apart from some restoration and
enlargement, the building was never replaced; it retained its official name, the
Domus Augustana (or more simply, the Palatium) until the very end of the

empire, indicating, by definition, the residence of the emperors. The endurance of the building, and the persistence of the name, proclaimed that an architectural type, the dynastic palace, had reached its classical form.

The project, we know, was directed by the architect Rabirius, one of the few great personalities that we can still recognize from the sphere of Imperial architecture. The work, begun perhaps at the beginning of Domitian's reign, was finished in AD 92. Study of the brick stamps has shown, however, that work on the Stadium continued until the end of Domitian's reign. The project began, therefore, with the so-called Domus Flavia, the official palace, and continued with that which is now usually called the Domus Augustana, the private quarters of the emperor, ending with the Stadium. Given the period during which the first excavations were carried out—the eighteenth century—and the veritable plunder that ensued, it is not surprising that what remains of the palace is in extremely poor condition. We still lack an adequate scientific publication of even the most recent exploratory excavations, completed between 1926 and 1928.

The western entrance of the palace consisted of an octagonal hall, located at the center of the building, flanked by several rooms distinguished by their highly complex floor plans. Another entrance is provided by the branch of the "Neronian" cryptoporticus that terminated in the room behind the apse of the basilica. Both of these were no doubt secondary entrances. A porticus with colonnade fronted the external wall on this side and turned the corner on the north, following the principal facade. Partition walls with doorways were inserted behind the columns of the porticus when work was still in progress. It is thought that their purpose was to reinforce the western wall of the basilica, which was in danger of collapsing under the weight of its vault. Since the basilica probably had a flat roof, more likely these were supports for an upper balcony that was added at a later date.

The center of the Domus Flavia comprises a huge rectangular peristyle (FIG. 41:1), with a porticus lined by columns of Numidian marble (giallo antico); fragments of the column shafts, bases, and capitals (in white marble) survive. The low walls of a monumental octagonal fountain, in the form of a labyrinth, rise at the center of the peristyle, most of which is a modern restoration.

A few large rooms arranged along the main north-south axis face the peristyle, the veritable heart of the building. At the center of the northern side is a grand hall, which eighteenth-century excavators named the **Aula Regia (2)**. The hall communicates with the peristyle through two doors that flank a shallow apse; an inscription commemorating the Farnese excavations of 1725 is located here. On the hall's short side, to the north, a single central door opened out onto a platform raised above ground level, from which three extensions project forward. The largest lies in front of the Aula Regia, while the other two correspond to the so-called *Lararium* **(4)** and *Basilica* **(3)**. The monumental porch looks out over the open space, generally identified as the *Area Palatina*, that extends in front of the palace. The dimensions of the hall and the relative thinness of the

walls exclude the possibility of a vaulted roof, which would have had a span of 30.60 meters. The roofing must have consisted of trusses hidden by a coffered ceiling that rose at least 30 meters from the floor. The walls are punctuated by projections framing niches of various shapes—a striking example of Flavian baroque. Large-scale statues of colored marble were placed in the niches: two of these, discovered in the eighteenth century and representing Apollo and Hercules (part of the Farnese collection), are now in the Museum of Parma. The room's function is clear from its dominant position on the central axis of the complex as well as from its dimensions. This is where *salutationes* were offered to the emperor on audience days by what must surely have been an impressive number of people. The apse was obviously reserved for the *princeps*, who would have appeared in all his majesty at its center as *dominus et deus* (lord and god), as Domitian for the first time insisted on being called.

The more modest western hall **(3)**, usually called the **Basilica,** is in no better state. Many of the architectural elements, placed here arbitrarily by the first excavators, do not belong to the room, which is rectangular and terminates on the south in a deep semicircular apse. A double row of columns must have divided the room into three aisles. The presence of the apse again suggests the public functions in which the presence of the emperor was required. A recent and well-founded theory identifies this as the *Auditorium,* the meeting room of the emperor's council. It was here, then, that the political and administrative decisions of the Empire were made.

To the east of the Aula Regia is another room **(4),** more modest in size and more difficult to identify. (The modern name **"Lararium"** lacks any credibility.) The fact that the street coming from the north (the name *Clivus Palatinus* is modern) runs to a point slightly east of this room, at the center of the Domus Flavia and the Domus Augustana complex, suggests that this was the main entrance to the palace. If this is so, the suggestion that the so-called Lararium housed the praetorian bodyguard responsible for protecting the main entrance should not be dismissed.

The opposite side of the peristyle, on the south, was devoted almost entirely to a large hall **(5)** that was flanked by two smaller rooms. The focal point was a shallow apse with two doors on either side that provided access to other rooms behind the hall, including the two libraries of the temple of Apollo. The room still has some of its rich marble floor, which was set over a hypocaust, a hot-air heating system comprising double flooring. The presence of the system indicates that this was a winter *cenatio* (dining room). Brick stamps date the hypocaust to the age of Hadrian, while the flooring above it belongs to a restoration undertaken during the reign of Maxentius. The hall is very likely the **Cenatio Iovis**—the emperor's dining room—mentioned by literary sources. Of the two symmetrical side rooms, only the one to the west is preserved to any degree **(6).** At its center is an oval fountain, much restored, which guests would have seen through windows in the dining room. Below the simple marble pavement dating from Domitian's

time, another earlier floor has come to light—one of the most remarkable known examples of Imperial marble flooring. The floor belonged to the second-story nymphaeum of a building covered over by Domitian's palace—one of Nero's two residences, possibly the *Domus Aurea*. The luxurious nymphaeum, originally furnished with small marble columns and bronze capitals, was discovered in 1721 but then destroyed, although a corner of it has been reconstructed in modern times. From one of the nearby rooms, cut through by walls belonging to the Domus Aurea, come painted ceilings with mythological scenes that provide one of the oldest known examples of Fourth Style wall painting. These have been detached and are now kept in the Palatine Antiquarium.

The foundation of a large circular room, extending beneath the Palatine Antiquarium, brings to mind the rotating *cenatio rotunda* of the Domus Aurea described by Suetonius (*Nero* 31). Water piped in from the large cistern connected to this dining hall might have fed the hydraulic system that drove its mechanism.

Remains of even older buildings have been discovered at various times beneath the palace's northern section. Below the Lararium **(4)** lies one of the most interesting Republican houses preserved in Rome, known as the **House of the Griffins** after the stucco decoration on one of its lunettes. The surviving rooms have been bisected by the massive foundations of Nero's and Domitian's buildings. Only a small portion of what must have been a considerably larger house has been brought to light. Sections of mosaic pavement from the upper floor also survive. The house itself, built in *opus incertum*, gives evidence of remodeling in *opus quasi reticulatum*, to which the wall paintings were added, as was observed when the frescoes were detached. The construction allows us to date the painting to between the end of the second and the beginning of the first centuries BC, while the house itself was probably built in the first half of the second century BC. The disappearance of the older First Style decoration probably resulted, as happened to other houses of the Palatine, from the devastating fire of 111 BC. The early Second Style decoration would thus date immediately afterward: the last decade of the second century BC. Luxurious houses appeared on the Palatine at precisely this period, such as those that belonged to the orator Crassus and to Lutatius Catulus, consul in 102.

The most complete of the paintings from two of the rooms are now in the Palatine Antiquarium. Other painted walls, the lunette with griffins in stucco that gave the house its name, along with several mosaics, remain *in situ*. One of the mosaics has a small square area at its center on a white ground; stones in three colors give the illusion of three-dimensional cubes. The frescoes are among the oldest surviving examples of Second Style paintings. Here for the first time we see the illusionistic representation of columns, which seem to project from the wall. The architectural design does not open onto a scenic background, as it does in later examples from the House of Livia; nonetheless, through the medium of painting, it re-creates on a flat surface the structure of a wall made of

blocks, an effect that the older mode of decoration—First Style—had created with relief work in stucco.

Under the basilica **(3)** excavators found the sparse remains of a Republican house called the ***Aula Isiaca*** (Hall of Isis), decorated at the beginning of the empire with paintings of the late Second Style, datable to around 25 BC. The name derives from the numerous subjects representing the Egyptian cult of Isis and Serapis. The hypothesis that this house belonged to the triumvir Marc Antony and, after his death, to Messalla and Agrippa is plausible. In fact, the house shows evidence of an early phase, with remains of early Second Style paintings dating to the middle of the first century BC whereas the late Second Style paintings date to a complete remodeling of the house in brick ca. 25 BC. The structural and decorative changes might well reflect the information passed down to us regarding the house of Marc Antony; namely, that it sustained serious damage in the fire of 25 BC. The paintings of the Aula Isiaca are executed in a style very close to that of the paintings in the House of the Farnesina, a residence that in all likelihood belonged to Agrippa. The paintings, now removed from the wall, have been placed in the Renaissance loggia near the Palatine Antiquarium.

Adjacent to the Domus Flavia on the east is another magnificent building, much more expansive in its length and complex in articulation, which is customarily named the **Domus Augustana** or *Augustiana;* in antiquity, this term was used for the entire complex of Imperial palaces, with the exception of the Domus Tiberiana.

This section of Domitian's palace constituted the emperor's private *domus,* his "home" in the truest sense, but it has been observed that the rooms that lie between the two complexes do not create a distinct divide, as one would expect if the functions were clearly differentiated. Some have suggested that only the southern area, in the direction of the Circus Maximus, gives the appearance of being a private residence. If this is true, it follows that the entire northern complex must also have been reserved for public functions. This hypothesis has merit, not only because the southern part of the building is physically divided from the rest, but also because it was apparently constructed at a later time, with features that we would associate with an architect different from Rabirius, who was responsible for the Domus Flavia.

The northern side, which is difficult to envisage because of the paucity of its remains, is arranged around a large peristyle **(10)**, set on the same level as that of the Domus Flavia, with an ornamental pool at its center. A small temple on a high podium was built in the middle of the pool, forming, as it were, an island that was approached by a small bridge supported by brick arches. We know that there was a temple dedicated to Minerva, a favorite divinity of the emperor, in Domitian's house. Therefore, it is not unlikely that the temple at the center of the pool is the shrine of which our sources speak.

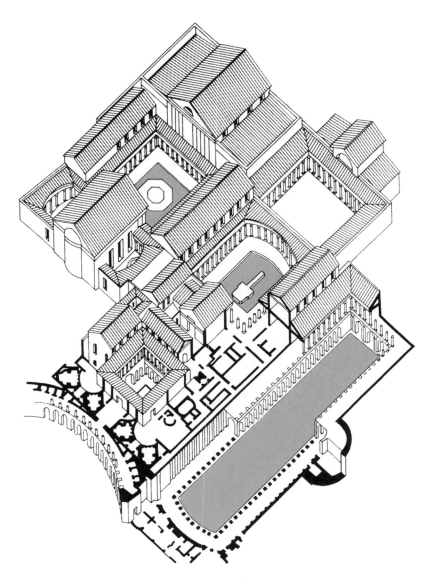

FIGURE 42. Reconstruction of Domitian's Palace.

The area farther north is in such a ruinous state that it is difficult even to reconstruct its plan **(11)**. This may have been a third peristyle. Relatively better preserved is the southern part, whose ground floor lies at a level considerably lower than the rest of the palace—that is, at the base of the vertical cutting that regularized the slope of the hill. The lower floor (not open to the public) is organized around a square courtyard, which originally had a two-story porticus **(9)**. The courtyard opens onto a large exedra on the south **(7)** that forms the facade of the part of the palace that looks out onto the Circus Maximus. At the center of the courtyard is a large fountain, designed around four crescent-shaped *peltae* (Amazon shields) set opposite each other. Only in the areas north and west of the courtyard have any of the rooms been recovered.

Beyond the fountain, at the back of the lower level, are two large octagonal rooms, roofed with pavilion vaults; their walls are decorated with alternately semicircular and rectangular niches. In between these, on axis with the building, is a square room, with two semicircular exedras on the sides and a rectangular one at the back. Several smaller rooms follow behind this, some of them cut into the rock.

The western wing consists of a large central hall that juts out in part into the peristyle and is flanked by two large nymphaea with basins at the center. A large stairway of two flights on the left side of this wing provides access to the upper floor. The rooms on this floor, which are at the same level as the Domus Flavia, are very poorly preserved; some are entirely reconstructed. We see here a rather complex plan, comprising many, mostly small, rooms; it is probably in this section of the building that the emperor actually resided.

The third part of Domitian's Palace, which lies to the east, is the so-called **Stadium (12)**. In fact, the structure is in the form of a circus—an elongated rectangle (160 × 50 meters), with one of the two smaller sides, that on the south, curved. The building extended along the whole eastern side of the Domus Augustana (from the facade facing the Circus Maximus to the second upper peristyle). Its perimeter was marked by a two-story porticus, whose lower level consisted of brick piers originally covered with marble, just like the rest of the structure; only the bases of the piers survive.

Marble columns on the upper level corresponded to the piers below. The northern corner, in part reconstructed, gives us some idea of the original appearance. At the center of the eastern side is a large tribunal **(13)**, in the form of a hemicycle, built upon three rooms that open onto the arena and rise to the same height as the porticus. The racetrack was divided in two by a *spina*, the typical longitudinal axis found in circuses that functioned as a divider around which the chariots turned; of this only the semicircular portions at the end remain.

This portion of the palace was finally completed at the end of Domitian's reign, as the brick stamps reveal. Work was done on the structure, however, under Hadrian, particularly in the porticoes, and the exedra was remodeled

under the Severan emperors. A small oval-shaped enclosure was erected in the southern end of the track, probably during the time of Theodoric. Its shape calls to mind the arena of an amphitheater, but it is hard to imagine that this site would have been used for the training of gladiators, since that kind of spectacle had been abolished for some time. The Stadium was in fact probably both a garden and a riding school. We know from the letters of Pliny the Younger that villas were often outfitted with private hippodromes—gardens in the form of a circus—probably also used as a place to ride horses. The building on the Palatine probably served such a function and, for this reason, might have been the *viridarium* (garden) that we are told existed within Imperial palaces. More plausible, however, is its identification as the *Hippodromus Palatii* mentioned in the *Acts of the Martyrs* in connection with Saint Sebastian, who was supposed to have been martyred nearby.

The Palace of Domitian represents a benchmark in the history of architecture. For the first time, it brings together systematically in a single organized structure all the functions overseen by the Imperial government that arose in response to the political and public relations needs that emerged in the course of the principate. Because these needs had heretofore never been codified into a coherent, hierarchical system, they never gave rise to organically structured architectural complexes until the time of Domitian. The House of Augustus suggests the mere juxtaposition of small preexisting residences adapted as far as possible to accommodate new needs. Although the basic division between the public and private sections already appears at that time, the ultimate form of this new configuration could not yet be fully realized, just as the inherent logic of the principate (absolute power) could not yet be expressed as power based upon codified law. Under Domitian, however, power became formally monarchical, and so it is not surprising that under this emperor the dynastic palace finally realized its architectural style at Rome. Unlike the Domus Aurea, which was freely articulated within its space in the manner of a large urban villa, the Palace of Domitian is an organically closed structure, rigorous even in the variety of its solutions to specific problems. The separation between the private residence and the official quarters fulfills the need of the *dominus et deus* to present himself to the public in a special, solemn light. That need, for example, explains the apses that appear in the most important rooms, which served to isolate the person of the emperor in a space intended for him, different from that of common mortals, while simultaneously focusing attention on him.

THE *PAEDAGOGIUM* AND THE *DOMUS PRAECONUM* Alongside the hemicycle **(7)** that forms the southwestern facade of the Domus Augustana rises a small contemporaneous building **(14;** cf. FIG. **36:20)**—clearly an addition to the nearby palace. Excavated in the middle of the nineteenth century by its then owner, Czar Nicholas I of Russia, the building was named the Paedagogium on the basis of several disputed graffiti discovered within it. We know only one part

of the complex, which was arranged on two levels, each containing a row of rooms separated by a courtyard with a porticus; the row of brick piers in which the building's one remaining column is embedded and which supports pieces of marble cornices is modern; the cornices themselves for the most part belong to the Domus Augustana above. The most important room is the exedra that lies to the north—but not on the central axis—flanked by nine smaller rooms. Remains of Severan paintings and mosaics are still visible in some of the rooms. The main interest, however, lies in the plastered walls on which many graffiti are scratched; the best known of these, now in the Antiquarium, shows a crucified man with the head of an ass and carries a Greek inscription: "Alexamenos adores [his] god." Individuals named in these graffiti are nearly always Greek, almost certainly slaves. The formula *exit de Paedagogio* (he leaves the Paedagogium), which occurs several times, is the basis for the traditional identification of the building as the schoolhouse for the emperor's slaves; that identification of this building, however, is suspect since we know that the Paedagogium was in fact located on the Caelian Hill.

To the south of the so-called Paedagogium, between it and the Circus Maximus, is another building, lying along a slightly different orientation (FIG. **36:21**). It consists of a small rectangular courtyard, with a porticus built of piers on four sides. To the north of the courtyard are three vaulted rooms, the central one being the largest, which must have supported a second floor. The building, containing mosaics and impressive painted decoration (now in the Antiquarium) and dated to the Severan period, was explored in 1888. The procession of heralds depicted in one of the mosaics has given the complex, which was certainly a public space, its name—Domus Praeconum (the House of the Heralds). An inscription, however, has recently brought to light the existence of a group named the *Nuntii Circi* (messengers of the circus)—the flag bearers who headed the circus parade that took place before the contests. It is probably these individuals who are represented in the building's mosaic, which accordingly should be identified as the headquarters of the *nuntii*. The proximity to the Circus Maximus makes this identification plausible.

THE *DOMUS SEVERIANA* *Domus Severiana* is used today—inappropriately—as the name of an enlargement of the Domus Augustana added by Septimius Severus (FIG. **36:22**). All that remains of this vast annex, located at the southern corner of the Palatine, are the exposed bricks of the foundations, which constitute one of the most distinctive features of this side of the hill. The lofty substructures created an artificial platform that allowed the new wing of the palace to extend beyond the area of the hill—which was by this time completely occupied—on the same level as the other parts of the palace. Several rooms within the substructures still preserve their mosaics with geometric patterns in black and white. Sparse remains of the palace baths, probably constructed by Domitian and entirely rebuilt by Maxentius, can be seen in the corner between the building and the

exedra of the Stadium. A branch of the *Aqua Claudia*, whose arches (still partially preserved) span the valley between the Caelian and Palatine hills, ended here. The actual Severan annex, of which almost nothing survives, rose on the terrace that was supported by this impressive foundation.

The celebrated **Septizodium** was situated on the side of the Palatine facing southeast toward Via Appia (FIG. **36:23**). This monumental facade-nymphaeum, with its several stories of columns, was raised, as the biography of Septimius Severus records, mainly to impress the emperor's fellow countrymen, the inhabitants of Roman Africa, who arrived in Rome by way of Via Appia. The splendid building, still partly preserved as late as the sixteenth century, was demolished by order of Pope Sixtus V, who made use of the materials recovered from it for various works, including the chapel that he had built in the basilica of S. Maria Maggiore. All that is left of the monument are the plan in the Severan *Forma Urbis*, several Renaissance drawings, and some structural remains, discovered together with fragments of ornamental sculptures during recent excavations.

THE EASTERN CORNER OF THE PALATINE The entire eastern section of the hill (the area of the churches of S. Sebastiano and S. Bonaventura) lies outside the confines of the Palatine excavations. A **vast artificial terrace,** rectangular in shape and built to support one building, dominates the area (FIG. **36:24**). The powerful brick foundations that enclose the bank of earth are best seen from the Arch of Titus and Via di S. Gregorio. The facade, located at the middle of the long side on the west, facing the Clivus Palatinus, contained a monumental entrance approached by stairways. There must have been several openings, but the ruinous state of the remains does not allow us to determine the precise number. This entrance has sometimes been identified as the *Pentapylum* (the gate with five entrances) to which the Regionary Catalogues refer. Recent excavations, however, confirm the existence of only three openings, a fact that seems to rule out this identification. Nearby, on the Clivus Palatinus, archaeologists have identified the remains of an arch (perhaps the entryway to the palaces on the Palatine and to the *Area Palatina*) that has been dated to the Domitianic period; several sculptural fragments are preserved on site.

The large platform was erected by Domitian at the same time as the adjacent palace. Scholars have suggested that this was the area occupied by gardens indicated on the Severan Marble Plan under the name *Adonaea* (i.e., sacred to the cult of Adonis). If so, this site may well be the "Gardens of Adonis," described as belonging to Domitian's palace (Philostratus, *VA* 32).

Several recent archaeological investigations have revealed the existence of a **large building** (approximately 60 × 40 meters) at the center of the large rectangular area supported by the terrace to the south of the Church of S. Sebastiano; the structure can be identified with certainty as a temple. Saint Sebastian was supposed to have been martyred on the *Gradus Heliogabali* (the Steps of Heliogabalus; i.e., Elagabalus); a church was built in his honor on

the site. This information allows us to identify the building as the temple that the emperor Elagabalus erected to the sun god (Elah-Gabal), whose name he assumed, with the clear intention of introducing to Rome the oriental cult of the living sovereign. The choice of the Adonaea for this building is easy to understand: Adonis, like Elagabalus, was a Syrian divinity, at times also identified with the sun. The penultimate representative of the Severan dynasty brought together all of Rome's most venerated sacred objects into this building: the aniconic representation of Cybele, the fire of Vesta, the Palladium, and the *ancilia* (shields of Mars, housed in the Regia). This action accords with the syncretistic practice, widespread by this time, of unifying the various manifestations of paganism under one cult—namely, that of the sun. After the death of Elagabalus, Alexander Severus renounced the cult of the sun and replaced it with that of *Jupiter Ultor*. Ongoing excavations have confirmed that the terrace was used as a large garden (perhaps the Gardens of Adonis) and have documented the presence of earlier phases dating as far back as the Republic. Of particular note is a cryptoporticus, probably from the Neronian period, oriented at an oblique angle with respect to the later Domitianic structures that covered it over.

THE PALATINE ANTIQUARIUM (MUSEO PALATINO) The museum, reorganized and reopened to the public in 1997, occupies a former convent that was built within Domitian's palace. Structural elements of the palace can be seen below Rooms 3 and 4. Also visible are the remains of earlier buildings, which can be dated between the reigns of Augustus and Nero. Among these, a section of a round hall has been tentatively identified as the revolving *cenatio rotunda* of Nero's Domus Aurea (Suet. *Nero* 31). Artifacts dating to the oldest phases of activity on the Palatine—from prehistoric times to the Republic—are displayed on the ground floor; the first floor is reserved for finds dated to the Imperial period.

GROUND FLOOR

Rooms 1–3. Pre- and protohistoric materials from the Paleolithic to the Iron Age. Ninth-century BC cremation tomb from the *Domus Liviae*. Seventh-century BC infant's tomb from the *Domus Flavia*. Material from the protohistoric settlement (ninth to eighth century BC). Model of the Palatine village. Small model of hut A.

Room 4. Archaic and Republican periods. Altar with the inscription of C. Sextius C. f. Calvinus, praetor (either the consul of 124 BC or his son), with a dedication to an unknown god. Antefix in the shape of a woman's head from the House of the Griffins (end of the sixth century BC). Antefixes bearing the head of Juno Sospita from the area around the Temple of the Magna Mater (beginning of the fifth century BC). Fragments of terracotta friezes from a building of ca. 540 BC. Terracotta heads of Zeus and

Apollo(?) from the decoration of the Temple of Victory (beginning of the third century BC).

Room 5. Augustan Period. Fragments (head and foot) of a large marble statue of Apollo, often thought to belong to the cult statue from the Temple of Apollo, attributed to Skopas. Decorative terracotta panels, probably from the Porticus of the Danaids, representing the contest between Heracles and Apollo for the Delphic tripod; Perseus, Athena, and the Gorgon; young girls standing on either side of a candelabrum; young girls standing on either side of a *baetyl* (sacred stone); *canephoroi* (basket carriers) on either side of a censer. Female herms in "nero antico" marble, probably representing the Danaids, from the porticus that bears their name, mentioned by Ovid and Propertius. Basalt *ephebe* (youth) from the Temple of Apollo. Fragment of a fresco with Apollo Citharoedus (Apollo the cithara player). Marble relief with the prow of a ship.

Room 6. Neronian Period. Altars from the Domus Tiberiana with dedications to Minerva and (Juno) Lucina. Pictorial decorations from the Neronian phase of the Palatine palace (beneath the Domus Flavia), with mythological scenes depicting the heroes Ulysses, Achilles, and Telephus. Inlaid marble that decorated the same hall.

Rooms 7 and 8. From the Julio-Claudians to the Tetrarchy. *Opus sectile* panels from the Domus Tiberiana. Imperial portraits: Nero, Hadrian, Antoninus Pius, Marcus Aurelius as a young man, Iulia Domna, Maximinus Thrax, Balbinus. Architectural decoration from the palace. Marble statue of a river god from the Septizodium. Graffito from the so-called Paedagogium, with the representation of a crucified man with the head of an ass and Greek inscription ("Alexamenos adores [his] god"), probably a caricature of Christ.

Room 9. Sculptural decoration from the palace. Marble bust of Diomedes. Marble heads of the Doryphorus (by Polycleitos) and of the Sosandra (by Calamis). From the Stadium, two statues of muses seated on a rock. Marble statue of the Hera Borghese type. Two heads from copies of the Pergamene Gauls. Seated statue of the Magna Mater, from the goddess's temple.

FIGURE 43. The Valley of the Colosseum and the Oppian Hill.
1 Colosseum. **2** Colossus of Nero. **3** Meta Sudans. **4** Arch of
Constantine. **5** Ludus Matutinus. **6** Ludus Magnus. **7** Buildings
under S. Clemente. **8** Domus Aurea. **9** "Sette Sale." **10** Porticus
of Livia. **11** Baths of Titus. **12** Baths of Trajan.

VALLEY OF THE COLOSSEUM

HISTORICAL NOTES

Region III occupied the valley between the Esquiline and Caelian hills. It was bordered on the south by Region II along the road that leads to the Lateran, generally referred to as *Via Tusculana;* on the north it included the Oppian Hill and probably a part of the Fagutal; it was bounded on the east and west by Regions V and IV, respectively (see FIG. **2**).

The region's name, Isis and Serapis, derived from a local sanctuary of the goddess Isis, probably of considerable antiquity. The shrine was possibly the *Isium Metellinum,* which may have been located on the slope of the Oppian Hill. The quarter's main street must have been the one that passed between the *Ludus Magnus* and the base of the Oppian, corresponding to the present-day Via Labicana.

The area contained within Region III probably played a role in the city's oldest political organizations—the *Septimontium,* which included the Caelian and Oppian hills, and the Servian city of the Four Regions; in fact, it also lay within the Servian Walls. Later, a large part was incorporated within Nero's *Domus Aurea;* this palace and the *Domus Transitoria* that preceded it completely transformed the valley's appearance. Numerous private homes were destroyed, and the entire expanse between the Palatine, Esquiline, and Caelian within

Regions X, IV, III, and II was fused into a single continuous space reserved for the Imperial residence. At its center (in the area now occupied by the Colosseum) was an artificial lake, the *Stagnum Neronis*, which was surrounded by groves, gardens, and pavilions.

The situation changed radically, and definitively, under the Flavian emperors. During their regime, large tracts of the area were restored to public use. The construction of the Flavian Amphitheater and the numerous buildings associated with it informed much of the area's reorganization. The amphitheater itself, the nearby barracks of the gladiators (*Ludus Magnus, Dacicus, Matutinus,* and *Gallicus*—the first two in Region III and the latter two in Region II), and the naval barracks housing the Imperial fleet from Misenum *(Castra Misenatium)*, as well as the various storehouses and hospitals connected with the gladiatorial games *(Summum Choragium, Armamentarium, Saniarium,* and *Spoliarium)*, occupied a large portion of the area, laid out according to an organic and regular plan that was completed under Domitian. To the east stood another group of buildings, those associated with the Imperial mint (the *Moneta*), which had been moved here from its original location on the Arx; this complex included a large building beneath S. Clemente. The Baths of Titus, probably converted from private baths in the Domus Aurea, occupied the slope of the Oppian Hill. At this time a pavilion of Nero's villa was restored and remained in use for a while; this may have been the *Domus Titi*, recorded by Pliny the Elder (*NH* 36.37), which housed the statue of Laocoön. The building was severely damaged in the fire of AD 104 and thereafter disappeared under the expansive Baths of Trajan; with their completion, the Oppian Hill was fully urbanized.

We know of several private homes in Region III. In addition to those mentioned above, the house of Bruttius Praesens (possibly consul in AD 180) is recorded. Some noteworthy Republican houses of the second century BC, with rich mosaics and wall paintings of the First Style, were discovered under the Domus Aurea and in the vicinity of the Ludus Magnus.

ITINERARY

From the Arch of Constantine to S. Clemente

THE ARCH OF CONSTANTINE The Arch of Constantine is the largest of Rome's three surviving triumphal arches, rising along the road taken by triumphal processions between the Circus Maximus and the Colosseum (FIG. **43:4**). Its proximity to the Palatine suggests that the arch should be included in Region X, but location in Region II should not be ruled out. Ancient literary tradition is silent on the subject of the arch's history, but the long inscription repeated on both facades of the attic is sufficient to identify the monument:

Imp(eratori) Caes(ari) Fl(avio) Constantino Maximo / P(io) F(elici) Augusto s(enatus) p(opu-lus)q(ue) R(omanus) / quod instinctu divinitatis mentis / magnitudine cum exercitu suo / tam de tyranno quam de omni eius / factione uno tempore iustis / rem publicam ultus est armis / arcum triumphis insignem dicavit. (To the emperor Caesar Flavius Constantine Maximus Pius Felix Augustus, the Senate and People of Rome, because, through the inspiration of a god and through the greatness of his mind, he took vengeance on the tyrant and all his faction at one time with just arms on behalf of the state, dedicated this arch in celebration of his triumphs.)

The monument commemorates the triumph celebrated after the victory at the Milvian Bridge on 28 October 312, during which Maxentius lost his life. The construction was completed three years afterward, and the monument was dedicated on the tenth anniversary of Constantine's reign, 25 July 315, as two inscriptions on the side facing the Colosseum indicate *(Votis X, Votis XX)*. The phrase *instinctu divinitatis* (through the inspiration of a god) has been seen as a confirmation of Constantine's celebrated vision of a cross before the battle.

This triple-passageway arch rises to a height of nearly 25 meters; the central span is 11.45 meters high and 6.50 meters wide. The structure bears a close resemblance to the Arch of Septimius Severus, particularly in the arrangement of the columns—detached from the wall and set on high plinths—and the style of the sculptures. According to a recent hypothesis, the arch as we find it is a reworking of an earlier monument. Certainly the monument is a patchwork of sculptures and architectural elements from several buildings. During this period, the city, having effectively lost its function as capital (it would soon lose even that nominal distinction to Constantinople), must have offered little employment for the artisan workshops, which survived principally on Imperial commissions. This might explain the extent to which the artists reused older sculptures and architectural elements taken from monuments erected during the time of Trajan, Hadrian, and Commodus.

The southern facade includes the following elements, from bottom to top (FIG. **44**). Barbarian prisoners and Victories bearing trophies on the pedestals of the columns, sculpted on three sides **(1)**. Flying Victories bearing trophies and personifications of two seasons in the spandrels of the central arch. River gods in the spandrels of the secondary arches **(2)**. Allegorical figures (unidentifiable owing to their very poor state of preservation) decorated the keystones of the arches. These elements are contemporary with the arch's construction, as are the six long and narrow reliefs, located directly above the secondary arches **(3, 4)** and at the same height on the short sides **(8)**, that recount the history of the campaign against Maxentius, beginning with the short (western) side facing the Palatine and continuing in sequence on the south, east, and north (these are treated further below).

Above the Constantinian reliefs are four Hadrianic *tondi* (medallions), which are more than 2 meters in diameter **(5)**. These represent, from left to right, the

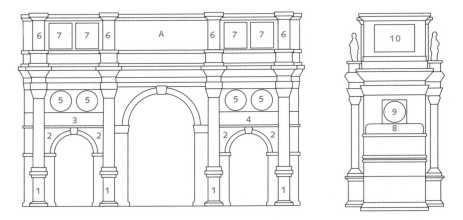

FIGURE 44. Arch of Constantine. *On the left:* **A** Inscription. **1** Victories and barbarian prison-ers. **2** River gods. **3–4** Constantinian historical reliefs. **5** Hadrianic medallions. **6** Statues of Dacians. **7** Reliefs of Marcus Aurelius. *On the right:* **8** Constantinian historical relief. **9** Sun (and moon). **10** Large Trajanic relief.

departure for the hunt; a sacrifice to Silvanus; a bear hunt; and a sacrifice to Diana. Suffused with a sort of romantic restlessness, these reliefs are perhaps the most remarkable public sculptures of the Hadrianic period, exhibiting a classicism quite different from the more rigid and authoritative form associated with Augustus. They may have originally belonged to a quadrifrons or to a triple-passageway arch. The scenes, which allude to real events, include portraits of Hadrian's lover Antinous as a boy and as a young man. The portraits of Hadrian were replaced by those of Constantine (in the hunt scenes) and Licinius (in the sacrifice scenes).

The two ends of the attic, flanking the dedicatory inscription, are filled by four large panels—more than 3 meters high—that were taken from a monument erected by Commodus in honor of his father, Marcus Aurelius **(7)**. It has been argued that the reliefs belonged to an arch built near (and thus contempora-neous with) the Column of Marcus Aurelius. The arch's reliefs, like those on the column, represent episodes from the wars against the Quadi and Marcomanni. From left to right: presentation of a barbarian chieftain to Marcus Aurelius; pris-oners led before the emperor; an *adlocutio* (a speech to the soldiers); and a sacrifice in camp. These splendid reliefs, their dimensions identical to those displayed in the stairwell of the entrance to the Museo dei Conservatori, although stylistically different, provide clear indications of the breakdown of the plastic mass in forms that become ever more pictorial, a tendency that was characteristic of the last years of the second century AD. The successive phase of this development can be observed by comparing the sculptural reliefs of the Column of Marcus Aurelius

and those on the Arch of Septimius Severus, which represent a more advanced stage. Four statues representing Dacians (taken from Trajan's Forum) occupy the plinths above the columns **(6)**.

The same arrangement is repeated on the other side: bases of the columns with reliefs representing prisoners and Victories writing on shields **(1)**; Constantinian reliefs above the secondary arches **(3, 4)**; Hadrianic *tondi* **(5)** depicting (from left to right) a boar hunt, a sacrifice to Apollo, a lion hunt, and a sacrifice to Hercules. Reliefs of Marcus Aurelius **(7)** feature the following scenes: the emperor's arrival in Rome *(adventus)* (represented here are the Temple of Fortuna Redux, probably in the Area Sacra di Sant'Omobono, and the Porta Triumphalis); the emperor's departure from Rome *(profectio)* (the Porta Triumphalis is again shown, here with its quadriga drawn by elephants); the distribution of money to the people *(congiarium)* (the building seen behind the emperor is probably the Basilica Ulpia); the surrender of a barbarian chief. On this side as well, four statues of Dacians stand on plinths supported by columns **(6)**.

The shorter side of the monument on the west (facing the Arch of Titus), above the Constantinian historical relief **(8)**, has a *tondo* representing the moon goddess **(9)**, also of Constantinian date, that was intended to complete the series of Hadrianic *tondi*. In the attic, a panel from a Trajanic bas-relief depicts a battle scene **(10)**. This, together with the relief on the opposite short side and the two reliefs within the central arch, formed a single imposing scene, approximately 3 meters tall and originally nearly 20 meters long; even incomplete, it is the most impressive surviving example of Roman historical relief. Casts of the four sections were assembled and are on display in the Museo della Civiltà Romana. The style is the same as that found on Trajan's Column. From right to left, the sections run in sequence as follows: the relief on the attic on the west; that in the central passageway on the west; that on the attic on the east; finally, that in the central passageway on the east. The arrangement of the reliefs on the short eastern side is the same as that on the west, with a representation of the sun god in the Constantinian *tondo* **(9)**.

Beginning with the short western side, the first of the Constantinian historical reliefs (a little taller than a meter and between 5.50 and 6.50 meters long) depicts the departure of Constantine's army from Milan **(8)**; there follows the siege of Verona **(3,** southern side on the left); the battle of the Milvian Bridge **(4,** southern side on the right); Constantine's triumphal entry into Rome **(8,** short side on the east); Constantine's discourse in the Forum from the Rostra **(3,** northern side on the left) (one of the most interesting representations of the Roman Forum: behind the tribune are Diocletian's five honorary columns; on the right, the Arch of Septimius Severus; on the left, the Arch of Tiberius and the Basilica Julia); and the *congiarium* held in the Forum of Caesar on 1 January 313 **(4,** northern side on the right). The use of perspective and the naturalistic treatment of space characteristic of Hellenistic sculpture are here replaced by a hierarchical and frontal arrangement of the figures, a design that prefigures medieval art.

Just north of the Arch of Constantine are the remains of the **Meta Sudans** (FIG. **43:3**). This monumental fountain had the shape of a truncated cone, but only the brick core remained, until even this was barbarously destroyed in 1936 to make room for Fascist parades. The monument is depicted on a coin of Titus of AD 80—the probable year of its construction. Its location probably marked the intersection of four of the Augustan regions (II, III, IV, and X). Structures belonging to the Domus Aurea and buildings preceding it came to light alongside the *Meta* during excavations in the 1980s.

THE COLOSSEUM After the Amphitheater of Statilius Taurus was destroyed in the fire of AD 64, Nero put up in its place a temporary building made of wood in the Campus Martius. It fell to the Flavian emperors to complete the task of endowing Rome with an amphitheater worthy of the capital. Construction began during the first years of Vespasian's reign in the valley between the Palatine, Esquiline, and Caelian Hills, which previously had been the center of the Domus Aurea (FIG. **43:1**). The structure was erected at the site of the artificial pool that Nero had installed, in accord with Vespasian's policy of restoring to public use those parts of the city appropriated by Nero to build his huge residence; the Baths of Titus served the same propagandizing function by opening up what were probably the private baths of the Domus Aurea to the public.

The Colosseum, though not yet finished, was dedicated for the first time by Vespasian before his death. According to a late chronicle of the fourth century, at that time the work should have reached the third tier of seats and thus the second architectural order. It fell to Titus to bring the work to completion and to offer a second gala inauguration in 80, lasting a hundred days, during which five thousand animals were killed. The project received its finishing touches by Domitian, who, according to the same chronicle, brought the work "up to the shields" that decorated the last exterior order. The subterranean complex underneath the arena, constructed in stone, was probably only completed at that time. Otherwise, it would be difficult to understand how the *naumachiae* (naval battles), which are recorded as having been offered in the amphitheater under Vespasian and Domitian, could have taken place. From then on, no further mention is made of this event; the arena was thereafter reserved for gladiatorial games *(munera)* and wild animal hunts *(venationes)*.

The outermost ring of the amphitheater rises to a height of nearly 50 meters; the long axis of the ellipse measures 188 meters and the short axis, 156. More than 100,000 cubic meters of travertine and 300 tons of iron for clamps were used in its construction. The outermost ring, built entirely of travertine, of which only about two-fifths survives, is four stories tall. The first three are composed of arches framed by semicolumns: Tuscan on the first story, Ionic on the second, Corinthian on the third. The fourth story, a sort of attic, is blind, partitioned by Corinthian pilasters, and pierced by square windows inserted in every other partition. A series of brackets (three per partition) was installed above the level

of the windows, corresponding to the same number of holes in the cornice (240 in all). These supported the poles to which the large segmented *velum* was attached; this huge covering was intended to protect the spectators from the sun. A detachment of sailors from the military port at Misenum was in charge of deploying the *velum;* they were stationed in special barracks in the immediate vicinity of the amphitheater (Castra Misenatium).

Eighty arches on the ground level provided access to stairways and, through these, to the various sections of the cavea (seating area); it was a complex system that facilitated the departure of spectators from the building. Section numbers corresponding to those on each spectator's ticket *(tessera)* can still be seen above each of the surviving arches. Of the four entrances along the principal axes, which were unnumbered, only the northern one survives, where traces of a small porch, signaling the importance of this entrance, can still be seen. Traces of decorated stucco are also visible on the vault of the corresponding corridor. This was the entrance of honor that led to the Imperial tribunal, located at the center of the amphitheater's northern side. The other three must have similarly accommodated particular categories of spectators: magistrates, the Vestals, the religious colleges, and guests of honor.

Large travertine cippi (truncated pillars) were installed a certain distance from the amphitheater; some are still visible where a short stretch of the original pavement survives. The cippi originally encircled the building and were employed in the furling and unfurling of the *velum*. The large holes still visible in the upper parts of each cippus must have held the winches that maintained the tension in the large cables that were a necessary part of the system.

What remains of the exterior wall is buttressed at each end by massive walls, built by Giuseppe Valadier in 1820 on the order of Pius VII (as the inscriptions indicate). Many irregular holes can be seen throughout the facade between the blocks of masonry; these are the result of attempts during the Middle Ages to extract the iron clamps that held the blocks together.

Inside the amphitheater, the first floor of the cavea consists of five concentric ambulatories, roofed with a barrel-vaulted ceiling and resting on massive travertine piers (FIG. 45). Several details of the mode of construction explain the remarkable speed with which the project was completed. The work done in constructing Nero's artificial basin, once drained, reduced the need to excavate foundations for the amphitheater. The foundations themselves were in effect a fifth (subterranean) story, consisting of travertine piers resting on a vast ring of concrete bedding. The radial walls, constructed of tufa blocks on the ground floor and of brick on the first, ran uninterruptedly from the ground level to the base of the cavea. Construction of the superstructure began with the erection of a load-bearing frame, comprised of the travertine piers connected by brick arches corresponding to the various floors and by sloping vaults on which the cavea rested. It was thus possible to work simultaneously on the upper and lower sections; the crew below could continue working even during inclement weather.

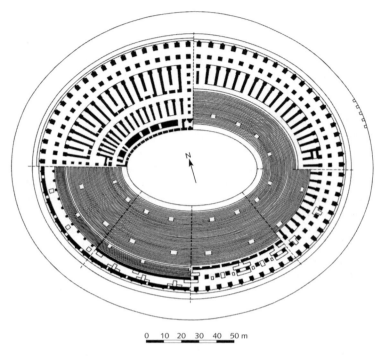

0 10 20 30 40 50 m

FIGURE 45. Colosseum. Plan.

The system resembles that currently in use as a result of the development of rein-
forced cement. It has also been shown that four different crews worked in the
building's four quadrants, as demarcated by the two principal axes.

The Colosseum's interior, half in ruins and missing all of its seating, can
give only a pale notion of the original appearance. The absence of the arena
floor, exposing the service quarters in the basement of the building, makes
it even more difficult to imagine what the monument originally looked like.
The basement complex—possibly installed no earlier than Domitian, though
after the rest of the amphitheater was completed—was where service items
indispensable for the games, such as machinery, cages for the animals, and
weapons, were kept. The perimeter wall has thirty deep recesses, which might
have accommodated small elevators raised by counterweights that brought the
animals and gladiators up to the level of the arena. Three concentric walls,
pierced by many openings to allow for movement in all directions, form three
annular corridors at the edge of the arena. At the center, the partitions become
rectilinear, parallel with the principal axis of the ellipse. There are four per side,
forming several corridors, the widest of which corresponds to the central axis.

Traces of the imposts that supported the large inclined wooden floors, which rotated on hinges and moved with counterweights, can still be seen; these were designed to bring scenery of various sorts to the center of the arena, especially during the *venationes*. Contemporary writers record with wonder the sudden appearance of entire hills, forests, and other spectacular elements. We know that Hellenistic theatrical tradition had for some time been preparing the ground for highly complex effects such as these.

The long central gallery extended in two directions beyond the amphitheater, as did the other, smaller gallery that ran along the axis perpendicular to it. The branch leading east reached the most important of the nearby gladiatorial barracks, the Ludus Magnus, part of which can still be seen across the street from the Colosseum.

The central part of the arena must have been covered by a large wooden floor that could be easily moved, or even removed altogether. Such a floor would explain the violence of the fire of AD 217, which began in the arena. Between the floor and the cavea a strong protective net was set up during the games on poles embedded between two brackets set at a lower level. The net, as one ancient writer describes it, had elephant tusks along the top, used as spikes, and ivory rollers that rotated horizontally, both of which hindered animals that might have tried to climb over from getting a firm grip. As a safeguard, a squadron of archers was stationed in the corridor that ran between the cavea and the net.

The cavea was divided into five superimposed sections. Beyond a small area of seats immediately behind the enclosure were three large sections *(maeniana)*, while a fourth, with wooden tiers *(maenianum summum in ligneis)*, stood at the top of the amphitheater covered by a colonnaded porch (FIG. 46). Then, as now, there were various categories of seats, the difference being that seating was not dependent on the price of the ticket, since entry was normally free. The various classes among the population could sit only in the places reserved specifically for them, and laws were promulgated along these lines at the end of the Republic. The seating closest to the arena (or in the theater, that nearest to the orchestra) was reserved for the senatorial class, the next fourteen tiers (the first *maenianum*) were reserved for the knights, and the remaining seats were allotted according to Roman social hierarchy. A portion of the seats in the *maenianum summum*, that part made of wood and so considered the least desirable section of the amphitheater, was set aside for women. Augustus instituted this restriction for moral purposes: to curtail the promiscuity associated with public events, which were prime spots to encounter potential lovers, as Ovid informs us in the *Ars Amatoria*. The inscriptions engraved on the surviving seats provide valuable information about the seating assignments. For example, we find the following notices: *Equitibus Romanis* (for the Roman knights); *Paedagogis Puerorum* (for elementary school teachers); *Hospitibus Publicis* (for Public Guests); *Clientibus* (for *Clientes*, that is, during the Imperial period, the city plebs); *Gaditanorum* (belonging to the Citizens of Cadiz), etc. These mark the seats not of individuals,

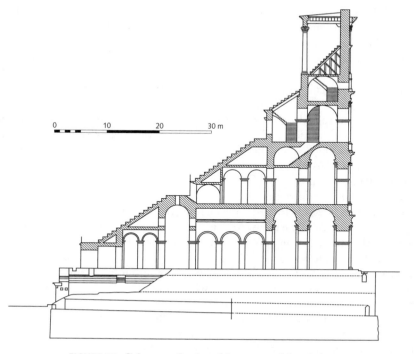

FIGURE 46. Colosseum. Section of the cavea and foundations.

but of whole categories of people. A well-known inscription, datable to the same year in which the amphitheater was inaugurated (80), confirms this practice: it transcribes a decree that grants the priestly association of the Arval Brethren (twelve persons in all) a fairly large number of seats, totaling some 129 feet—that is, more than 38 meters; these seats were thus reserved for the Arval Brethren themselves, their families, and their heralds. The individuals were, of course, seated throughout the amphitheater on the basis of their social rank.

The only exception to this practice were the seats reserved for the senatorial order, which were built entirely of marble (and not of brick surmounted by a marble block carrying the inscription, as was the case elsewhere in the cavea). The names of the senators were inscribed on the first rows of seats adjacent to the arena; numerous erasures and rechiselings show that the names were frequently replaced. Since every senator, who would have been assigned to one of three ascending categories *(Clarissimi, Spectabiles,* and *Illustres)*, had his own seat, it was clear that at his death—or at his promotion to one of the higher senatorial ranks and as a consequence to one of the better seats—his name would have been

erased in order to make room for his replacement. Those that we find are thus the names of the last occupants before the abandonment of the amphitheater.

The seating capacity of the Colosseum is a question that has not yet been entirely resolved, but the calculation made by Christian Huelsen at the end of the nineteenth century is generally accepted. According to him, the figure provided by the Regionary Catalogues (87,000 seats) designates the measurement, in feet, of the entire seating area. There were between 45 and 50 rows of seats in the Colosseum proper, with additional wooden tiers in the *maenianum summum*, resulting in a total area of 20,280 meters (68,750 feet). Assuming that the minimum space per person was 44 centimeters (1.50 feet), the amphitheater would have held no more than 40,000–45,000 seated spectators, to which we must add the roughly 5,000 who stood in the upper part of the last section. Other calculations, however, reckon the total length of the seating area at around 26,000 meters—that is, 88,000 Roman feet—which would correspond better with the 87,000 places mentioned in the Regionary Catalogues. Divided by the same measurement of 44 centimeters per seat, the second calculation would yield seating for about 68,000 persons, a capacity of roughly 73,000 in all with the addition of those standing. As it is, the maximum occupancy could have been larger, approaching the figures passed down by the ancient sources.

The building, struck by fires and earthquakes, was restored on various occasions. We know of restorations undertaken by Nerva, Antoninus Pius, Elagabalus, Alexander Severus (after the destructive fire of AD 217), and possibly by Gordianus. Another serious fire occurred in 250. Later restorations are particularly well documented by the inscriptions. The amphitheater was struck by lightning in 320 under Constantine; it was restored again by the city prefect Anicius Acilius Glabrio Faustus after the earthquake of 429; more work was required after another earthquake in 443.

The latter disasters occurred at the same time that Christian emperors were either suspending or setting limitations on the games. At the beginning of the fifth century, Honorius abolished the gladiatorial games. Valentinianus III reestablished them at the beginning of his reign, only to prohibit them once and for all immediately after 438. From that time forward, only *venationes* were put on. For the years following, we have documentation for the total reconstruction of the seating on the lowest level, where, between 476 and 483, the names of 195 persons of senatorial rank were inscribed during the reign of Odoacer. This was in effect the last restoration, aside from some minor work undertaken during the reign of Theodoric, under whom use of the amphitheater came to an end. The last documented event is mentioned in a letter written by Theodoric to the consul-designate for 523, Maximus, who sought permission to celebrate the assumption of his duties with a *venatio;* Maximus's request was granted, albeit with veiled disapproval. From the sixth to the eleventh century, when the amphitheater was turned into a castle and occupied by the Frangipane family, a silence, broken

only by Bede's apocalyptic pronouncement, descended upon the empty seats and deserted arena of the Colosseum.

Between the Colosseum and Via dei Fori Imperiali, the **base** that supported the colossal bronze statue of Nero—a large structure of 17.60 × 14.75 meters—has been partially reconstructed, following its senseless demolition for the opening of Via dell'Impero (as it was originally called) in 1936 (FIG. **43:2**). The statue stood on the boundary between Regions III and IV, but was technically within the latter, like the Meta Sudans. According to Pliny the Elder, the work was entrusted to a sculptor of Greek origin, Zenodoros, who had already built for the Gallic Arverni a colossal cult statue of their national divinity, identified as Mercury. The model for the Colossus of Nero was evidently the Colossus of Rhodes, an early third-century BC icon of Helios the sun god attributed to Chares of Lindos. The student surpassed his teacher, at least with regard to the proportions: the Colossus of Rhodes was 70 cubits high—that is, around 32 meters—while the Colossus in Rome reached, as Pliny (*NH* 34.45) informs us, 119 feet—that is, 35 meters. The dimensions of the base confirm Pliny's information; this must have been the largest bronze statue ever made in the ancient world. The statue, a representation of Nero as Helios, originally stood in the center of the atrium of the Domus Aurea; later Hadrian had it moved in order to build the Temple of Venus and Roma where the statue had stood. The architect in charge of the operation was named Decrianus, and he employed a team of twenty-four elephants to get the job done. After Nero's death, the statue was fully transformed into a representation of Helios. Later, Commodus had it reworked to represent Hercules (with the emperor's facial features); after his death, it was again turned back into Helios.

The appearance of the colossus, which with its base must have almost reached the height of the nearby amphitheater, can be reconstructed from several coins: the statue represented a standing figure leaning on a rudder (possibly added later), from whose head rays emerged. The name "Colosseum," ascribed to the amphitheater for the first time in the eighth century, derives not from the building's proportions but rather from its proximity to this colossal statue.

THE LUDUS MAGNUS The ruins of the northern half of the Ludus Magnus lie immediately east of the Colosseum, between Via Labicana and Via di S. Giovanni in Laterano; these were the main barracks of the gladiators, built, like the others, by Domitian (FIG. **43:6**; FIG. **47**). Though the site was discovered in 1937, excavations were not completed until 1961. The southern portion of the complex, which lies partially under Via di S. Giovanni and partially under the block between this street and Via dei SS. Quattro Coronati, can be reconstructed on the basis of a fragment of the Severan Marble Plan.

The rectangular complex, of brick throughout, had a large colonnaded courtyard in the middle; it probably stood three stories high originally. A series of rectangular rooms, which evidently served as lodging for the gladiators,

surrounded the courtyard. All fourteen rooms on the northern side and some on the west and east have been preserved. At the north, on axis with the courtyard, was a monumental gate, probably the building's principal entrance. A flight of stairs ascended from here to Via Labicana, whose level was raised by Trajan during his restoration of the Ludus Magnus. This type of construction is typical of a military barracks (not dissimilar, for example, to the barracks of the *vigiles* at Ostia). What makes this building unusual is the presence in the courtyard of a miniature amphitheater, half of which is preserved, that served as the training ground for the gladiators. The amphitheater abutted the colonnade at four points and included a small cavea, entered by external stairways, while the arena was reached through entrances located along the principal axes. A tribunal of honor stood at the center of the minor axis, on line with the principal entrance; this was probably entered from the upper story of the colonnade.

A triangular fountain graced each of the courtyard's four corners; one of these, heavily restored, can be seen in the northwestern corner. A tunnel leads directly from the Ludus Magnus to the underground facilities of the Colosseum. The remains of homes predating the Neronian fire were excavated underneath the building; they can be reached through trap doors. Examination of the Ludus, the only such structure extant, and of the considerable documentary evidence (especially inscriptions and graffiti) found within it, has clarified various aspects of the gladiators' daily lives and of the organization of the games.

South of the Ludus Magnus excavators found remains, no longer visible today, of barracks resembling the Ludus, although decidedly smaller; this may be the Ludus Matutinus, the training school for the *bestiarii*, who fought wild animals (FIG. **43:5**). The Ludus Gallicus must have stood nearby. Both were located in Region II. On the other hand, the Ludus Dacicus, like the Ludus Magnus, was located in Region III, according to extant fragments of the Marble Plan; it lay between the Ludus Magnus and the large exedra of the Baths of Trajan, directly in front of the facade of the Domus Aurea.

Other buildings in the area formed part of the extensive system of services dedicated to the management of the amphitheater; all were under the control of Imperial procurators of equestrian rank. These included the Castra Misenatium (for the sailors of the Imperial navy from the port of Misenum in charge of the *velum*), the Spoliarium (where the bodies of the dead gladiators were stripped), the Saniarium (the gladiators' hospital), the Armamentarium (the gladiators' armory), and the Summum Choragium (the workshop and warehouse for the amphitheater's complex stage machinery). With the exception of the Castra Misenatium, which was in Region III (probably in the area between the Ludus Magnus and S. Clemente), and the Summum Choragium, also in Region III, these buildings were all in Region II, near the Caelian Hill.

During construction of the modern municipal tax collector's office between the Ludus Magnus and S. Clemente, several rooms of a brick building were

FIGURE 47. Area between the Colosseum and S. Clemente. (After Guidobaldi)

brought to light. This structure, possibly the Summum Choragium, was con-
structed on the ruins of houses destroyed in the Neronian fire of AD 64; they
contained several splendid Republican mosaics, which are kept in the municipal
office, together with later mosaics. The discovery of several inscriptions from
a *compitum* (crossroad shrine) located east of the Ludus Magnus (probably under
the so-called Palazzina Verde Speranza) provides what must be the name of the
ancient street corresponding to the cross street that veers from the present-day
Via Labicana toward the south: Vicus Cornicularius.

S. CLEMENTE The Basilica of S. Clemente rises 400 meters east of the Colos-
seum on Via di S. Giovanni in Laterano. It sits on top of important Roman build-
ings, above which medieval structures were later built (FIG. **43:7**; FIG. **47**). The
location now occupied by the church was almost certainly within the area of
the Domus Aurea. The buildings on which the Christian sanctuary was erected
date, in their first phase, to the Flavian period. The remains are those of two
substantial buildings separated by a very narrow alley: one to the east, on which
the church was built, and another to the west, above which the apse stood. The
plan of the first building is a long rectangle, whose width (running north to
south) is 29.60 meters (100 Roman feet) but whose full original length is un-
known. It is likely, however, that the building extended all the way to the facade
of the church, where an ancient street ran, corresponding to the present-day
Piazza di S. Clemente. The western portion of the building has been suffi-
ciently examined that we can formulate a reconstruction of the entire structure.
What remains of a large external wall on the west, built of Anio tufa blocks,
has no openings; the entrance to the building (probably the sole entrance)
must have been located on the eastern side. The wall rests on a foundation
composed of flint chips supporting seven rows of rusticated ashlar blocks, 0.60
meters thick, finished with a top course of travertine. In front of the western
wall is a kind of travertine sidewalk that was probably installed to protect a
water pipe.

The interior of the complex, almost certainly contemporary with the large external wall, consisted of a series of rooms with partition walls in *opus mixtum* of reticulate and brick with a facade in *opus latericium*. The rooms, largely symmetrical albeit with some variation in the proportions (those on the west are smaller), had concrete barrel-vaulted ceilings. Holes for beams halfway up the walls show that during the building's first phase, the rooms were divided into two floors by the addition of wooden lofts. We know nothing about the central part of the building except that it had a courtyard, probably enclosed by a porticus. Three small rooms on the northern side, at what may have been the wall's midpoint, indicate the presence of a stairwell, some traces of which are extant. Thus, there was an upper story, probably built of brick, unlike the lower story. The level on which the complex sits, certain technical features, and information provided by the excavation allow us to date the building to the Flavian period, more precisely to the reign of Domitian; such a dating accords with the urban development of the zone to the east of the Colosseum.

In a second phase (perhaps second century), the floors of the rooms were raised 80 centimeters and the lofts were removed, as indicated by the thick plaster *(opus signinum)* used both to cover the walls and to fill in the holes made by the beams. The level of the courtyard, on the other hand, was unchanged. Finally, after the middle of the third century the entire building was modified; the first floor, including the courtyard, was abandoned and filled in with rubble after foundation walls were raised within for the construction that was to be built above. Many walls of the new building survive, incorporated into the earliest church; their configuration, however, is not sufficiently clear to enable us to distinguish whether the new structure constituted a radical change of function. Some have argued, for instance, that the changes were made to serve an early Christian community. It is nonetheless difficult to imagine that a public building, as the structure in question undoubtedly was, could have passed into private hands before the age of Constantine. Until evidence emerges that might show otherwise, it is preferable to argue for a continuity of function until the late fourth century.

Any attempt to identify the function that this building might have served should be based on the form of the plan, the structural features, and the evidence of inscriptions in the vicinity. What makes this building practically unique among Imperial constructions is the fact that the external wall was built in *opus quadratum* all the way up to the first story. This feature has often led scholars to date the remains much too early, a dating that is incompatible with the level of the floor and the internal structures. The fact that the interior, which is certainly contemporaneous with the outer wall, was constructed in a different technique (with all the problems of structural stability and the increase in cost that this must have entailed) indicates that the particularly sturdy construction of the external wall was necessary and intended to address the building's particular function.

Equally noteworthy is the absence of entrances within the extant portion of the walls. The likelihood that access to the building was limited to the eastern

side, together with the lack of tabernae on the outside, makes the identification of this complex as *horrea* (warehouses) untenable; such buildings would have required numerous easily accessible entrances. It has been suggested, more plausibly, that the building served an industrial function that required specific security measures (e.g., those found in buildings where slaves were sold or in the *ergastula,* where public slaves were housed, such as those of the *Horrea Galbana*).

A group of inscriptions found in the immediate vicinity of S. Clemente—principally in front of the eastern facade where the entrance of the building probably lay—provides a likely explanation of the complex's function. These inscriptions include dedications to various divinities (Apollo, Hercules, and Fortuna) made by functionaries and *officinatores* of the Moneta (employees of the Imperial mint), all dated to AD 115. We know that under Trajan the process of issuing coins was significantly altered, which would necessarily have involved the mint; the earliest restoration of the building might be linked to this event. The Imperial mint, as we know from the Constantinian Regionary Catalogues, was located near the Colosseum in Region III, having been moved here from its original location on the *Arx Capitolina* under the Flavians—or more precisely perhaps, under Domitian. We know that the ancient *Aerarium,* at the foot of the Capitoline, was destroyed in the fire of AD 80 and was not rebuilt afterward, but was replaced by the Porticus of the Dei Consentes. This event can thus be linked with the relocation of the Moneta to another area of the city. The destruction and reconstruction of the building during the second half of the third century might be connected with the revolt of the mint's workers against Aurelian, which occurred in 274, and with the bloody repression that followed, resulting in, among other things, the Roman mint's suspension of coin production. If the building is, as the evidence suggests, the Moneta—a hypothesis substantiated by a fragment of the Severan Marble Plan in which the mint is shown with features identical to those of the complex beneath S. Clemente—this would explain its peculiarities: the features associated with industrial buildings, the closed appearance of the plan, and the unusually massive scale of the external wall, which would have been designed to protect the precious metals and minted coins within.

The building to the west of the church presents a completely different appearance; the side of the facility that runs north to south (measuring approximately 32.50 meters) is wider than the church's substructure and built entirely of brick. It too can be dated to the reign of Domitian, and more precisely (on the basis of brick stamps) to the emperor's final years (AD 90–96). The structure, however, slightly postdates its neighbor on the east. Moreover, it was preceded by a building that was partially damaged during the fire of AD 64 and had the same orientation but a slightly different plan (perhaps another portion of the Domus Aurea).

The complex consists of a sort of corridor that surrounds an interior courtyard. On the east are four large rooms, two of which preserve a stuccoed vault. A large stairway on the south led to an upper floor, remains of which are preserved

to a height of more than 10 meters, which suggests the existence of a third story. The central courtyard was originally roofed by a low segmental vault pierced by beveled windows that let in light from above; a raised courtyard thus probably lay above this hall.

Following the partial modification of the structure, which involved cutting four doors into the wall and closing up another, the next phase included the installation of the **Mithraeum** (sanctuary of the god Mithras) in the central room. At that time, the walls were covered with thick plaster *(opus signinum)*, evidently to protect the room from humidity.

The function of the building is not at all clear, although it is certain that it was of a public nature, as the presence of the Mithraeum indicates. The most plausible hypothesis is that the building, like others in the area, served the amphitheater; it might have been connected with one of the *ludi* or perhaps the Armamentarium or the Summum Choragium. Remarkable confirmation of this theory is provided by an inscription (*CIL* 6.1647) that, though defective, records the existence of a *procurator Monetae et ludi magni;* that is, a functionary of equestrian rank in charge of the joint administration of the mint and the principal barracks of the gladiators.

The construction of the Mithraeum can be dated to the Severan period, between the end of the second and the beginning of the third century AD. The original doors that led to the room were closed at that time and the vault was decorated with stars, an allusion to the Mithraic cosmology. A niche for a statue of the god and an altar, with the representation of Mithras killing the bull on the front and the two torch-bearers, Cautes and Cautopates, on the sides, were added at the end of the room. As was customary, masonry benches for the celebrants were set along the side walls. Traces of vandalism (perhaps at the hands of Christians) predate the abandonment of the Mithraeum toward the end of the fourth century.

The founding of the Christian basilica, the *titulus* of Saint Clement recorded by various fifth-century sources, must be assigned to between the middle of the fourth century and the beginning of the fifth. The church occupied the eastern building for the most part; an apse reached the upper floor of the structure on the west, some of whose side openings were closed. The choir was fashioned at the juncture of the two preexisting buildings. A room at the side of the apse suggests that it was flanked by sacristies *(pastophories)*. The main body of the basilica had two rows of columns that formed nine arches and divided the space into three aisles. Each arch had its own window, though they were of different forms and sizes. The narthex communicated with the side aisles through wide openings and with the central nave through five archways. An atrium surrounded by colonnaded arcades opened to the east. It is likely that the side aisles had access to the outside through a series of side doors, thus reproducing the plan of the oldest hall. The church was later decorated with frescoes celebrating the legend of the saint and the mysteries of the Christian faith.

FIGURE 48. The Esquiline, western area. **1** Porticus of Livia. **2** Building under S. Martino ai Monti. **3** Building under S. Maria Maggiore. **4** Basilica of Junius Bassus. **5** Macellum Liviae. **6** Nymphaeum of Piazza Vittorio Emanuele. **7** Auditorium of Maecenas. **8** Temple of Minerva Medica.

ESQUILINE

HISTORICAL NOTES

The borders between Regions III, IV, and V of the city as restructured by Augustus are not fully clear (see FIG. 2). Nonetheless, recent ongoing studies have shown that the traditional theory, according to which Region V *(Exquiliae)* corresponded only to that part of the Esquiline that lay outside the Servian Wall, must be rejected. While the southern part of the Oppian Hill—including the Baths of Trajan and the Porticus of Livia—was situated within Region III, the border of Region IV must extend farther west than has previously been thought. On the other hand, Region IV also included the Velia and the entire area of the Forum north of the Sacra Via. In fact, the Regionary Catalogues include the Colossus of Nero, the *Meta Sudans,* the Temple of Venus and Roma, the Basilica of Constantine, the temples of Jupiter Stator and Antoninus and Faustina, and the Basilica Fulvia-Aemilia within Region IV. The Temple of Peace, which gave its name to the whole region, and the *Porticus Absidata,* which is to be identified as the colonnaded exedra tucked away in the small area between the Fora of Augustus and Nerva and the *Templum Pacis,* fall within this region as well. All the rest of the hill inside the Servian Wall—for the most part the Cispian—was part of Region V, thus including a large part of the fourth region of the Servian City that took its name from the hill (Exquiliae). It later extended well beyond the Servian

Wall to include the area around Porta Maggiore—the district *ad Spem Veterem*—and probably the Sessorium palace, thus bordering Regions III and II. The border between Regions V and VI must have run along a continuing stretch of *Vicus Patricius* on the northwest, Via Collatina on the northeast, and a line that connected these two streets on the north, excluding the area south of *Porta Viminalis*, with the barracks of the Third Cohort of the *Vigiles*.

This large district, the most densely populated area of the city after Trastevere, was inhabited quite early. According to one tradition, Servius Tullius was supposed to have included it within the city. It was here that he had his residence, fortifying the exposed eastern side of the hill by means of the *agger*. At that time, the Esquiline constituted one of the four territorial tribes into which the king divided the city, the others being the Palatina, Collina, and Suburana. It is likely, however, that the hill had already been occupied long before the Servian reorganization. The Iron Age necropolis, discovered at the end of the nineteenth century, began to be used in the first decades of the eighth century BC. The very name *Exquiliae* probably signifies "the [inhabited] area outside the city," but at a certain point, it must have become a kind of suburb of the Palatine city.

An embankment that blocked off the Carinae—the slope of the hill facing the Velia—was probably the remains of the Palatine-Velia city's fortification; this is the *murus terreus Carinarum* recorded by Varro (*L* 5.48). The *Tigillum Sororium*, a passageway comprising three beams arranged to form a rustic gate, is thought to have been an entrance into the Palatine-Velia city. In fact, we know its exact position within Region IV—at the point where the modern Via dei Fori Imperiali begins, near the Colosseum—following the fortunate discovery in 1932 of the *Compitum Acili*, a nearby crossroads shrine. The Sacellum of Strenia, from which the original Sacra Via began its course, and the Temple of Tellus, which was associated with the *Praefectura Urbana*, must also have been located nearby.

The layout of the streets in the district is notably complex and particularly unclear in the central part. The Argiletum ran through the northern valley of the Subura on its western flank and, as it reached the peak of the Cispian, split off into two streets: the *Vicus Patricius* on the left (corresponding to the modern Via Urbana) and the *Clivus Suburanus* on the right (corresponding to the modern Via in Selci). The present-day configuration of the roads is informed by the same topography as that in the ancient city, a condition evident today where Via Giovanni Lanza splits off from Via Cavour. Vicus Patricius, which formed the boundary between Regions V and VI, left the city through Porta Viminalis, while the Clivus Suburanus headed toward *Porta Esquilina* (possibly assuming the name *Clivus Esquilinus*), and from here, probably under the name *Via Labicana*, it continued on to the Porta Maggiore, from which point *Via Praenestina* began its course.

Two roads, running from north to south, followed the Servian Wall above and below the *agger (superagger* and *subagger)*. On the outside of the wall, the ancient *Via Merulana* formed another axial line. The course of this road—completely

different from that of its modern counterpart—began at the northern corner of Piazza Vittorio Emanuele and, running south, ended at the Ospedale di S. Giovanni near the Lateran. As was the case on the Caelian, the largest concentration of ordinary residences were grouped on the slopes of the hill and in the valleys, less salubrious than the hilltops, where the wealthy most often built their homes. The best-known working-class neighborhood in Rome was the notorious Subura. The booksellers' shops and the nearby *Horrea Chartaria* (the central paper warehouse) were also concentrated around the Argiletum.

The area between the Velia and Carinae, together with the Palatine, was one of the residential neighborhoods preferred by the Roman nobility at the end of the Republic and the beginning of the Empire. The Carinae was the site of Pompey's house, which later passed into the hands of Marc Antony and finally into the property of the emperors (Tiberius and later the Gordiani lived here). The house of Cicero's brother Quintus stood near the Temple of Tellus. Later, even the emperor Balbinus lived in this area. A large patrician house of the Imperial period was discovered under Via Cavour during construction of the subway.

Julius Caesar lived in a modest house in the Subura before moving to the *Domus Publica* in the Forum after he was elected *pontifex maximus*. Arruntius Stella, the friend of the poet Martial (10.19.6–7) and consul in AD 101, had his home at the summit of the Clivus Suburanus near the *Lacus Orphei*. Maecenas's villa, which extended beyond the *agger*, was on the Oppian Hill. After his death, the house passed into the hands of the emperor, and it was home to Augustus during his illness as well as Tiberius for some time. Later Nero linked it with the palaces on the Palatine by means of the *Domus Transitoria* (House of Passage).

Public monuments were rare on the Esquiline; the majority of these had a purely utilitarian function: the *Macellum Liviae*, the large food market probably located outside of *Porta Esquilina;* the Baths of Titus and the Baths of Trajan; and numerous minor baths and nymphaea. What few temples there were in this district often date back to a very early period—confirmed by the discovery of archaic terracottas at various points on the hill—such as the temples of Diana and Fortuna Virgo, ascribed to Servius Tullius. The Temple of Tellus, founded in 268 BC and restored by Quintus Cicero in 54 BC, stood on the Carinae. Varro (*R.* 3) records that a large painted map of Italy was displayed in this building.

Another important cult, that of Juno Lucina, protector of women in labor, was located on the Cispian; this was built in 373 BC and was surrounded by a sacred grove. An archive recording births was probably kept in this shrine. An inscription with a dedication to the goddess, found at the beginning of Via in Selci (the ancient Clivus Suburanus) near the Church of S. Francesco di Paola, identifies the exact location of the temple. The Temple of Mefitis, a Sabellan divinity probably summoned from Lucania during the course of the third century BC, must have stood on the slope of the Cispian descending toward Via Urbana (Vicus Patricius). A Temple of Minerva Medica is also recorded as having been

located in this area; a rich votive deposit of the fourth and third centuries BC, discovered in 1887 during construction of Via Carlo Botta near Via Merulana, is probably associated with this cult. An inscription bearing a dedication to Hercules, discovered in the vicinity of a pavilion of the *Horti Liciniani*, might suggest the position of the otherwise unknown Temple of Hercules Sullanus. The association of these sanctuaries with the lower classes, which corresponds quite well to the character of the neighborhood, is confirmed by the presence of oriental cults, such as Caelestis (the Phoenician god Tanit), Bellona, and the Egyptian Isis and Serapis; a temple of Isis Patricia stood in the immediate vicinity of the Temple of Minerva Medica. Large foundations in *opus reticulatum* from the end of the Republic can be seen on Via P. Villari; these appear to belong to the temple.

The foregoing discussion principally concerns the western section of the Esquiline, the part that lies within the Servian Wall. The eastern section is, on the other hand, quite different. During the archaic period and during the Republic it was occupied for the most part by a large necropolis, through which roads and aqueducts passed. In all probability, the sanctuary of (Venus) Libitina, tutelary divinity of all functions associated with death, was located in this cemetery, immediately outside Porta Esquilina (Arch of Gallienus). This was the headquarters of the *libitinarii*— (undertakers), where all the materials used in funerals were kept. The temple may have served as the archive of the deceased. Capital punishments originally took place in the vicinity as well.

As Horace records (*S.* 1.8), Maecenas began the reclamation of the cemetery. Little by little, a ring of villas and parks was formed and stretched toward the west, including the eastern part of the Quirinal and the entire Pincian; the latter ultimately assumed the name *Collis Hortulorum* (Hill of Gardens). Beginning with the Julio-Claudian period, all these private parks were progressively absorbed into the Imperial domain. In time, the Imperial villas ended up occupying a vast area of the city, from the *Sessorium* to the *Horti Sallustiani*.

ITINERARY 1

The Oppian Hill

THE DOMUS AUREA During the first years of his principate (between AD 54 and 64), Nero oversaw construction of the *Domus Transitoria* (House of Passage), whose name reflected its function of joining the Imperial possessions on the Palatine with the Gardens of Maecenas on the Esquiline. These two large Imperial properties were in fact separated by a wide expanse of public buildings and private residences. The house was thus situated between the Palatine and the Oppian Hills. The fact that Nero, according to Suetonius (*Nero* 38), witnessed the fire of 64 from a tower in the Gardens of Maecenas—that is, at the eastern edge

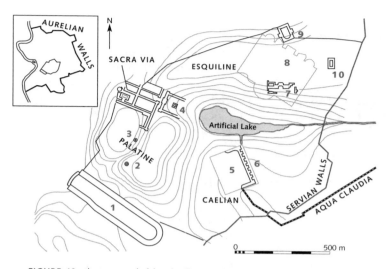

FIGURE 49. Area occupied by the Domus Aurea. The location of the Imperial residence within the Aurelian Walls *(inset on the left)*. **1** Circus Maximus. **2** Circular building. **3** Vivarium. **4** Colossus. **5** Platform of the Temple of Claudius. **6** Nymphaeum. **7** Domus Aurea. **8** Site of the Baths of Trajan. **9** Porticus of Livia. **10** Sette Sale.

of the Domus Transitoria—is significant. The terrible fire must have destroyed much of this residential complex. The emperor then replaced it with another, considerably more vast, construction—the Domus Aurea.

A passage of Suetonius (*Nero* 31) describes the complex's appearance quite precisely:

> The vestibule was large enough to hold a colossal statue of Nero, 120 feet high; the property was so large that it had triple porticoes one mile long and a lake, rather almost a sea, surrounded by large buildings similar to a city. Moreover, the grounds included fields, vineyards and pastures, woods full of every kind of animal, domestic and wild. Everything else was covered in gold, decorated with gems and shells. The dining rooms had ceilings with ivory panels that were moveable and had openings from which flowers and perfumes issued forth. The foremost of these was circular and rotated continuously, day and night, like the earth. The baths had both sea and sulfurous waters. When Nero inaugurated the house at the end of the project, he expressed his satisfaction with the statement that at last he had begun to live like a human being.

The architects commissioned for the work were Severus and Celer; a certain Fabullus (or Famulus) oversaw the painted decoration. We know that Nero

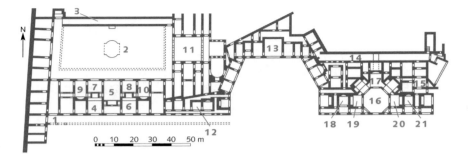

FIGURE 50. Domus Aurea. Plan of the pavilion on the Esquiline.

adorned his residence with a very large number of statues, plundered from all over Greece and Asia Minor, including the famous Pergamene groups representing Gauls (marble copies of the *Gallic Chieftain and Wife* and the *Dying Gaul* from this group are extant). The baroque style of these sculptures suited the taste and ideology of the emperor, as we know from contemporary writers and as is clear from tendencies in the figurative arts and even in the literature that were then emerging; one need only think of Seneca's tragedies. Various authors record the reaction people had to the enterprise that essentially expropriated a large part of the city center. Epigrams such as the following abounded: *Roma domus fiet: Veios migrate Quirites, / si non et Veios occupat ista domus.* (Rome will become a single house. Move to Veii, Romans; that is, unless this house is taking over Veii as well!)

The following is an approximate reconstruction of the full extent of the Domus Aurea. The property ran from the Palatine and Velia (where the vestibule was, on the spot later occupied by the Temple of Venus and Roma) to the edge of the Oppian—near S. Pietro in Vincoli—along the modern Via delle Sette Sale; from there it continued east along the Servian Wall to the Caelian, where the Temple of Claudius, transformed into a nymphaeum by Nero, marked its southern end; from here it returned to the Palatine and included the whole valley in which the Colosseum would one day stand (Nero constructed a lake on the site) (FIG. **49**). Of this enormous complex, which must have resembled a huge villa more than a palace, all that remains is a narrow section on the Oppian Hill (approximately 300 meters long by 190 meters wide); this was preserved only because it was incorporated within the foundations of the Baths of Trajan. Additions and restorations can be observed in what survives and confirm the tradition that Otho and possibly Titus added the final touches to this part of the house, which continued to be inhabited until its destruction by fire in AD 104; the Baths of Trajan were built above the ruins.

A quick glance at the plan reveals a clear difference between the two parts of the surviving structure (FIG. **50**). The western part is a self-contained segment

that is organized around a large rectangular courtyard; two wings, perpendicular to one another other (only the beginning of the western wing survives), with a porticus along the facade, appear to have enclosed a courtyard that was open toward the valley of the Colosseum on the south. This complex of rooms, with its simple classical plan marked by perpendicular axes, is flanked on the east by another unit that is organized around a considerably more ornate floor plan; its rooms are arranged around a large polygonal recess that is itself followed by yet another section in which rooms radiate from an octagonal room. The clash of style in the plans becomes particularly obvious at the point where they meet and have to merge. If these two sections were part of an original homogenous plan, the resulting creation of these very irregularly shaped rooms is difficult to explain. Evidently, then, the eastern part was added later.

To reach the modern entrance to the site, it is necessary to follow the large brick apse with brackets that supported an external balcony; this belonged to the exedra of the Baths of Trajan. At the rear of the apse, a small stairway provides entrance to a room that is, broadly speaking, triangular (FIG. **50:1**). The wall through which one enters and the one on the right belong to the Baths of Trajan, while those at the end and on the left, also of brick but originally clad with marble in the lower segment and decorated with paintings above, are situated along a different axis and belong to the Domus Aurea. The bases of two columns and a pier can be seen on the ground; this is all that remains of the porticus in front of the house. The columns, all the wall decoration and marble floors, and whatever else could be salvaged, were removed, probably during the construction of the Baths of Trajan, where they must have been reused. The Domus Aurea probably remained accessible and was used as an underground service area for the baths.

A large courtyard **(2)**, with a porticus on three sides (south, east, and west), occupies the rear portion of the house; a cryptoporticus **(3)** stands on the northern side, supporting the embankment at the back. At the center of the courtyard, which is now subdivided into a series of vaulted rooms supporting the construction of the baths above, stood a fountain basin.

A series of rooms in double file—some opening onto the porticus, the others toward the internal courtyard—form the southern side of the house, which is perfectly aligned according to the cardinal points. The western side has rooms with access to each other as well as to the internal courtyard. On the third side, facing the east, there is a large nymphaeum **(11)** on axis with the courtyard that it faces. This constitutes the building's focal point on this side.

The most important group of rooms in this section, that on the south, is divided into two apartments by a double central hall **(5)**, which lies on the center of the north-south axis. Alongside this hall and opening onto the exterior porticus are two rooms with alcoves **(4, 6)** that have been plausibly identified as the *cubicula* (bedrooms) of the Imperial couple. The two doors on either side of the alcoves lead to minor rooms **(7, 8)**, each in turn flanked externally by rooms

that end in an apse **(9, 10)**; the remains of brick bases, probably for statues, can be found within these.

These rooms, now dark and humid, had a much different appearance in antiquity, when large doors, subsequently walled in for the construction of the baths, exposed them to the light that entered from the porticus in front. The view of the valley with its artificial lake and the gardens that surrounded it could be enjoyed from this vantage point. A close look at the walls in the principal rooms will reveal that the original marble slabs that dressed the lower part were removed. The few fragments of painting that have survived, together with drawings made by the Renaissance artists who saw more of the original, give us an idea of the exceptional level of the decoration. Many of these artists came to these grottos for inspiration—a fact that gave rise to the term and idea of the "grotesque"—and often left their signature here. Of particular note, remarkable stretches of painting (unfortunately in the process of disappearing completely) survive on the vault of the apsidal room on the east **(10)**, of the so-called Sala della Volta Gialla **(8)**, and of the central room (**5**, the Sala della Volta delle Civette); some remains are also preserved in one of the rooms with alcoves (**6**, the Sala della Volta Nera). All the paintings reveal the hand of an artist of some talent. In fact, some have identified this artist as the Fabullus whom Pliny the Elder described as unusually formal during his work on the Domus Aurea—even to the point of wearing his toga on the scaffolding—and the style as *floridus et humidus* (*NH* 35.120). *Floridus*, Pliny states, refers to his use of the colors blue, blood red, grass-green, indigo, yellow-gold, and white lead; in short, all the colors that dominate these pictures. *Humidus*, on the other hand, indicates the softness and fluidity of the touch.

The luxurious **rectangular nymphaeum** to the east of the large courtyard **(11)**, discovered recently, was restored immediately after its discovery and is fortunately in better condition. The room—unfortunately divided in two by a foundation wall of Trajan's Bath—has a porticus of four columns on the two sides, east and west; east of this lies the nymphaeum proper, a small vaulted room with three windows per side, which originally opened onto side courtyards, and a cascading fountain on the back wall, whose waters collected in a central basin. An impressive mosaic ran along the walls of the nymphaeum, the corridor, and the room in front. The mosaic, however, had already been removed in antiquity; all that remains are outlines, framed by a line of shells.

The lower part of the walls was originally revetted in marble. The decoration of the vault, 10.2 meters above the ground level, is partially preserved. The background consisted of a layer of pumice, burnt sienna in color, in which four corner medallions surrounded a central octagonal medallion; only the latter preserves remains of the original mosaic decoration, depicting Polyphemus receiving the cup of wine from Ulysses (it may have been left in place after having been damaged in the attempt to remove it). The same chromatic richness still

evident in the paintings and the same colors—those characterized as *floridi*—can be found here as well.

Viewed from the courtyard, the effect must have been extraordinary. The superimposition of levels enhanced the impression, albeit illusory, of distance, ending in the hazy light that streamed in from the lateral windows in the nymphaeum and illuminated the mosaics and water displays. Here is a remarkable example in the development of the ancient baroque and illusionistic style that originated in the Hellenistic period and was revived and further elaborated in the Neronian and Flavian periods.

Exploration of the group of rooms south of the nymphaeum that formed the building's facade **(12)** uncovered the remains of **Republican houses,** buried by the Neronian structures. These preserve interesting floors in mosaic and *opus signinum,* as well as some fragments of painted decoration in the First Style. This, together with the fact that the walls were constructed in *opus incertum,* dates the houses to the second century BC.

The rooms behind the nymphaeum reveal the infelicitous connection made between the two complexes. The character of the painted decoration is quite different from that of the preceding section, and represents the height of the Fourth Style, characterized by architectural fantasies, a theatrical tendency for the layering of planes, and fusion of colors. The most compelling comparisons are with Pompeian paintings made before the eruption of AD 79. The level of decoration is altogether modest when compared with that in the other part of the building. This can be explained in part by the fact that the best-preserved rooms on the northern side (for example, the cryptoporticus **[14]**) belonged to a service wing. Thus, the decoration of room **13,** on axis with the pentagonal courtyard, is of a much higher level. This is the famous Sala della Volta Dorata, which is, unfortunately, only partially preserved but of which there remain Renaissance sketches.

To the east of the Sala della Volta Dorata lies the large cryptoporticus **(14)** that serves the same function as the cryptoporticus in the western section **(3).** The painted decoration, restrained and tentative but well preserved, is a simplified variation of the Fourth Style. Halfway along the corridor, a sloping arch supports an aqueduct that brought water to a large nymphaeum **(17).** Even the rooms at the eastern end of this section **(15)** have wall paintings that are in a good state of preservation. The second focal point of the wing is the octagonal room **(16)** roofed with a dome that passes from octagonal to spherical without the use of pendentives. The very clever design of the walls, which appear almost nonexistent because of the spacious openings, and the radial arrangement of the surrounding rooms make this complex a masterpiece of Roman architecture. The contrast between these animated spaces, which are articulated in a dynamically varied fashion, and the more traditional rooms of the western wing is quite marked.

The nymphaeum **(17)** was installed in the apsidal room, serviced by water that entered from the back wall, passing first above the corridor **(14)**. Rooms **18, 19, 20,** and **21** have preserved some of their decoration. In particular, the apse and vault in room **18,** excavated during the twentieth century, contain stuccos that are admirable to this day; a wall painting in the center of the vault illustrates the myth of Achilles among the daughters of Lycomedes. The type of decoration here, as well as in its symmetrical counterpart **(21)** and in the other rooms of this wing, is entirely consistent with that of the Sala della Volta Dorata.

In sum, the two parts of the Domus Aurea, viewed from both their architectural and decorative schemes, attest to two different stylistic spheres. Pliny the Elder, who reports that he saw the *Laocoön* in the *Domus Titi,* might provide an explanation. This statue, as is well known, was found at the beginning of the sixteenth century in the Baths of Trajan near the Sette Sale. If, as is likely, a large part of the decoration of the building beneath the bath complex was carefully removed and reemployed in the baths, should we not assume that the same thing happened in the case of a work of art that was so much more valuable? The section of the Domus Aurea that reveals so many alterations subsequent to Nero might thus be identified as part of the Domus Titi. Another explanation that does not preclude the first, however, seems preferable; namely, that the western wing of the Domus Aurea is a section of the Domus Transitoria. In fact, the latter, which fashioned a link between the Palatine and Esquiline, must have been located more or less in the vicinity of the Oppian Hill, very close to the *Horti* of Maecenas. Deep excavations in this area have not revealed the remains of any other buildings from the beginning of the Empire, but only of Republican houses. In the case of the Domus Aurea, on the other hand, we should expect to find two successive Neronian phases. Accordingly, one possible reading of these remains would identify the western section of the complex as a part of the Domus Transitoria and the eastern addition as a section of the Domus Aurea, while the successive restorations, which are concentrated especially around the nymphaeum of Polyphemus and show that the building continued to be used up to the fire of AD 104, would be ascribed to the Domus Titi.

Other remains of the Domus Aurea, found on the Oppian farther to the east and located in Region IV, are discussed below.

BATHS OF TITUS AND BATHS OF TRAJAN A plan by Palladio is the only document that gives us a general idea of the baths that Titus built in short order and dedicated in AD 80. The only visible remains are some brick piers with engaged columns north of the Colosseum. The building, approached by a grand stairway on the side facing the amphitheater, was not large. It shared exactly the same axis as the remains of the Domus Aurea, which bordered it to the east. This orientation, together with the speed with which the work was completed, as the poet Martial emphasized, suggests that the building was

merely a renovation or adaptation of a bath complex of the Domus Aurea mentioned by Suetonius. Such an interpretation well suits the Flavian political program of restoring Neronian buildings to public use.

The plan is typical of the great Imperial baths of Rome, which were characterized by a symmetrical duplication of rooms arranged around an axis, at the center of which stood a basilical hall as the main focus. Nero's architects probably developed this form. In fact, the first example of this type of construction was the Neronian bath complex in the Campus Martius. It is difficult to imagine that the plan of this complex was completely transformed in the reconstruction of Alexander Severus.

The Baths of Trajan, considerably larger and built in part on the remains of the Domus Aurea after the fire of AD 104, assumed a completely different orientation. The change, not an easy one to implement, can be explained almost certainly by the quest for a more favorable position in relation to the sun and prevailing winds. In this configuration, the *caldarium* would have captured the greatest amount of solar heat between noon and sunset. All the great Imperial baths—those of Caracalla, Diocletian, and Decius—have the same orientation. The influence of the previous Neronian layout, however, emerges at various points, particularly where the Trajanic complex assumes an orientation along the cardinal points similar to that of the Domus Aurea (for example, the cisterns of the baths, the so-called Sette Sale) (FIG. **51**).

Contrary to what late sources report, Domitian does not seem to have initiated the complex; the work is entirely Trajanic, begun after 104 and inaugurated on 22 June AD 109. Brick stamps found throughout the construction fully confirm these dates. The project has unreasonably been attributed to Rabirius; on the contrary, we know from Dio Cassius (69.4.1) that the architect was Apollodorus of Damascus, who designed Trajan's Forum. Other sources affirm that the building extended as far as the Gardens of Maecenas.

The complex, whose area measured at its maximum ca. 330 × 315 meters (the central part alone measured 190 × 212 meters), is the first fully executed example of the great Imperial bath, combining a large enclosure with exedra and a central bathing facility, a feature that would later be imitated in the Baths of Caracalla and Baths of Diocletian. The enclosure must be the porticus of the Baths of Trajan that literary sources mention. Fragments of the Severan Marble Plan, in addition to the sparse remains on the Oppian Hill, allow us to reconstruct the building's plan in its entirety.

A large propylaeum situated on the north (FIG. **52:1**) served as the entrance to the facility, giving access to the *natatio* (cold water swimming pool) **(2)**. From here one could turn left or right, as the plan was identical on both sides. After passing a large rotunda with four niches **(3)** and one of the two *palaestrae* **(4)**, the visitor reached the *caldarium* **(5)**, a rectangular hall with three apses, projecting beyond the main body of the building (the same plan is repeated in the Baths of Diocletian). The bath proper began here, with the bather passing from the

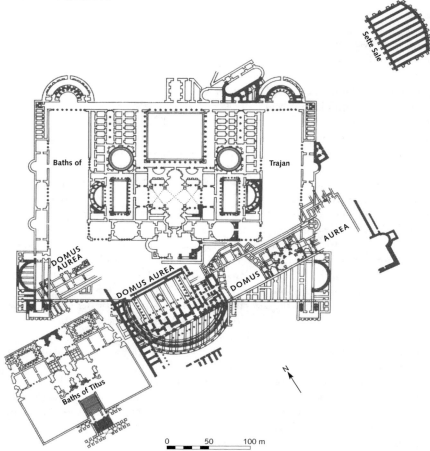

FIGURE 51. Position of the Domus Aurea with respect to the Baths of Titus and Baths of Trajan.

caldarium to the *tepidarium* **(6),** through the large central basilica **(7),** and back again to the *natatio* and from here to the exit.

The remains that are still visible in the Parco Oppio are as follows: an exedra **(8),** which should be identified as a nymphaeum; a hall with two apses **(9)** on the northeastern corner that lies along the same orientation as the Domus Aurea; some rooms and another exedra of the eastern enclosure **(10);** the exedra corresponding symmetrically to that on the western side, which has been restored and identified as a library **(11).**

Of the central core of the facility, there remains the exedra of the eastern *palaestra* **(12)** and, not far from this, the apse of a hall on the south **(13),** where

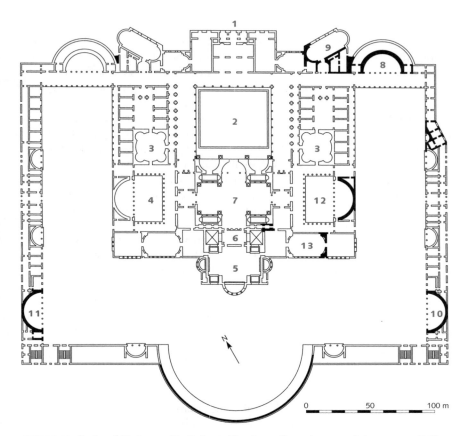

FIGURE 52. Baths of Trajan. **1** Vestibule. **2** Natatio. **3** Rotunda. **4,12** Palaestrae. **5** Caldarium. **6** Tepidarium. **7** Basilica. **8** Exedra-Nymphaeum. **9** Hall with two apses. **10,11** Libraries. **13** Hall.

a modern plan of the baths, incised in marble, is displayed. Mention should also be made of the load-bearing structures of the large southern exedra belonging to the enclosure that covered the façade of the Domus Aurea, as well as the facility's imposing cistern, the so-called Sette Sale, on the opposite side of Via delle Terme di Traiano.

The cistern is a two-story rectangular building (the lower story serves only as support for the upper one), divided into nine large interconnecting chambers, with the curved back wall resting on the hill. The chambers, long and narrow, connect with one another through nonaxial openings. The façade is decorated with niches, alternately rectilinear and curved. Excavations in 1967 and 1975 revealed that the upper part of the cistern was transformed into a rich fourth-

century *domus*, preceded by another in the second century. A large apsidal room and a hexagonal hall, off which other apsidal and circular rooms open, are among the distinguishing features of the house. The remains of the rich marble floors and of the *opus sectile* decoration in the walls of the apsidal room evince similarities to the Basilica of Junius Bassus and to the hall in the house outside of Porta Marina in Ostia.

A **nymphaeum** built in the form of a basilica—three aisles, an apse, and a courtyard in front—has been preserved near the intersection of Via delle Terme di Traiano and Viale del Colle Oppio. The original construction, probably Neronian, lies considerably lower than the modern level of the park (it is reached by a modern stairway); given its location, this was probably a part of the Domus Aurea. A complete rebuilding of the structure was probably undertaken under Trajan in connection with the construction of the nearby baths, as can be deduced from the brick stamps.

The Porticus of Livia lay in the area between Via in Selci (the ancient Clivus Suburanus) and Via delle Sette Sale (FIG. **48:1**). The only evidence we have for this structure comes from the Severan Marble Plan; there are no visible remains in the area. The building, approximately 120 meters long and 95 meters wide, assumed the form of a large rectangular piazza surrounded by a double porticus. One of the short sides was adjacent to the Clivus Suburanus. A stairway provided access to the porticus from the street, which was situated on a different level. The walls of the porticus contained niches. Recent excavations have demonstrated that the destruction of the monument must have been nearly total.

A rectangular structure occupied the center of the piazza, which had four-lobed fountains at each of its corners. Its plan and dimensions show a remarkable resemblance to the *Ara Pacis*. In all probability, this was the Ara Concordiae that Ovid (*Fasti* 6.637 ff.) records in conjunction with the porticus. Augustus erected the porticus between 15 and 7 BC in honor of his wife, Livia (who was closely associated with the cult of Concordia), reclaiming the area from the splendid house of Vedius Pollio, which had been willed to the emperor and was eventually torn down to illustrate the need to hold luxury in check.

ITINERARY 2

From the Porticus of Livia to the Hypogeum of the Aurelii

Just beyond the Baths of Trajan lies an area that, although not rich in monumental buildings, is of considerable interest as evidence of Rome's urban development. A group of fragments of the Severan Marble Plan offers a partial view of the area in question, situated between Regions IV and V, and shows that this was a typical working-class quarter, extremely irregular, with winding alleys and modest homes, among which one finds the occasional aristocratic *domus*.

On Via degli Annibaldi, almost at the intersection with Via Nicola Salvi and on the right from the direction of the Colosseum, a small metal door (the key is kept at the office of the X Ripartizione del Comune) provides access to a **nymphaeum,** discovered in 1894 and partially cut by the street. It consists of an apse, which was inserted into a rectangular room, and a water tank. Moreover, the room was cut in turn by Imperial foundations (probably belonging to the Domus Aurea). Four of the nine original niches are extant. The entire facade of the apse is decorated with architectural and pictorial motifs (lozenges, shields, and armor) fashioned out of pumice and shells. The construction of the wall in *opus reticulatum* using very small tufa blocks dates it to the Republican period (circa 50 BC). The nymphaeum probably belonged to a *domus* that was destroyed for the construction of Nero's palace.

From here, Via della Polveriera leads to Piazza di S. Pietro in Vincoli. The area occupied by the *Praefectura Urbis* must have extended all the way to this point, as the inscriptions found in the vicinity suggest. Nearby inscriptions also situate the *Curia Athletarum,* the association of Greek athletes, in what is now the garden of S. Pietro in Vincoli.

During the renovation of the floor of S. Pietro in Vincoli between 1956 and 1958, the remains were found of a **house dating to the middle Republic** (fourth to third century BC); at least three phases of further construction have been documented above it. The first of these includes the remains of two houses dated to the end of the second century BC, containing splendid pictorial polychrome mosaics. These homes, possibly rebuilt during the last years of the Republic, were subsequently replaced by a large *domus,* of which there remains a porticus with a fountain and garden, in addition to a few spacious rooms. The Neronian date of this building associates it in all probability with the Domus Transitoria and Domus Aurea, for both of which this must have been the northernmost end. The discovery of the older houses confirms the literary tradition that homes belonging to the aristocracy stood in the area between the Velia, Carinae, and Esquiline during the Republic. Moreover, these ruins confirm (as do the remains under the principal section of the Domus Aurea) ancient writers' reports of Nero's expropriation of property.

To reach the junction of Vicus Patricius (Via Urbana) and Vicus Suburanus (Via in Selci), which skirted the two sides of the *Cispius* (where the Temples of Juno Lucina and *Mefitis* were located), it is necessary to go along Via delle Sette Sale, to the left of S. Pietro in Vincoli, and through the stairway that leads to Largo Venosta. Via in Selci has preserved much of its ancient character. Where the street enters Piazza di S. Martino ai Monti, immediately beyond the Church of S. Lucia, a large **ancient brick facade,** on the right, has been preserved up to the second story (FIG. **48:2**). The lower part consists of a series of rough pillars in travertine (one of them carved with a Priapus), originally spanned by lintels and surmounted by relieving arches, which formed five openings (probably shops). Still visible 7 meters above these are five large rounded windows, which were

subsequently closed up and replaced by smaller rectangular ones. It is believed that this was the older Basilica of S. Martino, built in the fifth century AD and subsequently moved farther east, where it now lies. It is more likely, however, that the building, given its similarity to the Library of Agapitus on the Caelian, was a public basilica, dating to the third or beginning of the fourth century AD. It was probably turned into a church during the course of the seventh century. These churches—S. Martino and S. Lucia—were distinguished by the toponym *in Orphea.*

The Fountain of Orpheus *(Lacus Orphei)* was once thought to have been located somewhat far from here; in fact, it was in Region V, which was mistakenly believed to lie completely outside the Servian Walls. Recent studies have shown that part of Region V in fact lay inside the walls and included the area around the Church of S. Martino ai Monti, near which we can thus locate the fountain. It must have been located at the end of Via in Selci in Piazza di S. Martino ai Monti, between the two towers of the Capocci and Cantarelli. A representation of the fountain might be preserved on the Severan Marble Plan, which shows three adjacent circles, the central one larger than the two flanking, indicating a complex of basins. Martial described the whole area in an epigram (10.20) in which he indicates the street that leads to the house of Albinovanus Pedo. The fountain, located at the summit of Clivus Suburanus, was decorated with statues that represented the myths of Orpheus and Ganymede.

Recently, a large circular enclosure made of tufa slabs, probably dating to the sixth century BC, was discovered in the area between Palazzo Brancaccio, Viale del Monte Oppio, and Via delle Terme di Traiano. It is represented in a fragment of the Severan Marble Plan, which proves that it was still visible and important at the beginning of the third century AD. All this suggests that this was an **archaic tomb,** possibly the one believed to have been the final resting place of Servius Tullius.

The outside wall of the Church of S. Martino ai Monti on the east rests on a foundation of Grotta Oscura tufa blocks, which may have been appropriated from a tract of the nearby Servian Wall. At the end of the nineteenth century, some interesting **Iron Age tombs** were discovered in the immediate vicinity.

Inside the church and past the crypt (facing west) is an interesting building, dating to the first half of the third century AD, that consists of a large central hall, 11 × 18 meters, divided by piers into two wings three spans long; these were roofed with cross vaults. On the southwest is a vestibule that opened onto the street—the Clivus Suburanus—through three large doors. The extant stairs indicate that this was an upper floor. The vault of the vestibule still shows traces of painted decoration; copies made in the seventeenth century provide a better idea of the artwork. The building was probably transformed subsequently into the Church of S. Silvestro, but it is doubtful that this was, as some have argued, the seat of the older *titulus Equitii,* where Christians of the district met. The corner of the building is shown on the Severan Marble Plan.

The remains of another building (now difficult to visit) were found to the east of the church in 1885 during the construction of Via Giovanni Lanza. Inside, excavators found a *lararium* with a statue of Fortuna and several statuettes of various divinities, still in their original position within niches; these are now on display in the Capitoline Museums (in the rooms dedicated to eastern cults). From here, two flights of stairs descended to a **Mithraeum.** A few years later, in 1888, an even more interesting discovery was made on the other side of the street. The remains, which can be reached from the main door at Via S. Martino ai Monti no. 8, include a **marble altar,** resting on a high podium and preceded by a kind of platform, built of tufa blocks, that was originally dressed with marble slabs. Approach to the structure was made along two side stairs. Built up against the back side is a nucleus of travertine blocks on which column drums of the same material, evidently reused, have been mounted. The relationship between the various parts of the small monument is not clear, but the meaning of the inscription on the marble base, evidently intended to support a statue, is unequivocal:

> *Imp(erator) Caes(ar) Divi f(ilius) August(us) / Pontif(ex) maximus, co(n)s(ul) XI / tribuni-*
> *cia potest(ate) XIIII / e stipe quam populus Romanus / K(alendis) Ianuariis apsenti ei con-*
> *tulit / Iullo Antonio Africano Fabio co(n)s(ulibus) / Mercurio Sacrum* (The emperor Caesar,
> son of Divine [Julius], Augustus, Pontifex Maximus, consul for the eleventh time,
> invested with Tribunician power for the fourteenth time, from the money that the
> Roman people conferred on him in his absence on the first day of January during
> the consulship of Iullus Antonius and Fabius Africanus [erected this monument]
> sacred to Mercury).

The inscription identifies Augustus's monument, erected in 10 BC, as a *compitum;* that is, a crossroads shrine. We know from Suetonius (*Aug.* 57) that the practice of dedicating these small monuments was quite common. The statue of Apollo Sandaliarius, evidently dedicated in a quarter where shoe merchants worked, is recorded among these monuments; the statue gave its name to a street in Region IV, where the *compitum* was apparently located, probably near the Temple of Tellus.

In 1847, on the other side of the Cispian, alongside Via Cavour (then called Via Graziosa) and just before the intersection with Via Quattro Cantoni, the famous **paintings of episodes from the *Odyssey*** (now in the Vatican Museums) were discovered in a building datable to the middle of the first century BC. According to one suggestion, the structure might have belonged to the *domus* of the Papirii; the Temple of Mefitis also must have stood in the vicinity. Slightly north of here, still along Via Cavour, work on the Metropolitana in 1940 brought to light a **large patrician house** of the Hadrianic period; its atrium contained a monumental fountain embellished by, among other objects, two copies of the *Pothos* by Scopas, now on display in the Capitoline Museums.

Along the southern side of Via Urbana, to the right as you go up the hill, is the little Church of S. Lorenzo in Fonte. To the left of the nave a stairway leads to a Roman well, 18 meters southeast of the church. The well has a facing of *opus reticulatum* datable to the Republican period; the house to which it belonged was documented in 1684 on the northern embankment of the Oppian Hill, and a drawing by P. Sante Bartoli records the building, which contained a nymphaeum in *opus reticulatum* with a wall mosaic composed of shells, a porticus above it, and the remains of an aqueduct. This house is located a little to the west of the one containing episodes from the *Odyssey* and dates to the same period.

The Church of S. Maria Maggiore occupies the summit of the Cispian. Until a few years ago, almost nothing was known about the configuration of this area in antiquity, but excavations conducted here between 1966 and 1971 have fortunately provided important information on the topography of this region of the Esquiline (FIG. **48:3**). Six meters below the floor of the basilica, there appeared sections of a building, which was essentially composed of a **large courtyard with a porticus**—37.3 meters long and 30 meters wide—off of which there were a few rooms; the entrance was located on the side of the basilica's apse. The structure of the walls, the floors, and the bases of the columns have been assigned, unpersuasively, to the Augustan period. At a certain point, the marble decoration of the walls was removed and replaced, on the walls of the long sides, by a painted calendar, interspersed with scenes representing agricultural tasks associated with the relevant months. Although mostly ruined, these pictures, whose motifs have affinities with the art of Roman Africa, are among the finest examples of late Imperial landscape painting. Features of the calendar establish its date as subsequent to the Tetrarchy but not later than the third quarter of the fourth century, when the paintings were covered by a decoration of imitation marble. The landscapes may be viewed most plausibly as Constantinian in date; a calendar of 354 that has come down to us through late copies closely resembles this one and likely derives from the same models.

It has been argued that this building is the Macellum Liviae, the market inaugurated by Tiberius in 7 BC and dedicated to his mother, but this identification must be rejected. Although we now know that the area around S. Maria Maggiore fell within Region V (and not Region IV, as was once thought)—a fact that has been adduced to support the building's identification as the Macellum Liviae (sources situate this market in Region V)—other features suggest a different conclusion. The oldest phase of the building, that in *opus incertum*, dates to the second century BC, while the principal rebuilding appears to be Hadrianic. The plan and small scale of the structure, moreover, do not correspond to those of a *macellum*. This last factor in particular favors the association of this market with the remains of a large building (80 × 25 meters), in brick and *opus reticulatum*, that was excavated at the end of the nineteenth century immediately outside of Porta Esquilina (FIG. **48:5**). In fact, the Church of S. Vito, near this gate, is described as *in Macello Liviae*. The Macellum Liviae was probably located

near the Forum Esquilinum, situated most likely on the Cispian within the Porta Esquilina; information regarding the forum comes from several inscriptions set up by merchants in the area.

The building under S. Maria Maggiore probably belongs to a large late antique estate that occupied a good portion of the surrounding area; on the basis of numerous pieces of epigraphical evidence found nearby, this property can be associated with the important family of the Neratii.

The **Basilica of Junius Bassus,** built by the consul of the same name of 331 and transformed during the fifth century into the Church of Sant'Andrea Catabarbara, was located a short distance from S. Maria Maggiore, where now the Seminario Pontificio di Studi Orientali (at Via Napoleone III, no. 3) is housed (FIG. **48:4**). The basilica was a simple rectangular structure with an apse, entered through a narthex with rounded ends, whose interior surface was covered with beautifully figured marble inlays. Fragments of these are now in the Museo dei Conservatori, and others are displayed in the Museo Nazionale Romano, now located in the Palazzo Massimo. All that remained of the building was demolished once and for all after its rediscovery in 1930. On the same occasion, walls of an Augustan house were found, showing evidence of later reworking, including mosaic decoration; one of these mosaics features Dionysian themes, while another contains an inscription with the names of the owners: the Arippi and Ulpii Vibii. The mosaics, datable to the third century AD, were removed and are now displayed in the main office of the Seminario.

Following Via Carlo Alberto from the facade of S. Maria Maggiore, a fragment of the Servian Wall, comprising blocks of Grotta Oscura tufa, can be seen embedded in the second city block on the right. The line of the wall lies at an oblique angle with respect to the course of the modern street. A right-hand turn onto the very next lane, where the little Church of S. Vito is located, leads to the **Arch of Gallienus** (FIG. **53**), which follows the same orientation as the Servian Wall into which it was inserted. This was one of the gates of the oldest city wall, the Porta Esquilina, reconstructed in its entirety by Augustus. The inscription, with the dedication by M. Aurelius Victor to Gallienus and his wife Salonina, inscribed on the cornice beneath the attic, is a later addition. The original Augustan inscription must have been located on the attic, where traces of an erasure are still visible.

The structure of the arch is more visible on the city side of the gate, which is not so crowded in by neighboring constructions. Almost square in form, the gate is decorated only by simple cornices and Corinthian pilasters at the corners. Traces of a minor entrance that rested against the central one can still be seen on the left; the same arrangement must have been repeated on the other side. The gate thus would have had three entrances, similar to *Porta Trigemina,* which served the area around the Forum Boarium. Recent excavations under the Church of S. Vito have unearthed remains of the oldest city wall in cappellaccio (dating to the sixth century BC); this has a different course from that of the fourth-century

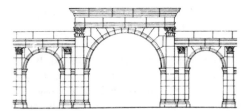

FIGURE 53. Arch of Gallienus (Porta Esquilina).

BC Grotta Oscura wall, a section of which can also be seen here. Remains of the *Anio Vetus* aqueduct have also been identified.

The most important archaic necropolis of Rome was excavated at the end of the nineteenth century outside this gate. Close to the wall and under the buildings on Via Carlo Alberto, two **painted tombs** of the middle Republic were discovered, whose paintings are included, along with a large portion of the finds from this area, among the city collections. The oldest of these, dating to the beginning of the third century BC, belonged to the Fabii, as the inscription on a fragment of the surviving painting attests. This may be the tomb of Q. Fabius Rullianus, the hero of the Second Samnite War. It is likely that these exceptional painted tombs, which were probably near the *Lucus Libitinae*, were erected at public expense, granted by the Roman state to individuals whose service to the Republic was exceptional. In fact, Cicero (*Phil.* 9.17) informs us that public tombs were generally erected in the *Campus Esquilinus*, which was located immediately outside the gate of the same name.

Via Carlo Alberto runs all the way to Piazza Vittorio Emanuele; a right-hand turn in the direction of Largo Leopardi leads to the so-called Auditorium of Maecenas.

THE VILLA OF MAECENAS AND THE OTHER PARKS OF THE ESQUILINE The discovery of the Auditorium of Maecenas occurred by chance in 1874 in the course of opening the new Via Merulana and the adjacent Largo Leopardi (in the area previously occupied by the Villa Caetani) (FIG. **48:7**). The apsidal hall that was brought to light (only to be immediately demolished) was part of a much larger complex that straddled the Servian Wall. The complex's so-called Auditorium, however, was preserved—an apsidal hall, 24.2 meters long, in which four sections can be distinguished: a kind of vestibule on the southeast that has the appearance of a rectangular room (13.2 meters wide and 5.7 meters long); the hall proper (10.5 meters wide and 13.2 meters long); the stepped exedra (radius 5.3 meters); and, finally, the double entrance ramp on the southwest (2.27 meters wide). The complex, which even in antiquity was partially underground, is constructed entirely in *opus reticulatum* of rather small tufa blocks (6.5 cm) and is thus relatively old. Three entrances provided access to the vestibule:

the one on the south, still in use, opened onto the ramp, and the other two connected the hall with the surrounding rooms. One of these stood opposite the first, on the east, and the other was located in the middle of the facade, on the southeast, and connected to a flight of stairs; both of these were closed after the excavation. To judge from the thickness of the walls (1.93 meters), the roof must have been vaulted. There may have been openings in the roof, as the remains of window glass found at the time of the excavation would suggest. Only the vault and the top of the walls would have been visible from the outside.

Six deep niches punctuate the walls of the central hall on each side (some ancient restorations in brick can be observed among them). The pictorial decoration, very well preserved at the time of its discovery, has partially faded. The walls are painted in red; above the niches runs a frieze with a black background, 27 centimeters high, with figures of animals painted in lighter colors. The niches' interiors were decorated with realistic representations of gardens. In the western corner of the hall there were two successive floors: the original floor consisted of a fine mosaic with two red stripes; the later one consisted of giallo antico and gray marble slabs. An enlargement of the exedra in brick sits above the second pavement and thus postdates it.

The **exedra** is occupied by seven very narrow steps, the lowest of which begins 1.1 meters from the floor. As mentioned above, it was enlarged later by a brick wall, 80 centimeters wide. The steps were originally clad with cipollino, traces of which remain. Above the steps are five niches, less deep than those of the main hall, but similarly decorated with pictures of gardens; under these runs a frieze that depicts animals and hunting scenes on a black background, continuing the theme of the hall. The upper section of the hall and exedra were both decorated with broad landscapes and slender candelabras entwined in vegetation.

The building's earliest phase can be dated to the end of the Republic, while the Third Style pictorial decoration (similar to that of Livia's villa at Prima Porta) dates to the second phase: high Augustan. The complex can be identified with certainty as part of the Villa of Maecenas on the Esquiline. We know from Horace and his commentators that the cemetery for the poor, which occupied this area of the Esquiline and was long considered unhealthy, was appropriated for the construction of this villa, and that the *agger* of the Servian Wall was partially leveled in the process. In fact, several blocks of Grotta Oscura tufa from the Republican wall are still embedded in the front of the building facing Via Leopardi. Even the date of the building's construction coincides with evidence that dates the foundation of Maecenas's villa to the same period (between 40 and 30 BC). The identification is definitively confirmed by the discovery near the building of a lead water pipe bearing the name of Cornelius Fronto—a famous rhetoric teacher who acquired the *Horti Maecenatis* as a gift from the emperor Hadrian. At his death, Maecenas had left his villa to Augustus. The

installation of the Third Style frescos can be dated with certainty to its transfer into the Imperial property; perhaps this modification occurred when Tiberius, returning from his exile in Rhodes in 2 BC, moved in.

The original identification of the complex as an *auditorium* or *odeon* should not be entirely discarded, even if the steps appear to be somewhat small to accommodate seated spectators. The presence of an inscription containing the first two verses of an epigram by Callimachus, set in the context of a banquet, has also prompted speculation that the building might have been a *cenatio,* a summer dining room. The hypothesis most commonly accepted, predicated on the fact that the building is partially underground and because of the nature of the decoration, is that this was a nymphaeum, the steps serving as stands for flower vases.

The gardens of Maecenas, which displaced the city's ancient cemetery, are the oldest on the Esquiline. They are probably an expansion of the estate belonging to the powerful minister of Augustus situated to the southwest, where the Baths of Trajan were later built. The boundaries of the property were thus between these baths, the *Porticus Liviae,* and the Clivus Suburanus; it is not certain how far they extended east of the Servian Wall.

The *Horti Lamiani* were subsequently built to the east of the Horti Maecenatis, probably by the consul of AD 3, L. Aelius Lamia, and afterward passed into the hands of Caligula, who stayed there frequently. Adjacent to these were the *Horti Maiani,* which later were owned by Nero. There he set up a gigantic portrait of himself, painted on linen, which, according to Pliny (*NH* 35.51), measured a good 120 feet (35 meters). The Horti Lamiani must have extended north all the way to Piazza Vittorio Emanuele. The *Diaeta Apollinis,* known from an inscription, must have been part of this property; it may have contained the statues of the children of Niobe, killed by Apollo and Diana, discovered in the vicinity of Piazza Vittorio Emanuele (they are now in the Museo degli Uffizi in Florence). The Diaeta has recently been identified as the impressive complex discovered during the excavations at the end of the nineteenth century between Piazza Dante and Via Emanuele Filiberto.

A boundary cippus, found *in situ* between Via Principe Umberto and the Termini station, enables us to identify the precise location of the *Horti Lolliani,* built perhaps by M. Lollius, consul of 21 BC, or by his daughter, Lollia Paullina.

The *Horti Tauriani,* property of the powerful Statilii Tauri, also date to the beginning of the Empire. In this case as well, the discovery of a boundary cippus marking the border between the latter and the *Horti Calyclani* marks Via Mamiani as its northern boundary. This property must have extended very far to the east along Via Labicana, all the way to Porta Maggiore, at least to judge from the tombs of the family's freedmen, found just inside the gate. The villa was absorbed into the Imperial domain during the reign of Claudius, after which it passed into the hands of Claudius's and Nero's two wealthiest freedmen, Pallas and Epaphroditus; thereafter the portion of property lying farther north in the

vicinity of Via Tiburtina assumed the name *Horti Pallantiani*, while that located immediately to the west of the Porta Maggiore was called the *Horti Epaphroditiani*. In the course of the Julio-Claudian period, all these urban villas were subsumed into the Imperial domain, thus forming a single huge park that linked up with the other Imperial properties on the Quirinal and Pincian. This is the case, for example, of the Horti Liciniani, belonging to the emperor Gallienus, which must have occupied the area north of Via Labicana, inside the Aurelian Walls. The dedicatory inscription on the Porta Esquilina indicates that the gate had become a kind of entrance to the Imperial estates, to which the large decagonal building, known as the Temple of Minerva Medica, probably belonged.

Urban development of the Esquiline at the end of the nineteenth century recovered an enormous quantity of works of art from these villas, the largest portion of which are displayed in the Museo dei Conservatori on the Capitoline Hill.

THE TROPHIES OF MARIUS, THE "TEMPLE OF MINERVA MEDICA," AND THE HYPOGEUM OF THE AURELII In the northern corner of Piazza Vittorio Emanuele stands the monumental brick structure called the **Trophies of Marius** during the Renaissance after the two Domitianic marble reliefs representing trophies; these remained here until 1590, when they were moved to the balustrade of the Capitoline, where they are now located (FIG. **48:6**). The spoliated reliefs were clearly not original to the monument. The structure was a huge fountain built on top of the *Aqua Iulia*'s distribution reservoir. The style of the brickwork dates the construction to the reign of Alexander Severus, which suggests that the building may have been connected with the *Aqua Alexandrina*, the last of the Roman aqueducts, whose construction this emperor oversaw. Several coins of Alexander Severus, dated to AD 226, depict the monument, which is also recorded by the Regionary Catalogues under the name *Nymfeum Alexandri*. Bounded by Via Labicana and Via Tiburtina, the fountain has a trapezoidal plan. The structure is three stories tall: the lower two contain various rooms and channels, while the third is nothing more than a facade with a central niche, facing west, flanked by two open arches, where the trophies were originally located. A basin collected the water that cascaded from on high. Evidence of marble revetment can be seen here and there; numerous statues stood in the niches that punctuate the facade.

Ruins dating to ancient Roman times were discovered south of the transept and behind the medieval apse of Sant'Eusebio in Piazza Vittorio Emanuele. The style of wall construction appears to date to the end of the second century AD. A group of inscriptions discovered here in 1875 suggests that a sanctuary of *Iuppiter Dolichenus* was located in this area; one of these was dedicated by a sailor from the fleet stationed at Misenum; he may have been quartered in the *Castra Misenatium*.

The remains of a large circular mausoleum resting on a square base, currently known as the *casa tonda* (round house), were once visible in the eastern part of

Piazza Vittorio Emanuele. It is tempting to identify this as the tomb of Maecenas, which literary sources locate *in extremis Esquiliis*. The poet Horace was buried alongside this monument.

From Piazza Vittorio Emanuele, Via Principe Eugenio and Via Pietro Micca lead to the so-called **Temple of Minerva Medica** on Via Giolitti, a large construction datable to the fourth century, noteworthy for its strange decagonal plan, 25 meters in diameter (FIG. **48:8**). Each side, except that of the entrance, features a semicircular niche. The dome springs from a polygonal base and gradually assumes its hemispherical form. Huge piers and lateral rooms help support this daring construction, which must have been part of the Horti Licini-ani. The building, illuminated by ten large windows, is generally identified— though incorrectly—as a nymphaeum. A number of sculptures were recovered here in excavations undertaken at various times. The two remarkable statues representing Roman magistrates in the act of throwing the *mappa* to begin the chariot races in the circus (now in the Museo dei Conservatori) were discovered between 1875 and 1878.

One of the most important surviving third-century AD funerary complexes is located near the intersection of Viale Manzoni and Via Luzzatti, halfway between Piazza Vittorio Emanuele and Porta Maggiore: the **Hypogeum of the Aurelii,** discovered in 1919. (The entrance is at Via Luzzatti no. 2.) The lower portion of the monument was carved out of the native tufa, while that section nearest to the surface was built in brick. The style of the painted decoration, as well as aspects of the monument's construction, date the monument to the first half of the third century AD. Only the lower part of the upper story, its brick work typical of the Severan period, survives; the funerary enclosure that was annexed to it was destroyed immediately after discovery of the complex. Past the ancient doorway there is a chamber on the left with two *arcosolia* inserted laterally in the walls; graves intended for inhumation were dug in the floor at a later date. The back wall, poorly preserved, features a scene depicting the Original Sin on the left and the Creation of man on the right, some of whose outlines survive. On the side walls, above and alongside the *arcosolia,* are perspective drawings of cities, and the figures of four teachers dressed in togas, whom some have identified as the Evangelists.

The stairway that descends to the lower chambers of the hypogeum leads to a landing. The ramp on the left leads to a chamber, that on the right to another chamber; the latter is preceded by an anteroom.

The first chamber is a small room of irregular form, completely painted. In the floor is a mosaic that records the names of the tomb's occupants:

Aurelio Onesimo / Aurelio Papirio / Aureliae Primae virg(ini) / Aurelius Felicissimus / fratris [sic] *et colibert(is) b(ene) m(erentibus) f(ecit)* (To Aurelius Onesimus, to Aurelius Papirius and to Aurelia Prima virgin; Aurelius Felicissimus made [this tomb] for his worthy brothers and freedmen).

Only this part of the tomb belonged to the deceased mentioned above. It is not clear, on the other hand, whether the brothers mentioned were blood relations or whether, as is more likely, they were brothers in a figurative sense, that is, members of a religious sodality. The impressive pictures that cover the walls of this chamber, among the most remarkable third-century paintings found in Rome, pose serious problems of interpretation that are not close to being resolved. The painting should probably be read as a unified cycle that begins on the wall to the left. On the lower portion of the wall are eleven imposing figures dressed in togas, at two-thirds normal height; these have been identified as the Apostles. The twelfth must have been effaced when a door was pierced at the chamber's rear, in a subsequent period, in order to provide access to a small catacomb. The vault is decorated with a series of polychrome panels, typical of the wall painting of this era, containing decorative elements, individual persons, or even complex scenes. The latter are located in the lower part of the vault, which descends quite low.

Immediately on the left is a large picture representing a mountain, at the peak of which is a clothed, bearded person reading from a scroll. A flock of sheep can be seen at his feet along the slopes. The significance of the scene is sufficiently clear: the picture must be a symbolic portrayal of Christ as the Good Shepherd (not, as some might posit, the Sermon on the Mount); other more traditional representations of the Good Shepherd—carrying a lamb on his shoulders—appear in the upper part of the vault.

There follows a scene that is more difficult to interpret: a knight on a galloping horse, holding a scroll in his raised right hand, passes in front of a temple. He is followed on the left by a group of persons, while another group, leaving the gate of a city depicted from a bird's-eye view, meets him on the right. The scene evidently alludes to official representations of the *adventus*, the triumphal return of the emperor. Some read this scene as representing the entrance of Christ into Jerusalem or the triumph of the Antichrist, but given the emphasis on death in this context, the sense of "triumph" that the artist might have intended suggests a symbolic representation of the arrival of the dead in the heavenly Jerusalem. This interpretation seems to be confirmed by the scene painted on the rear wall—again, a city surrounded by walls (the middle of the painting is partially destroyed by the later insertion of a door). To the left, a large colonnaded square is shown from a bird's-eye view. At the center, a man dressed in a white tunic, with a rod in his hand, appears to be pronouncing judgment on the crowd of people that surrounds him, with special focus on a small group composed of four men and a woman, who are on the right directly in front of him. On the right, still within the city walls, is a garden in bloom, in which the same five people seem to be represented. Figures dressed in white appear alongside the gates of the city. The articulation of the scene coincides perfectly with the heavenly Jerusalem in the *Apocalypse*, which describes the gates of the celestial city as guarded by angels, who can be clearly identified as the figures dressed

in white. The cycle of pictures thus appears to represent a coherent theme: it proceeds from the practice of Christian doctrine (the Good Shepherd) to the triumph after death and to the welcome in the heavenly Jerusalem following divine judgment.

On the wall on the right, we find a banquet scene, whose interpretation is uncertain (the heavenly banquet?), and a representation of the return of Ulysses. In the center of the latter scene, Penelope's loom figures prominently. Penelope turns toward Ulysses, half reclining on the right, while on the left are three nude males, who have been interpreted as the suitors. There follow two groups formed respectively of three and eight persons.

In the anteroom of the other chamber, a figure calls to mind the Crucifixion (a very rare representation in so early a period). Inside the chamber, which is decorated in the usual linear style albeit by a different and more modest workshop, twelve figures are represented in the *arcosolium* in the back wall; these too have been identified as the Apostles. Representations of men and veiled women, interpreted as initiates, can be seen in the *arcosolia* of the side walls. Even the medallion at the center of the vault would appear to represent a scene of initiation, in which a veiled woman is flanked by two elderly men, one with a rod and the other with a scroll. The tomb has been interpreted in various ways—as a pagan, Christian, Orthodox, or heretical Christian hypogeum—but the representation of Original Sin and of the Crucifixion make it certain that the tomb belonged to Christians.

ITINERARY 3

The Area around Porta Maggiore

The Sessorium and the area around it, where almost all the aqueducts of Rome converged, was known in antiquity as *ad Spem Veterem* (near the Old [shrine of] Hope) because of a temple in the area that was dedicated to this divinity in 477 BC. The sanctuary is thus "old" with respect to the better-known temple erected around 260 BC in the Forum Holitorium. The monument's exact location is unknown.

The convergence of the aqueducts in this area can be explained by the fact that the elevation here was significantly higher than that of the rest of the city— roughly 45 meters above sea level. The oldest aqueduct that passed through here was in fact Rome's second-oldest, the *Anio Vetus*, built in 275 BC. Traces of the subterranean conduit, constructed of small tufa blocks covered with slabs of cappellaccio, were seen at various times.

Several arches of the *Aqua Marcia* (144 BC), made of blocks of red Anio tufa with a travertine cornice, can be identified in Piazzale Labicano and Piazza di Porta Maggiore. The segment in Piazzale Labicano preserves three

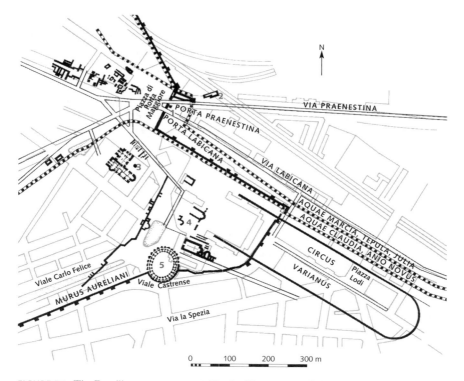

FIGURE 54. The Esquiline, eastern area. **1** Tomb of Eurysaces. **2** Subterranean basilica. **3** Thermae Helenianae (Baths of Helena). **4** Palatium Sessorianum (Sessorium). **5** Amphitheatrum Castrense.

superimposed conduits, visible in section: from bottom to top, they correspond to the *Aqua Marcia*, the *Aqua Tepula* (125 BC), and the *Aqua Julia* (33 BC). The reason for this configuration is that the arches of the Aqua Marcia were used for the other two aqueducts.

The gate known as Porta Maggiore consists of two arches of Claudian aqueducts that were transformed into a monument where they crossed Via Labicana and Via Praenestina. The complex became a true gate when it was included within the Aurelian Wall. Honorius added a curtain wall with two gates in front of the original arches. Porta Labicana, the gate farther to the south, was later closed, possibly in the sixth century AD. Demolition of this fifth-century AD complex in 1838 brought to light the tomb of Eurysaces, which owes its preservation to the fact of its incorporation in the tower erected between the two gates.

The gate—probably so named because it provided access to S. Maria Maggiore—is a kind of double-passageway arch, built of travertine, whose piers

are pierced by windows with a tympanum and engaged Corinthian columns. The opening for Via Praenestina (on the north) is set at an oblique angle, following the course of the ancient road (which runs at a higher level than Via Labicana). The high attic of three superimposed *fasciae,* divided by string courses, corresponds to the channels—visible where they were interrupted—of the two aqueducts *(Aqua Claudia* and *Anio Novus)* begun by Caligula in AD 38 and finished by Claudius in 52. The inscriptions (from top to bottom) of Claudius, Vespasian (commemorating the restoration of 71), and Titus (commemorating the restoration of 81) are visible on both sides of the attic. An inscription of Honorius (AD 403) was originally located on Porta Labicana; after the gate's destruction in 1838, the inscription was relocated to the left of Porta Maggiore as you enter the city. The structure of the monument reveals the typical rusticated Claudian style, whereby a large portion of the architectural elements in travertine was left rough-hewn.

Work undertaken between 1955 and 1959 has exposed the ancient level, uncovering the base of the horseshoe-shaped vantage court built of brick, which has survived together with the paving stones of the two roads that split off just inside the gate from the one street that passed beneath Porta Esquilina.

Immediately outside Porta Maggiore, between Via Labicana and Via Praenestina, stands the **Tomb of Eurysaces** (FIG. **54:1**). The structure's curious trapezoidal plan was determined by the position and presence of older tombs, traces of which were discovered following recent explorations. The dimensions of the monument are as follows: north side, 8.55 meters; west, 3.77; south, 5.44; east, 6.75. The total height must have been more than 7 meters. The interior nucleus is in *opus caementicium,* while the base is clad with five rows of Anio tufa blocks reinforced at the corners with travertine blocks. It is noteworthy that the footing of the foundation is higher on the northern side, facing Via Praenestina, whose elevation was higher than that of Via Labicana. The upper part of the monument, clad in travertine, is preserved in its entirety only on the western side, facing Porta Maggiore, while the eastern side, which was certainly its principal facade, is completely gone. The surviving facade, however, contains the most distinctive and curious element of the tomb. Four smooth pilasters at the corners, with Corinthian capitals surmounted by corner volutes, frame the body of the monument, which is divided from bottom to top as follows: a section with pairs of vertical cylinders between smooth pilasters; a horizontal inscribed *fascia;* a smooth surface pierced by three rows of hollow cylindrical drums whose openings face outward; a sculpted frieze; and a modillion cornice. How the building was crowned, though it is generally reconstructed as pyramidal in form, is not clear. The burial chamber must have been quite small and located in the upper part; the opening at the foot of the monument is modern, made by nineteenth-century excavators. The eastern facade—now lost—must have held the large marble relief now in the Museo Nuovo Capitolino, carved with life-size portraits of the husband and wife buried here.

The inscription, repeated three times with slight variations, and incomplete on the long sides, reads: *Est Hoc Monimentum Marcei Vergilei Eurysacis Pistoris, Redemptoris, Apparet* (This tomb belongs to Marcus Virgilius Eurysaces, baker, contractor, attendant). Eurysaces was thus a baker, the owner of a bread-making business who sold his products to the state and who was the subordinate ("attendant") of some magistrate or priest. His profession is confirmed by other elements: the urn containing the ashes of his wife Atistia—now in the Museo delle Terme—in the form of a kneading trough (the inscription describes it as a *panarium*); the subject of the reliefs; and even the cylindrical architectural elements, repeated in the reliefs of the frieze, which are the tomb's most conspicuous feature. These seem to depict the receptacles in which the dough was kneaded. The relief thus represents, in the same manner as the continuous narrative friezes on triumphal monuments, the various phases of bread making. On the short side facing the gate, the grain is weighed on a large balance scale. The grinding of the grain and sifting of the flour are shown on the south. The frieze resumes, after a lost portion, on the other side with the final phases: the preparation of the dough in a large cylindrical receptacle, the rolling, and finally the baking of the loaves. A person dressed in a toga oversees all the operations, which are undertaken by slaves in tunics; this figure is apparently Eurysaces himself. Eurysaces was a freedman who probably made his fortune during the civil wars. On the basis of the inscriptions, the materials used in the structure, and the stylistic features (some of which are antiquarian), the tomb can be dated to between the end of the Republic and the first years of the Empire—i.e., around 30 BC.

Architectural and decorative elements from other tombs of the same period are scattered nearby. Among these are sculpted blocks with a relief depicting breads in their typical circular form. If these blocks, as appears to be the case, do not belong to the tomb of Eurysaces, we would have to posit the existence of another contemporary tomb in the immediate vicinity also belonging to a baker. In fact, an inscription with the following text was found on the spot: *Ogulnius Pistor Simi(laginarius) / Amicus (Eurysacis?)* (Ogulnius, baker, dealer in flour, friend [of Eurysaces?]).

During the Empire, the *Vivarium*, a kind of park in which the wild animals intended for the amphitheater were kept, must have been located immediately outside Porta Praenestina. Other ruins are scattered in the square in front of the gate. The most important of these is a small funerary monument in the form of an altar, built of tufa and travertine, with a Doric frieze of metopes and triglyphs. Found in the vicinity, it was dismantled and then reassembled here.

Below the level of the square, late Republican and Imperial *columbaria* and *hypogea* have been found at various times, some of which are still accessible. The most important of these, containing more than seven hundred *loculi*, belonged to the freedmen of Statilius Taurus, a man of consular rank during the Augustan period who built the first amphitheater in Rome and owned an estate in this

FIGURE 55. Plan of the subterranean basilica of Porta Maggiore.
A Central aisle. **B** Left aisle. **C** Right aisle. **D** Atrium.

region. A luxurious Augustan *columbarium*, decorated with a remarkable painted frieze depicting myths of the origins of Rome, now in the Museo Nazionale Romano in Palazzo Massimo, is also recorded. A large circular mausoleum on a square base was seen at the corner formed by the Aqua Claudia and the Neronian branch that breaks off from it.

THE SUBTERRANEAN BASILICA OF PORTA MAGGIORE The subterranean basilica, currently described as "neo-Pythagorean," was discovered by chance beneath the railroad tracks in April of 1917 (FIG. **54:2**). The vibrations that result from the structure's unfortunate location have made it necessary to cordon off the site; this was done in 1951–52. Restorations are still needed on a regular basis.

The present entrance, on the left side of Via Praenestina, does not correspond to the ancient one, which has yet to be explored. The original entrance was a downward sloping corridor, coming from the east, whose first section ran parallel to the monument and then turned at a right angle to reach the atrium.

The building was constructed simply and economically: the piers and walls were created by excavating trenches and shafts in the tufa, into which concrete mixed with flint chips was poured, forming the structure of the basilica. The vault was poured on the surface, and once it hardened, the earth was removed, to a depth of 7.25 meters in the hall and atrium. The crude structure was

then plastered and dressed with stucco. The building is composed of a basilical hall preceded by a square vestibule or atrium (FIG. **55:D**) and subdivided by six rectangular piers into three aisles **(A, B, C)**, of which the central one **(A)** ends in an apse. The hall, vestibule, and piers show various irregularities and asymmetries, evidently due to the method of construction.

The function of the building is uncertain, although several diverse theories have been advanced, identifying it variously as a tomb or funerary basilica, a nymphaeum, or a neo-Pythagorean temple. The floor of the vestibule is paved in white mosaic with two black bands that run along the walls. Four ears of wheat in the corners of the room constitute the only figural motif. The sole source of light was originally from a skylight in the ceiling. Various elements of masonry faced in *opus reticulatum* are visible, providing useful evidence for dating the structure. The stuccos that decorated the walls have almost completely disappeared, and even those of the vault are poorly preserved. A tondo containing a maenad on a panther occupies the center of the two principal segments of the vault alongside the skylight; an eros with amphora is depicted in each of the other two smaller tondi. Minor segments are decorated with ornamental figures. The rich array of colors is still fairly well preserved.

The floor of the basilica proper has a similar pavement of white mosaics with two black bands outlining the architectural features, namely, the piers and the bases (removed in antiquity) that originally stood in front of each of the piers at the center of their spans. Another base, similarly removed, was located at the center of the nave. Traces of a chair survive at the rear of the apse. Rectangular cavities are preserved in the piers on the side facing the central nave in which panels, now gone, were inserted. The holes at the center of each arch probably served to secure hanging lamps. The looting of all these furnishings (statue bases, urns?) may have occurred soon after the construction of the complex, which owes its exceptional state of preservation to the fact that it was only utilized for a short time.

The hall measures a little less than 12 meters in length and around 9 in width. All the walls are completely plastered and covered with stuccos, which begin above a broad red band at ground level. Above this, figures standing on bases, possibly reproductions of statues, are represented below the cornice of the vault's impost. Of the two pictures on each of the piers, only one is well preserved, depicting Heracles seated while one of the Hesperides hands over the apples. The piers are decorated on the inside with candlesticks; two victories with outstretched wings adorn the soffits of the arches that join the piers.

The most important sections of the basilica are the central vaulted ceiling and the apse. The former **(A)** is divided into three sections, with a panel at the center of each. The first, near the entrance, depicts one of the Dioscuri raping a Leucippid, a subject obviously repeated in the picture at the opposite end, now lost. The center panel depicts the rape of Ganymede(?) by a winged

spirit, substituted for the conventional eagle. All around—and always within panels—mythic and realistic scenes, masks, and various decorative elements are arranged symmetrically (for example, the same subject, an Arimaspian with a griffin, appears in the four corners of the ceiling). The eight minor panels, positioned approximately at the corners of the three principal frames, represent, beginning from the facade, Calchas and Iphigenia; Heracles and Athena; Paris and Helen (or possibly Hermes leading Eurydice to Hades); Jason and Medea killing the serpent that guards the Golden Fleece; Orestes and Iphigenia in Tauris (or possibly Ulysses and Helen); Heracles and Hesione; the Twins; and the Bull.

The apse is occupied by a large portrait of Sappho, who, driven by a cupid, throws herself into the sea from the Leucadian cliff and is welcomed by Leucothea, who opens her veil, and a Triton, while Apollo and Phaon witness the scene.

Even the minor aisles (**B** and **C**) are richly decorated with stuccos. The following scenes are represented on the walls at the end of each aisle, from top to bottom: a female figure with open arms with a flower in each hand, a table with various furnishings, a landscape with a rustic sanctuary of Artemis, and another rustic landscape. An analogous scene is repeated on the short side at the other end, with Dionysian symbols in the rustic landscape in place of those associated with Artemis. Two panels with portraits (almost completely lost) were inserted in the piers.

The richness and complexity of the iconographic motifs and the lack of an evident unifying leitmotif make it difficult to explain the meaning of the decorative program. Nonetheless, the reductive interpretation that excludes all symbolic significance and sees the building as a simple nymphaeum can be rejected. Such an interpretation is incompatible with at least one of the representations, the most important of all: that of the apse, which features an episode very rarely represented in ancient figurative art. The leap of Sappho from the Leucadian cliff should signify, symbolically, the liberation of the soul from the burden of the material world and its transition to a different life. But even under this interpretation, the problem is not entirely resolved, since the subject suits both the idea of death as well as that of mystic initiation, which is itself a sort of death followed by resurrection.

Jerome Carcopino's interpretation of the building as a sanctuary for a neo-Pythagorean cult that was abandoned and sacked during the persecutions under Claudius poses several difficulties, not the least of which is the characteristically Third Style decoration, which dates the decoration more plausibly to the reign of Tiberius than that of Claudius. Perhaps the interpretation of the building as a kind of funerary basilica is still the least improbable. The problem, however, remains unsolved.

THE PALATIUM SESSORIANUM AND S. CROCE IN GERUSALEMME In antiq-
uity, the area between the Lateran and Porta Maggiore fell within Region V, that
is, Esquiliae. It formed a passageway between the Esquiline and Caelian, linked
to the latter by *Via Caelimontana* and the aqueducts. The whole area surround-
ing the Church of S. Croce in Gerusalemme is rich in ancient remains, often
monumental, that belonged to the same building complex, an Imperial villa of
the late Severan period. The most important of these are the Amphitheatrum
Castrense, the Thermae Helenianae, the hall used for the basilica of S. Croce
in Gerusalemme, the so-called Temple of Venus, and the racetrack known as the
Circus Varianus.

The **Thermae Helenianae** were located in the vicinity of the *Arcus Neroniani*,
at the point where they branch off from the Aqua Claudia, near Porta Maggiore
(FIG. **54:3**). Remains of the facility were visible up to the end of the sixteenth
century, after which they were covered over in the construction of Via Felice,
a project overseen by Sixtus V. Renaissance drawings record the plan of the
complex. Only the ruins of the water reservoir, consisting of twelve chambers
arranged in two parallel rows of six, are now visible. Also extant is a large
inscription (now in the Vatican Museums) that records the restoration of the
building by Helena, the mother of Constantine, after a fire. The older building
dates to the Severan period, as the brick stamps and a dedication to Julia Domna,
the wife of Septimius Severus, attest. The structure was probably connected with
the nearby Palatium Sessorianum (FIG. **54:4**).

The **Amphitheatrum Castrense,** recorded by the Regionary Catalogues
for Region V, has been identified as the small amphitheater still extant between
S. Croce in Gerusalemme and the Aurelian Wall (FIG. **54:5**). In late antiquity,
the word *castrum* also came to assume the meaning "Imperial residence," a sense
that is quite appropriate in this case. The building owes its partial preservation to
its inclusion in the Aurelian Wall. The structure was well preserved up to its third
order as late as the middle of the sixteenth century, but was then reduced for
defensive needs to the first story, leaving only a few remains of the second story
intact. Its plan is almost circular (88 × 75.8 meters), and the structure was built
entirely of brick, except for a few elements in travertine. The first order consists of
arches on piers, framed by engaged Corinthian semicolumns with brick capitals;
the second order was similar, with pilasters in place of the semicolumns. The
third order, as can be reconstructed from Renaissance drawings, was closed
and pierced by windows, with brackets for the *velum*, similar to the Colosseum.
Almost nothing remains of the *cavea*, although we can reconstruct it on the basis
of a section made by Palladio. The style of the bricks and the absence of brick
stamps date the building to the end of the Severan age.

An impressive covered corridor, more than 300 meters long and 14.5 wide,
extended from the amphitheater, skirting a large hall that was later transformed
into the Church of S. Croce, all the way to the **Circus Varianus.** Remains of
this corridor and of the circus are visible at various points in the area behind

the church. The Circus Varianus—a name established in modern times from Varius, the family name of Elagabalus—has recently been identified in the area north of the Sessorium, along the Aqua Claudia and the Aurelian Wall; the latter cut across its track, thus putting it out of use. It originally must have measured 565 meters in length and 125 in width; on the track's *spina* stood a reused obelisk, dedicated to Antinous, Hadrian's favorite. The obelisk must originally have formed part of his funerary monument, as can be deduced from the inscription in hieroglyphics, which situates the tomb on an Imperial estate. (The obelisk can now be seen in the gardens of the Pincian Hill.) In the former Caserma dei Granatieri, north of the church, there are other remains, among which is the back wall of a large apsidal hall, partially collapsed, whose masonry dates it to the reign of Constantine. From this building, dubbed in modern times the "Temple of Venus," comes a portrait statue of Sallustia Orbiana, wife of Alexander Severus, represented as Venus (now in the Vatican Museums).

The modern Basilica of S. Croce in Gerusalemme is the result of a radical structural transformation completed in the eighteenth century; five different building phases, however, can be distinguished.

The basilica was constructed by reusing a spacious rectangular hall lacking partition walls and internal stories. The two long sides of the hall, whose area measured 36.46 meters long, 21.8 wide, and 22.15 high, contained a series of five arched openings, surmounted by a row of windows with architraves and relieving arches on top. Two rows of five superimposed windows, of smaller dimensions and originally decorated in marble, pierce the short sides. The long side facing north, where the width of the openings is greater, probably formed the original facade. The roof was flat.

The *Liber Pontificalis* attributes the transformation of the building into a Christian basilica to Constantine, but the building technique dates the construction more plausibly to the middle of the fourth century AD. A semicircular apse was added to the short eastern side, thus converting the opposite side into the new facade. The hall was isolated from the surrounding rooms when the connecting doors were walled up. The basilica consists of the large hall, with a lateral corridor transformed into a small aisle, the apse, and another room, the present-day Cappella di Sant'Elena, which communicated with the rest of the building through two corridors that extended along the sides of the apse.

The Cappella di Sant'Elena, the long corridor, and the lateral aisle were roofed by barrel vaults; the central nave preserved its truss roof. Two transverse walls with three arched openings, of which the central one is the largest, divided the nave. These walls almost reached the level of the roof, but functioned as supports for the side walls rather than for the roof itself. The two rows of arches rested on columns or piers; in fact, they were probably supported by the same columns that divide the central nave from the side aisles in the modern church.

The relics of the Cross were believed to have been housed in the Cappella di Sant'Elena. The base of a statue with a dedication to Helena is still kept in the chapel.

All these buildings—the Amphitheatrum Castrense, the hall of the basilica and the nearby constructions, the long corridor, the circus, and probably even the Thermae Helenianae—were part of a single complex, certainly an Imperial villa, whose construction was begun by Septimius Severus and probably completed by Elagabalus. We know from a passage by a late biographer of Elagabalus that the emperor frequented the gardens *ad Spem Veterem*, where chariot races took place, undoubtedly in the Circus Varianus. The identification of these gardens as the Palatium Sessorianum is clear. Less certain is the meaning of the name *Sessorium*, perhaps derived from *sedeo* and thus signifying "sojourn." The villa certainly lost some of its facilities with the construction of the Aurelian Wall, whose wide salient at this point seems to have had as its only purpose the inclusion of the property within the city. It continued to be an Imperial property at the beginning of the fourth century, since it was chosen by Helena, the mother of Constantine, as her place of residence, for which she completed important restorations and additions.

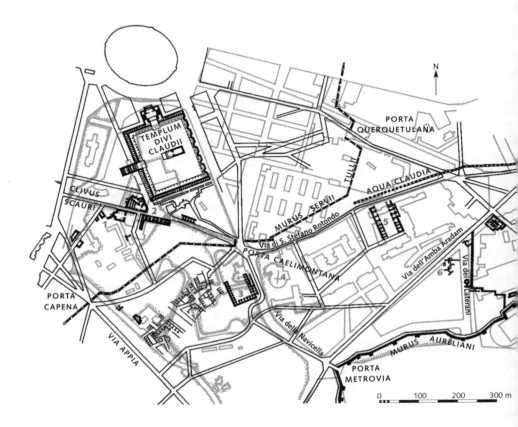

FIGURE 56. Map of the Caelian. **1** Buildings near the Church of S. Gregorio. **2** Buildings under the Church of SS. Giovanni e Paolo. **3** Fifth Cohort of the *Vigiles*. **4** Church of Santo Stefano Rotondo. **5** Imperial buildings. **6** Domus Faustae. **7** Castra Nova Equitum Singularium.

CAELIAN

Piazza di S. Giovanni
in Laterano

HISTORICAL NOTES

The Caelian Hill was divided among three Augustan regions: most of the area lies within the second region *(Caelimontium)*; the southeastern slope up to Via Appia was part of the first *(Porta Capena)*, while the eastern end, between the Lateran and *Sessorium*, belonged in part to the fifth *(Exquiliae)*. Our knowledge of the boundaries between Regions I and II, however, is not completely secure (FIG. 2). It is likely that the first included the area near S. Gregorio, where the discovery of an inscription allows us to locate the *Vicus Trium Ararum* (Street of the Three Altars), which the Regionary Catalogues assign to Region I. Shaped like a long and narrow band, this region extended along the left (northeastern) side of Via Appia, including the ancient Temple of Mars and the valley of the Almo, and thus went well beyond the Aurelian Wall. It is important to keep in mind that Augustus's division of the city into regions began from this area. The choice was possibly predicated on the fact that the ancient orientation of the city was based on the augurs' line of observation. Standing on the *Arx*, they probably directed their gaze toward Mons Albanus, situated southeast of the city. This is in fact the orientation adopted by the Severan Marble Plan. Consequently, Region I took its name from *Porta Capena*, the ancient gate that opened onto Via Latina, the road that ran to Mons Albanus.

Colonnades must have lined the first stretch of the road *(via tecta)*, while numerous tombs belonging especially to families of the Roman aristocracy stood alongside the thoroughfare, alternating with important cult places. Among these were the Temple of *Honos et Virtus* (immediately beyond Porta Capena), then that of the *Tempestates* (which must have been near the Tomb of the Scipiones), and finally the Temple of Mars (just outside Porta S. Sebastiano), all of which were on the left side of the street. The procession of knights known as the *transvectio equitum* began at this last temple and concluded in the Forum in front of the Temple of the Castors.

The sanctuary, fountain, and grove of the Camenae were situated in the little valley to the left of Porta Capena, at the foot of the Caelian, where King Numa was supposed to have met with the nymph Egeria. During the Empire, as Juvenal (3.10 ff.) indignantly records, the natural basin into which the fountain flowed was reconstructed in marble and frequented by Jewish merchants.

Roman proconsuls were greeted as they departed for their provinces just outside Porta Capena. The importance of Via Appia at this juncture necessitated the installation of a whole series of structures associated with the departure and return of magistrates during the Republic and of the emperors later on. The *Senaculum*, placed immediately outside the gate, similar to the one near the Temple of Bellona (see Campus Martius), must have served this function. This is where the Senate gathered, outside the urban *pomerium*, to meet with generals and magistrates returning from their provinces. The *Mutatorium Caesaris*, situated by the Regionary Catalogues in Region I, is located by a fragment of the Severan Marble Plan in this vicinity, immediately north of Via Appia. The building, which is represented as a large square hall supported by numerous columns, was probably used by the emperor for changing his clothes when departing from and returning to the city; that is, changing from the civilian toga to the military *paludamentum* or vice versa. It is certainly not by chance that Augustus had an altar built in this very area to *Fortuna Redux*—the divinity who ensured safe returns—in 19 BC on the occasion of his return from the east. Also associated with returns, as the name suggests, was the sanctuary of the god Rediculus, which also stood outside of Porta Capena and whose name was linked in legend with Hannibal, who, having advanced as far as this point, suddenly withdrew, terrified by unexpected visions.

The location of the *Thermae Commodianae*, situated by various sources in Region I, is not certain. We know that Commodus erected the complex between AD 183 and 187. The remains underneath the Church of S. Cesareo at the beginning of Via Appia, with floors in black-and-white mosaics depicting maritime scenes, have been ascribed to this complex.

The Caelian Hill, for the most part included within Augustan Region II, has the form of an elongated tongue (roughly 2 kilometers long and 500 meters wide at its maximum) and begins, like the Esquiline, in the area designated as *ad Spem Veterem* and extends all the way to the Colosseum.

The hill's oldest name, *Mons Querquetulanus* (Oak Mountain), was, as ancient tradition confirms, replaced by the current name after the occupation by Caelius Vibenna, one of the two brothers from Vulci who were associates of Mastarna, the future Servius Tullius. Later on, the Caelian was also the site of the sanctuary of Minerva Capta (captive Minerva), a cult that was said, perhaps mistakenly, to have come from Falerii; this would have occurred in 241 BC, following the conquest and destruction of that city. We know that the temple stood on a secondary peak of the Caelian, called *Caeliolus*, which is probably to be identified as the place where the Church of SS. Quattro Coronati now stands; that is, outside *Porta Querquetulana* and the Servian Wall. A very ancient shrine to Diana, which L. Piso Caesoninus, a contemporary of Cicero, demolished, was built in this same area, as was (probably) a Temple of Hercules Victor, erected by Lucius Mummius between 146 and 142 BC; the dedicatory inscription is preserved in the Vatican Museums.

Several tombs in the area can be assigned to the Republic, including a chamber tomb that was recently excavated on the ancient Via Caelimontana, not far from S. Giovanni in Laterano, and which produced a large sarcophagus, funeral urns, and a store of terracottas and ceramics datable to around 300 BC. More recent Republican tombs were discovered a little farther on along the same street.

From the late Republican period, the district became somewhat more residential, although it continued to maintain its working-class character. At that time, several particularly luxurious homes appeared, such as that of Mamurra, Caesar's *praefectus fabrum*, known best for the vicious attacks aimed at him by Catullus. His house was reportedly the first to have walls clad with marble slabs, and all of its columns were made of marble, cipollino and Carrara.

Violent fires struck the hill twice during the Imperial period: in AD 27 under Tiberius and again, famously, in 64 under Nero. The *Claudium*, the temple of the deified Claudius, dates to this period. Nero confiscated a series of affluent private houses from various persons whom he had condemned to death for having participated in the Pisonian conspiracy. Among the properties taken was that of the Laterani, which in subsequent years had a special place in the history of the city.

Nero incorporated the eastern retaining wall of the precinct of Claudius's temple in an imposing nymphaeum, which probably served as a monumental backdrop for the *Domus Aurea*, built in the valley between the Caelian, Esquiline, and Palatine hills after the fire of 64. Another construction in the region, this time public and also initiated by Nero, is the *Macellum Magnum*, a large grocery market intended to replace the one that had stood near the Forum during the Republic; the building, completed in AD 59, was located in Region II. At one time, this complex was believed to have been located under the Church of Santo Stefano Rotondo, but this area, as recent excavations have confirmed, was the site of the *Castra Peregrina*. A fragment of the Severan Marble Plan that

almost certainly depicts the Macellum Magnum can be located, for technical reasons, only in the area east of the Temple of Claudius; the market was thus between Via Celimontana and Via Claudia. The fragment, on which the name *Macellum* is inscribed, shows a nearly square structure, around 90 × 90 meters, surrounded on its exterior by shops opening onto a colonnaded porticus. Other shops faced the interior courtyard, in which there were triangular elements at the corners, probably fountains, and, in the center, a circular structure with columns, the *tholos* that was an integral feature of this type of building. Several Neronian coins, dated between 64 and 66, help reconstruct the appearance of this building.

One characteristic of the quarter was the presence of numerous barracks. In addition to the Fifth Cohort of the *Vigiles* (firemen) near S. Maria in Domnica (FIG. 56:3), there were the two barracks of the *equites singulares*, the emperor's mounted guard. The first, in all likelihood built by Trajan, who created the corps, was situated in the area around Via Tasso, where there was also a *Mithraeum*; the second, the *Castra Nova Equitum Singularium*, was built by Septimius Severus where the houses of the Laterani had stood (FIG. 56:7). The remains of this building, underneath S. Giovanni in Laterano, have been seen at various times in recent centuries and were uncovered again in 1934/1938. Both barracks were closed by Constantine, who disbanded the *equites singulares*. The Lateran Basilica was then built over the second of these installations. The Castra Peregrina was another camp in which detachments of soldiers from provincial armies were employed in Rome for specific functions, such as police duty, courier service, or the provisioning of the court. Remains of this complex were discovered in 1905, south of Santo Stefano Rotondo (FIG. 56:4). The splendid Mithraeum beneath the church, recently explored, was associated with these barracks.

The slope of the hill facing the Esquiline and Colosseum must have been occupied by rental apartment buildings of several stories *(insulae);* during the Imperial period its summit was mostly occupied by the luxurious residences of the aristocracy. The villa of Domitia Lucilla Minor, the mother of Marcus Aurelius, was located here; in fact, the emperor was born in this house, and his bronze equestrian statue, now on the Capitoline, comes from the Caelian, after having long stood near S. Giovanni in Laterano. Commodus, the son of Marcus Aurelius, often resided on the Caelian and was ultimately killed there.

The houses of some of the most important aristocratic families of the fourth century AD stood along Via Celimontana, including those of the Valerii (near Santo Stefano Rotondo) and the Symmachi (near the military hospital). Remains of these residences have been found on various occasions. Many homes were not rebuilt after the sack of Alaric in 410. One street, certainly very ancient, ran along the entire ridge of the hill, as was the case on the Quirinal. Its ancient name is unknown (it may have been *Via Caelimontana*). This street passed through *Porta Caelimontana,* the Arch of Dolabella and Silanus, and extended as far as Porta Maggiore, following the modern Via di Santo Stefano Rotondo, Piazza S.

Giovanni in Laterano, and Via Domenico Fontana. The four aqueducts that traversed the Caelian—the *Appia, Marcia, Iulia,* and *Claudia*—followed the same axis; the first three ran underground (the remains of pipes and conduits have been found at various points). The arches of the Aqua Claudia are still in large part visible and constitute an extension constructed by Nero to bring water to the Domus Aurea and the nymphaeum of the Temple of Claudius. Later on, Domitian extended the Aqua Claudia even farther, bringing it all the way to the Imperial residence on the Palatine. The arches were restored several times, in particular by Septimius Severus. From Porta Maggiore, where the initial stretch of the extension is well preserved, long sections of the aqueduct can be seen inside the Villa Wolkonsky, in Via Domenico Fontana, and on Piazza S. Giovanni; it can also be seen along Via di Santo Stefano Rotondo, near the military hospital, in the middle of Piazza della Navicella, adjacent to and above the Arch of Dolabella and Silanus, in the garden of the Passionists, and all the way to the Temple of Divine Claudius (SS. Giovanni e Paolo), where the large reservoir is located. This last section is also represented in a surviving fragment of the Severan Marble Plan.

Four streets branch off Via Caelimontana at the point where this major road enters the city through the gate of the same name: one of these passed within the Servian Wall and ran to the valley between the Palatine and Caelian *(Clivus Scauri);* another descended southwest toward Porta Capena *(Vicus Camenarum);* a third extended south toward the Valle della Ferratella; a fourth went north toward the valley of the Colosseum *(Vicus Capitis Africae).*

The other important major thoroughfare was *Via Tusculana,* corresponding more or less to the modern Via dei SS. Quattro Coronati. This street ran south of the *Ludus Magnus* and left the city through the Servian Wall at Porta Querquetulana, where the Church of the SS. Quattro Coronati is located. Farther ahead, beyond its intersection with Via Caelimontana, it passed through the postern gate in the Aurelian Wall near S. Giovanni in Laterano and headed toward Tusculum (located above Frascati).

ITINERARY

THE TEMPLE OF DIVUS CLAUDIUS Ruins of the temple dedicated to the deified Claudius can still be seen on the western end of the Caelian, facing the Palatine. The temple may have been built on the site of Claudius's private *domus,* perhaps near the ancestral home of the *Gens Claudia.* Immediately after the emperor's death in AD 54, his wife Agrippina began construction of the site, but this was partially demolished by Nero. Demolition was limited to the temple proper, while a monumental nymphaeum was added to the terrace wall—which remained intact—on the east, an alteration that transformed the foundation into a dramatic backdrop for the gardens of the

Domus Aurea. The huge fountain stood at the far end of Nero's urban villa, according to Martial (*Sp.* 2.9–10).

After Nero's death, Vespasian rebuilt the temple, which rose on top of an impressive rectangular platform (180 × 200 meters), formed by massive retaining walls that are partially preserved. A portion of the western side, visible within the bell tower (on the southwestern corner) and in the Convent of SS. Giovanni e Paolo, belongs to the oldest phase of the monument. It consists of a group of interconnecting rooms, two stories high, resting against a series of superimposed walls (a good 6.10 meters thick altogether), behind which run two parallel corridors. The facade is fashioned entirely of travertine blocks, many of which are still rough-hewn, following the characteristic "rusticated" style typical of the Claudian period (like Porta Maggiore, the arches of the Aqua Virgo in the Campus Martius, and the porticoes of the Port of Claudius). This part of the complex was constructed immediately after the death of the emperor. The piers between the arches on the facade are decorated with Doric pilasters, of which only the capitals are finished; these are surmounted by a heavy architrave. The present ground level corresponds to the original second floor, but exploration below this has brought to light a section of the ground floor. The radial walls within the rooms were made of brick, and the ceilings were vaulted; originally similar walls closed the arches as well, leaving openings for windows. At the center of the western side, a projecting platform supported the stairway leading to the temple; brick remains of the platform survive, incorporated in a modern building.

The northern side, of which very little survives, also consisted of a row of rooms built against a back wall. On this side, a short distance from the foundation, a terraced brick structure descended in the direction of the Colosseum; this was probably a large cascading fountain. From this side comes a large marble fountain head in the form of a ship's prow with a boar's head (now in the Museo Nuovo Capitolino), whose mid-first century AD date coincides with that of the associated building, unless it is a late Neronian addition.

Fewer remains survive on the building's south, where the hill was higher and accordingly where there was little need for structural support.

The eastern side is the most monumental and best preserved of all, and from this the full extent of Nero's modifications of the building are most clearly evident. This side was excavated in 1880 during the building of Via Claudia, which it follows for its entire length. It consists of a large brick wall with a series of niches and a larger chamber at the center. This enormous nymphaeum, originally equipped with fountains, is separated from the embankment to its rear by an empty space. A colonnaded porticus probably ran in front of the structure, with arches corresponding to the niches; it may have been designed to conceal some of the construction's anomalies that are easily observable even today. The entire facade must have been finished with rich sculptural decoration.

No trace of the temple survives above the platform foundations. Fortunately,

however, a fragment of the Severan Marble Plan partially fills in the gap. From this source, we know that the temple was prostyle hexastyle, with three columns on the sides. A garden occupied the rest of the area, which was probably enclosed within a porticus.

THE AREA BETWEEN S. GREGORIO AND VILLA CELIMONTANA The street that ascends between the churches of S. Gregorio and its three chapels on the right and SS. Giovanni e Paolo on the left follows the course of an ancient road. Its present name is probably the original one, **Clivus Scauri,** whose existence is attested not only in medieval sources, beginning in the eighth century, but even by an Imperial inscription. Construction of the street can thus be assigned to a member of the family of the *Aemilii Scauri,* thought to be M. Aemilius Scaurus, censor in 109 BC.

The street has preserved much of its ancient appearance, flanked here and there by Imperial period residences whose facades, interconnected by medieval arches that span the road, have been preserved to a remarkable height. On the left, an important group of ancient buildings is incorporated in the basement of the Church of SS. Giovanni e Paolo, but the street's right-hand side contains a building complex of some interest as well.

Various ruins are scattered about the area surrounding the Church of S. Gregorio (FIG. **56:1**): a section of a **cryptoporticus,** under the custodian's house to the right of the church; the remains of a multistory residential structure, dating to the beginning of the third century AD, under the Chapel of S. Barbara; a portion of a tufa wall in *opus quadratum* applied as facing for a concrete core associated with the remains of a Republican public building, located to the right of the Oratory of S. Silvia. Farther up, behind the Oratory of Sant'Andrea, lies an **apsidal basilical hall,** whose masonry dates it to a rather late period. The building has been identified as the library of Pope Agapitus I (535–36); we know of its existence from a letter of Cassiodorus *(De institutione divinarum litterarum, praef.)* and from the dedicatory inscription copied by the author of the Einsiedeln Itinerary.

A little farther ahead, along the Clivus Scauri, another building can be seen that was probably part of the same complex. The traces of three doors, now blocked, are still visible on the brick facade facing the road. Remains of another large brick building, dated to the beginning of the third century AD, are distinguishable in Piazza dei SS. Giovanni e Paolo on the right, essentially a row of **tabernae.** Traces of a second floor can be discerned.

THE HOUSE OF SS. GIOVANNI E PAOLO Along the northern side of the Clivus Scauri lies the Church of SS. Giovanni e Paolo, which sits above and in part reuses several residences of the Imperial age (FIG. **56:2**). The basilica opens onto a square from which an ancient street began, running north along the side of the Temple of Claudius. Another street, parallel to the Clivus Scauri on the

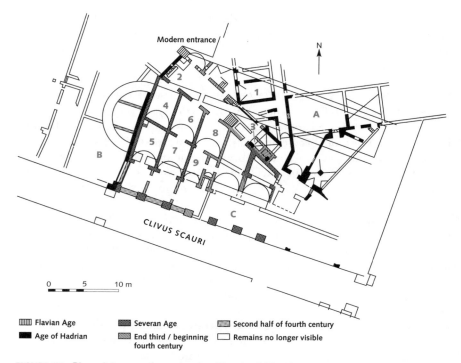

FIGURE 57. Plan of the remains under the Church of SS. Giovanni e Paolo. **A,B,C** The three original houses. **1** Bath building? **2** Nymphaeum with large wall painting. **3** "Confessio." **4** Room with painting of youths and garlands. **5,7,9** Shops. **6,8** Back rooms.

north, bordered the residential area to which the remains under the basilica belonged (FIG. **57**).

Two **houses** stood southwest of the church: to the right of the apse, a large wall in *opus mixtum* of the second century AD is preserved to a height of three stories **(B)**; a few remains of the other can be seen at the end of the right aisle (the large fresco of the nymphaeum in the entrance court, which will be treated below, covers an exterior wall of this second house). The left side of the church incorporates the facade of the second-century house located along the Clivus Scauri, which for this reason has been exceptionally well preserved; it was only partially covered by the medieval arches that spanned the street at this point **(C)**. The ancient building was adapted to its new function by cutting the facade to half the height of the second floor and blocking the windows and the six arches at ground level.

The house had two entrances (corresponding to the two central arches), one of which **(9)** led directly to the ground floor, while the other led to the upper floors

by means of a stairway. The windows were arranged in two nearly symmetrical groups on either side of a central axis—thirteen windows on the first floor above ground level, twelve on the second. A series of tabernae opened onto the porticus that fronted the ground floor.

Toward the end of the nineteenth century, archaeologists found two large multistory residential properties below the church (one of these is associated with the facade described above). The two dwellings were separated by an alley **(2),** which was later transformed into an elaborate nymphaeum. The house situated further to the northeast **(A)** originally faced both the road parallel to the Clivus Scauri and the street perpendicular to it that ran along the Temple of Claudius; one of its shorter sides also faced the Clivus Scauri. In its present state, the building can be dated to the reign of Hadrian on the basis of brick stamps, although the structure reveals earlier phases, dating back at least to the Flavian period. The rooms that have been excavated are concentrated under the right aisle of the church, cut by the foundation walls of the colonnade that separated the aisle from the central nave.

The ground floor of the structure consisted of large rooms, almost perfectly oriented to the cardinal points, which were originally decorated with stuccos, paintings, and polychrome wall mosaics. The ground descended suddenly toward the north, thus creating space for several rooms that were below ground level in relation to the aforementioned rooms but occupied ground level on the side facing the valley. These rooms constituted a small private **bathing facility (1)**; one of the rooms had a tub, and another a terracotta basin *(labrum)*.

The best-preserved house **(C)** is below the basilica's central nave and left aisle. Its facade, which forms the church's left side, is perfectly preserved along the Clivus Scauri. This house, whose site was previously occupied by an older building, was separated from the other **(A)** by means of the narrow courtyard **(2)**. This space was transformed, certainly during a second phase, into a rich nymphaeum and was at that time equipped with a masonry base with alternating square and semicylindrical niches, visible in two points—in front of room **8** and on the short western side. The new configuration featured fountains with special effects, while the floor was paved with a polychrome mosaic made of large tesserae. At the center there is a large well that was later raised to the level of the church floor. The walls of the room were decorated with lavish paintings. On the right, traces of a procession of *erotes* on sea monsters can still be seen. But the most remarkable section occupies the upper part of the short western side: an imposing fresco (5 meters long, 3 meters high) that may represent Proserpina's return from Hades.

At the other end of the courtyard, beyond the foundation wall of the church's interior colonnade, lies a **large stairway** abutting the northern wall of the house; this too belongs to a second phase. Thus the building, an *insula* of several stories subdivided into apartments, underwent extensive remodeling (possibly in the middle of the third century), its ground-floor level having been considerably

lowered, and was transformed into a deluxe home; a similar process can also be observed in numerous houses in Ostia. The nymphaeum evidently dates to this second phase.

The courtyard of the nymphaeum leads to the ground-floor rooms that lie between it and the Clivus Scauri. Rooms **5, 7,** and **9** were originally **tabernae** that opened onto the exterior porticus, which the addition of partition walls at a later period transformed into anterooms. Rooms **4, 6,** and **8** opened onto the courtyard and from here provided access to the house farther to the north, while a stairwell in the small passageway **(3)** led to the upper rooms. Rooms **4, 6,** and **8** had access to both the shops and the courtyard. Room **4,** immediately adjacent to the large fresco in the nymphaeum, contains a remarkable painting on a white background, depicting youths holding up a vegetal festoon, with peacocks and other large birds in between. Vines and tendrils, among which *erotes* and birds flit about, are depicted in the vault. The floor was paved with marble slabs, removed in antiquity, although traces of the paving remain. This remarkable decoration seems to be contemporary with that of the nearby nymphaeum.

Rooms **8** and **9** contain decorative work that is later, attributable to the first half of the fourth century AD, imitating, for the most part, the rich inlaid work of polychrome marble. In the "Aula dell'orante" **(8),** the painting, also dated to the fourth century, is richer and very well preserved, except for the central part of the vault, which is lost. A heavy frieze of acanthus tendrils runs above the typical decoration, which imitates marble *crustae*; above this rises the vault, decorated with a circular motif divided into twelve sections, containing, among other decorative elements, paired sheep as well as male figures holding scrolls. The figure of a man praying—shown in typical fashion with his arms outspread—appears in a lunette; the painting reveals the Christian character of the house in this period.

Of considerable interest for the history of the Church is the small **confessio** halfway up the stairway in the courtyard **(3).** This small niche, decorated with frescoes dating to the second half of the fourth century AD depicting Christian martyrs, was situated in a position that corresponds with an opening in the church's central nave. The frescoes, in two registers, covered three sides of the niche, onto which the *fenestella confessionis* opened. The sides of the confessional grating are decorated with two figures dressed in the *pallium*; below them a male figure prays while two individuals prostrate themselves at his feet. The most interesting scenes are those on the right: three figures—two men and one woman—marching, escorted by two others (possibly soldiers); the beheading of the three is depicted in the panel below. In the natural tufa of the area beneath the staircase, below the niche, are three openings that have been identified as **tombs.**

It would be difficult not to associate these very old representations with the account of the *passio* of Saints John and Paul. Yet, even if the titular saints of the church could have been added later, the similarity of the painting to the account

of the martyrdom of Crispus, Crispianus, and Benedicta at the time of Julian the Apostate is striking. The bodies of the latter three might have been buried in the house, which, from the third century on, belonged to a Christian named Byzas, who was supposed to have given it to the Church, transforming it into a *titulus*. The presence of Christian subjects in frescoes datable to the beginning of the fourth century; the probable use of the first floor of the house as a meeting place, whose form and dimensions resemble those of the later basilica; the frescoes of the second half of the fourth century (and thus not long after the events they narrate), in which the martyrdom of two men and a woman is depicted—all of this coincides quite closely with, and thereby confirms, what we know of the tradition.

The basilica that was subsequently built incorporated the *titulus* and the adjacent secular buildings. Construction must have begun around 410, after which the work was carried out in several fairly close phases. The nave (44.30 meters long and 14.68 wide) and the aisles (7.40 meters wide) were separated by thirteen arches supported on twelve columns. The foundations of the colonnade rested on the preexisting buildings in such a way that only part of the ground floor of the *titulus* remained accessible. A semicircular apse, with four large windows, was added to the nave.

A small museum contains the material found during the excavations.

THE ARCH OF DOLABELLA AND THE AREA AROUND S. MARIA IN DOMNICA

Via di S. Paolo della Croce begins at Piazza dei SS. Giovani e Paolo and follows an ancient road that is the continuation of the Clivus Scauri. After skirting Villa Celimontana, the street passes under a travertine arch that supports the **Neronian Aqueduct,** whose arches continue beyond the wall on the left in the adjacent gardens. A barely legible inscription preserved on the attic of the arch's exterior facade names the consuls of AD 10:

P. Cornelius P.f. Dolabella / C. Iunius C.f. Silanus flamen Martial(is) / co(n)s(ules) / ex s(enatus) c(onsulto) / faciundum curaverunt idemque probaver(unt) (P. Cornelius Dolabella, son of Publius, and Gaius Junius Silanus, son of Gaius, flamen of Mars, consuls, by decree of the Senate saw to the construction and inspection [of this monument]).

On the right side of the arch, below the brick wall, the beginning of a structure in blocks of Grotta Oscura tufa, closely joined to the arch, can be distinguished. The remains surely belong to the Servian Wall and, accordingly, the extant arch must be one of Augustus's reconstructions of the wall's gates (almost certainly Porta Caelimontana), similar to the reconstruction of Porta Esquilina and probably many others.

The square now occupied by Villa Celimontana rests upon large ancient walls, mostly of Flavian date, whose remains are visible principally on the piazza's

southern side. Within the perimeter of the villa, a short distance from its entrance off the Piazza della Navicella, lay the barracks of the Fifth Cohort of the *Vigiles*, seen in 1820, 1931, and again in 1958 (FIG. **56:3**). The identification is confirmed by inscriptions, two of which are still inside the villa. The remains belong to the Trajanic period.

In 1889, a building was discovered on the opposite side of the piazza, toward the Colosseum and within the grounds of the military hospital, whose mosaic floor had curious designs intended to ward off the evil eye. An inscription in the mosaic names the building: *Basilica Hilariana*. A base found among the ruins supported a statue of the basilica's founder, Manius Publicius Hilarus, a pearl merchant; the statue was dedicated to him by the college of *dendrophori*, worshipers of Cybele, to which Hilarus belonged. Excavations conducted between 1987 and 1989 have uncovered almost the entire building, which was constructed during the Antonine period (ca. AD 145–55) and restored in the first half of the third century. It is possible that the *arbor sancta* mentioned by the Regionary Catalogues as lying between the *Caput Africae* and the Castra Peregrina—that is, more or less in this area—could be a reference to the Basilica Hilariana and to the building of which the basilica formed a part, and which must be regarded as the headquarters of the *dendrophori*. Veneration of a sacred pine in fact played a role in the cult of Cybele. A recently excavated four-sided structure at the center of the courtyard probably housed the pine that was ritually transported to the Temple of the Magna Mater on the Palatine every year on 22 March.

An extraordinary residence dating to the second half of the third century was also discovered near the basilica; it belonged to a Gaudentius, as a mosaic inscription indicates, during a late phase of the building. This Gaudentius can with great probability be identified as a senator of the period between the end of the fourth and the beginning of the fifth century AD, and a friend of Q. Aurelius Symmacus, whose residence was certainly nearby.

THE LATERAN The Lateran forms only a marginal part of the Caelian, located inside the Aurelian Walls where Via Caelimontana, Via Asinaria, Via Tusculana, and another anonymous ancient street that corresponds to the modern Via dell'Amba Aradam converge (FIG. **58**). A series of excavations, both early and recent, provides a sufficiently clear explanation of the topography of the area.

Excavation below the Ospedale di S. Giovanni (Sala Mazzoni) undertaken several decades ago (1959–64) brought to light various phases of a building in use between the first and fourth centuries AD. This could well be the villa of Domitia Lucilla, the mother of Marcus Aurelius, where the future emperor spent his youth. Among other things, a peristyle was found, at the center of which was a basin that was replaced in the course of the second century by a pedestal. Several reliefs representing the Temple of Vesta and the Vestals probably belong to this. It has been suggested—probably incorrectly—that this was the original base of the equestrian statue of Marcus Aurelius, now on the Capitoline. As is well

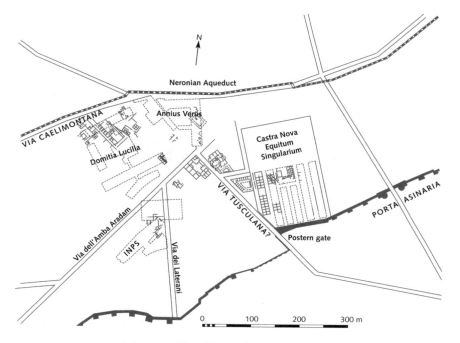

FIGURE 58. Plan of the area around the Lateran.

known, this monument originally stood in the vicinity of the Lateran, where it remained until 1538, when it was transferred to the Capitoline.

On the other side of Via dell'Amba Aradam, within the triangle formed by it and Via dei Laterani, an excavation undertaken a few years ago during construction of the headquarters of the Istituto Nazionale della Providenza Sociale revealed a **group of buildings** at a depth of 10 meters that descended gradually on terraces. Two different complexes dating to the Julio-Claudian period and with second-century AD restorations were identified here. At the beginning of the fourth century, these were then combined into a single complex containing a large corridor (5 meters wide) that was closed on the north and pierced on the south by wide windows. A spacious exedra opened onto the corridor, of which only a section of 27 meters remains, presumably at its center. Some have suggested that these buildings should be identified as the houses of the Pisones and Laterani, confiscated by Nero. The later merger of these houses into a single residence is thought to have constituted the *Domus Faustae*, the home of Maxentius's sister and Constantine's wife.

The remains of a **nymphaeum** were found at a depth of 7.50 meters a little farther to the north, at the intersection of Via dell'Amba Aradam and Via dei

Laterani. It consisted of a rectangular room flanked by two smaller rooms and ending in an apse, whose back wall contained a rectangular niche. Remains of glass mosaics belong to the building's first phase, the Julio-Claudian period. Later modifications were introduced and paintings added; those in a room to the right of the apse are well preserved. These improvements probably date to the third century AD. The baths, whose central hall is still preserved southeast of the Lateran Baptistry and which can be dated to the first half of the third century AD, are reasonably associated with these buildings.

Remains of a villa of the first century AD were discovered on the other side of Via Tusculana beneath the Baptistry; this was replaced by a bath complex at some point between the reigns of Hadrian and of Antoninus Pius. The building was in turn entirely rebuilt under Septimius Severus and Caracalla. The same phases can be found in the bath structure located farther to the southwest, mentioned above. The relationship between these two buildings is not clear.

The most remarkable complex of the area, however, was discovered between 1934 and 1938 underneath the Basilica of S. Giovanni in Laterano. A house of the third century, trapezoidal in form, had already been brought to light in the course of work undertaken in 1877–78 by Vespignani. The structure is located very close to, and in part underneath, the church's old apse. The floor mosaics of the courtyard have been partially preserved.

The remains of a wealthy house of the first century of the Empire were discovered beneath the nave and aisles of the church and under a part of the cloister; it was built on terraces sloping downward from northwest to southeast and situated at a slightly oblique angle to Via Tusculana. The rich Fourth Style decoration of Neronian date makes it likely that this belongs to the Lateran estate, seized by Nero in AD 65. At the end of the second century—probably sometime after AD 197—this residence, which lies 5.55 meters below the floor of the church, was replaced by the second barracks of the *equites singulares,* the mounted guard of the emperor *(Castra Nova Equitum Singularium)* (FIG. **56:7**). The complex, erected by Septimius Severus, was, like the house, also oriented along a north-south axis. The *praetorium,* the residence of the commander, was probably located between the second and third spans of the basilica. It comprised a courtyard, 15 × 21 meters, closed on the north by a porticus of piers, on the south by the camp's *sacrarium,* and on the other two sides by rooms belonging to the officials; an inscription dated to AD 197 comes from one of these rooms. Further west lie two long sections, each consisting of series of facing rooms (under the fifth span and transept) that served as housing for the troops. The mosaic flooring, with geometric designs in black and white tesserae, and remains of wall paintings are preserved in many of the rooms.

At the beginning of the fourth century all of these structures were cut off to make room for the basilica. The apse of the church, as mentioned above, encroached upon a house situated west of the barracks. The total length of the building can be reconstructed as 99.76 meters, the central nave measuring 90.55

meters. It was thus somewhat smaller than St. Peter's Basilica. The basilica proper consisted of five aisles; the two exterior aisles were shorter in order to make space for two chambers that formed a transept.

The date of the basilica can be assigned to the first years after the battle of Saxa Rubra. The construction was probably completed in a few years, between 314 and 318. Dedication must have taken place on 9 November 318. Accordingly, this is the oldest Christian basilica in Rome.

TOMBS ON THE CAELIAN Numerous tombs, the oldest of which dates to the end of the fourth century BC, lined *Via Caelimontana*. Several funerary monuments have appeared at various times within Villa Wolkonski, a property of the British Embassy. The tombs, of various periods, have almost completely disappeared.

Only the **columbarium** of Tiberius Claudius Vitalis, discovered in 1866 near the lodge of the villa, is extant. The structure was made of brick in a style commonly found between the first and second centuries AD; it originally had three stories, 9 meters high altogether, but is preserved to a height of 5.40 meters. The marble inscription, surrounded by a frame, is preserved above the door, which opens off center on the left. The dedicatory inscription, erected by an Imperial freedman and architect named Tiberius Claudius Eutychus, mentions Tiberius Claudius Vitalis, his father of the same name (also an architect), his mother Claudia Primigenia, and his sister, Claudia Optata. The interior consists of three superimposed rooms (4 × 3 meters) with mosaic flooring. The walls of the first two rooms contain three rows of loculi, in each of which are three or more cinerary urns. The third floor has no loculi and thus was probably intended for the funerary cult. Given its identification with a freedman of Claudius, the tomb should be dated somewhere between AD 41 and 80.

Further on, at the intersection of Via Statilia and Via di S. Croce in Gerusalemme, lies a notable group of **Republican tombs,** discovered in 1916 during an enlargement of the road and now protected by a shed. The first one on the left, with a facade of tufa blocks containing a central door, may be the oldest; the door is flanked by two round shields, fashioned out of the same blocks that form the facade. The funerary chamber is very small, partially cut in the rock and roofed with an irregular vault in *opus caementicium*. The inscription identifies the owners as a P. Quinctius, bookseller and freedman of Titus, his wife, and his concubine. The lack of a cognomen and the rather archaic appearance of the monument point toward a date of around 100 BC or a little earlier. The next tomb has two chambers with adjacent doors, decorated with busts of the dead (a woman with two men on the left, two women on the right). This is probably one of the oldest examples of the use of portraits of the deceased on tomb facades. The inscriptions, altered at some point, name six persons; the fact that several of the dead are listed with cognomina suggests a date a little later than the previous tomb, that is, around the beginning of the first century BC. Next to these are

a columbarium, almost completely destroyed, and a monument in the form of an altar that was later enlarged in *opus reticulatum*. The inscription of the latter assigns the monument to two Auli Caesonii, probably brothers, and a Telgennia. This small group of tombs allows us to follow at close hand the evolution of funerary monument types from the chamber tomb (the oldest belonging to P. Quinctius) to the isolated monument (the latest belonging to the Caesonii), between the end of the second and the beginning of the first century BC.

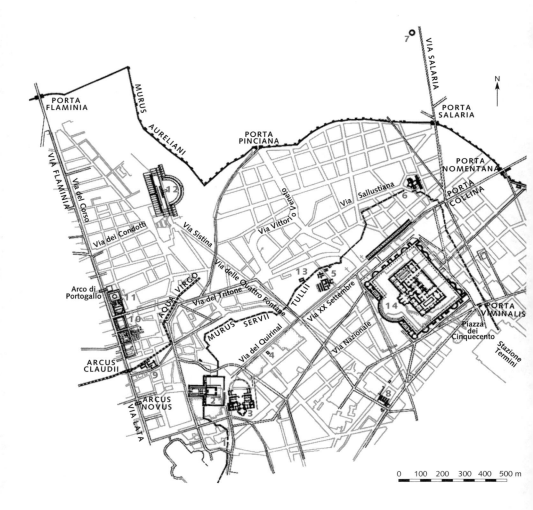

FIGURE 59. The Quirinal, the Viminal, and the Via Lata. **1** Porta Sanqualis. **2** Temple of Serapis. **3** Baths of Constantine. **4** Altar of the Neronian fire. **5** Imperial residences. **6** Complex of the Horti Sallustiani. **7** Tomb of Lucilius Paetus. **8** Buildings under S. Pudenziana. **9** Porticus Vipsania. **10** Hadrianic insulae. **11** Temple of the Sun. **12** Villa of Lucullus. **13** Barberini Mithraeum. **14** Baths of Diocletian. **15** Castra Praetoria.

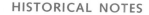

QUIRINAL, VIMINAL, AND THE VIA LATA

HISTORICAL NOTES

The sixth Augustan region comprised the territory occupied by the Quirinal and the Viminal, which were formally designated as *colles* (hills), unlike Rome's other elevations, which were distinguished as *montes* (literally, mountains). Region VI's boundaries were defined by Region VIII (area of the Fora) and possibly the Argiletum at the south; on the east by *Vicus Patricius* (the present-day Via Urbana) facing Region V, and by its extension, which runs to "Porta Chiusa" in the Aurelian Wall; on the north by the Aurelian Wall from "Porta Chiusa" to Porta Pinciana; on the west (facing Region VII) by *Via Salaria Vetus* (=Via Crispi and Via di Porta Pinciana). Both the Viminal and the Quirinal are spurs that break off from the eastern plateau (see FIG. 2).

The configuration of the streets in the region follows the lay of the land, forming in essence long parallel roads running from southwest to northeast; these include: Vicus Patricius, which forms one of its boundaries; *Vicus Longus*, which passes through the valley between the Viminal and Quirinal from the Forum of Augustus to the Baths of Diocletian, in part along the course of Via Nazionale; and *Alta Semita*, which runs along the ridge of the Quirinal on the course of Via del Quirinale and Via XX Settembre. The cross streets, which must have traversed the steep lateral slopes of the hills, formed the sec-

ondary routes. The present course of Via delle Quattro Fontane, which corresponds to an ancient street, gives some idea of the difficulties posed by the terrain in this region. The original topography was in fact extensively modified during the course of the centuries. The side valleys were filled in, as can be ascertained, for example, by comparing the present level of Via Nazionale with that of the Church of San Vitale, which corresponds to the level of Vicus Longus during the medieval period. In Piazza Barberini, the ancient level sits at a depth of 11.75 meters. The ascent of the ancient street that corresponds to Via delle Quattro Fontane was interrupted by a sheer cliff, almost 25 meters high, that suddenly jumped to a height of 50 meters. The hill's summit—approximately 57 meters—is at the crossroads of the Quattro Fontane, where the ancient and modern levels practically coincide. On the other side of the hill, facing Via Nazionale, the difference between the ancient and modern levels is more pronounced: an ancient pavement appeared 17 meters below the palazzo on the corner where Via delle Quattro Fontane intersects Via Nazionale. A large, recently identified fragment of the Severan Marble Plan depicts the entire southwestern corner of the hill.

The Quirinal included several peaks: *Collis Latiaris* on the south, rising from the area around the Imperial fora; *Collis Mucialis*, immediately behind it, in the area between Largo Magnanapoli—where the *Porta Sanqualis* stood—and Piazza del Quirinale; *Collis Salutaris* north of this, where the Temple of Salus was located, west of the Quirinal Palace; and *Collis Quirinalis*, which lay between Collis Salutaris and the eastern end of the hill, where the Temple of Quirinus and the gate in the Servian Wall of the same name, *Porta Quirinalis*, were located.

The hill was inhabited from the Iron Age, as attested by archaic tombs found near Porta Collina, Porta Sanqualis, and elsewhere. A votive deposit discovered in front of the steps of Santa Maria della Vittoria dates to the late eighth or early seventh century BC. On the opposite side, facing the southern slope (where Palazzo delle Esposizioni now stands), an ex-voto deposit was found, containing the famous Duenos Vase, a receptacle consisting of three small vases joined together, with one of the oldest known Latin inscriptions, dating to the beginning of the sixth century BC. This sanctuary might be that of Fortuna, which Servius Tullius was supposed to have founded on Vicus Longus. Alongside it was the shrine of *Pudicitia Plebeia*, founded by a Virginia in 296 BC as an alternative to that of *Pudicitia Patricia* in the Forum Boarium. Another archaic cult was that of Mamurius, which had given its name to a *vicus* on the Quirinal.

The first inhabitants of the Quirinal, according to ancient tradition, were the Sabines under Titus Tatius, who were later absorbed into the Latin city.

The future Region VI comprised the fourth urban tribe of Servius's political reorganization, namely, the *Collina*. It was bounded on three sides by the Servian Wall, whose course in this area is well documented and which had five gates, from the Sanqualis on the southwest to the *Viminalis* on the northeast.

During the Republic the Viminal was essentially a residential quarter, containing almost no sanctuaries or public monuments (the only known sanctuary is that of Naenia). Affluent houses dating to the second and first centuries BC have been documented on Via Panisperna, on Via Balbo, and along the ancient Vicus Patricius, the present-day Via Urbana. The barracks of the Third Cohort of the *Vigiles* were probably located near *Porta Viminalis,* and a bath complex called *Lavacrum Agrippinae* is situated by late sources near S. Lorenzo in Panisperna, the site, according to tradition, of St. Lawrence's martyrdom. Other structural remains, probably those of a bath, were discovered under the Church of S. Pudenziana, along the ancient Vicus Patricius. The large barracks of the Pretorian Guard, the *Castra Praetoria,* were built outside the Servian Wall under Tiberius.

The Quirinal too was essentially a residential zone, distinguished from the Viminal by the presence of numerous sanctuaries from early antiquity. The most important among these are mentioned below:

The *Auguraculum* stood on the Collis Latiaris, outside the Servian Wall, though it was later incorporated within the villa of Scipio Africanus. This was an inaugurated area, consecrated by the augurs for the taking of auspices in connection with the elections *(comitia)* that took place in the *Saepta* located in the Campus Martius below. The sanctuary duplicated the functional relationship of the Auguraculum on the Arx and the Comitium situated below it. The augural site on the Collis Latiaris must have been located more or less where the medieval Torre delle Milizie now stands. The *Vicus Insteius* or *Insteianus* must have started from here, as Varro (*L* 5.52) and other sources record. The small sanctuary of Diana Planciana stood nearby within the complex of the present-day Angelicum, as attested by recently discovered inscriptions.

The oldest cult in the area was probably that dedicated to *Semo Sancus Dius Fidius,* a divinity of Sabine origin, which was supposed to have been founded by Titus Tatius. The temple was supposedly constructed by Tarquinius Superbus but not inaugurated until 466 BC. Inside was a bronze statue, identified as a representation of Tanaquil, the wife of Tarquinius Priscus, whose spindle and distaff were also kept here. The sanctuary was on the Collis Mucialis near Porta Sanqualis, which took its name from that of the god. Several inscriptions situate the shrine near the Church of San Silvestro al Quirinale.

Other sanctuaries of considerable antiquity include the *Capitolium Vetus* and the Temple of Quirinus. The Capitolium Vetus was dedicated to the same triad worshiped in the Temple of Jupiter on the Capitoline and was supposedly the older of the two. It must have been on the Collis Salutaris, at the foot of which was a very old Temple of Flora, near which *minium* workshops were set up. The Temple of Quirinus was on the Collis Quirinalis, near the intersection of Via del Quirinale and Via delle Quattro Fontane, on the side facing Piazza Barberini. A relief, now in the Palazzo Massimo, depicts the Temple of Quirinus as a Tuscan building with a decorated pediment that portrayed Romulus and Remus taking the auspices for the foundation of the city. Prior to the Augustan restoration of

16 BC, the building must have been rather different. Vitruvius (3.2.7) describes it as Doric, octastyle peripteral, with two rows of columns on the sides. The temple was surrounded by a large porticus.

The Temple of Salus stood near *Porta Salutaris,* possibly corresponding to the present-day Quirinal Palace; the consul of 311 BC, C. Iunius Bubulcus, built it between 306 and 303 following his victories in the Second Samnite War. Paintings ascribed to Fabius Pictor, probably representing scenes from the war, decorated the temple.

Various sanctuaries stood along the course of Vicus Longus: those of Pudicitia Plebeia, Fortuna (mentioned above), Spes, and Febris. Three other temples dedicated to Fortuna, known collectively as the *Tres Fortunae,* were situated toward the eastern end of the hill, near Porta Collina; the temples of Venus Erycina, dedicated in 215 BC, and Hercules were located outside this gate.

During the Imperial period, a sanctuary of the *Gens Flavia* was built by Domitian on the site of his family home, where he himself had been born in AD 51. A recent hypothesis identifies this sanctuary as the large building whose remains were discovered under the westernmost part of the Baths of Diocletian.

Undoubtedly, the most imposing structure in the area was the Temple of Serapis, built by Caracalla along the western slope of the hill, between the present-day Piazza della Pilotta and Piazza del Quirinale. Even eastern cults were not lacking in this densely populated area, the most famous example of which is the rich Mithraeum discovered behind Palazzo Barberini.

The social profile of the quarter must have been quite mixed. Of special note are the residences of several important members of the equestrian order: T. Pomponius Atticus (the friend and correspondent of Cicero), Vespasian, and his brother Flavius Sabinus. The poet Martial lived in a third-floor rental apartment on the southern end of the hill, near Piazza del Quirinale.

The northernmost section, bordering the Pincian Hill, was filled with parks, the most important of which originally belonged to Caesar and was later acquired by Sallust. The *Horti Sallustiani* (considered among the most beautiful in the city) passed into the Imperial domain under Tiberius and were enlarged and embellished several times.

The density of the area's population is underscored by the construction in the late Imperial period of two of the city's most elegant bath complexes: the Baths of Diocletian, situated in the working-class area on the east, and the Baths of Constantine, a smaller and more refined building on the west. The remains of the latter were partially demolished during construction of Via Nazionale.

The hill was surrounded by cemeteries on the other side of the Servian Wall. Some tombs are Republican, like that of the Sempronii near the Campus Martius, but most date to the beginning of the Imperial period; many were discovered between Via Salaria and Via Nomentana during construction of the neighborhoods adjacent to Corso Italia and Via Po.

Region VII included the eastern part of the Campus Martius, to the right of Via Lata (present-day Via del Corso), and the western part of *Collis Hortulorum* (the Pincian Hill), forming a large triangle between the Corso, the Aurelian Wall (between *Porta Flaminia*—Porta del Popolo—and *Porta Pinciana*), Via Salaria Vetus (Via di Porta Pinciana and Via Crispi), and its extension to the slopes of the Quirinal, between the Trevi Fountain and Piazza dei Santi Apostoli. The axial road from which the region took its name *(Via Lata)* was the first tract of the *Via Flaminia*, built by C. Flaminius during his censorship in 220 BC. In addition to the streets that formed the western and eastern borders of the region, several cross streets are also recorded: one branched off Via del Corso on the right, a little north of Via del Tritone (present-day Via di San Claudio and Via del Pozzetto); two others corresponded to Via Frattina and Via dei Condotti. The course of the latter diverges from the other parallel streets and heads toward the modern stairway of Piazza di Spagna. The deviation was probably influenced by the villa of Lucullus, which stood, more or less, at the point where the Church and Convent of Trinità dei Monti now stand.

This area lacked buildings of any importance until the end of the Republic. Numerous tombs must have lined Via Flaminia and Via Salaria Vetus. Among these, only the tomb of Bibulus survives, very close to the Servian Wall (near the Monument of Vittorio Emanuele II).

Toward the end of the Republic, villas started to appear on the slopes of the Quirinal and Pincian facing the Campus Martius. The villa of Scipio Africanus, which later probably passed into the hands of Scipio Aemilianus, occupied the western slopes of the Quirinal, near Trajan's Markets. Lucullus built his villa immediately after his triumph over Mithridates (63 BC), taking advantage of the vast plunder amassed in the victory. According to Frontinus *(Aq. 22.2)*, the villa stood at the point where the *Aqua Virgo* emerged from its subterranean conduit on the Pincian and crossed the Campus Martius on arches.

The villas of the Acilii and later of the Anicii and Pincii must have occupied the northernmost section of the hill, encroaching on at least part of Lucullus's estate. The so-called Muro Torto, datable to the end of the Republic, is a remnant of their foundations.

Formal urbanization of Region VII did not begin until the reign of Augustus and is due primarily to Agrippa. The Aqua Virgo, built at this time, was one of the principal features of the quarter, especially after its restoration under Claudius, who transformed the span of the aqueduct over Via Lata into a commemorative arch.

The *Campus Agrippae* was located to the right of Via Lata. A recently discovered inscription identifies it as the site of the *Ara Providentiae*, erected at the beginning of Tiberius's reign, probably to complement the *Ara Pacis*, located on the opposite side of the street (Via del Corso). The *Porticus Vipsania* stood immediately south of the Aqua Virgo; this was begun by Agrippa and completed by his sister, Vipsania Polla, but dedicated by Augustus. Ruins discovered in 1885

during construction of the Galleria Sciarra (near Teatro Quirino) are probably those of the porticus, which Martial (4.18.1) situates next to the aqueduct. Inside the building was a map of the Roman world, perhaps similar to the "Tabula Peutingeriana," which was probably painted on the porticus's interior wall. Other buildings connected with Augustus's program of urban reform include the barracks of the First Cohort of the *Vigiles*, which were in the vicinity of Piazza dei Santi Apostoli. The narrow stretch along Via Lata was transformed under Hadrian into a densely populated residential zone. Occasional excavations undertaken at various points but especially under the modern Galleria Colonna at the time of construction in 1892, and more recently during the opening of the underground walkways, have brought to light an entire region of large, multistoried brick buildings with arcades, off of which shops were located. A similar—and contemporary—configuration is found at Ostia along the *decumanus* east of the Theater. Nothing belonging to these buildings can be seen any longer. One of these housed the *Catabulum*, the office of the *Cursus Publicus* (more or less, the central post office), which stood near the Church of S. Marcello. Other remains in the area were recently discovered on Via di S. Maria in Via, where it intersects with Via dei Crociferi, and above all on Via dei Maroniti, where an *insula* of several stories appeared, constructed of brick with floors of marble and mosaic.

The region saw a fairly intense amount of construction in the third century AD. Gordian III was supposed to have built a porticus 1,000 feet long below the Quirinal (though some have doubted this information); and Aurelian, sometime after 273, began the large Temple of the Sun, which was certainly in the area between Piazza S. Silvestro and Via del Corso. A drawing by Palladio, made when the building was still partially preserved, shows two contiguous enclosures surrounded by porticoes. The wine that was distributed at a discounted price— a practice introduced by Aurelian—was stored in these porticoes. The *Castra Urbana* (police headquarters) and *Forum Suarium* (the market for pork products) were also in the vicinity.

The Regionary Catalogues record the existence of a Porticus of Constantine in Region VII; this structure should perhaps be situated not far from Piazza dei Santi Apostoli.

ITINERARY 1

From Porta Sanqualis to the Horti Sallustiani

The walk begins at Largo Magnanapoli, which lies more or less at the border between the Latiaris and Mucialis hills. Five rows of Grotta Oscura tufa blocks from the Servian Wall can be seen in a flower bed at the center of the square; these may have belonged to a gate, Porta Sanqualis, which took its name from the sanctuary of Semo Sancus Dius Fidius (FIG. **59:1**). The shrine can be located,

on the basis of epigraphical finds, near the Church of S. Silvestro al Quirinale. Several Iron Age tombs were found near this section of the wall. Another stretch of the wall in cappellaccio is preserved farther to the south, along Salita del Grillo; it was incorporated into the construction of Trajan's Markets. Other remains can still be seen to the north, in the nearby Palazzo Antonelli, at Largo Magnanapoli no. 158. Inside, in the hall on the right, stands an arch of Monteverde and Grotta Oscura tufa blocks, which was installed in the upper section of the wall; it resembles a later structure near Piazza Albania. These small arches must have been openings for *ballistae* or other shooting weapons. Numerous fragments of sculptures and inscriptions of various eras are set into the walls in the same hall. Other remnants of the wall in Monteverde tufa and Republican structures in *opus incertum* lie at the rear of the courtyard in another vestibule.

At the end of the square, on a high embankment supported by a massive wall, stands the Villa Aldobrandini—all that remains of the rise, removed during the construction of Via Nazionale in the nineteenth century, on which the Baths of Constantine once stood. On the back side of the villa, facing Via del Mazzarino, are important **remains of a brick building,** which inscriptions identify as the warehouse of L. Naevius Clemens; it can be dated to the end of the first century AD, with restorations added under Trajan and the Severan emperors. Other parts of this complex, later covered over by the embankment laid for the baths, were brought to light during the construction of an air-raid shelter in 1940.

The Baths of Constantine originally occupied the area between Alta Semita and Vicus Longus; that is, between the present-day Via XX Settembre and Via Nazionale (FIG. **59:3**). The bath complex may have replaced the ancient *Lacus Fundani,* formed in this region by the *Fons Cati,* which gave its name to a street on the Quirinal. The bath's large northern exedra corresponds to Palazzo della Consulta, while the central body of the complex occupied the area of the modern Palazzo Rospigliosi, whose construction resulted in the loss of all that remained of the building. This was the last building of its type erected in Rome, probably the work of Maxentius, as the brick stamps indicate. Over time, the baths were associated by name with the emperor Constantine, as happened with the Basilica of Maxentius. A large number of older houses were incorporated within the artificial terrace required to accommodate so large a structure. Aligned with the southeastern slope of the hill, many of these were discovered at the end of the nineteenth century during the construction of Via Nazionale.

Renaissance drawings provide us with the plan of the baths, while numerous statues and paintings from its rich decoration have survived, including, among other works, three portraits of Constantine, now in St. John Lateran and on the balustrade of the Capitoline.

A street, running uphill from south to north, separated the Baths of Constantine on the east from a huge temple, whose remains can still be seen in the gardens of Palazzo Colonna (entrance at Via XXIV Maggio no. 17). The

controversy regarding the identification of this building—which some identify as the Temple of the Sun built by Aurelian, others as the **Temple of Serapis** built by Caracalla—has now been definitively resolved in favor of the second (FIG. **59:2**). The Temple of the Sun, which the Regionary Catalogues situate in Region VII, cannot correspond to a building that stood entirely in Region VI on the Quirinal. The Temple of Serapis is mentioned both in the *Historia Augusta* (*Caracalla* 9.10–11) and in a large inscription from the temple, which was discovered in the Church of Sant'Agata dei Goti. Several Renaissance drawings, made when the building was in a much better state of preservation, have given us a sufficient idea of its plan: an enormous complex, surrounded by porticoes, that rose at the edge of the hill on a largely man-made terrace. An imposing stairway, whose foundations consisted of a series of vaulted rooms, spanned the difference in level between the hill and the Campus Martius. One of these rooms housed a Mithraeum.

The lofty brick walls that supported the stairway can still be seen on the right side of the Colonna Gardens or from an interior courtyard of the Università Gregoriana. Inside the Colonna Gardens, near the edge of the terrace that defined one of the temple's boundaries, two enormous marble blocks from the sanctuary are preserved. One of these is a pilaster capital, whose stylistic similarity to those of the Porticus Octavia, which was reconstructed by Septimius Severus, dates the building to the beginning of the third century AD—providing further evidence to support its identification as the Serapaeum of Caracalla. The other block belongs to a corner of the pediment. The capital, weighing more than 100 tons and measuring in excess of 34 cubic meters, is the largest architectural element in Rome. The area occupied by the temple—the largest in the city, including the Temple of Venus and Rome—was 13,230 square meters (135 × 98 meters). The columns had a diameter of almost 2 meters and were 21.70 meters high. The style of the building, set on a hill with a monumental stairway, recalls the Serapaeum in Alexandria, which was probably the model for the Roman sanctuary. The two enormous statues of the Dioscuri, now on the fountain in Piazza del Quirinale, and the two large statues of river gods, the Tiber and the Nile, located at the base of the stairway of the Palazzo Senatorio in Piazza del Campidoglio, probably belonged to the decorative program of the temple complex.

The **Tomb of the Sempronii,** discovered in 1863 at the western end of the Quirinal, is on Via della Dataria, alongside the Cortile di San Felice. The tomb's facade, dressed in travertine blocks, faces southwest—that is, toward the street that ran up from the Campus Martius to a gate of the Servian Wall generally identified as *Porta Salutaris*. The tomb rested on a high platform, now reburied, above which stands an arched opening. A vaulted corridor, around three meters long (of travertine blocks, with the exception of the last row, which is made of tufa) led to the cella, built in brick, of which only a small section remains. The monument is one of Rome's oldest examples of this building technique.

The following inscription was carved above the entrance arch:

Cn(aeus) Sempronius Cn(aei) f(ilius) Rom(ilia tribu) / Sempronia Cn(aei) f(ilia) soror / Larcia M(anii) f(ilia) mater.

The tomb thus had three occupants: Gnaeus Sempronius, his sister, and his mother. Above the inscription is a frieze of palmettes surmounted by a cornice with dentilicatulation and an egg-and-dart molding. The appearance of the tomb's crown is uncertain, as no traces of it survive. The style of the monument, with raised door, is found in other, more or less contemporary, tombs, such as that of Publicius Bibulus near the Capitoline and another near Porta Salaria. The tomb of Sempronius can thus be dated to the end of the Republic, toward the middle of the first century BC.

During construction of the building at Via del Quirinale no. 30 (the former Ministero della Real Casa) in 1888, a **large travertine altar** (3.25 meters wide, 6.25 long, 1.26 high) was discovered (**FIG. 59:4**). The altar rests upon a platform of two steps that rises from a travertine pavement, marked off by a series of cippi that stood in front of the monument at intervals of between 2.50 and 3 meters. The core of the altar was originally clad entirely in marble, as the extant base molding shows. An inscription, probably from this monument, that was discovered in 1640 during the construction of the Church of Sant'Andrea identifies the altar's purpose: it is one of several erected by Domitian in every region of the city to mark the limits reached by the great Neronian fire; two other identical inscriptions were found: one near St. Peter's (not in its original position), and the other on the slopes of the Aventine. Sacrifices were offered on these altars on 23 August, the *Volcanalia* or festival of Vulcan, in order to avert fires *(incendiorum arcendorum causa)*.

THE HOUSE AND TEMPLE OF THE GENS FLAVIA An important discovery under the Caserma dei Corazzieri, along Via XX Settembre, just before the Church of S. Susanna, was confirmed some years ago during work on the refectory of the barracks, where the remains are still visible (**FIG. 59:5**). A short section of the Servian Wall appeared along the northern edge of the hill, where it turned at a slight angle; the use of cappellaccio dates it to the earliest period of construction. The northern wall of a large podium in *opus caementicium* was partially freed above it. The most important discovery was made farther to the north, a building that had occupied the area immediately outside of the wall, probably taking advantage of a series of terraces along the side of the hill, with structural elements dating from the late Republic to the beginning of the Empire.

A large wall, of which only the right half was exposed, was decorated in its entirety with a glass mosaic, featuring various architectural designs and mythological scenes, such as Hylas and the nymphs, in the Fourth Style. Above

this facade, slightly set back, is a semicircular niche, likewise decorated with a mosaic. A water pipe running toward the building makes it clear that this was a nymphaeum, and the water must have flowed down the mosaic. The impressive dimensions and exceptional quality of the decoration clearly suit the home of a patrician, which can be dated, on the basis of the style of the mosaics, to between the end of the Neronian and the beginning of the Flavian period. The discovery on the other side of Via XX Settembre of an inscribed lead water pipe and a boundary cippus identifies the owner as Flavius Sabinus, the brother of Vespasian. Accordingly, it has been suggested that the architectural complex under the Caserma dei Corazzieri is the *Domus Flavia*, the family home of the Flavii, which stood on the Quirinal. Domitian, who was born there, built a temple next to it, the *Aedes Gentis Flaviae*, dedicated to his deified family and intended as their final resting place. Vespasian and Titus were buried here.

THE BARBERINI MITHRAEUM AND HORTI SALLUSTIANI The remains of a Roman building of the second century AD appeared in 1936 between the back facade of Palazzo Barberini, on Via delle Quattro Fontane, and Via di San Nicola da Tolentino. The westernmost room had been transformed into a Mithraeum, a hall 11.85 × 6.25 meters, roofed with a barrel vault and furnished with side benches, as is typical of these buildings (FIG. **59:13**). The most interesting feature of this small sanctuary, dated with certainty to the third century AD, is the painting that decorates the rear wall, similar to those in the Mithraeum recently discovered in Marino and the Mithraeum in Capua. The central panel depicts the customary scene of Mithras killing the bull, whose blood is being lapped up by a dog and a serpent, while a scorpion bites its testicles. The two torch bearers, *Cautes* and *Cautopates,* stand alongside, observing the scene, above which are two curved lines that represent the celestial vault. The signs of the zodiac are portrayed within the lines, at the center of which is the god with a lion's head, standing on a globe and entwined in the coils of a serpent. The sun and moon are shown in the upper corners on the right and left. A series of ten small pictures of different sizes, divided into two vertical bands, frame the central portrait. As in other cases, these recount the sacred history of the god. Starting from the left and from top to bottom, we recognize Zeus striking the giants with a thunderbolt; Saturn; Mithras being born from the rock; Mithras making water gush from a rock by striking it with an arrow; and Mithras transporting the bull. On the right, we see the mystic banquet; Mithras climbing into the chariot of the Sun; the pact of allegiance between Mithras and the Sun; Mithras on his knees between two trees; and Mithras using the hoof of a bull to strike the sun god kneeling before him, a scene of initiation. Aside from the Mithraeum of S. Prisca, this is the only example of a painted Mithraeum in Rome, and it furnishes us with precious information regarding the mythology and ritual of a cult that had considerable importance in Imperial Rome.

The Temple of Quirinus must have stood above the area around Palazzo Barberini, for several bilingual dedications (Greek and Latin) from peoples of Asia Minor were found in the vicinity. These were similar to, and evidently copies of, the ones found at the foot of the Capitoline, and were displayed in the sanctuary on the Quirinal.

A small segment of the oldest **city wall in cappellaccio** can be seen at the center of Largo di S. Susanna; it follows the same line as the section recently discovered under the Caserma dei Corazzieri.

The remains of an **Imperial building** can still be seen under the Church of S. Susanna, three meters below the current level; access to the ruins is from the crypt. The oldest structural elements, in *opus mixtum* (reticulate and brick), lie at an oblique angle to the church; the latest ones, however, in brick and dated to the first half of the second century AD, follow the church's orientation. A black and white mosaic floor dates to the house's first phase (first century AD), though there is evidence of subsequent enlargement and restoration. Construction behind the church's apse in 1938 led to the discovery of other structures, including a section of the Servian Wall, against which a wall in *opus incertum* rested on the inside. At a short distance, outside of the wall, were brick structures, probably belonging to other Imperial residences. These remains were subsequently reburied.

Porta Collina stood farther down Via XX Settembre, at the corner of Via Goito; its remains were discovered at the end of the nineteenth century, during the construction of the Ministero delle Finanze. An important section of the Servian Wall can still be seen today in Via Salandra. Other remains, in particular the remnants of Porta Viminalis, are preserved in Piazza dei Cinquecento.

In antiquity, the Horti Sallustiani occupied the vast area between the continuation of Alta Semita (*Vicus Portae Collinae*, that is, Via XX Settembre) on the south, Via Salaria on the east, the Aurelian Wall on the north, and the modern Via Veneto on the west. This property originally belonged to Caesar; after his death it was acquired by the historian Sallust, after whom it was named. The estate was inherited by the writer's great-nephew, whom he had adopted, and at his death in AD 20 it passed into the hands of the emperor Tiberius. In the years that followed, the villa, enlarged and embellished several times, remained a part of the Imperial domain. We know that Vespasian enjoyed his stay on the property and that Nerva died here. The fierce battles that gave control of the city to Vespasian's army in AD 69 took place right in the area of the *Horti*.

Hadrian and Aurelian oversaw important renovations of the estate. The latter was said to have added a structure known as the *Porticus Miliariensis*, where he was in the habit of riding his horse. This tradition suggests that the building was a "hippodrome," a combination of porticus, garden, and riding track often associated with Roman villas. A copy of the obelisk of Ramesses II erected in the Circus Maximus, now located in front of the Church of Trinità dei Monti, may originally have stood in this part of the villa.

When Alaric gained control of the city in AD 410, making his way from Porta Salaria, the villa suffered severe damage and was never restored, as we learn from Procopius (*Vand*. 1.2).

One of the principal sections of the park occupied the deep valley that divided the Quirinal and Pincian Hills; it has now almost completely disappeared. The slopes of this depression were shored up by powerful walls that were strengthened by arches and buttresses and stood below the Servian Wall; remnants of these supporting walls, built in *opus reticulatum*, can still be seen in the courtyards on the right side of Via Barberini. These may be the foundations of the Temple of Quirinus that was rebuilt by Augustus on a much larger scale than its predecessor.

Structural elements of a remarkably **well preserved pavilion** belonging to the villa can be seen at the center of Piazza Sallustio about 14 meters below the present-day level (FIG. **59:6**). Built entirely of brick, it stood at the property's summit, where the Quirinal and Pincian Hills meet, dominating the protected valley that slopes down toward the west. The building is set into a cut of the hill that was regularized by the addition of two superimposed stories. Thus with considerable skill the architect took full advantage of what was quite a spectacular location. The principal feature of the structure is a circular hall (FIG. **60:A**), 11.21 meters in diameter and 13.28 meters high, roofed by a dome with alternating flat and concave segments, whose nearest parallel is the contemporary semidome of the Serapaeum in Hadrian's Villa. There were three niches on each side, two of which had doors providing access to side rooms (**L** and **E,** which can probably be identified as nymphaea). Some of the niches were already closed during the course of construction with masonry identical to that of the walls; this is clear from the fact that decorative marble slabs, of which only the clamp holes remain, revetted these walls as well. The closures were probably mandated by structural weaknesses discovered during construction. Below there was a marble floor, traces of which have been identified, while the upper part of the walls and the dome were stuccoed. The round hall was preceded by a rectangular vestibule (**D**) on one side and followed by a symmetrical room (**B**) on the other. The latter led to a rectangular hall (**C**), from which side doors provided access to smaller rooms (**J, K**), possibly bedrooms. The vault of the hall was double (only the imposts of the lower one remain) and the space in between was accessible through small side doors. This space was probably reserved for apparatuses connected with the banquets that were held in this room, as it was almost certainly a summer *cenatio*. To the left of the circular hall are other rooms, roofed with barrel and groin vaults (**E, F**), and a large stairway (**G**) that led to the upper stories; the facade of these rooms is preserved up to two stories but originally must have been considerably higher.

On the other side, a room of irregular form, exposed for the most part, occupies the space between the central building and a separate complex several stories high, with a semicircular plan that was embedded into the hill. The linear

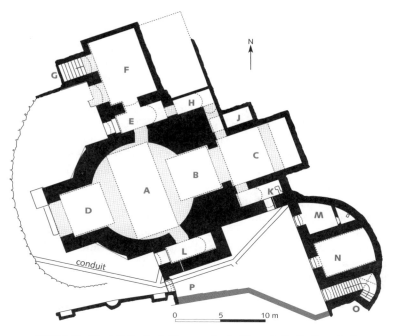

FIGURE 60. Horti Sallustiani. The complex in Piazza Sallustio *(lower level).*

facade of the structure (much restored in the nineteenth century), like the other surrounding walls, was originally covered with a thick layer of plaster imitating a wall of ashlar masonry, probably painted. Three stories of the building survive; the third, above the modern level, unlike the others, is built in *opus mixtum.*

The inside is divided into three sectors: that on the right **(O)** functioned as a stairwell; the one on the left **(M)** is divided in two by a partition; the back room housed a small latrine. The sectors, especially those in the middle **(N),** preserve rich painted decoration and floors of black and white mosaic. The brick stamps date the whole complex to the end of Hadrian's reign, after AD 126. The few third-century restorations are attributed to Aurelian.

Other remains of the Horti Sallustiani are still visible: the **Sallustian obelisk,** a Roman copy of the obelisk of Ramesses II erected by Augustus in the Circus Maximus (now in the Piazza del Popolo), has stood in front of Trinità dei Monti since 1789. Its granite base, now in the garden of S. Maria in Aracoeli on the Capitoline, was discovered in 1912 between Via Sicilia and Via Sardegna, behind the modern Istituto Archeologico Germanico. It probably stood on the *spina* of the hippodrome within the villa. The obelisk, carved when hieroglyphics could no longer be read, may date to the reign of Aurelian.

Remains of a **cryptoporticus** decorated with paintings on panels, probably dating to the third century, were discovered in the garage of the American Embassy (alongside Via Friuli). Not far away, the top of a wall with niches can be seen along Via Lucullo; this may have been part of a large nymphaeum, datable on stylistic grounds to the first phase of the villa—that is, at the end of the Republic.

A **large cistern** survives under the Collegio Germanico, at the corner of Via San Nicola da Tolentino and Via Bissolati. It has two floors: the first, 1.80 meters high, functions as a foundation for the second, which consists of four interconnecting parallel naves that are 38.55 meters long and 3.30 high. The work is Hadrianic, as are many of the surviving architectural structures in the Horti Sallustiani.

The Temple of Venus Erycina (i.e., Venus of Eryx), built between 184 and 181 BC, is also said to have stood nearby and may have been incorporated within the *Horti* at a later date. Other finds in the vicinity may have belonged to this temple, including the so-called Ludovisi Throne and the large marble head of a woman—perhaps the divinity's cult statue. Both were Greek originals from southern Italy, datable to the middle of the fifth century BC; they are now in Palazzo Altemps.

This sanctuary must have differed considerably from the other Temple of Venus in the Horti Sallustiani *(Venus Hortorum Sallustianorum)*, which is known from inscriptions. This temple may be the round building that was seen in the 1500s in an area corresponding to the modern intersection of Via Sicilia and Via Lucania. Its plan is recorded in a sketch by Pirro Ligorio: a round peripteral shrine with four symmetrical entrances, whose form appears to be identical to that of the sanctuary of Aphrodite at Cnidus, home of the famous Aphrodite of Praxiteles, as described by various ancient writers. This Roman reproduction—there is another in Hadrian's Villa—should be associated with the first owner of the *Horti*, Julius Caesar, who would have sought to underscore his close rapport with the mythical ancestor of the *Gens Iulia*. Other sculptures coming from this area are similarly associated with the person of the dictator, such as the Ludovisi Gauls (the *Dying Gaul* in the Museo Capitolino, and the Gallic warrior committing suicide, now in the Ludovisi collection housed in Palazzo Altemps). Both of these sculptures, originally displayed together on a single base, are first-century BC copies of the original bronze group that was displayed in the *temenos* of *Athena Nikephoros* in Pergamon, erected to commemorate Attalus I's victories over the Galatians. The copy might have served Caesar as a trophy similarly memorializing his Gallic victories.

THE AREA AROUND PORTA SALARIA Porta Salaria, a gate in the Aurelian Wall, which stood in what is now Piazza Fiume, was demolished in 1871 to improve traffic circulation. The plan of the gate, with its two semicircular towers, is indicated in the modern pavement at the center of Via Piave. Various

fragments of funerary monuments, reused in the construction of the wall, were found during the demolition. The remains of a circular tomb in travertine, datable to the early Augustan period, were embedded in the western tower. If the inscription found in the same place belongs to this, as it would appear, the tomb's occupant was a Cornelia, daughter of L. Scipio and wife of a Vatienus. The extant parts of the circular drum, a merlon decorated with a bucranion, the inscription, and a lion's torso, all belonging to the tomb, are now located on the lawn alongside the Aurelian Wall to the west of Piazza Fiume. The tomb's core, in *opus caementicium*, was seen during the construction of the automobile underpass.

The two monuments discovered within the eastern tower are now located a little farther back inside the wall. One is an **altar tomb,** built of peperino blocks, with pilasters and base molding of white compact limestone and probably a window on one side. It can be dated to the Sullan era. A **later monument** stands immediately next to it on the right, consisting of a travertine base that supports a marble cippus with a pediment and acroteria (the cippus is a copy; the original is in the Capitoline Museums). A youth dressed in a toga is portrayed in high relief within a niche in the middle of the monument; the remaining space—the sides and lower part—is taken up by a long inscription, in Greek and Latin. That on the base, in Latin, informs us that the tomb was built for Q. Sulpicius Maximus, a Roman citizen who died at the age of 11, by his parents, Q. Sulpicius Eugamus and Licinia Ianuaria. The boy had competed with 52 other poets in the third Capitoline Agon, thus in AD 94, in the category of extemporaneous Greek verse. Though he did not win, he dazzled the audience with his brilliant improvisational skills. Under the Latin inscription are two Greek epigrams, clearly the work of his father, in which he lauds the poetic achievement of the young man and laments his death, caused by the excessive amount of work he dedicated to his study. The improvised poem he wrote for the poetic agon is inscribed alongside the figure of the young man and on the scroll that he holds in his hand. The theme of the poem was Zeus's reprimand of the Sun for having allowed the inexperienced Phaethon to drive his chariot.

Around 500 meters from the gate, on the left side of Via Salaria, is a large **circular mausoleum,** built six meters below current ground level (FIG. **59:7**). It is a large cylinder, around 34 meters in diameter, whose core in *opus caementicium* is dressed with a travertine facing, with a base and two simple cornices above and below. The large inscription occupies the center of the side facing Via Salaria; it was carved on a marble panel (now missing the upper portion) that was framed with a Lesbian *kyma*. The panel extends far beyond the upper cornice of the drum, which must have had some form of terminal decoration. The inscription identifies the tomb as that of M. Lucilius Paetus—of the *Scaptia* tribe, a military tribune, *praefectus fabrum* (commander of the corps of engineers), prefect of the cavalry—and his sister Lucilia Polla. The tomb was built when Lucilius Paetus was still living, as the letter "V" preceding the inscription indicates, around

20 BC. The burial chamber, set in the middle of the rubble core and reached from a door located diametrically opposite the inscription, has three niches that contained as many funerary beds, of which only one survives. The owners of the tomb were thus not cremated. A catacomb was later constructed below the original cella.

A tufa wall can be seen between the tomb and the street. This structure evidently marked off a special area. Fragments of inscriptions from other tombs have been mounted here.

THE HYPOGEUM OF VIA LIVENZA A remarkable subterranean construction, excavated at the end of the nineteenth century, is preserved near the modern Via Livenza, within the "Sepolcreto Salario" on Via Salaria. At the time of its discovery, excavators saw a building, with a plan similar to that of a circus, oriented along a north-south axis, that had passageways leading to side rooms measuring 21 × 7 meters. The construction of modern homes above has destroyed much of the building, but the most significant portion survives.

A stairway that preserves many of the ancient steps leads to the hypogeum. The north wall has three arches—a large central opening flanked by two smaller ones—that are parallel to the straight back wall. A little farther on, at an oblique angle, is a rectangular pool (2.90 × 1.70 meters, 2.50 deep) that is separated from the rest of the hall by a perforated marble screen (now reconstructed). Three steps, the first of which is quite high, provide access to the pool, which was filled from a pipe inserted in the northern wall; the water drained through another pipe, set just above the first step, and a valved opening on the west wall.

Above the pool is a wall that opens into an arch. This and the side walls were elaborately decorated with frescoes in the lower section, and mosaics in the upper section. While most of the mosaic is gone, there remains a fragment on the left wall with a polychrome band on top and the remains of a rather interesting scene that includes the lower part of two figures, one kneeling in front of a fountain, the other standing. It has been suggested that the scene represents Saint Peter who, like Moses, causes water to gush forth from a rock in order to baptize the converted centurion. At the center of the arch was a large inscription in mosaic that has almost entirely disappeared. The lower register has a fresco depicting cupids fishing. A niche in the rear wall that is off axis from the rest of the building is decorated with frescoes imitating marble panels of porphyry and giallo antico. A *cantharos*, from which water springs and on which doves rest, is represented in the upper part of the niche. The figure of Diana the huntress, drawing an arrow from her quiver while two deer flee, is depicted on the left side of the niche; on the right, a nymph pets a roe-deer.

The coexistence of pagan and Christian subjects and the presence of the pool have prompted the suggestion that the building was a sort of baptistry or sanctuary belonging to a mystery cult, but a recent interpretation identifies the complex as nothing more than a monumental fountain. The chronology of the

building can be securely assigned to the second half of the fourth century AD on the basis of the building technique and a stamp bearing the monogram of Constantine, which provides a *terminus post quem*.

ITINERARY 2

From the Castra Praetoria to the Viminal

THE CASTRA PRAETORIA The Camp of the Praetorian Guard, Castra Praetoria, was built on the advice of Sejanus by Tiberius between AD 21 and 23 in the far northeastern section of the city, between Via Nomentana and Via Tiburtina (FIG. **59:15**). The praetorian cohorts, instituted by Augustus as a permanent guard for the emperor, had hitherto been housed in various areas of the city. Only under Tiberius were they concentrated in one fixed camp, built outside the Servian Wall, "at the outer edge of the inhabited area," according to Pliny the Elder (*NH* 3.67).

The field set aside for the training and drilling of the praetorians lay between the barracks and the Servian Wall. In addition to the residences, a series of other buildings was included within the enclosure of the barracks: the *praetorium* (headquarters of the commander), *aerarium* (treasury), *armamentarium* (armory), *valetudinarium* (hospital), and *horrea* (storehouses). According to canonical form, the principal sides of the walls were pierced by four gates. The northern and eastern gates are still visible, both made of brick, spanned by arches and flanked by piers and two wide bands in which slit windows were installed. The original enclosure, made of brick, was 4.74 meters high, including the merlons. Honorius lowered the level of the ground around the camp, exposing the foundations by as much as 3.50 meters near the northeastern corner. At that time the southern side, abutted by the Porta Chiusa, was entirely rebuilt in tufa blocks, possibly appropriated from the nearby Servian Wall. The reconstruction is not medieval, as once believed, but probably dates to the sixth century and follows the original line of the wall on this side. A strip of the western end of the camp is cut off by Viale Castro Pretorio, as can be seen from the continuation of the camp wall beyond the modern street up to where it joins the Aurelian Wall, near a postern gate (in Piazza della Croce Rossa). Excavations in the nineteenth century and in 1960–63, undertaken for the construction of the Biblioteca Nazionale, give a fairly precise idea of the camp's internal organization (FIG. **61**).

A continuous series of rooms, built in *opus reticulatum* and roofed with barrel vaults (3 meters high and 3.60 wide), was built up against the walls throughout the entire circuit, with a wall walk on top. Some of these rooms had mosaic flooring, others (probably used for storage) were paved in flagstone. The barracks proper, following conventional practice, consisted of long buildings with two rows of adjoining rooms facing opposite directions, similar, for example, to the *Castra*

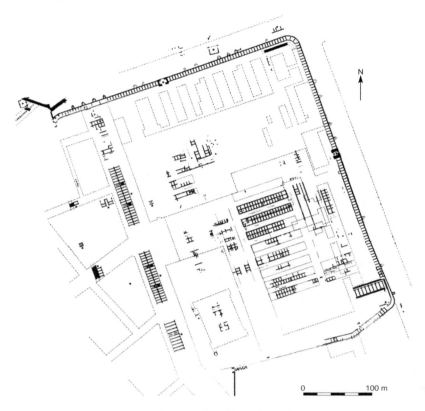

FIGURE 61. Plan of the Castra Praetoria.

Nova Equitum Singularium. On the western side, the rooms observed during the construction of Viale Castro Pretorio ran in a north-south direction, while to the east, those discovered during the construction of the Biblioteca Nazionale stood side by side, running east to west. In the latter section, seven units were seen, separated by streets and equipped with different types of flooring, including mosaic, *opus spicatum,* and even simple beaten earth. In the space between these rooms and the exterior wall, the buildings again appear to assume a north-south orientation.

THE BATHS OF DIOCLETIAN The Esquiline, Quirinal, and Viminal were some of Rome's most densely populated neighborhoods, so it is not accidental that the Baths of Diocletian, the largest ever built in Rome, were located at the northern end of this area, while those of Trajan stood on the opposite side, to the south. The building was constructed in a relatively short time, between AD

298 and 306, as we can deduce from the dedicatory inscription, reconstructed from fragments of four different copies, now on display in a large hall within the Museo delle Terme:

> *D(omini) N(ostri) Diocletianus et Maximianus invicti seniores Aug(usti) patres Imp(eratorum) et Caes(arum); et d(omini) n(ostri) Constantius et Maximianus invicti Aug(usti), et Severus et Maximinus nobilissimi Caesares thermas felices Diocletianas, quas Maximianus Aug(ustus) rediens ex Africa sub praesentia maiestatis disposuit ac fieri iussit et Diocletiani Aug(usti) fratris sui nomine consecravit coemptis aedificiis pro tanti operis magnitudine omni cultu perfectas Romanis suis dedicaverunt.* (Our masters Diocletian and Maximian, unconquered senior Augusti, fathers of the emperors and the Caesars, and our masters Constantius and Maximian, unconquered Augusti, and Severus and Maximinus, most noble Caesars, dedicated to their Romans the auspicious Baths of Diocletian, which Maximian Augustus, returning from Africa, in the presence of his majesty, laid out and ordered to be built and dedicated in the name of Diocletian, his brother, after purchasing a sufficient number of buildings for a work of such magnitude and attending to every detail of its ornamentation.)

Construction of the facility thus began with Maximian's return from Africa (autumn of 298) and was completed after the abdication of Diocletian and Maximian (1 March 305) but before the death of Constantius Chlorus (25 July 306). Many buildings were demolished to make room for the huge complex, as the dedicatory inscription records. Some of these were seen in Piazza della Repubblica during construction of the subway. The remains of one *domus*, dating to the first decades of the Empire, give evidence of two successive phases.

The area occupied by the baths was approximately 380 × 370 meters; the central building measured more than 250 × 180 meters. The large cistern, trapezoidal in form and more than 91 meters long, stood on the northeast side and was later called Botte di Termini; its last remains were demolished in 1876. The cistern was fed by a branch of the *Aqua Marcia*. The toponym *Termini*, which came to designate the central railroad station, preserves in altered form the memory of the baths *(thermae)*.

The plan resembles that of the Baths of Trajan—rather than that of the Baths of Caracalla—because of the semicircular exedra and the *caldarium*, which was not circular but rectangular with three semicircular apses. Aside from this detail, the scheme is canonical: a large central basilica, the *caldarium-tepidarium-natatio* complex across the short axis, and the palaestrae at the sides of the long axis. The building is constructed of bricks, whose stamps all date to the reign of Diocletian. The use of brick stamps, which lapsed in the third century, probably resumed with the construction of the baths. Slightly more than three thousand could use the services of the establishment at the same time.

The buildings of the central complex are the best preserved, but important sections of the large peribolus are also extant. On the northeastern side of

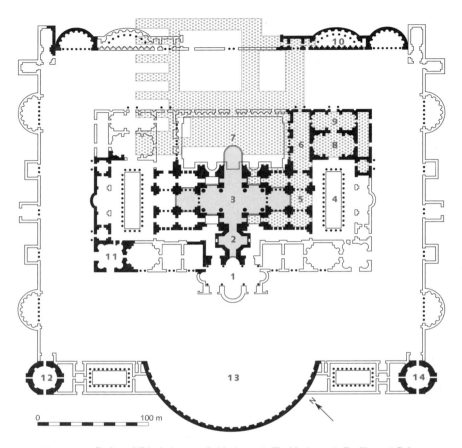

FIGURE 62. Baths of Diocletian. **1** Caldarium. **2** Tepidarium. **3** Basilica. **4** Palae-
stra. **5,6,8,9** Rooms occupied by the Museo delle Terme. **7** Natatio. **10** Apsidal hall.
11 Hall occupied by the Planetarium. **12** Rotunda (S. Bernardo alle Terme). **13** Large
exedra (Piazza della Repubblica). **14** Rotunda (Via Viminale).

Piazza della Repubblica, alongside the Facoltà di Roma III, remains of one of
the apses of the *caldarium* (FIG. **62:1**), which has largely disappeared, can still
be seen. Another apse, well preserved, functions as the entrance of the Church
of S. Maria degli Angeli, which was constructed out of the central hall (the
"basilica") of the baths **(3)**. This is reached by passing through the *tepidarium*,
a small circular hall with two large square exedras **(2)**. The church preserves the
ancient appearance of the complex, despite the modifications of Michelangelo
in the sixteenth century and above all of Luigi Vanvitelli in the eighteenth—the
most obvious being the raising of the floor and the addition of several brick

columns with a plaster that imitates granite. It incorporates not only the central hall, but also two side rooms; the apse built on the northeastern side has taken over part of the *natatio* (swimming pool) **(7)**. Of particular interest are the eight enormous monolithic granite columns and three large cross vaults that form the roof.

The nearby Museo delle Terme utilizes another part of the building: a group of rooms **(5)** between the basilica and the palaestra **(4)**, which is almost completely gone, and what remains of the *natatio* **(7)**, whose facade still preserves part of the decorative elements: a series of brackets, meant to support small suspended columns, typical of the Diocletianic architectural style. The eastern corner of the building is occupied by a large oval hall **(8)**, followed by another rectangular one **(9)**; the latter was one of the two main entrances to the bathing complex, and the former was probably one of the *apodyteria* (dressing rooms). The companion rooms on the other side of the building have completely disappeared. A section of the central building's facade, preserved well enough to be appreciated, can still be seen from the garden of the museum. On the other side of the garden, the two exedras of the peribolus's eastern corner remain in a good state of preservation; one of these **(10)** still has its mosaic floor. It is possible that these rooms were *auditoria*, halls for meetings and public lectures.

The facade of the Facoltà di Roma III corresponds perfectly to the northwestern facade of the ancient building. Its western corner consists of a large octagonal hall, with semicircular niches on the four corners, that was once occupied by the Planetarium **(11)** but is now an exhibition hall of the Museo delle Terme. One of the best views of the entire complex can be seen between Via Parigi and Via E. Orlando: a substantial section of the short northern wall can be seen along Via Parigi, while the facades of the modern houses along the western side of Via E. Orlando and the buildings surrounding Piazza della Repubblica, which were built on top of the ancient exedra, follow the line of the original peribolus wall.

The rotundas in the corners of the peribolus on the northwest and southeast are extant. The first was transformed into the Church of S. Bernardo alle Terme **(12)**, while the brick walls of the second **(14)** can be seen on Via Viminale where it meets Piazza dei Cinquecento. Between these two halls and the central exedra **(13)**, which may have been used as a theater, stood two rectangular halls, probably libraries. The books of the Biblioteca Ulpia were supposed to have been moved here, if we are to believe the implausible notice in the *Historia Augusta* (*Prob.* 2) that they had been transferred to the Baths of Diocletian.

Occasional excavations between the Baths and the Stazione Termini between the nineteenth century and 1950 revealed a whole neighborhood, of which today nothing can be seen. Among other structures, the excavations brought to light a remarkable third-century AD bathing facility, whose mosaics are displayed in the underpass between the station and the Metropolitana. An enormous quantity of structural remains and ancient material was discovered from 1861 on, particularly during the demolition of the so-called Monte della Giustizia, when

this artificial hill, roughly 15 meters high, was removed during the construction of the old railroad station. The hill, formed during the medieval period, rose at the spot where the Porta Viminalis once stood. In addition to various sections of the Servian Wall, a distribution tank *(castellum)* of Republican date, the so-called *bottino* (little barrel) was found. This small circular building, made of sperone (Lapis Gabinus) and travertine, 3.05 meters in diameter, with two large holes on the north side installed for water pipes, probably served the *Aquae Marcia, Tepula,* and *Julia.*

On the opposite side of the square, on the corner between Villa Peretti and Piazza dei Cinquecento, two travertine cippi with inscriptions were discovered in 1883 during the construction of the former Istituto Massimo, now part of the Museo Nazionale Romano; the markers indicate the boundary of the *Horti Lolliani,* which were located in the vicinity. This property probably belonged to Lollia Paulina, Agrippina's rival, and must have become Imperial property in AD 49 under Claudius, after the fall of Paulina.

THE VICUS PATRICIUS The existence of several churches of great antiquity and the assignment of a large fragment of the Severan Marble Plan to this area enables us to reconstruct the eastern slope of the Viminal where it borders Region V (and not Region IV, as was once held); that is, along *Vicus Patricius,* the present-day Via Urbana.

An extensive neighborhood of Imperial date, belonging to the eastern sector of the Viminal, was discovered at the time of the construction of the Ministero degli Interni and was immediately demolished.

The most substantial group of ruins still visible in this area is that below the Church of S. Pudenziana (FIG. **59:8**). A pious legend associates this place with the estate of Pudens, a member of the powerful family of the Acilii Glabriones, which was supposed to have hosted Saint Peter during his sojourn in Rome. The sons of Pudens, Novatus and Timotheus, were believed to have replaced the house with a bath complex, which thereafter assumed the name *Thermae Novatianae* or *Timothianae.* The historical basis of this legend was confirmed by the excavation in the vicinity of a private bathing facility that was subsequently occupied, at an early date, by a Christian *titulus.* The first reference to the *titulus* in 384 confirms that the transformation was completed in the last years of the fourth century AD by a certain Leopardus, who is mentioned not only in a funerary inscription but also in a mosaic in the apse of the church. It is likely that the buildings represented in this mosaic reproduce the appearance of the northern side of Vicus Patricius following the large-scale construction undertaken by the urban prefect Valerius Messalla at the beginning of the fifth century, as attested by inscriptions.

The oldest elements, which lie 9 meters below the front section of the church, include a wall built in *opus incertum* and a floor in *opus signinum,* with fragments of colored stones added, that can be dated to the second half of the second century

BC. Above this floor stood a second one, in mosaic, with fragments of colored marble arranged in regular patterns, which can be dated to the years between the end of the Republic and the beginning of the Augustan period. Remains of this same phase were recently seen in a section corresponding to the rear of the church. These remains evidently belonged to a luxurious **Republican house.**

In time, a large brick building, dating to the Hadrianic period according to the brick stamps, was constructed on top of this house. The later structure consisted of several large rooms roofed with cross vaults. Subsequently, another construction was erected next to this building, consisting of a series of large galleries set lengthwise that were the foundation for a **bath complex,** which was situated on the upper floor, namely, that of the church. The technique of the wall construction, which is quite rare, is noteworthy: a kind of *opus mixtum,* in which a *spicatum* made of brick replaces the reticulate work. A brick stamp found in a drain and other technical elements date the building to the reign of Marcus Aurelius. One of the rooms of the baths was later transformed into the present-day church through the addition of an apse. The large windows of the baths' upper floor are still visible in the women's gallery. At the center of the nave, excavations revealed several built-in tanks of mixtilinear form and the remains of a transverse porticus with three arches resting on two columns. Other remains of the same building, discovered and restored in 1932, can be seen at the rear of the church, facing Via Balbo.

A large fragment of the Severan Marble Plan, whose correct position has recently been determined, restores the appearance of a section of Vicus Patricius lying southwest of S. Pudenziana; it includes the street itself and the section north of it on the slopes of the Viminal. In addition to a large building that opens onto the street, there are three houses in a row, each of which has an atrium and peristyle; clearly, these were upper-class residences of the Republican period. Behind these stood an imposing complex measuring approximately 70 meters in length, built at a higher level and reached by a large stairway; this was a colonnaded platform that probably included gardens as well. The remains of this grand structure, largely visible up to the eighteenth century, were rediscovered during the extension of Via Balbo in 1888. A round building—which is not represented in the Severan plan, probably because it was built subsequently— stood at the center of the area. A contemporary chronicle records its presence in the sixteenth century. Here were discovered, among other things, the statues of two seated poets of the Hellenistic age, one of which is identified by the inscription as Posidippus, while the other may be his friend Asclepiades. Both statues, which were subsequently reworked, are now in the Vatican Museums. The circular building may be represented on the left side of the mosaic in S. Pudenziana; its dating to the reign of Decius is suggested by a late medieval tradition that situates in this vicinity the *Palatium Decii,* where St. Lawrence was supposed to have been martyred. A possible identification for the complex

in question is the *Area Candidi,* mentioned in the Regionary Catalogues, which probably belonged to a personage of the Antonine age, Tiberius Iulius Candidus, proconsul of Achaea between 134 and 137.

The Church of S. Lorenzo in Panisperna, located a very short distance west of this building, commemorates the martyrdom of the saint. Here too, various items spanning several periods were discovered, including the remains of walls in *opus reticulatum* and brick, as well as mosaic and marble floors. These can be seen behind the altar of the church, in the choir of the Poor Clares. In 1888, during the extension of Via Balbo, the remains of a small bath appeared, noteworthy for its walls finished in concrete plaster and a fine polychrome mosaic floor depicting fish, dating to the Republic and restored in antiquity (the mosaic is now in the Antiquarium Comunale).

ITINERARY 3

Via Lata

Region VII contains very few visible ancient remains. The itinerary follows Via del Corso (the ancient Via Lata) from south to north.

The first building on this walk, which is located near the Capitoline, is a tomb: the **Funerary Monument of C. Poplicius Bibulus,** whose main facade faces southwest, toward the street that passed through *Porta Fontinalis*. The remains almost touch the left side of the Monument of Victor Emmanuel II. The tomb, built of tufa and travertine, sits much lower than the present street level; its high base, which is almost completely buried, supported a rectangular cella, of which only one facade is preserved. At its center is a window, flanked by four Tuscan pilasters, between which lie two small panels. Only a small section of the upper frieze survives, ornamented with garlands festooned between rosettes and Hellenistic bucrania. The inscription, carved at the top of the base, was repeated on the sides as well. Several letters of the inscription on the right side still survive:

> *C(aio) Poplicio Bibulo aed(ili) pl(ebis) honoris / virtutisque caussa Senatus / consulto populique iussu locus / monumento quo ipse postereique / eius inferrentur publice datus est.* (To Gaius Poplicius Bibulus, plebeian aedile, in recognition of his valor and excellence, by resolution of the Senate and order of the People, a place for a monument where he and his descendants might be buried was granted at public expense.)

The monument is a rare example of a public tomb in Rome, in this case granted to a person who is otherwise unknown. The Campus Martius was the preferred venue for such an honor, as happened in the case of the consuls of 43 BC, Hirtius and Pansa. By reason of its architectural and decorative features

and the older style of the inscription, the monument can be dated to the first decades of the first century BC.

A **large building,** or rather series of buildings, built of brick on travertine piers occupies the left side of a small stretch of Via Lata. At one time this complex was thought to have been part of the *Saepta Iulia,* and it was here that scholars placed the fragment of the Severan Marble Plan that, as it turned out, represented the *Porticus Aemilia* in the Emporium. The Saepta, however, were located farther to the west, so the identification of the complex remains uncertain. Examination of the ruins preserved on the right side of Via Lata as far as Piazza Colonna has revealed that much of the street was reconfigured during Hadrian's reign as the result of the construction of large multistory residential *insulae* (FIG. **59:10**; FIG. **63**). The remarkable structural similarity of the building on the left side of the street (which, strictly speaking, belongs to Region IX), with that of Piazza Colonna suggests that it was another section of the same Hadrianic quarter, and it has a close affinity with other such complexes located along Via Lata.

The best-preserved section that can still be seen lies beneath the Church of S. Maria in Via Lata, at the intersection of Via del Corso and the modern Via Lata. It is a **large gallery,** supported by the usual square travertine piers, from which rise cross vaults, around 10 meters high. When the gallery was renovated at the beginning of the third century AD, the installation of brick walls resulted in the creation of six smaller square rooms with vaults added at a lower level (5.50 meters) that probably divided the original height of the construction into two floors and redeployed the spaces as warehouses or shops. During the fifth century, the two central rooms, to which an apse was added on the east, were transformed into a Christian chapel. This was certainly the older diaconate of S. Maria in Via Lata. The remains of seventh-century paintings are located in one of the rooms.

Three arches spanned the course of Via Lata. The first, at S. Maria in Via Lata, is identified as the *Arcus Novus,* erected in 303–4 by Diocletian on the occasion of the twentieth anniversary of his rule. The remains of the arch were demolished in 1491. Several surviving sculptural pieces, works of the first century AD that were reused by Diocletian, are presently embedded in the rear facade of Villa Medici. Two column pedestals, with a representation of the Dioscuri and of Victories and barbarian prisoners, now in the Boboli Gardens in Florence, are usually attributed to this monument, but in fact do not appear to belong to it, since they were discovered much farther to the north. They should probably be assigned to Aurelian's Temple of the Sun.

The Arch of Claudius, erected between AD 51 and 52 to commemorate the conquest of Britain, stood farther ahead, in Piazza Sciarra, immediately beyond Via del Caravita. The Aqua Virgo passed on top of it. A large fragment of its inscription is displayed in the courtyard of the Palazzo dei Conservatori, while the rest of the sculptures are in a wing of the Museo Nuovo Capitolino.

FIGURE 63. Complex of Hadrianic *insulae* near Piazza Colonna.

The third arch, known as the Arco di Portogallo, stood just before Via della Vite; it was demolished in 1662; a plaque on a house to the right records the original site. Two reliefs showing an *adlocutio* (exhortation) of Hadrian and the apotheosis of the emperor's wife, Sabina, now in the Museo dei Conservatori, come from the monument. These elements were certainly reused, and the arch's date is debated. They must have come from an arch that served as the entrance to the Temple of Hadrian precinct, to which other reliefs, now in the Museo dei Conservatori and Palazzo Torlonia, belong. The later arch, the Arco di

Portogallo, must have been a monumental entrance to Aurelian's Temple of the Sun (FIG. **59:11**).

Remains of the **Aqua Virgo** have been seen at various points in the Campus Martius. The most important segment is found at the beginning of Via del Nazareno no. 14. The inscription and style of architecture, in rusticated ashlar masonry, show that this portion of the aqueduct was refurbished by Claudius. The inscription, which dates to AD 46 and is repeated in another section of the aqueduct, preserved in the basement of Via della Stamperia no. 16, runs as follows:

> *Ti(berius) Claudius Drusi f(ilius) Caesar Augustus Germanicus / pontifex maxim(us) trib(uni-cia) potest(ate) V imp(erator) XI p(ater) p(atriae) co(n)s(ul) desig(natus) IIII / arcus ductus aquae Virginis disturbatos per C(aium) Caesarem / a fundamentis novos fecit ac restituit.* (Tiberius Claudius, son of Drusus, Caesar Augustus Germanicus, pontifex maximus, invested for the fifth time with tribunician power, acclaimed Imperator for the eleventh time, father of the fatherland, consul designate for the fourth time, reconstructed and restored from the foundations the arches of the Aqua Virgo, damaged by Gaius Caesar [Caligula].)

The damage referred to was probably caused by Caligula during the construction of an amphitheater in the Campus Martius, a project that was never completed.

The Porticus Vipsania, built by Agrippa and his sister, Vipsania Polla, must have rested against the arches of the Aqua Virgo on the south, and not north in the Campus Agrippae, which is certainly not Augustan. The structure in question is probably to be identified as the large porticus that was discovered in 1885 during construction of the foundations of the Galleria Sciarra (FIG. **59:9**). These remains in fact rest against two piers of the Aqua Virgo and are located precisely in the area where the Porticus Vipsania was known to have stood.

Agrippa's large painted map, which depicted the entire extent of the empire, perhaps even marking the major roads and cities, was housed within the porticus. The so-called Tabula Peutingeriana might have been a copy of the map. Association with the nearby Catabulum, the headquarters of the office of public transportation, which stood in the place now occupied by the Church of S. Marcello, suggests that the Porticus Vipsania served as the seat of the Cursus Publicus, the main office of the Imperial post. If this were the case, it might explain the function of Agrippa's large painted map.

We know with relative precision the location of the Villa of Lucullus *(Horti Luculliani)*, for a passage of Frontinus *(Aq.* 1.22) records that the arches of the Aqua Virgo that crossed the Campus Martius began right below this villa, and we know that this spot corresponds more or less to the corner of Via Capo le Case and Via Due Macelli. The Horti Luculliani must have occupied the area between this point and the Villa Medici (FIG. **59:12**). Accordingly, the large structure drawn by Pirro Ligorio that corresponds to the convent and gardens of

Sacro Cuore, north of Trinità dei Monti, must belong to the villa of Lucullus and not that of the Anicii, as is generally believed. The villa was built by Lucullus immediately after his triumph over Mithridates, celebrated in 63 BC, and was one of the wealthiest and most impressive estates in Rome. Under Claudius, it became the property of Valerius Asiaticus. When he was forced to commit suicide by Messalina in AD 46, the villa passed into the Imperial domain.

The main body of the *Horti* consisted of the building drawn by Pirro Ligorio, a complex of terraces and large stairways carved into the western slopes of the Pincian. The upper section, reached by a transverse stairway consisting of two ramps, terminated in a large semicircular exedra, at the end of which was a round building, similar to a shrine; this can be identified as a temple of Fortune, which was supposed to have been here from as early as the mid-Republic. The complex bears a striking resemblance to the late Republican sanctuaries of Latium, and in particular to the Temple of Fortuna Primigenia at Palestrina, which must have served as its model, and not without ideological implications: beginning with Sulla, Fortuna and Venus, when worshiped together, were personal tutelary divinities for *imperatores*, such as Lucullus, at the end of the Republic.

Several rooms preserved in the basement of the Convento del Sacro Cuore belonged to this estate, which must have begun its rise up the hill at the end of the ancient street corresponding to the modern Via Condotti; its visual impact was probably not unlike that of the eighteenth-century stairway of Trinità dei Monti. What remains are imposing vaulted foundations with a facing in *opus reticulatum* and horizontal bands of tiles that certainly date to the original phase of the villa. A large wall with semicircular niches, within which statues must have stood (clearly a nymphaeum), may also be assigned to the same phase. The wall was discovered in the cellars of the Palazzetto Zuccari, headquarters of the Biblioteca Hertziana.

The building's construction in a still somewhat irregular *opus reticulatum* confirms the date. Moreover, it is on the whole similar to a wall in the Horti Sallustiani, found on Via Lucullo. The niches, originally dressed with stucco and pumice, were later partially closed with walls, also reticulate, on which hung a glass mosaic depicting architectural structures and statues on bases. At the same time, the lower part of the nymphaeum was decorated with marble slabs. This renovation probably dates to the beginning of the Empire.

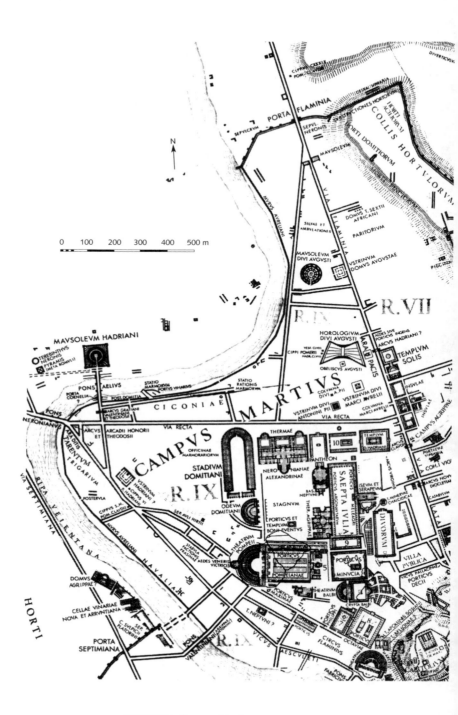

FIGURE 64. Campus Martius.

CAMPUS MARTIUS

HISTORICAL NOTES

The term "Campus Martius" in antiquity had different meanings that were determined by the quarter's various functions and by its historical development. In its widest application, "Campus Martius" designated the entire plain between the Capitoline, the Tiber, and the farthest slopes of the Quirinal and Pincian hills. The section east of the Via Lata, however, was later excluded from the Campus Martius—so much so that in Augustus's reorganization of the city's regions, it became Region VII (Via Lata), distinguished from Region IX, in which most of the Campus Martius was contained (see FIG. 2). Moreover, even within Region IX, the southernmost section— the area in the vicinity of the Circus Flaminius, which was built, like the road of the same name, in 220 BC—was always considered a separate entity. Nonetheless, it was this structure, Circus Flaminius, that gave its name to all of Region IX.

"Campus Martius" could also signify the area free of buildings that was reserved for military and athletic exercises. It is clear, however, that progressively this space fell victim to urban encroachments and crept north. In Augustus's day, it included the area north of the *Aqua Virgo*, but under the Antonines the Campus Martius shifted even farther north, beyond the present-day Piazza Colonna. For this reason, the Rione (region) Campo Marzio in the Middle

Ages—and still today—corresponds to the area north of the so-called Via Recta (Via dei Coronari and its extensions).

Finally, "Campus Martius" in its narrowest sense, especially during the Republic, could refer exclusively to the area set aside for elections held in the *comitia centuriata*, and later in the *comitia tributa*, as well as to the buildings associated with this activity—that is, the *Saepta*, where votes were cast, and the *Diribitorium*, where votes were counted.

Unlike many other regions of the ancient city, the Campus Martius, situated within the large bend of the Tiber, remained largely inhabited throughout the Middle Ages and up to modern times. As a result of continuous inhabitation, the grid of ancient streets and principal building blocks has remained largely intact. The most important streets of the district follow ancient courses, with the obvious exception of those that resulted from the large demolition projects undertaken at the end of the nineteenth century and during the Fascist era, such as Corso Vittorio Emanuele and Corso Rinascimento. The principal north-south axis was, and still is, *Via Flaminia*, built in 220 BC, whose urban tract assumed the name Via Lata. The area to the east of the road and that to the west, beginning from Piazza Colonna, followed the same orientation, lying at a slight northwest-southeast angle. The present-day Via del Corso faithfully reflects this layout. Other important axes are almost perfectly preserved: the ancient street corresponding to Via di S. Paolino alla Regola–Via Capodiferro–Piazza Farnese–Via di Monserrato and the parallel street corresponding to Via dei Giubbonari–Piazza Campo dei Fiori–Via del Pellegrino; the latter was probably the *Via Tecta*—the route taken by triumphal parades that in late antiquity assumed the name *Porticus Maximae*. Both of these axial streets led from the vicinity of the Circus Flaminius to the Pons Neronianus and from here to the Vatican. The northwestern-southeastern orientation of the entire surrounding quarter parallels that of the Circus Flaminius itself, unlike the orientation of the central Campus Martius, which follows axes almost perfectly aligned with the cardinal points. The persistence of the ancient layout can also be observed in the history of well-known buildings and spaces, such as Piazza Navona (which faithfully repeats the form of the Stadium of Domitian), Piazza di Grotta Pinta (the Theater of Pompey), and Palazzo Massimo (the Odeon of Domitian).

The persistence of activity in this region has preserved the ancient urban layout, recognizable in its general appearance, even where the buildings have not survived (or have not yet been discovered). Furthermore, numerous fragments of the Severan Marble Plan, especially those pertaining to the central and southern Campus Martius, have filled in gaps where archaeological evidence is absent. After decades of research, the combination of these various data has made it possible to reconstruct a relatively complete map of the area.

One of the legends regarding the origins of the Campus Martius associates it with the Tarquinii, who were believed to have occupied it as part of their

royal property; the area became public property, so the story goes, at the time of their expulsion from Rome, in the year when, according to tradition, the Republic was founded. Tradition also attributes the creation of Tiber Island to the family's last harvest being thrown into the river. The stories are not inherently improbable and would account for the public character of the district and, at the same time, the presence of a private cult, certainly of great antiquity, at the western end of the Campus Martius: a sanctuary of Dis Pater and Proserpina known as the *Tarentum*, located with certainty near Ponte Vittorio Emanuele. The two gods were worshiped in a ceremony involving an underground altar that had to be exhumed every time it was used ceremonially. Later on, the *Ludi Saeculares* were held here roughly every century and beginning with Augustus, every 110 years. During the empire, the festival is recorded as having been celebrated during the reigns of Augustus, Claudius, Domitian, Antoninus Pius, Septimius Severus, and Aurelian. Near the Tarentum, a course corresponding to the present-day Via Giulia was reserved for chariot races—the *Trigarium*, whose antiquity is revealed by its name, derived from *triga*, the archaic chariot drawn by three horses.

The archaic rites of the *Equus October* must also have been celebrated here. They consisted of a race, the sacrifice of a horse of the winning team, and a contest between the *Sacravienses*, evidently those who lived along the Sacra Via, and the *Suburani*, the residents of the Subura (the term may have referred to those who lived outside the oldest part of the city). The street that linked the Tarentum to the Porta Carmentalis at the foot of the Capitoline, coinciding with the modern stretch of roads comprising Via dei Giubbonari, Via dei Cappellari, and Via del Pellegrino, probably defined the general orientation of this area.

Another sanctuary of great antiquity stood in the central area of the Campus Martius: the Altar of Mars, associated with the principal function of the plain—war. For this reason, the traditional name prevailed over other known terms for the area, such as *Ager Tarax* and *Campus Tiberinus*. The precise location of the altar is not certain, though it was probably not far from *Porta Fontinalis*, to which it was physically linked by a porticus from 193 BC on. On the other hand, the sanctuary was closely linked to the functions associated with the Saepta and the *Villa Publica*, which are known to have stood within the area between Piazza Venezia, Via del Corso, and Piazza del Collegio Romano. A monumental structure, found under Via del Plebiscito, might be the base of the altar.

The Villa Publica was located in front of the altar and within the triangular area between it, the Saepta on the north, the Circus Flaminius area on the south, and the Capitoline to the east. The villa was actually a park with a building at its center in which the censors performed various duties, the most important of these being the census of the Roman people and the registration of citizens; these were undertaken every five years. This building was probably located alongside the Iseum of the Campus Martius, on the site of the *Divorum* (that is, the *Aedes Divorum* or *Porticus Divorum*)—a sanctuary constructed by the emperor Domitian

to sanctify the place (probably the original Villa Publica) where Vespasian and Titus had spent the night prior to their triumph over Judea.

The Saepta stood to the west of the Villa Publica, in the center of the Campus Martius. It was a huge square, rectangular in form, 310 meters long and 44 wide, including the porticoes, whose appearance as we know it can be traced back to the imperial period. During the Republic, the *comitia centuriata* (the ancient assembly of the people organized along the same lines as the army) and the *comitia tributa* convened here; these were the assemblies in which the principal magistrates were elected. Servius Tullius was credited with dividing the people into classes on the basis of a census, but the Saepta surely dates to the beginning of the Republic. As in the case of the *Comitium,* the site of these assemblies must have been inaugurated like a temple; that is, oriented along the cardinal points. The position and dimensions of the building, the oldest in this area, determined the structure of the central Campus Martius, which everywhere reflects this same orientation. From the last century of the Republic, the appearance of the plain was monumental. The flat topography of the Campus, and the fact that most of the property belonged to the state, made the area particularly suitable for buildings that served a variety of public functions. From the second century BC on, a series of porticoes, temples, baths, and performance complexes arose alongside the old sanctuaries and meeting places. Until the end of the empire, the area of Campus Martius was sufficiently large to accommodate a great many additional public buildings comfortably. For this reason, it never suffered from the suffocating density that characterized the ancient city center, which was confined within narrow boundaries and could develop only at the expense of the surrounding residential quarters.

Nothing remains to be seen of the earliest period. Thereafter, building activity can be divided into several significant phases, during which the urban fabric of the Campus Martius expanded continuously from the area nearest to the walls and Tiber (the southeastern corner) toward the north.

Several sanctuaries, which only in a few cases preserve their original appearance, belong to one phase, which can be dated to the Middle Republic. The oldest of these is the Temple of Apollo, founded in 431 BC near the Capitoline, not far from the Porta Carmentalis. The nearby Temple of Bellona was built somewhat later, at the beginning of the third century BC. These two buildings survive only in their imperial reconstructions. The complex of sanctuaries in the Area Sacra of Largo Argentina, however, is a different matter: here we find a complete inventory of temple buildings dating between the beginning of the third and the end of the second century BC.

The second century signals the beginning of a trend toward monumental construction, as evidenced in the building activity of the victorious *imperatores,* which occurred primarily in the area surrounding the Circus Flaminius; Greek architects, painters, and sculptors participated in this work from the beginning, endowing Rome for the first time with an urban architectural complex worthy of

a Hellenistic capital. This activity, which began with the temples of Hercules and the Muses, Juno Regina, and Diana (179 BC) and the porticoes of Octavius (168 BC) and Metellus (146 BC), extended to the middle of the first century BC, when Pompey completed the huge theater complex and contiguous porticoes. Caesar's grandiose plans for the area, in addition to the construction of many buildings and a theater (the future Theater of Marcellus), even included changing the course of the Tiber and unifying the Campus Martius with a portion of the Vatican. These plans, however, were interrupted by the death of the dictator.

The third phase coincides with the Augustan period. With the decisive aid of Agrippa, but also of other friends and relatives, the emperor began urbanizing the central part of the plain, in addition to completely restoring the complex of buildings surrounding the Circus Flaminius. The Theaters of Marcellus and Balbus, the Amphitheater of Statilius Taurus, the Baths of Agrippa and the Pantheon, the Saepta and the *Ara Pacis* are only the principal achievements of this long series of projects. With the consent of the Senate and People, Augustus continued the tradition of erecting public tombs in the Campus Martius and had an imposing mausoleum built for himself—the first important building raised in the northern sector of the plain.

Agrippa's activity in particular was of enormous importance. He had gained possession of a considerable portion of the Campus Martius, which had probably been privatized during the reign of Sulla, passing from Pompey to Marc Antony and then, after the battle of Actium, to Agrippa himself, who embarked on an ambitious program of urban development that in time established the definitive form of the central Campus Martius. Among his projects were the Saepta and the Diribitorium (already begun by Caesar), the *Pantheon*, and the Baths of Agrippa with the large adjacent pool (the *Stagnum Agrippae*), from which flowed the *Euripus*, a canal that emptied into the Tiber upstream from the *Pons Neronianus*. To supply the bath complex, Agrippa constructed an aqueduct, the Aqua Virgo, which crossed the Campus Martius on arches, dividing the section that was developed from that which was free of major structures, and extended all the way to Trastevere, probably crossing the river on the *Pons Agrippae*, which corresponds to the modern Ponte Sisto. At the same time, Agrippa reorganized, at his own expense, the administration of the public water supply and the aqueducts, whose headquarters were probably located by him in the vicinity of Largo Argentina (the *Porticus Minucia Vetus*). At his death in 12 BC, all these buildings were bequeathed to Augustus, who in turn made them public.

The activity of the other Julio-Claudian emperors was more limited, the most notable project being the Baths of Nero. But after the great fire that devastated the quarter in AD 80, Domitian oversaw another intense phase of construction, which included the Stadium and Odeon, the Divorum, the Temple of Minerva Chalcidica, and the *Porticus Minucia Frumentaria;* these were built along the western and eastern sides of the Augustan center. Almost all of the other preexisting structures were restored or rebuilt at this time.

Hadrian and the Antonine dynasty completed the urbanization of this central part of the plain, around the so-called Via Recta, corresponding to the long straight road that was the precursor to the present-day Via dei Coronari and its extensions. This area was essentially reserved for activities associated with imperial funerals and their associated apotheoses. On such occasions, pyres *(ustrina)* were erected; these were later "monumentalized" by constructing marble enclosures that imitated their dimensions and forms. Various temples of the imperial cult, such as the Temples of Matidia and of Divus Hadrianus, were also built. North of this line, Antoninus Pius and Marcus Aurelius erected the two famous columns to which they gave their names. Behind Marcus Aurelius's column stood the temple posthumously dedicated to him by his son Commodus, together with the column. During the third century, monumental construction was concentrated on the other side of the Via Lata in Region VII (e.g., Aurelian's Temple of the Sun).

The Greek geographer Strabo (5.3.8) describes the appearance of the Campus Martius during the Augustan period in which he lived and its importance with respect to the rest of the city:

> The extraordinary size of the plain permits not only chariot races and every other type of equestrian exercise without any obstruction, but also has space for the multitude of people playing ball and hoop games or wrestling. The works of art arranged all about, the grass that continues to grow throughout the year, and the crown of hills that reach all the way to the river's bank provide a theatrical setting from which it is hard to tear one's gaze. And near this open area is another [probably the Circus Flaminius] with porticoes arranged in a circle, groves, three theaters, an amphitheater, and lavish temples standing alongside each other, so marvelous as to make the rest of the city seem merely its appendage. Because they believe that this is the most sacred place of all, they have erected funeral monuments in honor of the most illustrious men and women here. The most noteworthy is the one called the Mausoleum, a large mound on a foundation of white marble, situated alongside the river and covered with evergreen trees all the way to the top. On the top is a bronze statue of Caesar Augustus and inside the mound are his tomb and the tombs of his relatives and most intimate friends. Behind the mausoleum is a large sacred grove with splendid walkways.

ITINERARY 1

The Southern and Western Campus Martius

THE AREA AROUND THE CIRCUS FLAMINIUS The very old street that crossed the entire length of the western Campus Martius, linking the Tarentum with *Porta Carmentalis*, probably established the orientation of this part of the plain. Nonetheless, the decisive factor in the placement of Republican buildings was

the construction of the Circus Flaminius in 220 BC, a project undertaken by the democratic leader C. Flaminius Nepos, who was also responsible for the construction of the Via Flaminia. In fact, from its beginning this monument was associated with the plebs; the *concilia plebis* took place here, while several of the temples built around the circus duplicated those in the plebeian area of the Aventine.

Until 1960, scholars situated the circus in the area south of Via delle Botteghe Oscure, and the Theater of Balbus was thought to have been located in the Ghetto, east of Via Arenula. But on the basis of the Severan Marble Plan and other evidence, the relative position of the two buildings was found to be precisely the reverse. Today we know that the Circus Flaminius occupied the area between the Theater of Marcellus and Piazza Cairoli and Via del Portico di Ottavia and the Tiber, while the Theater of Balbus corresponds to what was once believed to have been the curved part of the circus, preserved beneath Palazzo Mattei-Capranica. A series of porticoes and temples, at least two of which were marble (the work of a Greek architect, Hermodoros of Salamis), began to crowd around the circus, particularly in the course of the second century BC. That so many generals chose this location to build monuments to commemorate or give thanks for their victories can probably be explained by one of the functions of the circus: it was the place where triumphal processions assembled. The following is a running list of the sanctuaries, with dates and names of the founders, that, according to Strabo, stood in the area surrounding the circus: Apollo (431 BC, Cn. Iulius); Bellona (296, Appius Claudius Caecus); Vulcan (date uncertain, though not later than the third century); Pietas (181, M. Acilius Glabrio); Hercules and the Muses (179, M. Fulvius Nobilior); Juno Regina (179, M. Aemilius Lepidus); Diana (179, M. Aemilius Lepidus); Jupiter Stator (146, Q. Caecilius Metellus Macedonicus); Mars (132, Brutus Callaicus); Neptune (ca. 125, Cn. Domitius Ahenobarbus); Hercules Custos (Sulla); Castors (ca. 70 BC). To this should be added the reconstruction of the Temple of Apollo that was probably undertaken by M. Fulvius Nobilior in 179. Among the secular constructions are the *Porticus Octavia* (168 BC, Cn. Octavius); the *Porticus Metelli* (146, Metellus Macedonicus), and the *Porticus Philippi* (29 BC, L. Marcius Philippus).

THEATER OF MARCELLUS The area to the east of the Circus Flaminius is closed by the massive structure of the Theater of Marcellus (FIG. **66:1**). The building, begun by Caesar—who likely only had time to clear the land on which the building would later be built—and finished by Augustus, probably destroyed a portion of the curved side of the circus, which from that time on became a simple piazza. The site, next to the Temple of Apollo, was probably the location of temporary theaters built during the Republic in connection with the *Ludi Apollinares*. Two small buildings with altars, situated within the large exedra behind the stage as represented in the Severan Marble Plan, possibly replaced

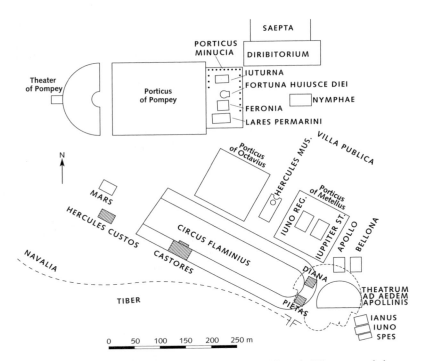

FIGURE 65. Schematic reconstruction of the Republican buildings around the Circus Flaminius.

two temples destroyed because of the construction of the theater. Pliny recorded the name of one of these, the Temple of Pietas; the other is perhaps the Temple of Diana (FIG. **65**).

Work on the theater was finished for the most part in 17 BC, when the building was used for the Ludi Saeculares, but its formal dedication took place in 13 or possibly in 11 BC in the name of Augustus's nephew and designated heir, Marcellus, who died prematurely in 23 BC. The only subsequent work we know of was a restoration under Vespasian that was limited to the stage. During the Middle Ages, the building was occupied by the Savelli, probably as early as the thirteenth century; it passed into the hands of the Orsini in the eighteenth. The palazzo that occupies the upper portion of the building is the work of Baldassarre Peruzzi.

Between 1926 and 1932, the theater was freed of its encroachments and restored. The external facade of the cavea, all in travertine, originally consisted of 41 arches, framed by 42 piers; some have been repaired. Only part of the first and second stories (Doric and Ionic, respectively) survives; few traces remain of the third, a closed attic with Corinthian pilasters.

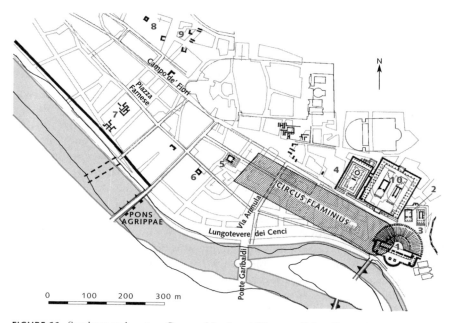

FIGURE 66. Southern and western Campus Martius. **1** Theater of Marcellus. **2** Temple of Apollo Sosianus. **3** Temple of Bellona. **4** Temple of Hercules and the Muses and Porticus of Philippus. **5** Temple of Mars. **6** Building near S. Paolino alla Regola. **7** Buildings under Palazzo Farnese. **8** Remains under Palazzo della Cancelleria. **9** Remains under the Museo Barracco. **10** Porticus of Octavia (former Porticus of Metellus).

The original height was around 32.60 meters; that preserved is a little more than 20. Large theatrical masks in marble decorated the keystones of the arches, some of which were recovered in the course of the excavations. The interior corridors and radial walls of the cunei are of tufa ashlars for the first ten meters; the inner segment is in *opus caementicium* with a reticulate facing. The interior ambulatories provide an important example of the use of brick at the beginning of the Augustan period. The vaults are in concrete and the vault of the room located at the back of the central entrance had stuccos decorated with figures, of which one section survives.

Scholars have calculated that the cavea (129.80 meters in diameter) could hold about 15,000 spectators and, under especially crowded circumstances, could manage up to 20,000, a figure that accords with the number reported in the Regionary Catalogues. Beyond the orchestra (37 meters in diameter), there remains almost nothing of the scaena. It was flanked by two apsidal halls; a pier and column of one of these, that on the left, remain standing. Behind the stage was a large exedra with two small shrines.

THE TEMPLES OF APOLLO SOSIANUS AND BELLONA An open-air sanctu-
ary dedicated to the Greek god Apollo, called the *Apollinar*, was founded by
449 BC and thus predated the temple that would later be built on the same spot
(FIG. **66:2**); this was the god's only temple in Rome before the construction of
his temple on the Palatine. It is possible that the last of the Tarquins was re-
sponsible for the introduction of the cult, which might thus have been connected
with the quasi-legendary embassy sent to Delphi. This in turn might explain the
celebration of the archaic *Ludi Taurii* in the circus, which, according to tradition,
were introduced by Tarquinius Superbus in the aftermath of a plague. The first
temple was vowed in 433 as the result of a plague and dedicated in 431—the
only cult building of any importance erected in Rome during that period of
crisis. Given the circumstances associated with its construction, the sanctuary
was aptly dedicated to *Apollo Medicus*, possibly introduced from Cumae. The
structure was restored and embellished in 353 and probably again in 179; finally,
in 34 BC the Temple of Apollo was completely reconstructed, possibly by C.
Sosius, although it is certain that the building was dedicated by Augustus. The
Senate frequently met in this temple, as it did in the adjacent Temple of Bellona,
especially when considering the granting of a triumph.

The oldest building was originally located several meters in front of the sur-
viving temple. Architectural elements, including a mosaic inscription, probably
from the restoration of 179 BC, were incorporated in the surviving podium,
which was built of concrete, tufa, and travertine ashlars, leaving empty spaces
that were filled with earth; it measured 5.50 meters high, 21.32 wide, and 40
long. The small amount of space (less than 6 meters) between the temple and
the Theater of Marcellus required the substitution of side stairs for the ear-
lier frontal stairway. Three magnificent Corinthian columns, reerected after the
excavation, rise on the podium; the columns are a little more than 14 meters
high, with flutes that are alternately wide and narrow, surmounted by a frieze of
bucrania and olive garlands. The temple was pseudoperipteral, with six columns
along the front and three on the sides; seven engaged columns lined each side
of the exterior cella wall. The engaged columns, like the cella walls, were of
stuccoed travertine, an indication of the continuing influence of the Republican
architectural style, which tended to be sparing in the use of marble.

The interior of the cella was adorned with a marble floor and sumptuous
architectural decoration, featuring aediculas surmounted by pediments, alter-
nately triangular and lunate, that sat on columns of polychrome marbles. The
cella was also a veritable museum. On display were paintings by Aristides the
Theban, statues by Philiscos of Rhodes, the Apollo with cithara by Timarchides,
and a group of Niobids attributed to Scopas or Praxiteles. Recent studies have
allowed us to reconstruct the rich decoration of the pediment, which featured an
Amazonomachy in the presence of the goddess Athena. The sculptures, dating
to the middle of the fifth century BC, were removed from a Greek temple and
remounted on the new Augustan building.

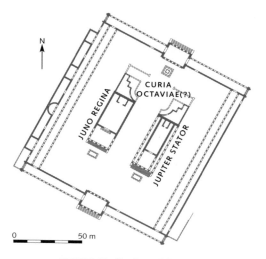

N

JUNO REGINA

CURIA OCTAVIAE(?)

JUPITER STATOR

0 50 m

FIGURE 67. Porticus of Octavia.

Just to the east of the Temple of Apollo is the foundation of another large building, which has been identified as the **Temple of Bellona,** built by Appius Claudius Caecus sometime after 296 BC (FIG. **66:3**).

THE PORTICUS OF OCTAVIA Of the three large porticoes that defined the northern side of the Circus Flaminius (Porticus of Octavius, Porticus of Philippus, Porticus of Octavia), the only one whose remains are visible is the Porticus of Octavia. An older building on the site, the Porticus of Metellus, was begun by Q. Caecilius Metellus Macedonicus in 146 BC after his victory and triumph over Andriscus (FIG. **65**). It enclosed an older temple, dedicated to Juno Regina in 179 by the censor M. Aemilius Lepidus, to which Metellus added the Temple of Jupiter Stator. Metellus's temple was the first in Rome constructed entirely of marble, the work of the Greek architect Hermodoros of Salamis. Even the statues of the two divinities were made by Greek sculptors, Polycles and Dionysios.

The Augustan reconstruction probably dates to between 33 and 23 BC, when the porticus was formally dedicated to the sister of the emperor, Octavia. The Severan Marble Plan shows an apsidal building behind the two temples; this is probably the *Curia Octaviae,* which, together with a library of the same name, was included in the new porticus complex that extended in all probability north of the original porticus, enclosing a space 119 meters in width and approximately 132 meters in length. The two temples had different plans: that of Juno to the west was prostyle hexastyle, while that of Jupiter was *peripteros sine postico* (i.e., lacking columns on its back side). The latter style might well have been an

Augustan innovation, since, according to Vitruvius (3.2.5), the older temple was a peripteral structure in the Greek style.

The porticus was restored after the fire of AD 80 and again under Septimius Severus after the fire that broke out under Commodus in 191. The remains that can be seen today belong to this restoration. The propylaeum at the front and a section of the porticus to its right, stretching out to the southern corner of the building, are all that survive (FIG. 67). Several columns of the left side and their supporting podium were exposed in a recent excavation; the segment that extends toward the Temple of Apollo and the Theater of Marcellus was exposed in the 1930s. The building rose on a low podium, on which the colonnade stood. Remains in *opus incertum*, belonging to the oldest phase and thus to the Porticus of Metellus, were seen inside the podium. An entranceway, preceded by two columns on plinths, opens on the south in the tufa wall in *opus quadratum* that forms the eastern side of the building.

The large propylaeum, the best-preserved section of the building, opened on the center of the southern side and extended beyond the line of the porticus both inside and outside. The brick side walls, originally clad in marble, were pierced by large arches that allowed one to enter the porticus. The two facades of the propylaea had four large Corinthian columns between antae, likewise Corinthian, that were fashioned out of the quoins of the side walls. Two columns of the external facade remain standing to the left. Those on the right were replaced in the Middle Ages by a large arch that provided access to the Church of Sant'Angelo in Pescheria, while three columns of the inner side survive intact.

A large Severan inscription (AD 203), which can still be read on the architrave, records that the porticus was restored by Septimius Severus and Caracalla after a fire. The tympana were constructed for the most part of reused material, recovered in all probability from the preceding phases of the building; this can best be seen on the reverse sides of the pediments, which would not have been visible in antiquity, since a wooden ceiling would have masked this area.

Of the two temples that stood within the porticus, several elements of only one of these—the Temple of Juno Regina—survive: podium and column bases in the basement of Via Sant'Angelo in Pescheria no. 5; and two columns still standing, with capital and a fragment of the architrave, visible from the upper stories of the building at no. 28.

Among the numerous works of art that decorated Octavia's porticus, temples, and library, the group of 34 bronze equestrian statues portraying Alexander and his officers who died at the battle of Granicus, the work of Lysippus, is especially noteworthy. The statues had been taken by Metellus from the sanctuary of Dion in Macedonia and were placed in the area between the front of the temples and the propylaea. The porticus contained a bronze statue of Cornelia, the mother of the Gracchi—the first public statue of a woman in Rome (ca. 100 BC). The inscribed base of this statue was found alongside the side door of Sant'Angelo in Pescheria and is now in the Museo Nuovo Capitolino.

THE AREA BETWEEN THE CIRCUS FLAMINIUS AND THE TARENTUM A brick arch framed by two Tuscan piers of travertine that support a flat arch, also of brick, can be seen at Via di S. Maria dei Calderari no. 23. Other elements of the same building, named *Craticula* in the Middle Ages, are visible in a nearby store. Renaissance drawings show a complex plan featuring two aisles and two stories that encroached upon the area of the Circus Flaminius. This fact assures us of an imperial date, since the circus was out of use at that time. The earlier identification of this building as the *crypta* of the Theater of Balbus is no longer tenable following the discovery of the actual position of the theater, near the Via delle Botteghe Oscure.

These remains have been identified by some as the Porticus of Octavius (*Porticus Octavia*, not to be confused with the *Porticus Octaviae*), built in 168 BC by the consul Cn. Octavius (**FIG. 65**). However, what we know of this porticus, which consisted of two rows of Corinthian columns with capitals clad in bronze, does not conform to the building in question, which was not after all a porticus. For that reason, the recent hypothesis identifying this building as the Porticus Minucia Frumentaria is clearly in error. More likely, the building was an entirely new structure erected after the fire of AD 80, which destroyed the Campus Martius. The date of the monument, which appears to be Domitianic, confirms this interpretation, but does not rule out the possibility that the building might have been a reconstruction of the Villa Publica in a different location; Domitian probably replaced the latter with the Diribitorium. The appearance of the structure, so similar to that of the Villa Publica as depicted on a Republican coin, tends to support this theory, as does the proximity of the church of S. Maria *in publicolis*, which may have preserved the ancient toponym.

The small hill nearby on which Palazzo Cenci sits was explained in the past as the remains of the Theater of Balbus, a cuneus of which is depicted in an etching by Piranesi. Given the fact that the theater was not located in this area, a more likely explanation for the rise might be the ruins of the Amphitheater of Statilius Taurus, the first in Rome to have been built in stone (in 29 BC) and later destroyed in the Neronian fire. The location accords quite well with Strabo's account, which describes an area surrounded by porticoes, three theaters, and an amphitheater; this would seem to correspond to the area around the Circus Flaminius. The substitution of an amphitheater for a circus would explain the transformation of the surviving space of the latter into a simple square, which doubtlessly occurred in the Augustan period.

At the western end of the Circus Flaminius, the block between Via degli Specchi, Via di S. Salvatore in Campo, and the piazza of the same name sits atop the remains of a **temple,** preserving the form of the ancient structure; the building has the same orientation as the Circus Flaminius and is still partially visible in the basements of the houses. The temple is peripteral, made of Pentelic marble, and rises on a crepidoma without a podium; it is thus purely Greek. It may have been built by Hermodoros of Salamis, the architect of the Temple of

Jupiter Stator and probably of the *Navalia*, the Campus Martius's military port, which flourished between 146 and 135 BC. Thus, the remains belong not to the Temple of Neptune, as has been argued, but to the Temple of Mars, built by Brutus Callaicus after 135 BC, which, as we know, was certainly the work of Hermodoros of Salamis (FIG. **66:5**).

The modern street grid in the area between the temple and Palazzo Farnese corresponds to ancient roads, in particular the Via dei Pettinari which runs in the direction of the Pons Agrippae, the ancient bridge that was replaced by the present-day Ponte Sisto. The remains of ancient buildings have been preserved in the cellars of several houses nearby. Important elements of a large brick building of the imperial period, with medieval alterations, were brought to light during restoration of the building located between Via di S. Paolino alla Regola and Via del Conservatorio (FIG. **66:6**).

The structures discovered under the Palazzo Farnese are particularly important (FIG. **66:7**). Among other things, excavators found a boundary cippus of the Tiber, still *in situ*, inscribed with the names of the censors of 54 BC (P. Servilius Isauricus and M. Valerius Messalla), and the remains of large brick public buildings, in which at least three distinct phases can be discerned. The second phase, Domitianic, evidently following the fire of AD 80, is the most important. Mosaics depicting *desultores* (acrobats on horseback) suggest a possible link with the Tarentum and the nearby Trigarium, where such shows generally took place, as well as with the *Stabula Factionum*, the stables of the four teams of chariot drivers. One of these was located with certainty near Piazza Farnese (the *Veneta*) and another near S. Lorenzo in Damaso (the *Prasina*).

In the immediate vicinity, the corner of a **porticus with columns,** a weighing table, and a fountain, clearly belonging to a large public building, were discovered at the end of the nineteenth century under the building known as Farnesina ai Baullari, now the site of the Museo Barracco (FIG. **66:9**). The porticus, already in one of its late phases (a column base was replaced by an overturned Doric capital), was later closed by a permanent partition wall that had paintings featuring scenes of hunting on horseback and fishing; the latter can be dated with certainty to the fourth century AD.

In 1938, the **Tomb of Aulus Hirtius** was discovered by accident under the northwestern corner of Palazzo della Cancelleria, facing Corso Vittorio Emanuele (FIG. **66:8**). Both Hirtius and his colleague Gaius Vibius Pansa, consuls in 43 BC, died fighting against Antony at the Battle of Mutina (Modena) at the head of the Senatorial army. Tombs were erected at public expense for both consuls in the Campus Martius. The inscription honoring Pansa was already known, having been found along Corso Vittorio Emanuele at the end of the nineteenth century. The more recent discovery confirmed the location of both tombs. The tomb of Hirtius consists of a perimeter wall of brick, one of the oldest examples with a travertine coping. It is located close to a perfectly preserved segment of Agrippa's Euripus.

Next to the tomb several important sculptures were also found, already removed from their original settings in antiquity: the so-called Altar of the Vicomagistri of Claudian date and the famous Cancelleria reliefs, which date to the reign of Domitian but were reworked under Nerva. (All are now in the Vatican Museums.) In all probability, these were spoils from an earlier building intended to be reworked in one of the many marble workshops in this marginal area of the Campus Martius.

Also discovered in the vicinity of the Cancelleria at the same time were the remains of a Mithraeum, probably frequented by the staff of the nearby *Factio Prasina*.

ITINERARY 2

The Central Campus Martius

THE AREA SACRA DI LARGO ARGENTINA The archaeological complex that is known as the Area Sacra di Largo Argentina occupies the area between the modern Via Florida, Via di San Nicola ai Cesarini, Via di Torre Argentina, and Largo Argentina (FIG. **68:2**).

Two temples (A and B) were already known prior to the discovery of two others, which occurred by chance during work on building projects in the area between 1926 and 1928. The importance of the discoveries resulted in the abandonment of the projects and in the conservation and ongoing study of the monuments, with the result that the section of the Campus Martius in which these temples are situated has now been extensively documented. It was bounded on the north by the Hecatostylum (the Porticus of 100 Columns) and Baths of Agrippa; on the south by the buildings connected with the Circus Flaminius; to the west by the complex comprising the porticoes and the Theater of Pompey; and to the east by a large square surrounded by a porticus, the Porticus Minucia Frumentaria.

Four temples stand in the Area Sacra, all of Republican date, which are designated—from north to south—A, B, C, and D (FIG. **69**). The oldest of these is **Temple C,** the third from the north. It is peripteral *sine postico*, lacking a colonnade on the back side. The simplest and oldest type of molding crowns the high tufa podium. The walls of the cella, in brick, and the mosaic floor, in white with black squares, are a Domitianic restoration undertaken after the great fire of AD 80 that destroyed a large portion of the Campus Martius. On this occasion, the travertine pavement that is still largely visible throughout the area was installed. The appearance of the building, the fragments of its terracotta architectural decoration, and several inscriptions allow us to assign it to a rather early period of the Republic, the end of the fourth or, more likely, the beginning of the third century BC.

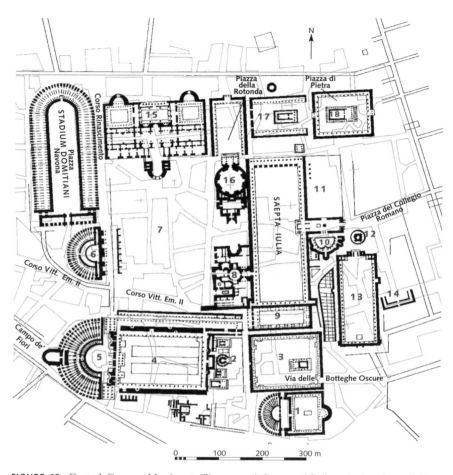

FIGURE 68. Central Campus Martius. **1** Theater and Crypta of Balbus. **2** *Area Sacra di Largo Argentina*. **3** Porticus Minucia Frumentaria and Temple of the Nymphs (Via delle Botteghe Oscure). **4** Porticus of Pompey. **5** Theater of Pompey. **6** Odeon of Domitian. **7** Stagnum Agrippae. **8** Baths of Agrippa. **9** Diribitorium. **10,11** Temple of Isis and Serapis. **12** Temple of Minerva Chalcidica. **13** Divorum. **14** Ara Martis? **15** Baths of Nero. **16** Pantheon. **17** Temple of Matidia. **18** Temple of Hadrian.

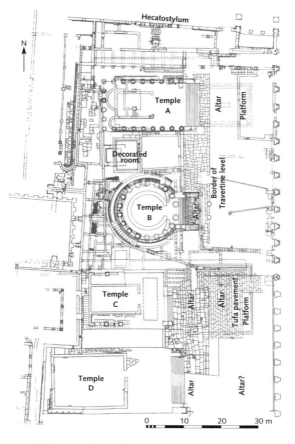

FIGURE 69. Plan of the *Area Sacra di Largo Argentina.*

Temple A, lying farthest to the north, is the second oldest of the buildings and can reasonably be dated to the middle of the third century BC. In the course of the centuries, the temple underwent radical transformations. In its present form, perhaps datable to the beginning of the Augustan period, it is a canonical peripteral, with columns of Anio tufa and travertine capitals. The travertine columns now visible belong to the Domitianic restoration.

Temple D, the largest, comes next chronologically and occupies the southern end of the area. It too gives evidence of having been rebuilt during the late Republic, entirely in travertine, while the oldest phase probably dates to the beginning of the second century BC.

The last building chronologically is **Temple B,** a circular structure seated upon a podium, with a travertine stairway on the front. The Corinthian columns

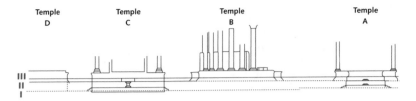

FIGURE 70. *Area Sacra di Largo Argentina.* Cross section. **I** Original level. **II** Republican pavement. **III** Domitianic pavement.

are of Anio tufa; the bases and capitals are travertine. A fragment of a frieze in Greek marble, decorated with tendrils, was recently discovered; it might belong to the upper portion of the temple.

Alongside this building, between it and Temple C, parts of a **colossal female statue** in Greek marble were discovered; the head alone including the neck (now in the Centrale Montemartini [ACEA] exhibit) is 1.46 meters high. The finds must have belonged to an acrolith, a statue whose clothed body parts were cast in metal. Scholars have identified this as the cult statue of the divinity worshiped in Temple B. This temple was built on a level of the Campus Martius much higher than the original one on which the others sit and, like the others, it was significantly modified over time. The first modification saw the closing of the intercolumniations with a wall of tufa slabs, with the result that the protruding parts of the columns assumed the appearance of engaged columns. The enlargement of the cella was accompanied by an enlargement of the podium; during the second alteration, the external facade was completely covered with a stuccoed brick wall to which stucco pilasters were added, corresponding to the original columns. On this occasion, the podium was further enlarged in brick. This last reconstruction must date to the years after the fire of AD 80.

The history of the Largo Argentina complex is quite involved. For the most part, the excavations were unscientific, taking no account of the site's stratigraphy. Several main periods of activity, however, can be reconstructed and dated with relative precision. The oldest buildings were erected on the original level of the plain (I), each separately from the other (FIG. **70**). Temple C was separated from the later Temple A by a space large enough ultimately to accommodate the construction of Temple B. The independent status of each of the temples was later underscored by the creation of spaces in front of the structures that were elevated a few steps above the surrounding ground level; altars at the center of these spaces were discovered in front of Temples A and C. These were accordingly autonomous sanctuaries.

A more significant transformation took place when the area was elevated by about 1.40 meters following a fire, probably the same fire that destroyed a large portion of the city in 111 BC. A tufa pavement was installed at this time (II)

that united the three existing temples in a single complex, which was probably already surrounded by a colonnade, of which traces were found on the northern and western sides of the area. The height of the podia of the temples was cut in half by the new pavement. In the case of Temple C, there was no alteration, while the podium of Temple A was clad with a new ashlar facing on the part exposed above the pavement; the podium of Temple D was noticeably enlarged (perhaps somewhat later) to its current form and entirely clad in travertine.

The circular Temple B was later built in the empty space between Temples A and C on top of the new tufa pavement. The chronology of this pavement, which presupposes the unification of the earlier isolated temples into one complex, is of great importance in identifying the divinities to whom the temples were dedicated. The inscription of the altar located in front of Temple C, in the center of the platform resting on the older level, furnishes crucial information. This altar was covered by the later tufa pavement (II), which it thus clearly predates. Yet this was not the original altar but a later reconstruction, erected in accordance with a *Lex Plaetoria* by Aulus Postumius Albinus, son and grandson of Aulus, whom some have identified as the consul of 180; more likely, we are dealing with the latter's son, the consul of 155. Thus, we can be certain that the installation of the tufa pavement and the subsequent unification of the area were completed after this date, at a time considerably late in the second century BC.

Among the buildings constructed at this time in the Campus Martius, those that we know from literary sources, the complex that best accords with the structural and chronological characteristics of this area would appear to be the Porticus Minucia Vetus, built by the consul M. Minucius Rufus after his triumph over the Scordisci, an ancient people of Thrace, in 107 BC. An inscribed fragment of the Severan Marble Plan that identifies the area immediately to the east of the Largo Argentina as a Porticus Minucia provides a proof of this identification. We know that there were two Porticus Minuciae: the Vetus and the Frumentaria, the latter being an imperial construction. The building to the east of the Largo Argentina, given its appearance and dimensions, is certainly the Porticus Minucia Frumentaria, which was in fact an enlargement of the Porticus Minucia Vetus—that is, of the Largo Argentina complex. This allows us to identify at least one of the four temples with a fair degree of certainty. We know from the Fasti Praenestini that the temple of the Lares Permarini, dedicated in 179 BC, was in the Porticus Minucia, evidently the Vetus. The only one of the temples of Largo Argentina that could be ascribed to the beginning of the second century BC is Temple D, which accordingly must be identified as that of the Lares Permarini.

Temple B must be the *Aedes Fortunae Huiusce Diei* (Temple of Today's Fortune), founded by Q. Lutatius Catulus, consul in 102 with Marius, after the victory at Vercellae over the Cimbri.

As for Temple C, the attribution to Feronia, an ancient Italic divinity who had a temple in the Campus Martius at an early date, seems fairly strong; the

first notice that we have of it dates to 217 BC. It is possible that the worship of Feronia, originally a Sabine cult, was introduced following Manius Curius Dentatus's victory over the Sabines in 290 BC. Among other things, the date coincides with that generally assigned to the building. Regarding the divinity of Temple A, two solutions are possible: it is either the Temple of Juno Curitis or that of Juturna. Both cults were established in the Campus Martius, the first by Q. Lutatius Cerco, probably after his victory over the Falerii in 241, the second by Q. Lutatius Catulus after his triumph over the Carthaginians in the same year. The identification of the building as the Temple of Juturna is preferable, however, on the basis of Ovid *Fasti* 1.463–64, which records that this temple stood close to a terminus of the Aqua Virgo, that is, the Baths of Agrippa. This bathing complex was located north of the Area Sacra, in the immediate vicinity of Temple A, the northernmost of the four shrines. Be that as it may, the founder of the temple is identified as a member of the *gens Lutatia*, a fact that explains the construction of Temple B right next to it by another member of the same family, the consul of 102.

Remains of the large porticus called the *Hecatostylum*—whose official name, as we know from a recently discovered inscription, was probably the *Porticus Lentulorum*—are visible on the north side of the area, underneath the modern street. A large podium made of tufa blocks can be seen behind Temples B and C. This structure has been identified with certainty as the curia of Pompey's theater complex, a place that became famous as the site of Caesar's assassination. In fact, we know that the curia was installed in an exedra that projected from the east side of the Porticus of Pompey, opposite the Theater of Pompey; this coincides with the position of the remains on the western side of the Area Sacra.

Finally, we turn to the large Augustan building that stood between temples A and B and reveals evidence of reconstruction and restoration up to the late Empire. Of particular importance are the modifications made under Domitian following the fire of AD 80 and under the Severan emperors. The attribution of three of the four temples to water divinities (Feronia, Juturna, and the Lares Permarini), the probable identification of the nearby temple on Via delle Botteghe Oscure as the sanctuary of the Nymphs, the proximity of the Baths of Agrippa, the identification of the archaeological complex as the two Porticus Minuciae, where grain was distributed at no cost to the people—all make it quite likely that the building in question housed the offices of those in charge of the aqueducts. Under Septimius Severus, these officials joined those who oversaw the free distribution of grain under one administration run by the *Curator Aquarum et Minuciae*. The proximity of the Porticus Minucia Frumentaria explains this merger. Moreover, we know from an inscription that the *Statio Aquarum* (Office of Waters) stood near a sanctuary of Juturna during the Empire; this can now be identified as Temple A. Under Constantine, the office was moved to the Forum, alongside the other ancient sanctuary of Juturna.

THE TEMPLE ON VIA DELLE BOTTEGHE OSCURE In antiquity, a large square with porticus (roughly 150 × 115 meters) stood to the east of Largo Argentina; this is identified, as mentioned above, as the Porticus Minucia Frumentaria (FIG. **68:3**). The porticus was built, probably under Domitian, in an area previously occupied by the Villa Publica; its function was to assist in the free distribution of grain to the people of Rome *(frumentationes)*. At its center was a **temple of Republican date,** which accordingly stood there before the installation of the porticus; remains of the temple were discovered in 1938 during the enlargement of Via delle Botteghe Oscure. A segment of the right side of the temple can be seen along the street. The podium was clad with travertine slabs, and on it two columns of stuccoed peperino with Corinthian capitals in travertine have been reerected. The wall of the cella, built of brick, belongs to a Domitianic restoration following the fire of AD 80. A small column and pieces of marble architraves from the surrounding porticus lie on the ground alongside the podium. These remains can also be attributed to the Domitianic restoration.

The temple is probably to be identified as that of the Nymphs, which stood in the Villa Publica. The archives of the censors, together with the names of those who had the right to receive *frumentationes,* were kept here. We know that the temple was destroyed by a fire in 57 BC; Clodius set the blaze expressly to destroy these archives.

THE THEATER AND CRYPTA OF BALBUS The smallest of the three theaters in the Campus Martius was built by L. Cornelius Balbus, consul of 32 BC, with the plunder amassed from his triumph over the Garamantes, a people of Africa, celebrated in 19 BC. Balbus was the first and last provincial to celebrate a triumph, which thereafter became the exclusive right of the imperial family. The theater was dedicated in 13 BC, but a flood of the Tiber on the day of the inaugural made the theater accessible only by boat. We know that it incurred damage in the fire of AD 80. Until 1960, the building was thought to be located under Monte dei Cenci, but studies have shown that it was actually beneath the modern Palazzo Mattei-Paganica, where once the curved side of the Circus Flaminius was thought to be (FIG. **68:1**).

Remains of the building can be seen in the cellars of the palazzo, headquarters of the Istituto dell'Enciclopedia Italiana. These consist of three cunei, separated by radial walls in perfect *opus reticulatum* with quoins of tufa and travertine ashlars. The upper part of one of these piers is preserved in a courtyard of the palazzo, while other remains of the cunei can be seen in a room on the first floor of the Istituto. Other structural elements are preserved in the cellars of both Palazzo Caetani and a house on Via Paganica, no. 7a. The radius of the cavea was approximately 30.60 meters and the theater's total diameter roughly 90 meters; the diameter of the Theater of Pompey was 150 meters and that of the Theater of Marcellus, 130. The Regionary Catalogues give the seating capacity of the Theater of Balbus as 11,510 spectators (as compared with the 20,500 that could

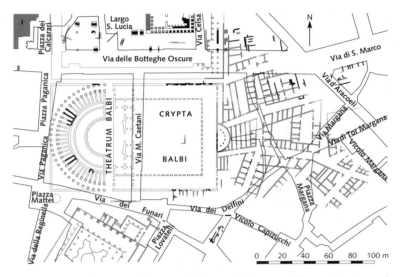

FIGURE 71. The Theater and Crypta of Balbus and the surrounding area (to the north is the Temple of Via delle Botteghe Oscure).

fit in the Theater of Marcellus and the 17,580 in the Theater of Pompey). There remains no trace of the scaena, on which four small columns of onyx stood, according to Pliny the Elder (*NH* 36.60). The Arco dei Funari and Arco dei Ginnasi, no longer extant, must have corresponded to the ancient arches that stood between the scaena and cavea.

Behind the theater's stage was a large porticus that is mentioned in the Regionary Catalogues as Crypta Balbi, a large open space surrounded by a porticus that is represented in the fragments of the Severan Marble Plan as roughly square, enclosed by a porticus with piers, with a large exedra projecting from the eastern side (FIG. 71). Recent excavations have exposed the exedra and made possible the study of a large part of the monument. Today it can be seen inside the large building complex bounded by Via delle Botteghe Oscure, Via M. Caetani, Via dei Delfini, and Via dei Polacchi, which has incorporated the remains of the *crypta*. In addition to the exedra, which is about 22 meters in diameter (it was later transformed into a latrine), the *crypta* consist of two long parallel walls, a section of which, about 40 meters long, is visible in the cellars of Via delle Botteghe Oscure between nos. 17 and 28; similar remains can be seen on the opposite side, along Via dei Delfini in the cellars of the buildings between nos. 5 and 10. The walls are made of tufa in *opus quadratum*, with corner supports in travertine, forming a kind of meander of opposing niches, the smaller ones (1.90 meters) facing north and the wider ones (3.60 meters) facing south. The niches on the south were later closed off by a wall of

brick-faced concrete, clearly part of the Domitianic restoration that followed the destructive fire of AD 80. In the Middle Ages, the *crypta* was used by rope makers *(funari)*, a function reflected in the name of the nearby church of S. Caterina dei Funari.

In antiquity, the porticus must have been used for high-level industrial activity, as suggested by the funeral inscription of an L. Aufidius Aprilis, who was a *Corinthiarius de Theatro Balbi,* that is, a manufacturer of the highly sought-after bronzes that were traditionally associated with Corinth. The Severan Marble Plan shows a small building, of which only a corner remains, at the center of the porticus, perhaps on a different axis. This might have been a small temple, possibly even the Temple of Vulcan of the Campus Martius; an inscription including a dedication to this god was found in the vicinity. The presence of the inscription, erected by a *Praefectus Vigilum* during the reign of Trajan, might be explained if the *crypta* also functioned as the headquarters of the *Praefectura Vigilum.* The Temple of Vulcan might have been the religious center, as well as archive, of this organization.

In the area east of the *crypta,* the Severan Marble Plan reveals the existence of a very irregular quarter, corresponding to the present-day area, mostly medieval, between Piazza Margana and Via delle Botteghe Oscure.

THE THEATER OF POMPEY AND THE PORTICUS OF POMPEY In several letters of 55 BC, Cicero mentions the elaborate games that were celebrated for the inauguration of the Theater of Pompey, which probably took place on 29 September, Pompey's birthday, during the year of his second consulship (FIG. **68:5**). This information would appear to contradict what we learn from Aulus Gellius (10.1.6 ff.), who dates the dedication of what he calls the Temple of Victory (instead of the Temple of Venus Victrix), which was at the summit of the theater's cavea, to Pompey's third consulship, that is, 52 BC. It is possible, however, that the theater was dedicated in 55 and the temple on 12 August 52. The placement of this temple *"in summa cavea"* followed a tradition widespread in Italy from the second century BC that closely associated theatrical games and religious worship. Even in Rome, dramas were performed in front of the temples of Magna Mater and of Apollo *in Circo.* Pompey would thus have avoided the censors' prohibitions—which had up to that time barred the construction of a permanent stone theater in Rome—under the pretext that the cavea was only a stairway in front of the Temple of Venus Victrix.

Work on the complex probably began in 61 BC, after Pompey's triple triumph. In fact, he probably owned the area selected for the site, since he built a home adjacent to the theater. We do not know how much truth there is to Plutarch's statement that the model of his new structure was the Theater of Mytilene.

The theater was 150 meters in diameter and, according to the Regionary Catalogues, could accommodate up to 17,580 spectators; Pliny's estimate of 40,000 is certainly exaggerated.

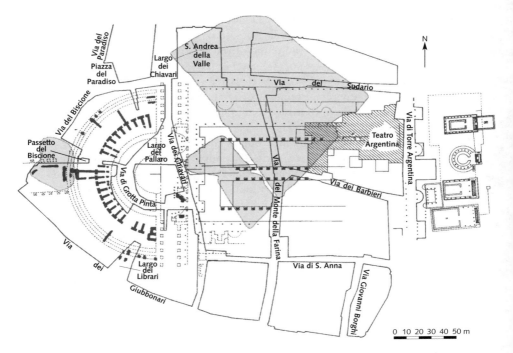

FIGURE 72. Theater of Pompey and the Porticus of Pompey. *At the right*, Largo Argentina.

An exceptionally large porticus—approximately 180 × 135 meters—extended behind the stage (FIG. **68:4**). A large rectangular exedra, with a statue of Pompey, stood opposite the theater and facing it; used as a Curia for senatorial meetings, it was the site of Julius Caesar's assassination on 15 March 44 BC; its remains can be seen inside the Area Sacra di Largo Argentina. The porticus was decorated with statues, the work of Greek artists, several of which were discovered at various times, together with inscriptions bearing the names of the artists. Atticus, Cicero's friend and a connoisseur of art, was responsible for selecting the pieces, which were limited to subjects connected with the theater and with the world of Venus (*hetairai*, actresses, etc.). Large statues of the Muses with Apollo were displayed on the scaena, two of which are to be identified with the enormous sculptures (4 meters high) in the Louvre and the Museo Nazionale di Napoli; others—in particular the statue of Apollo—are visible in the courtyard of Palazzo Borghese.

The porticus lay in the area between Largo Argentina and Via dei Chiavari (east to west) and between Via del Sudario and Via di Sant'Anna (north to south) (FIG. **72**). Nothing of it remains visible, except a portion of the eastern side in the excavations of Largo Argentina. The medieval quarter faithfully preserved the

shape and proportions of the space. The garden in the middle of the porticus had two groves of plane trees, bordered by rows of small fountains; traces of these were discovered during recent soundings below the Teatro Argentina. Fragments of the Severan Marble Plan allow us to reconstruct the layout of the entire complex.

We know that Augustus restored the theater in 32 BC, closing the Curia and moving the statue of Pompey to the *frons scaenae* of the theater. Tiberius rebuilt the stage, though the dedication of the new work did not take place until the reign of Claudius. Domitian repaired damage caused by the fire of AD 80. The fire that broke out under Carinus caused more serious damage, and accordingly the restoration under Diocletian and Maximian was more extensive. From that time on, the two sections of the porticus were called *Iovia* and *Herculia* in honor of the two emperors.

The theater is much better preserved than the porticus. The internal curve is perfectly reflected in the buildings that surround Piazza di Grotta Pinta—one of the most notable cases of urban continuity in Rome. The external curve can be observed particularly in Via del Biscione and Piazza Pollarola. Palazzo Pio-Righetti, just off Campo dei Fiori, rises above the exact spot where the Temple of Venus Victrix stood, utilizing its foundations. Numerous cunei in *opus reticulatum*, one of the earliest examples of this technique, can be seen in the cellars of many buildings, in particular in the basement of the restaurant Da Pancrazio.

Another porticus spanned the entire length of the Porticus of Pompey and the Area Sacra di Largo Argentina on the north, a section of which is preserved alongside Temple A and underneath the modern sidewalk. The building was called the **Hecatostylum** (Porticus of 100 Columns), but its official name was possibly Porticus Lentulorum or *Porticus ad Nationes*. Here representations of the nations of the world were on display, the work of the sculptor Coponius. The construction must have been contemporary with or slightly later than Pompey's complex. The Lentuli who erected the building were the two persons of this name, consuls in 57 and 49 BC, who followed Pompey and perished after Pharsalus or perhaps the two consuls of the same name in 18 BC.

THE BATHS OF AGRIPPA The oldest public baths of Rome stood in the area north of Largo Argentina, between Corso Vittorio Emanuele and Via di Santa Chiara; Agrippa began their construction around 25 BC and probably finished the baths in 19 BC, when the Aqua Virgo became operational (FIG. **68:8**). They were restored after the fire of AD 80 and again by Hadrian at the same time as work was being done on the Pantheon and the whole surrounding area. The last restoration took place in AD 345 during the reign of Constantius and Constans. The building measured between 80 to 100 meters wide (running east to west) and around 120 meters long; it is documented in a fragment of the Severan Marble Plan and in Renaissance drawings. The facility has the form of the older bath

complexes, such as those in Pompeii, with rooms irregularly arranged around a large circular hall; a section of this hall (a Severan construction or restoration), with a diameter of 25 meters, is still preserved, divided in half by Via dell'Arco della Ciambella. The baths were decorated with famous statues, among which was the *Apoxyomenos* of Lysippus.

Next to this, on the western side (between Corso Vittorio Emanuele and Via dei Nari), was an artificial pool, the Stagnum Agrippae, fed by the Aqua Virgo (FIG. **68:7**). Part of the *stagnum* appears on the Severan Marble Plan. It is likely that this served as the baths' swimming pool. Nero reportedly hosted luxurious parties on the water here, employing rafts that were towed by boats. A canal, the Euripus, branched off from the pool and crossed the entire Campus Martius, emptying into the Tiber near Ponte Vittorio Emanuele. It has been seen in several places, but the only section that is still visible lies under Palazzo della Cancelleria.

THE PANTHEON Of all the buildings in ancient Rome, the Pantheon is certainly the best preserved, due to the fact that the Byzantine emperor Phocas gave the temple to Pope Boniface IV and it was subsequently transformed into a church under the name of S. Maria ad Martyres (AD 609) (FIG. **68:16**).

Agrippa was responsible for the first phase of the temple, completed between 27 and 25 BC during his reorganization of this entire section of the Campus Martius. Excavations carried out at the end of the nineteenth century brought to light the remains of the earliest building under the pronaos. It appears that Agrippa's Pantheon was a temple of rectangular form (19.82 × 43.76 meters), with its facade on the long side, possibly facing the opposite direction of the present one; i.e., toward the south. A second phase dates to Domitian's restoration after the fire of AD 80, but we know nothing of this.

The third phase, the one that survived antiquity, can be precisely dated to the first years of Hadrian's reign, as we learn from the late biographer of the emperor and above all from the brick stamps that date the building between AD 118 and 125. The inscription on the architrave—*M(arcus) Agrippa L(uci) f(ilius) co(n)s(ul) tertium fecit*—was thus erected by Hadrian, who did not have his name inscribed on any of the numerous monuments he built except the Temple of Trajan. Agrippa's third consulship fell in 27 BC. A second inscription, in much smaller letters, was added below this, recording a restoration, of a very limited scope, by Septimius Severus and Caracalla in AD 202.

Hadrian's reconstruction completely modified the original building. Lacking space in front of Agrippa's temple because of the presence of the Basilica of Neptune, which stood on the other side of a square, opposite the temple, Hadrian turned the facade around 180 degrees so that it faced north. The later pronaos occupied the area of the original temple, while the great rotunda was inserted between it and the Basilica of Neptune.

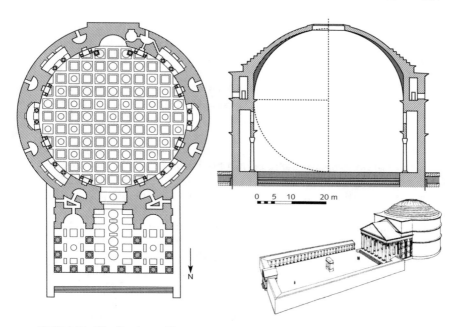

FIGURE 73. The Pantheon. Plan and section. *Below and to the right,* conceptual reconstruction of the building and facing porticus.

The present appearance of the Hadrianic monument differs considerably from what it would have looked like in antiquity. The Pantheon's sunken facade now lies in the lowest point of the area, whereas originally it rose on several steps, preceded by a much longer square and framed by lateral porticoes. From the front, the building must have resembled a normal peripteral temple; the drum of the rotunda was in fact almost invisible. The result was a total separation between its external appearance—a canonical temple—and its interior. Today, however, the huge drum (30.40 meters high), from which only the upper part of the dome emerges, is quite visible. In fact, the dome begins on the inside at the level of the second external cornice; the first two bracketed cornices of the external drum correspond to those of the two internal architectural orders (FIG. 73).

The large colonnaded porch (33.10 meters wide and 15.50 deep) is fronted by a facade of eight monolithic columns (ca. 14 meters high) of rose and gray Egyptian granite with capitals and bases of white marble; two of the columns on the left, removed in the Middle Ages, were replaced in the seventeenth century with columns from the Baths of Nero. The addition of two columns behind the first, third, sixth, and eighth columns results in the formation of three aisles. The central and largest aisle leads to the entrance, and the narrower side aisles

end in large niches; the statues that stood here were probably those of Augustus and Agrippa, which we know were located outside the oldest temple. On the evidence of the clamp holes, the pediment was decorated with an eagle and a wreath.

Behind the pronaos is a massive brick construction that connects it with the rotunda. Of the two side stairwells that were installed here to give access to the monument's upper sections, there remains only that on the left. The space that precedes the large door is decorated with sculpted marble slabs depicting priestly symbols and sacrificial instruments. The bronze that originally decorated the ceiling of the pronaos was melted down by the Barberini and used by Bernini for the great baldacchino over the main altar in St. Peter's. The huge bronze door that closes the magnificent marble doorway may be original, though it is much restored.

The rotunda rests on a solid foundation, comprised of a ring of concrete 7.30 meters wide and 4.50 deep. The cylindrical wall that supports the dome, 6 meters thick, is made of three superimposed sections that are marked by the cornices. The masonry becomes progressively lighter as it ascends, particularly in the dome, which is constructed of volcanic stone. The thickness of the walls, crossed at several points by brick vaults, is not uniform: eight internal niches, alternately rectangular and semicircular, break the drum into eight gigantic piers, in each of which there is a semicircular space with a passage facing the outside. A series of vaults and relief arches directs the thrusts toward the points of greater resistance. The dome was cast in one piece in a huge wooden mold that resulted in the creation of a perfectly hemispherical form. Its diameter is 43.30 meters, the widest solid-construction dome ever raised. The monumental simplicity of the interior derives from the proportions; for instance, the distance from the floor to the peak of the dome is identical to the diameter. In essence, the interior space is a perfect sphere inserted into a cylinder as tall as its radius.

The dome is decorated with five concentric rows of coffers (28 per row), which grow progressively smaller as they approach the circular opening, almost 9 meters wide, at the top. The edge of the opening still preserves the original embossed bronze revetment. The central exedra is semicircular and preceded by two pavonazzetto columns. The cornice of the first order runs within it, unlike the other exedras, of which there are three per side. The central exedra of each side is also semicircular, with one niche against the back wall, while the lateral exedras are rectangular with three niches within. In front of each of these exedras are two monolithic Corinthian columns that support the architrave; columns of the rectangular exedras are giallo antico, those of the semicircular exedras are pavonazzetto. Eight aediculas separate the exedras and are composed of two small columns—porphyry, granite, or giallo antico—that support pediments that are alternately triangular or lunate.

The second order begins above the frieze in porphyry and cornice in white marble; this was completely destroyed in 1747, although earlier reproductions of it are known. A modern reconstruction (1930) of this section can be seen above the first niche to the right of the apse: light Corinthian pilasters alternate with square windows. The same marbles used in the architectural decoration— porphyry, granite, pavonazzetto, and giallo antico—reappear in the floor. The floor's design of squares with inscribed circles has been preserved in its entirety, although some elements are restored.

The many niches in the exedras and aediculas were evidently occupied by statues of divinities; in fact, the building was dedicated, as the name suggests, to the *dodekatheon*, the twelve celestial divinities. The sanctuary, on the other hand, originally served as a dynastic temple, an *Augusteum*, modeled on similar examples found throughout the Hellenistic world. Even if Augustus, consistent with his political stance, demurred at the dedication of sanctuaries to himself, the presence of dynastic divinities of the Julio-Claudian family within the temple (Mars, Venus, and Divus Julius) is in itself sufficient to make the monument's purpose clear. During the Hellenistic period, the name "Pantheon" signified a temple that was dedicated to the deified king and to the twelve gods associated with him. In Agrippa's Pantheon, the statue of Augustus was not in the cella, but, more modestly, in the pronaos.

The back wall of the **Porticus of the Argonauts** can be seen on the left side of the building. The porticus ran the whole length of the western side of the Saepta; what survives is obviously a Hadrianic reconstruction of the monument. At the rear of the Pantheon is a large brick wall with niches and an apse at its center, framed by two Corinthian columns. This is all that remains of the **Basilica of Neptune.** The marble frieze of dolphins and tridents is particularly appropriate to the titular divinity. The hall, now cut in half by Via della Palombella, was roofed with a triple cross vault, as in the Basilica of Maxentius. Here too, like the Pantheon, we are not dealing with the building erected by Agrippa, but with the Hadrianic reconstruction. It is possible that the building served as a library, if we are to identify it with the "Library of the Pantheon" recorded in a papyrus of the third century AD.

THE AREA EAST OF THE PANTHEON The location of the *Saepta Julia*, immediately east of the Pantheon, was identified in the 1930s; the site was previously thought to have stood next to Via del Corso (FIG. **68**). The huge square (310 × 120 meters) occupied the space between Via dei Cestari, Via del Gesù, and Via del Seminario, while its southern annex, the Diribitorium, whose original function was the counting of votes, extended to the middle of Corso Vittorio Emanuele (FIG. **68:9**). The northern facade was aligned with that of the Pantheon and the nearby Temple of Isis and Serapis, along Via del Seminario, which corresponds to an ancient street. This is where the arches of the Aqua Virgo

ended, as Frontinus records (*Aq.* 22.2): *"arcus Virginis finiuntur secundum frontem Saeptorum."*

The sides of the square were framed by **two porticoes** that took their names from the works of art on display within: the one adjacent to the Pantheon was called the Porticus of the Argonauts, and the one on the other long side was called the Porticus of Meleager. As mentioned above, the large brick wall stretching along the left side of the Pantheon belongs to the former; the surviving structure, part of Hadrian's restoration, was originally clad in marble. These were the only visible remains of the two porticoes, which correspond exactly to the present-day Via dei Cestari and Via del Gesù, another remarkable example of urban continuity. Recent excavation has brought to light a tract of the Porticus of the Argonauts in the middle of the piazza. Once the original electoral function of the site was lost, the Saepta became a monumental square during the course of the empire. The poet Martial informs us that there was a large market here, specializing in antiques and works of art (2.14.5, 57.2; 9.59.1; 10.80.4).

At the opposite side of the original square, to the right of S. Maria sopra Minerva, which occupied the central part of the enclosed area, lies the intersection of Via Pie' di Marmo and Via del Gesù. The nineteenth-century building that partially obstructs the street occupies the location of a huge Hadrianic quadrifrons arch (21 meters high, 11.06 wide) that was demolished at the end of the nineteenth century. The arch afforded passage to the nearby Temple of Isis without interrupting the course of the Porticus of Meleager, the present-day Via del Gesù. The Via Pie' di Marmo corresponds to an interior courtyard of the temple, located between the cult building that lay farther to the south and a kind of monumental avenue that functioned as the traditional *dromos* of Egyptian temples; it ran from Piazza S. Macuto, the main entrance of the site (FIG. **68:10,11**).

The Severan Marble Plan shows a line of dots along the *dromos* that are too far apart to represent columns. These are most likely the small obelisks (about 6 meters high) that have been recovered from the area on various occasions. They can now be seen in the following places: (1) Piazza della Rotonda (with an inscription of Ramesses II, coming from Heliopolis); (2) Viale delle Terme, a monument to the soldiers who died at Dogali (also of Ramesses II and from Heliopolis); (3) Piazza della Minerva (erected by Apries, sixth century BC); (4) in the Boboli Gardens in Florence, formerly in the Villa Medici in Rome (Ramesses II, from Heliopolis); (5) various fragments assembled from two or three obelisks (erected by Apries) now in front of Palazzo Ducale in Urbino. The obelisk of Villa Celimontana, in honor of Ramesses II, the twin of the one in Piazza della Rotonda, might also belong to the temple, although, inasmuch as it came from the Capitoline, it could have been part of the decoration of the Temple of Isis Capitolina. The obelisks probably alternated with sphinxes, a few of which were also recovered. Some have included among these, though probably erroneously, the obelisk in Piazza Navona, set on the Fontana dei Fiumi by Bernini in 1651.

This comes from the Circus of Maxentius on the Via Appia, and the inscriptions in hieroglyphs bear the name of Domitian, proving that it originally belonged to another monument. Two large statues of the Nile and Tiber also came from Via Pie' di Marmo and are now in the Vatican Museums and Louvre, respectively. Many other Egyptian statues of the pharaonic and Roman periods found in the area are now in various museums. An important group, discovered in 1883, is in the Capitoline Museums.

On the other side of the building, facing Piazza del Collegio Romano, was **another arch,** known during the Renaissance as the Arco di Camigliano. It was once believed to have disappeared completely, but recent restorations in the house on the corner of Via di Sant'Ignazio have brought to light the entire left pier, built of travertine and preserved for a considerable height.

The temple proper corresponds exactly to the Church of Santo Stefano del Cacco. The large marble foot on the corner where the Via di Santo Stefano del Cacco intersects with the Via Pie' di Marmo probably belongs to a cult statue of this sanctuary. The same can be said of the colossal female bust, known as Madama Lucrezia, now on the corner of Piazza S. Marco. The knot in the clothing on its chest identifies the fragment as a portrait of Isis, and, given its size, it is probably a cult statue. The style is characteristic of the first half of the third century AD, which suggests that it was created during restorations under Alexander Severus. The sanctuary, the most important of the Egyptian cult in Rome, was probably first erected by the triumvirs in 43 BC, as Cassius Dio records (47.15.4). The sect was persecuted by Augustus and Tiberius; the latter was supposed to have completely destroyed the temple and thrown the cult images into the Tiber. Caligula probably rebuilt it almost immediately. The sanctuary was razed together with the entire quarter in the fire of AD 80 and was reconstructed in grandiose form by Domitian and again later by Alexander Severus.

The little Church of S. Marta in Piazza del Collegio Romano occupies the exact point where the Severan Marble Plan marks the presence of the circular shrine of Minerva Chalcidica (Minerva the Doorkeeper; FIG. **68:12**). The name is explained by the position of the building, located in front of the grand complex of the Porticus Divorum, a space set within porticoes with two shrines that Domitian erected in honor of his father, Vespasian, and brother, Titus, after they had been declared gods (FIG. **68:13**). The porticus may have taken over the space previously occupied by the Villa Publica, where the two generals had slept on the night before their triumph over Judea in AD 70. The shrine to Minerva, whose name was later associated with the Church of S. Maria sopra Minerva, was probably also built by Domitian, who professed a special veneration for this divinity. Today no visible remains survive of either monument.

THE TEMPLE OF MATIDIA AND THE TEMPLE OF HADRIAN Hadrian is perhaps the only man in the world to proclaim his mother-in-law a goddess; he

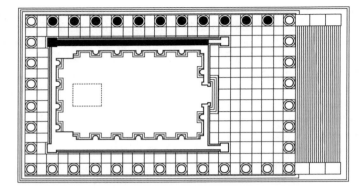

FIGURE 74. The Temple of Hadrian. Plan.

dedicated a temple to Matidia, the mother of his wife, Sabina, immediately after her death in AD 119 (FIG. **68:17**). A water pipe, found near Sant'Ignazio and inscribed *Templo Matidiae,* situates the temple in the vicinity of Piazza Capranica. Several large cipollino columns were seen here in the past, two of which are embedded in the house at no. 76 of the square. The trunk of a column is still visible on Vicolo della Spada d'Orlando, so-called because the deep cuts in the column recalled the magical power of the famous Durandal at Roncevaux. These columns probably belonged to the Temple of Matidia; given their remarkable diameter (1.70 meters), they must have been no less than 17 meters high, making this a rather imposing building. A Hadrianic coin, dated to 120, gives us an idea of its appearance. The temple is shown in between two other buildings, similar to porticoes, which must be the basilicas of Matidia and Marciana, mentioned in the Regionary Catalogues. These must have stood, respectively, under the Church of S. Maria in Aquiro and under the buildings along Via dei Pastini.

In a certain sense, the deification of Matidia was a prelude to Hadrian's own apotheosis. The temple and two basilicas anticipated a related project on the east; the whole complex was completed after the emperor's death with the temple dedicated to Hadrian in 145 (FIG. **68:18**). One side of the temple, almost completely preserved, can be seen on the northern side of Palazzo della Borsa in Piazza di Pietra. The building was peripteral with 8 columns on the short and 13 on the long preceded on the east by a stairway (FIG. **74**). Eleven of 13 Corinthian columns in white Proconnesian marble, 1.44 meters in diameter and 15 meters high, belonging to the right side of the temple survive; the facade of the building faced east. The columns rise on a lofty podium in peperino, about 4 meters high, and were exposed in their entirety. The podium was originally faced with marble, like the cella wall, which was also in *opus quadratum* of peperino. The architrave and frieze are only partially original, having undergone numerous restorations.

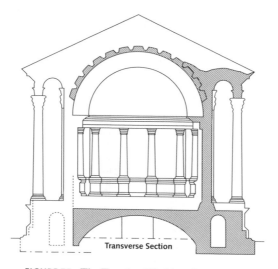

Transverse Section

FIGURE 75. The Temple of Hadrian. Cross section.

The cella did not have an apse and was roofed by a coffered barrel vault, of which a section is preserved inside the former Borsa (FIG. **75**). The interior was accentuated by engaged columns rising on bases decorated with reliefs of allegorical figures representing the Roman provinces, while the intermediate spaces were decorated with trophies, also in relief. The most important of the surviving sculptures are kept in the courtyard of the Palazzo dei Conservatori and in the Museo Nazionale in Naples. The ideological focus of the images was clearly Hadrian's political strategy, which stressed diplomacy (in contrast to Trajan's militarism) and sought above all to impose order on the empire's administrative apparatus, which assumed its definitive form at that time.

Around the temple was a large square (ca. 100 × 90 meters) with a porticus whose columns were of giallo antico and which probably had a monumental arch on the side facing Via Lata; two reliefs from this arch survive and are now in the Museo dei Conservatori and Palazzo Torlonia.

FROM THE BATHS OF NERO TO THE STADIUM OF DOMITIAN The area between Piazza della Rotonda and Corso Rinascimento (from east to west) and between Via del Pozzo delle Cornacchie and Via della Dogana Vecchia (from north to south)—ca. 190 × 120 meters—was occupied in antiquity by the **Baths of Nero** around AD 62 and restored by Alexander Severus in 227, after which they assumed the name *Thermae Alexandrinae* (FIG. **68:15**). The plan, which can be reconstructed from Renaissance sketches, remained the same, even after the reconstruction. This being the case, this is the earliest example of the grand

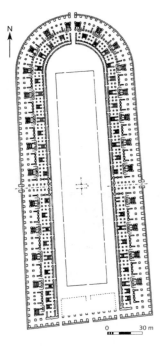

FIGURE 76. Stadium of Domitian
(Piazza Navona).

imperial bath complex, designed along a symmetrical axis, which thereafter
became canonical.

Remains of the building include several walls underneath Palazzo Madama
and two monolithic columns made of granite, which were discovered in Piazza S.
Luigi dei Francesi in 1934 and later reerected in Via Giovanna d'Arco alongside
Sant'Eustachio, together with the fragment of a white marble architrave. Two
other columns from the complex were inserted in 1666 in the pronaos of the
Pantheon to replace those that were missing. Between 1953 and 1957, work on
the building north of San Luigi dei Francesi brought to light the ruins of the
northwest corner of the baths, where one of the large symmetrical palaestrae was
located. A large column with Corinthian capital, still *in situ*, probably belongs to
this portion of the building. Other remains of the baths (fragments of columns,
sculptures, capitals, and mosaics, all belonging to a late phase of the building)
can now be seen in the cultural center of San Luigi dei Francesi.

The nearby Piazza Navona constitutes one of the most important examples of
urban continuity in Rome. It occupies the track of the **Stadium of Domitian,**
whose elongated rectangular form, including the curve of the narrow side on

the north, it preserves perfectly (FIG. **68**). The surrounding buildings were constructed on the tiers of the cavea, as can easily be ascertained in Piazza di Tor Sanguigna, where an intact section of the curved side can be seen beneath the modern constructions.

Domitian had the stadium built, possibly as early as AD 86, for the Greek athletic games of which he was particularly fond. These games, together with musical and equestrian contests, formed part of the *Certamen Capitolinum*, a competition in honor of Jupiter Capitolinus that was instituted in AD 86. Being a stadium and not a circus, the arena was completely free of structures, as can be seen from a coin that depicts the building; the obelisk that is now at the center of the square would not have been there in antiquity, as was once imagined. Alexander Severus restored the building, together with the nearby Baths of Nero. Christian hagiography locates the martyrdom of Saint Agnes in the stadium. Her death was supposed to have taken place in one of the brothels that, as was the case in the Circus Maximus, occupied the exterior arches, at the spot now occupied by the church named after the saint; ruins belonging to the stadium can be seen in the church's basement.

The stadium measured roughly 275 meters in length by 106.10 in width (FIG. **76**). The external facade was composed of arches rising on travertine piers with engaged Ionic columns. Between the first and second ambulatory, there was a section consisting of piers and radial walls in which stairs were built. From this point, the travertine was replaced by brickwork. Between the second and third ambulatory, there was a section of large spaces, supported by piers, between which were other stairs. The arena opened out beyond the wall of the podium. Two principal entrances were located at the center of the long sides; traces of one of these remain in the area to the right of Sant'Agnese. Another stood at the center of the curved side, preceded by a porticus lined with columns of Porta Santa marble, one of which remains *in situ*. This section, discovered between 1936 and 1938, was left open to view under the Palazzo dell'INA and is the best-preserved part of the stadium. A fourth entrance was probably located on the short straight side on the south. The cavea consisted of two superimposed sections *(maeniana);* the exterior facade must thus have had a second order, possibly Corinthian. From a careful calculation of the length of the tiers, the number of spectators can be estimated at 30,000, a figure that accords precisely with the number handed down by the Regionary Catalogues. The statue of Pasquino, located at the corner of Palazzo Braschi in Piazza Pasquino, was probably part of the stadium's rich sculptural decoration, several pieces of which were recovered during the excavations of the 1930s. The statue is a copy of a piece from a Hellenistic group from Pergamon that probably represents Ajax with Achilles.

South of the stadium, Domitian commissioned an **Odeon,** which, according to the Regionary Catalogues, seated 10,600 (FIG. **68:6**). Like the stadium, Domitian's Odeon was also intended to host some of the competitions of

the Certamen Capitolinum—in this case, the musical events. The facade of Palazzo Massimo on Corso Vittorio Emanuele, built on the cavea of the building, preserves the curve of the ancient construction. The only element of the Odeon that is still visible is the large monolithic cipollino column that is now in front of the rear facade of Palazzo Massimo in Piazza dei Massimi; the column may have been part of the scaena.

ITINERARY 3

The Northern Campus Martius

THE COLUMN OF MARCUS AURELIUS North of the ancient street that has arbitrarily been called *Via Recta,* corresponding to Via dei Coronari–Via Sant'Agostino–Via delle Coppelle, the buildings of the Campus Martius change orientation and line up with Via Flaminia (Via Lata). The urban development of this area began under the Antonines. The most important ancient monument still visible today is the Column of Marcus Aurelius, standing at the center of Piazza Colonna (FIG. **77:1**). It was erected after AD 180, the date of Marcus Aurelius's death, and before 193, the year in which Adrastus, the procurator in charge of the column's construction, received authorization to help himself to the wood from the scaffolding in order to build a house, as we learn from an inscription.

The column, clearly modeled on that of Trajan, stood 3.86 meters lower than the modern level on a pavement that in turn was three meters above Via Flaminia, with which it was connected by a flight of steps. The very tall base (10.50 meters) was originally decorated on three sides by a frieze with Victories holding up festoons and on the principal side, facing Via Flaminia, with a scene depicting the submission of barbarians. These sculptures, known from Renaissance drawings, were destroyed in 1589 by Sixtus V, who also restored some of the damage incurred by the column and placed the statue of Saint Paul on top.

The height of the shaft is 29.601 meters (100 Roman feet), bringing the whole monument to a height of 41.951 meters. The figure reported in the Regionary Catalogues (175.50 feet, equal to 51.95 meters) clearly included the part of the base now underground together with the statue. As in Trajan's Column, a spiral staircase carved into the marble provided access to the top of the monument.

The relief that adorns the column depicts Marcus Aurelius's wars against the Germani and Sarmatae. As in Trajan's Column, the narrative begins with a Roman army crossing a bridge over the Danube (possibly at *Carnuntum*). Again as in Trajan's Column, halfway up a Victory divides two series of episodes, the first possibly referring to the campaigns of 172–73 and the second probably to those of 174–75. Despite these similarities, the reliefs are completely different from those of the earlier column: the depth of the relief work is greater, the figures

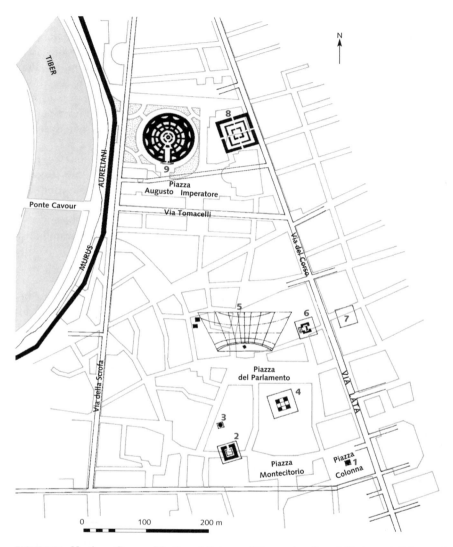

FIGURE 77. Northern Campus Martius. **1** Column of Marcus Aurelius. **2** *Ustrinum*. **3** Column of Antoninus Pius. **4** Ustrinum of Marcus Aurelius. **5** Horologium. **6** Ara Pacis. **7** Ara Providentiae. **8** Ustrinum of Augustus? **9** Mausoleum of Augustus.

less dense, more detached from one another and from the background, resulting in a more legible decorative program. Stylistically, the relief lacks the qualities of compositional refinement and complexity of foreground and background that in Trajan's monument clearly derived from the Hellenistic tradition, tending instead toward simplification and schematization throughout. On the more pronounced and detached volumes, the drill work is deep, animating the surfaces with violent contrasts of light and dark. The work could well be described as expressionistic, a precursor to the violently dramatic style that characterizes the third century.

We are told that Commodus erected a temple to Marcus Aurelius after he was declared a god. The building probably stood behind the column. Recent soundings have uncovered fragments of a ceiling and several marble roof tiles that show that the building must have been completely demolished, perhaps as early as the Middle Ages. Nothing is known of the arch that some believe stood in the vicinity and that was probably the source for the reliefs incorporated into the Arch of Constantine.

THE COLUMN OF ANTONINUS PIUS AND THE ADJACENT MONUMENTS

Three square enclosures north of the Column of Marcus Aurelius are to be identified as **ustrina,** or, more precisely, altars of consecration, intended to commemorate within suitable enclosures the funeral pyres erected for the cremation of the emperors and their families. The first of these was discovered, together with the Column of Antoninus Pius, in 1703 on Via degli Uffici del Vicario (FIG. **77:2**). The monument consisted of two travertine enclosures, one inside the other, set within a border of cippi that marked off a paved area of roughly 30 × 30 meters. Two other structures, similar in form and aligned in the same orientation as the Column of Marcus Aurelius, were found in 1907 a little farther to the east, during work on the enlargement of Palazzo Montecitorio (FIG. **77:4**). Their remains are kept in the Museo delle Terme. These must have been the monuments that commemorated the apotheoses of Marcus Aurelius and Lucius Verus.

The remains of the **Column of Antoninus Pius** were found in front of the northern facade of the *ustrinum* discovered in 1703, and it is this discovery that allows us to attribute the enclosure to this emperor (FIG. **77:3**). The base of the column, in white marble, is now located in the Cortile della Pinacoteca in the Vatican. A fragment of the column survived; an inscription on its edge shows that it was quarried in AD 106, long before it was finally used. The base depicts the apotheosis of the emperor on the side opposite the dedication to Antoninus Pius. He is being transported heavenward by a winged genius, together with his wife, Faustina; the goddess Roma and the Genius of the Campus Martius, identified by the obelisk he holds—that of the nearby *Horologium*—attend the scene. The other two sides represent a *decursio*, the ceremonial ride around the pyre and military parade with which the funeral concluded.

Granite fragments of the column were used in 1792 to restore the **obelisk** now in Piazza Montecitorio. This obelisk, belonging, according to the hieroglyphs, to Psammeticus II, was brought to Rome from Heliopolis in 10 BC. Augustus had it erected in the Campus Martius to serve as the gnomon of an enormous solar clock that was located in the area between Piazza del Parlamento and Piazza di San Lorenzo in Lucina (FIG. **77:5**). The obelisk was discovered in 1748 near a house at Piazza del Parlamento no. 3, where an inscription records the event. Recent excavations have brought to light a part of the pavement of the Horologium, with inscriptions in large bronze letters that may date to a Hadrianic restoration (access from Via di Campo Marzio no. 48). These indicated the hours and the days, as well as the period when the Etesian winds, associated with the eastern Mediterranean, ceased to blow. The model for the Horologium must have been Alexandrian and Egyptian, as the inscribed obelisk suggests.

THE ARA PACIS The discovery of the Ara Pacis dates to 1568, when nine sculpted blocks appeared under Palazzo Peretti (later Palazzo Fiano and now Almagià) (FIG. **77:6**). In 1859, a relief of Aeneas and a relief head of Mars of the Lupercal were recovered. The German archaeologist Friedrich von Duhn was the first to identify the monument as the Ara Pacis in 1879. The first systematic excavations, undertaken in 1903, led to the discovery of the main body of the altar and the recovery of other reliefs. Finally, in 1937–38, on the occasion of Augustus's bimillennial, the excavations were brought to a definitive conclusion with the discovery of two sides of the altar, one of which was almost intact. Attention then turned toward the reassembly of the monument (no longer oriented east-west, but north-south) in the pavilion appropriately built near the Mausoleum of Augustus, alongside the Tiber. Inauguration of the monument took place on 23 September 1938.

In Augustus's account of his achievements, inscribed on two bronze tablets placed at the entrance of his Mausoleum, he mentions the construction of the Ara Pacis. The altar, vowed on 4 July 13 BC, was dedicated four years later on 30 January (9 BC). It stood west of Via Flaminia, possibly set opposite the *Ara Providentiae,* which Tiberius erected in AD 14 on the other side of the street in the *Campus Agrippae,* as we know from a recently discovered inscription (FIG. **77:7**). When the ground level of the Campus Martius was significantly raised during Hadrian's reign, the monument was isolated from the surrounding area by a brick wall that supported an embankment. From that time on, the altar emerged from ground level only from the level of the sculptured frieze.

The altar complex comprises a rectangular enclosure on a podium, measuring 11.65 × 10.625 meters, which was approached by a stairway. There were two large doorways (3.60 meters wide) on the long sides, originally set along an east-west axis. The altar proper stood inside the enclosure on three steps that continued along all four sides. Five additional steps on the western side allowed the priest celebrating the sacrifice to reach the altar table.

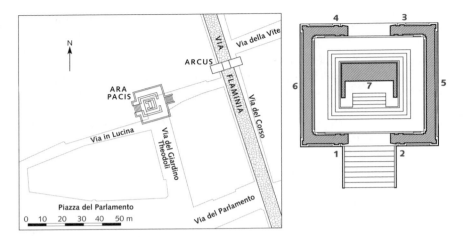

FIGURE 78. *Left:* original position of the Ara Pacis. *Right:* plan of the Ara Pacis. **1** Lupercal. **2** Aeneas sacrificing to the Penates. **3** The goddess Tellus (Earth). **4** The goddess Roma (?). **5,6** The imperial family in procession. **7** Altar.

The enclosure features rich sculptural decoration, inside and out. On the outside, the sculpted panels are framed by marble pilasters decorated with reliefs depicting candelabra and surmounted by Corinthian capitals. The lower zone is identical on all four sides: scrolling acanthus tendrils proceed symmetrically from a single plant set at the center of each panel. Animal figures placed here and there enliven the composition, which is not merely ornamental. The tendrils allude to the *stemmata* (in Greek, "branches") of the family tree, symbolizing Augustus's lineage, which is represented explicitly in the reliefs above.

The upper zone has a more varied presentation (FIG. 78). On the longer sides, flanking the doorways, are four marble panels with mythological (**1** and **2**) and allegorical (**3** and **4**) scenes. Panel **1**, very little of which survives, represents the Lupercal, the grotto where the she-wolf of legend nursed the twins Romulus and Remus. The scene is almost entirely lost; all that remains are part of a person on the right (doubtless the shepherd Faustulus), the figure of Mars on the left, and the remains of marsh plants that identify the venue of the action—the bank of the Tiber near the Velabrum. Much better preserved is the other scene on this side (**2**), in which Aeneas sacrifices the sow that had the thirty piglets to the Penates, whose shrine can be seen above to the left. In front of Aeneas are the attendants at the sacrifice *(camilli);* behind him stands another person, leaning on a staff (Acates?)—the head assigned to this figure probably belongs to another relief.

On the opposite side, the panel on the left (**3**) represents the Earth, portrayed as a buxom woman with two children. The two seminude female figures at her

side symbolize the other elements: water (on the right) seated on a sea monster, and air (on the left) on a swan. The scene, interpreted by some as an allegory of Peace, is completed by animals and plants, whose meaning is transparent. The panel on the right (**4**) is almost completely lost, but it surely contained a representation of the goddess Roma.

The shorter sides featured representations of a "historical" character. The more important of the two is the frieze on the south (**5**), which is the better preserved, representing the leading members of the imperial family, arranged hierarchically in procession (FIG. **79**). The northern side (**6**), of which considerably less is preserved, was less important. Almost all the heads of the figures are missing; those on the monument were remade in the sixteenth century. A group of women and babies stand out on the left; these have been identified as the widows of the imperial family.

The interior of the enclosure was also divided into two zones, mirroring the exterior. The lower part contains a series of vertical relief panels that simulate a fence. The upper section, divided from the first halfway up by a band of palmettes, is a smooth background on which festoons, in half relief, hang from bucrania; *paterae* are suspended in the field above the festoons. In the corners there are smooth pilasters with Corinthian capitals.

It has been reasonably argued that the enclosure is a reproduction in marble of the temporary *templum* erected on the occasion of the ceremony of 13 BC. Even the altar (**7**) was richly decorated, with allegorical female figures on the base. The few surviving fragments have not been reassembled, and the surface of the base has been left coarse. The upper part of the altar is much better preserved; its sides are decorated with scrolling tendrils resting on winged lions. A small frieze in half relief ran around the table, inside and out, depicting the annual sacrifice that was offered on the altar. The frieze is well preserved on the left, where the Vestals and *pontifex maximus* are portrayed on the interior and the priests and *camilli*, with the animals selected for the *suovetaurilia* (sacrifice of a pig, sheep, and bull), on the exterior.

The Ara Pacis is key to understanding the official art of the Augustan period. Motifs from three different traditions come together in its creation. While the large friezes depicting the procession are evidently inspired by Greek art of the Classical period, the direct contribution of Hellenistic art is evident in the floral decoration and the panels representing Tellus (Earth) (**3**) and Aeneas (**2**). The small frieze of the altar, in contrast, incorporates features that are clearly Roman. Accordingly, what we have before us is an eclectic work.

On the other hand, the political and propagandistic side of such monuments of official art cannot be ignored. The symbolism of the monument is quite clear: the association of the name of Augustus with peace; the rebirth of Italy and the earth under the universal dominion of Rome (**3** and **4**), the city whose origin is associated with the offspring of Aeneas (**1** and **2**) and thus with Augustus, who was adopted into the Julian family that claimed descent from Aeneas. The

A C B C D

FIGURE 79. Frieze of the south side. **A** Lictors. **B** Augustus. **C–D** Flamens. **E** Flaminius Lictor. **F** Agrippa. **G** Gaius Caesar. **H** Julia, daughter of Augustus. **I** Tiberius. **L** Antonia Minor. **M** The young Germanicus. **N** Drusus. **O** The young Domitius, son of Antonia Major and L. Domitius

history of Rome and of the world are thus linked by the hand of providence to the name of Augustus.

THE MAUSOLEUM OF AUGUSTUS Upon his return from Alexandria following his victory in the war against Antony and his conquest of Egypt in 29 BC, Octavian began construction of a monumental tomb in the Campus Martius (FIG. 77:9). The dynastic aim is obvious: with this gesture Octavian essentially assumed the position of a Hellenistic sovereign. In fact, the inspiration for the tomb is explicit: right from the beginning the monument was called the Mausoleum, a name that designated dynastic burials beginning with Mausolus of Caria and his famous tomb.

The architectural and ideological model was probably the most prestigious of Hellenistic funerary monuments. We know that in 30 BC Octavian went to visit the tomb of Alexander the Great in Alexandria, declining to see those of the Ptolemies. Alexander's tomb was possibly a circular tumulus. Thus, the comparison of Augustus's Mausoleum with archaic Etruscan tumuli, which are in no way a precedent for the Mausoleum, is erroneous.

Excavations undertaken at various times—especially between 1936 and 1938—have unearthed the monument, which is in deplorable condition, having been reduced by centuries of pillaging, so much so that it is difficult to reconstruct. During the excavations, the entire surrounding area was demolished to construct Piazza Augusto Imperatore, one of the dreariest achievements of Fascist architecture. The arrangement of the square around the Mausoleum of Augustus and the Ara Pacis is an interesting example of the regime's characteristic use of Roman antiquity for ideological purposes.

The monument is circular with a diameter of roughly 87 meters, consisting of a series of concentric walls, made of concrete faced with tufa and linked

Ahenobarbus. **P** Antonia Major. **Q** Domitia, daughter of Antonia Major and L. Domitius Aheno-
barbus. **R** Maecenas (?). **S** L. Domitius Ahenobarbus.

by radial walls (**FIG. 80**). The exterior base, in marble, was approximately 12
meters high and possibly capped by a Doric frieze of tryglyphs and metopes. The
extremely thick outer wall was lightened by large semicircular spaces divided by
radial walls; the spaces were not used, but filled with earth. Two more circular
walls, connected by small dividing walls, formed a second series of enclosures.
Finally, the first usable space is reached at the end of the long entrance corridor:
a circular space, in front of which there originally stood another heavy wall,
clad in travertine, with two entrances. This wall, preserved only at this point,
provided the foundation for a drum that must have emerged from the tumulus,
creating a second terrace. Accordingly, we are not dealing with a simple tumulus,
but a complex structure of superimposed terraces that ultimately derives from
Hellenistic funeral monuments, in which the actual burial site was located below
and the funerary temple above.

Beyond the wall, a functional annular passage ran around the circular cella,
which had a doorway on axis with the main entrance and three symmetrical
niches that corresponded to the two major axes. At the center was a large pier,
inside of which there was a small square room; this must have been Augustus's
tomb. Its location within the monument thus corresponded to the bronze statue
of the emperor that could be seen on top of the pier, signaling on the outside
the exact position of the tomb within.

The other tombs were situated in the three niches that punctuated the wall of
the innermost ring. The first to be buried in the Mausoleum was Marcellus, who
died in 23 BC. The funerary inscription, carved on the same block of marble
as that of his mother Octavia, was discovered in 1927 and is displayed on the site.
Agrippa, Lucius, and Gaius Caesar followed. Augustus joined the others in AD
14, followed by Drusus Minor, Livia, and Tiberius; we do not know whether
Claudius was buried here. Caligula had the ashes of his brothers Nero and

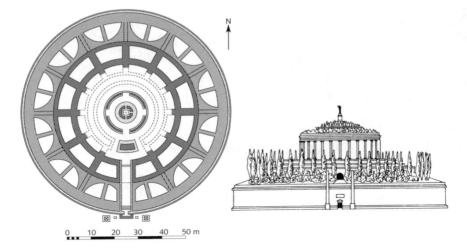

FIGURE 80. Mausoleum of Augustus. Plan and reconstruction. (After Gatti 1934)

Drusus, as well as those of his mother, Agrippina, brought into the Mausoleum; Agrippina's marble urn, now in the Museo Nuovo Capitolino, was used as a grain measure during the Middle Ages. Like Augustus's daughter Julia before him, Nero was excluded from the dynastic tomb.

In accordance with pharaonic custom, two obelisks (now in Piazza del Quirinale and Piazza Esquilino) stood in front of the southern entrance. Bronze tablets with Augustus's official autobiography were affixed to pillars by the side of the entrance. A replica of this document, inscribed on the entrance walls of the Temple of Rome and Augustus in Ankara, has survived; a modern copy of the work was inscribed on the side of the pavilion that houses the Ara Pacis, designed in the 1930s by the Italian architect Vittorio Ballio Morpurgo.

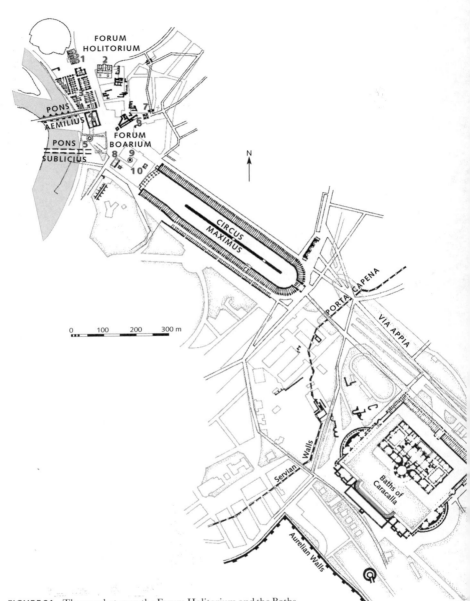

FIGURE 81. The area between the Forum Holitorium and the Baths of Caracalla. **1** Temples of the Forum Holitorium. **2** Church of Sant'Omobono. **3** Imperial *Horrea* (probably Aemiliana). **4** Temple of Portunus. **5** Temple of Hercules Victor (Olivarius). **6** Janus of the Forum Boarium. **7** Arch of the Argentarii. **8** Ara Maxima. **9** Aedes Aemiliana Herculis. **10** Mithraeum of the Circus Maximus.

FORUM HOLITORIUM, FORUM BOARIUM, CIRCUS MAXIMUS, AND THE BATHS OF CARACALLA

HISTORICAL NOTES

The lowland between the Tiber and the hills nearest the river (Capitoline, Palatine, and Aventine) was of fundamental importance from Rome's origins and perhaps even earlier. Rome's very existence cannot be explained without taking into account the early function of this strip of land along the river. It was here, in fact, that the two main traffic arteries of central Italy crossed: the Tiber itself, which was navigable from its mouth almost as far as Orte, and one of the north-south roads, running from Etruria to Campania; the road arrived at the point where the Tiber could be easily crossed by ferry downstream of Tiber Island, the location of Rome's first bridge, the *Pons Sublicius*. The city's commercial port, the *Portus Tiberinus*, occupied the area between the three temples of the Forum Holitorium (S. Nicola in Carcere) and the Temple of Portunus, the tutelary god of the market, the so-called Temple of Fortuna Virilis. At one time, the swamp of the Velabrum spread through this area, making its way into the depression between the Capitoline and the Palatine as far as the valley of the Forum. The Etruscan kings of Rome took steps to reclaim the area by installing the Cloaca Maxima, which emptied into the Tiber after making a large bend immediately to the north of the round temple. Legends regarding the Forum Boarium emphasize the presence of Greek or eastern peoples

307

in this area—Evander and the Arcadians, Hercules, and Aeneas—before the foundation of the city. In founding the new city, Romulus was supposed to have included the great altar of Hercules—the *Ara Maxima*—within the *pomerium*. The altar, then, was considered older than the city itself. This is not surprising: the market on the bank of the river, near a crossing point and port, could well predate the city; indeed, the market was a crucial factor in the settlement's evolution. The name *Forum Boarium* (Cattle Market), which this low ground has been called for more than two millennia, in itself attests to these origins. In addition to livestock, salt from the salt beds at the mouth of the Tiber played a decisive role from prehistoric times onward: here ended the Via Salaria, the road used by the pastoral Sabine peoples to supply themselves with this precious commodity. The Bronze Age materials that were found at Sant'Omobono and in Ostia confirm that these places were frequented from a very early date. Discovery of geometric Greek pottery sherds from the eighth century BC in the area of the Forum Boarium gives us archaeological corroboration of the tradition that Greeks were a presence in the city from its very beginning.

The first large-scale organization of the area occurred under the Etruscan kings, especially during the reign of the second of these, Servius Tullius, whose anti-aristocratic, pro-mercantile politics resembled those of contemporary Greek tyrants. Servius's activities, however, were concentrated in the commercial districts of the Forum Boarium and the Aventine and thus lay outside the city proper. We can credit him with designing the Tiber's port, beside which rose sanctuaries such as those of Fortuna and Mater Matuta in the Area Sacra di Sant'Omobono, and probably also the sanctuary of Portunus. The remarkable antiquity of the latter divinity, like that of Neptune, is attested by the presence of his cult in the oldest Roman calendar, attributed to Numa. Excavation of the first two sanctuaries has confirmed a mid-sixth-century date for the earliest construction; they are thus contemporary with the reign of Servius.

After a pause during the fifth century BC, building activity revived markedly at the beginning of the fourth, when Camillus rebuilt the temples of Fortuna, Mater Matuta, and Portunus. The most intense phase of activity, however, coincides with the end of the third and above all with the second century BC, when the conquest of the Mediterranean was completed and an enormous field of action was opened to Roman enterprise. During those years, the Roman censors took advantage of an extraordinary string of calamities and embarked upon a large-scale program of public works to repair the damage: in 213 BC a fire raged from the Aventine to the Capitoline, destroying the Forum Boarium, which stood inside the walls, and the Forum Holitorium, which stood outside; a few years later, in 192 BC, the whole area between the Forum Boarium and the Tiber burned in another fire. The area was hit by a succession of four large floods in 202, 193, 192, and 189, which made it necessary to attend to the river banks; in fact, we know of significant work on the Tiber's embankment, ascribed chiefly to the censors of 179 BC. It was probably then that the section of the Servian Walls parallel to the river disappeared, to be replaced by a more

sophisticated defensive system that probably included parts of Trastevere. In 212 or soon after, the temples of Fortuna and Mater Matuta, the Portus Tiberinus, the Temple of Portunus, and certainly also the Ara Maxima, whose remains have been identified with those under S. Maria in Cosmedin, were rebuilt. The latter consists of Anio tufa ashlars and thus probably dates no earlier than the mid-second century BC. Among the most important monuments of the period is the *Pons Aemilius*, whose piers were constructed by the censors of 179 BC and whose arches were added by the censors of 142, Lucius Mummius and Scipio Aemilianus. Scipio built the round Temple of Hercules near the Ara Maxima, while a late second-century merchant, M. Octavius Herrenus, was responsible for the other temple of Hercules Victor, outside the Porta Trigemina. This has been identified as the circular shrine (erroneously known as the Temple of Vesta), constructed of marble, that still stands near the bank of the Tiber. A series of important works, about which little is known, must have been undertaken between the end of the second and beginning of the first century BC; these include the temples of the Forum Holitorium and the Temple of Portunus.

Transformation of the area during the empire is more evident. It included the construction of a series of brick warehouses near the river's port; these were preceded by a similar Republican complex that can be identified as the *Horrea Aemiliana*, probably attributable, as is much of the organization of the area, to Scipio Aemilianus.

The Forum Boarium and the Circus Maximus, together with the strip of land along the river, were included by Augustus in Region XI, which took its name from the Circus Maximus (see FIG. 2). The Forum Holitorium was still part of Region IX. The area around Sant'Omobono was part of the Forum Romanum (Region VIII), while the eastern limits of the quarter bordered the Palatium (Region X).

The oldest thoroughfares in the area consisted of two streets that followed the bottom of the hills so as to avoid the valley's swampy ground level. The *Vicus Iugarius* followed the base of the Capitoline to the Forum; the *Vicus Tuscus* skirted the Palatine, also in the direction of the Forum. Two other roads must have made their way into the valley of the Circus (the *Vallis Murcia*), similarly following the lower slopes of the Palatine and the Aventine. Several gates marked the intersection of these roads with the walls in the direction of the bridges: the Vicus Iugarius exited through the *Porta Carmentalis*, the Vicus Tuscus (or rather an extension of it, the *Vicus Lucceius*) ran to the *Porta Flumentana*, which in its Augustan reconstruction was preserved until the fifteenth century and was situated in the immediate vicinity of the Temple of Portunus. The roads of the Vallis Murcia passed through the *Porta Trigemina*, near S. Maria in Cosmedin, which may have survived until the fifteenth century. Beyond the wall, all these roads led to bridges: the Pons Sublicius, Rome's oldest wooden bridge, and the Pons Aemilius.

At the southeastern end of the Circus Maximus, to the right of the Via Appia, is a hill, a kind of appendage of the Aventine, separated from it by a small valley through which the *Vicus Piscinae Publicae* passed. Its continuation, the *Vicus Portae*

Raudusculanae, is named from the gate situated at this point of the Servian Wall. Part of the Little Aventine, as it is commonly called, was included within the Servian Walls, which opened on the east through another gate, *Porta Naevia*. From the time of Augustus on, this area formed Region XII, which took its name, *Piscina Publica*, from a pool, possibly artificial, that is mentioned as early as 215 BC but disappeared soon thereafter. Its probable function as a public bath was to some extent continued by the nearby Baths of Caracalla, the region's best-known bathing facilities. The barracks of the Fourth Cohort of the *Vigiles* were near the Church of S. Saba. The region's main sanctuary, the Temple of the *Bona Dea Subsaxana*, must have been located at the bottom of the cliff of the Little Aventine, toward the north. We also know from the Regionary Catalogues of a temple dedicated to Isis Athenodoria. Among the important documented houses in this quarter are Hadrian's private house and the residences of Cornificius and Cilo. The remains of the *Domus Cilonis*, the house of L. Fabius Cilo, city prefect in AD 203 and consul in 204, are all that have survived. The residence, which was given to him by his friend the emperor Septimius Severus, is indicated on a fragment of the Severan Marble Plan; its remains can still be seen in the convent near the Church of S. Balbina, now the Ospizio di S. Margherita. Its identification has been confirmed by the discovery in the area of a lead pipe with the name of the proprietor on it.

From the third century on, the principal axis of the region was the *Via Nova*, a large road parallel to Via Appia, which must have originated at the southeastern gate of the Circus Maximus. The road may have been built by Septimius Severus; it was along this thoroughfare that the Baths of Caracalla would eventually rise.

ITINERARY 1

The Forum Holitorium and the Forum Boarium

THE AREA SACRA DI SANT'OMOBONO Near the little church of Sant'Omo-bono, along the westernmost stretch of Vicus Iugarius at the foot of the Capitoline, is a now quite famous archaeological zone discovered in 1937 (FIG. **81:2**; FIGS. **82,83**). The area's excavation, which is still far from finished, has already provided exceptionally important documentation for the history of archaic and Republican Rome. It is a sacred area that includes two small temples, which were correctly identified as those of Fortuna and Mater Matuta from the very time of their discovery; the foundation of these temples was attributed by ancient tradition to Servius Tullius.

In-depth excavations, still limited to a very small part of the area, have made possible the reconstruction of the site's chronology, including the various phases of its construction. Above the level that predates the sanctuary and shows some traces of activity, we find:

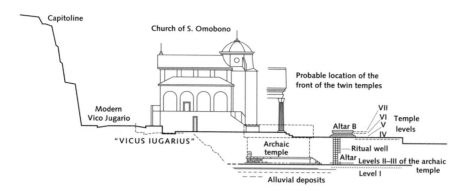

FIGURE 82. *Area Sacra di Sant'Omobono*. Longitudinal section.

I. A level in which there was already a cult with an altar but no temple building (end of the seventh to beginning of the sixth century BC). It is at this depth that an archaic Etruscan inscription was found.

II. Construction of the first archaic temple.

III. A total rebuilding of the temple, probably following a fire, with an enlargement of the podium and replacement of the architectural terracottas. At the end of this period, the area was systematically destroyed and abandoned.

IV. Construction of an impressive terrace that raised the level about 6 meters and of a pavement in cappellaccio on which two temples were built, with an orientation different from that of the earlier sanctuary. The material dumped for fill, which probably came from a village on the nearby Capitoline, includes Iron and earlier Bronze Age pottery sherds, the latter termed Apennine (fourteenth–thirteenth centuries BC), as well as imported Greek pottery. The fragments of the latter came perhaps from Euboea and Ischia and are datable to around the middle of the eighth century BC; this is the oldest evidence we have of relations with the Greek world, which is, significantly, contemporary with Rome's traditional foundation date.

V. Construction of a new pavement in Monteverde and Anio tufa, and the rebuilding of the two temples, as well as construction of two altars, facing east, and a circular *donarium* at the center of the area. Several bronze statues, traces of which still remain, were originally placed on the *donarium*.

VI. The rebuilding of the whole area, following a fire, and new pavement in Monteverde tufa.

VII. The last pavement in travertine, installed during the Empire possibly under Domitian but with Hadrianic restorations, as is clear from the brick stamps.

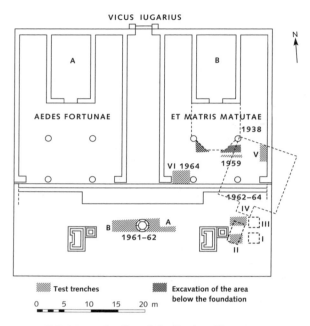

FIGURE 83. *Area Sacra di Sant'Omobono.* Plan.

Traces of a four-sided double arch survive at the center of the area; this can in all probability be identified as the *Porta Triumphalis*, through which triumphal cortèges entered the city, marking the beginning of the ceremony. From representations on reliefs and coins and from literary texts, we know that two quadrigas drawn by elephants stood upon the attic of the arch.

The connection between these archaeological phases and the references to the two temples in literary sources seem sufficiently clear. We have evidence of the Etruscans in Rome even before the construction of the first archaic temples (Level I). A recently discovered small ex-voto, made of ivory, bears the name of an Etruscan, a member of the Spurinna family, whose origins are in Tarquinia. This is an important indication of the presence in Rome of Etruscan *gentes* from Tarquinia and indirect confirmation of the Etruscan origins of the Tarquinian dynasty. The building of the temples in the second phase can be dated to around the middle of the sixth century BC, a clear confirmation of the validity of the tradition that attributes these buildings to Servius Tullius, whose dates are conventionally given as 579–534 BC.

The abundant evidence of imported Greek pottery (Attic, Laconic, and Ionic), discovered in connection with the temples, confirms their chronology and the

age of their deliberate destruction, somewhat before the end of the sixth century. Even in this, the congruence with the date of the Republic's origin is striking: the dynastic temples of Rome's Etruscan kings seem to have been destroyed during the course of a violent change in governmental institutions. The architectural terracottas of the eastern temple—the only archaic-period temple discovered to date—include decorative pieces, friezes that depict divinities riding chariots, and statues of Hercules with an armed goddess, two-thirds life-size. Almost all of these are associated with the second phase of the temple (the third phase of the sanctuary) and are datable to around 530 BC. These finds, like other material recovered in the area, are currently displayed in the Centrale Montemartini.

The rebuilding of the temples must have been the work of Camillus, shortly after the sack of Veii (396 BC). This may in fact constitute the fourth phase of construction, when the surface was paved with cappellaccio. The fifth phase is dated by the fragments of an inscription on blocks of peperino, discovered at the center of the area: *M. Folv[io(s) Q.f cos]ol d(edet) Vols[inio] cap[to]* (Marcus Fulvius, son of Quintus, the consul, dedicated following the capture of Volsinii). The inscription refers to the Marcus Fulvius Flaccus who captured Volsinii in 264 BC and carried away two thousand bronze statues, probably by looting the nearby Etruscan federal sanctuary, the *Fanum Voltumnae*. Some of these statues were likely placed on the nearby circular base, which preserves some traces of them. All those involved in the reconstruction of the sanctuary of Fortuna and Mater Matuta had some connection with the Etruscans, and they dedicated temples on the Aventine: Servius Tullius—the Temple of Diana; Camillus—Juno Regina; Fulvius Flaccus—Vertumnus. Accordingly, these divinities were *evocati* (called away), that is, taken from their respective places of origin. Level VI corresponds to the rebuilding of 212, recorded by Livy after the fire of 213, which destroyed the Forum Boarium.

On the other side of Vicus Iugarius, at the southern corner of the Capitoline, is a small **late Republican porticus,** which consists of two parallel arcades in peperino, with Tuscan semicolumns, continued on the north by a similar structure in travertine. The porticus ran toward Porta Carmentalis (FIG. **85:9**), traces of which have been seen at the center of the modern street, and must have continued all the way up to the temples of Apollo and of Bellona (FIG. **85:2** and **3**). A section of a porticus, identical in dimensions and technical characteristics, is still visible today along the right side and rear of the Temple of Bellona. The structure must have begun at the Porticus of Octavia, although its course suggests that it was part of the *Porticus Triumphalis* (FIG. **85:4**), located along the route of the triumphal processions between the Circus Flaminius and Porta Triumphalis.

THE THREE TEMPLES OF THE FORUM HOLITORIUM In ancient times, the small square between the slope of the Capitoline, the Theater of Marcellus, and the *Portus Tiberinus* was called the Forum Holitorium, signaling its probable

original function as a vegetable market. This stood outside the Servian Walls and probably belonged to Region IX.

At the center of the square, beneath and next to the Church of S. Nicola in Carcere, important remains of three Republican temples survive; they are attributable to the cults mentioned by ancient authors as lying in the Forum Holitorium: Janus, Spes, and Juno Sospita (FIGS. **81:1, 85:6-8**). A fourth, the Temple of Pietas, built by Manius Acilius Glabrio and his son of the same name between 191 and 181 BC, was demolished to make room for the Theater of Marcellus. Its scant remains were recently discovered immediately north of the three surviving temples. While it is difficult to determine which specific divinity is associated with which temple, it is likely that the one nearest the Theater of Marcellus is the Temple of Janus, which is in fact situated near the theater by the ancient sources, while that of Hope *(Spes)* ought to be the Doric structure nearer to the *Portus Tiberinus*, given that this sanctuary burned together with the temples of Fortuna and Mater Matuta in 213 BC and was immediately outside the Porta Carmentalis. This is confirmed by the fact that the third temple, that of Juno Sospita, was built only between 197 and 194 BC by C. Cornelius Cethegus. Accordingly, it did not yet exist at the time of the fire, a fact that suggests that the latter was the central building, enclosed within the present-day church (FIG. **84**).

This last temple, which is about 30 meters long without its staircase (almost 34 including it) and 15 meters wide, was Ionic peripteral hexastyle, probably with three rows of columns in front and two at the back. The podium was preceded by a staircase in travertine, in the center of which stood the altar. Of the building itself, other than the podium (visible in the church's basement), there remain only some columns from the front section of the temple. The structure that we see today, in peperino with the nucleus of the podium in concrete, dates to a restoration in 90 BC prompted by Caecilia Metella. Its other remains are preserved on the left side of the church near the apse.

The temple to the north, in a better state of preservation, was probably that of the god Janus. The podium, in *opus caementicium*, was faced with travertine. The building's preservation is particularly fine on the south side in the church's basement; the regular openings in the podium, partially closed in the second century AD with brick walls, have found no convincing explanation to date. The temple, about 26 meters long with the staircase and 15 meters wide, is peripteral *sine postico* (that is, without a colonnade at the back), with two rows of six Ionic columns on the facade and eight on its sides; seven columns on the south and two on the north, made entirely of peperino, capitals and bases included, remain standing. The architrave with its frieze, however, is of travertine and was embedded in the right side of the church, where it can be seen, together with that of the central temple. The Temple of Janus, built by C. Duilius during the First Punic War, was restored by Tiberius in AD 17.

The southern temple is smaller and considerably different from the others. It is Doric peripteral hexastyle, with eleven columns of coarse travertine (originally

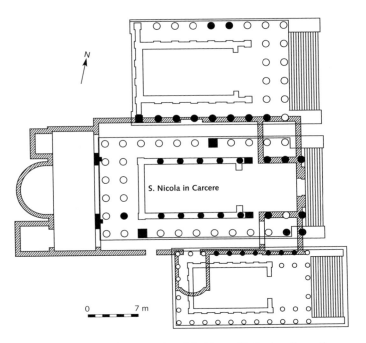

FIGURE 84. The three temples of the Forum Holitorium (beneath S. Nicola in Carcere).

stuccoed) on its sides. The building must have measured about 25 meters in length by a little more than 11 in width. The Temple of Spes, if this is (as it seems) the correct identification, was built by A. Atilius Calatinus during the First Punic war and was restored once after the fire of 213 BC in 212 and again by Germanicus in AD 17. The surviving structure, like the other two, is a reconstruction undertaken near the beginning of the first century BC. An inscription discovered in front of the three temples records a restoration by Hadrian after a fire (*CIL* VI 978); the brick structures, preserved primarily in the podiums of the two northern temples, date to this reconstruction.

THE PORTUS TIBERINUS AND THE TEMPLE OF PORTUNUS The port of Rome, the Portus Tiberinus, lay south of the Forum Holitorium in the area now occupied by the Palazzo dell'Anagrafe (FIG. **81:3,4**). Construction work on this building in 1936–37 brought to light a district of **Trajanic warehouses** built entirely of brick and travertine. Similar remains have been found on the other side of the street and are still visible in the courtyards of the modern buildings. The entire complex is probably associated with the Imperial reconstruction of the (Horrea) Aemiliana, a grain storehouse thought to have been

built by Scipio Aemilianus in 142 BC; it must have subsequently served as a silo for the free grain that was distributed to the Roman people.

Connected with the port is the rectangular building known as the Temple of Fortuna Virilis but that can be identified with certainty as the Temple of Portunus (FIG. **85:12**). We know that this sanctuary was in the immediate vicinity of the Pons Aemilius, and the temple is indeed quite close to Ponte Rotto. The street that led to the bridge, which a recent discovery allows us to identify as the Vicus Lucceius, probably passed through the Porta Flumentana (FIG. **85:11**) in the Servian Wall near this point, and then continued on between the temple and the port. Excavations in 1947 brought to light an earlier phase of the temple, dating to the fourth or third century BC.

The present building rises on a large terrace, built after the beginning of the second century BC in connection with the new embankments. The temple gives clear signs of having been restored several times. The structure, as we see it now, likely dates to the first century BC, although there is evidence of a subsequent series of restorations.

The temple rises on a podium of rubble masonry, clad in travertine. It is Ionic pseudoperipteral tetrastyle. The larger sides consist of two travertine columns plus five semicolumns of Anio tufa, with travertine bases and capitals, attached to the cella walls, built of the same tufa. The entire structure was covered with stucco, even the frieze with candelabra and festoons, which belongs to an early Imperial restoration. The large cornice and lion protomes are well preserved. Remains of an ashlar wall, perhaps part of a sacred precinct enclosure, rest against the temple's back left corner.

On the other side of Piazza Bocca della Verità, beside the House of Pierleoni, two small monuments, found in 1939, are on display in a flower bed. These are a travertine pedestal, certainly intended for a statue, and in front of it, an altar (also of travertine) bearing a dedicatory inscription to *Concordia Augusta*, distinguishable on the basis of the several letters that remain. Some have assigned the monument to one of the three statues dedicated by Augustus in 11 BC to *Salus Publica*, *Pax*, and *Concordia* (Cassius Dio, 54.35.2).

The round temple near the Tiber south of the Temple of Portunus is Rome's oldest almost completely marble building. (The oldest structure made entirely of marble was the Temple of Jupiter Stator in the Porticus of Metellus, but the temple has not survived.) The small temple by the Tiber is a peripteral circular building with twenty columns (of one of these only the base remains), resting on a stepped *crepidoma* with a foundation in Grotta Oscura tufa (FIG. **86**). The cella, which is also of marble with a travertine revetment, has a large door facing east. The top of the building is unfortunately completely gone from the architrave upwards, as is the upper half of some of the capitals, which are Hellenistic in style. Close study of the latter shows that the building was completely restored during the reign of Tiberius, probably after the flood of AD 15, when nine columns and eleven capitals in Luna marble were substituted. The original building,

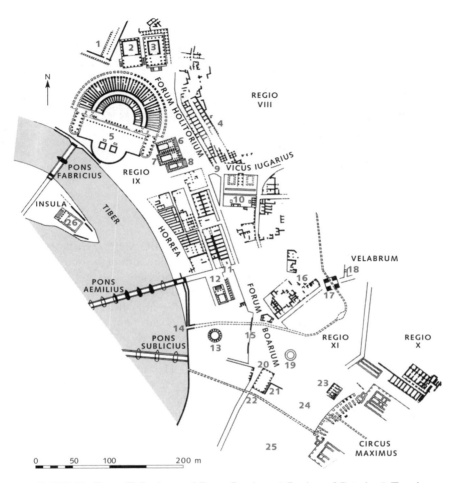

FIGURE 85. Forum Holitorium and Forum Boarium. **1** Porticus of Octavia. **2** Temple of Apollo. **3** Temple of Bellona. **4** Porticus Triumphalis? **5** Theater of Marcellus. **6** Temple of Janus. **7** Temple of Juno Sospita. **8** Temple of Spes. **9** Porta Carmentalis. **10** Temples of Fortuna and Mater Matuta. **11** Porta Flumentana. **12** Temple of Portunus. **13** Temple of Hercules Victor. **14** Cloaca Maxima. **15** Republican walls. **16** Imperial buildings. **17** Quadrifrons arch. **18** Arch of the Argentarii. **19** Aedes Aemiliana Herculis. **20** Porticus of S. Maria in Cosmedin. **21** Ara Maxima. **22** Porta Trigemina. **23** Mithraeum. **24** Aedes Pompeiana Herculis. **25** Temple of Ceres. **26** Temple of Aesculapius.

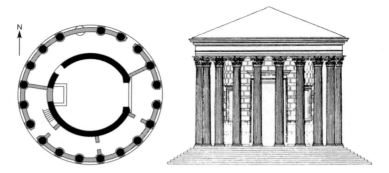

FIGURE 86. Round temple in the Forum Boarium. Plan *(left)* and reconstruction of the elevation *(right)*. (After Rakob and Heilmeyer)

which can be dated to the end of the second century BC, was in Greek Pentelic marble. The plan corresponds to the Vitruvian canon, although some licenses in the elevation reveal the involvement of local workmen. The architect, who was clearly Greek, should perhaps be identified as Hermodorus of Salamis, who worked at Rome during the last half of the second century BC.

The discovery of an inscribed block, probably the base of a cult statue, and certain topographical data (such as the proximity to Porta Trigemina; FIG. **85:22**), supply important information for identifying the temple. The partially preserved inscription names the god—Hercules Olivarius—as well as the statue's Greek sculptor, Scopas Minor, who lived around the end of the second century BC and probably also worked in the area of the Circus Flaminius. The round temple in question can now be identified as the Temple of *Hercules Victor* (called *Olivarius*) that was located outside Porta Trigemina. It was founded by a Roman merchant, Marcus Octavius Herrenus, whose wealth probably derived from the olive trade. Hercules was in fact the patron divinity of the *olearii*, the olive oil merchants, as attested by several epigraphic documents from Delos. The proximity of the river port may be significant in this regard.

THE ARA MAXIMA OF HERCULES Ancient tradition, especially as recorded in the version handed down in Vergil's *Aeneid*, recounts that the monster Cacus, who lived in a cave on the slopes of the Aventine, robbed Hercules of some of the cattle of Geryon that he had brought with him upon his arrival in the area of the Forum Boarium. After Hercules killed the bandit, the Arcadians, the ancient inhabitants of the Palatine, and their king, Evander, were believed to have honored the hero as a god by dedicating an altar to him in the Forum Boarium near the Circus Maximus and the Aventine (FIGS. **81:8; 85:21**).

The exact location of the Ara Maxima is indicated by inscriptions that were found behind the Church of S. Maria in Cosmedin. These were erected by the

praetors who recorded the annual sacrifices that they were obligated to carry out at the altar. Accordingly, the altar is probably to be identified with the large nucleus of Anio tufa in the back part of the church; the church's crypt was built into this structure. The altar was, to be sure, a monument of significant size, perhaps similar to the great Hellenic altars, and must have been rebuilt during the impressive building programs of the second century BC, as is clear from the use of Anio tufa. The original altar, however, likely dates to a period immediately before the foundation of the city. This tradition, which has for the most part been rejected, now seems plausible in light of recent discoveries in the Forum Boarium.

The Greek character of the sanctuary lasted into the Imperial period. But long before then (in 312 BC), the cult was advanced from private to public status by the censor Appius Claudius. It was probably then that a temple dedicated to Hercules Invictus was constructed (or rather reconstructed) near the Ara Maxima, between it and the Circus. The terracotta Hercules *(Hercules Fictilis)*, a work of Vulca (like the statues of the Temple of Jupiter Capitolinus [Pliny, *NH* 35.157]), may well have belonged to the older temple. After the building's restoration by Pompey, it was known as the *Aedes Pompeiana Herculis* (FIG. **85:24**); Vitruvius (3.3.5) mentions it as a typical example of an Etruscan temple.

Adjacent to the altar, on the west, there was a sort of **colonnaded gallery,** remains of which can still be seen in the Church and Sacristy of S. Maria in Cosmedin (FIG. **85:20**). The structure was composed of a rectangular podium, oriented widthwise, with three marble Corinthian columns on its smaller sides and seven on the facade, upon which a row of small arches rested; it is not clear whether the building was roofed. The back wall, in brick, was attached to the base of the structure that can be identified as the Ara Maxima. The seven columns of the facade and the three of the left side are still extant. As the style of the capitals shows, what survives is a building of the Flavian period, remodeled at the end of the fourth or at the beginning of the fifth century AD. The traditional identification of the building as the main provisions office *(Statio Annonae)* is unconvincing. More likely, the building was a shrine functionally associated with the altar.

Not far from the Ara Maxima was another temple of Hercules, known as the *Aedes Aemiliana Herculis* because it was probably dedicated by Scipio Aemilianus during his censorship in 142 BC (FIGS. **81:9**; **85:19**). The circular building was decorated with paintings by Pacuvius, the artist and poet of Brindisi who worked in Rome during the second century BC. Remains of the structure survived until the fifteenth century, when it was demolished. The temple was probably located in the area now occupied by the former Palazzo dei Musei di Roma, to the north of S. Maria in Cosmedin. The bronze statue of the young Hercules, now in the Museo dei Conservatori, comes from the neighborhood of this temple, next to which stood the small temple of Pudicitia Patricia.

THE ARCH OF THE ARGENTARII AND JANUS OF THE FORUM BOARIUM

At the outlet of an ancient street (now closed), perhaps coming from Vicus Iugarius, there is a small arch (or rather a monumental door) dedicated to Septimius Severus and his family by the *argentarii* (bankers) and by the cattle merchants of the district (FIGS. **81:7; 85:18**). The structure should probably be identified as one of the entrances to the Forum Boarium, situated at the boundary between Augustan Regions VIII, X, and XI. Two piers (that on the right is encased in the church), made of rubble cement work and clad in marble with travertine bases, support a horizontal marble architrave; statues of the imperial family probably stood above this. Altogether, the monument was 6.80 meters high and 5.86 meters wide. The inscription, containing a dedication to Septimius Severus, Caracalla, and Julia Domna, was installed in the year AD 204 by the *argentarii et negotiantes boarii huius loci*. Evidence of erasures that were replaced by other phrases shows that the monument originally contained the name of Geta, put to death by Caracalla, as in the Arch of Septimius Severus in the Forum, as well as those of the praetorian prefect Plautianus and his daughter Plautilla, the wife of Caracalla, both of whom Caracalla had killed.

A very rich decoration of natural vegetation takes up almost the whole surface of the piers and architrave that was not occupied by inscriptions and figurative relief. A smaller frieze, which runs along the lower part of the piers, represents the solemn sacrifice of bulls. A band with sacrificial instruments and emblems divides this from the upper panels, which are considerably larger. That on the left of the facade, which is quite worn, represents a standing figure, perhaps Caracalla. Roman soldiers are represented with a barbarian prisoner on the pier's outer face. The two most important reliefs are found on the inside of the arch. To the left is Caracalla in the act of offering a libation on a portable altar. An empty space can be clearly observed on the left, which was evidently chiseled out; the figures of Plautianus and Plautilla, or perhaps Geta, must have originally stood here. On the other side, Septimius Severus and Julia Domna appear, also in the act of sacrificing. Here too a figure is missing, this time on the right—Geta or Plautilla. Victories holding garlands, eagles with standards, and minor figures are represented above the panels, between the two Corinthian capitals that crown the corner pilasters. Representations of Hercules and of a Genius (of the Roman People?) flank the inscriptions on the attic.

A taste for the purely ornamental, a sort of *horror vacui*, dominates the composition, which is void of spatiality and narrative content. The figures are treated in the same manner as the ornamental decoration, which is clearly closer to the sensibilities of those who crafted the monument. We should conclude, as seems evident from the status of those who dedicated the work, that this is the production of an unofficial atelier confronted, perhaps for the first time, by a challenge of significant scope; the results are mediocre.

The large quadrifrons arch (Janus) that rises nearby should perhaps be identified as the *Arcus Constantini* situated by the Regionary Catalogues in Region

XI (FIG. **85:17**). In all likelihood an honorific arch, the monument stands in the easternmost part of the Forum Boarium, immediately above a branch of the Cloaca Maxima. The imposing structure has a rubble core clad in partly reused marble. A cross vault covers the center section. Above the high socle two rows of semicircular niches, separated by a cornice, occupy the two outer surfaces of each pier. The niches (presumably intended for statues) terminate in rounded half-domes decorated with fluted shells and are framed by small columns supported by ornamental brackets. The four keys of the arches are sculpted with figures of Rome and Juno (seated) and of Minerva and perhaps Ceres (standing). The attic, now completely gone, was constructed in brick-faced rubble clad in marble; it survived until 1830, when it was demolished in the belief that it was a medieval addition.

Fragments of a large fourth-century dedicatory inscription, which certainly belonged to the arch, are preserved in the nearby Church of S. Giorgio in Velabro. Part of the inscription is inserted in the facade's wall on the porch, and part is inside, where it was reused in the Middle Ages. These pieces are now walled over, and the inscription is no longer visible. The inscription's mention of a tyrant conquered by an emperor seems to refer to Constantius II; it is thus possible that the arch was erected by this emperor on the occasion of his visit in AD 357. Near the arch, passing through a modern gate, a well-preserved section of the Cloaca Maxima can be seen.

ITINERARY 2

The Circus Maximus and the Baths of Caracalla

THE MITHRAEUM OF THE CIRCUS MAXIMUS In 1931, remains of an Imperial brick building, clearly public in nature, came to light during construction on Via dell'Ara Maxima. The original facade looked onto the starting gates *(carceres)* of the Circus Maximus (FIGS. **81:10; 85:23**). The ground floor, rather well preserved, consists of a series of five parallel rectangular rooms (FIG. **87:D–M**) that communicate with one another. Toward the east (i.e., toward the Circus Maximus) two large stairways (**P** and **T**), which extended almost the whole length of the building, led to the first floor, which does not survive. Below these are several smaller rooms. The stairways were added during a second phase of construction, not long after the building was erected in the second century AD. Given the character of the building—apparently comprising one or more large halls that were approached by way of the monumental stairways that began only a few meters from the starting gates of the Circus—it is likely that this was the *Secretarium Circi Maximi*, the headquarters of a tribunal of the city prefect *(praefectus urbi)* mentioned by Cassiodorus.

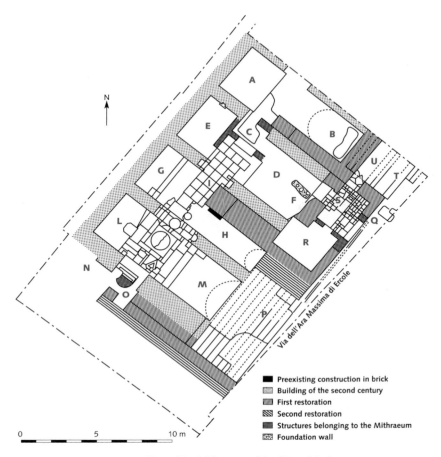

FIGURE 87. Plan of the Mithraeum of the Circus Maximus.

During the third century, the group of rooms designated **A** through **O** was remodeled to accommodate a Mithraeum. The main access to the shrine must have come from the east from room **S** through hallway **D**; rooms **A** and **B,** which provide the modern entry to the site, functioned as a secondary entrance. From room **C,** a door led to the sanctuary itself—a *spelaeum*, or grotto. On the right, an isolated room, with a niche revetted in marble on the right wall, might have served as a kind of sacristy *(apparatorium)*. The first section of the floor is paved with large, square bipedal tiles from the reign of Diocletian—the beginning of the fourth century AD. Two niches were inserted, with two marble bases, in the opening of the walls separating the room that functions as an atrium from the one following; these evidently contained the statuettes of the *dadophori* Cautes

and Cautopates. The brackets that protrude at the sides held the small columns of the two aediculas that framed the niches.

The next four rooms **(G–M)** are the most important part of the Mithraeum. The first two rooms have banks of couches only on the right side, as there was insufficient space for them on the left. The opening between the two groups of rooms was widened and made into a large arch to create a single unified space. Here too, in the thickness of the wall on each side of the opening between the two rooms, are two niches, in one of which (on the right side) a terracotta receptacle rests; two aediculas frame the openings. At the center under the arch is a round hole, in which a large amphora is sunk into the ground. The entire pavement, beginning at a point near the middle of the complex **(G–M)**, is marble, much of it reused. A number of bases rest against the back wall, on which several niches were also carved out and framed by aediculas. The wall features an arch in which the intrados is dressed in pumice stone. Inside the arch is a small brick aedicula with a semicircular cavity, at the top of which is a half-dome. This must have held a small statue of Mithras, but the original location of the large relief of Mithras slaying the bull, flanked by Cautes, Cautopates, the Sun, the Moon, and a raven, is uncertain; it may have been located in front of the center arch. Below on the left, Mithras is shown carrying the bull over his shoulders, while at the top an inscription names the relief's dedicator: *Deo Soli Invicto Mithrae Ti(berius) Cl(audius) Hermes ob votum dei typum d(ono) d(at)* (To the Sun God, Mithras the Invincible, Tiberius Claudius Hermes offers the image of the god in fulfillment of a vow). In a recess of the back wall, on the right, is another small relief representing the bull sacrifice. Other inscriptions carry dedications by other worshipers, all of them freedmen.

THE CIRCUS MAXIMUS The first circus intended for chariot races built in the Vallis Murcia between the Palatine and the Aventine should be attributed to the first Etruscan king of Rome, Tarquinius Priscus, even if tradition holds that chariot races in honor of the god Consus, whose altar was in the area, took place there earlier (FIG. **81**). Romulus's inauguration of the races is said to have taken place on the occasion of the festival that ended with the rape of the Sabine women. The wooden stands for spectators, called *fori publici*, would have gradually been replaced with masonry tiers. In 329 BC, starting gates for the chariots *(carceres)* were constructed—at that time of painted wood—on the short side to the north. It was perhaps in the same years that the spina was installed and that the water course *(Euripus)*, which crosses the valley in the direction of the Tiber, was channeled. The center of the southern curve was pierced by a gate, which L. Stertinius replaced with a triumphal arch in 196 BC. The first *carceres* in stone were built in 174 BC, when the seven eggs that were used to count completed laps of the chariots were located on the spina, to which Agrippa, in 33 BC, added seven bronze dolphins that served the same purpose. Caesar oversaw significant expansion of the facility in 46 BC. Under Augustus,

the *pulvinar* was installed on the Palatine side. This was not so much an emperor's box as a sacred area, reserved for the gods that presided over the games. But the main innovation occurred in 10 BC with the installation on the spina of the 23.70-meter-high obelisk of Ramesses II from Heliopolis; the monument was moved to Piazza del Popolo in 1587. Much later, in AD 357, a second obelisk, that of Tuthmosis III, was brought from Thebes in Upper Egypt and added to the spina by Constantius II (at 32.50 meters, it is the tallest of Rome's obelisks). This was moved, again in 1587, to Piazza di S. Giovanni in Laterano by Sixtus V.

According to Dionysius of Halicarnassus, in the Augustan period the circus was three and one-half stadia long (621 meters) and four plethra wide (118 meters). It would have accommodated 150,000 spectators. After a fire in AD 36, repairs and alterations were undertaken by Caligula and by Claudius; the latter built the marble *carceres* and the *metae*, the cone-shaped markers at the ends of the spina, in gilded bronze. Further, and this time total, destruction occurred during the fire of Nero in AD 64, which began precisely at the curved side of the Circus Maximus. Rebuilding of the Circus under Nero must have enlarged its capacity, because Pliny calculates the number of spectators at 250,000. After another fire during the reign of Domitian, the Circus was rebuilt again by Trajan. The surviving section of the curve near the Palatine and the Caelian, which is also shown on the Severan Marble Plan, dates to this restoration. An arch dedicated to Titus at the center of the curved side replaced that of Stertinius, which had probably been gone for some time. The inscription on the arch, transmitted to us by the Einsiedeln Itinerary, allows us to date the monument to AD 81. It was erected by the Senate to commemorate the emperor's victories over the Jews.

Various other restorations are indicated up to the fourth century AD, when the Regionary Catalogues indicate a capacity, perhaps exaggerated, of 385,000 spectators. The dimensions of the Circus must then have surpassed 600 meters in length by a maximum width of about 200 meters. The length of the spina must have been about 340 meters. The cavea had three stories with arches that supported the tiers, the last of which was probably made of wood. In addition to the two obelisks, the seven eggs, and the seven dolphins, there were various aediculas and small sanctuaries set out at intervals along the spina. Numerous monuments representing the spina, especially the mosaics from Barcelona and Piazza Armerina, give us an idea of its appearance.

The Circus was used mostly for chariot races, especially four-horse chariots, the most important of which took place during the *Ludi Romani* or *Magni* from the 4th to the 18th of September. The races became increasingly more important, until they reached their acme in the fourth century AD, when the four *factiones* (teams) of charioteers (*Albata, Russata, Prasina,* and *Veneta,* characterized by their respective colors—white, red, green, and blue) came to assume the character of actual political parties, a phenomenon that would have more importance still in Constantinople.

Several plebeian temples of great antiquity, associated with commerce, stood on the Aventine side of the Circus, outside the *pomerium*. The Temple of Ceres, Liber, and Libera was built probably by Spurius Cassius in 493 BC, who employed Greek artists whose names we know—Damophilos and Gorgasos. The sanctuary, which stood together with the Temple of Flora along the *Clivus Publicius* (the present-day Clivo dei Publici) above the *carceres* of the Circus Maximus, quickly became the political center, as well as home of the archives, of the plebeians. The Temple of Mercury, patron of merchants, must have been at the opposite end of the Circus. This temple, founded in 495, was also very old. Here we should also situate the Temple of Venus Obsequens, built in 295 BC by Q. Fabius Gurges, and that of Venus Verticordia, which replaced an archaic shrine of Fortuna Virilis attributed to Servius Tullius. No trace of these structures, nor of the others that once stood in the same area, remains.

The most important visible remains of the Circus are those of the eastern half of the curved side, excavated in 1934–35, when some vestiges of the Arch of Titus that once stood at the center of the curved side were also seen. Excavations were interrupted because of the large amounts of water that seeped into the area, and much of what was found was then reburied. Exploration undertaken in 1976 has revealed rooms of the *ima cavea* next to the track. The visible remains belong to the *media cavea*, as it appeared during the Hadrianic period; later on, other sections farther east were added, which are no longer visible. These consist of two rows of radial rooms, the lower row wider and the higher longer and narrower. The wall that divided them, constructed in *opus reticulatum*, probably dates to Caesar's restoration, while most of the remaining construction belongs to the large restoration carried out at the time of Trajan, as brick stamps indicate. The outer rooms are arranged in groups of three: the first has a blind wall, the second opens onto another room farther in, and the third has stairs that lead to a landing above. Outside, a street paved in basalt formed the edge of the Circus at the time of Trajan.

A better-preserved area on the margins of the Circus occupies the lowest slope of the Palatine. Two inscriptions indicate the probable name of this area: the Cermalus Minusculus—the Smaller (or perhaps "less important") Germalus, as distinct from the better-known Germalus between the Palatine and the Forum Boarium. One of these inscriptions (*CIL* VI 33920) mentions *Vestiarii* (clothing merchants) *de Cermalo Minusculo* in connection with an obelisk, undoubtedly the same obelisk that Augustus placed in the Circus Maximus. Among the buildings that have been preserved on this side (in addition to the headquarters of the *Nuntii Circi*, identified as the so-called *Domus Praeconum*), mention should be made of a number of **small shops,** such as the structures preserved beneath the Church of S. Anastasia. Outside the church, in the direction of the Circus, are several **narrow rooms,** some of them still used as workshops, which should be associated with the Circus itself. On the other side, under the right aisle of the church, was an ancient street flanked by one or perhaps two large buildings,

of which only the first floor and the mezzanine remain. On the other side of these, toward the Palatine, there is evidence of another street, parallel to the first. Ten successive phases have been identified in this complex, some of which are probably simultaneous. The first two, which are Republican in date, are limited to the eastern corner, near the apse of the church, and have an orientation completely different from the later ones, which follow the line of the Circus Maximus. Directly or indirectly, the successive enlargements of the Circus probably affected the profile of the entire area. From the third phase, there is a series of large tabernae (shops), 5 meters wide and 12 meters deep, with piers made of peperino on each side of the openings that face the street. Halfway up the side of the piers, blocks of travertine with slanted sides were inserted to accommodate flat arches, which were possibly also of travertine. Above this, the facades were completed by brick arches.

The use of these materials dates the third phase no later than the first century of the Empire. Tacitus's description of the *nova urbs* constructed by Nero after the terrible fire in the Circus Maximus comes to mind, both because of the widespread use of peperino piers in the construction of houses at this time and because the fire began precisely on the side of the Circus that faced the Palatine. It thus seems possible to date the construction of the buildings under S. Anastasia, in the form that we now see them, to the Neronian period. A subsequent total reconstruction of the tabernae can be dated, on the basis of brick stamps, to the reign of Domitian or the beginning of Trajan's reign. We know in fact that under Domitian the two larger sides of the Circus Maximus were damaged by a fire and then rebuilt on a larger scale. At a later stage, the peperino facades of the shops were covered over by enormous brick piers.

Possibly at the same time, the eastern side of the construction was cut through by four huge walls, with a thickness of 2.35 meters, which put the earlier rooms out of use. It seems likely that these walls belonged to foundations employed in the enlargement of the Circus. The dating of these to the first half of the third century AD calls to mind the work recorded as being undertaken by Caracalla. Other restorations appear to date to the fourth century. Finally, after the middle of the fourth century, the church was built at a higher level, using the ancient masonry as foundations, with the addition of an apse on the eastern side.

THE LITTLE AVENTINE The existence of a group of rich Imperial houses on the Little Aventine is indicated by late sources, such as the Regionary Catalogues and the *Historia Augusta*. Particular mention is made of the *Privata Hadriani*, probably the house of Hadrian before he assumed the throne, the *Horti* of Celonia Fabia, the *Domus Cornificia*, and the *Domus Cilonis*.

Several important second-century AD houses were demolished to make room for the Baths of Caracalla. One of these was discovered in 1858 and partially excavated, revealing numerous rooms, richly decorated with mosaics, paintings, and sculptures. During resumed excavations in 1970, the remains of

a magnificent painted ceiling, which had collapsed, were discovered; it can be dated to the late Hadrianic period (ca. AD 130–38).

The remains of a **large Imperial house,** preserved inside the convent of S. Balbina (today the Ospizio di S. Margherita), date to the same period, to judge from brick stamps. They consist of numerous sections of wall in *opus mixtum* of reticulate and brick. The discovery of a water pipe with an inscription during the excavations of 1859 identifies the house as that of a very powerful personality from the Severan period: L. Fabius Cilo, consul in 193 and 204, twice prefect of Rome, a friend of Septimius Severus (who gave him the house), Caracalla, and Macrinus. Because the house dates to the Hadrianic period and belonged to the Imperial estate, scholars have supposed that it was Hadrian's private residence, the Privata Hadriani. The importance of the house lies also in the fact that it is identified by the name of its proprietor on the Severan Marble Plan and is still mentioned as late as the fourth century in the Regionary Catalogues. Some remains of the Servian Walls are preserved within the same convent.

The Church of S. Balbina occupies a spacious **basilical hall** in *opus vittatum* that can be dated to the second half of the fourth century. It is 24.18 meters long and 14.67 meters wide, with two series of six niches, alternately semicircular and rectangular, on the two sides. The plan is similar to that of the Basilica of Junius Bassus. It is not clear whether the hall was built from the outset to house the church or whether the church reused a preexisting building.

THE BATHS OF CARACALLA The *Thermae Antoninianae*—the official name of the Baths of Caracalla—are the grandest and best-preserved surviving example of an Imperial bath complex (FIG. **81**). They were erected by Caracalla beginning in AD 212, as brick stamps show, and not in 206 by Septimius Severus, as is sometimes still asserted. In this same year, a special branch of the *Aqua Marcia* was built, the *Aqua Antoniniana Iovia,* which passed over the Via Appia on the so-called Arch of Drusus, just before Porta San Sebastiano. Before the construction of the gate, this arch functioned as a monumental entry to the city on this side, as was also the case with Porta Maggiore. Work must have continued until about 216, when the dedication took place. The peribolus wall *(porticus),* however, was the work of the last two emperors of the Severan dynasty, Elagabalus and Alexander Severus. Restorations took place under Aurelian, Diocletian, and Theodoric. During excavations at various periods, especially in the sixteenth century, numerous works of art were discovered: the three gigantic Farnese sculptures (the Bull, Flora, and Hercules), now in the Museo Nazionale in Naples; a mosaic depicting athletes, found in 1824, that is now in the Vatican Museums; and the two granite basins now in Piazza Farnese. Important excavations were also carried out in the last century: in 1901 and 1912, the underground facilities and the large Mithraeum were partially opened up.

In its fullest extension, including the peribolus, the building measured 337 by 328 meters, although when the projection of the exedras is included, the longer

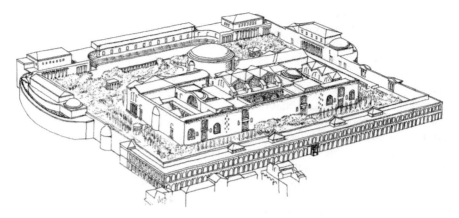

FIGURE 88. Reconstruction of the Baths of Caracalla.

side exceeds 400 meters. The central core of the complex measures 220 by 114 meters, but more than 140 meters if we include the circular hall of the *caldarium*. These dimensions are surpassed only by the Baths of Diocletian.

The outer peribolus, facing northeast, consisted of a porticus, of which almost nothing now remains (FIG. **88**). This was preceded by a series of adjoining rooms on two levels, probably used as shops. The structure served to support one side of the enormous artificial terrace on which the bath complex rose, dominating the Via Nova that ran in front.

Two large exedras extend beyond the sides of the peribolus wall, each of which enclosed a central apsidal hall preceded by a colonnade and flanked by two smaller rooms. One of these is an octagonal hall, covered by a dome on spherical pendentives, which is the first known example of such a structure. On the back wall of the peribolus, a flattened exedra in the form of a stadium, furnished with tiers but without one of its long sides, hid enormous cisterns consisting of two rows of rooms (sixty-four in all, laid out on two floors) with a capacity of 80,000 cubic meters. The two apsidal rooms on either side of this exedra were probably libraries; only that on the right remains. An elevated passageway, which follows the internal side of the peribolus wall for its entire length, was probably covered by a porticus; that would explain the name *porticus* that ancient sources give to this enclosure. There were gardens in the space between this and the bath complex itself.

The central core of the building, whose plan is more or less the same as that of older baths (especially those of Trajan), was accessible through four doors in the northeastern facade of the complex; the orientation is thus the same as in all the other large bathing establishments in Rome. Two of these doors opened to

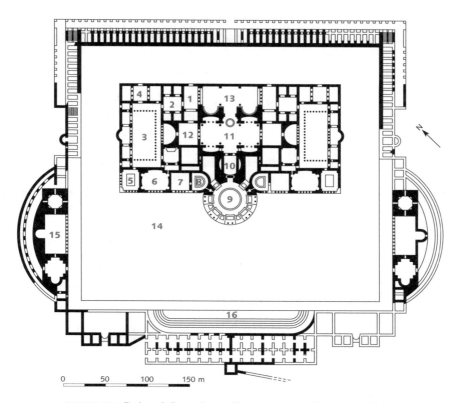

FIGURE 89. Baths of Caracalla. **1** Entrance. **2** Apodyterium. **3** Palae-
stra. **4** Side entrance. **5–8** Heated rooms. **9** Caldarium. **10** Tepidarium.
11 Basilica. **12** Rooms alongside the basilica. **13** Natatio. **14** Garden.
15 Exedra. **16** Stadium.

the vestibules next to the *natatio* (swimming pool), and two to the rooms that gave
direct access to the *palaestrae* (exercise areas).

The entrance today corresponds to the central doorway on the right (FIG.
89:1). From here it is best to follow more or less the same sequence of rooms that
was followed in antiquity. The vestibule **(1)**, which on the left opens onto the
natatio **(13)** through a porticus of four columns, leads into a square room on the
right **(2)**; this is flanked by a pair of smaller rooms with barrel-vaulted ceilings; in
the second room on the right, a stairway led to the upper floors. This section can
perhaps be identified as the *apodyterium* (dressing room). There followed one of
the two large palaestras **(3)**, which were arranged in symmetrical positions along
the short sides.

The central part of the palaestra, an open courtyard (50 meters long and 20 meters wide), was enclosed on three of its sides by a porticus with columns in giallo antico and a vaulted ceiling. A large hemicycle opened onto the porticus through six columns, while the opposite side, which lacked a colonnade, consisted of five rooms, the central one apsidal in form. It was here that the ancients usually began their bathing routine, with various exercises that could be taken either under cover or in the open air. The floor still has its wonderful polychrome mosaics; the mosaic of the athletes, discovered in 1824 and now in the Vatican Museums, was originally in the hemicycle. The next rooms, differing in size and shape and abundantly furnished with basins, lie southwest of the palaestra **(6, 7, 8)**. The rectangular room, curved on two of its sides **(6)** and open toward the southwest, might have been a *laconicum* (steam bath). Of particular note are the narrow angular passageways, which were designed to prevent loss of heat from the room.

Next comes the *caldarium* **(9)**, only a part of which remains standing. It was a large circular hall, 34 meters in diameter, surmounted by a dome that rested on eight massive piers, of which two survive, as do traces of the others. Large windows on two floors let in the sun from late morning until sunset. There was almost certainly a large circular basin at the center of this room, while six other, smaller ones were placed between the piers.

The same route described thus far could be taken in the other half of the building, which was identical in its layout. But in the middle, from the *caldarium* on, the facilities were not repeated but instead were unified. After the sweat bath in the *laconicum* and the hot water rinse in the *caldarium*, bathers went into a smaller room, the *tepidarium* **(10)**, which also had a basin on each side. This room, where the temperature was reduced to a more moderate level, connected with the central hall, the basilica **(11)**, which is, as usual, the largest room; it measures 58 meters × 24 meters and is roofed over by three large cross vaults, supported by eight piers, each originally fronted by a granite column. One of these remained *in situ* until 1563, when it was taken to Florence and erected in Piazza di S. Trinità. The two large granite basins now in Piazza Farnese were probably the centerpieces of the two rectangular rooms off the short sides of the basilica. The *natatio* **(13)** was certainly unroofed. Of particular note is the architectural arrangement of the back side of the facade, with groups of superimposed niches on two stories, three niches to each intercolumniation, that were certainly designed to hold statues. At the center of the opposite side is a rectangular niche that is open in the direction of the basilica and flanked by two large hemicycles, where four large capitals with representations of divinities now stand.

The **underground rooms,** which were excavated in 1901 and 1912, are also quite interesting. It was here that basic services necessary for running the baths were deployed, using what is in effect an underground network of streets. The area was divided into two levels, the higher of which was intended for

services, the lower for drainage that flowed into a large sewage channel along the southwestern side. A **Mithraeum,** the largest known in Rome, was installed in one of these subterranean rooms, near the large exedra of the northwestern side (a guard with the key escorts interested visitors to the site, which is entered from the outside). The room at the center, which is roofed by a series of cross vaults on piers, preserves its white mosaic pavement with black bands as well as the two large side-benches. As usual, the central hall is preceded by a vestibule that is followed by two other rooms; some scholars have identified one of these rooms as the stall for the sacrificial bull.

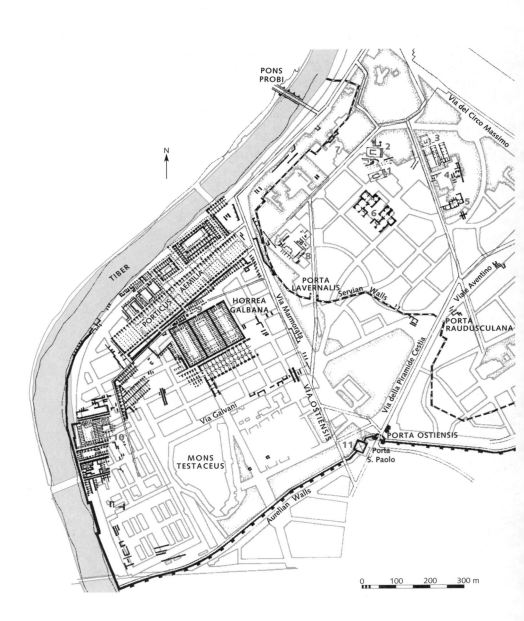

FIGURE 90. Map of the Aventine. **1** Temple of Diana. **2** Temple of Minerva. **3** Unknown temple. **4** Thermae Suranae. **5** Buildings under S. Prisca. **6** Thermae Decianae. **7** S. Sabina. **8** Buildings under Sant'Anselmo. **9** Tomb of Galba and Horrea Galbana. **10** Horrea Lolliana. **11** Pyramid of Gaius Cestius.

AVENTINE, TRASTEVERE, AND THE VATICAN

PORTA
NAEVIA

HISTORICAL NOTES

The Aventine is Rome's southernmost hill and the one closest to the Tiber. The hill's steep slopes, which isolated it to a large extent from its surroundings, and its proximity to the river had a profound influence on its history, which was closely bound with the struggle of the plebs. Its original name may have been *Mons Murcus,* a name reflected in the nearby Vallis Murcia and in an ancient shrine belonging to the goddess Murcia, who was probably later identified with Fortuna Virilis and Venus Verticordia.

We do not know when the Aventine was first inhabited. According to one plausible tradition, Ancus Marcius introduced people from *Ficana, Tellenae, Medullia,* and *Politorium*—towns that he conquered and destroyed. Later, because of its particular position, the Aventine became a quarter that was primarily mercantile, frequented by foreigners, and thus outside of the *pomerium,* despite the fact that the hill was already included within the Servian Wall in the sixth century BC, as the remains near S. Sabina prove. Only during the reign of Claudius was the hill brought within the *pomerium.* Servius built a temple of Diana here (FIG. **90:1**), apparently taking as his model the sanctuary of Artemis in Ephesus. The cult may have been introduced to replace that of Diana Aricina as the federal sanctuary of the Latins, unless, as is more likely, the latter was inspired by the

Roman sanctuary. The temple stood alongside that of Minerva (FIG. **90:2**), occupying the center of the hill and corresponding, more or less, to the present-day Via S. Domenico. A fragment of the Severan Marble Plan represents both buildings. The Temple of Diana shown on the plan has the appearance it assumed following its reconstruction by L. Cornificius after 36 BC: a large octostyle peripteral temple with two rows of columns—Greek in style and quite similar to the Artemision of Ephesus. It was located at the center of a large porticus that also had two rows of columns. Farther to the north was the Temple of Minerva, founded in the third century BC, which functioned as the center for the trade guilds—in particular for the guild of writers and actors from 240 BC on. The history of the Aventine thereafter was informed by these precedents: the inhabitants of the hill, from different points of origin—often foreigners—ultimately formed the plebeian class, giving rise to the long struggle between patricians and plebs that began with the Republic. Following the secessions of the fifth century, the situation was settled only at the beginning of the third century, when the two social groups were given political parity.

Other temples were subsequently built near these older ones; for example, the sanctuary of Ceres, Liber, and Libera at the foot of the hill, headquarters of the plebeian aediles and center of the plebs' political and economic organization. Moreover, various foreign cults were recorded as *evocati* (summoned) from enemy cities with a typically Roman rite: the Temple of Juno Regina, founded by Camillus after the destruction of Veii in 396 BC; the temples of Consus and Vertumnus, founded respectively by L. Papirius Cursor in 272 BC and by M. Fulvius Flaccus in 264 BC after the conquest of the Volsinii. The sanctuaries of Luna, Iuppiter Liber, and Libertas should also be mentioned. In 456 BC, with the promulgation of the *Lex Icilia*, the entire hill was declared public property and distributed to the plebs so that they might build homes there. From that time forward, the quarter continued to attract inhabitants and ultimately became so densely populated that during the Augustan period practically no usable space was available for public buildings. The plebeian associations of the hill were still in force during the second century BC when, in 122 BC, Gaius Gracchus took refuge there with his friends and partisans for their final stand. The historical account of this event allows us to reconstruct the position of the most important cult buildings. At first, Gaius took refuge in the Temple of Diana, from where he moved on to the nearby Temple of Minerva. Forced from here too, he pushed forward to the westernmost point of the hill, at the Temple of Luna, where he injured his ankle jumping down from the podium. After descending from the Aventine, he passed through the Porta Trigemina and across the *Pons Sublicius,* while some of his friends sacrificed their lives trying to impede his pursuers. Finally, after he reached the Janiculum, the tribune gave up all hope of survival and committed suicide in the grove of Furrina.

During the Empire, the Aventine lost its associations as a working-class and commercial quarter and was transformed into an aristocratic neighborhood.

The poorer inhabitants moved south to the plain near the Emporium and to the right bank in Trastevere. In fact, whereas during the Republic, with the exception of the *domus* of the Sulpicii Galbae, we know only of the houses of some poets (Naevius, Ennius), the situation changes radically under the Empire, when mention is made of the houses of the emperor Vitellius, of L. Licinius Sura, the friend of Trajan, and of Trajan himself before he became emperor. The region's status as an affluent quarter was probably a factor in its near-total destruction at the hands of Alaric, when the Goths vented their fury and sacked Rome and the houses of the wealthy inhabitants in particular. In addition to the archaeological evidence, the letters of St. Jerome record this destruction. Consistent with its social character, the Aventine was the site of two bathing establishments that must have been particularly elegant: the *Thermae Suranae* (FIG. **90:4**), built by Licinius Sura near his house or perhaps by Trajan in the house that was bequeathed to him by his friend, and the *Thermae Decianae* (FIG. **90:6**). Popular eastern cults are less often represented here than they are in Trastevere. We know, however, of a sanctuary of Iuppiter Dolichenus, commonly referred to as the *Dolocenum*, and a Mithraeum under the Church of S. Prisca (FIG. **90:5**). During the first centuries of the Republic, commercial activity took place in the Forum Boarium near the northern slope of the hill; from the beginning of the second century BC, it shifted to the plain to the south, where the new river port *(Emporium)*, the *Porticus Aemilia*, the large warehouses and stores behind the latter *(Horrea Galbana, Lolliana, Aniciana, Seiana, Fabaria)*, and the general bread market *(Forum Pistorium)* were built. The name *Marmorata*, which the whole area continues to be called, alludes to one of the most important items that was unloaded here: marble. Enormous quantities of quarried blocks have been discovered in the area at various times.

Behind these buildings rises Monte Testaccio *(Mons Testaceus)*—the hill of potsherds—30 meters high, created entirely from the accumulation of amphoras dumped here from the nearby port. Though largely unexplored, it constitutes an archive of Rome's economic history.

The last of the fourteen Augustan Regions included the neighborhoods on the right bank of the Tiber and Tiber Island: Trastevere to the south, the Janiculum in the middle, and the Vatican to the north. Until the reign of Augustus, this area remained formally outside of the city; it lay outside the *pomerium* until Vespasian came to power.

The Janiculum forms a natural bastion for the city in the direction of Etruria; rising opposite the Pons Sublicius, which tradition assigns to King Ancus Marcius, it was vital to the city's defenses. Its important role can be observed in the custom, certainly of great antiquity, of raising a red flag on the hill as a signal that all was secure when elections were being held in the Campus Martius; the citizens were in a dangerous position at that time, being outside of the walls. The district contained several fairly old sanctuaries, such as that of Fors Fortuna, at the first milestone of Via Portuensis, the ancient Via

Campana. Servius Tullius was believed to have founded the shrine, near which the consul Spurius Carvilius erected a second sanctuary in 293 BC, dedicated to the same divinity. Another temple, also dedicated to Fors Fortuna, stood at the sixth milestone of the same road, near that of Dea Dia, in the care of the priesthood of the Arval Brothers. Remains of this sanctuary were seen in the nineteenth century; excavation of the site is now in progress.

Initially the occupation of the right bank must have been limited to the cultivation of arable land by private citizens, as can be deduced from the mention of the *Prata Mucia* awarded to Mucius Scaevola and of the *Prata Quinctia*, between the Janiculum and the Tiber, that belonged to the celebrated Cincinnatus. Famous Romans were buried on the Janiculum: the poets Ennius and Caecilius Statius, as well as the mythical king Numa.

From the end of the Republic, Trastevere came to be filled with utilitarian buildings and private residences; the latter were associated particularly with the workers and small businessmen drawn by the economic activity of the port and the related services in the vicinity. Inscriptions dating to the last decades of the second century BC, discovered in the middle of the nineteenth century during the construction of a tobacco factory in Piazza Mastai, attest to the presence of a *Pagus Ianiculensis* in the area.

We can deduce from inscriptions and other literary sources that by the Imperial period Trastevere had already become a vast neighborhood, consisting of seventy-eight *vici*—more than twice the number of Region XI, the second in importance. This was the home of potters, craftsmen specializing in leather, ivory, and ebony, millers who worked at watermills on the slope of the Janiculum (FIG. 91:6), porters who toiled in the innumerable warehouses and stores, and furnace operators at the brick factories of the *Montes Vaticani*.

The working-class character of the neighborhood is particularly evident in the cults found there; excluding the oldest cults—Dea Dia, Fors Fortuna, Furrina, Fons, Divae Corniscae, Albionae—the number of eastern divinities is particularly striking: Dea Syria, Hadad, Sol in Trastevere, Isis and Cybele in the Vatican. The latter's temple, the *Phrygianum*, was near the facade of St. Peter's, while a sanctuary of the Syrian divinities was discovered in 1906 on the slope of the Janiculum, although the phase of this sanctuary as we know it more closely resembles a syncretic cult (FIG. 91:7). Important colonies of Syrians and Jews formed here from as early as the end of the Republic. The oldest Jewish cemetery in Rome was discovered in the vicinity of Porta Portese. This district, which preceded the ghetto on the left bank, must also have contained the oldest synagogue in the city.

As is always the case in regions on the periphery, the unhealthy lowlands were occupied by the hovels of the poor, while the slopes and peaks of the hills and the banks of the Tiber were dotted with suburban villas and gardens. Cicero mentions a considerable number of affluent residences in several letters of 45 BC. One of the most important villas belonged to the infamous Clodia—Catullus's Lesbia—sister of the tribune who was Cicero's archenemy. Some have identified

the Villa della Farnesina, an imposing Augustan building that lay along the bank of the river, as Clodia's estate (FIG. **91:10**); its splendid pictorial decoration was removed and is now in Palazzo Massimo. (The building was unfortunately destroyed immediately after its discovery in 1880.) It is more likely, however, that the villa belonged to Agrippa, who had substantial landholdings in the nearby Campus Martius and the Vatican region. His daughter Agrippina, the mother of Caligula, probably inherited the Vatican *Horti* from him. Near the villa were warehouses for wine, identified by an inscription as the *Cellae Vinariae Nova et Arruntiana* (FIG. **91:9**), and the important "Tomb of the Platorini" (FIG. **91:8**), which in fact belonged to an individual named Artorius Priscus and dates to the first half of the first century AD; it was dismantled and reconstructed in a hall of the Museo delle Terme. The most important estate of Trastevere, however, was Caesar's, which must have extended into an area that was later occupied by the *Naumachia Augusti*, located between the Tiber, the first milestone of Via Campana-Portuensis, and the slope of Monteverde. Caesar bequeathed the gardens to the people of Rome.

There were two large parks in the Vatican: the *Horti* of Agrippina, roughly between the Tiber and St. Peter's, where Caligula later built his Circus, and the *Horti* of Domitia, in the area around Hadrian's Mausoleum and Palazzo di Giustizia (FIG. **92**).

Traffic movement on the right bank of the Tiber was dependent on two fairly old streets, originally outside of the city, that ran toward the oldest bridge, the Pons Sublicius. The bridgehead was located just downstream of the later *Pons Aemilius* (Ponte Rotto). From this point, Via Campana-Portuensis veers to the south and Via Aurelia to the west. The former ran toward the salt pans at the mouth of the Tiber and later, after the construction of artificial ports by Claudius and Trajan, was the first segment of *Via Portuensis*, whose course was more direct than Via Campana, which followed the bends in the river. Ancient sanctuaries, such as those of Fors Fortuna and Dea Dia, flanked the road. A fragment of the Severan Marble Plan represents a section of the street, on either side of which stand large warehouses, and a round building on a square base, possibly the Temple of Fors Fortuna, at the first milestone. A large rectangular open area is probably the Naumachia Augusti. A building with two courtyards, located near Piazza S. Cosimato, is certainly a barracks, probably the *Castra Ravennatium*, the quarters of the sailors stationed with the fleet in Trastevere. The sailors probably served as harbor police, as well as overseeing preparations for mock sea battles (the *naumachiae*).

The course of Via Aurelia is much better known. It was probably built in 240 BC, though it was certainly preceded by an older road that led from the cities of southern Etruria to the ford of the Tiber. The road corresponds exactly to the modern course of Via della Lungaretta and can be followed up to Piazza di S. Maria in Trastevere. From here it ascended the Janiculum and left the city from Porta Aurelia. In the stretch lying roughly between Piazza del Drago and Piazza Tavani Arquati, the road passed over a low and swampy area on

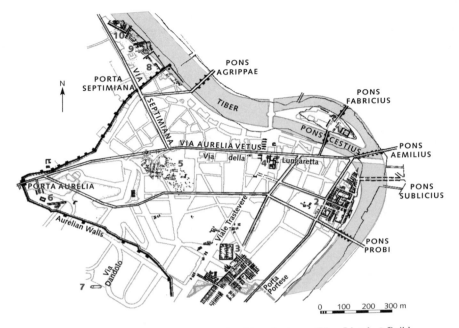

FIGURE 91. Map of Trastevere. **1** Temple of Aesculapius on Tiber Island. **2** Buildings under S. Cecilia. **3** Buildings associated with the Annona documented by the Severan Marble Plan. **4** Excubitorium of the *Vigiles*. **5** Buildings documented by the Severan Marble Plan. **6** Watermills. **7** Syrian sanctuary. **8** "Tomb of the Platorini." **9** *Cellae Vinariae Nova et Arruntiana.* **10** Villa della Farnesina.

a viaduct, supported by arches made of tufa in *opus quadratum* that rose to a height of more than 5 meters. This impressive work, elements of which have been seen at various points, probably dates back to the middle of the second century BC, when the Pons Aemilius was completed. Later, at the beginning of the Empire, the surrounding level was raised; large utilitarian structures of brick and travertine piers were built up against the viaduct.

Another street, parallel to Via Aurelia, splits off from this just before Porta Aurelia and, following the course of Via Luciano Manara for a distance, reaches the Tiber, passing south of S. Cecilia (**FIG. 91:2**). A bridge was built in conjunction with this road, traces of which were seen a little upstream of the Ospizio di S. Michele and which is usually identified as the *Pons Probi*. Another ancient road, west of and parallel to Via Portuensis, corresponds to the course of Via della Luce.

Yet another ancient road afforded passage between Trastevere and the Vatican. This broke off from Via Aurelia on the right at Sant'Egidio and from here went north, following the course of the present-day Via della Scala as far as

Porta Septimiana; from here it passed between the Janiculum and Tiber, probably following the same course as Via della Lungara. It crossed the area where the archaic Prata Quinctia were located, as well as a swampy region called *Codeta*. A branch broke off from this street toward the Campus Martius, in conjunction with the *Pons Agrippae*, the modern Ponte Sisto.

Traffic in the Vatican moved essentially along two major roads (FIG. **92**): Via Triumphalis, which ran from the *Pons Neronianus* directly toward Monte Mario, and Via Cornelia, which branched off from it to the left. The latter followed the course of present-day Via della Conciliazione and ran toward the Circus of Caligula, which it followed for its entire length.

It is uncertain whether the walls included any part of Trastevere during the Republic; it is likely, however, that an outpost was established on the Janiculum at the beginning of the second century BC. Vespasian's enlargement of the *pomerium* must have extended to a small area of Trastevere, as the inscribed cippus found at S. Cecilia shows. The Aurelian Wall, on the other hand, enclosed a large portion of the region. There were three gates here: *Porta Portuensis* on the south, *Porta Aurelia* on the west, and *Porta Septimiana*—it is uncertain whether this was its ancient name—on the north.

ITINERARY 1

The Aventine and Emporium

THE AREA AROUND S. SABINA The Church of S. Sabina occupies the north-western side of the Aventine in an area crossed by the *Vicus Armilustri*, corresponding to the present-day Via di S. Sabina (FIG. **90:7**). Soundings taken beneath the church and its environs at various times, in particular in the years 1855–57 and 1936–39, have uncovered a series of remains dating between the archaic period and the end of the Empire.

In the nineteenth century, the area north of the church, at the edge of the modern garden, was explored. Important remains of the **Servian Wall** were discovered here, clearly revealing two successive phases: archaic in cappellaccio and early fourth century BC in Grotta Oscura tufa. At the time of construction of the wall in Grotta Oscura tufa, the cappellaccio blocks of the earlier wall were recut to create a level course that served as the new structure's foundation. From this fact, it is clear that the cappellaccio wall represents an older phase. Various buildings were built very close to the walls. The oldest of these, with construction in *opus incertum* and mosaic floors into which colored stones were inserted, are second-century BC private residences. Later, from the end of the Republic, several buildings in *opus reticulatum* were built outside the walls, into which four openings were pierced to allow for passage between the outside and inside—an indication that the wall no longer served a defensive function. In the second

FIGURE 92. Map of the Vatican. **1** Meta Romuli and Terebintus Neronis. **2** Mausoleum of Hadrian. **3** Vatican necropolis. **4** Necropolis of the *autoparco.*

century AD, several of these rooms were restored and used by a community dedicated to the worship of Isis, as attested by wall paintings and surviving graffiti. Reconstruction in brick during the third century AD transformed some of these rooms into a bath complex.

Soundings below the quadriporticus of the church (1936–39) revealed the presence of an **ancient street** that ran parallel to Vicus Armilustri on the west. Because its course follows the highest ridge of the hill, some have suggested that this street is the *Vicus Altus* cited in an inscription. A brick building with an interior courtyard, off which there were small rooms, stood along the first. The style of construction and the mosaics date the structure to the Augustan period at the latest.

The excavations that were undertaken directly underneath the basilica are even more important, revealing **early Imperial residences** with marble floors. Among other things, there appeared a **small temple** *in antis* with two peperino columns between the antae, certainly quite old (ca. third century BC). At the end of the Republic or at the beginning of the Empire, the spaces between the columns were closed with walls in *opus reticulatum.* Excluding the possibility that this was the Temple of Juno Regina, which is documented in the vicinity— the temple would have been built on a considerably grander scale—it may be one of several smaller sanctuaries in the area—perhaps the Temple of Iuppiter Liber or of Libertas, if these two did not actually constitute the same cult. The Temple of Juno Regina, with which the preceding was closely associated, as

can be deduced from the fact that they share the same *dies natalis,* must have occupied an area corresponding to that of the church. Some remains found below the northern end of the basilica probably belong to the temple.

The Regionary Catalogues and other sources report the presence of a **sanctuary of Jupiter Dolichenus** on the Aventine, which, following various attempts to locate the site of the cult, can now be situated in an area not far from Sant'Alessio and S. Sabina. Discovery of the building, whose surface area spanned 22.60 × 12 meters, occurred in 1935 during construction of Via di S. Domenico. Only the long northern side and part of the short sides were excavated. The sanctuary, perhaps a courtyard originally, was part of a larger building that revealed an older phase, probably Augustan. It consisted of a hall preceded by an atrium and followed by a third room that was almost square. In the central and most important room, the remains of an altar were found, as well as a large inscription with a dedication to Jupiter Dolichenus commissioned by Annius Iulianus and Annius Victor. A remarkable number of statues, reliefs, and inscriptions was found in the building. The variety of the divinities that are represented underscores the syncretistic tendency of the cult, originally from Asia Minor, that associated itself with the principal divinity of the Aventine, among others; there is evidence that Diana was worshiped here, in addition to Isis and Serapis, Mithras, the Dioscuri, Sol, and Luna. All the material discovered in the sanctuary is now on display in the Capitoline Museums, in the Hall of the Eastern Cults.

The complex, originally open to the sky, dates to the reign of Antoninus Pius, after AD 138, as attested by brick stamps and an inscription bearing the date of AD 150. Stamps on the roof tiles provide evidence that it was roofed in the second half of the second century, and it was restored periodically, especially during the third century, when the cult must have reached its peak.

THE MITHRAEUM OF S. PRISCA AND THE THERMAE SURANAE The Church of S. Prisca is probably the oldest Christian cult site on the Aventine. It corresponds to the *titulus* of Aquila and Prisca, where St. Peter and St. Paul were supposed to have lodged. Excavations, begun in 1934 and resumed in recent years under the direction of Dutch scholars, have uncovered a rich Mithraeum that occupied the rooms of an older house (FIG. **90:5**). Brick stamps date the building, situated north of the church, to around AD 95 or a little afterward. A quadriporticus on the building's eastern side was transformed into a residence around AD 110, while a large apsidal nymphaeum was built to the south, in the area of an adjacent house. A building with two aisles was added on the south toward the end of the second century. The present church rests on this (perhaps the paleochristian *titulus?*); the Mithraeum was installed in another room during the same period. The latter was violently destroyed around AD 400, just before construction of the church, evidently by the Christians themselves.

The excavators believe that the original building was the *(Domus) Privata Traiani,* the house in which Trajan lived before he became emperor. There is

another possible explanation, however. A fragment of the Severan Marble Plan representing the Thermae Suranae, adjacent to the slab on which the Temple of Diana was represented, shows that these baths were immediately north-west of S. Prisca, under the present-day Scuola di Danza; recent excavations have brought to light important remains of the complex (FIG. **90:4**). On the other hand, the arches of the Aqua Marcia, which extended to the Thermae Suranae, passed directly through the area later occupied by the church. There-fore, identification of the late-first-century AD house as the residence of Licinius Sura seems more plausible; it was probably adjacent to the baths. We know from inscriptions that these baths were restored by Gordianus and again in AD 414 to repair damage incurred in the sack of Alaric, who thoroughly ravaged the Aventine.

On the fragment of the Severan Marble Plan that represents the baths, a peripteral temple, *sine postico* and certainly Republican, appears northwest of the complex. The position could well correspond to that of the Temple of Consus or of Vertumnus.

A stairway leads from the right aisle of the church to the Mithraeum. The nymphaeum with hemicycle is the first stop along the way—the site of a small museum in which material from the excavations is displayed. Of particular note are the magnificent representation of the Sun in *opus sectile* of polychrome marbles and the stucco heads—including that of Serapis—from the decoration of the Mithraeum. Several drums from large peperino columns (90 centimeters in diameter) have been reused in a small room nearby; they certainly came from a Republican temple somewhere in the vicinity, perhaps that of Diana. Other columns of the same sort are embedded in the wall to the right of the church's facade.

Beyond the crypt of the church lies the room that precedes the *spelaeum*. In its earliest phase, this room functioned as an atrium; later it was linked to the rest of the facility through the addition of side benches and enlargement of the doorway. In this way, the original length of the hall—11.25 meters (its width was 4.20 meters)—reached 17.50 meters. The first layer of paintings was later replaced by another, and new stucco figures completed the decoration of the rear wall.

Statues of Cautes and Cautopates stood in the two niches at the entrance. Only the former is preserved. It was probably in origin a statue of Mercury transformed by the addition of stucco. The niche in the rear wall, recently restored, is unique in Rome. In addition to the usual image of Mithras killing the bull (the nude representation of the god, however, is exceptional), the niche contains a representation of the god Saturn lying down; his body is made out of amphorae covered with stucco. In a large graffito on the left side of the niche, a follower proclaims his birth into the light—that is, his rebirth, thanks to the initiation—on 21 November AD 202. The Mithraeum was thus already in existence in that year.

The most important feature of the sanctuary is the paintings that decorate the side walls above the benches; a break in the middle of the right wall that originally contained a door was later closed and transformed into a throne. There are two superimposed registers that, however, represented analogous subjects.

On the right wall, from left to right, the paintings depict the following:

1. A seated man wearing a Phrygian cap and dressed in red. To the left of his head is the inscription *nama (patribus) / ab oriente / ad occidente(m) / tutela Saturni*.

2. A young man with a halo and holding a globe in his hand. The inscription reads *(na)mai tute(l)a S(ol)is*. The inscription of the lower level, visible higher up where the plaster fell off, is *nama h(el)iodrom(i)s / t(utela ...)*.

3. The legs and right arm of a figure, above which runs the inscription *(na)ma persis / tutela (Mer)curis [sic]*.

4. Another person whose image is less easily distinguishable. Above the head is the inscription *nama l(e)on(i)b(us) / tutela Iovis*.

5. A person, in a three-quarter pose, who holds the cloak of the preceding figure and carries a roundish object with the other hand, clasped against his chest. The inscription reads *nama militibus / tutela Mart(is)*.

6. A person standing and holding a deep red object in his hand. Above the head is written *nama nym(phis) / tut(ela Ve)n(eri)s*.

7. Only traces of this figure are visible.

The meaning of this procession and of the strange names is best explained through a letter of St. Jerome written in AD 403:

> Did not your relative Gracchus ... a few years ago when he was the city prefect [in 377] overturn, smash, and burn a Mithraic grotto and all those monstrous images by which they are initiated, such as the Crow *(corax)*, the Bridegroom *(nymphus)*, the Soldier *(miles)*, the Lion *(leo)*, the Persian *(perses)*, the Runner of the Sun *(heliodromus)*, the Father *(pater)*, and, after sending them forth like hostages, did he not obtain the baptism of Christ?

This is a case of a destruction of a Mithraeum by Christians, during approximately the same years that the Mithraeum at S. Prisca was destroyed. The interest of the passage from St. Jerome is the list of the grades involved in Mithraic initiation, which we find in the same sequence along the painted wall of the Mithraeum. Thus, we can complete the inscription by adding the missing last figure: *nama coracibus—tutela Lunae*. A planet corresponds to each of the seven grades of initiation, which are listed in ascending order of importance *(corax, nymphus, miles, leo, perses, heliodromus, pater)*. *Nama* is a Persian word that may signify honor or veneration. The phrase that is continuously repeated can thus be trans-

lated, for example, "honor to the lions, protected by Jupiter." The presence of the planets in a cosmic cult is not surprising. The seven heavens are represented, for example, in the floor of the Mithraeum of the Seven Spheres at Ostia.

The six figures that follow on the same wall, beyond the door, are real persons, indicated by their names, all of whom hold the grade of *leones*. They are bringing a bull, a rooster, a ram, a crater, and a pig. A similar scene must have been represented in the preceding painting, as appears at some points where it is visible.

The procession of the *leones* continued on the left wall. A grotto with four persons is shown at the end of the cortège on the right. Two of these, Mithras (on the right) and the Sun (on the left), are reclining at a banquet, while the other two, one of whom has the head of a crow, are serving them. This is evidently a representation of the alliance between Mithras and the Sun. To the left of the main room are other rooms that must have been used for functions connected with the sanctuary, such as initiatory ceremonies.

THE THERMAE DECIANAE In AD 252, the emperor Decius commissioned a bath complex, which he named after himself: the Thermae Decianae (FIG. **90:6**). The location of this complex is known and some remains from it still survive. Inscriptions found more or less *in situ*, one of which is preserved in the courtyard of the Casale Torlonia, allow us to reconstruct the history of the building in addition to confirming its location. We know of one restoration that was undertaken under Constantius and Constans and another in 414, after the sack of Alaric. Numerous works of art were discovered in the area of the baths, including the young Hercules in green basalt and the relief of the sleeping Endymion, both in the Capitoline Museums. The plan of the building is recorded in a sketch by Palladio, making it possible to reconstruct the surviving remains. The most noteworthy of these is an apse in the hall at the southern corner. The size of the complex's central section was approximately 70 × 35 meters.

The baths were built on top of older buildings, partially preserved in the basement of the Casale Torlonia and underneath Piazza del Tempio di Diana. Several walls in *opus quasi reticulatum* contain First Style paintings, dating to the end of the second century BC—among the few known examples of this style in Rome. Several halls of a large building have been preserved up to their vaults, together with their mosaics and paintings (small objects, landscapes, masks, and flowers in panels). Brick stamps and the style of the wall paintings date the structure to the time of Trajan or Hadrian. The buildings may have eventually come into the possession of Decius, and were adapted by the emperor to construct his baths. In fact, we know that other members of his family resided on the Aventine. The possibility that this is the (Domus) Privata Traiani, which some identify as the building under S. Prisca, should not be ruled out. Decius's assumption of Trajan's name confirms the association he sought to foster between himself and his predecessor.

THE PLAIN OF THE EMPORIUM The ancient port of Rome, situated on the left bank of the Tiber in the bend that faced the Velabrum and Forum Boarium, had no room for expansion, as it was hemmed in between heavily built areas. After the Second Punic War, Rome experienced an intense growth in both population and in commerce. It then became necessary to find space for a new port complex that could meet the needs of the times. The most suitable place was the open plain south of the Aventine. Here the aediles of 193 BC, Lucius Aemilius Lepidus and Lucius Aemilius Paulus, built their new port (Emporium) and the Porticus Aemilia that stood behind it. Subsequently, the censors of 174 paved the Emporium in stone, subdivided it with barriers, and made stairways that descended to the Tiber; they were also responsible for completing the Porticus Aemilia (FIG. 90), of which important elements survive in the area south of Via Marmorata, between this street and Via Franklin. The Severan Marble Plan represents the porticus with remarkable precision.

This immense building made of tufa in *opus incertum*—one of the oldest examples of this technique—was 487 meters long and 60 wide. The interior was divided by 294 piers into a series of rooms, arranged seven rows deep, that formed fifty aisles, each 8.30 meters wide; these were roofed by a series of small vaults, one above the other, following the light slope of the terrain. Several walls are still visible on Via Branca, Via Rubattino, and Via Florio. The building, standing about 90 meters from the river, was closely connected to the port, evidently functioning as the depot for arriving merchandise. Little by little, this space was subsequently filled in with other constructions, especially during the reign of Trajan.

The Emporium was discovered in the years 1868–70 during work on the Tiber's embankment and was reexplored in 1952; several sections, recently cleaned and restored, are still visible, embedded in the massive wall of Lungotevere Testaccio. The facility was a wharf, roughly 500 meters long and 90 meters deep, with steps and ramps that descended to the river (the dock at Aquileia provides a similar, better-preserved example). Large protruding travertine blocks with holes for mooring the ships were built into the front of the dock. The surviving structural elements, for the most part in *opus mixtum,* are Trajanic reconstructions.

Over time, the entire plain of Testaccio became filled with buildings, especially with food warehouses, as the needs of the city grew. With the increase in population at the end of the second century BC and the beginning of subsidized distributions of grain and other foodstuffs, instituted during the tribunate of Gaius Gracchus, new warehouses became necessary. In response to this need, the Horrea Sempronia, Galbana, Lolliana, Seiana, and Aniciana were built. The best known among these were the Horrea Galbana, called the *Horrea Sulpicia* during the Republic (FIG. 90:9). A part of this building is shown on the same fragments of the Severan Marble Plan on which the Porticus Aemilia appears; it stands behind the porticus, but with a different orientation. During construction

of the Testaccio neighborhood, several of its walls reappeared. The building, constructed entirely of tufa in *opus reticulatum*, was laid out around three large rectangular courtyards surrounded by porticoes, onto which long rooms opened. It was recently demonstrated that this was only a part of the building, the one reserved for the lodging *(ergastula)* of the slaves, who were divided into three *cohortes*, one for each courtyard. The warehouse proper stood farther east, between the *ergastula* and Monte Testaccio, which was formed from the refuse of the nearby *horrea*.

The building was restored by the emperor Galba (AD 68–69), but its original construction can be precisely dated: in front of the *horrea* was the tomb of the consul Servius Sulpicius Galba, almost certainly the official of 108 BC who was responsible for the construction of the building. This would date the building to around 100 BC, during the era of the tribune Saturninus. The irregular *opus reticulatum* in which the warehouse was constructed is one of the oldest known examples of this technique.

MONTE TESTACCIO The artificial hill called Testaccio (that is, *Mons Testaceus,* "mountain of potsherds") is about 54 meters above sea level (30 above the surrounding area), with a circumference of one kilometer and a surface area of about 20,000 square meters (FIG. **90**). It is roughly triangular, occupying a portion of the corner that lies between the Aurelian Wall and the river, at the southern end of the city. The hill was created from the discarded amphoras that contained the products brought to Rome's home port.

The wagons that climbed the hill to unload the amphoras originally ascended by way of a ramp that divided in two at the northeastern corner. The surface area of the dump, the only part that we know very well, consists almost exclusively of somewhat spherical oil amphoras—they are called Dressel 20—that came from Spain, bearing a trademark on one of the handles. The name of the exporter, the various inspections at departure and arrival, and the consular date were marked on the body of the vessels with a brush or a quill. Most of the amphoras are dated between 140 and the middle of the third century AD.

This extraordinary hill contains the entire economic history of the late Republic and Empire.

THE PYRAMID OF GAIUS CESTIUS The Pyramid of Gaius Cestius was incorporated within the Aurelian Wall, alongside Porta S. Paolo, and was known in the Middle Ages as the *Meta Remi* (FIG. **90:11**). The pyramid, like the so-called *Meta Romuli* that was in the Vatican near the modern Via della Conciliazione, is a funerary monument, as we learn from the twice-repeated inscription, on the eastern side and on the western side, where the modern entrance is located: *C(aius) Cestius L(uci) f(ilius) Epulo, Pob(lilia tribu), praetor, tribunus plebis, (septem)vir epulonum* (Gaius Cestius Epulo, son of Lucius, of the Poblilia tribe, praetor, tribune of the plebs, septemvir in charge of sacred banquets). A second inscription in smaller letters on the eastern side states that the work was completed

in fewer than 330 days in accordance with the provisions of Cestius's will. Two inscriptions, engraved on bases (now housed in the Capitoline Museums) that must have held bronze statues of the tomb's occupant, mention several of Cestius's famous heirs. Among these were the consul of 31 BC, M. Valerius Messalla, Lucius Cestius, the brother of the deceased, and M. Agrippa, Augustus's son-in-law. The statues were erected with the money earned from the sale of Pergamene tapestries *(attalica)*, which could not be placed in the tomb because of a law prohibiting extravagant display. This fact allows us to date the pyramid after 18 BC, the year of the law's enactment, while mention of Agrippa precludes dating the monument any later than 12 BC, the year of the latter's death.

Gaius Cestius is probably the praetor of 44 BC; his brother may have been praetor in 43 BC. It is not unlikely that one of the two was responsible for the construction of the earliest Pons Cestius, located between Tiber Island and Trastevere. Mention of the *attalica,* precious tapestries from Pergamon, and the extravagance of the tomb suggest that this Cestius might also be identified as a knight of the same name who resided in Asia Minor between 62 and 51 BC; he was probably a merchant or a tax contractor.

The pyramid measures 29.50 meters at the base and rises to a height of 36.40 meters (100 × 125 Roman feet). Four columns stood at its corners, two of which were reerected during the excavation of 1660 by order of Alexander VII, as a third inscription on the monument records. The structure was inspired by Egyptian models—Ptolemaic rather than pharaonic—that became fashionable in Rome after the conquest of Egypt in 30 BC; it resembles the Hellenistic pyramids of Meroe in Nubia. The foundations are in *opus caementicium* faced with travertine, while the superstructure, also in *opus caementicium,* was revetted in marble. On the western side a small door leads to the funerary chamber through a tunnel; this entrance is modern, however, opened in the seventeenth century. The chamber, preserved in the concrete core, is rectangular (5.85 × 4 meters) with a barrel vault. The brick revetment is among the oldest datable examples of the use of *opus latericium* in Rome. The rich decoration in the Third Style (the oldest datable example of the style), featuring panels with candelabra that frame two women standing and two seated, has for the most part disappeared. In the corners of the ceiling, four Victories with crowns drew attention to the center of the vault, which has now collapsed; a painting here probably depicted the apotheosis of C. Cestius. During the third century AD, the pyramid was incorporated in the Aurelian Wall.

An **ancient road,** *Via Ostiensis,* is visible nearby; it left the city through a gate of the Aurelian Wall that was later closed, probably by Maxentius. Alongside the street are the remains of buildings, probably *horrea,* and some cippi with dedicatory inscriptions to Silvanus and Hercules, which were discovered in 1930. In 1936, the remains of a bathing complex with mosaics were found on the outside of the walls; these can be dated to the first half of the second century AD.

ITINERARY 2

Trastevere

TIBER ISLAND According to an ancient legend, the island in the Tiber was formed from a harvest of grain gathered in the Campus Martius that belonged to the Tarquins and was thrown into the river after they were driven out. The island, however, is not that recent. Soundings of the island's core undertaken during the large-scale reconfiguration of the Tiber at the end of the nineteenth century reveal that it consists of volcanic rock, similar to that of the nearby Capitoline, which was built up over the years by alluvial deposits. We do not know when the island was first occupied. The oldest cult is possibly that of the river god Tiberinus. A shrine on the island was dedicated to this divinity, together with Gaia, at least during the reign of Sulla.

The first important building that was to determine future activity on the island was the **Temple of Aesculapius** (FIG. **91:1**). In 293 BC, the city was struck by a devastating plague. The Sybilline Books were consulted (between 292 and 291 BC) and it was decided that an embassy should be sent to Epidaurus in Greece, home of the cult of Aesculapius, the god of medicine. The Roman trireme sent to Epidaurus returned with a sacred snake, symbol of the god. The serpent swam from the *Navalia*, the military port situated along the bank of the Campus Martius, to the island, where it disappeared, thus indicating the place where the new temple should be built.

Construction began immediately afterward, and the shrine was inaugurated in 289. Its location coincides with the Church of S. Bartolomeo. The medieval well that survives near the church's altar might correspond to the ancient sanctuary's sacred fountain. Varro (*L* 7.57) reports that a painting with a military subject—knights who bore the archaic title *Ferentarii*—dated to the temple's first phase; the work disappeared during the reconstruction of the building toward the middle of the first century BC. The porticoes in the sanctuary, as in Epidaurus, functioned as a hospital, as attested by the surviving inscriptions recording miraculous cures, votive offerings, and dedications to the divinity. The oldest dedications, found in the Tiber, date to the period just after the temple's construction. Use of the island as an infirmary can be easily explained by its isolation from the rest of the city, a function that continued during the Middle Ages. Even today, the Ospedale dei Fatebenefratelli, founded in 1548, maintains the island's age-old function. A dedication to Jupiter Dolichenus, offered by an official of the *Ravennates*, sailors of the fleet stationed in Trastevere, attests to the assimilation between this Asiatic divinity and Aesculapius.

Other minor sanctuaries occupied the northern side of the island. Shrines dedicated to Faunus and Veiovis in 194 BC probably stood near each other. A sanctuary to *Iuppiter Iurarius*, "guarantor of oaths," stood on the site of the chapel of S. Giovanni Calibita, near the *Pons Fabricius*, where a mosaic with the name of

the divinity was discovered. The name, unique to this cult, is a Latin alternative for "Semo Sancus Dius Fidius," who thus effectively had a sanctuary on Tiber Island. The remains that were recently discovered in the hospital's eastern sector probably belong to this shrine. An inscription also records the existence of a cult dedicated to Bellona, called *Insulensis*.

There must have been only one *vicus* on the island, whose name—*Vicus Censorii*—survives in several inscriptions. This is probably also the name of the street that connected the two bridges, the Pons Fabricius and Pons Cestius, by which the Campus Martius was connected with Trastevere. The present configuration does not differ significantly from the ancient. The small obelisk, two fragments of which are now in the Museo Nazionale di Napoli and a third in Munich, may have stood where the monument erected by Pius IX now stands.

The **Pons Fabricius,** called Ponte dei Quattro Capi (Bridge of the Four Heads) in Italian, links the island to the bank of the Campus Martius near the Theater of Marcellus. We know the precise date of its construction—62 BC: that is, the year after Cicero's celebrated consulship—from Dio Cassius (37.45). On the other hand, we do not know whether it replaced another bridge or a ferry. The bridge is 62 meters long and 5.50 meters wide. The core of the structure consists of tufa and peperino ashlars, while the revetment, only partially preserved, is travertine. The brick facing dates to 1679, as attested by the inscription of Innocent XI still preserved at the bridgehead facing the island. The two large arches, slightly depressed, have a span of roughly 24.50 meters, resting on a central pier pierced by a small arch to reduce the force of the water against the structure during flooding. Even the parapets, which disappeared during the construction of the embankment wall at the end of the nineteenth century, were punctuated by two similar arches. Two quadrifrons herms were inserted in the modern balustrade at the beginning of the bridge facing the Campus Martius. The grooves in the statues may have supported the original bronze balustrades.

An inscription in large letters, repeated four times above the two large arches on both the upstream and downstream sides, records the name of the builder, Lucius Fabricius, son of Gaius, curator of roads *(Curator Viarum)*. The style of the construction and the inscription accord with the date of 62 BC reported by Dio Cassius. A later inscription in smaller letters appears twice on the arch closest to the Campus Martius, bearing the names of Marcus Lollius and Quintus Lepidus, the consuls of 21 BC. Evidently, the inscription records a restoration that was probably undertaken after the great flood of 23 BC; on that occasion the Pons Sublicius was destroyed, and the Pons Fabricius must have suffered damage as well.

The other bridge of the island, connecting it with Trastevere, is the **Pons Cestius,** which was partially demolished between 1888 and 1892. Like the Pons Fabricius, it was probably built in the first century BC. Two praetors of this name, who were in office in 44 and 43 BC, come to mind. The praetor

of 44 may be the individual buried in the pyramid of C. Cestius. If one of these officials was the builder, then the earliest phase of this bridge would date to around the middle of the first century BC. The last reconstruction was completed in AD 370 under the emperors Valentinian, Valens, and Gratian, as attested by an inscription in the bridge's right parapet; a second identical inscription was thrown into the river by those defending the Roman Republic in 1849 during their unsuccessful attempt to cut the bridge off. There is some speculation that the medieval name of the island, *Lycaonia,* derived from a statue on the bridge representing this region of Asia Minor, which became a province in AD 373.

On the eastern tip of the island, a segment of a prow, carved in travertine, can still be seen; the sculpture alludes to the shape of the island, which resembles a ship. The island's other end might have been distinguished at one time by the complementary image of a stern, but the hypothesis that the island was entirely transformed into a ship of stone should be dismissed. The prow has a core of peperino with a travertine facing; its form is that of a trireme, the warship that brought the snake of Aesculapius to Rome. The serpent is shown entwined around a staff in Aesculapius's hand; the bust of the god, though seriously damaged, is still easily recognizable. A bull's head may have served as a bollard for mooring cables. The construction almost certainly dates to the first half of the first century BC and is thus contemporary with the bridges; an inscription in fact attests to an extensive reconfiguration of the island at mid-century.

TRASTEVERE Very little remains visible of what was the most populous neighborhood in Rome during the late Empire (FIG. **91**). Nonetheless, we can still discern the routes of several ancient streets that were partially preserved by their continuous use during the Middle Ages. One of the temples in the area, that of Fors Fortuna at the first milestone of Via Portuensis, may be represented on the Severan Marble Plan as the circular building just beyond the present-day Porta Portese; the traditional view that the remains found in 1860, in what was then the Vigna Bonelli, constitute this temple should be rejected. A sanctuary of Hercules Cubans was discovered in 1889 along Viale Trastevere, halfway between Piazza Nievo and the Trastevere Railway Station, containing, among other things, busts of charioteers. The sanctuary of Fons must have been in the place now occupied by the Ministero della Pubblica Istruzione. In 1914, during the excavation of the ministry's foundations, an inscription was discovered with a dedication to Fons offered by two freedmen and dated 24 May AD 70. The legendary tomb of King Numa was located near this sanctuary. The position of the sanctuary of Furrina along the hillside below Villa Sciarra has also been ascertained on the basis of an inscription.

No trace remains of the largest public complex in Trastevere, the Naumachia built by Augustus in 2 BC near the *Horti* of Caesar. The inauguration of the Temple of Mars Ultor was celebrated here with naval battles; the Aqua Alsietina,

stretching almost 33 kilometers from Lake Martignano and Lake Bracciano, provided the water. The discovery of a section of the aqueduct allows us to locate the site near S. Cosimato and is confirmed by a fragment of the Severan Marble Plan relating to this area; it reveals an open space of dimensions analogous to those recorded in the *Monumentum Ancyranum:* 536 meters long by 357 meters wide.

The ruins of ancient Trastevere that can still be seen lie mostly along the first stretch of Via Aurelia, the modern Via della Lungaretta. **Important ancient buildings** are visible under the Church of S. Cecilia, uncovered for the most part in 1899 and further in recent excavations (FIG. **91:2**). The building under the central nave on the east is the oldest. There remain a tufa wall in *opus quadratum* and several columns and piers, also of tufa. The features of the structure call to mind a utilitarian building *(horrea)* of the Republican era. Remains of another structure, probably a private house, lie under the front porticus of the church; here too are indications of a Republican date, including a wall in *opus reticulatum* and a floor in *opus signinum* with a triple meander in white stone tesserae. The ruins attest to reconstructions undertaken during the Empire—from the second to the fourth century.

The transformation of the tufa building can be dated to the period of the Antonines. The change involved the insertion of a room with seven hemispherical tanks made of brick, which gave rise to the notion that this was a tannery; it has been hypothetically identified as the *Coriaria Septimiana* recorded in the Regionary Catalogues. In a nearby room there is a kind of *lararium*, a niche with a tufa relief representing Minerva in front of an altar. The sides of the niche are revetted with two terracotta reliefs of the so-called Campana type that come from the same mold, depicting a Dionysian scene. A Christian *titulus* was later installed in these buildings, while the basilica itself was built by Paschal I at the beginning of the ninth century.

On the corner of Via di Montefiore and Via della VII Coorte, near Viale Trastevere, there is an Imperial building that is of considerable importance for the topography and history of Region XIV: the *Excubitorium* of the Seventh Cohort of the *Vigiles* (FIGS. **91:4; 93**). The discovery took place in 1865–66, but the excavations were completed only later. The building was a private house that had been converted into a barracks toward the end of the second century AD. It can be identified with certainty as the main headquarters of Cohort VII, which oversaw Regions IX (or XI) and XIV, and not as one of the smaller posts, as is generally held. The building, whose floor is 8 meters below modern ground level, consists of a large hall that was paved with black-and-white mosaics, which disappeared during World War II. At the center is the basin of a hexagonal fountain with concave sides; it lies on axis with a rectangular exedra containing an arched entrance that is framed by two Corinthian pilasters surmounted by a pediment; the construction is entirely of brick. Some of the original frescoes within are still preserved. A graffito reveals the function of the room: it was the chapel of the barracks, a kind of *lararium* dedicated to the Genius of the

FIGURE 93. Excubitorium of the Seventh Cohort
of the *Vigiles*.

Excubitorium. Other rooms open onto this central area all around, evidently
the dormitories of the *vigiles*. One of these was a bath.

Numerous graffiti were discovered on the walls of the large atrium. The words
sebaciaria and *milites sebaciarii*, evidently connected with the word *sebum* (tallow),
appear often. The terms must have pertained to the soldiers on guard duty and
night patrol, for which they were equipped with tallow torches. Many of the
graffiti can be dated to between AD 215 and 245.

The Excubitorium of Trastevere provides us with a precise idea of the
organization and life of the *vigiles*, a unit that was founded by Augustus in 6
BC with duties similar to those of modern firemen and night police. We know
that there were fourteen *excubitoria* in all, one for each region; seven of these
were the official headquarters of the seven *Cohortes Vigilum*, of which the station
in Trastevere was one. We also know the location of five of these barracks: those
of Regions II, V, VII, XII, and XIV.

Several ancient buildings, datable between the beginning of the empire and
the Severan era, were found on various occasions in the immediate vicinity of
the Church of S. Crisogono on Viale Trastevere. None of these can be seen

today, excluding the few remains that are still accessible in the basement of the church; the first Christian building was installed here in the eighth century.

Extensive excavations in the area of the Caserma Manara, located between the churches of S. Francesco a Ripa and S. Maria dell'Orto, have brought to light a series of large Imperial warehouses that face the river. An important fragment of a first-century AD marble plan, on the same scale as the Severan *Forma Urbis,* was found here and provides a view of the area around the Temple of the Dioscuri in the Circus Flaminius.

THE SYRIAN SANCTUARY OF THE JANICULUM A sanctuary dedicated to eastern divinities was discovered in 1906 on the southern slope of the Janiculum; the modern entrance is on Via G. Dandolo, no. 47 (FIGS. **91:7; 94**). Of the three phases that were identified at that time, only the last one has left substantial remains that can still be seen. An inscription in Greek found on the site contains a dedication to *Zeus Keraunios* and to the *Nymphae Furrinae.* The sacred grove of Furrina was thus in the immediate vicinity, probably near Villa Sciarra, which rises above the site. It was here in 121 BC that Gaius Gracchus took his own life after his flight from the Aventine. Here was the source of a fountain sacred to the nymph Furrina, which was diverted into a channel below the temple. Later on, the ancient cult became associated with Syrian divinities.

The change must have occurred as early as the beginning of the first century AD, as several inscriptions indicate. Afterward, the temple was reconstructed, probably by Marcus Antonius Gaionas, a Syrian (probably a wealthy merchant) who was a contemporary of Marcus Aurelius and Commodus, mentioned in a funerary inscription, among other notices. The sanctuary was destroyed, possibly in a fire, and much material from the earlier structure was reused in the building that survives, whose date, a topic of debate, has been assigned to the fourth century AD.

The sanctuary, an elongated structure built mostly of small parallelepipedal blocks of stone, consists of three distinct parts: a rectangular court in the middle **(A)** that functions as the entrance (the main door was at the center of the southern side); a room with a curious floor plan incorporating a number of shapes **(C)**; and a basilical structure on the west **(B)** that is preceded by a sort of atrium or narthex onto which two lateral cellas open. A single entrance leads into the central nave, which terminates in an apse that has a semicircular niche flanked by two smaller niches; a human skull was discovered below the central niche. The side aisles could be entered only from the central nave and terminated in rectangular niches. There are four other semicircular niches located along the sides of the doors in the walls that divide the central nave from the two aisles.

The main cult statue, located in the central niche, was discovered by the excavators. It is a seated Jupiter that is unfortunately missing its head and other features, but that resembles a Serapis. A triangular altar stands in the middle of the central nave.

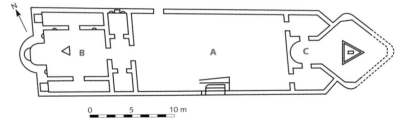

FIGURE 94. Plan of the Syrian Sanctuary of the Janiculum.

The third part of the sanctuary, lying to the east, is the most unusual. It was approached from the courtyard through two doors (one of which was blocked off at a later time), leading to two small rooms. Side doors in these antechambers led to an octagonal hall with an apse on the western end. Several sculptures were found here: an Egyptian statue in black basalt (in the apse), a statue of Bacchus with gilded face and hands, and other statues, all predating and reused during the temple's last phase. The most interesting discovery was made within a hollow space underneath the triangular altar at the center of the octagonal hall: several eggs and a bronze statue of a man caught in the coils of a serpent. The significance of the statuette, which is to be identified as Osiris, seems clear: Osiris (possibly also the subject of the Egyptian statue), god of nature, dies and is reborn every year. The burial of the god and his rebirth through the seven celestial spheres, symbolized by the seven coils of the serpent, allude, like the eggs, to the allegorical death and rebirth of the neophyte before and after initiation to the cult. The ceremony apparently took place in this secluded room.

The likely date of the sanctuary—mid-fourth century AD—and its syncretic character identify it as one of those cult sites typical of late paganism, before its final extinction after the battle of Frigidus; the most important example of cults of this sort is the Phrygianum in the Vatican.

ITINERARY 3

The Vatican

THE CIRCUS OF CALIGULA, THE VATICAN NECROPOLIS, AND THE BASILICA OF ST. PETER The Vatican hills and the plain enclosed between them and the Tiber—the *ager Vaticanus*—never constituted a formal part of the city, but were a suburban area, crossed by streets lined with tombs and villas, the most important of which came into the Imperial holdings at an early date (FIG. **92**). The Circus

of Caligula, the most important building in the area in addition to Trajan's *Naumachia* and Hadrian's Mausoleum, was probably a private circus, part of the Villa of Agrippina and thus similar to the Circus of Maxentius.

An important group of monuments was discovered during construction of the river embankment at the end of the nineteenth century. They lie outside Porta Settimiana, on the road along the Tiber that linked Trastevere with the Vatican, and include the so-called tomb of the Platorini, the Cellae Vinariae Nova et Arruntiana, and the Villa della Farnesina (FIG. **91:8–10**). Identification of the latter as the Villa of Agrippa is confirmed by the proximity of the *Horti* of Agrippina, Agrippa's daughter, and of the Pons Agrippae, corresponding to Ponte Sisto.

The remains discovered in 1959 under the Ospedale di Santo Spirito may belong to the **Villa of Agrippina.** Three structures can be distinguished: one farther to the west with walls in *opus reticulatum* and courses of brick; one in the middle that reveals two phases (the first in *opus reticulatum*, the second in *opus reticulatum* and brick); and another farther to the east, in *opus latericium*, distinguished by the inclusion of a large exedra. The oldest phase of these buildings dates to the beginning of the first century BC, as the structures and polychrome mosaic floor show. A large marble basin with sea scenes, dated around 100 BC, comes from here; it was discovered a few decades ago and was moved to the Palazzo Massimo.

The position of the **Circus of Caligula,** on the left side of St. Peter's Basilica, is secure. Its northern side corresponds to the left aisle of the church and was bordered by the row of tombs of the Vatican necropolis. Even the position of the **obelisk** is certain, as it remained in its original position until 1586, when it was moved to the center of the modern Piazza S. Pietro. The foundation of its base was discovered during an excavation near the side of the church, between it and the sacristy. Later, when the circus was no longer in use, a large mausoleum, dating to the reign of Caracalla and later transformed into the Rotonda di Sant'Andrea, was built near the obelisk.

The uninscribed obelisk is the second largest in Rome, after the one near S. Giovanni in Laterano. It measures 25 meters and was brought from Egypt on a boat of exceptional size, as we learn from Pliny the Elder (*NH* 16.76); Claudius later had the vessel sunk to serve as the foundation for a break-water in his artificial port. Recent excavations have brought the remains to light and have confirmed Pliny's report. Caligula's dedication to Augustus and Tiberius is repeated on two sides of the obelisk's base. Several holes from an earlier inscription reveal the name of C. Cornelius Gallus, prefect of Egypt under Augustus, who had the obelisk cut for a *Forum Iulium* that he built in Alexandria.

The size of the circus has recently been shown to be considerably larger than previously thought—that is, if a curved wall, discovered on Via del Santo Uffizio beyond Bernini's colonnade, belonged to it. The discovery has led some to argue

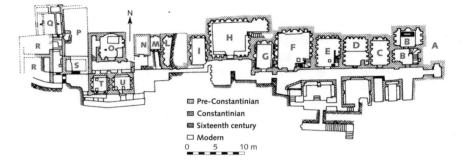

N

☒ Pre-Constantinian
☒ Constantinian
☒ Sixteenth century
☐ Modern
0 5 10 m

FIGURE 95. Plan of the Vatican necropolis.

that the *carceres* were located here. The identification is uncertain, however. In any event, the fact that this wall contains no openings, together with its position east of the circus, suggests that is was associated with the curved end that lies opposite the *carceres*. The starting gates would thus have been located near the apse of the basilica. This configuration better suits the orientation of other circuses in Rome, whose *carceres* are on the western or northwestern sides.

An important necropolis was excavated under the basilica, consisting of brick mausolea that lined a street running along an east-west axis (FIGS. **92:3; 95, 96**). The northern row of tombs is older, dating to the second century AD, as the preference for cremation burials indicates. A chronological development can easily be observed in the buildings as they progress from east to west. The tombs at the south are later, dating to the third century.

Mausoleum **A,** which was not excavated, has an important inscription on its facade that records a part of the will of the deceased, C. Popilius Heracla, according to which he asks that his tomb be built "on the Vatican, near the Circus alongside the tomb of Ulpius Narcissus." This provides valuable topographical information regarding the location of the Circus of Caligula. Mausoleum **B** contains two rooms and rich architectural and painted decoration. An inscription mentions that a Fabia Redempta was buried here. Mausoleum **C** has an inscription on its facade that names its owner: L. Tullius Zethus; his two sons are named in funerary inscriptions within the mausoleum on the northern side. The tomb is richly decorated in stuccos and preserves its black-and-white mosaic floor. Many sarcophagi were thrown inside the mausoleum during the construction of the basilica. Mausoleum **E** was built by Tyrannus and Urbana, Imperial freedmen of Hadrian. Of particular note among the paintings is a pair of peacocks facing a basket of flowers and fruit. Mausoleum **F** belongs to two families of freedmen, the Tullii and the Caetennii. Mausoleum **G** also preserves its elegant decoration, one scene of which features a slave giving money to his master, who is seated alongside a table.

Mausoleum **H** is one of the largest and most remarkable structures in the Vatican necropolis. It belonged to the Valerii, as the inscription of a Valerius Herma that was affixed to the facade reveals. The stucco decoration was in origin partially gilded; herms, also made of stucco, line the walls. Several sarcophagi are preserved inside. Next to the central niche, which contains a representation of Apollo-Harpocrates, several Christian paintings and inscriptions were added at a later date. Among these is the following: *Petrus roga Christus Iesus pro sanc(tis) hom(ini)b(us) chrestian(is) (ad) corpus tuum sepultis* (Peter, pray to Jesus Christ on behalf of the holy Christians buried near your body).

Mausoleum **I** predates that of the Valerii. The central apses in the walls are framed by small stuccoed terracotta columns and also have lunettes dressed in stucco. The walls preserve remarkable paintings, among which are two that represent the myth of Alcestis. On the floor is a black-and-white mosaic portraying the rape of Proserpina, whose association with death is clear. Mausoleum **L** belonged to the Caetennii, as the inscription on the facade bearing the name of M. Caetennius Hymnius reveals. Here too the elegant decoration is preserved within.

Mausoleum **M** is among the most important in the necropolis. The tomb, which had already been seen in the sixteenth century, belonged to the Julii and should be dated to the Severan age. Figures that are clearly Christian can be found within: Jonah in the jaws of the whale, a fisherman, the Good Shepherd. An important mosaic on the vault depicts Christ on the chariot of the Sun, like Apollo. Mausoleum **N** is still largely buried. The inscription on the facade names the owners of the tomb: M. Aebutius Charito and L. Volusius Successus. Mausoleum **O** belonged to the freedman T. Matuccius Pallas, as we learn from the inscription on the outside. In front of Mausoleum **O** are Mausoleum **T,** which belongs to Trebellena Flaccilla and is richly decorated with stuccos and paintings, and Mausoleum **U,** which is similar in all respects to the previous tomb. Other mausolea, also dated to the second and third centuries, were discovered farther to the west under the Church of S. Stefano degli Abissini and follow the same alignment as the others.

Later on, other tombs filled all the available space, but there were few traces of Christian burials, which were instead concentrated to the west of the mausolea. Here there was a small rectangular space **(P),** roughly 7 × 4 meters, that was closed on three sides and only half closed on the east. The area is almost completely surrounded by mausolea that were built from the first to the fourth century around what has been identified as the tomb of Peter. This was originally a simple grave, over which a monument was erected around the middle of the second century, at the same time as the surrounding mausolea. The monument rested against a wall in the rear and was accessible from the south by two stairways.

The monument, inproperly called the **Trophy of Gaius,** consisted of a niche crowned by a slab of travertine that was supported in front by two columns;

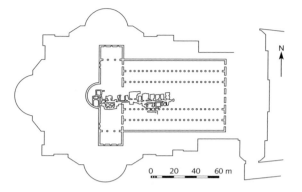

FIGURE 96. The Vatican necropolis and the successive basilicas of St. Peter.

another smaller niche was inserted above. Its curvature was irregular, being deeper on the right, but perfectly symmetrical to an underground niche that held the tomb of the apostle. A graffito on the rear wall, next to the largest niche, confirms the identity of the monument; it bears the name of Peter in Greek letters.

The tomb must have always been an object of veneration and particular concern among the faithful. In fact, although it had suffered damage in the third century (explained by some as the result of the need to move the remains of the saint *ad catacumbas* in 258), walls were subsequently added on the sides, and the floor and the largest niche were revetted in marble; the square in front of the monument was decorated with mosaics.

The basilica was built during the fourth century in such a way that the monument stood at the center of the presbytery, visible to the faithful (FIG. 96). The choice of the site on which to build the basilica in honor of the saint—the slope of a hill—is thus linked to the location of the tomb and required a solution to various and difficult problems. On the north, it was necessary to cut away a section of the hill, while on the south, a huge terrace wall was needed for filling in the difference in levels, which was as high as 8 meters. Some of the buildings that were considered dispensable had to be sacrificed, however, such as the two wings of the "red wall" against which the monument rested and even the upper part of the monument itself. Constantine's basilica measured 85 × 64 meters and had five aisles, each separated by twenty-two columns. The colonnaded atrium was impressive.

The apse was on the western end at the center of a narrow transept that was clearly separated from the rest of the basilica by means of a foundation wall. The transept communicated with the side aisles through two three-mullioned openings accented by two columns. The rows of columns stopped in front of

the transept, while the exterior walls that ran along the side aisles continued around the transept, forming two symmetrical open spaces at either end. The central part of the transept was also left open and contained St. Peter's funerary monument, whose base sat 36 centimeters under the floor of the presbytery.

The tomb was isolated at the center of the presbytery within a base of pavonazzetto, on which a kind of aedicula, clad in the same marble and in porphyry, was erected. Above this stood a baldacchino supported by four spiral columns of Parian marble with representations of putti harvesting grapes *(pergula)*. Two other similar columns stood behind and to the side, at the beginning of the curve of the apse. One of Constantine's sons commissioned the decoration of the upper part of the apse with a mosaic, as can be inferred from an inscription; its subject is ambiguous. It may represent the entrusting of the law to Peter, or Christ among the apostles. An altar was not built, since the Constantinian basilica was designed as a funerary monument.

During the sixth century, the need to accommodate regular liturgical services and to protect the relics led to the raising of the presbytery floor and to the installation of a double row of six spiral columns, the inner row of which was closed by *plutei*. The tomb was approached by two lateral stairways that led directly to the monument along a semicircular corridor. Eleven of the twelve spiral columns were incorporated in the construction of the modern basilica: one, the "holy column," was in the Chapel of the *Pietà* until fairly recently; two are in the Chapel of the Most Blessed Sacrament; and eight are in the balconies of the relics in the piers that support the dome, where Bernini wanted them. The basilica remained largely intact until, in the fifteenth century, Pope Nicolas V ordered its reconstruction, because at that time the fourth-century building was no longer stable.

Remains of a **Roman street,** sometimes identified as Via Triumphalis, were discovered inside Vatican City, north of Piazza S. Pietro along Via del Pellegrino. A variety of tombs lined the street, and their remains were discovered near the Fontana della Galera, under the Annona Vaticana, and above all under the *autoparco* built after 1956 (FIG. **92:4**). During excavation for the foundations of this building, a burial site covering an area of roughly 240 square meters was found; it contained tombs for both cremation and inhumation burials and was in use between the Augustan period and the fifth century AD.

The Meta Romuli is another of the various tombs in the *Ager Vaticanus*, regarding which there is literary testimony. It was in the form of a pyramid, similar to that of Gaius Cestius, and remained standing until 1500, when Pope Alexander VI had it removed. In 1948, its foundations were discovered during the construction of the Casa del Pellegrino at the beginning of Via della Conciliazione. The *Terebintus Neronis,* a funerary monument consisting of two superimposed cylindrical elements, was preserved near the pyramid up to the fourteenth century (FIG. **92:1**).

THE MAUSOLEUM OF HADRIAN Nerva was the last emperor buried in the Mausoleum of Augustus. As already noted, Trajan's remains were interred in the base of his column. Hadrian began work on a new mausoleum that would become the dynastic tomb of the Antonines (FIG. **92:2**). The site chosen for the monument was the *Horti* of Domitia in the Vatican. In order to link the tomb to the Campus Martius, a new bridge was built, the **Pons Aelius,** which was inaugurated in AD 134, as attested by the inscriptions at the two entrances, recorded in the Einsiedeln Itinerary; much of the structure still exists under the name Ponte Sant'Angelo. The bridge stood just upstream of the Pons Neronianus and consisted of three large central arches—the only features that survive—and two inclined ramps, supported by three small arches on the left bank and two on the right (FIG. **97**). The ramps were discovered in 1892 during work on the river and then incorporated in the huge embankment.

The mausoleum rises on the right bank, immediately on the other side of the bridge. Because it was incorporated within the Castel Sant'Angelo during the Middle Ages, its structure remains largely intact (FIG. **98**). We do not know when the work was begun, possibly around 130, but it was completed only in 139, after the death of Hadrian at Baiae; the emperor's body was at first buried in Pozzuoli.

The building consists of a square base—89 meters on each side, 15 meters high—built in *opus latericium,* with vaulted radial rooms. At the center of this enclosure is the circular drum, 64 meters in diameter and 21 meters high, which the radial walls of the enclosure abut. For unknown reasons, the enclosure appears to have been built during a second phase, immediately afterward.

The exterior wall was revetted in marble, and marble tablets were affixed to it containing the epitaphs of those who were buried within the monument. Pilasters framed the enclosure, which was capped with a frieze of bucrania and garlands, fragments of which are preserved in the Castle Museum. Procopius (*Goth* 1.22) records that four bronze groups representing men and horses stood on each of the corners of the base. Outside the main structure there was another enclosure, a railing supported by piers, the peperino foundations of which have been excavated. Peacocks cast in gilded bronze probably stood on some of these piers; they are now in the Cortile della Pigna in the Vatican.

The original entrance with three bays does not survive. The drum of the tomb that forms the lower part of the Castello can best be viewed from the modern entrance, which is 3 meters higher than the ancient one. It is built in *opus caementicium* and dressed with peperino tufa and travertine. The exterior facing was marble.

A short corridor leads to the square vestibule, which has a semicircular niche in the rear wall (FIG. **98**). This was probably where a large statue of Hadrian stood, the head of which is now displayed in the Sala Rotonda of the Vatican Museums. The original location of the large portrait of Antoninus Pius, the head of which is in the Castle Museum, is not known. The atrium was revetted in

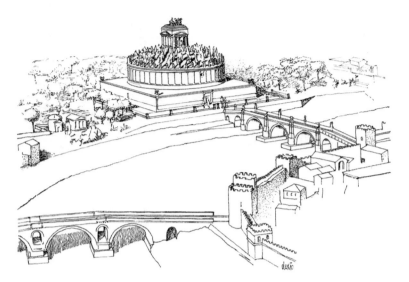

FIGURE 97. Reconstruction of the Mausoleum of Hadrian along the Tiber.

giallo antico marble (the clamp holes are still visible). The winding gallery that leads to the funerary chamber begins on the right. This corridor was built in *opus latericium* and had a marble wainscoting to a height of 3 meters, where it ended in a cornice. The vault is of rubble masonry, and the floor, several sections of which are preserved, is white mosaic. Four vertical light wells illuminate the passageway, which makes a complete circle and reaches a level 10 meters above the vestibule. From here, an axial corridor leads to the funerary chamber, located at the monument's center.

The chamber is square (8 × 8 meters), with three arched rectangular niches, located on three of the sides and originally entirely revetted in marble. Two windows that open at an oblique angle in the vault illuminate the room. The funerary urns of Hadrian, Sabina, and Aelius Caesar were placed here. All the Antonine emperors and the Severans up to Caracalla were buried in the same place.

Above the funeral chamber there were two superimposed rooms, and possibly a third as well, contained within the square structure that emerged at the center of the monument. The space between this and the exterior drum was filled in by a tumulus of earth. The central superstructure, which served as a kind of podium, supported a bronze quadriga carrying the statue of Hadrian.

Early on, the mausoleum served as a bastion of the Aurelian Wall, a transformation that can probably be attributed to Honorius in AD 403. In 537, it endured the siege of the Goths under Vitigis. At that time, as Procopius records,

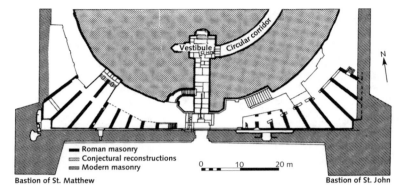

Bastion of St. Matthew Bastion of St. John

FIGURE 98. Southern part of the Mausoleum of Hadrian. The area in hatching indicates the Castel Sant'Angelo.

the defenders used the numerous statues that decorated the monument as projectiles. The transformation of the tomb into a castle probably took place in the tenth century.

North of the mausoleum, between Via Alberico II and Via Cola di Rienzo, the remains of a very large building were seen on various occasions. The structure was constructed in *opus mixtum* of reticulate and brick and was 102 meters wide and at least 300 meters long, to gauge from that part of the building that is visible. Its appearance recalls a circus, with a short curved side and two parallel long sides. Rather than identify this as the *Gaianum*, Caligula's private hippodrome, it seems preferable to identify it as the *Naumachia Vaticana*, possibly built by Trajan to replace Augustus's facility in Trastevere.

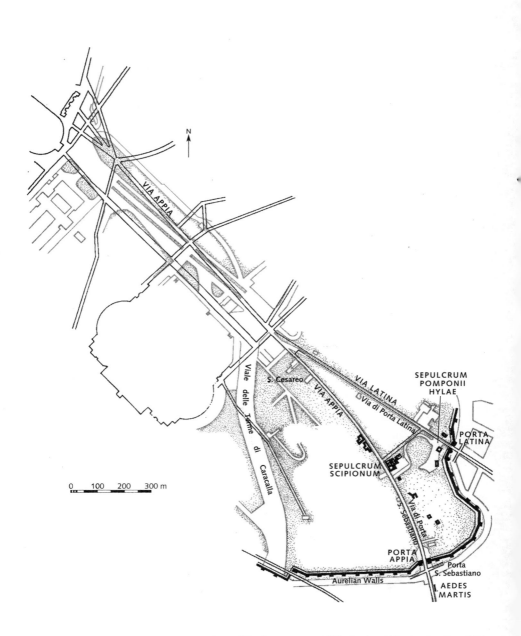

FIGURE 99. The first segment of Via Appia within the Aurelian Walls.

VIA APPIA

HISTORICAL NOTES

The Appian Way is the first of the great Roman roads that was named not for its function (as were the oldest, such as Via Salaria) or after the place to which it led (like Via Praenestina) but for the magistrate who built it. This development is indicative of a profound political and ideological change. It is hardly an accident that the censor Appius Claudius Caecus, the creator of the Appian Way and also of the earliest Roman aqueduct, is the first Roman public figure about whom we know anything substantial.

Via Appia was designed to connect Rome and Capua at a time when Campania began to form a unified political entity with Rome. Work on the road began in 312 BC and was completed in the following two years. The road was originally only graveled *(glareata)*. A few years later, in 296, the Ogulnii brothers, the curule aediles of the year, paved the road in *saxo quadrato* from the Porta Capena to the Temple of Mars for a length of one mile. Three years after that, the pavement was extended to Bovillae and only later was the entire course paved, at first as far as Benevento and then, by the time of the Gracchi, all the way to Brindisi.

The route of Via Appia is uncompromisingly straight, except for occasional deviations, for the most part caused by unavoidable features of the topography. A road of this type

required a remarkable number of infrastructures, such as stations for changing horses *(mutationes)* and rest stops *(mansiones)*. The first of these stops was at Ariccia, at the sixteenth mile.

The initial twelve-mile stretch of the road (from Porta Capena to Bovillae) is exceptionally well preserved. Only here can we get an overall idea of Rome's ancient suburbs. There are, it is true, more splendid and often more representative monuments elsewhere than those that survive on Via Appia. But these others are for the most part more isolated from one another than the monuments on the Appian Way, and they are separated from their original context, making it difficult to grasp their historical significance.

The outlying districts of Rome, even though economically interdependent with the city, did not take part in much of city life. Their functions were typically rural. Above all, they produced goods essential to the maintenance of life. Even in such an exceptional city of the ancient world as Rome, which depended for its survival on supplies from the provinces, the role of the suburban areas was far from insignificant. Of all the basic features that we now associate with the suburban Roman landscape—the farm, the villa, the tomb, the aqueduct—it is the farm that was most likely to disappear during the last centuries of the Republic, often replaced by the luxurious villa that depended upon slave labor.

From one period to the next, we can distinguish areas populated by various groups, each of which had its own character. Beginning in the late Republic, large wealthy villas were for the most part restricted to a limited zone, about a day's journey from Rome, so that it was easy for the owner to commute in a reasonable time. This area of villas included some of the region's most beautiful countryside. Between these estates and the city were the more modest settlements, whose owners probably grew vegetables and raised small animals, as we know from Roman treatises on agronomy.

The situation changed radically during the late Empire, between the second and the fourth centuries, when large luxury villas were concentrated in Rome's immediate outskirts. The villas of the Quintilii and of the Gordiani, the Sette Bassi, the Triopion of Herodes Atticus, and finally the villa of Maxentius especially come to mind. The urban aristocracy tended increasingly to transfer their usual places of residence to the outlying areas. It is probably more accurate, in fact, to speak of palaces rather than villas on Rome's outskirts. This phenomenon became more pronounced during late antiquity and was clearly the consequence of a crisis in city life.

The other dominant feature of the suburban landscape is the tomb, whose location depended on several factors. Very often an imposing mausoleum marks the environs of a nearby aristocratic villa, whereas the presence of a modest columbarium signifies something quite different. When we speak of catacombs, we should keep in mind that it was not only Christians who observed the custom of burying their dead in underground hypogea—tunnels and small rooms

carved out of the tufa. The practice arose as an outgrowth of the rite of in-humation, which became widely diffused from the second century AD on. In-humation, of course, required more space than did cremation; the hypogeum and the catacomb, for those who were inhumed, are thus the counterparts of the columbaria used in cremation burials. This explains why in the third century we find so many catacombs of "heretics," who were in fact ordinary pagans and often interred side by side with Christians. The separation be-tween pagans and Christians, in life as in death, is a modern legend. The fact that in the fourth century the catacombs are almost exclusively Christian confirms a well-known reality: after the Peace of Constantine and the conver-sion of the emperors, the population of Rome embraced the new religion en masse.

ITINERARY 1

From Porta Capena to the Tomb of the Scipios

Via Appia began near the curved end of the Circus Maximus at Porta Capena. Remains of this gate, which are no longer visible, came to light during the excavations of 1867–68. It was from this point that the ancients began to count the miles. Immediately outside the gate was the Temple of Honos et Virtus. A sanctuary dedicated to the first of these gods was built in 234 BC by Q. Fabius Maximus, while the other was added despite the Senate's opposition in 208 by M. Claudius Marcellus, the conqueror of Syracuse. The tomb of the Marcelli probably stood next to the temple. On the tomb's facade were statues of three generations of the family—the consul of 208, his son, and his grandson—erected by the last of these around the middle of the second century BC. Dating to the same period is the nearby facade of the tomb of the Scipios, which had a similar appearance.

A little beyond the point where Via Latina splits off from Via Appia (and on the right of the latter) is the Church of S. Cesareo, erected over a **building of the second century AD** (FIG. **99**). A large black-and-white mosaic with marine subjects belonging to the ancient structure is preserved intact just below the floor of the church. Some have associated the building with the Thermae Commodianae, recorded in the Regionary Catalogues.

THE TOMB OF THE SCIPIOS Various ancient authors, including Cicero, give the approximate location of the Tomb of the Scipios. It is on the left side of Via Appia, several hundred meters before Porta S. Sebastiano (FIG. **101:1**). Although it had already been seen in 1614, around mid-May of 1780 the Sassi brothers, owners of the land, found the tomb quite by chance while excavating a cellar, and they explored—or rather sacked and vandalized—it.

FIGURE 100. Tomb of the Scipios. Reconstruction of the facade.

In 1926, archaeological excavation was completed and the monument restored by removing, among other encroachments, the walls that had been erected by the monument's eighteenth-century discoverers to support the crumbling vaults. At the same time, copies of the inscriptions were made and attached to the sarcophagi in their original positions; the original inscriptions themselves are in the Vatican Museums.

The tomb is on a side road between Via Appia and Via Latina, with the facade oriented to the northwest. Only a small section (on the right) remains, where we also find the entrance to the smaller side hypogeum, comprising an arch of Anio tufa blocks. The facade can be reconstructed as similar in design to a monumental stage facade, having a row of engaged tufa columns with Attic bases (only one of which survives) that rise on a molded cornice (FIG. **100**). The lower base, cut into the tufa on which the semicolumns rise and in which the entrances to the tombs open, was adorned with frescoes along its entire length. From the few existing remains, we can discern various layers of painting, several of which depict a historical scene, probably of a military and triumphal character, while the most recent was a simple decoration of stylized waves painted in red. Several of these paintings may date to the tomb's first phase. The later ones can be dated between the middle of the second century BC, when the tomb's monumental facade was built, and the beginning of the first century BC, when the burials apparently stopped.

The main entrance to the hypogeum was at the center; its architectural revetment is lost. Farther to the left is a medieval lime kiln, which destroyed a corner of the tomb. The burial chamber, carved into a natural bank of cappellaccio, is nearly square, with four galleries along the edges and two others that cross perpendicularly at the center. The **tufa sarcophagi** were placed along the walls, sometimes within purpose-built recesses, and within the four pylons that were formed by the intersection of the galleries. There must have been more than thirty of these sarcophagi. These are of two types: one type

was carved from a single piece of tufa; the other was formed by joining large slabs of the same material. The oldest examples—those of Scipio Barbatus and of his son—belong to the first type. The rest are all of the second type. In the smaller hypogeum on the side, we find significantly larger sarcophagi.

It is instructive to follow the chronological order of the burials when visiting the site.

A (*CIL* I². 6–7). Copy of the sarcophagus of L. Cornelius Scipio Barbatus, consul of 298 BC.

The original sarcophagus in peperino, along with all the other inscriptions, is in the Vatican Museums. This is the oldest burial in the tomb and the only decorated sarcophagus. It derives from prototypes in Greek Sicily and dates to about 280 BC. The coffin, tapered and molded at the bottom, has a Doric frieze at the top with metopes decorated with rosettes. The sides of the lid have volute bolsters *(pulvini)*.

The inscription, painted on the lid, gives the name and patronymic of the deceased: *[L. Corneli]o(s) Cn. f. Scipio*. The longer inscription on the coffin, in Saturnian verse, replaced the original, which was shorter (traces of the original chiseling can be seen), and likely dates to the epoch of Scipio Africanus in the first years of the second century BC. The translation of the text runs as follows:

> Lucius Cornelius Scipio Barbatus, son of Gnaeus, a strong and wise man, whose appearance was fully equal to his valor, was consul, censor, aedile among you. He took Taurasia and Cisauna in Samnium, subjected all Lucania, and carried away hostages from there.

B (*CIL* I². 8–9). Remains of the original sarcophagus and copy of the inscription of L. Cornelius Scipio, son of Scipio Barbatus, consul of 259 BC.

This sarcophagus also carries two inscriptions, both preserved. The inscription on the lid is painted and gives the name as well as the principal offices held by the deceased: *L. Cornelio(s) L. f. Scipio / aidiles, cosol, cesor.* (We do not know the year in which L. Cornelius Scipio was aedile, but he was consul in 259 and censor in 258.) The inscription incised on the coffin, like that on the previous sarcophagus, is in Saturnian verse:

> About him alone are most of the Roman people unanimous, that he was the best of the best, Lucius Scipio. Son of Barbatus, he was consul, censor, aedile among you. He conquered Corsica and the city of Aleria, and in thanksgiving for favors received he dedicated a temple to the Storms.

The inscription (around 230 BC) appears to be older than the preceding one, for his father.

C (*CIL* I². 10). A copy of the inscription (in sperone) of P. Cornelius Scipio, son of Publius, Flamen Dialis.

This Scipio is generally held (perhaps wrongly) to be the son of Africanus, who—according to Cicero—was sickly and died young. The translation of the inscription, also in Saturnian verse, is as follows:

> You who have worn the *apex,* the emblem of the Flamen Dialis, death made it so that your honor, fame, valor, glory, and genius were of short duration. If you had enjoyed these through a long life, you would have surpassed in your own deeds the glory of your ancestors. Thus the earth gladly receives you in her bosom, Publius Cornelius Scipio, son of Publius.

E (*CIL* I². 12). Remains of a sarcophagus in slabs of Anio tufa and copy of the inscription of L. Cornelius Scipio, quaestor of 167 BC.

> L. Cornelius Scipio, son of Lucius, grandson of Publius, quaestor, military tribune, dead at the age of thirty-three. His father conquered King Antiochus.

This is certainly the son of Scipio Asiaticus, conqueror of Antiochus III, king of Syria, at Magnesia in 190 BC, and thus the grandson of Africanus and perhaps the cousin of the preceding Publius.

F (*CIL* I². 13). Remains of a sarcophagus and copy of the inscription.

> . . . Cornelius Scipio Asiagenus Comatus, son of Lucius, grandson of Lucius, dead at the age of sixteen.

From the name of the father and grandfather and from the added name Asiagenus, it seems clear that this is the son of the preceding individual.

I (*CIL* I². 16). Cornice of a sarcophagus in travertine and Anio tufa with inscription (copy).

> Paulla Cornelia, daughter of Gnaeus, wife of Hispallus.

The sarcophagus to which this inscription belonged had been placed behind that of Scipio Barbatus, within a niche that was enlarged to receive it.

D (*CIL* I². 11). Remains of a sarcophagus in sperone and copy of the inscription of Lucius Cornelius Scipio, son of Gnaeus, grandson of Gnaeus.

This stone contains great wisdom and many virtues along with a tender age. As for the one buried here, life failed him in his pursuit of political office, not honor. He was never surpassed in virtue. At the age of twenty years he was buried in this tomb. Do not search for the offices that he held. He had none.

This is, as we can deduce from the name of the father and that of the grandfather, the son of Hispallus and perhaps of the preceding Paulla Cornelia, thus a brother of Hispanus (praetor in 139 BC and subject of the next entry, H).

H (*CIL* I². 15). Remains of a sarcophagus in Anio tufa and copy of inscription (in elegiac couplets).

Gnaeus Cornelius Scipio Hispanus, son of Gnaeus, praetor, curule aedile, quaestor, twice military tribune, decemvir for judging lawsuits, decemvir for offering sacrifices. I have by my habits of life heaped virtues upon the virtues of my family. I begot a family. I have tried to match the deeds of my father. I have won the praise of my ancestors so that they are happy to have produced me. My offices have ennobled my descendants.

The inscription commemorates a son of Scipio Hispallus (consul of 176 BC) and perhaps of Paulla Cornelia (I), brother of the preceding Lucius Cornelius, dead at the age of 20 (D).

K (*CIL* I². 14). Sarcophagus in Anio tufa and copy of inscription.

[—]is / [—Sc]ipionem / [cum qu]o adveixei.

A careful study of the Tomb of the Scipios and its inscriptions in the context of ancient literary texts, especially those of Cicero, brings the history of this tomb to life. Its founder must have been Lucius Cornelius Scipio Barbatus, consul of 298 BC, or his son. The prominent position of Barbatus's sarcophagus, directly opposite the entrance, shows that it was the first and most important burial. The date of the tomb, which was perhaps constructed while Scipio Barbatus was still alive, can be assigned to the beginning of the third century BC.

There are several indications of how long the tomb continued to be used for burials. First, there is the existence of two different sections: the main section, which is the older of the two, nearly square in shape, and the side gallery, which in origin probably did not communicate with the other hypogeum but is certainly the more recent of the two. The older section must have held more than thirty sarcophagi, which accords with the number of Scipios documented between the beginning of the third and the middle of the second centuries. (Scipio Africanus was not interred here but rather on the grounds of his villa at Liternum.) The

main hypogeum must have been completely filled toward the middle of the second century BC, as we can deduce from the inscriptions.

Paulla Cornelia, the wife of Hispallus, consul of 176, probably died toward the middle of the second century BC. Her sarcophagus (I) was placed behind that of Scipio Barbatus (A). It was certainly a later burial, because her sarcophagus did not have its own front but was joined to the back of Barbatus's. The family tomb was then entirely filled at the time of her burial, so that it was necessary to resort to any free space available.

Another confirmation of the fact that the burials in the main hypogeum must have stopped around the middle of the second century BC comes from tomb F, which was also set in a narrow space beside the sarcophagus of Barbatus. Tomb F held the remains of a grandson of the conqueror of Antioch and son of the quaestor of 167, who died at the age of 33, shortly after the year of his quaestorship and certainly before 160. The son of this man, Scipio Asiagenus Comatus, thus died no later than 145, probably around 150. All that was left for his father's sarcophagus (E) was a narrow space, a short distance from the entrance.

We find additional chronological evidence in the only complete inscription that survives from the newer chamber of the monument (H): the epitaph of Gnaeus Cornelius Scipio Hispanus, son of Hispallus. He was praetor in 139 BC and must have died shortly afterward (he held no other offices). His eulogy, moreover, is in elegiac distichs, a meter of Greek origin introduced to Rome by Ennius in the early decades of the second century, while all the other epitaphs are in Saturnian verse, characteristic of the oldest Roman poetry.

The extension of the tomb into this second chamber must have taken place after 150, the latest burial date in the earlier section, and sometime before about 135 BC, the date of the one burial that has been identified within it.

We should also assign the monumental facade of the tomb to these years, for the entrance to the new hypogeum was set into it. The influence of Hellenistic architecture, which manifested itself in Italy after the conquest of the East in the second century BC, is evident here. The transformation of the tomb can likely be assigned to Scipio Aemilianus in the period between the destruction of Carthage (146 BC) and that of Numantia (133 BC). It is certainly to this period that the building of the facade and the marble portraits of Scipio Africanus, Scipio Asiaticus, and Ennius, recorded by Cicero and Livy, belong.

During the Imperial period, the monument received several cremation burials of the Corneli Lentuli, the family that inherited the tomb after the extinction of the Scipios during the early years of the Empire. Some of the Lentuli probably wanted to be buried beside the most famous Scipios to emphasize their relationship to this illustrious Republican family.

In 1927, an area occupied by tombs of various periods was discovered between the tomb of the Scipios and Via Appia. The most important of these is a large, rectangular columbarium. The ceiling rests on two cylindrical piers, one of which

is almost completely preserved, while only a few traces of the other remain. Five superimposed rows of semicircular niches, framed by stucco cornices, are still largely well preserved in the piers and in the walls. In each of these rested two terracotta urns for the ashes of the dead. The walls still have much of the original plaster and painting; below each niche are panels painted in lively colors (blue, red, yellow), intended for funerary inscriptions that, unfortunately, were never executed. During the third century AD, a multistory house was built above the tomb of the Scipios, damaging part of the monument. Evidently, the knowledge, and perhaps even the memory, of the monument and its importance had already been lost. Alongside the Roman house, toward the south, are the remains of a small catacomb.

THE COLUMBARIUM OF POMPONIUS HYLAS

In 1831 Pietro Campana discovered a small, richly decorated columbarium within the park that lies between Via Appia and Via Latina. The site was near the latter and only a short distance from the Aurelian Wall (FIG. **99**).

Entry is by the original steep stairway. The columbarium is in brick-faced concrete and can be dated to the first decades of the Empire. Above and facing the lower steps is a niche, whose apse is decorated with small limestone stalactites hanging from its roof in the manner of a nymphaeum. Below this, a glass mosaic panel, framed by a band of shells and by a plaited motif, carries a mosaic inscription that names two individuals in the genitive case: *Cn(aei) Pomponi Hylae* and *Pomponiae Cn(aei) l(ibertae) Vitalinis*. Below the inscription are two griffins flanking a cithara.

The rectangular space of the columbarium is in part carved out of the rock (approximately 4 × 3 meters). The complexity of the tomb's architecture, as well as its stucco and pictorial decoration, is striking. A spacious apse opens at the back, with an aedicula resting on a podium at the center. The latter is framed by two small columns that support the frieze and pediment. The entire structure is of brick and plaster. On either side are two other aediculas, their triangular pediments broken in the middle to frame a rounded arch set within. On the right side, the wall ends in another aedicula with a triangular tympanum. A terracotta sarcophagus, covered with tiles, was set into a rectangular space cut out below the staircase.

The left side of the tomb was redone at a later date. Two aediculas with triangular pediments, larger than the others and decorated with brightly painted stuccos, were superimposed on an older architectural part, symmetrical to that on the right side. The style of the decoration and the inscriptions date this redesign to the Flavian period. The original construction and the rest of the decoration are, therefore, older. Several inscriptions, in particular those naming Celadius, freedman of Tiberius, and Paezusa, beautician of Octavia, the granddaughter of Claudius and the first wife of Nero, are Julio-Claudian, from the years between the reigns of Tiberius and Nero (14–68 AD). To this

period belong the paintings that decorate the apse and the vault (slender grape clusters with figures of women, two of them winged, fluttering among them); the large arch above the apse, with representations of Pegasus and human figures; and the pediment and the frieze of the center aedicula, where we see a satyr (?) between two tritons, and a Dionysiac scene. At the sides of the niche with the urns there appear a male figure with a scroll in his hand and a female figure; a mystic basket, also clearly of Dionysian significance, is placed between them at the top of the niche. These figures probably represent the couple buried here, whose names are given on the marble tablet underneath: Granius Nestor and Vinileia Hedone. They, and not Pomponius Hylas, are the first owners of the tomb. The burial of Hylas probably took place in the second phase of the structure. One of the aediculas on the left, dating, as we have seen, to the Flavian period, also contains figures of a clearly symbolic and funerary nature: the centaur Chiron with Achilles, and perhaps, on the frieze, the punishment of Ocnos. The cinerary urn of Pomponius Hylas and of his wife, stolen in the Middle Ages, made its way to Amalfi, where it is still to be found.

THE COLUMBARIA OF THE VIGNA CODINI Around the middle of the nine-teenth century, three columbaria were discovered inside the former Vigna Codini (now on private property), at a short distance beyond the tomb of the Scipios, between it and the Aurelian Wall.

The first columbarium was discovered in 1840 by G. P. Campana. The hypogeum has a four-sided plan (5.08 × 7.06–7.42 meters) and is built completely of brick, except for the reticulate podium that runs along the inside walls. The floor is about 6 meters below ground level. A large square pier—even this was used for burials—supports the ceiling. Arch-shaped loculi for cinerary urns occupy the entire surface of the walls. There are, in all, about five hundred such burial niches. Above each of these is a painted surface meant for a nameplate to identify the deceased (more than sixty have been found with names), but in many cases the name was inscribed on a marble plaque, which was then applied over the painted surface. Nearly two hundred of these inscriptions have survived. To these we can add about a dozen urns and marble cippi, now in the Museo Nazionale Romano. The narrower sides and the upper sections of the pier are divided into four panels and adorned with frescoes of symbolic Dionysian scenes. The inscriptions date the tomb to the late Tiberian period, and the paintings belong to the same era.

A high marble relief from the Severan period, showing the *dextrarum iunctio* (the joining of right hands) of a man and his wife, also stands within the columbarium. This certainly does not belong to the tomb, which by the third century had been closed for some time. Anyone, on payment of a fee, could be laid to rest in this monument. A few burials belong to Imperial slaves and freedmen, but no single family name prevails.

The second columbarium was discovered in 1847 by Campana. This too is a hypogeum with a four-sided plan in *opus reticulatum*, measuring 5.90 × 5.20 meters. The floor (of crushed pottery with some marble tiles) is about 7 meters below the surface. All the walls are covered with arched loculi, each containing two burial urns. There are nine rows, the ninth being preserved only on wall B; wall A has in large part been restored. The total number of loculi comfortably exceeds three hundred. On wall C and in part on D there are substantial remains of ornamental paintings featuring vine shoots from which tambourines, masks, drinking horns, and baskets hang at regular intervals. Unlike in the first columbarium, here we find no painted surfaces for names; instead the burials are marked by small marble plaques, many without inscriptions, that evidently date back to the monument's construction. These plaques were later either incised with names or replaced with larger marble *tituli* identifying the dead. Nearly all the inscriptions on the wall were placed there when the tomb was restored in the nineteenth century, and many probably do not belong to the columbarium. It is likely, however, that an inscription that dates the arrangement of burial urns to AD 10 is original to the columbarium. An inscription in mosaic ascribes the dedication of the flooring to two *curatores* of the funeral association. Many of the burials belong to slaves and freedmen of the Imperial court. The suggestion that this is the tomb of the Marcelli, however, can be dismissed.

Several vases and small urns with meager relief work, now in the Museo delle Terme, come from this columbarium. Three portraits of good workmanship, all in the Museo delle Terme, are probably also from the tomb. One is of a woman from the Neronian period; another, from the Claudio-Neronian period, is of a man; and a third, also male, may be Flavian in date. The columbarium, then, was constructed in the late Augustan period, but the paintings are probably later. There are many references to trades and functions carried out in the sphere of the Imperial household represented here.

The third columbarium was discovered in 1852 by Pietro Codini. It is the least well known of the three. The plan is U-shaped, with its three wings interconnected. Entry is by way of two flights of stairs. The walls contain many loculi of larger than usual dimensions, and are quadrangular, broken up by aediculas and even by arcosolia. This tomb must originally have been much richer than the other two. Its walls were decorated with slabs of marble, engaged pilasters with colored marble capitals, and paintings (much of the vault is preserved, decorated with ornamental motifs clearly later than the original structure of the tomb). More than thirty cippi and small urns come from this columbarium, several of which (now in the Museo delle Terme) are of high quality. A small sarcophagus was also found, an indication that the columbarium continued to be used at a later date for inhumation burials.

The volume of epigraphical material (excluding the urns) is surprisingly small given the size of the columbarium. No more than 150 name plaques survive;

many inscriptions record names of slaves and freedmen from the Imperial household, as well as the occupations and roles performed by the deceased. The travertine brackets are evidently meant to support the platforms that would provide access to the higher loculi. Construction of the tomb must date to the reign of Tiberius, while use of the monument apparently continued throughout the second century AD, since, in addition to T. Claudii and T. Flavii, we also encounter freedmen of Hadrian, Antoninus Pius, and Marcus Aurelius.

ITINERARY 2

From the Tomb of the Scipios to Frattocchie

The course of the Appian Way beyond the city begins at Porta S. Sebastiano (the ancient *Porta Appia*) (FIG. **101:2**), the most monumental of the gates in the Aurelian Wall.

Slightly more than a hundred meters from the gate, on the right, is a copy of the first milestone (the original, inscribed with the names of Vespasian and Nerva—probably found inside Porta S. Sebastiano—was erected on the balustrade of Piazza del Campidoglio). The distance (about 1,480 meters) was calculated upon exit from the Servian Walls at Porta Capena. Shortly after this, on the left side of the street, is where the Temple of Mars must have stood **(3)**. This section of Via Appia, in fact, had the name *Clivus Martis* (Slope of Mars). A little before the railroad overpass, on the right, are the remains of a group of tombs of various periods.

The road slopes gradually downward until it crosses the course of the ancient Almo (Acquataccio or Marrana della Caffarella). This stream was of great importance in Roman cult. On 27 March, the statue of Cybele was brought in procession and received a ritual bath in the river at the point where it flowed into the Tiber.

Somewhat beyond the Almo, on the left, is a large tower-shaped tomb **(4)**, which now has a small house on top of it. Some, without good reason, have attributed the tomb to Geta, the unfortunate son of Septimius Severus, who was assassinated by his brother Caracalla in AD 212.

On the right side of the street, just before the junction with Via Ardeatina, is an old inn that blocks the view of a large cylindrical tomb standing on a base **(5)**. Five niches are carved into the cylinder. The tomb is generally identified as that of Priscilla, the wife of T. Flavius Abascantus, the most powerful freedman of Domitian (Stat., *Silv.* 5.1.208–245).

Opposite this tomb, on the left side of the street, is the little church called *Domine Quo Vadis* **(6)**, the place of the legendary encounter between St. Peter and Christ, whose footprints appear to have been miraculously

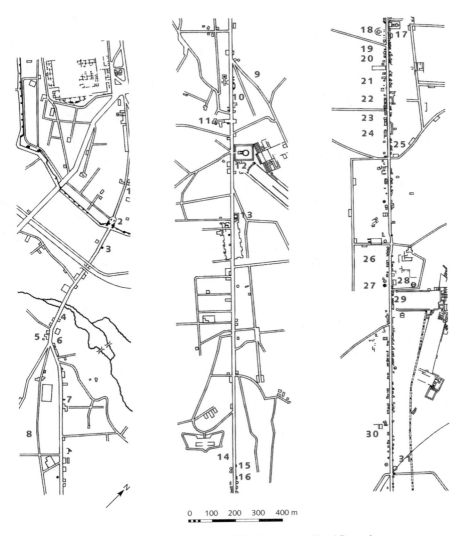

0 100 200 300 400 m

FIGURE 101. The monuments of Via Appia up to Casal Rotondo.

impressed in one of the street's paving stones, now preserved in S. Sebastiano (there is a copy *in situ*). The original is actually a typical ancient ex-voto.

As the road continues, it veers to the left. A tomb of remarkable dimensions appears on the left 350 meters farther along. Less than 100 meters ahead, again on the left (inside the inn at no. 87), are the remains of the so-called Columbarium of Augustus's Freedmen. The Columbarium of the Freedmen of Livia, discovered in 1725 a short distance beyond this (on the left side of the street), is now completely destroyed.

The shrine of the god *Rediculus* was located nearby (Pliny, *NH* 10.122). According to one ancient tradition, Hannibal brought his march to Rome to a halt at this spot.

At Via Appia no. 101, again on the left side of the street, is the little Hypogeum of Vibia **(7)**—one of the most intriguing late third-century BC funerary monuments in Rome—associated with the worshipers of the Thraco-Phrygian god Sabazius. Two arcosolia face one another in the central corridor of the tombs. That on the left, intended for two burials, held the body of Vincentius, a priest of Sabazius, and of his wife, Vibia. On the undersurface of the arch are three small paintings. In the one on the left, the motif of the rape of Proserpina is used as a symbol for death. Preceding her is *Hermes Psychopompos*, Mercury in his role as escort of the dead to the next life, who is preparing to descend into an opening below, evidently the entrance to the underworld. The inscription explains the meaning of the scene: "the Abduction and Descent of Vibia." The central painting represents the judgment of the dead woman. The small painting on the right depicts the "seven devout priests," among whom is Vincentius, reclining at a banquet, an obvious metaphor for joy in the afterlife. In the lunette of the arcosolium, Vibia appears on the left. Preceded by her *angelus bonus*, she walks through the door that leads to the world of the blessed. On the right, a banquet enjoyed by six persons ("those who have been judged as good") is underway, and Vibia is among them.

The arcosolium opposite this features designs of great interest that are more difficult to interpret. These, too, are evidently associated with the cult of Sabazius.

THE CATACOMBS OF ST. CALLISTUS The entrance to the catacombs of St. Callistus **(8)**, also spelled *Calixtus*, which are without question the most important Christian hypogea in Rome, is at Via Appia no. 110 (the entrance for automobiles is at no. 102, near the intersection with Via Ardeatina). The first systematic exploration of the catacombs was undertaken by Giovanni Battista de Rossi, beginning in 1849.

As is true of other catacomb complexes, the cemetery of Callistus was created during the course of the fourth century AD out of the union of various preexisting groups of burials, for some of which a Christian origin is anything but certain. The oldest section, named after Lucina, is immediately adjacent to Via Appia.

This consists of two burial areas, joined together when Pope Cornelius, who died at Centumcellae (Civitavecchia) around 253, was laid to rest. The creation of the Crypt of Lucina is thus older, probably to be dated near the end of the second century AD.

The so-called Area I, the region that includes the papal crypt, is only slightly later. We know that Pope Zephyrinus (199–217) entrusted to the banker Callistus (the future pope) management of the Christian cemeteries. This assignment marks the beginning of a collective organization of the Christian catacombs under the control of the church. Pope Zephyrinus himself was buried in this same complex in a surface grave not yet identified. The first pope to be entombed in the papal crypt was Pontian, who died in Sardinia during the year 235, followed immediately by Anterus, who died in January of 236 after scarcely forty days of his pontificate. It was then left to Pope Fabian (236–50) to inaugurate the crypt with the burials of his two predecessors; the event, which we can date to 236, furnishes a secure chronological terminus for Area I.

The other main sections of the cemetery of Callistus are designated by the following names: the Region of Pope Melchiades (or Miltiades), that of the Greek martyrs (sometimes called the Region of Pope Eusebius), the Region of St. Soteris, the Liberian Region, and finally the Labyrinth or the *Arenarium* (quarry) of Hippolytus.

The entrance to the catacomb is now by way of Area I. It is preceded by a structure with three apses *(cella trichora)*, identified as the Basilica of St. Sixtus and Cecilia, which has been transformed into a museum. Inscriptions and sculptures (in particular fragments of sarcophagi) from surface burials are displayed here, as is the bust of de Rossi. It is usually supposed, but without conclusive evidence, that the body of Pope Zephyrinus, together with that of the martyr Tarcisius, was buried in the central apse. Some situate the martyrdom of Pope Sixtus II here as well; he was seized and decapitated on the spot along with four deacons during the persecution of 258, as we learn from a letter of Cyprian.

Two stairways lead down to Area I (FIG. **102:A** and **B**). The first ends in a vestibule with graffiti-covered walls (a sign that people who were venerated were buried nearby). From here we enter the papal crypt **(L),** discovered in a deplorable condition in 1854 and now almost completely reconstructed with attention to the original plan. The crypt contains four niches for sarcophagi and twelve loculi, six on each side (it was designed to accommodate sixteen burials). According to the *Liber Pontificalis* and other sources, at least fourteen popes were buried in the catacombs of Callistus. Among these, Zephyrinus was buried in a surface grave, Cornelius in the crypts of Lucina, and Gaius perhaps in the Region of St. Soteris. Of the other eleven, we have definite testimony from surviving inscriptions of five pontiffs in the papal crypt: Pontian (230–35), Anterus (235–36), Fabian (236–50), Lucius (253–54), and Eutychian (275–83). The inscriptions, cut into the marble slabs that closed the loculi, carry quite simply the name of the pope, in Greek, with the designation

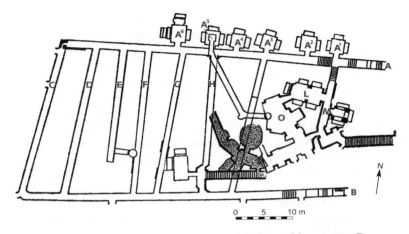

FIGURE 102. Catacombs of St. Callistus. Area I: **L** Crypt of the popes; **O** Crypt of St. Cecilia; **M** Cubicle of Orpheus; **A** Gallery of the Sacraments.

episkopos. The presence of the body of Sixtus II is assured by graffiti with his name.

Pope Damasus decorated the chapel with spiral columns and an architrave at the entrance. He had two poems engraved by his calligrapher, Philocalos. The first was found in fragments, reassembled, and placed at the rear of the crypt. It exalts the martyrs and the popes buried in the cemetery, as well as an unknown group of Greek martyrs. The poem ends with an expression of the pope's desire to be buried next to his predecessors, a wish that modesty compelled him to renounce. (Damasus was in fact buried, with his mother and sister, in another cemetery, next to the catacombs of Callistus.) Remains of the altar base and the episcopal chair stand in front of the inscription.

The crypt next to that of the popes is named for St. Cecilia **(O)**, whose tomb tradition situates in this spot, although her very existence is doubtful. She is said to have been killed in her house in Trastevere. The chapel is adorned with Byzantine frescoes depicting the saint, Christ, and St. Urban. A copy of the saint's statue by Stefano Maderno (the original is in the Basilica of S. Cecilia in Trastevere) now stands in the niche in place of the sarcophagus.

Another chapel adjacent to the papal crypt **(M)** features a beautiful painted ceiling that contains a rather unusual representation of Orpheus.

Stairway **B** leads into a corridor, joined to another parallel corridor by a series of transverse passageways that form a regularized area. Six chapels (FIG. **A¹** to **A⁶**) open onto corridor **A,** evidently intended for wealthy families, as attested by the rich pictorial decoration. The subjects depicted in these chapels have been interpreted as symbolic representations of the sacraments (the popular name of corridor **A**—the "Gallery of the Sacraments"—derives from these

images). Nevertheless, the complexity of the decoration defies a single thematic explanation. In the first cubicle we find the figure of Moses causing water to gush from the rock, a fisherman, and a banquet scene. In the second cubicle we again find Moses and the fisherman, but also the baptism of Christ, Jesus' healing of the paralytic, and a banquet. Opposite this are the sacrifice of Abraham and the figures of Jonah and of the Samaritan woman. The banquet appears in other cubicula as well, along with the cycle of Jonah.

From here one can go on to the Region of St. Soteris, where there is a small *trichora* basilica resembling that of Sts. Sixtus and Cecilia. In the "Cubicle of the Sheep" (neither this nor the following sites are on the plan) there are paintings of the Good Shepherd, Moses making water spring from the rock, and the miracle of the loaves.

The cubicle of St. Severus is especially important because of the discovery of a long inscription incised on the panel of a marble grille, in which Severus, the deacon of Pope Marcellinus (296–304), records the construction of the "double cubiculum with arcosolia and skylight" intended for his own family. A cubicle east of this may be that in which Pope Gaius (283–96) was buried; an inscription in Greek bearing the name of the pope and the date of his death, 22 April, was found here.

Nearby, there is a painting with a judgment scene, either that of a woman martyr or of Susanna defended by Daniel.

The two large cubicles opposite one another in the area behind **A¹** are very interesting for their paintings, with symbols of the seasons in the first, while the vault of the second illustrates the resurrection of Lazarus.

The widened area at the juncture of four galleries (called the "Four Piers") gives access to the other areas of the catacomb, among which are the so-called Liberian region and the Crypts of Lucina; the latter are probably the oldest section of the catacombs of St. Callistus.

The heart of the entire complex is the crypt (not on the plan) that houses the tomb of Pope Cornelius (251–53). The inscription, in contrast to those of the other popes, is in Latin—*Cornelius martyr ep(iscopus)*—perhaps because this was a private tomb. The body of the pope was transferred in the ninth century to S. Maria in Trastevere. The crypt is decorated with Byzantine paintings representing Sixtus II, Cornelius, and St. Cyprian.

THE CATACOMBS OF PRAETEXTATUS AND THE JEWISH CATACOMBS The entrance to the Catacombs of Praetextatus is at Via Appia Pignatelli no. 11, on the left side of the street (FIG. **101:9**). Several features of the catacomb make it unusual among Rome's Christian cemeteries, including the large dimensions of the central gallery and the exceptional sophistication of the decoration in some of the cubicula, as well as the presence of a group of third-century sarcophagi. The fact that one of these belonged to the emperor Balbinus underscores the possible relationship of the cemetery to the nearby Triopion of Herodes Atticus,

which must have come into the Imperial domain perhaps as early as the death of its original owner.

The central gallery (the *spelunca magna*) seems originally to have been a large cistern. This was taken over by the cemetery at a very early phase, toward the middle of the second century. The other large section, accessed through two entrances located a little to the west (the so-called major stairs and minor stairs), is of later date. The entrance to the underground galleries is by way of a large quadriporticus, built in 1930 as an antiquarium. At one corner we see a beautiful third-century AD sarcophagus with figures of a sea cortège. The sarcophagus of the emperor Balbinus, killed in 238, stands at the center of the back wall. A representation of the emperor with his wife decorates the lid. On the sides of the sarcophagus are scenes from Balbinus's life. In another corner stands a large sarcophagus depicting a lion hunt, with two horsemen in the presence of Virtus (military valor) and the Dioscuri at the far edges of the scene.

Two Christian sarcophagi occupy the room to the right of the quadriporticus. From here we descend into the catacomb, entering the *spelunca magna*. The name ("the great cave") is attributed by the medieval itineraries to the large central gallery, where the principal martyrs must have been buried. On the right is a large arched entrance in brick, and a little farther on (to the left) we see the large inscription from the time of Damasus praising the martyrs of the catacomb. There follows, on the left, another large brick portal, providing access to a cubicle. A little farther, on the left, is another brief inscription from the age of Damasus, containing a dedication to the martyr St. Januarius.

Opposite this, on the right, is the entrance to the most important cubicle in the site, attributed (albeit without clear evidence) to Januarius. The room is square, with three niches and a pavilion vault. The lower part of the room was revetted with slabs of giallo antico, while the upper part is covered with an extraordinary and florid decoration, painted on a white background. In the vault are representations of the four seasons and tufts of flowers with crowns. Birds of variegated color fly among clusters of grapes. Farther along, on the right, a widened area opens up, semicircular in form, in front of which is an arcosolium (perhaps a martyr's tomb) flanked by porphyry columns.

Continuing for a short distance, on the left side we enter an important cubicle of the fourth century, with inscriptions that assign it to a certain Lucentius. A corridor begins on the right, which leads quickly to a cubicle with three large arcosolia, much damaged by landslides and pillaging but nonetheless—owing to the exceptional nature of its decoration—one of the more significant in the entire hypogeum. The lower part of the walls was in fact covered with marble *opus sectile*.

A little beyond the Catacombs of Praetextatus, on the right, is the entrance to a small Jewish catacomb. The entrance to another and more important Jewish hypogeum on Via Appia—that of the Villa Randanini, discovered in

1859—lies a short distance beyond the intersection with Via Appia Pignatelli, on the left (FIG. **101:10**). This underground cemetery made use of an earlier pagan structure.

ST. SEBASTIAN (S. SEBASTIANO) The archaeological complex of St. Sebastian (FIG. **101:11**), among the most important in Rome, has several features that make it unique among Rome's cemeteries. First of all, it was here that the term "catacomb," which was at first used exclusively for S. Sebastiano, was born. The name (Greek: *katà kýmbas*, "near the hollows") alludes to the deep cavities, primarily stone quarries, that mark the area. Though known at an earlier period as the *Memoria Apostolorum* because of its association with the cult of Sts. Peter and Paul, it was only later that the cemetery assumed the name of the principal martyr buried here, St. Sebastian.

The history of the site begins at the end of the Republic, when the underground quarry must have been occupied by the first tombs. Over time, a series of buildings arose above the quarry: to the north a double line of columbaria, datable between the Julio-Claudian period and the beginning of the second century AD; to the west of these, the so-called Small Villa, a third-century building; to the southeast, the Large Villa. After the collapse of the quarry, a large open cavity was created, the so-called *Piazzuola* or "Small Square," in the area adjacent to it on the southeast. The brick facades of the three remarkable hypogea—of Claudius Hermes, of the *Innocentiores*, and of the Axe—were later built to open onto this square. During the middle of the third century, the Piazzuola was completely filled in and replaced by the *Triclia*, an open courtyard with large colonnaded galleries, intended for the celebration of the cult of the apostles. Finally, at the beginning of the fourth century, the whole area was buried under the foundations of the cemetery's large basilica. Numerous mausolea were added on the side of the basilica in late antiquity (FIG. **103**).

The basilica owes its present appearance to a restoration by Scipione Borghese (1609–12), which narrowed the church, originally considerably larger, to its central nave. The earlier structure thus resembles the kind of church typically found within Roman cemeteries, such as those at S. Agnese, S. Lorenzo, the mausolea of Helena, and of the Villa of the Gordiani. The shape was probably inspired by that of a circus, as we can surmise from the facade, which is clearly oblique with respect to the nave's axis.

The construction, in the usual *opus vittatum* of the fourth century AD, was 73.40 meters long overall and was preceded by a courtyard without a porticus. The nave and aisles were divided by piers, surmounted by brick arches. The wealthiest tombs, which were basilical in structure and articulated along a central plan, opened around the smaller aisles. Among these tombs the most important is the "Platonia," a structure of irregular shape dating to the end of the fourth century, southeast of the apse, in which the tomb of St. Quirinus has been identified. Near the southeastern corner of the aisle is the crypt of St. Sebastian,

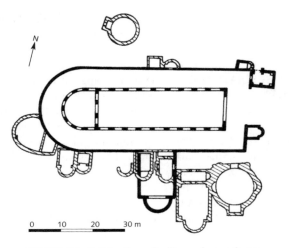

FIGURE 103. S. Sebastiano. Basilica and mausoleums.

where the body of the martyr was laid to rest. The crypt was remodeled several times between the Middle Ages and the seventeenth century.

The Memoria Apostolorum (the so-called Triclia), which was still partly accessible after the construction of the basilica, forms the cult center upon which the whole complex was focused (FIG. **104**). It was essentially a trapezoidal courtyard (23 × 18 meters), paved in brick and closed by porticoes with piers on its northern and eastern sides. The Memoria Apostolorum lies between the Large Villa to the west and a row of columbaria on the north. The eastern side of the courtyard was originally occupied by a vaulted room associated with the villa, of which only a small section on the north survives. A niched structure— probably the cult center—was built up against this. On the opposite side, to the south, an apsidal cella with two columns at the front was added later.

The red plastered walls of the porticoes are covered with hundreds of graffiti celebrating Peter and Paul. It is clear that gatherings and funeral meals in honor of the apostles took place here. Documents of remarkable antiquity date the foundation (or the refoundation) of the cult of the apostles on Via Appia to 258, the year of Valerian's persecution. It is thus presumed that, on this occasion, the bodies of Sts. Peter and Paul were provisionally transferred here. Others, however, maintain that this was in fact the original tomb of the apostles.

The tradition that Peter and Paul resided here for a time has various arguments in its favor. Among these is the presence of a graffito that reads *domus Petri* (the home of Peter) in one of the fourth-century mausolea. The founding date of 258 can be explained by a provisional transfer of the cult that came to be celebrated in the basilicas of St. Peter and St. Paul, but which had become too dangerous during the persecution. The transfer of the bodies to this location

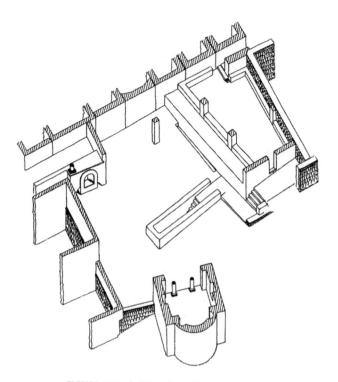

FIGURE 104. S. Sebastiano. Perspective view.

could thus be explained by the belief—correct or incorrect—that the apostles once resided here.

The Large Villa is entered down a small flight of steps from the street that lies on the west. The building consists of several rooms arranged around a courtyard with a white mosaic pavement. The construction, in *opus reticulatum* with some brick work, probably dates to the first century AD, and the wall paintings, which represent a late phase of the Fourth Style, date between the end of the first and the beginning of the second century. The decoration of the largest room, with a very beautiful landscape of seaside villas, is especially interesting.

North of the Large Villa is the so-called Small Villa, which can be entered directly from the street west of it by a stairway. It consists of a small paved courtyard in black-and-white mosaic, with piers that support a covered porticus. Below the courtyard, illuminated by a central skylight, is a large room completely covered with perfectly preserved paintings that constitute some of the most remarkable examples of geometric wall painting characteristic of the first half of the third century. The brick bench along the walls suggests that the room was

used for gatherings or as a waiting area. The building may have been intended for funeral rites.

The decoration of several nearby columbaria, aligned along a side road that must have intersected Via Appia, is of particular interest. Among the most striking of Rome's columbaria complexes, it documents the development of funerary architecture and decoration over the course of the entire first century AD.

The next phase is well documented by the three tombs erected in the Piazzuola, which were later obliterated by the Triclia. The area houses a funerary complex—certainly pagan, as is the preceding one—built all at one time toward the end of the Hadrianic period or immediately afterward (AD 125–40). The first tomb on the right, belonging to M. Clodius Hermes (as we can gather from the inscription still *in situ*), has a beautiful facade of very fine brickwork. Inside is a cubicle with small niches for cremation burials, as well as loculi for inhumation. The rich decoration (a transparent vase with fruit, a parrot and other birds, the head of Medusa on the ceiling) dates to the tomb's first phase. During the first half of the third century, the room was refurbished and given a second pictorial decoration. Especially important is the octagonal medallion in the vault, which depicts a heroic individual before a group of people, which some have interpreted (incorrectly) as a representation of Christ. In fact, it should be considered quite simply the heroization of the deceased person.

The "Tombs of the *Innocentiores*" (at the center) and "Tomb of the Axe" (on the left) have brick facades identical to that of the tomb of Clodius Hermes. The arrangement on the inside, however, is different, with very steep stairs leading to the funerary cells, the vaults of which are sumptuously decorated with stucco medallions, featuring rose ornaments and other vegetal elements.

THE CATACOMBS OF DOMITILLA Via delle Sette Chiese (north of St. Sebastian) leads to Via Ardeatina, where the entrance to the catacombs of Domitilla is situated (see FIG. **126**). According to modern tradition, the Domitilla who gives her name to this hypogeum was the wife of the consul Flavius Clemens, put to death by Domitian in AD 95, or alternatively Domitian's niece, exiled to the island of Ponza, having played a leading role in the conspiracy that led to the emperor's murder. Recent studies, however, have shown that no part of the Christian cemetery can date back to such an early period. The first tombs, for the most part privately owned, are in fact no older than the second century, and their fusion into a single funerary complex occurred only at the end of the third or in the fourth century.

One of the original clusters of tombs belonged to the Flavii, a hypogeum, certainly pagan, that dates to the end of the second century. It was built into the side of a hill and has a large brick facade.

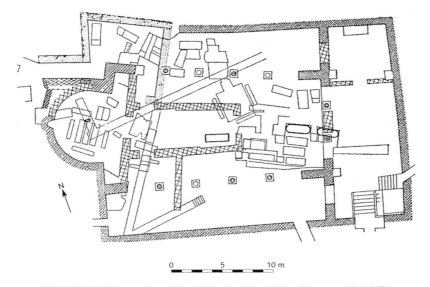

FIGURE 105. Catacombs of Domitilla. Basilica of Sts. Nereus and Achilleus. (After Testini)

The hypogeum of Ampliatus is at the foot of a large stairway and in its first stage consisted of only two cubicles. That on the right belonged to an individual named Ampliatus and his wife, Aurelia Bonifatia, as inscriptions indicate. This, too, was probably a pagan hypogeum, inserted into this network of catacombs in the second half of the third century.

The largest and most important section of the complex is that of the Good Shepherd, entered through a large stairway that leads into a long gallery. This is the first segment of the region, which in origin was privately owned like the others. Opening onto the main gallery are rather large and rich cubicles, some originally faced in marble, as well as transverse galleries that intersect it. A second flight of stairs, narrower than the first, leads down to the second level of the hypogeum, consisting of a very wide gallery without burials. At the end of this is a room onto which the third-century "Cubiculum of the Good Shepherd" opens. The name alludes to a painting of a shepherd represented with his flock—a very common theme—at the center of the vault.

Three other groups of tombs surround the underground Basilica of Sts. Nereus and Achilleus: the hypogeum of the sarcophagi, containing several strigilated sarcophagi with lions' heads and medallions, and that of the Flavii Aurelii, usually considered to be a single unit but in reality comprising two sections. These very poor and simple funerary complexes were used by Christians

from the end of the second century. The soldier-martyrs Nereus and Achilleus, as well as Petronilla, were buried here.

The fourth century witnessed a large-scale reoccupation of the entire cata-comb, with richly decorated cubicula and arcosolia, in addition to an enormous number of very simple loculi. Among these additions in the section of the "Good Shepherd" mention should be made of the cubicle of David, named for the un-usual painting on the vault that depicts David with his slingshot. Also of great interest is a fourth-century arcosolium, decorated with mosaic, that was found in 1960 in the central part of the cemetery. The lunette depicts Christ enthroned between Peter and Paul; the vault contains three scenes, including the three Hebrew men in the furnace at the center and the resurrection of Lazarus on the left. The scene on the right is almost completely destroyed.

At the end of the fourth century, the crypt of the martyrs Nereus and Achilleus was incorporated within a large basilica. Identification of the tomb of the martyrs is made certain by the discovery of fragments from an inscription of Damasus, stating that the martyrs were honored here, and of a small column, now placed in front of the apse, that contains a depiction of Achilleus's martyrdom.

THE VILLA OF MAXENTIUS Between the second and the third milestones on the left side of Via Appia lies the sprawling villa and circus of Maxentius, which includes the mausoleum of Romulus (FIG. **101:12**). The whole complex, built during the brief reign of the emperor Maxentius (AD 306–12), extends over an area bordered by Via Appia, Via Appia Pignatelli, Via di Cecilia Metella, and Vicolo della Basilica.

Of the three buildings that constitute the Maxentian complex, the least well preserved and the least known is the palace, set on top and along the slopes of a small hill, which was regularized for this purpose. In front of the villa, abutting the northern corner of the porticus that encloses the mausoleum, are remains of several rooms from the baths.

In front of the villa's foundation lies the larger of two nymphaea, which faces south. It was built into the rock, dressed in *opus reticulatum*, and roofed by a concrete vault. Some traces of its pictorial decoration and of glass mosaics still survive. The smaller nymphaeum is similar and lies on a line with the first but farther to the east.

The terrace of the villa, as was typical of the times, was built over a cryptopor-ticus, originally 115 meters long, consisting of two long parallel galleries, roofed by a barrel vault and divided by piers. Light entered through raking windows. The cryptoporticus dates to the villa's first phase: the late Republic. During the third phase (mid-second century AD), the cryptoporticus was interrupted by a series of three rooms; at that time, two large towers, which were in fact panoramic viewing pavilions, were added to the ends of the cryptoporticus.

At the terrace level, various rooms flank the basilica-shaped room, which is the most important hall of the entire palace complex. Two entrances opened

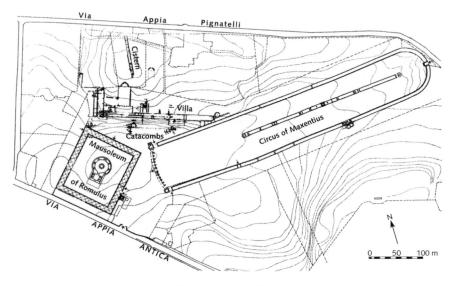

FIGURE 106. Villa of Maxentius. Plan of the complex.

onto a rectangular atrium; two additional doors are located to either side of the apse. The hall, which measures 33.10 × 19.45 meters, was heated by terracotta pipes in the walls. The hall, evidently dating to the time of Maxentius, was in the form of a basilica, the room in the palace characteristically used for public meetings and ceremonies.

North of the apsidal hall is a long and narrow cistern, of which a section approximately 63 meters long has been preserved. East of the cistern rises a vaulted, semicircular structure, probably in origin round and usually now identified as the monumental entrance to the palace in its last phase, that of Maxentius.

As is evident from the preceding discussion, there are four identifiable phases of construction in the building. The earliest of these was in the first century BC. In the second phase, during the Julio-Claudian period, the nymphaea and the cistern were built in *opus reticulatum*. An important phase, with construction in *opus mixtum*, followed at the middle of the second century AD. This phase is especially interesting because it should probably be assigned to the Triopion of Herodes Atticus. The fourth and last phase is that of Maxentius, when the villa was transformed into an Imperial palace by the addition of the basilica, the large northern entrance, and above all the circus and the mausoleum.

The **Circus of Maxentius** is an integral part of a single complex that includes the palace and the mausoleum. Antonio Nibby carried out important excavations in 1825 on behalf of the Torlonia family, who owned the property at the time. A long ambulatory, which continued the walkway built above the villa's

cryptoporticus, connects the palace to the circus. The Imperial box, positioned just above the finishing post, was a large rectangular enclosure, joined at the back to a rotunda. The circus, in *opus vittatum* like the villa and the mausoleum, extends from east to west for a total length of about 520 meters. Its width varies, reaching 92 meters at its widest. The twelve *carceres*, the stalls from which the chariots started, are located at the western end. The largest entrance to the circus, now mostly in ruins but originally spanned by an arch, was at the center of the *carceres*. At the ends of the western side rise two towers whose plan is square, though the side bearing the facade is curved. The tiers, which rested on a vault lightened by the insertion of amphoras within the masonry, have largely collapsed. We can reconstruct the grandstands as having twelve steps, allowing for six rows of seats, with a total capacity of around ten thousand spectators. There was also a box, quite complex in design, on the south, at a point two-thirds down the length of the circus east of the starting gate.

In the curved eastern end of the circus stood a large arch (the triumphal gate), which could not have accommodated chariots, since the approach was over a stairway. It was here that fragments of the dedication to Romulus, the son of Maxentius, were found in 1825. These, now displayed on a side wall within the arch, identify the complex as belonging to Maxentius and not, as was once supposed, to Caracalla.

At the center of the track (which measures approximately 500 × 78 meters) is the *spina*, the axis around which the chariots turned. It measures 296 meters in length (corresponding to 1,000 Roman feet). Two semicircular *metae* (still standing but detached) marked the ends of the *spina*. Each was surmounted by three cone-shaped elements, which were partially sculpted with scenes of chariot races. The *spina* consisted of a series of water basins, placed so that they formed a canal *(euripus)*, with sculptures and small shrines (aediculas) set at intervals along its course. At the center, a foundation bed within a recessed space indicates the original site of Domitian's obelisk, taken from some unknown structure and moved by Innocent V in 1650 to Bernini's Fountain of the Four Rivers in Piazza Navona.

The **Mausoleum of Romulus,** commemorating the deified son of Maxentius who died in AD 309, stands near and faces Via Appia (FIG. **107**). There is no question that Romulus was entombed here, but the structure was in all likelihood intended as a dynastic mausoleum for the whole family, as the number of loculi suggests.

The tomb itself was surrounded by a large, somewhat irregularly shaped quadriporticus. The arcade, facing the inner courtyard, rests on brick piers and runs parallel to the solid exterior wall. The ceiling was formed by small cross vaults, of which some traces survive on the east.

The mausoleum stands at the center of the porticus. It is a circular building roughly 33 meters in diameter, and was preceded by a rectangular porch (21.50 × 8.60 meters), similar in type to the Pantheon and to a large number of fourth-century sepulchral monuments. The structure had two floors, of which

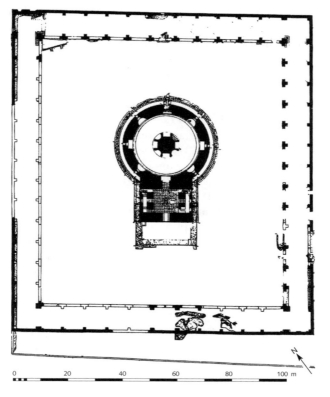

FIGURE 107. Villa of Maxentius. Mausoleum of Romulus.

only the lower story, which is now partly below the surface of the ground, survives. The mausoleum is partly hidden on the side facing Via Appia by a large nineteenth-century farmhouse; it has been completely stripped of the masonry that faced it.

The porch had two sections, the first of which originally supported the front colonnade. The tomb proper is a barrel-vaulted circular room, at the center of which is a massive pier (7.50 meters in diameter). In the outer walls are the niches, alternately rectangular and semicircular, intended for sarcophagi. Two of the eight niches, those on the longitudinal axis, were replaced with entrances; eight niches in the central pier were similarly arranged. The upper level of the monument, which was certainly meant to accommodate the funerary cult, has almost entirely disappeared; it probably had a large cupola, as is the case with similar buildings of this period. On the eastern side, along the exterior of the mausoleum's enclosure wall, are the remains of a smaller funerary

monument, perhaps dating to the early Augustan period, called the Tomb of the Sempronii.

The location of the **Triopion of Herodes Atticus** has been ascertained by the discovery of an Antonine phase within the villa of Maxentius. The documentation for the large suburban complex known as the Triopion consists essentially of six Greek inscriptions, found between the second and third milestones of Via Appia. It is now clear that the Triopion, recorded in these inscriptions, was on the left side of the street between the middle of the second and the middle of the third mile, precisely in the area today occupied by the villa complex of Maxentius.

Herodes Atticus was an Athenian millionaire, a well-known orator, and an exponent of the cultural movement known as the Second Sophistic. He arrived in Rome under Antoninus Pius and became the teacher of his two adopted sons, the future emperors Marcus Aurelius and Lucius Verus. Herodes attained the consulship at Rome in AD 143 and married a member of the Roman nobility, Annia Regilla, who brought him her dowry, including the properties on Via Appia. Annia Regilla died suddenly, and her hot-tempered husband was suspected of involvement in her death. Annia's brother, Annius Appius Atilius Bradua, who was consul in the same year, had Herodes Atticus brought to court. The trial, which took place in Rome, exonerated Herodes. To further dispel suspicion, he indulged in a dramatic show of grief, consecrating the entire Via Appia estate—renamed the Triopion—to the gods of the underworld and to the funeral cult of Annia Regilla. It is likely that the name *Triopion* was derived from the sanctuary of Demeter at Cnidus, which was founded by the Thessalian hero Triopas.

Several important facts emerge from inscriptions found in the villa, including the position of the Triopion at the third mile of Via Appia and the existence of a village within the property. We also learn that there was a temple dedicated to Demeter (the Greek counterpart to Ceres) and to the "new Demeter": the deified empress Faustina. A statue of Regilla, "neither mortal nor goddess," as the inscriptions define her, was displayed in this temple, thus transforming her into a figure of heroic stature and a participant in a cult dedicated to the deified wife of the emperor.

The heart of the villa should be identified, as observed, with the third (i.e., the Antonine) phase of the complex, which in time came into the possession of Maxentius. The most important remains of the Triopion can be seen by turning back toward Via Appia Pignatelli where, roughly in the area of Maxentius's palace, a path veers off to the left and leads to the Church of S. Urbano alla Caffarella (now on private property). What survives is a prostyle, tetrastyle shrine, which originally stood on a podium (now completely buried) that was transformed into the church in the ninth century. The four Corinthian columns of the facade, as well as the architrave (composed of three undecorated fascias), are of Pentelic marble from quarries near Athens, once the property of Herodes

Atticus. The rest of the temple is in *opus latericium*, with brick stamps dating to the era of Marcus Aurelius. The cella is nearly square and roofed with a barrel vault. The articulation and decoration of the side walls and of the vault were largely respected during its transformation into a church. The original paintings were replaced by a group of frescoes in 1011, with scenes from the New Testament and depictions of Sts. Urban and Cecilia.

The vault preserves substantial remains of the original stucco decoration. At its base is a frieze of weapons (partly preserved on the right side), while the rest of the vault is divided into a series of octagons, which enclose small squares in the spaces formed where they intersect. The only substantially preserved octagon is the most important one, that at the center. Here we see two figures in procession, a female on the left and a male on the right, bearing offerings to the divinity. That these represent Herodes Atticus and Annia Regilla, as has at times been suggested, seems quite plausible. The building at some point came to be identified as the temple of Ceres and Faustina, as one of the inscriptions indicates.

Another building that certainly forms part of the Triopion complex is the so-called Nyphaeum of Egeria, located at the foot of the hill on which a temple rises, facing the Almo. This is a rectangular, vaulted structure in *opus mixtum*, preceded by a projecting anteroom. A channel runs behind the building, supplying water for the fountain that issued from the main niche inside the building.

A visit to this area might also include the Valley of the Caffarella and the so-called **Temple of the god Rediculus,** also mistakenly identified as the tomb of Annia Regilla. It is actually a beautiful and well-preserved yellow and red brick tomb, dating to the first half of the second century AD.

FROM THE TOMB OF CAECILIA METELLA TO THE ELEVENTH MILESTONE

Immediately beyond the Villa of Maxentius, Via Appia rises in the direction of the tomb of Caecilia Metella, located on the left side of the street (FIG. **101:13**). This is the best-known and the best-preserved mausoleum along the Appian Way. The tomb is in the form of a circular drum (29.50 meters in diameter, equal to 100 Roman feet, with a height of 11 meters) set upon a square concrete base now stripped of its revetment. The facing is preserved, however, over the entire surface of the drum and consists of smooth travertine blocks. The marble frieze carries a relief of bucrania and festoons; the inscription, flanked by trophies at each end, identifies this as the tomb of Caecilia Metella, the daughter of Q. Metellus Creticus (consul in 69 BC) and the wife of a Crassus, probably M. Licinius Crassus, son of the fabulously wealthy contemporary of Caesar and Pompey. The importance of the person buried here accords with the grandeur of the monument, which almost certainly dates to the beginning of the Augustan period. The top of the mausoleum would originally have been a cone-shaped earthen mound, not the medieval battlements now seen in its place.

The castle of the Caetani family that incorporated the monument abuts the south side of the mausoleum, which was used as a large tower for the fortress.

To the right of the entrance, fragments of tombs excavated in the area during 1836 are inserted into the wall. Within the castle, in a small antiquarium, is a display of decorative fragments and inscriptions.

Entrance to the tomb is through a long corridor. The cella had the form of an enormous cone, faced in brick, one of the oldest dated examples of *opus latericium*. Opposite the mausoleum, on the other side of the street, is the small Church of S. Nicola di Bari, built by the Caetani.

Farther down the road, beyond Casale Torlonia (on the right at no. 240), there are no longer walls along the sides of the street, making it much easier to reach the tombs.

Some distance beyond on the right is a marble relief **(14)** representing a life-size figure of a man in heroic nakedness, with a breastplate at his feet, in the style of Hellenistic sculpture.

Next, on the left, is one of the monuments constructed by Antonio Canova in 1808 **(15)** to preserve the remains discovered on the site in that year. These remains, as the inscription tells us, are from a tomb erected by the freedman M. Servilius Quartus at his own expense.

At this point we have reached the distance of the fourth milestone. Immediately beyond this, on the left, is another of Canova's monuments, upon which various sculptural fragments are fixed.

On the left is an interesting circular tomb from the beginning of the Empire. The inner chamber **(16),** which is vaulted, had four niches containing sarcophagi.

Again on the left, beyond the casale, a marble slab with a verse inscription commemorating a certain Sextus Pompeius Iustus is embedded in a small monument typical of those found along Via Appia.

On the same side of the street are the remains of a large building **(17),** set on top of a brick podium, which has apses on three sides and had granite columns on the facade (now lost). A short stairway allows access to the building, which dates to the second century of the Empire. It was surrounded by a rectangular porticus and opened onto the street. Some have proposed that the structure was the Temple of Jupiter at the fourth milestone, mentioned in the *Acts of the Martyrs*.

Almost directly opposite this, on the other side of the street, is a side road that leads to a villa excavated during the nineteenth century **(18).** The way is blocked halfway by a large brick tomb. Some have posited that the tomb is the burial place of St. Urban, and that the villa is the *Domus Marmeriae*.

A little farther on, we encounter a tomb in the form of an altar **(19),** built of peperino ashlars. Its Doric frieze is quite well preserved, with metopes depicting a helmet, rosettes, and vessels. The tomb is of particular importance because the structure, dating to the Sullan period, is one of the earliest instances of a Doric frieze on this type of monument, a use that became widely diffused during the late Republic and the early Empire.

The reconstructed monument that follows on the right, ascribed to Luigi Canina, joins together elements of a relief pediment with five busts. The original

relief was transferred to the Museo delle Terme. What we see now is a cement cast, as is the case with other similar monuments along the ancient road. An inscription naming Ilarius Fuscus, which may have been part of the pediment, is now gone **(20).**

Continuing along the right side of the street, we come to a brick columbarium and Canina's reconstruction of a monument belonging to freedmen of Claudius. Beyond lie remains of another columbarium in *opus latericium,* and a modern reconstruction that assembles various architectural fragments. The tomb **(21)** probably belonged, as the inscription (now removed) attests, to a man named Q. Apuleius Pamphilus.

The next tomb on the right is an impressive construction in *opus latericium,* datable to the second century **(22).** It has the familiar underground crypt with niches for sarcophagi and a small vaulted templelike shrine on a high podium with a frontal staircase.

Continuing along the right are the reassembled fragments of a remarkable monument in the form of an altar. The marble relief with three busts (replaced here with a cast) might have been part of this structure **(23).** From left to right are the portraits of the individuals named *C. Rabirius Post(umi) l(ibertus) Hermodorus, Rabiria Demaris,* and *Usia Prima sac(erdos) Isidis (CIL* VI.2246). The first two were probably freedmen of the famous C. Rabirius Postumus, defended by Cicero, a wealthy merchant and banker who was also the minister of finance for Ptolemy Auletes. The third figure, the priestess of Isis, was added at a later period by recarving an earlier representation, probably of a male.

Next on the right is another important Sullan altar-shaped tomb built of peperino ashlars **(24),** surmounted by two volute cushions on the sides, with a mask of Medusa and a frieze that depicts cupids holding garlands. The monument has been extensively restored. The next tomb is in the form of a high tower. A pediment with a central rosette is displayed on the tomb, along with the copy of a relief depicting four busts.

On the left side of the road is a monument in the form of a four-sided arch **(25),** probably imitating the Porta Triumphalis and symbolizing the apotheosis of the tomb's occupant.

The remains of several poorly preserved tombs and aediculas, as well as a number of funerary statues, follow on both sides of the street after the intersection of Via Appia with Via Erode Attico and Via Tor Carbone. An impressive line of tombs skirts the next stretch of the road. On the right is the core of a large round tomb, dominated by a medieval tower.

At this point, the street veers slightly to the left and then resumes a straight course a little farther on. The cippus for the fifth mile must have stood at the center of the curve. For some time this irregularity in the street has been noted and connected with the tradition of the *Fossae Cluiliae,* a trench that marked the border between the territory of Alba Longa and that of Rome. Here the conflict between the Horatii and the Curiatii was supposed to have taken place during

the reign of Tullus Hostilius. The encounter definitively settled the question of Rome's supremacy in Latium and marked the disappearance of Alba as an autonomous center.

Thus the beginning and the end of the curve in the road are marked by round mausolea **(26),** both on the right. The first has already been mentioned; the second is known as the Tumulus of the Curiatii.

About 300 meters farther, on the right side of the street, are two more circular mound tombs, placed very close together **(27).** The identification of these tumuli as the tombs of the Horatii and the Curiatii has by now been almost universally abandoned; rather, they are simple tombs. Livy (1.25), however, affirms that in his lifetime, during the reign of Augustus, at the fifth mile of Via Appia, the tombs of the Horatii and the Curiatii could still be seen. This complex may be a learned reconstruction informed by Augustan ideology, eager to restore venerable traditions of the Roman people.

On the left, just before the tumuli of the legendary figures, stands the large core of a tomb with a square base upon which a pyramid rises **(28).** Fragments of sculpture and remarkably rich architectural decoration, found at various periods around the monument, confirm its importance: it is probably a tomb belonging to the owners of the nearby Villa of the Quintilii.

On the left of the street is one of the entrances to the extensive **Villa of the Quintilii (29),** the largest on the outskirts of Rome—so large that it was once called Roma Vecchia (Old Rome), a name that it shares with two other villas of comparable size, the Sette Bassi on Via Latina and the Villa of the Gordiani on Via Praenestina. The identification is confirmed by the discovery of lead water pipes bearing the name of the Quintilii. This was one of the most important senatorial families of the Antonine period. The brothers Sextus Quintilius Condianus Maximus and Sextus Quintilius Valerianus Maximus were consuls together in AD 151 under Antoninus Pius. The son of one of these was consul in 172. The two brothers achieved notoriety especially because of their tragic end; accused of conspiring against the emperor, they were murdered by Commodus around 182, and their property passed into the Imperial estate.

The villa clearly attests to two major phases of construction, the first in *opus latericium* attributable to the original owners around AD 150 or a little later, and the second in *opus vittatum,* which is perhaps to be connected with renovations by Commodus, although the second phase may date to the late third century.

The villa contains five distinct sections (FIG. **108**): 1. the group of structures west of the main complex, in the corner between this and Via Appia; 2. the large garden terminating in the semicircular nymphaeum at the street; 3. the buildings associated with the living quarters; 4. another large garden in the form of a circus with several buildings connected to it; 5. a group of small buildings to the north.

The first group is included within the property of S. Maria Nuova; the farmhouse rises on a beautiful rectangular cistern with powerful buttresses,

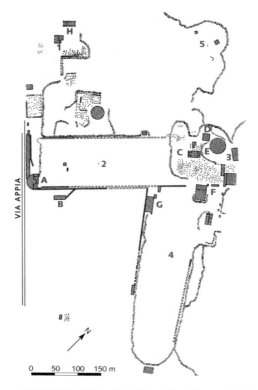

FIGURE 108. Villa of the Quintilii. **1** Group of buildings on the west. **2** Garden. **3** Residential area. **4** Hippodrome. **5** Country villa? **A** Nymphaeum. **B** Cistern. **C,D** Bathing halls. **E** Circular hall. **F** Residential quarters. **G,H** Cisterns.

corresponding to the internal dividing walls. Other buildings in a poor state of preservation are scattered over the terrain to the southeast. In front of the facade, which looks toward Via Appia, are several rather simple structures, probably tabernae. The most important building is a large **semicircular nymphaeum,** in which there were two principal phases. During the first phase, the building had no opening toward the street and was bounded by a wall in coarse flint chip cement work. In the second phase, carried out in *opus vittatum*, perhaps still in the third century, an entrance was opened up toward Via Appia, with two columns on bases at the center and brick piers on the sides. Opposite this is a large nymphaeum with fountains, fed by the aqueduct, that formed a monumental entrance toward the street. During the Middle Ages this was occupied by a castle, of which there are still many remains.

Behind the nymphaeum is the **large garden,** originally much smaller. In the second phase the western wall was demolished, which widened the garden to about 108 meters, while its length remained around 300 meters. Along the southeastern side runs a flint rubble dividing wall, supporting the channel of the aqueduct. Two round pavilions, which resemble those in the Villa of Maxentius, were subsequently built at the southern and western corners. Outside the garden there is a brick cistern with reticulate buttresses.

At the other end of the garden, toward the north, we first see an imposing rectangular hall (13.50 × 11.60 meters), with large arched windows in the upper walls and smaller rooms surrounding the central space. A very large hall nearby was part of a bath. At the center of this hall, which is the largest room preserved, lies a spacious pool, originally faced with marble. Next to this is a large circular room, with an internal diameter of 36 meters, which apparently was unroofed. To the east, at the edge of the hill, which slopes in the direction of Via Appia Nuova, are numerous traces of large foundations and scanty remains of rooms that have almost completely disappeared.

The main residential section was farther to the south. All that is left of this is almost entirely limited to foundations. Here we can see an expansive courtyard and the remains of an octagonal room.

Toward the southeast extends the large **hippodrome** that was added to the villa at a much later phase and is even larger than the first garden (400 meters long and between 95 and 115 meters wide).

Beyond the villa, the monuments along the sides of the road become sparser and are spread farther and farther apart. The majority of the remains (especially on the right) are bases of small Republican tombs, built mostly of peperino ashlars.

On the right, a little before Casal Rotondo, are the remains of baths (FIG. **101:30**)—perhaps belonging to a rest stop for travelers—and of a large villa. Just before the sixth milestone, situated on the left, is the round tomb known as **Casal Rotondo,** the largest on Via Appia **(31).** Its base measures approximately 35 meters on each side.

Unfortunately, we do not know who the owner of this impressive tomb was. Canina assigned the marble fragments, now on an adjacent wall, to this tomb, along with the fragment of an inscription with the name *Cotta* (whom he identified as M. Valerius Messalinus Cotta). But this hypothesis should be rejected. The fragments, too old to belong to the tomb of a person who we know was still alive in AD 32, can now be dated to the first years of the Augustan age. The diameter of this small structure is only slightly more than 4 meters and Canina, in an attempt to relate it to the much larger tomb nearby, hypothesized that it was a kind of pinnacle for the top of the larger structure. In fact, it is probably an independent monument, which has recently been explained as a closed circular aedicula.

Beyond this, on the left, stands the large medieval tower known as the Torre Selce, which rises on the remains of a circular tomb atop a square base.

The road bends sharply to the right as it slopes downward. On the left side of the road, we see arches of the aqueduct that carried water from the *Anio Novus* to the villa of the Quintilii. Farther along on the left is a brick building with a togate statue. A similar statue stands across the street. The seventh milestone, containing inscriptions pertaining to Vespasian and Nerva, once stood at the end of the slope. It now adorns the balustrade of the Capitoline square.

Not far from here we reach the Raccordo Anulare (the outer ring road), which cannot be crossed by automobile at this point. To continue the tour it is necessary to go to Via Ardeatina on the right, and then turn back to Via Appia Antica after crossing the Raccordo.

On the left, we find in succession a sizeable exedra with three large statue niches, completely stripped of its revetment, which must have been topped by a semidome. The structure may well have been a resting place connected with a tomb. Next is a brick tomb, with a niche on a high podium, originally framed by two columns. Only the recesses in which the columns were set survive; these must have supported a pediment that has now disappeared.

Several peperino columns have been reerected in the open area to the right. Some have identified this porticus with the Temple of Hercules built by Domitian at the eighth milestone. Instead, it is certainly a building of the Republican period, perhaps dedicated to Silvanus, as we can deduce from an inscription found here. The eighth milestone must have come immediately after this.

Farther along, on the left, is a brick tomb, its facade located on a high podium with a niche, practically identical to but better preserved than the tomb at the eighth milestone.

Immediately after this stands a large domed circular tomb known as the "Priest's Berretta" because of its shape. The monument's dome survives, but the tomb lacks the outside ambulatory that once made it resemble S. Costanza (it is in fact a building of the fourth century AD). Its state of preservation is due to its transformation into a church, no later than the tenth century, under the name of S. Maria Genitrice.

Almost 3 kilometers down Via di Fioranello, which cuts off to the right a little farther on, lies the site of a small fortified *oppidum*, which Nibby in the nineteenth century identified as Tellenae, one of the centers of Latium destroyed by Ancus Marcius. Recent excavations, however, have shown that it is a much later foundation, of the fourth century AD, built by the Romans for defensive purposes.

A little before the ninth milestone, on the right, we find a large round mausoleum in brick, originally domed and surrounded by a marble colonnade, fragments of which have come to light. The chronology (third century AD) and the position of the monument are consistent with the identification of this

structure as the tomb of Gallienus. We know in fact that it was located precisely on Via Appia at the ninth milestone.

Behind the tomb are remains of a large villa, striking for the works of art that have been discovered on its grounds. It seems likely that the villa, which must have had a close relation to the tomb, also belonged to Gallienus.

The ninth milestone was a little way beyond this point, where the *statio ad nonum,* a rest stop for changing horses, must have been stood.

Farther along, on the right, are the remains of a gigantic mound tomb, which has the same dimensions as Casal Rotondo.

A little before the midpoint between the tenth and the eleventh miles is another circular mausoleum on the left, built entirely in concrete, including the conical element at the top. The brick facing contains niches, alternately semicircular and square, that are separated by semicolumns.

A short distance before the point at which Via Appia joins Via Appia Nuova, beyond the eleventh milestone, there rises on the left a tumulus burial monument, with a square base and circular core, topped by the remains of a medieval tower. The itinerary concludes here at the Osteria delle Frattocchie.

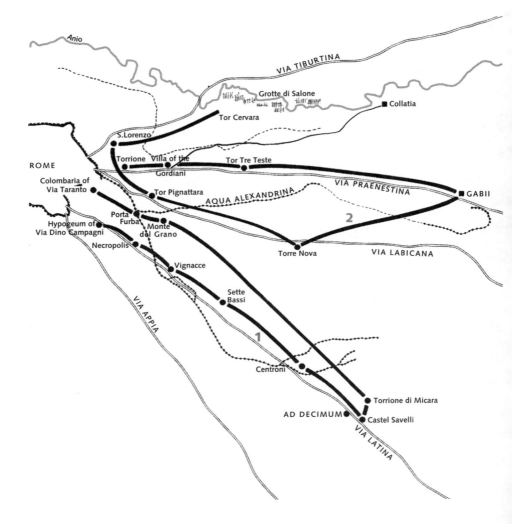

FIGURE 109. Environs east and southeast of Rome. Itinerary **1**: Via Latina; Itinerary **2**: Viae Praenestina, Labicana, Tiburtina.

EASTERN ENVIRONS

Viae Latina, Praenestina,
Labicana, Tiburtina

HISTORICAL NOTES

Via Latina, like Via Appia, follows very ancient routes that were established long before the creation of the celebrated highways. Originally, Via Latina linked Rome with the sanctuary of Mons Albanus, the center of the Latin League (from which it probably derived its name). Later on, it also connected Rome with Capua, running inland along the fluvial valleys of the Sacco and Liri-Garigliano. Like Via Appia, for which it functioned as an alternative route, Via Latina is associated with the period of the Samnite Wars. Thus, it would date between 328 and 312 BC, just before the construction of Via Appia.

The road began at Porta Capena in the Servian Wall, together with Via Appia, and both shared the same course until they split. The original fork can still be observed in Piazzale Numa Pompilio, just beyond the Baths of Caracalla. The road passes through the Aurelian Wall at Porta Latina and, after making two slight bends, runs in a straight line toward the southeast. Unfortunately, the uncontrolled and chaotic expansion of the Appio-Latino neighborhood has not only resulted in the disappearance of most of the antiquities but has even destroyed the course of the ancient road, many sections of which have been completely lost because of the erection of modern buildings. Thus, it is no longer

possible to reconstruct a coherent picture of how the road looked in antiquity, which can now only be envisaged from a series of fragmentary episodes, albeit often very significant ones.

Rome developed relations with Praeneste and Tivoli, important centers east of the city, from the beginning of its existence; the resulting interaction influenced the system of roads in an area that was crossed by routes of considerable antiquity. From south to north we find Via Labicana, Via Praenestina, and Via Tiburtina. Originally, the first ran toward Labici (or Labicum), a Roman colony founded in 418 BC; it was located 15 miles from Rome and can possibly be identified with Monte Compatri. The road was later extended, ultimately merging with Via Latina. It left the city by way of Porta Esquilina (the Arch of Gallienus) in the Servian Wall and shared its first stretch with Via Praenestina, from which it branched off just before Porta Maggiore.

Via Praenestina, like all the roads that derive their name from the chief city toward which they ran, is of great antiquity. Originally, this road probably followed a different route and did not extend beyond Gabii (Via Gabina). Its importance was minimal during the Empire, as it is today.

Via Tiburtina, which linked Rome with Tivoli, was much more crucial, both during antiquity and later. The road assumed strategic importance during the Samnite Wars, when the Romans began their expansion toward the east. At that time Via Valeria was added as an extension. Sources also mention Via Collatina, which branched off from Via Praenestina and passed through the area between it and Via Tiburtina until it reached Collatia (present-day Lunghezza).

The area east of Rome was of vital importance to the city, for it was the source of most of the city's water. The largest aqueducts—from the *Anio Vetus* to the *Aqua Marcia* and *Aqua Claudia*—originated in an area with abundant water, situated below Subiaco, and crossed the territories of Tivoli and Praeneste over long meandering routes that were needed to maintain a constant slope.

Another important feature that characterizes the area is the Anio, which ran between Via Praenestina and Via Tiburtina. This modest river was crucial to the Roman economy as a transport route for construction materials: the red tufa, called *Pallensis* in antiquity and today "Anio tufa," as well as travertine, which the river water had deposited as sediment in the plain below Tivoli. The Anio was also the route for the transportation of the gray tufa from Gabii *(Lapis Gabinus* or *sperone).*

ITINERARY 1 (FIG. 109)

Via Latina

The itinerary begins outside Porta Latina, beyond Piazza Galeria. Just before the railroad overpass there is an important brick tomb that is called **Torre**

dell'Angelo; its name derives from a painting that may represent Michael the Archangel. The building, dating to between the end of the first and the beginning of the second century AD, has three floors (the first is half underground), and each floor has a vaulted roof and niches in the walls for cinerary urns.

The **Hypogeum of Trebius Justus,** one of the most important painted crypts in Rome, can be reached from Via Mantellini no. 13. The monument was discovered in 1911, then lost, and has only recently been rediscovered. A gallery that has not yet been fully explored leads to the perfectly square cubicle (2.60 meters per side). Each of the side walls contains three loculi, while the back wall has an arcosolium. Inside the arcosolium, the deceased is represented as seated on a folding chair *(sella)* with writing tablets on his knees and a scroll in his hand. A long inscription in four lines in the curve of the arcosolium names the occupant: "Trebius Justus and Honoratia Severina made this for their son Trebius Justus, nicknamed Asellus, who lived 21 years, 7 months, and 25 days."

In a curious scene above the arcosolium, a young man (evidently the deceased) is seated on a throne and rests his feet on a footstool, while a gentleman (on the right) and a lady, clearly his parents, are standing and holding before him an embroidered cloth on which there are numerous objects of great value. Under the arcosolium is a more complex scene: in the center, the deceased (indicated by his nickname, *Asellus*) is giving orders to a group of farmers who have just laid before him baskets filled with agricultural products. A painting on the left wall depicts five masons standing on a scaffold, working on the construction of a brick building. On the opposite side, an older man with a staff, probably the father of the deceased, converses with a person who can be identified as a foreman or architect by his trowel, wooden slat, and especially by the inscription *Generosus Magister* (Master Generosus). Two mules flank the entrance, facing the inside, each loaded down with two baskets and accompanied by a driver. Finally, a medallion, located at the center of the vault and set within a floral decoration, depicts a shepherd with syrinx between two sheep. There is no reason to think that this is not a pagan tomb. The hypogeum has been assigned to the beginning of the fourth century AD.

The most notable recent discovery in the field of late-Roman painting is unquestionably the painted tomb, known as the **Hypogeum of Via Dino Compagni,** that came to light by chance in 1955 at the intersection of Via Latina and Via D. Compagni (FIG. **109**). The complex was designed and built all at one time, as is evident from the tomb's remarkably regular plan (FIG. **110**). The structure comprises two sections: one begins at the entrance and includes the stairs and Corridors **1, 2, 3** with Cubicles **2a, A, A', B,** and **C;** the other is the hypogeum proper, from Corridor **4** to Cubicle **O,** which is also organized with almost perfect symmetry around a central axis. The configuration suggests that the two sections accommodated the tombs of two families or two branches of the same family.

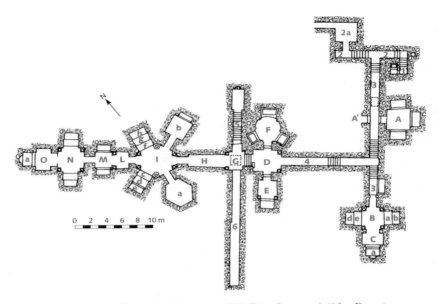

FIGURE 110. Plan of the Hypogeum of Via Dino Compagni. (After Ferrua)

The first room in the visit is Cubicle **A.** On the entrance wall, paintings depict the original sin, Daniel in the lions' den, and the intoxication of Noah. In the niche of the arcosolium on the left, Isaac is shown blessing Jacob in the presence of Rebecca, while above on the outside are episodes from the life of Jonah. The arcosolium on the left has a representation of Susanna among the elders; the scene, ruined by a later tomb, is surmounted by a representation of Christ teaching among the apostles. In the loculus on the right there is a pastoral scene. Episodes from the life of Moses and the three young Hebrews in the furnace can be seen in the intrados. The center of the vault features the Good Shepherd, and its sides contain biblical scenes that are partially destroyed.

At the end of Corridor **3,** and thus in a position of emphasis, lies the most important unit of this section of the catacomb, consisting of Cubicles **B** and **C.** The predominant themes in the first are also biblical. The arrival of Jacob in Egypt is represented in the arcosolium at the center on the left; around it, scenes featuring Samson and Lot, Joseph and Moses, Adam and Eve, and Cain and Abel are arranged symmetrically. In the arcosolium on the right we find the ascension of Elijah and the stories of Abraham, Isaac, and Jacob; on the ceiling are Noah in the ark, Samson fighting the lion (now almost completely lost), and Absalom hanging from the oak tree.

Cubicle **C** also features biblical themes. Under the large arch on the left we find stories of Moses and the sacrifice of Abraham; that on the right depicts

the crossing of the Red Sea. The one arcosolium here, located in the center, is more elaborately decorated: a peacock (the symbol of immortality) in the middle, flanked by the expulsion from the earthly paradise and by stories of Jonah, Job, and Moses.

The second branch of the hypogeum begins from Corridor **4,** which widens farther ahead to form Hall **D,** off either side of which lie Cubicles **E** and **F.** The first was designed for a single burial, in the arcosolium in the rear wall, which is flanked by two columns. The decoration of this room is fully pagan: a representation of *Tellus* (the goddess Earth) occupies the center of the arcosolium; the other paintings include Victories, female dancers, animals, and floral decorations.

Cubicle **F** on the opposite side, oval in plan, contains three arcosolia. The style of the decoration is quite similar to that of Cubicle **E.** The arcosolium in the center features a representation of Samson killing the Philistines; that on the left, Jesus and the Samaritan woman; that on the right, Balaam stopped by the angel.

A new sector of the hypogeum, clearly of uniform structure with the preceding one, begins with Atrium **G.** Corridor **H** leads to the large Atrium **I,** hexagonal in form, with columns chiseled out of the tufa in the corners. The painted decoration of the hall is concentrated in the two arcosolia and in the vault. Christ enthroned between Peter and Paul, with Moses and Job on the sides, is represented in the lunette of the arcosolium on the left; the lunette of the arcosolium on the right contains an absolutely exceptional subject: an anatomy lesson over a cadaver. This scene may be connected with the pictures on the ceiling, an umbrella vault in six sections with a central tondo. The bust of a man with a scroll, and a codex in the background, is represented in the latter, while all around there are other busts of persons with scrolls and codices, separated by boxes of scrolls.

The next room **(L)** functions as the vestibule of Cubicle **M,** which may be part of a complex of rooms that includes Cubicles **N** and **O.** The sacrifice of Abraham and Samson's battle with the lion are represented on the sides of **L.** Cubicle **M** contains two lateral arcosolia; the one on the left has a lunette depicting two soldiers with a curious device for drawing lots; the stories of Jonah are depicted on the sides. In the lunette of the cubicle on the right we find a depiction of the original sin, flanked by other stories of Jonah. The Good Shepherd surrounded by birds is featured on the vault.

Cubicle **N** is particularly grand, with four columns carved out of the rock in each of the corners; the bases and capitals of the columns are of marble. Here the subjects of the paintings are entirely pagan. The arcosolium on the left features a dying Admetus, flanked by Hercules alongside a slain figure (Cacus), and Hercules with Athena. In the arcosolium on the right a scene portrays Hercules bringing Alcestis back to Admetus; the sides are decorated with the legends of Hercules and the Hydra and Hercules and the apples of the Hesperides. It is clear that this cubicle was a pagan burial, as the themes of the paintings show.

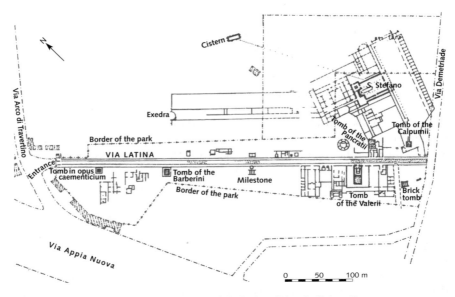

FIGURE 111. Necropolis of Via Latina. (After Quilici 1978)

The last cubicle **(O)** contains a single arcosolium and thus only one burial, which must have been particularly important. Within the intrados are representations of the miracle of the loaves and fishes and the three young Hebrews in the furnace, while paintings on the sides depict Noah in the ark and a man at prayer. The niche on the left depicts the resurrection of Lazarus and stories of Moses; that on the right, the flight from Egypt and the crossing of the Red Sea.

In sum, the hypogeum includes a mixture of Christian and pagan tombs, evidently belonging to members of the same family. The paintings constitute a single stylistic program and can be dated to the first half of the fourth century.

The Necropolis of the Fourth Milestone, in the modern Park of the Latin Tombs, is one of the few sections of Via Latina that preserves its original appearance, a fact that is due to the excavations undertaken at his own expense in 1857–58 by Lorenzo Fortunati, a private citizen. The finds that could be moved—in particular the remarkable sarcophagi—were acquired by the Lateran Museum and are now in the Vatican. In addition to the important tombs, which can still be visited, a large second-century AD villa also came to light, but almost nothing of this remains visible today.

Beyond the entrance, on the right-hand side of the street, is a tomb of which only the nucleus in *opus caementicium* survives (**FIG. 111**). Also on the right lies the so-called Barberini Tomb, a two-story structure—originally three, including the

basement—made of polychrome brick. A back door, flanked by two windows and originally bearing an inscription, provided access to the inside.

The so-called Tomb of the Valerii lies beyond several minor structures; the name is completely fanciful, and its exterior is a nineteenth-century reconstruction. In the lower story an atrium provides access to two vaulted rooms lying opposite each other. The one below the shrine preserves its ornate decoration. The walls had a veneer of marble slabs, of which only traces survive, while the vault's rich stucco decoration comprises a series of connected medallions with representations of Dionysian and marine themes (satyrs, maenads, nereids, sea centaurs, and sea panthers). The Three Graces were depicted in the lunette of the central panel opposite the entrance. The tomb can be dated to the end of the reign of Antoninus Pius or to the beginning of the reign of Marcus Aurelius (ca. AD 160–70). Almost directly ahead, on the other side of the street, is a circular tomb, with a series of radial rooms surrounding a central core.

The next structure on the left is the Tomb of the Pancratii. All that remains of its upper level is a mosaic floor decorated with themes pertaining to the sea. A stairway leads to the lower story, consisting of two successive rooms, half of which lies below ground level. The first room contained shelves supported by small brick arches along three of its walls; these held sarcophagi, one of which was left in the burial chamber. The second room is largely filled by a huge undecorated marble sarcophagus with a large double-pitched lid and corner *acroteria*. The mosaic floor is decorated with a fish-scale motif.

The most remarkable feature, for which the tomb is so well known, is the stucco work and painting that decorate the cross vault and the upper part of the walls. The decoration revolves around a central oval in which a male figure is shown being carried by Jupiter's eagle (a common motif in representations of apotheoses). On four sides of this medallion are small rectangular wall paintings representing the judgment of Paris, Priam's conversation with Achilles about the ransom of Hector, Admetus and Pelias, and Hercules Musagetes with Athena and Apollo. Landscapes and numerous other decorative motifs flank these mythic scenes. In the lunette of the rear wall, a Victory holding a shield and a palm is situated between Apollo and a bearded Dionysus; that on the right depicts a seminude heroic figure, probably Achilles, between two armed men; in that on the left, Diomedes with the Palladion stands between Ulysses and Philoctetes; the lunette over the entrance depicts Hermes and Dionysus. The tomb dates to the Hadrianic period.

The Tomb of the Calpurnii, identified by numerous inscriptions referring to this *gens*, lies a little farther ahead. It consists of a subterranean room with large brick arches within which the sarcophagi were placed.

The Basilica of S. Stefano, now enclosed in a modern wall, was built within a large hall of a villa in the middle of the fifth century, during the pontificate of Leo I (440–61). There remain traces of the walls and several columns, on the basis of which its simple three-aisle plan can be reconstructed. The discovery

of the epitaph of Sextus Anicius Paullinus, the consul of AD 325, has led some to posit that the villa belonged to the celebrated family of the Anicii. The first phase of the estate—Trajanic or Hadrianic—must be ascribed to C. Valerius Paullinus, consul in AD 107, and to his daughter, Valeria Paullina, as can be determined from the water pipes. It is possible that the Tomb of the Pancratii can also be assigned to this family.

From here the itinerary proceeds to Tor Fiscale, a tower dating to the first half of the thirteenth century that rests on two arches belonging to two aqueducts, the larger one from the Aqua Claudia and the smaller from the Aqua Marcia. At this point, the aqueducts crossed each other twice in the course of a short distance, forming a kind of elongated lozenge that runs northwest to southeast for about 300 meters. In AD 539, during Vitigis's siege of Rome, which was defended at the time by Belisarius's Byzantine troops, the attacking Goths used this enclosed space as their camp. Procopius, in *De Bello Gallico* (2.3), describes the encampment, which from the sixth century on was called Campo Barbarico.

The Villa delle Vignacce can be reached easily by turning left on Via del Quadraro and then turning right onto Via Lemonia. Its principal structure was a large rectangular apsidal hall, flanked by two rooms on each side. North of the existing complex ran a corridor roofed by cross vaults, like the main structure to the south. Another group of rooms lies to the east, one of which is apsidal; to the east of these stands a large domed rotunda.

South of the villa, a large, elongated cistern of two stories lies alongside and parallel to the Acqua Felice (formerly Aqua Marcia). The discovery in 1780 of lead pipes inscribed with the name of Q. Servilius Pudens—a discovery that almost certainly took place here—identifies the villa's owner. He was one of the great brick manufacturers at work during the second half of Hadrian's reign; his activity appears to have begun in AD 123.

Returning to Via del Quadraro, it is possible to follow on foot the course of Via Latina and the Aqua Claudia, which run parallel to each other at a close distance for a long stretch. This is the best-preserved and most evocative section of the aqueduct, which crosses a rather deep valley on arches and reaches its greatest height here.

The Casale di Roma Vecchia, a name that was once given to the nearby Villa dei Sette Bassi, lies along Via Latina. Within the complex, whose original buildings date back to the thirteenth century, a courtyard contains an important group of archaeological materials. (Visits must be arranged at the Amministrazione Gerini in Rome.)

Immediately to the north of the Casale di Roma Vecchia lies one of the few surviving original sections of the Aqua Marcia. The upper part of the aqueduct, which sits atop arches hollowed out of the ground, is built in *opus quadratum* of peperino and Anio tufa. This section, then, belongs to the original construction of 144 BC.

The course of Via Latina that continues toward the southeast can be recognized from the tombs and the remains of villas that flank it. The side road that leads to the **Villa dei Sette Bassi** began approximately at the point where the Viale di Roma Vecchia makes a sharp turn toward the east (FIG. **112**). The Villa dei Sette Bassi is among the largest known private suburban complexes. The heart of the estate, surrounded by a series of other structures, comprises three groups of buildings bordering a large space in the form of a circus, probably intended as a garden. The earliest of these groups, which replaced a late Republican country villa, lies farthest to the east, closest to Via Tuscolana **(1)**. The structure is essentially a peristyle—the complex's principal entrance—with colonnades on the east and north and a covered walkway with windows on the west. The principal group of rooms of this phase lay to the south, while to the west of the peristyle there was a single row of rooms with a terrace. A group of relatively large rooms was added to those lying west of the peristyle slightly later, during a second phase **(2)**.

The complex north of the hippodrome **(4)** was built during the third phase **(3)**. To compensate for the 5.20-meter difference in elevation between this and the preceding area, it was necessary to build foundations of considerable strength, in which two cryptoporticoes and other service rooms were installed. Half of the eastern part of this section is occupied by baths; the other half consists of a large hall, south of which lies another, smaller, hall. The construction of the large hippodrome on the lower terrace is contemporary with this.

Numerous other structures were loosely arranged around this complex of buildings, which formed the heart of the estate. An isolated building to the southwest, along Via Latina, consists of a large hall roofed by a cross vault in the middle and barrel vaults on the sides. The cistern **(6)**, located on the other side of the hippodrome, was fed by a private aqueduct diverted from the Aqua Claudia (just before Via delle Capannelle). A noteworthy brick building to the northeast of the main peristyle can be identified as a small temple *in antis* **(5)**. The foundations and at least one story of a large building in the direction of the Osteria del Curato could well have been a winter pavilion.

Precise dates for the sequence of buildings that constitute the Villa dei Sette Bassi can be established on the basis of brick stamps. The first phase can be assigned to the beginning of the reign of Antoninus Pius, between 134 and 139; the second phase was completed in 140; the third phase dates between 140 and 150. On the basis of the water pipes, the owners of the villa can be identified as the Bellicii Calpurnii, an important consular family, originally from Narbonne, that was prominent during the reign of Antoninus Pius.

Casal Morena, situated at the ninth milestone, sits atop a large Roman villa, of which numerous remains, excavated in 1929, can be seen south of the settlement. On the other side of the road, almost directly in front of Casal Morena, there is another large villa, whose facade originally extended over a length of nearly 200 meters, that occupies the raised surface of a lava

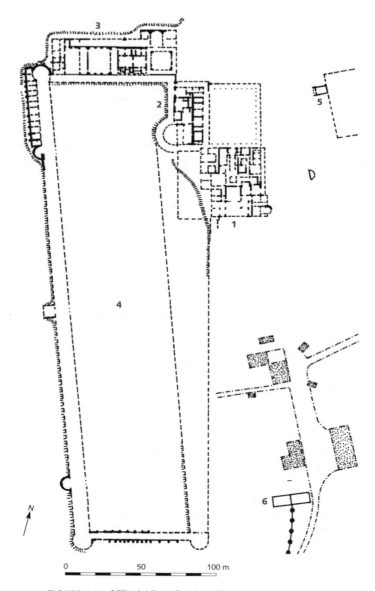

FIGURE 112. Villa dei Sette Bassi. **1** First group of buildings. **2** Second group of buildings. **3** Third group of buildings. **4** Hippodrome. **5** Temple. **6** Cistern. (After Quilici 1978)

flow from Mons Albanus; the *opus incertum* facing is very irregular. A large multilevel swimming pool *(natatio)* on the northwestern side was discovered in 1943. The wall facing the pool is of considerable interest: it is decorated with an architectural facade of small blind arches, framed by a row of small pilasters constructed up against a corridor to the rear. The decorative program, like the rest of the villa, must date to the Republic, probably within the first half of the first century BC, and thus provides a remarkably early example of the ornate urban villa.

The tenth milestone of Via Latina is reached along Via Anagnina. Via Cavona, a road of considerable antiquity, intersects Via Latina just before this marker. One of the highway stops, known as *Ad Decimum,* was located here. Its official name, according to an inscription, must have been *Vicus Angusculanus.* The few surviving traces of the village can be seen in the vicinity of Villa Senni, among which are the core structures of large tombs, datable for the most part to the beginning of the Empire.

A catacomb in this area has provided important information regarding the social composition during the late Empire of this small village, which stood within the territory of Tusculum. The entrance to the catacomb lies just before the sixth kilometer of Via Anagnina; the monks of Grottaferrata have the key. The burial site is a small, very modest hypogeum. Use of the facility does not appear to predate the end of the third century AD.

VIA TUSCOLANA From this point, one can proceed to Grottaferrata and Frascati and return along Via Tuscolana.There are interesting monuments to be seen along this road, whose antiquity is a matter of debate.

Turning to the left, the first monument we encounter, lying beyond the eighteenth kilometer, is the so-called Torrione di Micara (FIG. **113**). This structure was originally a large circular tomb, around 27 meters in diameter and 8.43 meters high, whose structural core is in *opus caementicium* with a peperino revetment in *opus quadratum.* The marble slab intended for the inscription survives, but the inscription has either disappeared or was never engraved. The funeral chambers within constitute one of the earliest documented examples of *opus latericium.* During the Middle Ages, the tomb was transformed into a fortress. The original tomb, datable to the Republican period, might well have belonged to Lucullus, whose villa on Via Tuscolana was nearby.

Beyond the Torre di Mezzavia, Osteria del Curato, and Cinecittà, and just before Porta Furba, "Monte del Grano" can be reached from a side street off Largo dei Quintili (FIG. **114**). During the Middle Ages, this name (probably derived from *modius grani,* that is, "bushel of grain," on account of its shape) was given to an imposing funerary tumulus (around 45 meters in diameter) that over time assumed the appearance of a natural hill; the structure's interior is quite well preserved. Access to the central area was provided by a long corridor, faced with brick, that was illuminated at the back by a skylight set at an oblique angle,

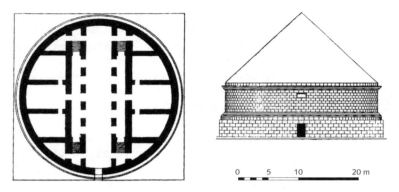

FIGURE 113. Torrione di Micara. Plan and reconstruction. (After Canina)

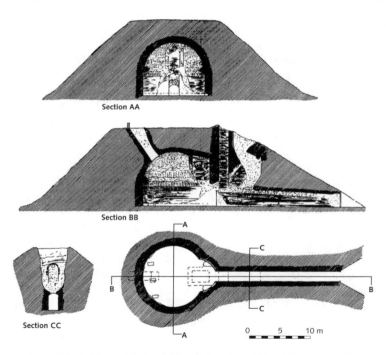

Section AA

Section BB

Section CC

FIGURE 114. Monte del Grano. Plan and sections. (After Ashby and Lugli)

which is now closed and replaced by an almost vertical modern aperture. A dome above the large chamber, which a second floor (now collapsed) originally divided into two stories, was lit by another skylight that opened diagonally.

In 1582, a large Attic sarcophagus (now in the Capitoline Museums), said to belong to Alexander Severus, was discovered in a room on the second floor; episodes from the life of Achilles decorate the exterior. Although the ornate monument, found in a secondary area of the tomb, is not necessarily that of the ruler, the attribution of this tomb to the emperor is plausible: the tumulus might be the large tomb recorded in the biography of Alexander Severus (*S.H.A. Alex.* 63.3).

The course of Via Tuscolana leads to the Porta Furba, whose name may allude to its reputation as a haunt for criminal types (*fur* means "thief"). Here several aqueducts, coming from Via Latina, converge to form one of the most evocative of the monumental intersections. These include the Aqua Marcia, the complex of Claudian aqueducts, and the Acqua Felice. Porta Furba is an arch of the Acqua Felice, monumentalized at the point where the aqueduct passes over Via Tuscolana. Commemorative inscriptions of Sixtus V (1585) are located on both sides; farther along is the fountain erected by Clement XII in 1733 on the occasion of a restoration of the aqueduct. The arches of the Aqua Claudia and Aqua Marcia, for the most part incorporated within or replaced by those of the Acqua Felice, can be followed from here for a considerable distance along Via del Mandrione, with the Claudian arch on the left and the Marcian arch on the right.

Farther along Via Tuscolana, and to the right on Via Verbania, lies a block of houses between Via Taranto, Via Enna, and Via Pescara, where two painted columbaria were discovered in 1932. Access is from the courtyard of the building facing Via Pescara.

ITINERARY 2 (FIG. **109**)

Via Praenestina

Via Praenestina, which follows the same course as Via Labicana, left the city from Porta Esquilina (i.e., from the Arch of Gallienus) in the Servian Wall. The two roads separated right before passing through Porta Maggiore.

Among the few surviving monuments, the so-called Torrione, on the left side of the street directly after Piazzale Prenestino, is particularly important. This is in fact a gigantic circular mound tomb (with a diameter of 42 meters), of which the external ring wall, in *opus caementicium*, and the cella, in *opus quadratum* of peperino, remain standing. Entry to the cella is from the back, through a long corridor.

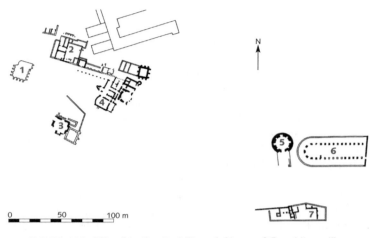

FIGURE 115. Villa of the Gordiani. Plan. **1** Cistern. **2** Republican villa.
3 Octagonal hall. **4** Baths. **5** Mausoleum. **6** Basilica. **7** Columbaria.

At the center of Largo Preneste is a brick tomb in the form of a temple, with remains of its decoration on the rear facade, where the door was also situated.

The Villa of the Gordiani—one of Rome's largest suburban villas, comparable in size to the Villa of the Quintilii and the Villa dei Sette Bassi—spreads out along Via Praenestina, in an area that corresponds to the third milestone. This has been identified as the *praedia* of the Gordiani, the short-lived dynasty that governed the Empire between 238 and 244. The ruins extend on both sides of the road, which led some scholars to treat the two segments as belonging to two different complexes.

On the right side of the road a large cistern, square in plan and reinforced with buttresses, rises to two floors with six rooms on each level (FIG. **115:1**). Other remains, for the most part in *opus mixtum,* are scattered over the terrain. Several tombs line the road, among which is a columbarium at the corner of Via Olevano. The remains on the left side of the road, enclosed within a park, are much more important. A cistern built in *opus mixtum,* supported by large buttresses, dates to the second century. Joined to this is a later cistern, and behind it, at the farthest point of the road, are a few remains of a Republican villa **(2)**, with walls in *opus incertum* and polychrome mosaics (now reburied).

Nearby are the remains of a large octagonal hall, upon which a tower containing a large central pier was constructed in the Middle Ages **(3)**. The hall's upper section was circular, with round windows, and supported a dome, lightened by the insertion of amphoras in the masonry and hidden on the outside by the drum. This remarkable hall and the other nearby rooms from the time of the Gordiani formed part of a bath complex with other adjoining rooms **(4).**

Among these, the most important room, which lies northeast of the octagonal hall, preserves a beautiful apse with a ribbed vault.

Farther east is the large round mausoleum, called Tor de'Schiavi after the family that owned the land in the 1500s **(5)**. The monument, which resembles the Tomb of Romulus on Via Appia, had two floors. The lower one, half-buried (entry is from a door at the back), is a ring-shaped, barrel-vaulted room with a large central pier; sarcophagi were placed in the alternately rectangular and semicircular niches. A tetrastyle pronaos at the end of a stairway led to the upper room, which was probably reserved for cult use; niches on this level correspond to those of the floor below. The dome was partly hidden by an extension of the cylindrical base, pierced by round windows. Early fourth-century brick stamps date the monument to the reign of Constantine. Consequently, this is probably the tomb of an important, though unidentified, member of Constantine's family.

The basilica east of the mausoleum must date somewhat later **(6)**. It measures approximately 67 by 33 meters and has the typical circus form, as seen at S. Sebastiano. In the vicinity of the basilica are remains of first-century AD columbaria as well as catacombs **(7)**. The complex, then, seems to have been a funerary basilica adjacent to a large mausoleum and extensive cemetery.

On the right side of Via Praenestina, almost parallel to it, runs the Aqua Alexandrina, built by the emperor Alexander Severus (AD 222–35). This uses the water of the Pantano Borghese and thus begins at the twelfth milestone of Via Praenestina, across from Gabii. The arches were built in rubble masonry and faced with *opus caementicium*. Significant sections of this structure can be seen in Via dell'Acquedotto Alessandrino, Via dei Pioppi, and Via degli Olmi, as well as in the countryside south of the street.

Just before reaching the distance of 15 kilometers, at the ninth milestone of the ancient road, stands the most striking monument still preserved along the road: the Ponte di Nona (Bridge of the Ninth), which owes its name to its position (a *mutatio*, or relay station, may have been located nearby). The bridge is about 125 meters long and 16 meters high, with seven arches of various heights. It is built in rubble masonry and faced with *opus quadratum* of sperone except for the keystones of the vault, which are in travertine, and the crown, in Anio tufa. The central arch incorporates the older (and much lower) bridge that crossed the gully. The monument can be dated to the late Republic, between the end of the second and the beginning of the first century BC. On the little hill opposite the bridge, beyond the gully, a small settlement sprang up around a sanctuary.

Via Labicana

From Osteria dell'Osa, Via di Rocca Cencia leads to Via Casilina, which in this stretch follows a completely modern course, while Via Labicana passed farther south. The courses of the two streets overlap at the casale Torre Nova, one

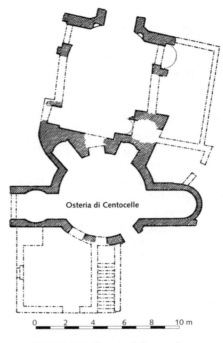

FIGURE 116. Osteria di Centocelle.
(After Ashby and Lugli)

of the most beautiful villas of the Roman countryside, originally medieval but completely rebuilt in the 1500s by Giovanni Fontana.

On the left, at a distance of 8 kilometers, is the Osteria di Centocelle, which sits upon an ancient building consisting of a round room with a dome, constructed of small blocks of tufa and brick (FIG. **116**). A large apsidal room abutted this building on the south.

The famous Tomb of the Haterii was discovered in 1848 near the street; its sculptures are now in the Vatican Museums. The tomb was reexcavated not long ago, leading to the discovery of other important pieces. A little farther ahead, on the left, is a small cluster of tombs recently found during the widening of the street.

This route leads to the large modern church of Sts. Marcellinus and Peter. Here, at the third milestone of Via Labicana, was the heart of one of the most important Imperial possessions, known by the topographical name *Ad Duas Lauros* (at the two laurel trees). The Imperial mausoleum called "Tor Pignattara," one of the many buildings that made up the complex, is still visible, while the large and impressive catacombs of Sts. Marcellinus and Peter lie below ground level.

The Life of Saint Silvester (*Liber Pontificalis,* 182D) recounts Constantine's donation of this large property to the church. The description of this gift, probably made by Constantine's mother, Helena, at the time of her death, provides useful information about the boundaries of the enormous estate, which is connected with the *Sessorium,* the large urban villa within which S. Croce in Gerusalemme stands. The center of the property, which probably included a villa (no traces survive), must have been exactly at the third milestone of Via Labicana. The cemetery of the *equites singulares,* the mounted Imperial guard dissolved by Constantine, was located here. A Christian catacomb, established nearby in the second half of the third century, was the necropolis for martyrs of Diocletian's persecution, including Marcellinus and Peter (who gave their names to the catacomb), as well as Tiburtius, Gorgonius, and the mysterious Santi Quattro Coronati (Four Crowned Saints).

Around AD 320, a funerary basilica very similar to those of S. Sebastiano, S. Lorenzo, S. Agnese, and the basilica in the Villa of the Gordiani was erected next to this catacomb and the cemetery of the *equites singulares.* The basilica, oriented east-west, is 65 meters long and 29 meters wide and has the usual form of a circus (FIG. **117**). The church is surrounded by a porticus, around which mausolea were densely concentrated, as at S. Sebastiano. Soon after the construction of the basilica, a large circular mausoleum, which can be dated between 326 and 330, was built right next to the facade. St. Helena was buried in this mausoleum, but it was almost certainly intended for Constantine. This hypothesis, among other things, more plausibly explains the battle scenes carved on the magnificent porphyry sarcophagus (now in the Vatican) in which Helena was buried.

The villa must have continued to be used into the fifth century; in 455 Valentinianus III was murdered here by soldiers of his guard. The basilica was still in use toward the end of the eighth century, but its deterioration began shortly thereafter.

Today, the mausoleum of Helena (Tor Pignattara) and the catacombs of Sts. Marcellinus and Peter (not ordinarily open to the public) are all that survive of the estate. Access to the mausoleum is through the doorway to the left of the modern church. The mausoleum, which has in part collapsed, is a rotunda with an external diameter of 27.74 meters and an internal diameter of 20.18 meters. The original height was 25.42 meters. The structure consisted of two superimposed cylinders. In the lower (and larger) cylinder there are eight niches, one of which, opening onto the basilica's narthex, served as the mausoleum's western door, while the other seven were intended to hold the sarcophagi. That of St. Helena occupied the central niche on the east. The cupola, lightened by the insertion of amphoras, was partly screened from view within the external ring.

Near the mausoleum is the entrance to the catacomb of Sts. Marcellinus and Peter. This developed out of a complicated interlacing of underground passages, which were reserved for humbler burials, but the catacombs

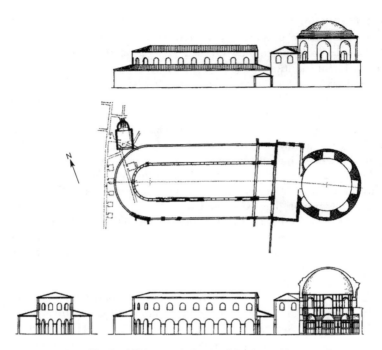

FIGURE 117. Tomb of Helena and church of Sts. Marcellinus and Peter on Via Labicana. Elevation, plan, and sections. (After Deichmann and Tschira)

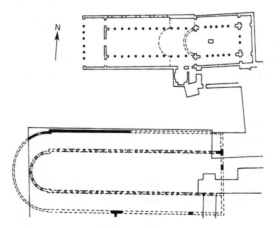

FIGURE 118. The S. Lorenzo complex with the Basilica Maior below. (After Gatti 1957)

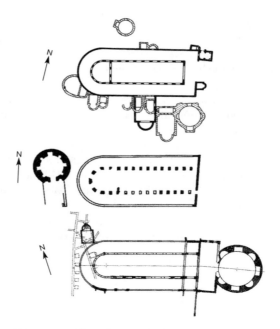

FIGURE 119. From the top, the funerary basilicas of S. Sebastiano, the Gordiani, and Sts. Marcellinus and Peter. The style is similar to that of S. Lorenzo.

contain many painted cubicles as well, mostly from the fourth century, to such an extent that it is justly described as a veritable art gallery of Constantinian painting.

Via Tiburtina

The Basilica of S. Lorenzo, which faces Piazzale del Verano where Via Tiburtina enters the square, is one of the most important paleochristian complexes outside of Rome (FIG. **118**). The archdeacon Laurentius was probably martyred during Valerian's great persecution in 258 and then buried in the cemetery of Cyriaca in the *Ager Veranus*. Constantine had a basilica built near the remains of the saint and included a stairway that led to the tomb. Later, Pope Pelagius II (579–90) erected a church directly above the tomb, to which Honorius III (1216–27) added another, joined to the earlier building. Excavations carried out in the 1940s resolved the complicated identification of all these structures and brought to light a large funerary basilica (99 meters long, 36 meters wide) to the north of the present-day Church of S. Lorenzo. This basilica is in the form of a circus, a type that was familiar around Rome, and was evidently the *Basilica Maior* mentioned in

the sources. The constructions ascribed to Pelagius II and Honorius III have come to be identified with the two sections—clearly from different periods—that make up the present Basilica of S. Lorenzo, respectively that on the east and that on the west. Recently, some have assigned the Basilica Maior not to Constantine but to Sixtus III (432–40).

In the course of the fifth century, a complex that included, in addition to the Basilica Maior, two convents and two other churches, along with a series of later installations, was established around S. Lorenzo. The area was fortified around the year 1200, when it was named *Laurentiopolis*.

The huge quarries of Anio tufa can be reached from Via Tiburtina. This stone was primarily used in the period between the end of the Republic and the Empire (especially after 144 BC, when large quantities were used to construct the Aqua Marcia). The three main groups of quarries are located at Tor Cervara, which is reached by Via Tor Cervara, on the property called La Rustica, and along Via di Salone, which begins at the intersection of Settecamini.

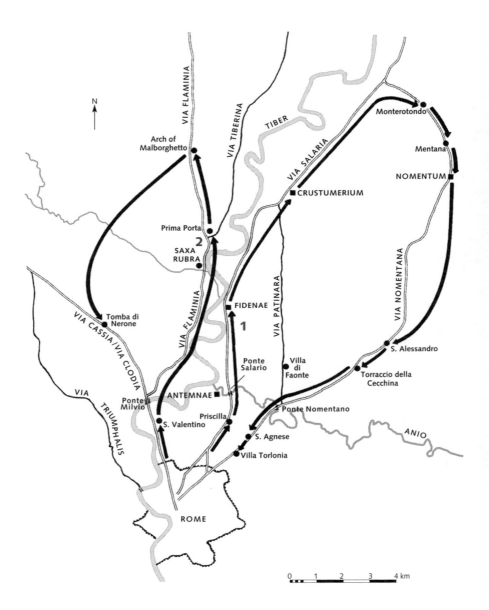

FIGURE 120. Northern environs. Itinerary 1: Viae Salaria,
Nomentana; Itinerary 2: Viae Flaminia, Cassia.

NORTHERN ENVIRONS
Viae Salaria, Nomentana,
Flaminia, Cassia

HISTORICAL NOTES

The roads that leave Rome and proceed north are largely
defined by the valley of the Tiber. Only a small portion of the
valley is discussed in this chapter, because in Rome's earliest
period the right bank of the Tiber was considered Etruscan
territory. Indeed, Veii, the Etruscan city nearest Rome, is only
a few kilometers away.

Via Salaria, the oldest road leading out of Rome, proceeds
to the northeast. Via Tiberina was also of great antiquity, as
attested both by its name and its course, which, like that of Via
Campana, follows the valley of the Tiber, reaching archaic
centers such as the sanctuary of Feronia (Lucus Feroniae). All
these roads were originally natural trails with typically winding
courses. Via Nomentana, which terminated at Nomentum
(near present-day Mentana), is more recent, though its origins
are nonetheless archaic.

The courses of Via Flaminia and of Via Cassia are of a
completely different nature. These long arterial routes are
entirely artificial and consistent in construction, connected
by their very names with specific well-known persons and
historical events. Via Flaminia was built by C. Flaminius, the
censor of 220 BC, and was intended to connect Rome with the
Adriatic Sea and with the *Ager Gallicus* (the northern Marches).
The first stretch of the Cassia was named Via Clodia, and was

probably built to connect Rome with the colonies of Nepi and Sutri. It can thus be realistically dated to the end of the fourth century BC. Via Cassia was probably laid out by C. Cassius Longinus, the censor of 156 BC, in order to reach central Etruria.

This pair of roads branched off from a single route: the urban section of Via Flaminia that began at Porta Fontinalis and then crossed the entire Campus Martius, from south to north, under the name Via Lata, the modern Via del Corso. This road passed through Porta Flaminia in the Aurelian Wall and finally reached the Milvian Bridge, probably constructed at the same time as Via Flaminia since it is first mentioned in 207 BC. It was only on the other side of this bridge that the two roads—Clodia-Cassia and Flaminia—separated. This configuration made it unnecessary to add more bridges.

ITINERARY 1 (FIG. 120)

Via Salaria

The most important catacombs on Via Salaria (and the only ones on the road normally open to the public) are the **Catacombs of Priscilla**. Entrance is at Via Salaria no. 430. The cemetery owes its importance above all to the fact that many popes were buried there between 309 and 555.

The cemetery is composed of three main groups of tombs: the area of the Acilii, the so-called arenario (pozzolana quarry), and the area of the "Greek Chapel." The first is characterized by an elbow-shaped tunnel (FIG. **121:B,D**) that ends in a large room **(E),** identified as the tomb of the Acilii and of Priscilla on the basis of several inscriptions, which refer to Priscilla as a *clarissima femina* (thus a member of the Roman aristocracy) and name other members of the family. In fact, room **E** is not a burial place but a cistern, and the inscriptions of the Acilii probably come from the ground level above. The "Greek Chapel" region, which some have assigned to an early date (second half of the second century AD), also poses vexing problems of interpretation. The complex is arranged around a large elbow-shaped corridor, whose southern branch **(B–C),** along with **M,** must originally have been the cryptoporticus of a villa standing above it.

The chapel itself (which takes its popular name from painted Greek inscriptions in the main cubicle) is a long hall, with three apses at the back, divided into two sections by a large arch. The room was certainly a burial chamber, richly decorated with stuccos and frescoes. High up on the facade of the entrance we find a depiction of Moses causing water to gush forth from the rock. Above him is a bust, perhaps the portrait of a deceased person, flanked on the left by the three young Hebrews in the furnace and on the right by an unidentified person. On the large arch that divides the room is the Madonna and Child and the Magi. The side walls depict episodes in the life of Susanna.

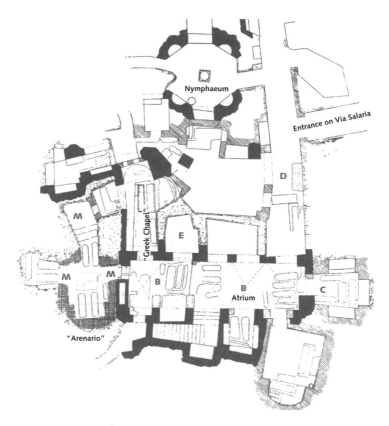

FIGURE 121. Catacombs of Priscilla. The area of the "Greek Chapel."
(After Marucchi)

The vault of the second half of the room is covered with vine tendrils, along with representations of four persons (two in the posture of prayer). The arch above the apse depicts a banquet in which—quite exceptionally—a woman appears. Opposite this, on the other side, the resurrection of Lazarus is depicted. On the right are Daniel among the lions and Noah; on the left, the sacrifice of Isaac. The frescoes probably date at the earliest to the second half of the third century.

The oldest area of the Christian catacomb is probably the "arenario," a modest cemetery for collective burials, perhaps already in existence in the first half of the third century. It includes a well-known chamber called the cubicle of the *velatio*. Here, at the center of the vault, the image of the Good Shepherd is framed within a medallion, surrounded by various species of birds. On the entrance and side walls are Old Testament scenes: Jonah, the sacrifice of Isaac,

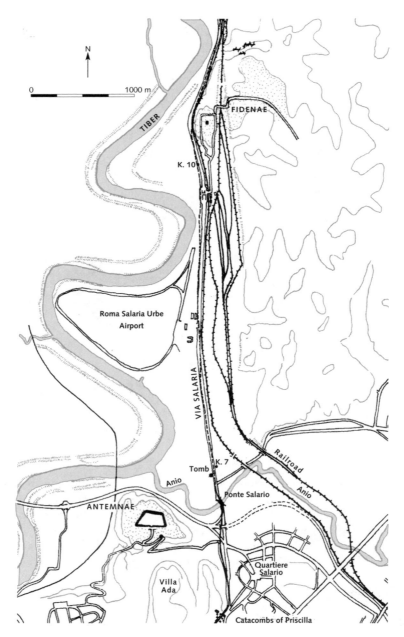

FIGURE 122. Via Salaria between the Catacombs of Priscilla and Fidenae. (After Quilici and Quilici-Gigli)

and the three young Hebrews in the furnace. The lunette at the back contains a praying figure at its center, flanked on the right by a woman with a child and on the left by a seated person, in front of whom there are two other figures. The general consensus is that the last scene represents the consecration of the Virgin and that the scene on the other side depicts the Madonna and Child.

The ancient Latin town of **Antemnae** can be reached by taking Via di Ponte Salario on the left, and then Via di Forte Antenne, but almost nothing of the site remains visible (FIG. **122**). The name of the city, according to Varro, is derived from its position before the Anio (*ante amnem:* "before the river"), because it stood at the point where this watercourse flowed into the Tiber. The Roman annalistic tradition connects Antemnae to some of the earliest episodes in Rome's legendary history.

At the end of a long slope, the road crosses the Anio on **Ponte Salario,** an almost entirely modern bridge (only the arches at each end are ancient). Old prints show a large central arch and a medieval tower on the north. Two inscriptions (*CIL* VI 1199), now lost, were attached to the parapets and recorded Narses' restoration of the bridge in AD 565 after its destruction by Totila.

Directly after the bridge on the left is a seventeenth-century farmhouse that stands next to a medieval tower, built above the remains of a tomb in *opus quadratum* of tufa that some have identified as the tomb of Gaius Marius. The tomb is presumed to be near the Anio, since, as Plutarch records, Sulla threw his remains into the river.

Between the fourth and fifth milestones on the road a group of hills rises on the right (Villa Spada and Borgata Fidene). The location of **Fidenae** in this area now seems certain. This city, situated at the fifth milestone, was traditionally aligned with Veii and hostile to Rome; it often appears as such in Roman annals of the fifth century BC. The road, as it continues, runs alongside Castel Giubileo and then, immediately beyond the Raccordo Anulare on the right, reaches Sette Bagni, which probably owes its name to the substantial remains of a villa at this point. A little beyond the entrance to the *autostrada*, a narrow road on the right leads to a group of hills called the Colline della Marcigliana Vecchia, where according to a recent theory the ancient town of Crustumerium stood.

A little before the 24-kilometer point, a street on the right leads to Monterotondo, and from there proceeds to Mentana, which preserves the ancient name **Nomentum,** albeit in corrupted form. The old city did not lie exactly on the site of the modern center but 1.50 kilometers to the south, in the place called Casali, where various ruins—including walls in *opus quadratum* of tufa—point to the existence of an ancient settlement.

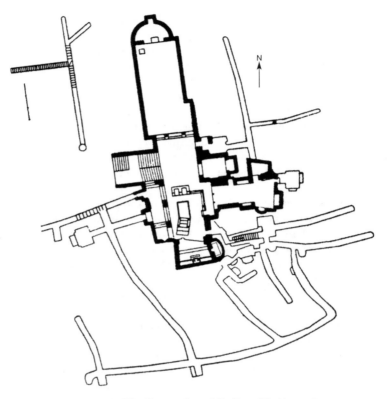

FIGURE 123. The Catacombs and Basilica of S. Alessandro
on Via Nomentana.

Via Nomentana

The return to Rome on Via Nomentana leads to the **Catacombs of S. Alessandro** (at the 13-kilometer point), a small cemetery that should perhaps be associated with the village of Ficulea, which was in this neighborhood (FIG. **123**). Here a small basilica *ad corpus* (near a revered burial place) was constructed at the beginning of the fifth century.

At 9.20 kilometers, on the left side of the street, are the remains of an important brick tomb, called **Torraccio della Cecchina** (or "Torraccio di Spuntapiedi"). The monument dates to the mid-second century AD. The road crosses the Anio over **Ponte Nomentano,** which is still well preserved, resembling Ponte Salario before it was totally rebuilt. Like Ponte Salario, Ponte Nomentano was damaged by the Goths in AD 549 and restored by Narses in 552. The large travertine arch in the center and the two small side arches, however,

probably date to an older phase, perhaps the early Empire. The upper part—a medieval reconstruction—resembles a fortified castle.

In Piazza Elio Callisto, there is another interesting tomb, on the right side of the street, called **Sedia del Diavolo** (Devil's Chair). It has two floors and is constructed of brick. The total collapse of the facade has made the interior visible, revealing niches for burials on the lower floor and, on the upper floor, a large central niche framed by small pillars that must have supported a pediment. A small marble cylindrical tomb from the Flavian period, transferred from the area of Tor di Quinto, was recently reconstructed on a traffic divider in the middle of the street.

S. AGNESE AND S. COSTANZA One of the most remarkable paleochristian complexes, in this case associated with St. Agnes, thought to have been martyred under Diocletian, rises at the third milestone of Via Nomentana. The complex includes, in addition to the galleries of the cemetery, the remains of the Basilica Constantiniana, the Mausoleum of Constantina, and the Basilica Honoriana (FIG. **124**).

Following excavations in 1954–55, the Basilica Constantiniana was securely identified with an apse supported by large buttresses (visible on the western side of the basilica), which had once been considered a part of the cemetery. It was only later, as happened at S. Lorenzo, that a second basilica, the one now seen, came to be erected in the area above the martyr's crypt; this occurred during the reign of Pope Honorius I (625–38), when the first basilica was already in ruins.

The Mausoleum of Constantina was later erected along the southern side of the Basilica Costantiniana, which was certainly built during her residence in Rome (between 337 and 351). Constantina was mistakenly identified as a saint and, as a result, the building assumed the name of S. Costanza. As in other cases, the tomb was erected near a place of worship, probably before the death of Constantina, which took place in 354 in Bithynia.

The mausoleum is a large circular structure with a diameter of 22.50 meters, joined to the southern side of the basilica by an apsidal porch. The building's exterior was surrounded by a porticus, which has now disappeared. The rotunda consisted of two concentric rings, the inner one emerging at a higher level than the outer. The latter was a sort of encircling ambulatory, covered with a barrel vault, in which there were eleven niches, alternately semicircular and rectangular. The most important niche, on an axis with the entrance, contained the magnificent porphyry sarcophagus of Constantina now in the Vatican Museums (a replica stands here in its place). The central part of the mausoleum is a rotunda 19 meters high with a diameter of 11.33 meters, separated from the ambulatory by twelve pairs of granite columns that support arches. The drum, pierced by twelve windows and roofed by a ribbed dome of brick, rises above these.

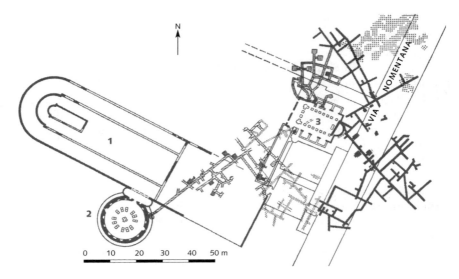

FIGURE 124. S. Agnese complex on Via Nomentana. **1** Basilica Constantiniana. **2** Mausoleum of Constantina (S. Costanza). **3** Basilica Honoriana. (After Frutaz)

The mosaics that decorated the dome have unfortunately been destroyed, but they are recorded in drawings. The very fine mosaics of the ambulatory vault, partially restored in the first half of the nineteenth century, are divided into eleven panels with white backgrounds. Those flanking the door bear a simple geometric design, while figurative motifs predominate closer to the monument's axis. The designs are repeated on both sides. The third panel on the right and left bears a repeating motif of *erotes* harvesting grapes. At the center of each panel is a bust, male and female respectively, that some have interpreted as portraits of Constantina and Hannibalianus, her first husband. The last two panels contain still lifes of flowers, fruit, amphoras, and birds. The eleven niches were also decorated with mosaics. Those of the first two niches remain and have scenes depicting Christ presenting the law to Peter and Paul (on the left), and the conferral of the keys upon St. Peter.

The Basilica Honoriana of St. Agnes is the only basilica in Rome that contains a *matroneum*—a women's gallery raised over the central nave. A mosaic dating to the seventh century (as does the building itself) depicts St. Agnes flanked by two popes: Honorius I, holding a model of the church, and perhaps St. Symmachus. Beside the altar is a splendid marble candelabrum that belonged originally to the Church of S. Costanza. Its base is decorated with *erotes*- and rams' heads. The piece is a neo-Attic work dating to the second century AD. Numerous inscriptions and sculpture fragments, which come from excavations carried out in the area, are displayed on the walls of the stairway that descends from the

narthex of the basilica to the crypt below. Among the inscriptions is the poem of Damasus in honor of St. Agnes.

There are interesting Jewish catacombs (not currently accessible) within Villa Torlonia, which were discovered during work on the stables in 1918.

ITINERARY 2 (FIG. 120)

Via Flaminia

The courses of Via Cassia and Via Flaminia overlap between Porta Flaminia (now Porta del Popolo) and the Milvian Bridge, after which they go in different directions.

On the right of Via Flaminia, more or less at the first milestone, a side street off Viale Pilsudski leads to the remains of the **Basilica di S. Valentino,** named for a martyr under Claudius Gothicus (AD 268–70). Here there is a small catacomb, above which lies an open cemetery that was partly occupied by the basilica that Pope Julius I (337–52) erected as a memorial over the saint's tomb.

The **Milvian Bridge** must already have existed in 207 BC, since it is mentioned in that year. Although heavily restored, the structure as it appears today is substantially that of 109 BC, the work of the censor in that year, M. Aemilius Scaurus. The bridge, which runs at an angle with respect to the river, has five piers that support six arches, the two near the river banks being rather narrow and the four central ones much wider. Rounded openings have been carved into the piers to allow the current to pass through. The nucleus of the structure is Grotta Oscura tufa, while the revetment is sperone and travertine. Several famous historic episodes took place near the bridge—the oldest bridge in Rome still in active use. The famous battle between Constantine and Maxentius was fought here on 28 October AD 312. It was from the bridge that the conflict took its common name, the Battle of the Milvian Bridge.

After crossing the two ravines of Acquatraversa and Crescenza, the road enters the narrow passage of *Saxa Rubra* between the rocky mass of reddish tufa that gives the place its name (now Grottarossa) and the Tiber, where important quarries were worked during the Republican period. This is the site of the famous **Tomb of the Nasonii,** now in a dilapidated state, discovered in 1674. Several of the tomb's paintings, depicting mythological scenes and representations of the afterlife, have been detached and are now in the British Museum. These date, as does the tomb itself, to the second half of the second century AD.

At the top of Monte delle Grotte, overlooking the tomb, a Republican villa was discovered in 1944 containing two atriums and an exterior porticus on two of its sides (south and east).

At Casale di Grottarossa, on the right side of the road, remains of three large tombs can be seen, dating to the period between the end of the Republic and the

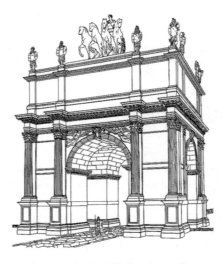

FIGURE 125. Arch of Malborghetto. Reconstruction. (After Töbelmann)

beginning of the Empire. It seems likely, however, that at an earlier period the road passed farther to the east, alongside the river. The little village of Prima Porta lies at the ninth milestone. It should perhaps be identified as the ancient *Mansio ad Rubras*.

The **Villa ad Gallinas Albas** in the same neighborhood owes its name to an event recorded by several ancient authors, who recount that an eagle dropped a white hen with a laurel branch in its beak into the lap of Livia, the villa's owner (Pliny, *NH* 15.136). The foundations of the villa are still visible between the road and the Tiber at the foot of the hill that dominates Prima Porta. The southeastern corner is supported by two large converging walls in *opus reticulatum*, with substantial buttresses. Above this, near the middle of the hill, is a cistern constructed of rough cement with a round lowered vault. The only accessible rooms (discovered in 1863) are on the south, carved into the rock, which can be reached by a stairway, reconstructed in modern times. The celebrated frescoes depicting garden scenes, detached from the walls in 1951–52 and now in the Museo Nazionale Romano (Palazzo Massimo), come from here, as does the famous statue of Augustus wearing a breastplate (the "Prima Porta Augustus"), which is displayed in the Vatican Museums.

Nineteen kilometers from Rome, on the right side of the street, is the fascinating monument known as the **Arch of Malborghetto** (FIG. **125**). The name comes from a village that grew up around the little church of S. Nicola and became infamous as a haven for bandits. The monument, its arches walled up and almost completely stripped of its marble decoration, was transformed

into a farm house. It was originally a cross-vaulted rectangular Janus arch (14.86 meters × 11.87 meters, and 17.50 meters high) with an entrance on each of the four sides. Several cornice blocks of its marble revetment survive. The monument's purported connection with the battle between Constantine and Maxentius in AD 312 is entirely plausible: the arch was almost certainly erected precisely at the location of the *praetorium* in Constantine's camp, where the emperor, according to the account of his contemporary Lactantius (*De Mort. Pers.* 44), had a vision of the Cross, which he subsequently put on his troops' shields.

Via Cassia

From Via Flaminia it is possible to reach Via Cassia by taking the Raccordo Anulare. At the sixth milestone of Via Cassia there was a *mansio* known as *Ad Sextum*. The monument erroneously called the **Tomba di Nerone** (Tomb of Nero) since the Middle Ages (it gives the quarter its modern name) stands exactly at this point. It is a large marble sarcophagus, with a sloping cover and acroteria at the corners, raised on a high base. On the side of the monument, a *tabella ansata* (a sign plaque with handles) identifies the occupants of the Antonine sarcophagus as P. Vibius Marianus, born in Tortona and procurator of Sardinia, and his wife, Regina Maxima (*CIL* VI.1636). Reliefs depicting the Dioscuri flank the inscribed plaque.

FIGURE 126. Western environs. Viae Aurelia, Campana, Ostiensis.

Calepodio

VIA AURELIA

Colombaria

Villa Doria
Pamphilj

S. Pancrazio

VIA VITELLIA

FORS
FORTUNA

ROME

N

VIA PORTUENSIS

VIA ARDEATINA

VIA APPIA

Via delle Sette Chiese

Necropolis of
St. Paul

Catacombs of
Commodilla

Catacombs of
Domitilla

Catacombs of
Thecla

VIA CAMPANA

VIA OSTIENSIS

Catacombs
of
Generosa

EUR
Museums

Abbey of the
Three Fountains

VIA LAURENTINA

TIBER

LUCUS
DEAE
DIAE

0 1 2 km

WESTERN ENVIRONS
Viae Aurelia, Campana, Ostiensis

HISTORICAL NOTES

The region west and southwest of Rome was shaped by the final stretch of the Tiber and was always crucial to the city's commerce because of its connection with the area around the port. The region was economically important, since the survival of Rome depended rather early in its development on provisions arriving by sea. With the exception of Via Aurelia—probably founded by C. Aurelius Cotta, the consul of 241 BC—which connected Rome with maritime Etruria and later with Liguria and Provence, all the other roads that run southwest were intended to connect the city with the sea. The oldest is certainly Via Campana, so called after the *Campus Saliniensis,* the salt beds along the sea, which were connected by this road with the Forum Boarium and the salt warehouse close to Porta Trigemina. Via Campana followed the meandering valley of the Tiber in all its twists and turns. After Claudius built Portus, it was transformed into a transport road over which animal teams dragged barges loaded with goods from the port to Rome. Before that, when Rome's major port was Ostia, the transport road must have followed the left bank. Two roads whose courses were shorter and straighter connected Rome directly with Ostia and Portus: Via Ostiensis (on the left bank of the Tiber) and Via Portuensis, both of which began at the gates of the Aurelian Wall bearing the names of their respective roads.

Two other early roads proceeded in a southerly direction: Via Laurentina and Via Ardeatina, which connected Rome with two very ancient Latin settlements along the sea, Lanuvium-Laurentum (the mother city of ancient Latium) and Ardea.

ITINERARY

Via Aurelia

Via Aurelia Vetus begins at Porta S. Pancrazio. As often happened, the name of this gate, which derives from the nearby tomb of the martyr, replaced the ancient one, Porta Aurelia, during the Middle Ages. A little farther on, near the entrance to the Villa Doria Pamphilj, lies the intersection where Via Aurelia (now Via Aurelia Antica) veers toward the right, while on the left another street (the present-day Via di S. Pancrazio, which becomes Via Vitellia) follows an ancient course, probably called Via Vitellia in ancient times as well. The second road leads to Piazza S. Pancrazio, where the entrance to the basilica and catacombs, named for the saint, are located.

According to tradition, Pancratius was martyred under Diocletian on 12 May 304. He was buried in a cemetery that was already in existence during the late Republic, around which the galleries of a Christian catacomb subsequently multiplied. Pope Symmachus (498–514) erected a small basilica over Pancratius's tomb, of which no trace remains. The present basilica is the work of Honorius I (625–38), with substantial renovations dating to the twelfth and seventeenth centuries. Entry to the catacomb is from the church. The galleries, parts of which have not yet been fully explored, are divided into three regions; none date back prior to the fourth century.

To visit the ancient remains inside the Villa Doria Pamphilj it is necessary to turn back and enter the public park of the villa through the gate at Piazza di S. Pancrazio.

The most interesting columbaria still visible are behind Casino del Belrespiro. The "colombario maggiore," discovered in 1821, is half underground and contained more than five hundred burials. This columbarium is particularly remarkable for its paintings, now detached and preserved in the Museo delle Terme. The "colombario minore," with its four arcosolia and its rich painted stucco, was discovered in 1838. This site, possibly Hadrianic, clearly postdates the "maggiore."

Nearby, just east of here, there is a burial enclosure made of tufa ashlars, with a false door at the center of the front side.

Along the right side of Via Aurelia the remains of the Aqua Traiana come into view almost immediately beyond the park of the Villa Doria Pamphilj; the aqueduct carried water from Lago di Bracciano all the way to Trastevere. Later, part

of the structure was reused for the Acqua Paola, brought to Rome by Pope Paul V (1605–21). The showpiece of this aqueduct is the monumental fountain on the Janiculum. Farther ahead, the road is spanned by the large papal arch over which the aqueduct passes, known as the Arco di Tiradiavoli.

Via Campana

Between the fifth and sixth milestones of Via Campana stood the very ancient sanctuary of the Dea Dia, whose cult was in the care of the *Fratres Arvales*, created, according to tradition, by Romulus himself. As has long been known, the sanctuary was at the early border of Roman territory, the *Ager Romanus Antiquus*. A second temple of Fors Fortuna in this area, which we know was situated at the sixth milestone of Via Campana, must have stood near that of the Dea Dia.

Although we know very little about the earliest worship of the Dea Dia, we do know a fair amount about the nature of the cult as it was renewed by Augustus. A large number of fragments from inscriptions have come down to us, recording the proceedings of the ceremonies during the period between the reigns of Augustus and of Gordianus.

The sanctuary spanned both sides of the present Via della Magliana, between Colle delle Piche and the Tiber. Chance discoveries occurred during the sixteenth century, and an excavation was carried out in 1857. At that time a plan of the buildings that were still visible was made, part of which is quite fanciful. The French Archaeological School has been conducting regular excavations of the site since 1975 that are beginning to clarify the sanctuary's complicated topography. Several of the main buildings mentioned in the inscriptions (the Temple of the Dea Dia, the *Caesareum*, the *tetrastylum*, the circus, and the baths) have been identified. The temple, part of which is still visible in a basement along Via della Magliana, was a large rotunda situated at the northern edge of the area. At the other end of the sanctuary, near the Tiber, remains of the baths have come to light. The work undertaken to date has shown that the complex was completely rebuilt under Alexander Severus and that its various buildings were brought together within a large porticus, closed on the north by the temple and on the south by the baths. The original sacred grove *(Lucus Deae Diae)*, then, was set within a monumental enclosure.

The **Catacombs of Generosa,** which occupy Monte delle Piche directly above the sanctuary of the Dea Dia, were begun and developed entirely during the course of the fourth century AD (FIG. **127**). The cemetery was originally intended for the burial of a group of martyrs during the persecution of Diocletian, including Simplicius, Faustinus, and Beatrice. We know nothing of Generosa, who was probably the owner of the property.

During the second half of the fourth century, a small apsidal basilica, perhaps the work of Pope Damasus, was erected near the tombs of the martyrs. The grilled window above the cathedra, at the center of the apse, is especially interesting.

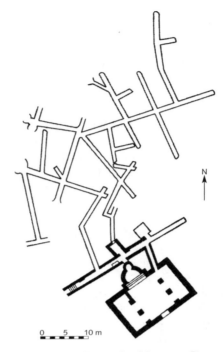

FIGURE 127. Catacombs of Generosa. Plan.
(After Testini)

EUR The EUR (Esposizione Universale Roma) district is well worth visiting because of the important museums located there, including the Museo della Preistoria e Protostoria del Lazio (formerly the Museo Pigorini), the Museo della Civiltà Romana, and the Museo dell'Alto Medioevo.

The Museo della Preistoria e Protostoria del Lazio collects the materials from the region that were formerly in the Museo Pigorini, with the addition of some of the finds in several very fruitful recent excavations, such as those at Osteria dell'Osa. The museum has been installed on the second floor of the Palazzo delle Scienze.

Via Ostiensis

When Via Ostiensis reaches the Basilica of St. Paul, the road encounters a bottleneck between the Tiber and the Roccia di S. Paolo (FIG. **128**). This whole area has the character of a huge necropolis, which was occupied from the Republican period to the end of antiquity. It is of special historical importance because it was the site of the tomb of the Apostle Paul.

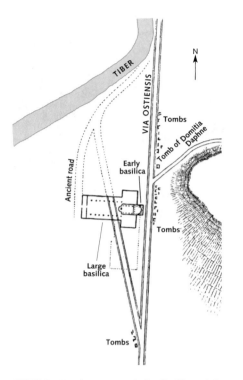

FIGURE 128. Area around the Basilica of St. Paul. (After Marucchi)

In addition to the cluster of tombs north of the church, which are under a protective roof, remains of other burials can be seen beside the rock behind the basilica's apse. Paintings now in the Museo della Via Ostiense at Porta S. Paolo come from one of these burial sites, which consisted of a room with three arcosolia.

No traces of the apostle's tomb have been found, but only some remains of the "trophy" (resembling that of the grave of St. Peter) built above it by the presbyter Gaius around 200. After this, at the urging of Pope Sylvester (314–35), Constantine erected a small basilica within the narrow space available between Via Ostiensis and the *iter vetus*.

The large basilica was begun under Valentinianus II, Theodosius I, and Arcadius in 384 and completed under Honorius around 403, as attested by an inscription on the triumphal arch, although the inscription itself belongs to the restoration by Pope Leo I and Galla Placidia that took place after a fire around the middle of the fifth century. The Theodosian basilica is of a character quite

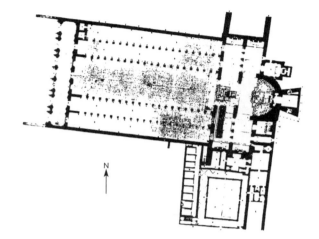

FIGURE 129. The Basilica of St. Paul before the fire of 1823.

similar to the Basilica of St. Peter and had equivalent dimensions (128 meters long and about 65 meters wide), with five aisles and a transept but without the rectangular exedras at the end of the short sides. The building remained substantially intact until 1823, when it was half destroyed by a fire (**FIG. 129**). The basilica was reconstructed between 1825 and 1854 in a style that provoked much controversy, and major work on the project continued until 1890; the quadriporticus was finished only in 1928.

In the course of widening Via Ostiensis north of the basilica in 1919, a large portion of a necropolis was found, one section of which is displayed under a protective canopy. It is a fascinating complex, which developed over five centuries, beginning in the second century BC and continuing to the fourth century AD, expanding from west to east; i.e., from Via Ostiensis toward the Roccia di S. Paolo. At a number of points one can see several strata of tombs, built on top of one another. The necropolis clearly documents the progressive change from the rite of cremation to that of inhumation during the course of the second and third centuries AD. From a historical perspective, this evidence makes the cemetery one of the most interesting in Rome.

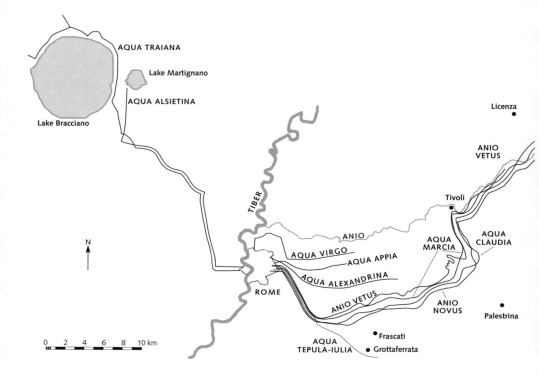

FIGURE 130. The Roman aqueducts.

AQUEDUCTS

AQUA
CLAUDIA
Arsoli

AQUA
MARCIA

Agosta

ANIO
NOVUS

Subiaco

HISTORICAL NOTES

Our knowledge of Roman aqueducts is extremely precise for two reasons: not only are some of the monuments remarkably well preserved, but we are especially fortunate in having a treatise that Frontinus, an important individual of consular rank who lived between the Flavians and Trajan, wrote while serving as *curator aquarum* (curator of aqueducts) in AD 97. This work contains, in accurate detail, essential information ranging from the position and importance of the water sources to the course and volume of the aqueducts and the number and organization of the personnel employed in this critical branch of Roman public administration. Since this information comes from public records, it is about as precise and, for this reason, precious as one could ever hope to have. Here is how Frontinus (*Aq.* 4) summarizes the history of how Rome's citizens obtained water during the centuries stretching from the city's foundation to the creation of the aqueducts:

> For 441 years after the foundation of Rome, the Romans were satisfied with the amount of water that could be drawn from wells, springs, and the Tiber. Even today, local springs are associated with religion and are objects of cult. In fact, it is believed that they can cure sicknesses, as is the case of the fountains of the Camenae, Apollo, and Juturna. Now, instead,

445

water flows into the city by means of aqueducts, which include the Aqua Appia, Anio Vetus, Marcia, Tepula, Julia, Virgo, Alsietina (also called Augusta), Claudia, and Anio Novus.

Frontinus has listed here in chronological order the nine aqueducts that existed during his lifetime; the Aquae Traiana and Alexandrina were built later. In short, an enormous quantity of potable water flowed into Rome, making it unquestionably the city with the best water service in the ancient world, and perhaps even of any era. What follows is a survey of the aqueducts in the chronological order suggested by Frontinus.

1. *Aqua Appia*. The oldest aqueduct to serve Rome was built by the censor of 312 BC, Appius Claudius Caecus, the same individual who oversaw the construction of Via Appia. The discoverer of the springs, which were located between the eighth and ninth miles of Via Praenestina, was Appius's colleague in the censorship, C. Claudius Venox. The location of the springs has been lost to posterity; some situate them near La Rustica, while others maintain that they have dried up. Traces of their covered channel *(specus)* outside of the city have not yet been identified. The watercourse, which was almost completely underground except for a short segment that intersected Porta Capena, extended over a distance of more than 16 kilometers. The aqueduct, like many others, entered Rome at the place known as *Spes Vetus* (Ancient Hope), where Porta Maggiore now stands. From here it ran toward the Caelian, spanning the hill's entire length, and crossed the valley between the Caelian and Aventine on arches that incorporated Porta Capena. After crossing the Aventine in an underground channel (sections of which were identified in 1877 and at the end of the same century), it terminated near Porta Trigemina in the Forum Boarium. The channel, which has been observed at various points, consisted of interconnected tufa blocks hollowed in the center. Its capacity was 73,000 m^3 per day. The system was restored by Q. Marcius Rex (144 BC), Agrippa (33 BC), and Augustus (11–4 BC).

2. *Anio Vetus*. The second aqueduct of Rome was installed in 272 BC—a few years after the construction of the Aqua Appia. Built by the censor Manius Curius Dentatus after the war against the Sabines in 290, the new project, extending over a distance of 63.64 kilometers, was considerably longer than its predecessor. The aqueduct's water came from the Anio, originating at a point 261.57 meters above sea level, near the bridge of Vicovaro on the river's left bank. Descending from here, the aqueduct followed the river as far as Tivoli; from there it reached Via Praenestina, along which it extended to Gabii; afterward, its course followed Via Latina (between Casal Morena and the fourth mile) and then Via Labicana up to Porta Maggiore. Fifteen hundred meters before reaching the gate, the *Specus Octavianus* (Octavian

Channel) broke off from the aqueduct and followed the future course of the Aurelian Walls all the way to Porta Latina; the channel's water was distributed near the *Horti Asiniani*. The main aqueduct entered Rome at Spes Vetus, crossed the Esquiline in its entirety in an underground channel, and ended near Stazione Termini. The aqueduct's maximum capacity was 175,920 m³ per day. The system was restored by Q. Marcius Rex in 144 and later by Agrippa (in 33 BC) and Augustus (between 11 and 4 BC).

3. *Aqua Marcia*. This aqueduct, which still today is one of the most important in Rome, was built by the praetor Q. Marcius Rex in 144 BC. Its waters also came from the Anio, but from an area farther up in the mountains on the river's right bank, in the valley of Arsoli at the thirty-sixth milestone of Via Valeria. The course of the aqueduct between its source and S. Maria di Cavamonte is known; after the latter, however, it is lost as far as Romavecchia, where it intersected the Aqua Tepula and the Aqua Iulia. Some arches of the following stretch can be seen before reaching Tor Fiscale. Beyond Porta Furba, it ran alongside the Aqua Claudia. A branch that extended to the Baths of Caracalla broke off from the aqueduct at an unknown point. The length of its entire course was a little more than 91 kilometers. From Spes Vetus, where most of the Roman aqueducts entered the city, the conduit followed the course of the Aurelian Wall, which incorporated most of its arches, up to Porta Tiburtina; from here it followed a course that corresponded to the present-day Via Marsala and ended near Stazione Termini (a short section continued up to the former Ministero delle Finanze). From this point, several subsidiary branches broke off and served several other parts of the city, in particular the Capitoline Hill, which only then, because of its height, could be reached, and only by way of the saddle that connected it with the Quirinal. The volume of water carried by the Aqua Marcia, exceeded only by the *Anio Novus*, was approximately 187,600 m³ per day.

4. *Aqua Tepula*. Begun in 125 BC by the censors Cn. Servilius Caepio and L. Cassius Longinus, this aqueduct originated in the Alban Hills near Marino. Its source, which was located on a property owned by Lucullus, has been identified as the Fonte Preziosa in the Valle Marciana at the twelfth milestone of Via Latina. The aqueduct owes its name to the somewhat elevated temperature of its waters. It, too, arrived in the city at Spes Vetus and followed the same course as the Aqua Marcia. Its capacity was approximately 17,800 m³ per day.

5. *Aqua Iulia*. The water that fed this aqueduct came from a source in the territory of Tusculum, near Ponte degli Squarciarelli, two miles to the right of the twelfth milestone of Via Latina. The source was tapped by Agrippa in 33 BC. The Aquae Tepula and Iulia merged in a new conduit, created at that time, which ran for 21,677 meters. The capacity of the Aqua Iulia

reached 48,240 m³, and the aqueduct's course through the city was the same as that of the Aqua Marcia.

6. *Aqua Virgo.* The Aqua Virgo owes it name to a young girl who led soldiers in search of a new source of water to a suitable spot. This aqueduct was also constructed by Agrippa and was completed in 19 BC. It followed a course completely different from the others. Beginning to the left of Via Collatina, near the present-day Casale di Salone, the aqueduct ran completely underground and reached the city along the slopes of the Pincian Hill. From here, specifically from the Villa of Lucullus (Piazza di Spagna), the conduit continued its course on arches. After crossing Via Lata (Via del Corso) atop the Arch of Claudius, the aqueduct passed along Via del Seminario. Its arches terminated, as Frontinus records, "in front of the *Saepta*," that is, in the immediate vicinity of the Pantheon. Running underground from here, the water reached the Baths of Agrippa. This is the same source of water that today feeds the Trevi Fountain. The capacity of the aqueduct was 100,160 m³ per day.

7. *Aqua Alsietina.* The water from this aqueduct, absolutely undrinkable according to Frontinus, was brought to Rome by Augustus in 2 BC. It came from Lakes Martignano and Bracciano and reached Rome by way of the Janiculum, a course of approximately 32,815 meters. Its sole function was probably to feed Augustus's *naumachia* in Trastevere. The capacity of the aqueduct was 15,680 m³ per day.

8. *Aqua Claudia.* This aqueduct, together with the Anio Novus, was begun by Caligula in AD 38 and completed by Claudius in 52. The project was, without a doubt, the most ambitious of Rome's aqueducts. The source was tapped at the thirty-eighth milestone of Via Sublacensis and reached Rome after a course of 68,681 meters, 15,060 of which ran aboveground. It followed the Anio on the right, above Via Valeria, crossed the river below Vicovaro on impressive arches two stories high, and, after joining up with the Anio Novus, Anio Vetus, and Aqua Marcia, it continued along the same course as these aqueducts up to Castel Madama. From here, it veered off toward Tivoli, crossing the Ponte degli Arci, and from there to the valley of Gericomio, where the four aqueducts merged once again. Only the Aqua Claudia and Anio Novus crossed the bed of the Aqua Raminga on the majestic Ponte di S. Antonio and thereafter the Valle dell'Inferno. The four aqueducts joined again at S. Maria di Cavamonte and continued up to Casale delle Capannelle. The celebrated arches that supported the Aqua Claudia for the last 10,508 meters to Rome are among the most impressive features of the Roman countryside. The aqueduct arrived in Rome at Spes Vetus. The monumental double arch known as Porta Maggiore is its most striking feature. In addition to Claudius's original inscription, other inscriptions on the attic record the restorations of Vespasian (AD 71) and Titus (AD

81). These arches, like those that precede and follow them, were later incorporated in the Aurelian Walls.

Nero added a subsidiary branch to the Aqua Claudia that began at Porta Maggiore and ran toward the Caelian on arches, more or less following the course of the Aqua Appia. The arches can be seen near S. Giovanni Laterano, in Piazza della Navicella, and above the Arch of Dolabella and Silanus. From here, they turned toward the Temple of Claudius, feeding Nero's nymphaeum along the side of the temple complex. Domitian extended the arches all the way to the Imperial palaces on the Palatine, crossing the valley between the Palatine and Caelian. This entire section was later restored by Septimius Severus. The capacity of the Aqua Claudia was 184,280 m³ per day.

9. *Anio Novus*. The Anio Novus, built at the same time as the Aqua Claudia, for the most part followed its course, but its sources were farther up in the mountains than those of the Claudia. The aqueduct ran along the left bank of the Anio and joined the Anio Vetus, Aqua Marcia, and Aqua Claudia near Vicovaro, its course thereafter diverting from these toward Tivoli. At Gericomio, it rejoined the Aqua Claudia. Its total length measured 86,876 meters and its capacity was 189,520 m³ per day—the largest of all the aqueducts.

10. *Aqua Traiana*. This is one of the two aqueducts built after the publication of Frontinus's treatise, about which we are accordingly much less informed. It was built in AD 109 and above all served Trastevere, although it also fed the Baths of Trajan. From its source near Lago di Bracciano the aqueduct ran for 32,500 meters to the Janiculum, where its course at first followed Via Clodia and Via Cassia and thereafter Via Aurelia up to Porta Aurelia (S. Pancrazio). A large section of the aqueduct, constructed in *opus mixtum*, was discovered in 1912 underneath the American Academy on Via Angelo Masina.

11. *Aqua Alexandrina*. The Aqua Alexandrina was the last of the aqueducts, built by the emperor Alexander Severus and brought to the city around AD 226. The water originated three kilometers north of the territory of Colonna (Pantano Borghese, opposite Gabii) and reached Rome atop the brick arches that followed Via Praenestina and Via Labicana and terminated at Porta Maggiore. Among other things, the aqueduct fed the Thermae Alexandrinae, the reconstruction of the bathing facility in the Campus Martius that was originally erected by Nero.

The total capacity of the nine oldest aqueducts, for which we have secure information, was thus about 992,200 m³ per day. With Rome's population during the reign of Trajan estimated at roughly one million, this system would have provided each inhabitant of the city with almost a thousand liters of water per day.

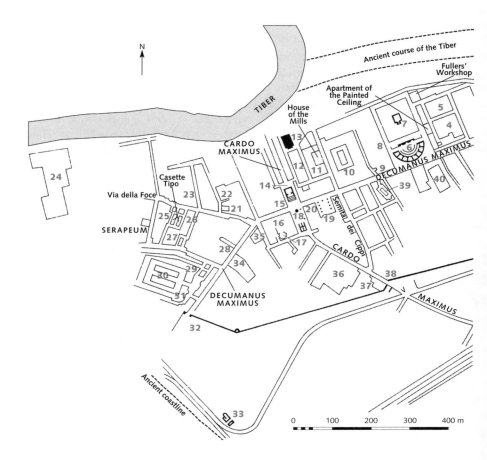

FIGURE 131. Map of Ostia Antica. 1 Porta Romana. 2 Piaz-
zale della Vittoria. 3 Baths of the Wagon Drivers. 4 Baths of
Neptune. 5 Barracks of the Vigiles. 6 Theater. 7 Square of
the Corporations. 8 House of Apuleius and Mithraeum of the
Seven Spheres. 9 Small Republican temples. 10 Large ware-
houses *(horrea)*. 11 House of Diana. 12 Apartment Block of the
Wall Paintings. 13 Museum. 14 Forum and Capitolium. 15 Cu-
ria. 16 Basilica. 17 Circular temple. 18 Temple of Rome and
Augustus. 19 Forum Baths. 20 Apartment Block of the Tri-
clinia. 21 Area of Republican temples. 22 House of Amore and
Psyche. 23 Baths of Mithras. 24 Imperial palace. 25 Baths of
Trinacria. 26 Baths of the Seven Sages. 27 Apartment Block of
the Charioteers. 28 Christian basilica. 29 Insula of the Painted
Vaults. 30 Garden Houses. 31 House of the Dioscuri. 32 Porta
Marina. 33 Synagogue. 34 Schola of Trajan. 35 Macellum.
36 Caupona del Pavone. 37 Campus of the Magna Mater.
38 Porta Laurentina. 39 Headquarters of the Augustales.
40 Horrea of Hortensius.

OSTIA

HISTORICAL NOTES

Ancient tradition attributes the foundation of Ostia to Rome's fourth king, Ancus Marcius. Modern historians have for the most part rejected the second half of the seventh century BC as a wholly fanciful date for Ostia's founding; their conclusions are supported by the absence of archaic remains among excavations at Ostia, which date the city's earliest stages to the last quarter of the fifth or to the first half of the fourth century BC. However, recent excavations in the surrounding area, from Decima to Ficana, suggest that the earlier settlement known by tradition as Ostia may actually have been situated within the bend of the river, where Dionysius of Halicarnassus (3.44.4) places it, in an area that remains unexplored.

The oldest part of the city is the so-called *Castrum*, a small fortified maritime colony, which was probably created soon after the destruction of Fidenae in 427 BC; its remains occupy the center of the later city (Livy 4.30.5–6). The oldest settlement had both a military and economic function. It was intended to protect the mouth of the Tiber (*ostia* means both "river mouth" and "entry" or "door"), which gave access to Rome's commercial and military harbors, situated as far inland as Tiber Island. Beginning in 267 BC, the colony probably became the seat of the *quaestores classici* (quaestors of the fleet)—one of several magistracies instituted in that year. From the beginning of the

second century BC, these officials assumed primarily nonmilitary functions, especially responsibility for the importation of grain.

The city was seized and pillaged by Marius in 87 BC during the first civil war, and suffered other disasters during the course of the first century BC, including sacking by pirates in 67 and the attacks of Sextus Pompey in 39.

While Ostia in its early stages was strictly dependent upon Rome, after the end of the Republic it was given a certain administrative autonomy, which lasted until the port's extinction. The chief magistrates were the *duoviri*, who were assisted by two aediles. The most important priest was the "pontifex of Vulcan," who served the main divinity of the colony.

During the reign of Claudius, the creation of a new port (afterward enlarged by Trajan) reduced Ostia's importance, although it nonetheless remained the center for Rome's food supply under the procurator of the *Annona*. A crisis in the local administrative organization must have occurred toward the middle of the third century AD, when evidence for the existence of magistrates disappears. From then on, power was probably concentrated in the hands of the prefect of the Annona. The city appears to have been almost abandoned at the beginning of the fifth century, when many multistory houses were converted into luxurious residences for an aristocracy that must have appreciated the city's isolation and tranquility. The final blow was delivered by Saracen raids during the ninth century.

The history of building in the city has been reconstructed on the basis of significant remains that were brought to light in the excavations. From the very beginning, the settlement's principal axis was Via Ostiensis, which became the *Decumanus Maximus*. From the beginning of the third century BC, a more extensive settlement began to expand around the original colony (a rectangle of 194 by 125.70 meters, enclosed within walls of *opus quadratum*). During the first half of the first century BC, the larger town was enclosed within the circuit of a large wall (around 2,136 meters), constructed in *opus quasi reticulatum*, which surrounded 69 hectares.

We know very little about the Republican city, which was covered over in great part by the buildings of the middle Empire. It is above all the public buildings that are known, especially the sanctuaries, such as the sacred area of the Temple of Hercules and the four small temples. In the Augustan period, a large-scale program of public works began, the most impressive of which are the theater and the forum, probably not completed until the reign of Tiberius. Between the end of the first and the beginning of the second century AD, the face of the city was completely transformed following a series of large-scale urban renovations carried out between the reigns of Domitian and Hadrian. The Ostia we see today is the result of the latter's far-reaching, systematic building program, which witnessed the construction of great public buildings (such as the Capitolium), large grain warehouses *(horrea)*, and residential quarters consisting of multistory buildings in *opus latericium*—perhaps the city's most impressive feature. Ostia reached its maximum expansion under the Antonines, when the

population must have approached fifty thousand. Subsequent building programs involved little more than remodeling and restoration; when Portus became the region's economic center, Ostia finally became a purely residential area, as we can gather from the existence of many luxurious late antique houses.

Over time, alluvial deposits from the Tiber extended the coastline about two kilometers into the sea. Beginning in the Middle Ages, Ostia, which had already been abandoned for some time and was now far from the sea, became a quarry for building material, which was often transported great distances, even as far as Pisa and Amalfi.

Archaeological excavations started at the beginning of the nineteenth century (1802–4) and continued at irregular intervals, starting again in 1824 and on a greater scale in 1855. Work was abandoned following the annexation of the Papal States to Italy, but began anew on a grand scale in 1907, after which it progressed slowly during the decades following. Between 1938 and 1942, the area excavated was practically doubled, until it reached its current 34 hectares. These excavations, however, were carried out hastily and largely unscientifically. After World War II and up to the present, exploration has been limited, focusing above all on levels preceding the late Empire.

ITINERARY

The Eastern and Northern Area (from the Necropolis of Via Ostiensis to the Horrea Epagathiana)

The tour of the city begins from the last stretch of Via Ostiensis, where the ticket booth now stands. The road, following typical Roman custom, is lined with **tombs**. Concentrated on the south, these are datable to the end of the second century BC. By the beginning of the first century BC, the available space was exhausted, and it became necessary to open a second road (unpaved) that lies between Via Ostiensis and Via dei Sepolcri (which runs farther to the south). The latter was used from the middle of the first century AD. The oldest tombs are of the altar type, rectangular or square, made of tufa in *opus quadratum*. At the beginning of the Empire, the columbarium in the form of a rectangular chamber with niches for cinerary urns was the prevailing style.

Via Ostiensis leads to the city's eastern gate, **Porta Romana** (FIG. **131:1**). Directly behind the gate, at a lower level, stands a Republican cippus (second century BC), inscribed with the name of the urban praetor C. Caninius; the marker defines the public area between Via Ostiensis and the Tiber that was to remain free of buildings. Next to this stands an early Imperial marble base, with a dedication to the health of the emperor *(Salus Augusta)*.

Porta Romana, which dates to the Republican period, was set back from the line of the walls and flanked by square towers. The remains of the marble

decoration preserved on site and the fragments of a dedicatory inscription that reproduces the text of an earlier Republican inscription (kept in the nearby Piazzale della Vittoria) date to a restoration under Domitian. The square's modern name is derived from a winged statue of Minerva-Victory that once must have adorned the city gate.

The **Decumanus Maximus**—the urban stretch of Via Ostiensis—measuring 9 meters in width and flanked by porticoes, begins here and extends in a direct line for a good 820 meters up to the Castrum's western gate. At several points, the large lead pipe of the aqueduct has been exposed under the level of the street.

On the right, a little beyond the gate, are the so-called **Republican warehouses,** which more likely should be identified as a commercial establishment (a sort of bazaar). During the Hadrianic period, the whole northern section was transformed into a bath complex, the **Baths of the Wagon Drivers** (Terme dei Cisiarii; FIG. **131:3**). The identification was made on the basis of an inscription on the mosaics of the *frigidarium*, where two circuits of the concentric walls are represented, along with scenes depicting wagon drivers and their life.

After the intersection with Via dei Vigili, on the right of the decumanus, excavations have brought to light a large quarter of the city that was developed during the Hadrianic period. Behind the large porticus that borders the street are the **Baths of Neptune** (Terme di Nettuno), among the largest in the city (FIG. **131:4**). Begun by Hadrian and finished by Antoninus Pius, these were built at the expense of the government. The facility has a square plan (around 67 meters per side). A small terrace at the top of a flight of stairs affords a panoramic view. The name of the baths derives from an impressive black-and-white mosaic (FIG. **132:8**) that depicts Neptune in a chariot surrounded by a cortège of sea creatures. The adjacent hall **(9)** contains a similar mosaic, with the figure of Amphitrite, the wife of the god. The rooms that comprised the baths take up the whole eastern side of the building; its western part consists largely of the palaestra, bordered on three sides by a marble colonnade. Below the palaestra is the large cistern (36 × 26 meters).

A mosaic floor from an earlier (Claudian) bath complex razed for the construction of the Hadrianic street can be seen at a lower level on Via dei Vigili; the mosaics carry symbols representing the provinces.

The entrance to the **Barracks of the Vigiles** (Caserma dei Vigili) lies behind the Baths of Neptune (FIG. **131:5**). A detachment of *vigiles*, men who served as nighttime police and firefighters, was in residence at Ostia perhaps as early as the reign of Claudius. The plan of the barracks consisted of a large central courtyard that was surrounded by a porticus, fashioned of piers, which originally ran two stories high, onto which the living quarters opened. Along the back wall there was a spacious exedra for the Imperial cult (a *Caesareum*), preceded by a vestibule with columns. A Severan floor mosaic depicts the sacrifice of a bull. The inscriptions on the numerous bases now set in the exedra indicate

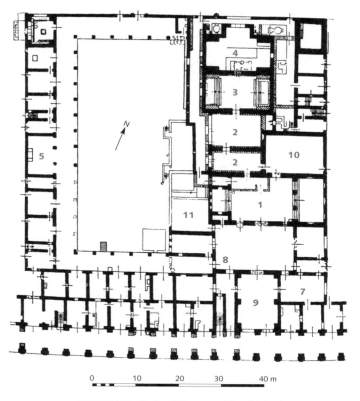

FIGURE 132. Baths of Neptune. (After Meiggs)

that they held statues of the emperors between Antoninus Pius and Septimius Severus (with the exception of Commodus, all memory of whom was officially forbidden). Two semicircular fountains occupy the corners at the front of the courtyard; a latrine is preserved at the building's southeastern corner.

Via della Fullonica, named for a fuller's workshop, one of the largest facilities in Ostia for the making and laundering of cloth, extended along the northern side of the Barracks of the Vigiles.

Turning to the left, we enter Via della Fontana, the site of a well-preserved public fountain. On the right side, about halfway up the street, is the **Apartment of the Painted Ceiling** (Insula del Soffitto Dipinto), named for an impressive painting dating to the reign of Commodus in one of its rooms.

Turning onto the decumanus, we soon reach one of the most important public building projects in the city, which includes the **Theater** and **Square of the Corporations** (Piazzale delle Corporazioni; FIG. **131:6-7**). The complex

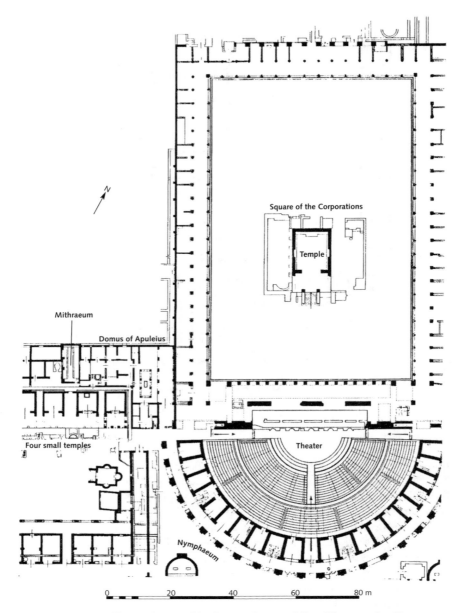

Square of the Corporations

Temple

Mithraeum

Domus of Apuleius

Four small temples

Theater

Nymphaeum

0 20 40 60 80 m

FIGURE 133. Theater, Square of the Corporations, small Republican temples. Plan.

was built by Agrippa, and thus dates to the Augustan age, as we learn from an inscription. Another inscription documents the restoration by Commodus and Septimius Severus of the oldest buildings, originally in *opus reticulatum*, at the end of the second century AD.

The cavea (seating area) of the theater almost reaches the decumanus, where it is flanked by two semicircular fountains. The fountain on the east was later transformed into a Christian oratory. At the center of the cavea, two twin arches, of which the piers remain, spanned the decumanus. Fragments of an inscription on the piers identify the structure as an honorific arch, erected by Caracalla.

The **Theater** would originally have seated some three thousand spectators; Commodus's enlargement increased its capacity by a thousand (FIG. **133**). The present appearance of the theater results from extensive restoration in 1927: the arches of the exterior brick porticus and the stairs are entirely rebuilt. The passageways that enter the orchestra largely preserve the original masonry in *opus reticulatum*. Fragments of the inscription from the second-century restoration, with the names of Septimius Severus and Caracalla, are affixed on the northern wall. The *scaena*'s facade is punctuated with alternating rectangular and curved niches; several pieces that survive from the marble decoration are displayed here.

The **Piazzale delle Corporazioni,** which stands behind the stage, was built at the same time as the theater. It consists of a huge porticus (107 × 78 meters), at the center of which stands a small temple, probably dedicated to Vulcan, as an inscription found in the vicinity seems to indicate. The porticus's original design must have employed piers, while the first colonnade apparently dates to the Claudian period. The presumably Severan mosaic decoration, the most striking feature of the porticus, occupies the floor both of the porticus and of the individual stalls that opened onto the colonnaded walkway. The designs include subjects pertaining to navigation (ships and lighthouses) and commerce. The inscriptions document corporations of ship owners and merchants who probably had their offices here. Beginning on the eastern side (to the right as one leaves the theater), inscriptions identify the following: *stuppatores res[tiones]*, towrope and cord makers; *corpus pellion(um)*, tanners; the *stat(io) Sabratensium*, the office of the African city of Sabratha in Libya, represented by an elephant; *navicul(arii) Karthag(ienses) de suo*, Carthaginian shipowners "at their own expense"; and *navicul(arii) et negotiantes Karalitani*, shipowners and merchants of Cagliari. On the northern side, we find the *navi(cularii) Narbonenses*, shipowners of Narbonne; and on the west, the *[Ale]xandrin(i)*, those of Alexandria, and the *codicari(i) de suo*, the owners of the barges that went up the Tiber as far as Rome carrying merchandise transferred from the large ships.

From the southwestern corner of the porticus, we approach the **House of Apuleius** (Domus di Apuleio), a beautiful house dating to the reign of Antoninus Pius, which was built on top of a residence of Republican date; its owner, P. Apuleius, is identified by the inscription on a water pipe (FIG. **131:8**).

The identification of this Apuleius as the famous author of the *Metamorphoses* has been proposed.

Next to the House of Apuleius stands the **Mithraeum of the Seven Spheres** (Mitreo delle Sette Sfere), one of the best preserved of the seventeen sanctuaries of the Persian god Mithras that have survived in Ostia. The name alludes to the seven semicircles symbolic of the seven heavens and the seven stages of initiation into the cult. These are represented in the mosaic that occupies the center of the hall between the two elevated benches, typical of Mithraic sanctuaries, upon which the faithful reclined during the ceremonies.

To the south of the Mithraeum is a square, dominated by the single large podium that supported the **four small Republican temples** (FIGS. **131:9; 133**). These were shrines or chapels in *opus quasi reticulatum*, built at the beginning of the first century BC by one of the most influential citizens of Ostia, P. Lucilius Gamala, according to an inscription that also records the names of the associated divinities: Venus, Fortuna, Ceres, and Spes. The little temple farthest to the west has a mosaic, naming four freedmen who furnished the money for the restoration of the flooring; the date is indicated by the names of the year's *duoviri*, including the famous C. Cartilius Poplicola, one of the best-known Ostian personages in the second half of the first century BC. A **shrine of Jupiter,** open to the sky, and a brick construction with three apses stand in the sacred area in front of the temples.

Farther along the decumanus on the right stand the **large warehouses** *(horrea)*, the largest commercial complex known in Ostia (FIG. **131:10**). It was constructed during the Republic and remodeled under Claudius and later under the Severans. The interior is rectangular, surrounded by a porticus with rows of storage chambers in *opus latericium*. A small Republican temple occupies part of the narrow area between the *horrea* and the decumanus.

Immediately after this, the decumanus reaches the **eastern gate of the Castrum,** in *opus quadratum* of tufa, which is in a good state of preservation (FIG. **134**). Here the street has been lowered to its level during the Republican period. A well-preserved section of the Castrum walls in *opus quadratum* of Fidenae tufa can be seen along Via dei Molini (Street of the Mills) to the right; several small shops, also in *opus quadratum* and dating to the second century BC, adjoin the walls.

On the left side of Via dei Molini, beyond the intersection with Via di Diana, a **large mill** contains numerous millstones carved of volcanic rock.

Turning back to Via di Diana, on the right side of the street are the ruins of the large **House of Diana** (Casa di Diana; FIG. **131:11**). The house is in fact a large *insula* with balconies, originally several stories high, which housed rental units and possibly a hotel. A narrow corridor provides access to the central courtyard, where there is a fountain and a little terracotta panel with the figure of Diana, from which the insula takes its name. The main room on the south preserves fine pictorial decoration from the mid-second century AD. The space

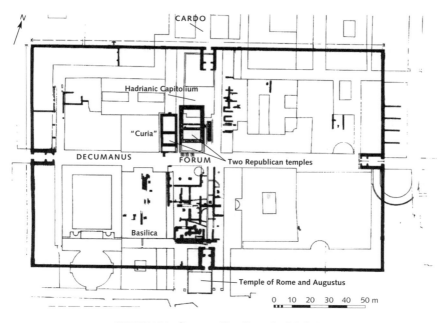

FIGURE 134. Castrum. Plan (from *Scavi di Ostia I*).

was later used as a stable, as attested by a feeding trough. Two rooms at the northeastern corner house a small Mithraeum.

On the left side of Via di Diana, two alleyways lead to a small square, at the center of which stand a fountain and a round marble altar that depicts two fauns and an altar. The inscription identifies the monument as a *compitum*, a shrine dedicated to the *lares* of the district. Farther down the street is an interesting example of a **thermopolium** (a wine shop or bar), with a characteristic marble counter and shelves for service items. The surviving paintings, as well as other features of the building, date the establishment's last phase to the fourth century AD.

The **Apartment Block of the Wall Paintings** (Caseggiato dei Dipinti) comprises a large block, subdivided into three *insulae* dating to the end of the Hadrianic period (FIG. **131:12**). The largest of the group is the **Insula of Jupiter and Ganymede,** distinguished by its rich Antonine wall paintings. The principal room (number 7, called the *tablinum*) preserves Ostia's largest fresco: an architectural design, with a vignette (now lost) at its center representing Jupiter and Ganymede, from which the house takes its name. The other two apartment buildings, the **Insula of Bacchus as a Child** (Insula di Bacco Fanciullo) and **Insula of Wall Paintings** (Insula dei Dipinti) also preserve rich painted decoration.

At the end of the street is the **Museo Ostiense** (FIG. **131:13**), housed in a fifteenth-century building (the Casone del Sale) refurbished in the nineteenth century and subsequently enlarged several times. Among the museum's highlights are the following:

Room 1. Reliefs with scenes from daily life, in marble or terracotta. An ancient marble model of a temple.

Room 2. Republican terracottas from the Castrum and city temples. A large terracotta statue of Isis from the shrine of Isis.

Room 3. This and the following room are dedicated to eastern cults. An altar with the twelve Olympian gods. A large Hadrianic marble statue that depicts Mithras killing the bull, signed by the Attic sculptor Kriton (from the Baths of Mithras). A group of sculptures from the sanctuary of Attis.

Room 4. The lid of a sarcophagus with the recumbent figure of the deceased, identified as an *archigallus,* the priest of Cybele (mid-third century AD). Two reliefs found together with the sarcophagus depict the priest in the exercise of his functions.

Room 5. Roman copies of Greek sculptures. Of particular note are the three bases with signatures of Greek artists, from the Temple of the Round Altar, and the famous herm with the portrait of Themistocles.

Room 6. Among the various sculptures, special attention should be given to the colossal bust, probably of Aesculapius, that was the cult statue of the Tetrastyle Temple (end of the second century BC). A large relief in Greek marble from the Temple of Hercules, possibly depicting the myth of Theseus and Ariadne (around 8o BC); a relief sculpture dedicated by the *haruspex* Fulvius Salvis and depicting the fortuitous discovery of a statue of Hercules (from the Temple of Hercules, dating to the early first century BC).

Room 7. A series of copies of Greek statues, dating from the archaic and Hellenistic periods.

Room 8. Late Republican and Imperial Roman portraiture. At the center, a votive statue of C. Cartilius Poplicola from the Temple of Hercules. Particularly important is the large posthumous relief of Trajan.

Room 9. Devoted to sarcophagi, among which the well-preserved example depicting the Centauromachy is especially interesting.

Room 10. Roman portraiture. Statue of Isis Pelagia in black marble.

Room 11. Impressive marble wall decoration in *opus sectile,* from a fourth-century AD building outside Porta Marina: panels depicting lions seizing deer; a bust probably of Christ giving a blessing.

Room 12. Paintings and mosaics. Of particular note are the paintings from the necropolis of the Isola Sacra (arcosolia with hunting scenes, landscapes, and Nilotic scenes).

From the museum, we reach the **Cardo Maximus,** the main north-south street, which intersects the decumanus at the Forum. Turning to the right, we reach the so-called **Piccolo Mercato** (small market), a large Hadrianic warehouse with a long colonnaded courtyard at its center, now used as a lapidarium.

The **forum,** in its present shape, essentially dates to Hadrian's reign (FIG. **131:14;** FIG. **134**). The first public square appears to have been built as late as the second century BC; it was reconfigured under Tiberius, at the same time as the construction of the Temple of Rome and Augustus. To the north of the decumanus stood two temples, whose remains were exposed during excavations and are still partially visible. The absence of an early forum can be explained by Ostia's status as a Roman colony when it was first settled; at this stage of its existence, the municipality lacked its own political structure.

The northern side of the square is dominated by the **Capitolium,** a large building in *opus latericium* that was originally clad in marble and flanked on both sides by porticoes with gray granite columns. The monument, built around AD 120 and dedicated to the Capitoline triad, is a prostyle hexastyle temple on a high podium (35 × 15.50 meters). The threshold of the cella consists of a huge block of African marble. The interior walls contain niches that housed statues; the cult images stood on the extended podium that is still preserved along the back wall.

North of the decumanus there is a building with a templelike cella, preceded by a hexastyle porticus (FIG. **131:15**). It is usually identified as the **curia,** but, on the basis of its inscriptions, ought rather to be identified as a temple of the Imperial cult or as the headquarters of the *Augustales*.

The **basilica,** dating to the beginning of the second century AD, lies south of the decumanus (FIG. **131:16**). This large hall with a central nave had colonnades on four sides, which opened on the north and east through double porticoes.

At the center of the square are the remains of a circular monument dated by its inscription to AD 51. It has been identified as the **shrine to the *lares* of Augustus.**

The southern end of the forum, opposite the Capitolium, is occupied by the remains of a marble temple, identified as the **Temple of Rome and Augustus** (FIG. **131:18**) erected during the reign of Tiberius. Only the foundation in *opus reticulatum* remains; one of the cult statues (that of Roma) has been placed on the back wall, while the remains of the rear pediment have been reconstructed to the left of the temple.

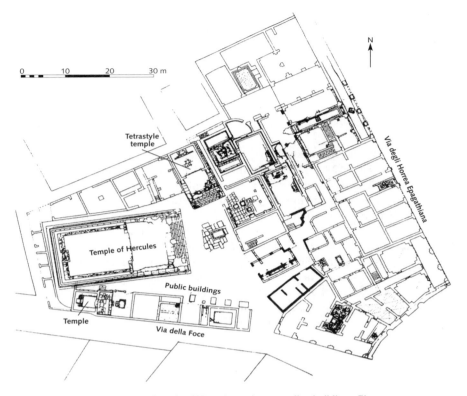

FIGURE 135. Temple of Hercules and surrounding buildings. Plan.

Passing through the east porticus of the forum, by way of Via della Forica, we approach a large **public latrine,** divided into two sections, one for men and the other for women. Opposite the latrine is the entrance to the **Forum Baths** (Terme del Foro; FIG. **131:19**), the largest and most luxurious of the city, built by M. Gavius Maximus, an important functionary during the reign of Antoninus Pius (around AD 160). The building was completely restored in the fourth century AD. At the center of the complex is a large hall roofed with a cross vault; this is the basilica, although, as typically happens in treatments of Imperial baths, it has been mistakenly identified as the *frigidarium*. Heated rooms of various plans are set in a line along the southern side of the baths, beyond which, to the south, is a large colonnaded courtyard of irregular shape that should be identified as the palaestra. At its southern corner is a small temple, probably associated with a group of rooms that constituted the headquarters of a corporation.

The so-called **Forum of the Heroic Statue** (Foro della Statua Eroica) opens up along the opposite side of Via della Forica. The square, whose name is derived from the heroic statue set in its center, was designed at a late date (fourth century AD).

The **Apartment Block of the Triclinia** (Caseggiato dei Triclini; FIG. **131:20**), which stands immediately to the west of this square, features a central courtyard, surrounded by a series of *triclinia* (banquet halls), evidently intended for collegial banquets. This was certainly the headquarters of a guild, probably that of the *fabri tignuarii* (carpenters).

Across the forum and back on the decumanus, beyond the so-called curia, lies the **Apartment Block of the Lararium** (Caseggiato del Larario) on the right, an interesting example of a market. Opposite this is the **round temple,** a large circular building of the third century, originally topped by a dome and interesting for its large rectangular courtyard. The temple was probably dedicated to the Imperial family (an *Augusteum*) and may have been erected in the first half of the third century AD.

Via degli Horrea Epagathiana begins just beyond the Castrum's western gate. The street is named for the large warehouse (mid-second century AD)—**Horrea Epagathiana et Epaphrodisiana**—owned by two wealthy Imperial freedmen recorded in an inscription on a marble tablet over the impressive entrance. The doorway is flanked by two brick columns that support a pediment; the interior, as is typical of warehouses, consisted of a central courtyard surrounded by elongated rooms; the building is now used as a repository for archaeological finds.

The Western and Southern Quarters of the City

Immediately outside the western gate of the Castrum the decumanus divides in two. One branch goes southwest, to the left, while the other branch (Via della Foce) veers northwest, in the direction of the ancient mouth of the Tiber.

At the corner formed by Via della Foce and Via degli Horrea Epagathiana lies a **monumental nymphaeum** in *opus latericium* from the fourth century AD. A rectangular foundation in *opus quadratum* a little farther on should be identified as a **compitum** (a crossroads shrine).

Following Via della Foce, we soon approach, on the right, an important **Sacred Precinct of the Republican Era** (Area Sacra Repubblicana), which contains three temples (FIGS. **131:21; 135**). The largest and most important is the **Temple of Hercules** (31 × 16 meters), occupying the westernmost section of the area. It was prostyle, probably hexastyle (i.e., with six columns on its facade), and rose on a high podium approached by a wide stairway. Structural features date it to around 100 BC. This site surely belonged to an oracular cult, as shown by the large votive relief discovered in the vicinity; dedicated by the *haruspex* C. Fulvius Salvis, the relief depicts the miraculous discovery of the god's

statue, which was caught in fishermen's nets. A cast of the relief (the original is in the museum) is displayed next to the temple. A marble statue of C. Cartilius Poplicola, identified by the inscription on its base (the original is also in the museum), stands inside the pronaos. The building was restored in the age of Trajan and again at the end of the fourth century AD.

A **tetrastyle temple,** oriented in a different direction, occupies the northern side of the area. This much smaller building has a plan similar to that of the Temple of Hercules but with a pronaos of only four columns (hence the name). The use of *opus quasi reticulatum* indicates that it is contemporaneous with the other temple; a cult statue now housed in the museum identifies the temple's titulary deity as Aesculapius.

The smallest building in the sacred precinct, immediately to the south of the Temple of Hercules, is the so-called **Temple of the Round Altar** (Tempio dell'Ara Rotonda). It is a restoration in *opus latericium,* revetted in marble, of a Republican temple. The divinity worshiped here has not been identified, but on the basis of some circumstantial evidence, it should probably be assigned to Neptune.

Opposite the Temple of Hercules, a short distance from the remains of the altar, is a rectangular hall, containing four altars of peperino belonging to the Republican period. This cult place probably predates the others in the area.

The entrance to the **House of Amore and Psyche** (Domus di Amore e Psiche), a luxurious fourth-century AD remodeling of an older building, lies on Via del Tempio di Ercole, which passes behind the temple (FIG. **131:22**). The house includes a series of rooms to the left of the entrance corridor, in one of which the sculpture group that has given the house its name was discovered (the original is in the museum, with a cast on site). On the other side of the corridor stands a large fountain with niches. The back room is a large salon with splendid marble decoration.

Proceeding in the same direction, we come to the **Baths of Buticosus** (Terme di Buticosus), an interesting example of a private bath of the second century AD with rich pictorial and mosaic decoration. The complex's name derives from a mosaic with the figure of a bath attendant.

As we continue along Via della Foce, the first street on the right (Via delle Terme del Mitra) leads to another bath complex, the **Baths of Mithras** (Terme del Mitra), on the left side of the street (FIG. **131:23**); a Mithraeum in one of the basement rooms contained a large statue of the god, now housed in the museum.

Returning to Via della Foce, we come to a sacred precinct with a temple **(Temple** and **Hall of the Mensores),** behind which there is a large warehouse **(Horrea dei Mensores).** The name is derived from that of a guild that had its headquarters here, an association of *mensores* (measurers of grain).

A large building, partially excavated in the nineteenth century, lies 200 meters beyond the archaeological zone on the line of Via della Foce (FIG. **131:24**).

The structure is part of an **Imperial residence,** identified on the basis of an inscription from Ostia that mentions it.

Retracing Via della Foce in the opposite direction, we next see the large residential quarter enclosed within the triangle between this street and the decumanus. Turning to the right on Via del Serapide, we reach the building to which this street owes its name. The **Serapeum,** a temple dedicated to the Alexandrian deity Serapis, dates in its present form to the Hadrianic period. The temple rises at the end of a courtyard, preceded by a small porticus. It contains a badly preserved mosaic featuring Nilotic scenes.

Opposite the temple is a Hadrianic bath complex, the **Baths of Trinacria** (Terme della Trinacria) (FIG. **131:25**). From here, return to Via della Foce.

The **Casette Tipo** (typical small houses) lie to the right off Via della Foce on the street of the same name. These consist of two rectangular parallel blocks, each divided into two apartments, creating residential quarters for "middle-class" families, who apparently resided throughout Ostia in the mid-Imperial era (the age of Trajan).

Block X of Region III, situated between Via della Foce and Via degli Aurighi, constitutes a single large building complex, completed between the reigns of Hadrian and Antoninus Pius. It comprises two large apartment blocks, one named after Serapis and the other called the Aurighi (charioteers), with a service bath complex at the center, the so-called Baths of the Seven Sages.

The **Apartment Block of Serapis** (Caseggiato del Serapide; FIG. **136**) is arranged around a courtyard with very tall brick piers, surrounded by shops (the apartments were probably on the upper stories). A shrine on the southwestern side of the courtyard contains a figure of Serapis painted on plaster.

The **Baths of the Seven Sages** (Terme dei Sette Sapienti; FIG. **131:26**) are directly accessible from the adjacent apartment houses. The main room—the *frigidarium*—is a large round central hall, originally domed; its mosaic floor is decorated with scrolls and hunting scenes. In a small room to the side are the paintings to which the building owes its name: the figures represent the Seven Greek Sages, each distinguished by his name and by a humorous maxim.

The **Apartment Block of the Charioteers** (Caseggiato degli Aurighi; FIG. **131:27**) is separated from the baths by a corridor decorated with two painted panels depicting charioteers (hence the name). Other important paintings can be seen in various rooms of the building.

Immediately to the west, accessible from the walkway north of the Caseggiato degli Aurighi, is the **Chapel of the Three Naves** (Sacello delle Tre Navate), a cult place with side podia and stuccoed brick columns that divide it into three aisles; the back wall terminates in an aedicula. Even though the shape is quite similar to other Mithraea, this chapel was probably that of a different, as yet unidentified cult.

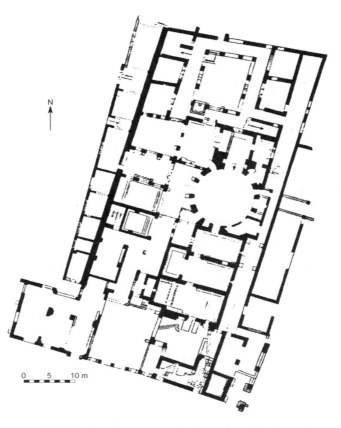

FIGURE 136. The Apartment Block of Serapis and the Baths of the Seven Sages. (After Becatti)

Back on Via della Foce, a narrow passageway leads to one of the most interesting Mithraic chapels of Ostia, the **Mithraeum of the Painted Walls** (Mitreo delle Pareti Dipinte), with important paintings that represent the levels of initiation in the cult.

After returning to the intersection of Via della Foce and the decumanus, the walk continues along the latter toward the southwest. A little farther ahead, on the right, lies the **Christian basilica,** an elongated building with two aisles, with a sort of vestibule at the front (FIG. **131:28**). At the entryway to the aisle on the left an inscribed architrave mentions Christ and the four rivers of Paradise.

Not far beyond the basilica, on the right, is the **Temple of the Shipbuilders** (Tempio dei Fabri Navales), the cult place of a guild of carpenters that specialized

in the construction of ships. The Schola of Trajan, which lies opposite, is almost certainly the official headquarters of this guild (FIG. **131:34**).

The intersection of Via degli Aurighi and the decumanus lies just ahead. A short walk along the former leads to Street of the Painted Vaults (Via delle Volte Dipinte), which provides access to another very interesting Hadrianic quarter, located within the triangle between Via degli Aurighi and the decumanus.

The **Insula of the Painted Vaults** (Insula delle Volte Dipinte), built early in the reign of Hadrian, contains a suite of rooms along a long corridor; the rooms preserve impressive Hadrianic and Severan frescoes (FIG. **131:29**).

Facing this building, on the opposite side of the street, is the **Insula of the Muses** (Insula delle Muse), which belongs to the organized complex of "garden houses" built during the reign of Hadrian (see below). This is the largest and most sumptuous residence of the quarter. Its rooms are arranged around a courtyard with covered arcade; one of these rooms preserves a representation of Apollo and the Nine Muses that belongs to what is perhaps the most important figurative cycle in Ostia. The nearby **Insula of the Yellow Walls** (Insula delle Pareti Gialle) also has elegant paintings.

Immediately adjacent to this is the large entrance to the **Garden Houses** (Case a Giardino), a trapezoidal complex that was developed during the reign of Hadrian (FIG. **131:30**). A garden with six fountains graces the center of the residence, that consists of two blocks of residential units, each of which is divided by a covered passageway into two halves; each of these halves has two almost identical apartments on each floor. This is one of the most interesting examples of Imperial domestic architecture.

The **Insula of the Temple Slaves** (Insula delle Ierodule) lies at the western corner of the complex. This apartment building, recently excavated, was also decorated with sophisticated paintings.

Not far from the entrance to the Garden Houses is the **House of the Dioscuri** (Domus dei Dioscuri), one of the most luxurious aristocratic residences of the late Empire known in Ostia (FIG. **131:31**). A hallway leads to a bedroom *(cubiculum)* containing the mosaic of the Dioscuri that has given its name to the house. Connected with this room is a salon with a mosaic floor that represents Venus Anadiomene at the center of a sea cortège. Near the salon is a bath complex, the only one to be found in a private house at Ostia. The bath and the distinctive opulence of the house suggest that this must have been the residence of C. Ceionius Rufus Volusianus Lampadius, an illustrious personage of the mid-fourth century AD.

Opposite this is another affluent house from the same period, the **Domus of the Nymphaeum** (Domus del Ninfeo), named for the large fountain with an architectural perspective that occupies its courtyard.

The **Porta Marina,** which is incorporated into the Republican walls, lies farther along the decumanus (FIG. **131:32**). The gate is flanked by two square towers and has a specially reinforced structure built in *opus quadratum*.

A rather extensive residential quarter developed outside the gate, the only example of such expansion beyond the walls. Immediately to the right is a large funerary monument, preceded by three exedras; this may have belonged to P. Licinius Gamala, the builder of the four small temples. A house of the first century AD, the **Domus Fulminata,** derives its name from a small moundlike structure in masonry at the southwest corner of its courtyard that consecrated the place where lightning struck, as indicated by the inscription: *f(ulgur) d(ium) c(onditum)* ("a divine thunderbolt is buried here").

The decumanus terminates in front of the colonnaded entrance of the complex that consists of a large square surrounded by a peristyle, onto which several rooms open. This is probably the headquarters of a guild. One room of this building is part of a wing added during the fourth century AD. Its walls were originally decorated with extraordinary marble *opus sectile*, some of which is displayed in the museum.

The **Tomb of Cartilius Poplicola** stands to the right on the first street, Via di Cartilio, that intersects the decumanus. The tomb is an altar-shaped monument, erected in the early Augustan period and decorated with a scene of naval combat. The inscription recounts that the tomb was erected at public expense for this important individual, eight times *duumvir* of the colony between the end of the Republic and the beginning of the Empire. The frieze probably records the defense of the city organized by Cartilius Poplicola during an attack by Sextus Pompey in 39 BC.

Via di Cartilio leads to the **Baths of Porta Marina** (Terme di Porta Marina), whose ancient name, known from inscriptions, was the *Thermae Maritimae*. The facility was constructed during the Trajanic period, probably by the emperor.

The **synagogue,** the most interesting and oldest example known in the west, can be reached from here (FIG. **131:33**). It was discovered in 1961.

Back on the decumanus, the next site to visit is the **Sanctuary of the Bona Dea** (Santuario della Bona Dea), the later of the two temples at Ostia dedicated to this divinity, whose mystic cult was restricted to women.

Immediately after this is the entrance to the so-called **Forum of the Porta Marina** (Foro di Porta Marina), consisting of a wide enclosed area that ends in an exedra with an apse. The presence of an altar in front of this space indicates that this is a sanctuary, perhaps dedicated to Vulcan, the most important divinity of the colony. Back inside Porta Marina (FIG. **131:32**), on the eastern side of the gate, there is an inn that was built during the Antonine period. The establishment was called the **Caupona** (inn) **of Alexander** after a boxer pictured on a mosaic.

A porticus fashioned of piers, dating from the reign of Hadrian, lines the right side of the decumanus, extending some 120 meters. The **Schola of Trajan** (Schola del Traiano) lies at the end of the porticus (FIG. **131:34**). This was the most important guild headquarters discovered in Ostia, probably belonging to the *Fabri Navales* (whose temple stands immediately opposite). The building,

dating to the middle of the second century AD, comprises a large facade with an exedra preceded by four Corinthian columns, a vestibule, and a large colonnaded courtyard, at the center of which is a narrow basin. The courtyard ends in an apsidal room that served as a dining area.

The food market (**macellum**) lies immediately before the intersection of Via del Pomerio and the decumanus (FIG. **131:35**). It has an interior courtyard equipped with a central basin around which a number of shops were grouped. The facade, which looks toward the decumanus, took the form of a porticus with columns that form a monumental entrance. Vendors established two seafood stores within the arcade.

A right turn onto Via Pomeriale and then a left turn onto Via del Tempio (behind the circular temple) lead to the southern stretch of the *Cardo Maximus*, which veers south at an oblique angle. Here are remains of a second-century BC house preserving the old atrium plan of the Roman house (**Domus di Giove Fulminatore**) and some opulent residences of the fourth century AD (**Domus delle Colonne** and **Domus dei Pesci**). Across from these is a bar with attached inn (**Caupona del Pavone**), containing interesting Severan paintings (FIG. **131:36**).

The **Campus of the Magna Mater** (Campo della Magna Mater) lies at the very end of the cardo (FIG. **131:37**). It is a large triangular complex located between the cardo and the Republican walls at Porta Laurentina. This sacred area was reorganized in the Julio-Claudian period, replacing a late Republican complex that housed the cult of Cybele (more often called Magna Mater) and other associated divinities, such as Attis and Bellona. The main entrance opens onto the cardo, opposite the principal temple (FIG. **137:1**), which occupies the far corner of the triangle; this is the center of Cybele's cult. Near the temple, but outside the precinct, is a Mithraeum (**Mitreo degli Animali**), named for the figures of animals in the floor mosaic. A long colonnaded porticus spans the southern side of the square, at the end of which—near Porta Laurentina—sits the small **Temple of Bellona (2)** with a complex of small buildings in front. This group of cult buildings is identified as the **Sanctuary of Attis (3)**.

The return to the decumanus is made by proceeding back along the cardo and turning onto **Semita dei Cippi,** an important commercial boulevard. A right turn on Via della Fortuna Annonaria leads to the **domus** after which the street is named, an outstanding example of an affluent fourth-century AD residence. To the left along Via del Mitreo dei Serpenti, which intersects with Via della Fortuna Annonaria just ahead, is the **Mithraeum** that gives its name to the street. Even more important is the **Headquarters of the Augustales,** the entrance to which opens onto the decumanus (FIG. **131:39**). At the back of the large colonnaded courtyard is an apsidal hall, where statues of the emperors, venerated by the guild, were placed. Two portraits, one of Sabina (the wife of Hadrian) and the other perhaps that of Fausta (the wife of Constantine), were found here; both of these are now in the museum (with casts on site).

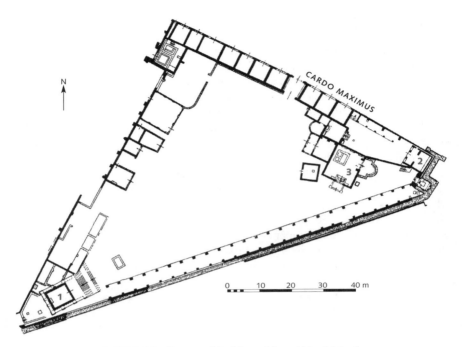

FIGURE 137. Campus of the Magna Mater. (After Meiggs)

A right turn onto Via degli Augustali leads to the **Fullonica,** an interesting industrial building used for the preparation of wool.

Continuing in the same direction, we come to the **Mithraeum of Felicis-simus** (Mitreo di Felicissimo), noteworthy for its floor mosaic, which depicts symbols associated with the hierarchy of initiation. The name of the man who dedicated the mosaic, *Felicissimus,* is also contained within the design.

Right next to this is the entrance to the Flavian **Baths of the Swimmer** (Terme del Nuotatore). Careful investigation of the site has recently allowed scholars to reconstruct the history of the building and has added important information about the economic life of the city.

The alleyway behind the Mitreo di Felicissimo allows access to the **Santuario della Bona Dea,** a cult site founded during the Republic, which takes the form of a trapezoidal precinct, at the center of which is a temple without any podium.

Returning to the decumanus, immediately on the right we find the **Collegial Temple** (Tempio Collegiale), with an inscription commemorating the guild of *Fabri Tignuarii* (carpenters and woodworkers). The sanctuary includes a temple with an apsidal cella, preceded by a kind of vestibule.

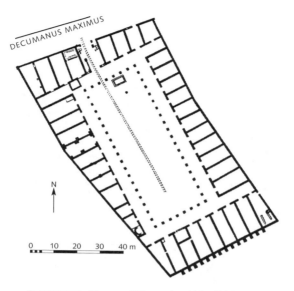

FIGURE 138. Horrea of Hortensius. (After Rickman)

From this point, the right side of the decumanus is taken up by a series of warehouses. Especially interesting are the late Republican **Horrea of Hortensius,** among the oldest preserved in the city (FIG. **131:40; FIG. 138**). As is usually the case, the facility consists of a large rectangular courtyard with a tufa colonnade, onto which a series of shops opens.

Farther ahead and to the right, on Via del Sabazeo, lies the small **Sanctuary of Sabazius,** which, with its two long side-podia, resembles a Mithraeum in its design. The mosaic bears an inscription that names its dedicator, a certain *Fructus*. The building's identification as a sanctuary of Sabazius (originally a Thracian god) is possible thanks to the discovery of a votive inscription.

Thereafter, the decumanus leads back to the entrance of the excavations.

The Environs of Ostia

THE BORGO OF OSTIA ANTICA The area of the *borgo* (village) of Ostia Antica was occupied in late antiquity by a cemetery, where among others St. Aurea, a martyr under Claudius the Goth, was buried. This explains why a suburb sprang up in this vicinity, which became the final place of refuge for the people of Ostia during the Middle Ages. The keep of the **castle,** which defended the entrance to the Tiber when its course passed through this area, was built by Pope Martin V (1417–31); the rest of the building was completed between 1483 and 1486 by Cardinal Giuliano della Rovere, the future pope Julius II. Inside is

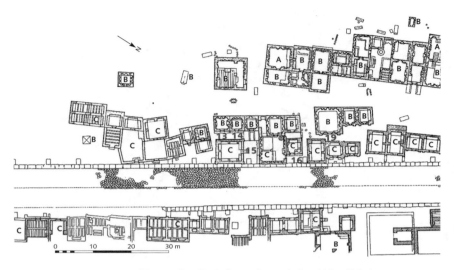

FIGURE 139. Necropolis of Isola Sacra. General plan. (After Calza)

a provisional exhibition of material from the excavation of the Basilica of St. Hippolytus (Isola Sacra).

Within the medieval walled village is the **Church of S. Aurea,** originally built above the tomb of the martyr and completely rebuilt in the 1400s. St. Monica, the mother of St. Augustine, died at Ostia in 387 and was buried in this church (her body was later transported to the Church of St. Augustine in Rome). The saint's epitaph, composed by Anicius Auchenius Bassus in 408, is recorded in medieval documents. A fragment of the epitaph, discovered in 1945, is displayed in the chapel on the right.

ISOLA SACRA AND ITS NECROPOLIS To reach the necropolis of Isola Sacra, it is necessary to take Via dei Romagnoli from the excavations at Ostia and make a sudden right turn onto the Via G. Calza, which then continues toward the airport at Fiumicino. The side street leading to the site is located beyond the Tiber over Ponte della Scafa (about 1.80 kilometers) on the right.

Isola Sacra is an artificial island, bordered on the south and east by the Tiber, on the west by the sea, and on the north by the canal (the Canale di Fiumicino) that was dug by Trajan for his port. In antiquity the site was called *Insula Portus* or *Portuensis*. The first person to ascribe the current name to it was Procopius in the sixth century AD.

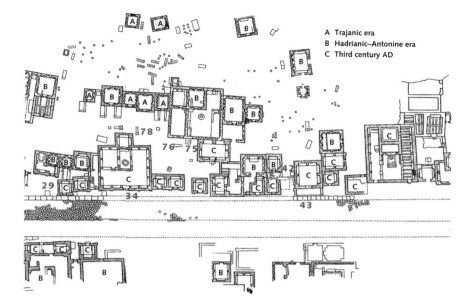

A Trajanic era
B Hadrianic–Antonine era
C Third century AD

A necropolis was built in the northernmost area of the island soon after the foundation of the port by Claudius, and it continued to be used until late antiquity. A section of cemetery—that which we can see today—was discovered by chance in 1925 and subsequently excavated (FIG. **139**). Of the approximately 150 tombs that came to light, about a hundred are included within the archaeological zone.

The necropolis was crossed by a street that connected Portus to Ostia, usually identified as Via Severiana. This road, however, primarily served Ostia, not Portus. The name *Via Flavia*, attested by an inscription together with the recent discovery of tombs from the second half of the first century AD below the first line of tombs that faced the same road, show that the road was marked out soon after the creation of Claudius's port.

When the side of the road was completely filled, a second line of tombs was created in the space behind them during the second century AD. When even this space was filled, new tombs were built during the Severan period over the earlier ones along the side of the road. The prevalent type is the square chamber tomb in brick, often preceded by an enclosure that is sometimes equipped with a dining couch for two persons *(biclinium)* used during funeral meals. The ovens and wells found in some of these small courts were also intended for such occasions. The form of burial attested in these tombs is mixed, with niches in the walls for

cremation in some and arcosolia or shallow graves for inhumation in others. From the third century AD, however, inhumation burials prevailed.

The tombs that have been preserved lie almost exclusively on the left side of the street. Tombs **13, 14,** and **15** in the first row are especially interesting because of their beautiful red brick facades and surviving paintings. Tomb **16** preserves a beautiful mosaic Nile scene in front of its door and stuccoed surfaces decorated with painted figures inside. The large Tomb **19,** from the early Antonine period, is remarkable for its rich pictorial decoration of sea horses and masks. Its portraits of the dead, which have been detached from the walls, are now in the Museo Ostiense. Tomb **29** features a beautiful facade with Corinthian pilasters. Two brick reliefs, now replaced by casts, represent a tool grinder and a hardware store, evidently an allusion to the profession of the deceased.

Tomb **34,** dated to the Severan age, is also striking. It consists of a large enclosure before a small cell, in front of which there is a mosaic depicting a portrait and doves. Under the paved forecourt, some one hundred and fifty inhumation burials have been discovered. In all likelihood this is the tomb of a burial association.

In front of Tomb **43** (of the Severan period) is a mosaic that shows the port lighthouse and two ships, with an inscription in Greek declaring, "Here all suffering ends." Just behind this is Tomb **42,** one of only three tombs that have two stories. The lower chamber preserves its painted decoration in the form of a cross vault, while the upper room has a mosaic representing a vase and doves.

Behind these tombs is the **Campo dei Poveri** (Field of the Poor), a plot of land set aside for humbler burials. Some were monuments curved on the top with a shape reminiscent of a traveler's trunk; others were made of large tiles that formed a pitched roof; the simplest of all consisted of the insertion of an amphora neck into the ground over the ashes of the deceased, to be used for the pouring of libations into the grave.

Inspection of the second row of tombs best begins from Tombs **75–76,** which were originally a single burial monument, dating to the Trajanic period, that was later divided into two chambers by a wall. The separation is documented by an inscription as having been carried out by a certain M. Antonius Agathias, the heir of M. Cocceius Dafnus (the owner of Tomb **75**).

The next tombs, remarkably well preserved, present an almost completely uniform appearance. Tomb **78** is noteworthy for its inscription flanked by two reliefs (casts have replaced the originals) that show a boat and a mill, indicating the tomb owner's profession, probably a baker or a grain merchant.

THE BASILICA OF ST. HIPPOLYTUS To reach the site of the **Basilica of St. Hippolytus,** it is necessary to return to the road for the airport and turn right onto Via Redipuglia. The historicity of the martyr appears to be supported by an inscription, dated as early as the fourth century AD, that mentions a bishop of Portus of the first half of the third century. Excavations in 1970 uncovered

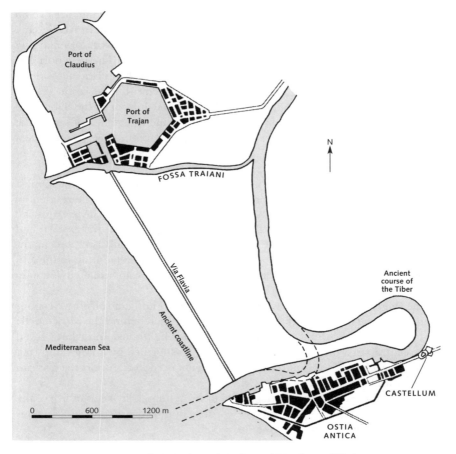

FIGURE 140. Ostia Antica and the Ports of Claudius and Trajan.

the remains of the basilica, which stood upon a structure belonging to a bath complex at the center of an area that was densely built up. The older building was reconstructed during the fourth century AD according to the canonical basilical form. The church was destroyed by the Vandals, as an inscription attests, and was later rebuilt and embellished by Pope Leo III (795–816), with the addition of a remarkable ciborium, now in the castle of Julius II. In the ninth century, the saint's relics were moved to Tiber Island, although the building continued to function as a church; the bell tower dates to the twelfth century.

PORTUS In AD 42, Claudius began construction of an artificial port two miles north of the Tiber's mouth **(FIG. 140)**. Work was probably completed by Nero

around AD 64. The basin, created by two moles and set within an area of 80 hectares, soon proved to be too exposed and dangerous; a storm in AD 62 sank two hundred vessels. The emperor Trajan thus began the work of enlarging the facility, probably around 106, and inaugurated it in 113. The new port was excavated behind the first and consisted of a **hexagonal basin,** each side of which was 358 meters long, with an area of 32 hectares. The Fossa Traiani (the present-day Canale di Fiumicino) linked the new harbor to the Tiber and Claudius's port. Little by little, the new port became the center of sea traffic on the Tyrrhenian until, not later than the reign of Commodus, even the fleet of grain vessels from Alexandria, which earlier had made Pozzuoli its port of call, was diverted here.

The main buildings, including a palace, a theater, and a bath complex, must have been concentrated on the northwestern sides of the basin. The residential quarters, on the other hand, were set out on the east and south. The remains of a large round building, called the **Temple of Portunus,** lie at the eastern end of the harbor. For a long time, the town was dependent on Ostia, but under Constantine it obtained administrative autonomy. From then on, up to the end of the use of the port in the eighth century, its importance continued to increase at the expense of Ostia.

The **Port of Claudius** lies within the area of the Fiumicino airport. Sections of the right, and especially of the left, mole can be seen behind the Museo delle Navi (ca. 500 meters long). The large, four-story lighthouse must have stood in the central area of the port. Its foundation was formed by a large ship (104 meters long), sunk for this purpose, that Caligula used to transport the Vatican obelisk from Egypt.

The **Museo delle Navi,** inaugurated in 1979, houses the keels of five of the ships that were discovered during the construction of the airport and various archaeological finds from the same site.

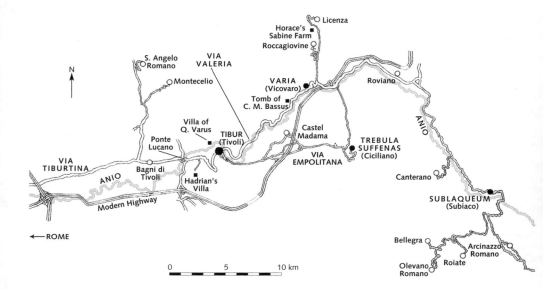

FIGURE 141. Map of the territory around Tivoli.

TIVOLI AND THE
TIBURTINE TERRITORY

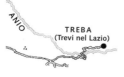

HISTORICAL NOTES

Tivoli (ancient Tibur) enjoyed a strategic position on the route
between the upper and lower Anio basin, a situation that
made it the key to Latium Vetus for those traveling from
the area corresponding to present-day Abruzzo. From a very
early period, Via Tiburtina, which originally connected Tivoli
with Rome, must have proceeded inland, on a route that was
continued by Via Valeria, established at the end of the fourth
century BC.

The foundation of Tivoli is attributed to Tiburnus, one of
the three sons of the Argive hero Amphiaraos. Hercules, the
most important local divinity, probably assumed his epithet
"Victor" after the ancient Tiburtines routed the Volscians. The
Tiburtines were among the Latins who fought the Romans
at Lake Regillus at the beginning of the fifth century BC.
Immediately after, through the *Foedus Cassianum,* Tivoli became
part of the league dominated by Rome.

In 361 BC war between the two cities began again. In this
conflict Tivoli must have been allied with the Gauls, who for
several decades continued their pillaging in central Italy. The
war ended with Rome's capture of Empulum and Saxula in
354 BC. The last conflict between Rome and Tibur took place
during the Latin War, which ended in 338, when Latium
became Rome's subject once and for all. The chaos of the

479

Social War, and the subsequent civil wars, must have engulfed the city, which probably supported Marius.

Toward the end of the second century BC at the latest, and especially from the first century on, the outskirts of Tivoli became one of the areas favored by the Roman nobility for their luxurious villas. The beauty of the countryside and its proximity to Rome, less than a day's journey, added to its attraction. Among the local families were the illustrious Munatii, of which the famous L. Munatius Plancus, consul in 42 BC and founder of the cities of Lyon and Augst, was a member.

While it was still independent, Tivoli must have included in its territory almost the entire valley of the Anio, perhaps as far as Subiaco, covering an area of about 352 square kilometers, the most extensive in Latium after Rome. This was substantially reduced in 338 BC. When Tivoli became a *municipium* after the Social War, the praetors were replaced as magistrates by the *quattuorviri*, who assumed the function of censors every five years *(quinquennales)*. The most important cult, that of Hercules Victor, gave rise to a *collegium* of *Herculanei*. When the *Seviri Augustales* were introduced during the Augustan period, the college adopted the name *Herculanei Augustales*.

ITINERARY

Via Tiburtina passes through a district of travertine quarries that are still very much in use. The remains of the ancient quarries can be seen on the right side of the road (with a turnoff after 24 kilometers), near Casale del Barco. These occupy an area of more than 500,000 square meters near a large bend in the Anio.

Somewhat beyond this, the ancient Via Tiburtina veers toward the right with respect to the modern road, crossing the river over a well-preserved bridge, the so-called **Ponte Lucano** (FIG. **141**). Originally, this had five arches, of which four are still visible (the fifth is buried). The third arch from the left bank was destroyed and then restored in antiquity. As was the case with the Ponte Nomentano and the Ponte Salario, the bridge was probably cut off by Totila during the Gothic War.

At the end of the bridge, toward the east, lies the **Tomb of the Plautii**— a high cylinder clad in travertine blocks resting on a base, with a protruding cornice band a little more than halfway up its surface. Alterations undertaken in the fifteenth century noticeably changed the appearance of the tomb, which was put to use as a tower to protect the bridge. The oldest inscription, carved on a marble slab above the middle cornice, records the name M. Plautius Silvanus, consul with Augustus in 2 BC, who was in Illyricum with Tiberius in AD 10. The tomb can be dated between AD 10 and 14.

Later, inscriptions were installed in a kind of antechamber, whose facade was accentuated by Corinthian semicolumns; only the largest of these, at the center, and another on the right remain. On the central plaque—the largest—

the inscription within the tomb is repeated, naming the consul of 2 BC, as well as his wife, Lartia, and a son, A. Plautius Urgulanius, who died at the age of nine. The son took his cognomen from his grandmother Urgulania (whether maternal or paternal is unknown), a powerful woman of Etruscan origin and a personal friend of Livia, the wife of Augustus.

The inscription on the right, the longest, carries the very interesting *elogium* of *Ti(berius) Plautius M(arci) f(ilius)*, perhaps another son of the consul of 2 BC. Tiberius, the subject of the *elogium,* was consul in 45 and again in 74. He must have died before 79, the year of Vespasian's death, as the emperor is not called *divus* in the inscription. The family's tribe, identified in the inscription as *Aniensis,* did not belong to Tivoli; the tribe of Tivoli was in fact the *Camilia.* We know that the Plautii originated in Trebula Suffenas, present-day Ciciliano, where other inscriptions naming members of the same family have been found.

Hadrian's Villa

The largest Roman villa, the work and residence of the emperor Hadrian (AD 117–38), occupied a spacious plateau that ran from southeast to northwest on the slopes of the Monti Tiburtini southwest of Tivoli (FIG. **142**). Its size (covering about 120 hectares), its richness, and its variety of architectural forms, along with its picturesque location, make it one of the most extraordinary archaeological sites in Italy.

A late biographer of the fourth century recounts that Hadrian "built his villa at Tivoli in a marvelous way, and he named parts of it after provinces and famous places, calling them for example the Lyceum, the Academia, the Prytaneum, the Canopus, the Poecile, and Tempe. So as not to omit anything, he even created a Hades" (*S.H.A., Hadr.* 26.5). The custom of taking inspiration from famous models in constructing villas—albeit very freely—was hardly new. The practice is documented as early as the Republic.

At one time the complex at Tivoli was presumed to have been the work of Hadrian's old age, but today we know that the villa came into existence during the first ten years of his reign. The emperor retired permanently to Tivoli only following a serious illness, probably the same illness that ultimately led to his death. Hadrian's direct involvement in the villa's design is confirmed by what we know of him as an architect. The emperor's character was summed up as follows (*S.H.A., Hadr.* 14.11): "He was at once austere and congenial, serious and fun-loving, deliberate and fast to act, stingy and generous, guarded and open, cruel and forgiving, and likely to change at any minute." We can perhaps see traces of this personality in the varied and even capricious architecture of his villa, which might be considered Hadrian's one true work of art. The villa does not give the impression of having been built according to a unified plan (the park is a later addition—a feature that became common from the Renaissance on, as exemplified by the nearby Villa d'Este). Rather, it is a series of pavilions,

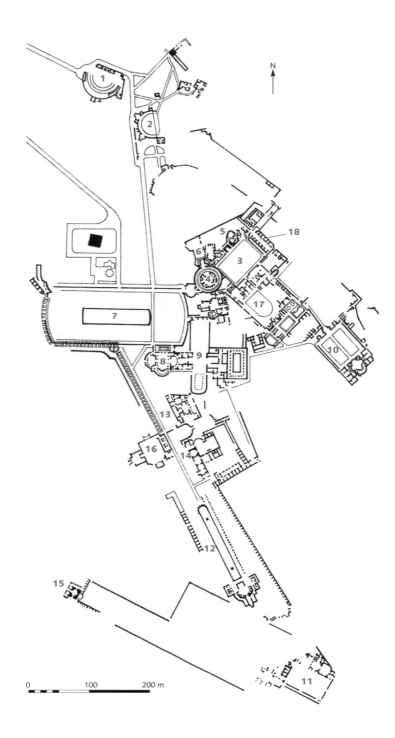

N

set randomly against the background of nature, determined, it would seem, by the changing landscape or the varying levels of the terrain rather than by some preconceived design. Hadrian's complex was preceded by a Republican villa, which occupies the heart of the palace (FIG. **142:17**). The Republican villa itself sits upon a platform, partly carved out of the natural tufa, in which a cryptoporticus of four branches was created. An enclosed area (corresponding to Hadrian's Court of the Libraries) precedes the platform, with a nymphaeum situated on the central axis toward the north. Hadrian's great palace developed and spread out from this central point, which remained the heart of the Imperial residence. The complex was created entirely during the first ten years of Hadrian's reign, while in the last years of the emperor's life there were at most only small alterations and repairs.

Various building projects followed the rhythms of the emperor's long journeys. The work, however, seems to have been concentrated mostly in the years when Hadrian was in Italy (from 118 to 121 and from 125 to 128). In the beginning, the project was limited to the Imperial residence around the old Republican villa, with the addition of baths and a gymnasium (the porticus north of the Poecile with the library—to be identified, perhaps, with the so-called Sala dei Sette Sapienti), as well as the official dining room (the building with three exedras) and the large and small baths for personnel. The remainder dates to a second phase, when the villa assumed its definitive monumental form.

One little-noticed feature of the villa, which has recently been studied, is its elaborate system of underground passageways, some large enough for ox carts and others suitable only for foot traffic. The main entrance to the underground complex must have been to the north, on a side road coming from Via Tiburtina. Of the isolated buildings beyond those most often visited, the so-called Greek Theater and the small Temple of Venus can still be seen. The temple, partially restored in recent times, is set within a large semicircular exedra. The discovery here of a copy of the Aphrodite of Cnidus by Praxiteles (a cast of the original, which is in the villa's museum, is displayed on site) suggests one model for Hadrian's building: the small round Temple of Aphrodite on Cnidus that housed the original of the famous statue.

Ordinarily, a visit to the villa begins from the modern pavilion, north of the Poecile, near the center of the northern double porticus, where a large model of the villa is displayed. The main entrance, however, was probably northeast of the so-called Ospitali (FIG. **142:18**). Here we see a rectangular room, which opens to the north with two columns *in antis*, preceded by a porticus, probably a later

FIGURE 142. Hadrian's Villa. **1** Greek Theater. **2** Temple of Venus. **3** Court of the Libraries. **4** Maritime theater. **5** Latin library. **6** Greek library. **7** Poecile. **8** Summer *cenatio*. **9** Stadium. **10** Piazza d'Oro. **11** Academy. **12** Canopus. **13** Small baths. **14** Large baths. **15** Tower of Roccabruna. **16** Vestibule. **17** Republican villa and central area of the palace. **18** Ospitali.

addition. A long wall, which runs at an angle toward the west from this point, barred access to the palace. The area in front of this, on the east, is occupied by the so-called Tempe Terrace, which looks over a deep hollow usually identified (probably correctly) with the region that Hadrian named after the famous valley in Thessaly.

The dormitories behind this, now called the Ospitali, were probably intended for the praetorian guards who protected the entrance. The complex consisted of two groups of what are obviously bedrooms, five on either side of a wide corridor. South of this are latrines and a large central room, perhaps a sanctuary for the Imperial cult. The black-and-white floor mosaic represents graceful geometric and vegetal designs.

The **Court of the Libraries** lies to the west (FIG. **142:3**). This is the oldest part of the palace, dominated on the south by the podium of the Republican villa and on the north by the two buildings, once thought to be libraries, that have given the complex its name. The structure consists of a peristyle, enclosed by a porticus on all four sides (the central section has not been excavated), with a nymphaeum in the middle of the northern side that dates to the oldest (Republican) phase. Two passageways on the sides of the nymphaeum lead to the "libraries" (FIG. **142:5–6**). In reality, these are two summer dining rooms whose orientation (almost perfectly north-south) is completely different from that of the nearby buildings. On the western side of the Court of the Libraries a stairway descends to the Maritime Theater. It is, however, better to continue to the south and visit the residential section of the villa.

The southern end of the Court of the Libraries is closed by the podium of the **Republican villa**. Near the center of this, an opening built in Hadrian's time gives access to a rectangular-shaped cryptoporticus with four branches. The southern section of this building contains fragments of a beautiful mosaic pavement, as well as important decoration in its vaulted ceiling, including a framed panel in small tesserae of white marble and blue glass, with a round medallion at the center (dating to the second quarter of the first century BC).

On the floor above, remains of the Republican structures are visible, along with copious restorations and alterations by Hadrian. This is an important section of the Imperial palace, certainly intended as the official reception area. At the center of the south side there is a large square exedra, transformed by Hadrian into a library, probably for his private collection. (A full-scale reproduction of this can be seen in the Museo della Civiltà Romana in EUR.) East of the library is a basilical hall, divided into three aisles by two rows of four columns. On the opposite side, we can make out traces of a peristyle, at the end of which (toward the south) a large doorway gave access to a small group of impressive rooms that were probably intended to receive representatives of state.

Immediately behind the doorway is a large room with a semicircular niche at the north, a porticus, and a large nymphaeum in the form of a theater at

the south. This precedes the spacious rectangular **Hall of the Doric Piers** (32 meters long, 23 meters wide), a true basilica, from which a rectangular chamber with two columns *in antis* leads to what must have been, because of its axial position, the main room of the complex. It has traditionally been called the throne room, not unreasonably, given the raised floor at the center of the apse.

Behind the hall, but outside the palace, is the small building known as the **Caserma dei Vigili** (firemen's barracks). This is a purely utilitarian structure, in striking contrast to the luxurious rooms nearby. It was probably meant to house the slaves who were stationed here to serve the palace. A long porticus and an octagonal vestibule (approximately 10.35 meters in diameter) lead to the **Piazza d'Oro;** the vestibule contains one of the most interesting examples of a segmented dome, supported by arches resting on brackets (FIG. **142:10**).

A porticus with two aisles borders the large peristyle of the Piazza d'Oro (61 × 51 meters). The columns that separate the two aisles have an intercolumniation twice as wide as the external colonnade, which consists of square piers with engaged columns. The perimeter wall of the porticus has small blind arches resting on piers with engaged columns. The whole is of solid masonry construction, which was originally covered with stucco.

To the right and the left of the vestibule are two small, square cross-vaulted rooms, pierced by niches, that are apsidal on the sides and rectangular on the back. The room on the west is much better preserved than the other, with traces of the marble facing on the walls and of the polychrome mosaic with a geometric design on the floor. Outside the porticus, on the western and eastern sides, are two corridors (cryptoporticoes) with a series of cross vaults that give access to the rooms facing the Vale of Tempe. At the center of the open piazza was a long axial basin, bordered by gardens that were set off by small walls.

The most remarkable feature of the building is the complex at the south. At its center is an octagonal space with curved sides, alternately concave and convex, each of which is supported by two columns. At the rear is a large apsidal nymphaeum, with alternating semicircular and rectangular niches, each enclosing a fountain. The convex sides open onto small apsidal nymphaea, while the concave sides lead to a pair of small courts, each with two convex and two straight sides, onto which three barrel-vaulted rooms open. Whether a dome spanned the center room has been extensively debated; the question seems now to have been resolved in favor of the absence of a roof. We have, then, an open court with a nymphaeum. The complex seems to have served as a summer dining room. The bas-reliefs on the epistyle frieze of the side courts, with scenes of hunting, confirm this identification.

Returning to the Court of the Libraries, a small stairway leads to the **maritime theater,** which is at a lower level (FIG. **142:4**). This fanciful (and completely unwarranted) name describes a circular building with an annular porticus, covered with a barrel vault that rests on a marble colonnade on the opposite side. A canal separates the porticus from the little island at the center, which

contains a villa in miniature. Originally, the canal would have been crossed by two small wooden bridges, which could be retracted to the island (the mechanism is displayed in a model in the south exedra of the porticus); these were later replaced with a brick bridge. This picturesque island villa was probably meant to be a place of refuge. We can, perhaps, identify the model that inspired it: a similar building also isolated by a canal in the palace of Dionysius I of Syracuse (Cic., *Tusc.* 5.59).

A group of buildings surrounding the maritime theater was probably meant to represent a similar complex familiar to Hadrian from his travels, perhaps a Greek gymnasium (the Academy or the Lyceum?). From the maritime theater, a small stairway leads directly down to the so-called **Hall of the Philosophers**. This rectangular room, with an apse on the south, might have served as a library; if so, the seven niches in the apse were perhaps intended to hold bookcases.

South of the Hall of the Philosophers is a bathing complex, the **Heliocaminus Baths,** the most important of all the baths annexed to the palace. On the south of the large hall is the remarkable room that has given its name to the whole complex: a circular space, entirely taken up by a large circular pool, originally spanned by a coffered dome. The lack of any hydraulic installations, together with the five large windows on the southwest, has suggested to some that this was a *heliocaminus,* a room heated by the sun, but the evidence of artificial heating in the room makes it likely that it was a *sudatio* (sauna).

At the northeastern end of the **Poecile,** the curved end of a long double porticus touches the western wall of the Hall of the Philosophers (FIG. **142:7**). A spina wall that supported a double pitched roof divides the porticus, providing separate walkways on both sides of the wall. At the two ends of this spina, circular passageways made it possible to turn around from the inside of the wall to the outside without leaving the cover of the porticus. An inscription, found probably nearby in 1735, specifically refers to this building: "Porticus measured: the circumference is 1,450 feet long, a lap around it seven times makes 2,030 paces." The measurement corresponds to about 429 meters—double the length of the porticus (around 214 meters). This is therefore one of those *ambulationes* or *xysti*, intended for healthful walks of a measured length, so often described by Latin writers.

The Poecile square (232 × 97 meters), added at a later phase, was enclosed within a quadriporticus, with its shorter sides slightly curved. It in turn enclosed a garden with a large pool at the center. The entire western section rested upon a very large foundation, consisting substantially of a series of rooms arranged on four levels on the west and three on the south (the **Cento Camerelle,** or Hundred Chambers). The rooms were probably intended to house the large number of slaves who worked at the villa.

On the southern side of the Poecile is a building with three exedras, which can be identified as a large **dining room** *(cenatio)* for formal banquets (FIG. **142:8**). Its two distinct phases largely correspond to those of the villa itself. From the

first phase there is a large covered rectangular room, in front of which (on the north) stands a rectangular room containing a basin. The building's southern end is occupied by a semicircular exedra with a porticus. In the second phase, the two lateral semicircular exedras and the fountains were added.

On the east, we find a series of other buildings, all oriented in the same direction as the Poecile. Recent excavations in the so-called **stadium** have revealed that it is in fact a very large nymphaeum divided into three sections (FIG. **142:9**).

Farther to the east is a complex of buildings that some have identified as the **Winter Palace**. Its most striking feature is a large porticoed courtyard (59 × 33.50 meters), which originally had forty marble columns raised on a podium that includes part of the cryptoporticus below. At the center of the courtyard is a pool enclosed by a high wall containing niches for statues.

The next group of buildings on the south assumes yet a different orientation, informed by the contours of the small valley. This group includes two bath buildings, along with the so-called Praetorium and Vestibule, and the Canopus. The first of these buildings houses the **small baths,** whose very small area incorporates an impressive variety of plans with amazingly diverse designs (FIG. **142:13**). The external facade is undulated, containing three niches flanked by columns. The heart of the building is an octagonal room, whose alternately convex and flat walls provide access to other rooms of the complex. Along the western side is the circular domed *caldarium*, and through this, a pool with curved short sides and the *tepidarium;* the *frigidarium*, containing two large apsidal pools, lies to the south.

These baths form a single, unified complex with those farther south, the **large baths,** which were designed at the same time, although they may have been built somewhat earlier (FIG. **142:14**). The large baths show a more classic design, with a preference for square and rectangular rooms. Here too the heated rooms are on the western side, with the long external corridor for furnaces (the *praefurnium*) situated alongside. The small baths were probably reserved for women, and the large baths for men. The complex was apparently intended for the villa's extensive service personnel.

Fronting the hill south of the large baths is a multistory complex of tabernae (the **Praetorium**), which has been identified as either a residence for the complex's personnel or, less likely, a group of storage rooms.

In the long narrow depression south of this lies the **Canopus,** one of the most famous and evocative of the villa's architectural groups (FIG. **142:12**). The valley was leveled and reinforced with a buttress wall on the east and a retaining structure preceded by two stories of tabernae on the west. A long pool (119 × 18 meters) runs through the center of the valley. The short end on the north is curved and embellished with a colonnade that carries an alternately flat and arched architrave, re-erected after excavations in the 1950s. Another two colonnades run along the sides of the pool; the one on the east was a double colonnade, while that on the west was single. At the middle of the latter, six

caryatids replace the columns, four of which are copies of the caryatids in the Erechtheum on the Athenian acropolis; the other two represent Sileni. The originals, discovered in the pool like the rest of the ornamental pieces, are in the nearby museum, and cement copies have been set up on the site. Replicas of other statues—the Nile, the Tiber, and a crocodile—are displayed on the curved end of the pool. Between the columns are copies of Severan statues of Ares, Athena, and Hermes, as well as two reproductions of the Amazons by Phidias. At both ends of the pool are bases that supported Scylla groups, fragments of which were found here.

The valley is closed off near its end by a large nymphaeum (the **Serapeum**) in the form of a semicircular exedra, which extends in a long and high barrel-vaulted corridor that terminates in a rounded apse. The exedra has a ribbed half dome, whose segments are alternately concave and flat. An elaborate system of fountains enlivened the building, which can be identified as a large summer *cenatio*. The inspiration for the plan came from temples of the Egyptian cult. This, along with the elongated shape of the pool and numerous Egyptian statues discovered in the area, suggests that the complex may be the Canopus mentioned in Hadrian's biography, modeled on the Egyptian canal that joined Alexandria to the city of Canopus, which contained a famous temple dedicated to Serapis. The Villa of Hadrian contains what is in effect a reconstruction of the course of the Nile (the rectilinear area in front of the Serapeum) and of the Delta (the Serapeum itself), thus representing Upper and Lower Egypt. The Egyptian Museum of the Vatican has a reconstruction of the monument, showing the statues that were originally placed here.

The **museum,** which is located in the rooms west of the Canopus, houses some of the materials discovered during excavations in the 1950s. It displays, of course, only a small portion of what has been discovered at various times, much of which is now dispersed in museums throughout Italy and Europe.

Room 1. Four reproductions in Pentelic marble of the Caryatids from the Erechtheum (2.06 meters high), surmounted by Doric capitals with ovolos. Two Sileni carrying baskets *(canephoroi)*.

Room 2. Statue of a crocodile in cipollino. Statues of the Nile and the Tiber.

Room 3. Statues of a warrior (probably Ares) and of Hermes. Fragmentary statue of an athlete from an original by Myron.

Room 4. Copy of the Amazon by Phidias. Male portrait, probably that of the young Lucius Verus. Portrait of a young man, from the Canopus.

Room 5. Torso of Aphrodite of Cnidus by Praxitiles. Portraits of Caracalla, Septimius Severus, and Julia Domna.

Room 6. Numerous decorative and architectural pieces found in recent excavations.

On the small hill that overlooks the valley of the Canopus on the southwest is a group of once well-known buildings now, unfortunately, in large part gone. These include the Tower of Roccabruna, as well as the so-called Academy, probably a small detached palace (FIG. **142:11**). The **Tower of Roccabruna** is a nearly square building (16.50 × 16.75 meters), standing alone at the northwestern end of the terrace; it was probably one of those isolated towers of a type often found in ancient parks on sites with exceptionally panoramic views (FIG. **142:15**).

Tivoli

A number of large Republican villas occupy the western slopes of Tivoli facing Rome. A large winding road, known as the Girata delle Carrozze, leads down to the so-called **Villa of Cassius**. There remain three foundation terraces belonging to this property that face west. The villa is famous for the discovery of an important group of sculptures (now mostly in the Vatican) on two occasions—in the 1700s and again in 1846.

Walking upward along Via Tiburtina, between it and the street above called Pomata, we can see from below a huge foundation that is distinguished by a reticulate facing in two colors (tufa and palombino) with linear and triangular geometric designs. The building is known by the wholly fanciful name **Villa of Brutus** and is often confused with the Villa of Cassius, situated a bit farther to the south. The ancient Via Tiburtina, following a more direct route than the modern road, passes the **Tempio della Tosse** (Temple of the Cough) on the right side of the street (FIG. **143:1**). This is a large circular hall in *opus vittatum*, topped by a dome in the shape of a hemispherical bowl. It was transformed during the Middle Ages into a church, called S. Maria di Porta Scura (or S. Maria del Passo). The structure was probably the monumental atrium of a villa from the first half of the fourth century AD, certainly part of an Imperial estate, and was perhaps a remodeling of the villa that belonged to Augustus.

Via Tiburtina next reaches the **Temple of Hercules Victor** (FIGS. **143:2; 144**). Part of this was occupied by a convent at the end of the fifteenth century and subsequently by factories. Finally it became a paper mill, which was dismantled only a short time ago. At the time of writing, the temple was under restoration and not open for public visits.

The cult of Hercules Victor, one of the most important in Latium, originated in Tivoli, from where it was introduced into Rome during the late Republic. Hercules came to be worshiped as the protector of transhumant flocks. Tivoli's position, on the route between the Abruzzi Apennines and the plain of Latium, explains why a god with this function would have his cult place here. The sanctuary is mentioned several times by ancient authors as the most important of the city. It was the seat of an oracle, based like that of Fortuna at Praeneste on the drawing of lots. The impressive size of the sanctuary, which exceeds

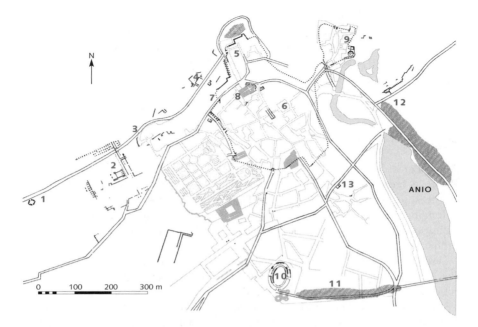

FIGURE 143. Map of Tivoli. **1** "Tempio della Tosse." **2** Temple of Hercules Victor.
3 Via Tiburtina. **4** Republican villa. **5** Porta Esquilina and cryptoporticus. **6** Rione S. Paolo.
7 Porta Maggiore. **8** Forum. **9** Acropolis. **10** Amphitheater. **11** Iron Age necropolis. **12** Necropolis and tomb of the Vestal. **13** Baths.

that of the Temple of Fortuna at Praeneste, confirms the prestige that ancient
tradition attributes to it. Its position, certainly outside the city walls, shows that
it was a suburban sanctuary; indeed, cults tied to commercial routes and to
markets, as that of the Tiburtine Hercules must have been, were often outside
the boundaries of the city.

The heart of the sanctuary was its large porticoed square, constructed on
cyclopean foundations in *opus incertum*, with blind arches separated by buttresses,
especially on the northwestern side, where the hill slopes down to the Anio valley.
Via Tiburtina was diverted at an oblique angle through a barrel-vaulted tunnel
in the podium of the temple (the medieval Porta Oscura known in antiquity as
Via Tecta). A series of noncommunicating rooms opens onto this off the right
side as one ascends. On the other side there is a more systematic organization
of rooms, which are larger and perpendicular to the street, and onto which a
symmetrical series of tabernae faces on two sides. The complex had, without
question, a commercial character that preserved the function of the older market
tied to the sanctuary.

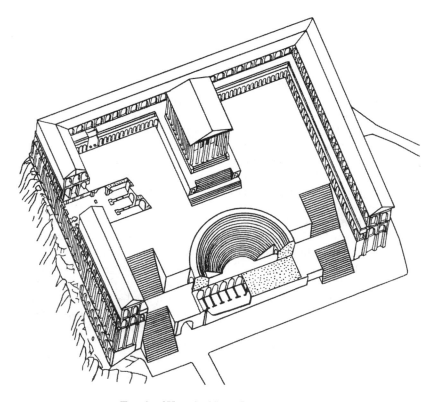

FIGURE 144. Temple of Hercules Victor. Reconstruction. (After Giuliani)

The public square above, surrounded by a porticus on three sides, measures about 152 by 119 meters. The southwestern side, facing the Roman Campagna, was left open; it was probably entered by two large stairways, located at the sides of a theatrical cavea. The porticus consisted of a series of arches framed with Doric semicolumns, an architrave, cornice, and high attic. The whole building was constructed in *opus incertum,* while the arches are travertine and the capitals are monoliths.

The square, like the Terrazza della Cortina at Palestrina, formed the central part of the whole sanctuary. The temple stood at the back end of the enclosed space; a theatrical area (about 70 meters wide, much of it recently excavated) that takes advantage of the sloping ground rises along the southeastern perimeter of the complex. The combination of temple and theater is typical of a group of sanctuaries in central Italy. In addition to Palestrina, there are examples at Gabii, Pietrabbondante, Teano, the Theater of Pompey at Rome, and the so-called Punic Temple of Cagliari.

The Temple of Hercules was covered in 1925 with huge cement tanks and is not currently visible, except for the two long sides of the lower foundation. It stands quite close to the porticus in a position that is not perfectly axial. As we can gather from old reliefs, it was a large *peripteros sine postico*, an Italic modification of the Greek peripteral temple that eliminated the rear colonnade. The dimensions are remarkable: about 61 by 41 meters for the lower podium, and 42 by 25 for the temple itself. The oldest inscriptions discovered in the sanctuary (*CIL* XIV 3664, 3667, 3668) allow us to date it with fair precision to between 90 and approximately 82 BC.

The forum corresponds to the present-day Piazza del Duomo, but it was considerably larger than this square, extending to the so-called market (FIG. **143:8**). The latter was probably the foundation that supported the southwestern side of the square, eliminating the original difference in ground level in the area of the Duomo. The "market" consists of an ascending row of five niches with a street, certainly earlier in date, that passed in front, arranged into a series of ramps and covered in this stretch by a barrel vault.

Via del Colle passes by this building along a north-south orientation. The street corresponds to an ancient access road, parallel to the *Clivus Tiburtinus*. Here the walls form a salient on the right that protected a gate through which the road passed. Some elements of this gate, today called **Porta Maggiore,** can be seen on the right, including the springing of an arch with travertine voussoirs and the attic in brick, probably a late Imperial addition (FIG. **143:7**).

An important building of the forum once stood in the area of the Duomo. This structure was an apsidal hall of rectangular plan, perpendicular to the northeastern edge of the square. In a hollow space at the rear of the church, a large apse (with a diameter of 15.60 meters) in *opus quasi reticulatum* is still visible. At the center of this is a rectangular niche, 3.35 meters high and 1.20 meters wide. The shape of the building and its position with respect to the forum correspond well to those of a basilica. The construction technique dates the building to the second quarter of the first century BC.

The southeastern side of the forum was bordered by a line of structures, two of which were found quite by chance at the end of the nineteenth century and in 1920. The **mensa ponderaria** (office of weights and measures) was discovered in 1883. The remains include two niches next to one another, in which we can recognize at least two building phases: an older one, in *opus incertum* (side walls), and a more recent one, in polychrome *reticulatum*. In the niche on the right is a marble table with four bowl-like recesses for measures carved into its surface. The table is supported by three vertical slabs that have figures of thyrsi and a club on their edge. The inscription on the front of the table attests that M. Varenus Diphilus, the *magister* of the Herculanei (surely a commercial guild), had the table of weights made at his own expense. A similar table with the same inscription and with two recesses now stands in an exedra on the left.

Right next to the *mensa ponderaria,* to the southwest, an apsidal hall, slightly trapezoidal in plan (4.10 meters wide by 5.47 at its maximum length), was discovered in 1920. The hall has marble flooring and walls with remains of frescoes and a marble baseboard. In the center of the apse was a statue base (probably a seated Augustus), the fragments of which were found and put back in place; unfortunately, the head has not survived. As an inscription indicates, M. Varenus, the donor of the nearby *mensa ponderaria,* also constructed the hall, certainly an *Augusteum*—a chapel of the Imperial cult—at his own expense to commemorate one of Augustus's returns to Rome, probably that of 19 BC.

The city's **acropolis** (known today as Castrovetere) lies on a strip of land jutting out to the north (FIG. **143:9**). It was completely cut off from the rest of the city by an artificial moat that is now spanned by a modern bridge, which certainly replaced an ancient one. East of this, where the famous waterfall of the Anio plunges over a projecting rock, are two important small temples reached by passing through a restaurant. In the Middle Ages they were transformed into the (rectangular) Church of St. George and the Church of S. Maria Rotonda (FIG. **145**).

The temples do not date from the same period. The one on the north, the **rectangular temple,** is older. Its podium, 1.76 meters high, is in *opus quadratum* of travertine, with a simple *cyma reversa* molding at both the top and the bottom. Only the two lateral columns of the front colonnade, which was originally tetrastyle, remain. The walls of the cella, built in travertine *opus quadratum,* terminate in the front with three-quarter columns. The four other semicolumns on the long sides and the four along the back completed the scheme of this pseudo-peripteral structure. Only one Ionic capital has been preserved, the second from the north on the back. The building, measuring 15.90 by 9.15 meters, dates to the middle of the second century BC.

The **round temple** is later in date. It rests partly upon an artificial platform, consisting of two rows of concrete vaulted rooms set on top of each other, with a tufa facing in *opus incertum.* It is closely akin to and contemporary with the structures found along the entire urban perimeter of Tivoli, all of which are part of a monumental project of urban renewal undertaken in the last decades of the second century BC. The structure is a peripteral temple (14.25 meters in diameter) with Corinthian columns, standing on a concrete podium (2.39 meters high) and dressed in travertine *opus quadratum.* The base molding is a rather flattened *cyma reversa,* while the crowning molding is somewhat more pronounced. The original peristasis consisted of eighteen columns with Corinthian-Italic capitals, of which ten remain. The entablature includes the architrave, which once carried the dedicatory inscription, and the frieze with complete bulls' heads of Hellenistic type instead of mere skulls. These supported garlands, within whose loops were *paterae.* The ambulatory ceiling was finished in travertine and had coffers embellished at the center with rich four-leaf flowers.

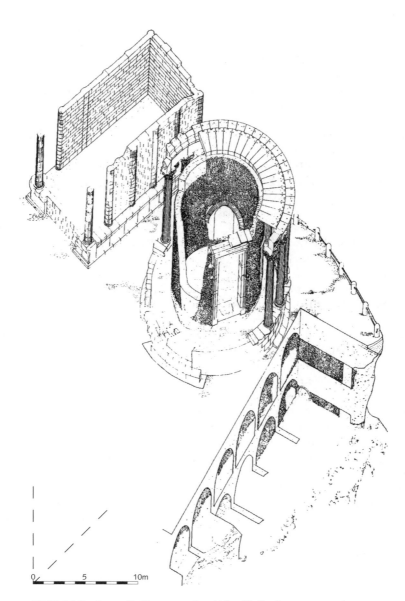

FIGURE 145. Acropolis. Reconstruction. (After Giuliani)

0 5 10m

The original stairway, which has disappeared, corresponded to the doorway and faced the southwest. The entrance is 5.01 meters high, with jambs and lintel in travertine blocks, surmounted by an elaborate cornice. Of the two windows at the sides of the door, only the one on the right survives. A travertine cupboard—perfectly on axis with the door—was inserted into the wall at the back of the circular cella, which is entirely in *opus incertum* that was meant to be stuccoed. The cupboard must originally have been closed by a door of two small leaves, as holes for its hinges show. The short fragment of an inscription that survives on the outer architrave names a certain Lucius Gellius, son of another Lucius, perhaps to be identified as Lucius Gellius Poplicola, praetor in 94 and consul in 72 BC.

The position of the two temples corresponds to what the literary sources record for the cults of the city founder, Tiburnus, and Albunea, the Tiburtine Sibyl, which were near the Anio waterfall. The small stone cupboard, originally furnished with doors and set into the wall behind the cult statue, may have held the prophetic book of the Tiburtine Sibyl, to whom the round temple was probably dedicated. The rectangular temple may have been dedicated to Tiburnus.

On the opposite side of the ravine, inside the **Villa Gregoriana,** a series of foundations in *opus incertum* survives, part of a villa that stood opposite the small temples of the acropolis. The villa must be that of Manlius Vopiscus, a wealthy man who lived during the reign of Domitian; Statius describes it at some length in a poem (*Silv.* 1.3).

North of the Rocca Pia is the **amphitheater,** attested by an inscription found in the sanctuary of Hercules (FIG. **143:10**). Its foundations, in fact, had been seen in 1491 during the construction of the Rocca Pia. They were rediscovered by chance in 1948 in the area north of the Rocca and excavated beginning in 1957. The visible remains, belonging to the northern half, are in *opus mixtum;* they allow us to reconstruct a rather small building, 85 meters on its major axis, 65 meters on the shorter.

The whole area between the Rocca Pia and the regional hospital was once occupied by an important **Iron Age necropolis,** which was excavated between 1953 and 1954 and then again in 1964 (FIG. **143:11**).

The street of Quintiliolo, with beautiful views of the waterfall and the old city of Tivoli, runs from the square in front of Villa Gregoriana to what was formerly the convent of Sant'Antonio, now a private villa (not on the map); the latter corresponds to the site of an important **Republican villa,** once identified as that of Horace. The modern building rests upon the upper terrace of the villa, which is oriented differently from the two lower ones. At the lower level there are three rooms, those on the sides being cisterns, while that in the center is a large nymphaeum facing the south, in perfect line with the splendid panorama of the waterfall and the two small temples. The nymphaeum, in *opus incertum* tending toward *quasi reticulatum*, is rectangular and roofed with a barrel vault.

At the back is an apse, while the sides are occupied by two narrow aisles. The apse has a concrete base, and the fountain preserves traces of stucco decoration. The building technique, along with architectural and decorative details, dates the nymphaeum and the complex as a whole to the second quarter of the first century BC.

Farther along on the same street is the little church of the Madonna di Quintiliolo, beyond which appear the foundations of an enormous **villa,** the largest known in the area of Tivoli. The terrace, at its widest, measures 270 × 152 meters; the total land surface occupied is a little less than six hectares. The building dominates the plain facing Rome on one side and the valley of the Anio, the Temple of Hercules, and the old city of Tivoli on the other. The huge podium was built in a rather coarse *opus incertum* of limestone and in *opus reticulatum.*

The toponym "Quintiliolo" allows us to associate the building, with some confidence, with the important senatorial family of the *Quintilii Vari,* and in particular with Quintilius Varus of Cremona, the friend of Vergil and Horace. After his death in 23 BC, the villa may have passed to the consul of 13 BC of the same name, made famous by the Romans' terrible defeat in the Teutoburg Forest (the *clades Variana*), in which he lost his life.

A large necropolis was discovered near the ancient bridge opposite Villa Gregoriana, on the right bank of the Anio (FIG. **143:12**). The approach to the area was partly by way of a ramp in polychrome *opus reticulatum,* a section of which is still visible beside the older bridge. The most interesting find here occurred in 1929, when a landslide exposed a **tomb**, still intact (visible *in situ*), belonging to Cossinia, one of Tivoli's Vestal Virgins. The monument has two parts. That in front is a raised platform with five travertine steps, on which sits a marble altar with pulvini. In the center of the altar, within a frame, is the following inscription: "Because she gave obedience to Vesta for eleven-times-six years, the virgin is buried here and rests after being carried to this spot by the people, a burial granted by decision of the Senate."

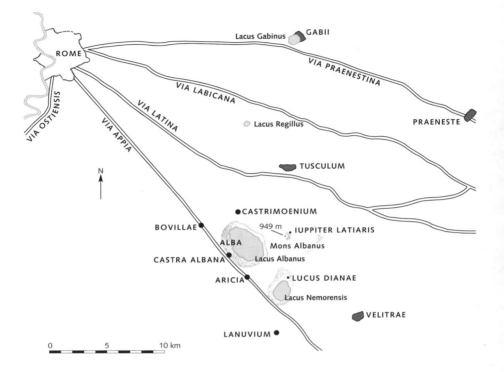

FIGURE 146. Rome's southeastern environs.

THE ALBAN HILLS
AND PRAENESTE

THE ALBAN HILLS

HISTORICAL NOTES

The massif of the Alban Hills consists of a group of volcanic craters, about 10 kilometers in diameter, that culminates in the two summits of Monte Cavo (949 meters above sea level), the *Mons Albanus* of antiquity, and Monte Faete (956 meters). The activity of these volcanoes, extinct for about 25,000 years, and the fluvial erosion that followed largely shaped the territory of *Latium Vetus*. The Alban Lake and the Lake of Nemi occupy the cavities of ancient craters (FIG. **146**).

Roman tradition connected the birth of Latium's most ancient centers with Aeneas and his descendants. Aeneas is supposed to have founded Lavinium, and his son, Ascanius-Iulus, is the mythic founder of Alba Longa, from which in turn Rome was founded. The same foundation myth, moreover, must have been common to all the other cities of primitive Latium, which according to tradition were almost all colonies of Alba Longa. Archaeological research has not yet confirmed the priority of Alba Longa; its status is probably best understood as a politico-religious hegemony centered in the common sanctuary of Mons Albanus that was sacred to *Iuppiter Latiaris*. In reality, the oldest evidence of Latial culture appears not only in the Alban Hills but also at Rome.

The prevalence of necropolises in the western belt of the hills confirms that the dominant center—i.e., Alba Longa—

occupied the area that corresponds to Castelgandolfo. The early disappearance of Alba Longa, however, is confirmed by archaeological discoveries. The most important necropolises discovered so far are those of the Villa Cavalletti and Boschetto near Grottaferrata, Campofattore and Riserva del Truglio near Marino, and S. Lorenzo Vecchio near Rocca di Papa.

The disappearance of Alba Longa at an early stage favored the growth of certain other cities (Tusculum, Aricia, and Bovillae), but the ancient city left traces, especially in religion, where practices are more difficult to eradicate. Proof of this is the persistence of the cult of Jupiter Latiaris on Monte Cavo as a federal institution, and, from a later age, the cult of Diana Nemorensis. The "Alban families" in Rome, such as the Julii, among whom the memory of the mythic origins was cherished, were living witnesses to ancestral traditions at Rome.

The four centuries between the destruction of Alba Longa and the Latin war constitute the history of Rome's progressive emergence and final hegemony over Latium. With its definitive victory over the coalition of Latium's cities in 338 BC, Rome assumed the leadership of the region. From that moment on, Latium Vetus became a kind of appendage to Rome. The picturesque Alban Hills, about a day's journey from Rome, became the country residence of choice for the Roman aristocracy. From the end of the second century BC, and especially in the Ciceronian period, large luxurious villas arose; their remains are still visible today, scattered over the slopes of the hills. Many of these properties eventually passed into the hands of the emperors, either through inheritance or more often by expropriation, until most of the area became part of the Imperial domain.

The villa of Pompey (and perhaps that of Clodius as well) formed the nucleus of the Imperial possessions in the area. It was here that Domitian spent most of his youth, which explains the emperor's special love of the region and the desire to enlarge his villa as his need for space grew. Part of Domitian's villa is believed to have occupied the site of Alba Longa, as several ancient authors attest. The Alban Lake was for all practical purposes included among the Imperial possessions, and Domitian used it for holidays aboard his barges, as Caligula did on nearby Lake Nemi and Nero on the Stagnum of Agrippa in the Campus Martius.

ITINERARY

Bovillae

At the twelfth milestone, on the left side of Via Appia Nuova, stands the cement core of a large tomb called "il Torraccio." The little city of Bovillae, of which very few remains are still visible, began at this point on the other side of the road (FIG. **146**). According to ancient tradition, Bovillae was a colony of Alba

Longa, founded under the latter city's second king, Latinus Silvius. After the destruction of the mother city, Bovillae must have inherited its cultic functions, which—as we know from other sources—continued without interruption. Even those Roman families, like the Julii, who boasted an Alban origin preserved their sacral ties with Bovillae.

The "Alban" traditions of Bovillae were evidently revitalized in the propaganda of the Julio-Claudian emperors. In AD 14, Tiberius established the *Sodales Augustales*, who had responsibility for the cult of the *gens Julia* in a shrine that was also founded by the emperor. He probably inaugurated the games in honor of Augustus, and it was for these that the theater and circus at Bovillae must have been built, probably also by Tiberius. With the exception of a large brick cistern, the circus, measuring 337.50 meters long and 68.60 wide, is the only one of several monuments excavated during the nineteenth century that is still partially visible. Part of it makes use of the hillside, and part of it is an independent structure.

Today only several arches of the *carceres*, which belong to the short northwest side, are still standing. Three of the original twelve arches are visible, in addition to a fourth that is now within the neighboring farmland. Nothing of the theater remains visible, nor of a curious octagonal building to its northwest.

The Albanum of Domitian

Beyond Bovillae, Via Appia rises noticeably as it skirts the lower reaches of the Alban Hills. On the right side, just before the 22nd kilometer of Via Appia Nuova, is a large stretch of wall in *opus quadratum* of peperino, which formed the side support of the ancient street.

On the left side of Via Appia at Ercolano, at the fourteenth milestone (within the Villa S. Caterina, formerly the Villa Orsini), are the remains of a Republican villa, identified—probably erroneously—as that of Clodius.

South of Castelgandolfo, on the slope leading up to the modern town, lies the central part of Domitian's villa, which is preserved within the papal gardens, the former Villa Barberini, and to a lesser extent under the Palazzo of the Propagation of the Faith. The building was laid out upon three large, narrow terraces, about 500 meters long. The first of these, beginning from the top, was on the summit of the hill and contained the service quarters, the cemetery of the Imperial slaves, and, most important, the large cisterns, in which water from the Malaffitto and Palazzolo aqueducts was collected.

The second terrace was occupied on the southeast by the residential quarters, of which only scattered remains are visible today; maps drawn in the nineteenth century indicate that the rooms were grouped around three courtyards, all aligned with one another. A long road led from the residential area to the theater. The southeastern section of this road is bordered by a long high wall along the upper terrace, near the middle of which a passageway (no longer

open) was carved into the rock. This gave access to a terrace with a panoramic view of the lake that was built on large foundations in *opus reticulatum*, possibly dating to an earlier phase of the villa. Four large recesses that open to the northeast in the support wall for the upper terrace belong to the same phase (perhaps that of Pompey's villa). These constitute four nymphaea, whose plans were alternately rectangular and semicircular and which contained niches for statues and for water displays. The construction technique, *opus reticulatum* with projecting stones in blocks of peperino, suggests a late Republican date even for this monumental complex. It was restored in the Imperial period, as some additions in brick show.

The theater, resting on the slope of a hill (but with its own masonry foundations), connects the second and third terraces. Behind the scaena, in the area that is now a garden, was a large porticus, of which few remains (mostly columns) are extant. The porticus rested on foundations rising from the level of the first terrace in which there are six rooms facing north. At least two building phases can be documented here, one in *opus reticulatum* dating to the Republican period, and another, in *opus latericium*, evidently from the reign of Domitian.

Of the theater, only scattered remains of three cunei and of the staircases, now stripped of their marble veneer, can still be seen. The diameter of the structure must have been around 50 meters. The most interesting and best-preserved section is the corridor *(crypta)* that runs below the cavea. A portion of this has been excavated and is accessible. The right wall is covered by fine stucco decoration, which has the appearance of a three-dimensional aedicula, rather like Fourth Style painting. The aptly theatrical subjects represented include Dionysus, Medea, the Muses, a satyr, and a hermaphrodite.

The most interesting feature of the first terrace is the huge cryptoporticus in *opus latericium*, the largest of any known private residence (including Imperial residences). The length of what now remains—only a part of the original—is about 120 meters, and its width is 7.45 meters. The second terrace rests in part on the cryptoporticus's round vault. The northernmost part of the vault is decorated with large, square coffered panels, which still preserve some of their stucco, originally painted and gilded. Nearly all traces of the circus have disappeared. It was probably a garden, a feature of many villas.

An interesting equestrian statue stands at the lowest level, near the exit of the pontifical villa. The head, although ancient, is not original, and almost all the statue's upper part is a modern restoration. It might well have been a statue of Domitian. Close to the entrance is the Antiquarium, where sculptures from the villa and from the nymphaeum of Bergantino are on display.

At the foot of Castelgandolfo, along the western bank of the lake, several interesting monuments have been preserved, some associated with the villa of Domitian, others predating it. The so-called **Doric nymphaeum,** datable to the first half of the first century BC, stands on the left at the end of the street that descends to the lake, just before it meets the bank. The fountain consists

of a rectangular room cut into the rock with two series of niches on two levels, surmounted by a Doric frieze. On the short side at the rear is an exedra, flanked by two semicircular niches, crowned by two half-pediments. Behind the exedra is a small room where the water arrived through a channel cut into the rock.

About two kilometers away, the **Bergantino nymphaeum,** fashioned out of a grotto faced with walls in *opus mixtum*, stands on the western bank of the lake. In the front section, which is almost circular, about 17 meters in diameter, sits a round basin, now filled in, in the middle of which is a base, placed slightly off-center. To its left is a circular room with a bench along the walls, preceded by a rectangular antechamber. The grotto ends at the back with a podium, reached by steps on the right, onto which two other rooms open. A polychrome mosaic depicting a marine cortège (of which fragments remain) covered the pavement around the basin.

Several sculptures have been recovered from this nymphaeum, which were certainly part of Domitian's villa. Among these are the fragments of a group portraying the blinding of Polyphemus and of another depicting Scylla, now displayed in the Antiquarium of the pontifical villa at Castelgandolfo. The presence of these sculptures in this particular kind of nymphaeum strongly suggests that it was a copy of the grotto-nymphaeum in Tiberius's villa at Sperlonga.

A little more than a kilometer farther lies the entrance to the lake's outlet, which was probably made during the siege of Veii (before 396 BC) on the advice of the oracle of Apollo at Delphi. The physical appearance of this outlet, about 1.80 meters long, resembles that at Nemi and seems to confirm the early date.

Albano

The modern center of Albano includes the site occupied from the time of Septimius Severus by the camp of the Second Parthian Legion. Before that, the area was occupied by villas. In the Imperial period, the entire district gravitated toward the emperor's villa, the *Albanum*, which, at least by Domitian's age, extended to this point.

The whole area was transformed with the building of the *Castra Albana* (FIG. **147**). After the disbanding of the Praetorian guards according to the wishes of Septimius Severus, the Second Parthian Legion was transferred to Italy. The camp, built at the edge of the Imperial villa, was already finished by AD 212, when the legion mutinied after the murder of Geta; Caracalla must have personally calmed the soldiers with promises of gifts.

The encampment was on a steep slope, between the lake and Via Appia. The legionaries' necropolis was east of the camp (FIG. **147:9**); numerous tombs comprising a trench cut into the natural tufa with a cover in the shape of a heavy trunk lid have been discovered here on various occasions. We do not know how long the legion continued to be stationed in the Castra Albana; some have argued that its presence there lasted until the middle of the third century AD.

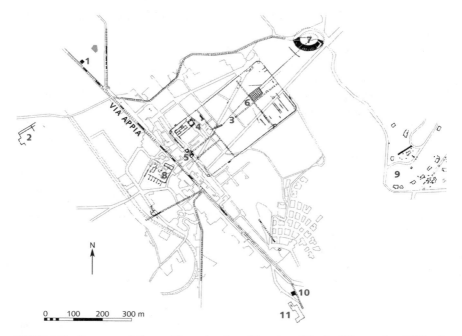

FIGURE 147. Area around Castra Albana (modern Albano). **1** "Tomb of Pompey." **2** "Villa of Pompey." **3** Castra Albana. **4** Rotunda. **5** Porta Praetoria. **6** Cistern. **7** Amphitheater. **8** Baths of Cellomaio. **9** Necropolis of the Legionaries. **10** "Tomb of the Horatii and Curiatii." **11** Catacombs of S. Senatore. (After Tortorici)

In any case, the camp was already abandoned when Constantine made a gift of it to the local church.

A little before Albano, on the left side of the street, is the cement core of a large **tower-shaped tomb,** which was set in the triangle between Via Appia and the side road that leads to the villa of Domitian (**FIG. 147:1**). It is an imposing structure, with four successive levels, probably crowned by a pyramidal top with a total height of perhaps about 45 meters. The old hypothesis that identifies this exceptional monument as the tomb of Pompey may well be correct.

The **villa,** which is usually (though incorrectly) identified as that of Pompey, lies inside the Villa Comunale di Albano, formerly the Villa Doria Pamphilii (**FIG. 147:2**). This terraced complex, measuring about 340 × 260 meters, was fully excavated in 1923–24, but a large part of it is now reburied.

At the center of the southwest facade (**FIG. 148:A**), facing the sea, is a projecting square with six semicircular exedras on the front, at the center of which is a nymphaeum. Identical exedras decorate the rest of the facade as well. Entrances to two symmetrical cryptoporticoes **(D, E)** stood at the back of two of

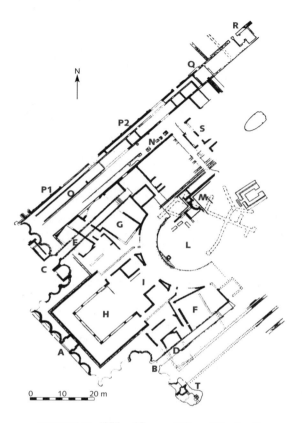

FIGURE 148. "Villa of Pompey." Plan. (After Lugli)

the exedras; these led up at a slightly oblique angle to the level of the residences. The northwestern side consists of a long wall with pilasters **(P1–P2)**, behind which is a vaulted corridor. Behind this corridor runs another corridor, at a higher level, flanked by a porticus **(N),** in which a masonry column drum is still visible.

Farther along, on the left of Via Appia, the heart of Albano occupies the *castra* of the Second Parthian Legion (FIG. **149**). The fortification walls form an elongated rectangle, with maximum dimensions of 240 × 438 meters, oriented southwest-northeast and descending gradually by terraces. The walls, in *opus quadratum* of peperino (ranging between 0.80 and 1.20 meters thick), were certainly designed by craftsmen of the same legion. Numerous stretches of the walls are still visible.

The most imposing section of the fortification is the **Porta Praetoria,** which is in the center on the southwest (cf. FIG. **147:5**). It formed the monumental

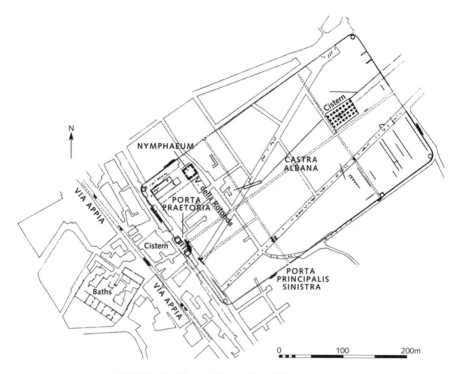

FIGURE 149. Castra Albana. Plan. (After Tortorici)

entrance on the side facing Via Appia. The gate, enclosed within modern structures until World War II, is now visible as a result of the bombing that destroyed the quarter. It is entirely in *opus quadratum*, with three arched passages of varying size; the largest, at 6.40 meters, is in the center and was reserved for vehicles. The best-preserved passage is that on the right, whose arch with radial voussoirs is still standing. From the side passageways, one entered two small rooms through small side doors, which led in turn into two large halls with walls extending outward. These probably formed part of the towers flanking the entrance.

Remains discovered at various points during periodic work give an idea of the installation's layout. This was quite regular and subdivided, according to normal practice for Roman camps, with transverse blocks of houses in the upper level, and longitudinal blocks in the lower level.

S. Maria della Rotonda, the large building facing Via della Rotonda, predates the *castra*, and must have originally been a monumental nymphaeum of Domitian's Albanum, toward which the plan of the *castra* in its entirety was

FIGURE 150. Albano. S. Maria della Rotonda. Plan. (After Tortorici)

probably oriented (FIG. **147:4**). Its construction, heavily restored between 1935 and 1938, is completely of *opus mixtum*. Square-shaped on the outside, it is almost fully circular (16.10 meters in diameter) within (FIG. **150**). Large semicircular niches on the diagonals with basins, possibly originally elements of fountains, were carved out of the massive walls. Its walls are pierced by four arched doors, one at the center of each side.

In the Severan period, the main entrance was moved to the southwestern side, where a kind of rectangular antechamber was built. The original pavement, with its black-and-white mosaic of sea monsters, is still intact. The building is roofed with a hemispherical dome, which originally had a circular oculus at the center. The large octagon at the center of the hall, with its zigzag mosaic, belongs to the Severan restoration. A small *antiquarium* has been set up in the sacristy of

the rotunda, where fragments of sarcophagi, inscriptions, and a collection of brick stamps are on display.

In the upper part of the *castra* is the large **cistern,** where the aqueducts of the Centro Bocche and Malaffitto converge (FIG. **147:6**). The large construction is trapezoidal, with a maximum measurement of 31.90 × 47.90 meters, and is divided into five compartments. It is inaccessible, having been put back into use in 1884.

The **amphitheater** sits upon an extensive artificial terrace along the western slope of the hill of the Capuchin monks, northeast of the *castra* (FIG. **147:7**). The part still extant is built of masonry and faces the south, while the other half— which has now totally disappeared—must have been carved into the slopes of the hill. The principal axis measured around 113 meters, and the arena, enclosed by a canal *(euripus)*, was 67.50 × 45 meters. The structure has been dated to the Severan period and may have been built several years after the camp.

The *castra* contained a bath complex, centered around the rotunda; another, situated outside the walls beyond Via Appia in the modern quarter of Cellomaio (from *cella maior?*), was known from the Middle Ages as the **Palace of Ascanius** (FIG. **147:8**). Toward the southwest, where the slope was greater, the building, constructed by Caracalla (as brick stamps indicate), occupied two levels. Toward the street, it was on a single level. One of the best-preserved rooms forms the Church of S. Pietro, facing Via Appia.

Beyond Albano, Via Borgo Garibaldi turns abruptly to the left, leaving the route of the ancient Via Appia, which bends to the right. Here, at a level below and concealed by the modern street, is the so-called **Tomb of the Horatii and Curiatii** (FIG. **147:10**). The monument originally stood on the left side of the street; on the right, somewhat behind it, there was another small Republican tomb. The tomb is square in plan (approximately 15 meters on each side), with a cement podium dressed in peperino blocks, much of which is a nineteenth-century restoration. At each of the four corners of the base there is a truncated cone, again of peperino. At the center a fourth element, much larger than the others, is preserved, but only minimally. The monument, late Republican or early Augustan, is unique. The only structures at all comparable are some tombs depicted on Etruscan urns from the Hellenistic period. Pliny the Elder's description of the tomb of Porsenna (*NH* 36.91–93) also calls this unusual building to mind.

Near the Chiesa della Stella, immediately opposite the Tomb of the Horatii and Curiatii, is one of the most important **catacombs** of the more remote environs of Rome, that of S. Senatore—proof of the importance of the early church in Albano (FIG. **147:11**). A stairway leads down from the entrance to a wide and somewhat irregularly shaped crypt. Farther along on the left, a fifth-century fresco depicts Christ at the center, flanked by Sts. Peter and Paul, along with four local martyrs. A little beyond there is a Byzantine fresco, probably from the ninth century, with Christ, the Virgin, and St.

Smaragdus. In the cubicle beyond is an arcosolium that depicts Christ and four saints, among whom Sts. Peter, Paul, and Laurence (sixth century) are recognizable.

The **Museum of Albano** is housed in the Villa Ferraioli. Materials on display illustrate local history from prehistoric times to the late Roman period.

Ariccia

At the sixteenth milestone of Via Appia lies the site of the ancient community of Aricia (modern Ariccia). A viaduct of Via Appia Nuova leads across the valley directly into the modern village, where the acropolis once stood. The ancient road, however, goes through the lower part of the old city; during the Middle Ages the village's inhabitants resided on the acropolis. The first rest stop *(mansio)* for those traveling from Rome toward the south was established here. A famous battle between the Etruscans led by Arruns, son of Porsenna, and the Greeks led by Aristodemos at the end of the sixth century BC was supposed to have taken place before the walls. The city owed its fame above all to the sanctuary dedicated to Diana of Aricia, which was in its territory near Lake Nemi. Only a few traces of the walls, constructed of parallelepiped blocks of peperino, are still visible on the acropolis.

The street that must have formed the central axis of the acropolis, corresponding to the modern Corso, ran downhill across the lower city in a direction perpendicular to Via Appia, and then continued on to Ardea. The Republican city most likely developed around the intersection of these two roads.

Near the center of the residential area, part of a **small Republican temple** survives, located about 60 meters from Via Appia. The walls of its cella are still in place, in very exacting *opus quadratum* of peperino. An arched gate from the Republican walls still stands southeast of the city.

The most remarkable monument near Ariccia is the large **viaduct of Via Appia,** which carried the street across the cliff of the hill toward the southeast. Today, only the valley side of this construction in *opus quadratum* can be seen, for a length of 198 meters and a maximum height of 11.56 meters. The original structure may well date to the time of the Gracchi, who according to Plutarch restored Via Appia.

The Sanctuary of Diana at Nemi

The famous Sanctuary of Diana was located slightly to the north of the small volcanic Lake of Nemi in the ancient territory of Aricia (FIG. 151). An archaic custom demanded that the priest of the goddess, who had the title of king (the *rex nemorensis*), be a runaway slave. Succession to this priesthood followed a savage ritual in which the contender who succeeded in killing the reigning king in a duel became the new *rex*. Two other divinities were worshiped with Diana

FIGURE 151. Nemi. The Sanctuary of Diana and the Museum of the Ships. (After Ucelli)

at Nemi: Egeria, the nymph associated with King Numa, and Virbius. The sanctuary apparently became a center for the league of the Latin peoples after the destruction of Alba Longa. Cato the Censor records the dedication of the sanctuary by Egerius Baebius, a dictator of Tusculum.

The street that joined Aricia to the sanctuary passed along the western bank of the lake. The best-preserved stretch of the ancient road lies between the modern Museo delle Navi and the sanctuary (FIG. **151**). From the museum, it followed a direct line to the southwestern corner of the **temple.** The complex as rebuilt at the end of the second century BC consisted of a large platform,

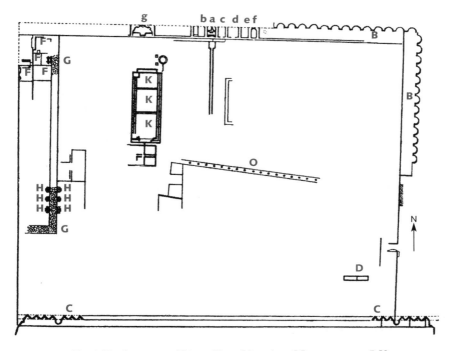

FIGURE 152. Nemi. The Sanctuary of Diana. Plan of the ruins: **C** Lower terrace. **B** Upper terrace with niches. **F** Residences of the priests? **G,H** Porticoed street? **K** Temple cella? **D** Altar. **O** Porticoed street. **a–f** Exedras. **g** Exedra with statues of the Julio-Claudian *gens*.

resting partly on structures that were formed on the south by a massive wall with buttresses that create triangular niches. The part of the sanctuary that was carved out of the hill was supported by other walls, which had semicircular niches, visible on the northern and eastern sides (FIG. **152**). The area, about 45,000 square meters, was surrounded by a colonnaded porticus, at least on its north and east. On the north it was divided by rectangular walls in *opus reticulatum* into a series of rooms that were one to three steps higher than the rest of the area.

A building (30 × 15.90 meters) consisting of a row of three rooms, deliberately set off to the west with respect to the axis of the sanctuary (FIG. **152:K**), cannot be the temple, which—to judge from a design by Pietro Rosa—must have stood on a higher terrace and with a floor plan in the form of a transverse cella, as described by Vitruvius (4.8.4).

Caesar owned a villa near the lake, probably along its west and south, which must have formed the core of the Imperial property that spread over much of the area. Within the villa, immediately below Genzano, is the opening of the

lake's emissary or outlet, an enormous project that was probably undertaken to drain the area of the sanctuary, which was recurrently subject to stagnant water resulting from changes in the lake's level. The drainage channel that discharges into the valley of Ariccia extends over a length of 1,653 meters and was created by digging simultaneously at both ends.

Our most tangible evidence of the Imperial villa consists of the two large ships that sank a short distance from the bank on the northwestern side of the lake. The ships, which were recovered between 1927 and 1932 by a partial draining of the lake, were housed with all the material found with them in a museum designed specially for their display; they were completely destroyed on the night between 31 May and 1 June 1944 in a fire deliberately set by occupying German forces. The two ships, measuring 71.30 × 20 meters and 73 × 24 meters were constructed of several types of wood and covered with lead sheets padded with wool. Inscribed pipes and stamped bricks securely attribute the ships to Caligula (AD 37–41). The vessels were luxurious rafts intended for recreation and parties on the lake.

The materials that were saved from the fire, as well as two models one-fifth the size of the original ships, are displayed in the museum, which has been reopened to the public.

The Sanctuary of the Alban Mount and Palazzolo

From its height of 949 meters above sea level, the summit of Monte Cavo (the ancient Mons Albanus) dominates the volcanic mass of the Alban Hills, occupying the eastern edge of the highest crater. The ancient federal sanctuary of *Iuppiter Latiaris,* which constituted the sacred center of the Latin peoples, once stood here. The *Feriae Latinae,* celebrated in the sanctuary, preserved the memory of the primitive festival, during which meat from a white bull, sacrificed to Jupiter, was distributed to each of the Latin peoples taking part in the rite. The close tie between the Capitoline cult and that of the Alban Mount is clear from the triumphal ritual. Some generals, who were not authorized by the Senate to celebrate a triumph in Rome, celebrated their triumph *in monte Albano* instead. Indeed, the custom of the triumph probably had its origin here and was then later instituted on the Capitoline Hill at Rome.

With the exception of some tufa blocks, moved from their original locations, nothing survives of the ancient sanctuary. Excavations carried out in 1929 did not even settle the question of whether a temple ever existed here, although they brought to light structures of minor importance, albeit in very poor condition.

On the other hand, the ancient street, which led to the summit at a steep incline, is well preserved. It began its course from Via Appia at Aricia, then followed the eastern edge of the Alban Lake, passing near Palazzolo. Some interesting monuments are still extant in this area. The most important of these is a large rock tomb, which can be seen near the convent of Palazzolo. The

tomb's monumental facade was sculpted from a rock wall that rose above a terrace, about 40 meters wide, which in turn lay on a steep slope above the lake. The monument comprises a base with a sculptured band above, surmounted in turn by a stepped pyramid. The sculptures of the tomb depict a *sella curulis* (magistrate's chair) with a cushion, on which lie a scepter with eagle *(scipio eburneus)* and a cap. Two cupids carry drapery above the chair. On each side of the *sella* are six fasces (bundles of rods and axes), a clear indication that the tomb belonged to a consul. Entry to the tomb, over seven steps and through a corridor, was from the base of the pyramid. The cross-vaulted crypt was rectangular (2.60 × 2.26 meters). The structure, style, and typology of the reliefs date the monument to the first half of the first century AD. The remains of a Republican villa, or perhaps a sanctuary, are still partially visible near the east bank of the Alban Lake.

Marino and Grottaferrata

The ancient municipality of *Castrimoenium*, probably founded during the reign of Sulla, was in the territory of present-day Marino, somewhat to the north of the modern city. Though its exact location is not known, everything points to the area near Villa Galassini on Colle Cimino.

The most important ancient monument still to be seen in the area is a **Mithraeum** discovered by chance at the foot of the town near the railroad station in 1962. The sanctuary consists of a very long room (20 × 3 meters) on an incline, probably a reused cistern carved into the rock of the hill. At the entryway, two small square panels at the sides are painted with figures of the *dadophoroi*—the torch carriers, Cautes on the right, with his torch held erect, and Cautopates on the left, with his torch lowered toward the earth. The most important painting, the depiction of Mithras slaying the bull, is on the rear wall and flanked by two series of small paintings arranged vertically. Their scenes should be read beginning from the top on the left. The first represents the giants struck by Jupiter's thunderbolt. The figure of Ocean follows; then the birth of Mithras from the rock; and finally Mithras taming and riding the bull. The panels on the right, again starting from the top, show Mithras carrying the bull into the cave; Mithras about to strike the shoulder of the Sun, who kneels before him to be initiated into his cult; next, the alliance between Mithras and the Sun, who are about to shake hands in friendship; and, finally, Mithras with bow and arrow aimed at a rock to make water flow from it. This is one of the very rare examples of Mithraic painting in Italy, of which only two others are known, both contemporaneous with this example (which dates to the second half of the second century AD): at Capua and at Rome (the Barberini Mithraeum). The quality of the painting from Marino is much superior to that of the other two.

The nearby **peperino quarries,** which are still in use today, can be seen after visiting the Mithraeum.

The **Abbey of Grottaferrata** probably owes its name to the cryptoporticus on which it is in part built. The abbey was constructed, together with the Church of S. Maria, on the site of a large Roman villa, which some identify as the famous Tusculan home of Cicero. (It is more likely, however, that Cicero's villa was located around the Villa della Rufinella, between Frascati and Tusculum.) Visible remains of the villa include the foundations and a well-preserved cryptoporticus with two aisles. The *opus reticulatum* and the parallelepiped blocks date the villa to the end of the Republican age.

The abbey contains a small **museum**.

Room 1. On display here is the most important monument in the museum, an Attic funerary stele with a seated young man reading (430–420 BC).

Room 2. Herms with portraits of Homer and Euripides, which are thought to have adorned the library of a Roman villa; reliefs from funeral monuments dating to the beginning of the Empire.

Room 3. A large collection of cinerary urns and Roman sarcophagi from the middle and late Empire.

Room 4. Excavation material, which traces the historical development of the area from protohistory to late antiquity.

Tusculum

Tusculum was one of the oldest and most important centers of Latium Vetus. The city's foundation was attributed to Telegonus, son of Odysseus and Circe, and it was also thought to have been a colony of Alba Longa, founded by Latinus Silvius. That the area was settled from a very early period is clear from Neolithic and Aeneolithic remains, but above all from the first Iron Age materials. The necropolis at Vigna Cavalletti, halfway between Frascati and Grottaferrata, is especially important because it dates to the two earliest phases of Latial culture. The name *Tusculum*, clearly derived from the name of the Etruscans, is in itself interesting. Direct Etruscan intervention in Latium began early in the seventh century BC, when Etruscans evidently besieged the city. Octavius Mamilius of Tusculum was supposed to have married a daughter of Tarquinius Superbus, who took refuge in Tusculum when he was driven out of Rome. This was the start of conflict between Rome and the Latins, which ended in 499 BC with the famous Roman victory at Lake Regillus (perhaps to be identified as Pantano Secco, north of Tusculum), and with the stipulations of the Treaty of Cassius *(Foedus Cassianum)*, which accorded Rome preeminence within the Latin league. From then on, Tusculum was on the whole faithful to Rome and must have been the first among the cities of Latium to obtain Roman citizenship (around 380 BC).

Loss of autonomy, however, diminished Tusculum's importance as an urban center, and the city and its territory became a summer residence for wealthy

FIGURE 153. Tusculum, plan of the ancient city. **1** Amphitheater. **2** "Villa of Cicero." **3** Forum and theater. **4** Cistern. **5** Fountain. **6** Acropolis.

Romans. We know from numerous references in Latin literature of the Tusculan villas of Sulla, Lucullus, Catulus, Gabinius, Cato Uticensis, and Asinius Pollio. During the Imperial period, Tiberius, Agrippina, Nero, Galba, Marciana, and Matidia had villas there.

But the villa that has become almost the symbol of an entire historical period is that of Cicero. This can be located either on the Colle delle Ginestre, northeast of Grottaferrata, or near the present-day Villa della Rufinella, on a hill east of Tusculum (about 600 meters from the amphitheater). From Cicero's writings, we know various particulars about his villa in Tusculum. It had once been the property of Q. Lutatius Catulus (the consul of 78 BC) and had become the property of the orator as early as 68 BC. Part of it was laid out to resemble a Greek gymnasium, with two porticoes, rather pompously called the Academy and the Lyceum (the latter also housed the library). Atticus, Cicero's close friend, had purchased a number of statues in Athens to decorate this section of the villa. We are told that these included herms in Pentelic marble with bronze heads representing Athena and Hercules. The *Tusculanum*, which was only a short distance from Rome, was the orator's preferred area of respite between one political battle and the next.

The ancient city, which can be reached by a road from Frascati, occupies a long crest that peaks at 670 meters above sea level at the acropolis. The main excavations took place in the first half of the nineteenth century. The earliest campaigns were undertaken between 1804 and 1820 under Lucien Bonaparte, the brother of Napoleon, who had taken possession of the area. The property next passed to Maria Cristina of Sardinia, the wife of King Carlo Felice, who had the excavations carried forward between 1825 and 1840 under the direction first of Luigi Biondi and then of Luigi Canina. Further exploration took place in 1859 (at the so-called Villa of Tiberius) and in 1867 (the amphitheater); and finally, more recently, between 1952 and 1957.

The present-day Via Tuscolana is probably not an ancient road; the main routes that gave access to Tusculum were Via Latina and Via Labicana, from which various side roads led to the city. The **amphitheater** stands at the city's

western end, outside the ancient walls (FIG. **153:1**). Today the structure is hardly visible and half buried, covered with vegetation. Its lower section was built in *opus quadratum* of peperino, while the cavea's supporting walls are in *opus mixtum* of reticulate and brick. The building, which measures 80 meters by 53 meters, can be dated, on the basis of brick stamps, to the middle of the second century AD.

East of the amphitheater is an impressive building in *opus reticulatum* and *opus mixtum,* of which only the foundations are now visible. The rooms that are accessible are on the southwest. Brick stamps found in the construction seem to belong to at least two phases, one in the first century AD and a later phase in the second century. The large building, known since the sixteenth century as the Villa of Cicero, was later associated with Tiberius, but it might well in fact be a large sanctuary (FIG. **153:2**).

The motor road ends in a large square, where there is a small contemporary building (known as the guard's house), made partly of ancient materials. At this point the ancient road, which follows the axis of the hill, leads to the site. A little before the forum, the road splits in two. The left branch leads almost immediately to a tract of the ancient walls in *opus quadratum,* built of no fewer than eleven rows of large peperino ashlars. This was probably a gate through which the road coming from Via Labicana passed. The basalt pavement along the wall is still in rather good condition. A little farther on, the wall rests against a structure with a crudely executed polygonal facing, which sits on another structure fashioned of very large blocks in *opus quadratum.* A door leads to a cistern, a rectangular room roofed with a false corbelled vault; water entered through a channel, whose opening is visible toward the bottom of the back wall. One of the purposes of the cistern was to feed a fountain, which bears the following inscription: "Quintus Coelius Latiniensis, son of Quintus, and Marcus Decumius, aediles, (had this constructed) in compliance with a decree of the Senate" (FIG. **153:5**).

Turning back to the fork in the road and proceeding along the right branch, we come to the **forum**. The eastern side of the square abuts the stage of the **theater,** an arrangement that suggests that this is not a forum but rather a porticus *post scaenam* (FIG. **153:3**). The large inscription at the top of the cavea commemorates the visit of Pope Gregory XVI to Queen Maria Cristina of Sardinia on 7 October 1839. The cavea, now heavily restored, is set directly against the hill behind it. Traces of a porticus at the top were seen during excavation. A parapet *(pluteus)* divides the cavea from the orchestra. The scene building, rectangular in plan, lacks the curvilinear niches typically found in stage facades of Imperial theaters, indicating an early date, probably around the first half of the first century BC.

Beyond the theater, on the right, the sparse remains of a large stepped semicircular fountain can be seen. This was fed by a rectangular cistern, located behind the cavea of the theater, divided into four chambers by three rows of five piers (FIG. **153:4**). From this point the street leads up to the **acropolis,** where there are no visible remains (FIG. **153:6**). It is here that the temple dedicated to

Castor and Pollux, the main cult of the city, must have stood, along perhaps with that of Jupiter.

Turning back the way we came, we can follow the **Street of Tombs,** which descends to the south toward the Valle della Molara from the so-called Villa of Tiberius. Particularly interesting is the core of a large circular tomb, whose inscription (preserved nearby) identifies the monument as the tomb of Marcus Caelius Vinicianus, tribune of the plebs in 53 BC.

Gabii

The very old city of Gabii stood at the twelfth mile of the road originally called Via Gabina and only later Via Praenestina. It occupied a strip of land between the road and a lake (Lago di Castiglione), which is now dried up (FIG. **154**). The earliest remains of the city have vanished almost entirely, having been eaten away by the quarrying of its famous local stone (*lapis Gabinus*, or sperone), which was in use until the Imperial period. The origins of Gabii were traced by ancient writers to the Siculi or even to Alba Longa, of which it was supposed to have been a colony. Recent excavations on the site of Osteria dell'Osa, about two kilometers west of the ancient site, have uncovered an important Iron Age necropolis that sheds light on the period before the area's urbanization.

At the end of the sixth century BC, the city apparently entered the orbit of Rome, as suggested by the tradition of its occupation by Tarquinius Superbus. At that time, a treaty, the *Foedus Gabinum*, was supposed to have been signed between Gabii and Rome. The original text of this treaty, written on a leather shield, was preserved in the Temple of Semo Sancus on the Quirinal at Rome as late as the early Empire. During the late Republic, Gabii, like many other centers in the same situation, must have already been half-deserted. Augustus and the early Julio-Claudian emperors intervened to help restore a semblance of life to this moribund center, though this renewed vitality was due almost exclusively to the affluent inhabitants of the nearby villas.

Early Christians left a visible sign of their presence in the Church of S. Primitivo, a local martyr; traces of the church are visible in the area once occupied by the forum of the Roman city.

The most convenient way to reach Gabii and its ruins is from the gas station located 1.50 kilometers beyond the cross street to Poli. From here one can reach the ancient Via Praenestina, whose course is easy to discern, and the nearby **Temple of Juno,** the most important monument on the site. The temple's large sacral area, oriented almost exactly north-south, is partially cut into the rock and rests in part on artificial foundations. A Doric porticus, with shops on the eastern and western sides (only those on the east are now visible), lines three sides of the sanctuary's northern end (FIG. **155:3**). The southern end was intended to include a theater, the cavea of which, though no longer visible, must have been carved into the rock (FIG. **155:5**).

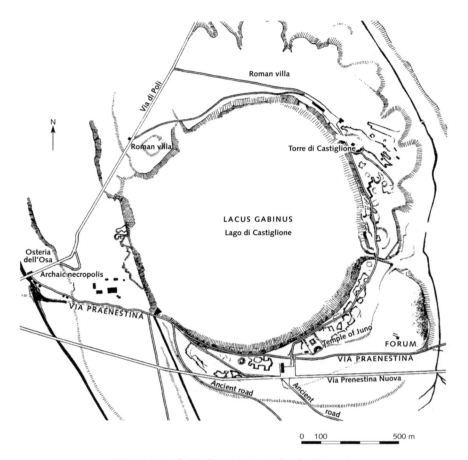

FIGURE 154. Gabii. General plan. (After Quilici 1977)

The temple, generally identified with the worship of Juno, occupied the center of the area, and its cella still rises to a considerable height (FIG. **155:1**). The building, *peripteros sine postico* (i.e., with colonnades only on the front and on its long sides), was preceded by a stairway and large altar. The podium is preserved only at the back. The elevation is constructed in blocks of local stone on only one course. Excavations have brought to light a basement, which was entered by a stairway at the southeastern corner of the cella.

An interesting system of channels, connected to a cistern hollowed out of the rock, ensured that the square was properly drained (FIG. **155:2**). The northeastern corner, which is the best preserved, reveals a number of large holes, which have been interpreted as receptacles that once held trees (FIG. **155:4**).

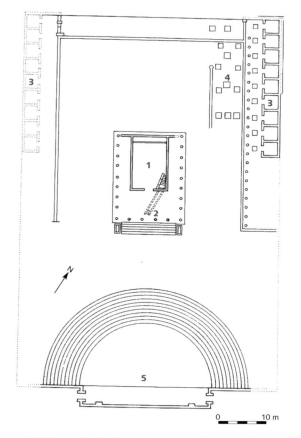

FIGURE 155. Gabii. Temple of Juno. **1** Temple. **2** Underground channels. **3** Porticoes. **4** Holes for trees. **5** Theater cavea.

The configuration suggests that this was a sort of ritual reconstruction of the sacred groves *(luci)* from which many rural sanctuaries originated.

Fragments of inscriptions pertaining to the temple and the porticus have been found in recent excavations. One of these, on part of a Doric frieze from the altar, carries the name *Cethegus*. The consul of 160 BC comes to mind, and the date accords with the absence of cement in the sanctuary's construction. If so, this is one of the earliest datable examples of a temple associated with a theater, an arrangement that came to be quite characteristic of Hellenistic-Italic architecture.

Nothing remains to be seen of the forum (excavated in 1792), which lay in the area east of the sanctuary. In fact, very little of the ancient city is visible. Signs of

the old quarries, however, are evident almost everywhere, especially along the road that skirts the bank of the now-vanished lake toward the east. South of the city, between the quarries and the Church of S. Primitivo, recent excavations have revealed the presence of a sanctuary and of an archaic necropolis with chamber tombs.

PRAENESTE (PALESTRINA)

HISTORICAL NOTES

Praeneste lies 23 miles east of Rome on Via Praenestina (FIG. **146**). Rising on the slopes of Monte Ginestro, the last projecting spur south of the Praenestine mountains, the city dominates the narrow expanse of land between the mountains and the Alban Hills, and along with it the natural roadways at the bottom of the valley: Via Labicana and Via Latina. The saddle between the Colli Albani and the Monti Lepini allows easy communication between Praeneste, Velletri, and Anzio; this strategic position explains the importance of Praeneste as early as the seventh century BC.

The territory of Praeneste must have largely coincided with that of the medieval diocese, thus enclosing an area of about 250 square kilometers. The ancient population would never have exceeded fifteen thousand, about half of whom resided in the main center of the city; the rest were distributed among the nine towns *(oppida)* spread over the whole territory.

Various traditions have come down to us about the foundation of the city, which connect it alternatively with Telegonos, the son of Odysseus and Circe, with Praenestos, a son of Latinus, or with Caeculus, the son of Vulcan. The latter legend has striking points of contact with the traditions surrounding Romulus and Servius Tullius. Remains of tombs date the site's occupation as far back as the first quarter of the eighth century BC. The importance of Praeneste in the orientalizing period is clear from an important group of princely tombs (Bernardini, Barberini, and Castellani), material from which is displayed in the Villa Giulia and the Capitoline Museums.

The first references to the city among the ancient historians date to the beginning of the Republic. There is evidence that by the end of the fifth century BC, Praenestine families like the Anicii had gained entry to the Roman senate. During these years, the city was in frequent conflict with Rome, and in 380 it was conquered by Cincinnatus. More revolts followed, however, in subsequent decades; there is mention of an alliance between Praeneste and the Gauls in 358. Praeneste, of course, took part in the Latin War and after 338, along with Tivoli, it was deprived of part of its territory. From that time forward, with the

dissolution of the Latin League, Praeneste's political importance, along with that of other cities in Latium, declined drastically.

A period of great prosperity, resulting in part from trade with the East, is evident in the last decades of the second century BC, to judge at least from the grandeur of the constructions that transformed the appearance of the city during that period. After the Social War, the city must have received Roman citizenship and become a *municipium*. The outbreak of the Civil War saw Praeneste aligned with the followers of Marius, and it was here that the younger Marius took refuge after his defeat at the hands of Sulla at Sacriportum (82 BC). The destruction of two armies that came to his aid induced his defenders to capitulate, and Marius committed suicide. Sulla's retribution was terrifying: the Romans were spared, but the Samnites and Praenestines were massacred, except for women and children and a few friends of Sulla. The city was commandeered to house a military colony installed by Sulla. In 41 BC Praeneste once again served as a refuge, this time for the army of Fulvia, Antony's wife, during the War of Perugia.

During Aurelian's persecutions, St. Agapito, the city's patron, was probably martyred in Praeneste's amphitheater, whose existence is attested in an inscription of the Claudian age.

The free city was governed, until its transformation into a *municipium*, by a senate, two *praetores, aediles,* and *quaestores,* and two censors were elected every five years. We have no information about the magistrates of the *municipium,* but the colony's magistrates, which included *duumviri, duumviri quinquennales, aediles,* and *quaestores,* are well documented.

The principal divinity of Praeneste was Fortuna Primigenia, whose sanctuary was among the most important in Latium.

ITINERARY

Via Praenestina beyond Gabii

The stretch of **Via Praenestina** beyond S. Maria di Cavamonte is one of the best preserved in the Roman Campagna. The basalt pavement continues for almost its whole course alongside the modern street and is lined by the remains of tombs from the late Republic and the early Empire. At S. Maria di Cavamonte an impressive ancient cutting in the tufa allows the street to cross a hill. The remains of a **Republican bridge,** the Ponte Amato, can be seen farther along, on the right. A narrow path leads from here to the **Tondo,** a very small amphitheater in *opus reticulatum* that lies on the hill halfway along the road between S. Maria di Cavamonte and Zagarolo.

The most striking features in the landscape around Praeneste are the monumental remains of four **aqueducts,** the Anio Vetus, Aqua Marcia, Anio Novus, and Aqua Claudia. The most interesting of these viaducts cross the Fosso

dell'Acqua Rossa (parallel to the modern Via di Poli), Fosso della Mola, and Fosso dell'Acqua Raminga (between Via di Poli and Via S. Vittorino-Gericomio).

From Via di Poli (at 32 kilometers), a path leads to **Ponte S. Pietro,** on which the Aqua Marcia crosses the Fosso della Mola. This is more than 90 meters long, almost 19 meters high, and (including its buttresses) about 12 meters wide. The original construction of 144 BC, in *opus quadratum* of limestone, is entirely faced with masonry of a later date. The restorations in *opus mixtum* can be dated between the end of the first and the beginning of the second century AD. The revetment of the northwestern part of the bridge, with its buttresses in brick, was probably installed under Septimius Severus.

The **Ponte della Mola** is somewhat farther downstream along the same channel. It is part of the Anio Vetus, consisting of a long viaduct (136 meters) on two levels of superimposed arches in *opus reticulatum* and brick, datable probably to the reign of Hadrian. The central arches collapsed in 1965.

At kilometer 31 along Via di Poli, a path to the left leads to **Ponte Lupo** (27 meters high and about 80 meters long), the largest and most picturesque of the bridges, which allowed the Aqua Marcia to cross over the Fosso dell'Acqua Rossa. The original arches, in *opus quadratum* of tufa, were partially covered by a massive reticulate construction—a restoration by Agrippa. Many other restorations can be distinguished, making this work a veritable palimpsest. The most extensive date from the reign of Septimius Severus.

The **Ponte di S. Antonio** can be reached from the S. Vittorino-Gericomio road, by turning just before this village onto a path on the right. The bridge, which passes over the Fosso dell'Acqua Raminga, is part of the Anio Novus. It is around 125 meters long and about 30 meters high. A very high arch, spanning the stream, is flanked on each side by small arches on two levels. The original phase, from the Claudian period, is in *opus quadratum* of tufa with reinforcing piers in reticulate. Somewhat later, during the third or fourth century, the bridge was incorporated into a large brick reinforcement.

The Center of Praeneste

Via Praenestina runs into the modern Viale Pio XII. A left turn onto this street leads to the intersection with Via degli Arcioni at the Church of S. Lucia. This street follows the southern side of the oldest part of the city. The first monument encountered is a large trapezoidal cistern in brick, from the Imperial period, that is decorated with niches and set against the southwestern corner of the walls (FIG. **156:1**).

A large wall in *opus quadratum* of tufa with a cement core follows along Via degli Arcioni (FIG. **156:2**). At the center of the network of walls are the remains of a large **monumental propylon,** with a vaulted ceiling and niches for fountains (FIG. **156:3**); a second propylon, some traces of which are extant, forms a matched pair. This monumental entrance, like the walls leading up to it, is in

opus caementicium with *opus incertum* facing. The use of this technique and the structure's perfectly axial relation to the Sanctuary of Fortuna prove that there was a monumental redesign of the sanctuary at the end of the second century BC. The wall in *opus quadratum* eventually replaced the original fortification in polygonal masonry, which is still preserved on the other sides. The use of coarse rubble filling dates this phase of construction to the second century BC, perhaps a few decades before the large-scale remodeling of the walls in *opus incertum*.

Beyond the propylon, we find a row of eleven **vaulted rooms** in *opus incertum* (which gave rise to the modern name Via degli Arcioni), with arched openings consisting of tufa voussoirs in the facade (FIG. **156:4**). The wall continues and, turning sharply, reaches the sixteenth-century Porta del Sole, which projects outward with a bastion constructed partly in *opus quadratum* and partly in *opus incertum* (FIG. **156:5**). From here on the walls that follow preserve their original polygonal construction. This large monumental structure, corresponding to the walls and to the *pomerium*, supported the first large terrace of the city.

In Piazza S. Maria degli Angeli a gate in the polygonal walls corresponds to the most important east-west street, the present-day Via Anicia, which led to the forum (FIG. **156:7**). Piazza Regina Margherita corresponds to the ancient **forum,** originally larger than the modern square, which occupied part of the second terrace of the city (FIG. **156:8**). The Cathedral of S. Agapito corresponds to a **temple** of considerable antiquity, certainly predating (perhaps by two centuries) the urban reorganization of the second century BC, as is clear from its different orientation. Structural remains in *opus quadratum* of tufa can be seen inside and on the facade. This might well be the Temple of Jupiter Imperator whose statue was carried off to Rome and installed on the Capitoline in 388 BC after the defeat of Praeneste.

On the right side of the cathedral at the ancient level, considerably below the present surface, are remains of a flagstone pavement and of some steps parallel to the church (revealed during the excavations of 1907). The main buildings of the forum occupied the far end of the square, but at a higher level. A two-story colonnade closed the forum's northern end (see FIG. **157**). The lower story corresponded to the level of the terrace, while the upper story contained an internal colonnade parallel to the lower. Two superimposed limestone **colonnades** can be seen within the courtyard of the former seminary (behind the cathedral), in a gap that opens to the south. The lower colonnade is in the Doric order, while the upper one was probably Corinthian.

The large facade of the **apsidal hall,** which dominates the square on the north (incorporated into the former seminary), provides further evidence of the sophisticated technical solution to the terrain's unevenness. The lower part of the hall, which is in *opus reticulatum* of tufa, corresponds to the lower colonnade of the forum, for which it served as the back wall. The higher level consisted of a large facade in *opus incertum*, originally stuccoed, with two pairs of semicolumns

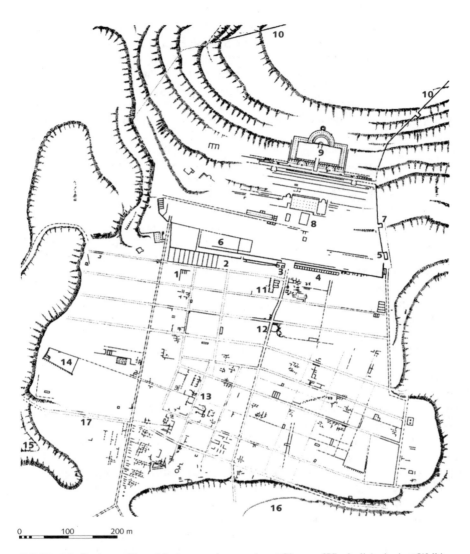

FIGURE 156. Praeneste. Plan of the lower and upper city. **1** Cistern of Via degli Arcioni. **2** Wall in *opus quadratum*. **3** Monumental propylon. **4** Vaulted rooms. **5** Porta del Sole. **6** Cistern. **7** Gate. **8** Forum. **9** Sanctuary of Fortuna. **10** Polygonal walls. **11** Public buildings and baths. **12** Exedra. **13** Madonna dell'Aquila. **14** Cistern. **15** Sanctuary of Hercules. **16** Necropolis of the Colombella. **17** Via Praenestina. (After Quilici 1989)

made of tufa blocks, topped by rich Corinthian capitals with flowering acanthus. This corresponded to the second level of the porticus. At the center was a grand entrance surmounted by a large arch, evidently accessible from the second level, while two statue niches occupied the spaces between the two sets of columns. The technique used, and the type of capital—identical to that of the small *tholos* in the sanctuary—allow us to date the building to the same period as that of the sanctuary itself: the last decades of the second century BC.

A gate with a flat arch, largely modern, opens onto the left side of the lower wall. This allowed access to a small room with a barrel-vaulted ceiling (6.80 × 4.37 meters), constructed entirely in *opus quadratum*, that rests against the stepped rock. The hall reveals three phases of construction. The vaulting was built in the third phase, when an important inscription was cut into the back wall. The inscription identifies the building's function: "Marcus Anicius Basus, son of Lucius, and Marcus Mersieius, son of Gaius, aediles, had this *Aerarium* [Treasury] built." The presence of the city's public treasury confirms that the square in front of the building was in fact the forum.

From the area in front of the Aerarium come the fragments of two Egyptian granite obelisks in the Museum of Palestrina and in the Naples Archaeological Museum. The name of Claudius appears among the hieroglyphs. A door at the back of the square gives access to the courtyard of the former seminary. This area was once thought to be part of the Sanctuary of Fortuna—the so-called Lower Sanctuary—but it is now clear that this was part of a complex of public buildings annexed to the forum.

The courtyard behind S. Agapito, known as the **Area Sacra,** lies at a level significantly higher than the forum and is screened by the two-story colonnade whose remains can be seen on the south. The area was originally roofed and divided into four aisles by rows of columns, of which there are occasional traces in the pavement. Fragments of Italo-Corinthian capitals have also been recovered. The building, a typical hypostyle hall (a hall with a roof supported by rows of columns), is probably the **basilica**. This too dates to the overall redesign of the forum, during the last decades of the second century BC.

The basilica, positioned with its broad side fronting the northern end of the forum, was framed by two other structures, the so-called Cave of the Lots (on the west) and the apsidal hall (on the east). The hall also rested against a cutting in the natural rock and, in part, the vault of the Aerarium. Its interior, later divided into several rooms that were once used as a kitchen for the seminary, was a large rectangular room, originally with a trussed roof, whose northern end terminated in an apse surmounted by a half dome that contained five niches. The large floor mosaic featuring an Egyptian landscape, now displayed in the museum, came from this apse.

The side walls, of which only the northern section is still in place, are decorated by a series of engaged semicolumns and Ionic pilasters in tufa and limestone, with niches for statues in between. The lower part of the walls has a

projecting podium, now visible only on the eastern side, carrying a Doric frieze surmounted by an Ionic cornice with egg-and-dart molding and denticulation. The metopes are decorated with *paterae* and rosettes. Remains of a fine white mosaic are still on the floor. There has been much difference of opinion about the purpose of the hall. Recently it has been suggested that it was a sanctuary dedicated to Isis.

On the opposite side of the basilica is the so-called **Cave of the Lots,** possibly a natural grotto that was widened; it occupied a position exactly symmetrical to the apse of the presumed Isis sanctuary. The space in front of the grotto, paved in fine white mosaic, has never been excavated, but it is likely that this too was a roofed hall, symmetrical to the apsidal hall. There is an arch of tufa voussoirs in front of the grotto with three deep niches on the sides and at the back.

The flooring consisted of a very elegant polychrome mosaic, of which some traces remain. Its extremely small tesserae formed a seascape, depicting a large variety of fish and marine creatures. This is one of the most striking surviving examples of Hellenistic mosaic, a style found in Rome, Pompeii, and elsewhere. Like the other examples, this too can be dated to the end of the second century BC and must have been the creation of a workshop of Hellenistic artists from Alexandria.

The Sanctuary of Fortuna Primigenia

The most important document concerning the Sanctuary of Fortuna comes from Cicero (*De Div.* 2.41), which may be derived from the archives of Praeneste itself:

> The official records of Praeneste affirm that Numerius Suffustius, a man of a distinguished noble family, was directed by recurring and ultimately threatening dreams to split open a flint rock in a specified place. Terrified by these visions and ignoring the ridicule of his fellow citizens, he began to cut. The instant he broke open the rock, *sortes* (lots) carved from oak and inscribed with archaic letters fell out. Even to this day, the spot where the rock was found is walled off and treated as sacred. It is right near the statue of Jupiter as a young boy, who is seated in the lap of Fortuna and is being nursed together with Juno. The cult is devoutly revered by mothers. The Praenestine records go on to tell us that at the same time honey oozed from an olive tree where the temple of Fortuna now stands. The *haruspices* declared that these *sortes* would without question become well known. On their advice, a chest was made from the wood of the olive tree as a receptacle for the lots, which are drawn even now whenever Fortuna dictates. What credence should we place in these lots, which are shaken up in their box under the supposed inspiration of Fortuna and drawn by the hand of a little boy? . . . Divination of this kind is in disrepute nowadays but the beauty and hoary antiquity of the temple keep the fame of Praeneste's *sortes* alive—among the common people, that is. What self-respecting magistrate or man concerned about his reputation would be caught consulting the lots?

From this very important passage, we learn of the foundation myth for the sanctuary (dated by Cicero to a very early period), its decline (which had already begun by the middle of the first century BC), and finally its appearance, as well as the technique of consulting the oracle. Especially important is the indication of a double cult, that of Fortuna, as mother of the young Jupiter and Juno, and the other—located at a different site—corresponding to the temple itself. The first was strictly connected with the consultation of the *sortes*.

As far as cult is concerned, the most important part of the sanctuary seems to correspond not so much to the temple itself, the last and highest element of the sanctuary (FIG. **158:8**), but rather to the so-called Terrace of the Hemicycles, and in particular to the eastern hemicycle (FIG. **158:4**). It has thus been possible to reconstruct an older phase, in which there were two principal centers of cult activity, corresponding to the eastern hemicycle and to the temple. Cicero's text, which makes reference to two cult centers, could not offer a better confirmation of this hypothesis. We read about a statue of Fortuna with Jupiter and Juno as children that was next to the spot where the *sortes* were discovered, and about the temple proper at the place—evidently different—where an olive tree oozed honey. The Terrace of the Hemicycles is thus to be identified as the first. The second corresponds to the group consisting of the Terrazza della Cortina, together with the theater area and the temple above it.

The complex is laid out in a series of superimposed terraces, connected by ramps and stairways in a perfectly axial alignment converging at the temple above. The cult statue was the point of focus that unified the sanctuary. The prevailing construction technique employed is coarse rubble concrete dressed in limestone *opus incertum*, while the use of cut stone, mainly tufa, is limited to the exterior arches and columns that mask the vaulted concrete structures within. The external appearance thus largely creates the impression of traditional architrave architecture.

The excavation of the sanctuary was carried out following World War II, after heavy bombing in 1944 destroyed the medieval part of the city that had been constructed over it.

The first structure that can be considered a part of the sanctuary is the large polygonal wall, on top of which the double ramp was built. Two large side stairways gave access to the level above the polygonal wall. These ended in front of the two tetrastyle exedras enclosing fountains, which were in fact lustral basins placed at the entrance to the sanctuary (FIG. **158:1**). Various rooms adjoined the exedras, but only those on the west survive.

The principal approach was by a gigantic double ramp, forming a triangular facade, with two large superimposed niches in the center (FIG. **158:3**). Along their length, the two ramps divided into two sections; the one on the inside was uncovered and paved with stones, while the other on the outside was vaulted and closed, with a Doric colonnade whose capitals were angled to accommodate the slope of the epistyle.

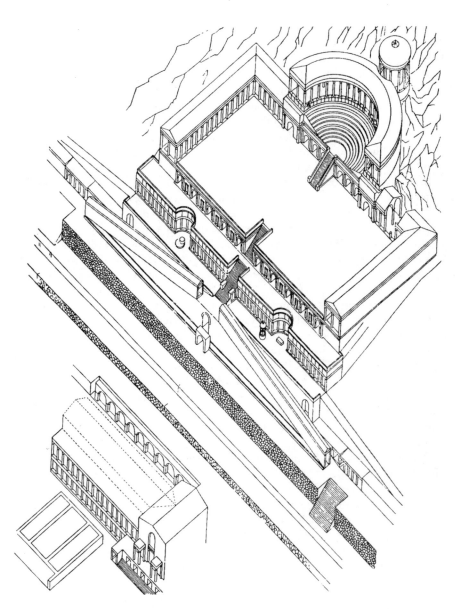

FIGURE 157. Praeneste. The Sanctuary of Fortuna Primigenia. Perspective. (After Kähler)

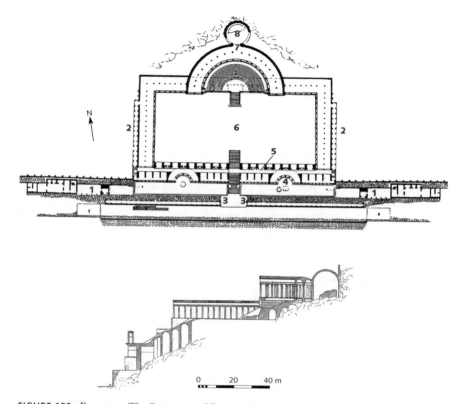

FIGURE 158. Praeneste. The Sanctuary of Fortuna Primigenia. *Top*, plan (after Kähler): **1** Fountains. **2** External ramps. **3** Frontal ramps. **4** Sanctuary of the *sortes*. **5** Terrace of the arches with semicolumns. **6** Terrazza della Cortina. **7** Theater and porticus. **8** Temple. *Bottom*, cross section (after Fasolo and Gullini).

The axial staircase (mostly restored) leading to the upper levels begins at the center of the terrace where the double ramps converged. A passageway beneath the staircase ensured access between the two sections of the Terrace of the Hemicycles. The terrace gets its name from the two large hemicycles that mark the center of the two halves divided by the stairway. The hemicycles are flanked by two series of four rooms on each side, in front of which there was a porticus (originally roofed by a coffered vault) with faceted Doric columns that followed the curve of the hemicycles. The one on the right (toward the east) is better preserved; some columns with Ionic capitals and a part of the high attic remain *in situ*. Within the hemicycles are remains of a large bench, a clear indication that these were rest areas for those waiting to consult the oracle. The seat of the oracle was immediately in front of the hemicycle on the right (FIG. **158:4**).

On axis with this was a base decorated with a Doric frieze, of which some fragments have been found. This must have held a seated statue—surely that of Fortuna with Jupiter and Juno as children. The oversized marble head now in the museum was found in the well near the hemicycle; it was undoubtedly the statue of Fortuna described by Cicero. Cicero recounts that the *sortes* were discovered right next to the statue. In addition to the head of the statue, the well near the hemicycle, measuring 1.90 meters across, yielded the remains of a round aedicula that originally adorned the well's mouth. The circular structure, made of travertine, had a single row of seven Corinthian columns rising on a high podium, adorned with a Doric frieze. The spaces between the columns were closed at the bottom by a stone balustrade, above which there were metal grates that could be partly opened. This was obviously a *sacellum* erected to cover and thereby consecrate the well in which the *sortes* were supposed to have been found; Cicero called it a *locus saeptus religiose*.

The axial staircase allows access to the next level, which is called the **Terrazza dei Fornici a Semicolonne** because of the presence, along its northern side, of a series of rooms framed by Ionic semicolumns (FIG. **158:5**). The **Terrazza della Cortina** follows, which is both higher and more spacious (FIG. **158:6**). This, together with the adjacent buildings, formed the upper sanctuary, which opened to the south toward the valley, while the other three sides were bordered and enclosed by a porticus consisting of a double row of Corinthian columns. A roof over the porticus masked its two parallel barrel vaults.

The cavea of a theater, with a diameter of approximately 59 meters, rises at the center of this level on the north (FIG. **158:7**). Underneath the cavea ran a cryptoporticus, which was entered through six arches framed by Ionic semicolumns. Two large vaulted niches (each with a fountainhead at the center), framed by Corinthian pilasters, were installed at the ends of the cavea. The steps of the cavea were destroyed in the fourteenth century. Those that we now see are largely restorations dating to the seventeenth century, when this part of the sanctuary was transformed into a palazzo. The wellhead in the center of the stairs dates to the same period. At the top of the stairs, the bases of the Corinthian columns that formed the porticus can still be seen. This structure, with its double row of columns, occupied the *summa cavea*. The bases of the central row of columns, as well as the back wall, are visible inside Palazzo Barberini, as is the pavement on which they stood. At the back of the entrance hall are substantial portions of the foundation (viewed more easily from the floor above) that supported the circular temple, which concluded the upper section of the sanctuary (FIG. **158:8**).

The chronology of Praeneste's sanctuary has long been debated, but canonical dating of the complex to the reign of Sulla is no longer supportable; the complex clearly dates to the last years of the second century BC. That the people of Praeneste enjoyed an especially important, perhaps even a privileged,

position among the merchants trading in the East from the last decades of the second century and during the reign of Sulla is certain. This fact explains, at least in part, how it was possible to rebuild the sanctuary on such a monumental scale.

The sanctuary of Praeneste, together with the slightly later sanctuary of Hercules Victor in Tivoli, is one of the greatest examples of Italian Hellenistic architecture, evidently inspired by models from the eastern Aegean such as those on Rhodes and Cos, but constructed with the local technique of *opus caementicium*.

The Museum

Since 1953 the Museo Archeologico Prenestino has been housed in Palazzo Barberini, displaying materials from local collections, from the Villa Giulia Museum in Rome, and from recent excavations. The museum was radically reorganized in 1996. It is best to proceed from the entrance room (no. 4) directly to the last room of the left wing (no. 1) and begin the visit there.

FIRST FLOOR

Room 1. In this room is the large marble head, a late Hellenistic original from the end of the second century BC, belonging to the cult image of Fortuna, which once stood near the well of the *sortes*. The small sculpture with two headless figures on a *ferculum* (litter) represents the cult statues of the two Fortunes of Praeneste, one of which was portrayed as a matron, the other as an Amazon, with her right breast exposed. At the back of the room is a large statue in gray marble, lacking the parts of the body that were exposed; these would have been executed separately in white marble. This is a good example of late Hellenistic sculpture from Rhodes, perhaps to be identified as the cult statue of Isis.

Room 2. On display here are three important statues of women in Greek marble (the heads are unfortunately missing), which are original Hellenistic works dating from the end of the second to the beginning of the first century BC. They are probably ex-voto offerings carved locally by Greek sculptors and then erected in the Terrazza della Cortina, where they were discovered. Among the works displayed here is the marble head of a woman wearing a characteristically Hellenistic melon-shaped hairstyle.

Room 3. A group of interesting portraits is displayed here. Particularly noteworthy are the head of a man from the Republican period (middle of the first century BC); a man dressed in a toga and another wearing a *lorica* (cuirass), both headless and from the Imperial period; and a statue of a figure in heroic nudity (which could also represent a divinity). Several inscribed bases exhibited here must have held statues of important Praenestine citizens.

Back in the atrium, a small room (at the center toward the rear) contains an important Imperial marble group, representing the Capitoline triad (Jupiter, Juno, and Minerva). The group, dated to the Antonine period, comes from a villa near Tivoli (Guidonia).

The visit continues in the rooms of the right wing.

Room 5. This room is devoted to works of the Augustan period. Of considerable importance is the relief on a slightly curved surface that represents a *cinghialessa* (wild boar) nursing its young in a woodland landscape. Discovered recently in the excavations of the lower city, the work is part of the same series as the two Augustan "Grimani reliefs" (now in Vienna), whose provenance can thus also be traced to Palestrina. A marble altar from the age of Tiberius, dedicated to Divine Augustus, shows the deified emperor between two cornucopias from which garlands hang. The two marble bases with garlands suspended from bucrania and dedicated by the *decuriones* and the people of Praeneste to the *Securitas* and *Pax Augusta* are also noteworthy. The gigantic head of Augustus displayed was part of a large cult statue.

Room 6. This room is devoted to Imperial works. A striking relief, recently discovered in the lower city, depicts Trajan's Parthian triumph. There is also a beautiful female portrait of the Flavian age, as well as the colossal head of Faustina the Elder, the wife of Antoninus Pius, found together with the head of Augustus displayed in Room 5; the two statues must have originally been placed in a temple of the Imperial cult.

Room 7. This room features epigraphic documents. Among the most important items are an inscription of the *Aere(tinae) Matronae* (the matrons of Eretum), datable to the third century BC, and a cippus inscribed with the names C. Magulnius Scato Maxs(imus) and C. Saufeius Flaccus, praetors of the city, who are depicted in the act of consecrating an object, probably a statue, to a divinity.

Room 8. On display here are documents related to the other Praenestine cults, including dedications to *Iuno Palostcaria* (perhaps a *Iuno Palustris*, related to *Iuno Caprotina* of Rome) and to Hercules, dating to the second century BC. The dedication to Jupiter Dolichenus and two statuettes of Cybele and Mithras attest the presence of Eastern cults in Praeneste. A Republican marble relief of a battle scene is also of interest.

SECOND FLOOR

The visit begins in the rooms on the right.

Room 9. This and the following rooms (10 and 11) house material from tombs of the necropolis of Praeneste that dates to the middle Republic; the cippi

displayed in Room 10 also come from this cemetery. The furnishings (*cistae*, bronze mirrors, bathing equipment, toilet articles in wood and ivory, and ceramics) were buried with the corpses in tufa sarcophagi and urns. An important group of cylindrical and oval *cistae* and mirrors with incised figures is exhibited in this room, with some small strips of carved bone and part of a casket with representations of gods. Three bronze plates represent a seated Hercules, a warrior battling an Amazon, and Athena in the act of slaying a giant. The cover of a large sarcophagus in the form of a roof and made of peperino comes from the necropolis of the Colombella (FIG. **156:16**) and dates to the fourth century BC.

The left wing is devoted to the sanctuary of Hercules located outside the city (FIG. **156:15**) and to its architectural decoration.

Rooms 12 and 13. The sanctuary of Hercules lies in the suburban region of the city near the Church of S. Rocco; excavation of the site was undertaken as early as the eighteenth century. The sanctuary belonged to a commercial cult associated with a cattle and sheep market *(forum pecuarium)*. The remaining structures, in *opus caementicium*, date to a second-century BC renovation, but the sanctuary certainly was already in existence during the archaic period. From here comes, among other things, the fragment of a frieze with a chariot race, datable to about 530 BC. Two cippi with dedicatory inscriptions dating to the third century BC must have held bronze statuettes of Hercules. Numerous terracotta votive objects were recovered from the site—human heads, statuettes, anatomical parts of the human body, and animals—all dating between the fifth and the second centuries BC.

Room 14. The rich and diverse architectural terracottas testify to the city's striking number of temples and shrines. The oldest examples, datable to the last decades of the sixth century BC, come from sanctuaries in the lower city (that of Hercules near S. Rocco and another sanctuary near the Church of S. Lucia), including a triumphal scene depicting leaders of the local aristocracy. The series of antefixes and revetments, dated between the fifth and second centuries BC, is most impressive. Especially interesting is the fragment of a frieze representing the struggle between an Arimaspus and a griffin, dating to the end of the fourth century BC.

THIRD FLOOR

Rooms 15 and 16. At the back of the room is the large polychrome mosaic that was originally on the floor of the apsidal hall (probably the Iseum or the Serapeum). This and the mosaic depicting the Battle of Alexander discovered in Pompeii are the largest Hellenistic works of this sort to come down to us. The Praeneste mosaic, dating to the last years of the second century BC, is

a sort of large-scale perspective map of Egypt, represented at the moment of the Nile's flooding. On the other side of the room there is a large model reconstruction of the Sanctuary of Fortuna Primigenia.

The Lower City

The large rectangular area below the oldest city—a plateau bordered by Via degli Arcioni on the north, the present-day Via Prenestina on the south, the Valle dello Spedalato on the east, and the Valle dei Sardoni on the west—was the site of a rather large settlement, which is generally recognized as the Sullan colony founded after 82 BC. It seems likely, however, that the city had already extended to this area in the preceding decades, when the rebuilding of the sanctuary and the monumentalization of the area around the forum took over a considerable part of old Praeneste.

The archaic and middle Republican necropolis of the city was south of this area, in La Colombella. At its southern end, now partly incorporated in the modern cemetery, are the remains of a large villa. Several of its vaulted rooms in *opus mixtum,* datable to the first half of the second century AD, are visible. The identification of the property as an **Imperial villa** of Hadrian is secure. In fact, the famous Antinous Braschi, now displayed in the Sala Rotonda of the Musei Vaticani, was discovered here in 1793. This was likely the villa that once belonged to Augustus, the place which Tiberius loved to visit and where he once became seriously ill.

Still farther south, along the street of Valmontone, are remains of the **Basilica of S. Agapito,** the city's patron saint.

FIGURE 159. Wall types. **1** *Opus quadratum.* **2** *Opus incertum.* **3** *Opus quasi reticulatum.* **4** *Opus reticulatum.* **5** *Opus mixtum.* **7** *Opus vittatum.* (Not shown: *Opus latericium.*)

BUILDING TECHNIQUES AND CONSTRUCTION MATERIALS

BUILDING TECHNIQUES

1 *Opus quadratum.* Construction in uniformly shaped rectangular—more specifically parallelepiped—ashlars, which was in use from as early as the archaic period (end of the seventh / beginning of the sixth century BC). From the fourth century BC, masons in Rome typically laid alternate courses of headers and stretchers.

2 *Opus incertum.* With the introduction of concrete and *opus caementicium,* it became necessary to add facings, composed of smaller pieces, that would adhere to the concrete core. The earliest type of facing is *opus incertum,* made of small pyramidal blocks of tufa that were set into the core of the wall; the shape of its surface lacked a regular pattern. The oldest examples of *opus incertum* in Rome date to the first decades of the second century BC (the Temple of the Magna Mater, *Porticus Aemilia*) and the last, to the end of the same century.

3 *Opus quasi reticulatum.* Facings on walls built in *opus caementicium* show a progressive tendency toward regularization. In the course of this development a distinct phase can be identified, *opus quasi reticulatum,* in which the joins between tufa blocks are arranged along a continuous line, even if occasionally broken. This stage is the prelude to the perfect regularity that characterizes *opus reticulatum.* The oldest examples of this technique date to the last quarter of the second century BC (*Horrea Galbana,* the Fountain of Juturna, the second phase of the Temple of the Magna Mater, and the House of the

Griffins on the Palatine). The latest are contemporary with the initial occurrences of *opus reticulatum* in the first quarter of the first century BC.

4 *Opus reticulatum*. The next stage is *opus reticulatum,* a perfectly regular pattern of small tufa blocks with square bases that are arranged in the form of a net. The use of this type of facing begins in the first half of the first century BC (older examples include the restoration of the Servian Wall around 87 BC, and the Theater of Pompey between 61 and 55 BC) and continues up to the Julio-Claudian period, when the use of bricks or a mixture of brick and reticulate becomes the norm.

5 *Opus mixtum*. The practice of reinforcing *opus reticulatum* with horizontal courses of brick or broken tiles began at the end of the Republic, since the reticulate work, as Vitruvius records, had a tendency to become damaged along the slanted lines of the facing. During the Empire, this technique was perfected with the addition of side toothing; the reticulate panels were thus enclosed within brick frames. The use of *opus mixtum* was especially popular between the Flavian regime and the reign of Hadrian.

6 *Opus latericium* (or *testaceum*). The first facings of broken tile, as a substitute for tufa blocks, in wall construction occur at the end of the Republic. Use of the technique, however, becomes widespread at the beginning of the Empire. The first large monument built entirely in brick is the Castra Praetoria, erected during the reign of Tiberius.

The practice of stamping bricks and tiles with a trademark begins fairly early, in the first century BC, and provides invaluable assistance in dating brick walls, as one might well imagine. Initially, the stamps have an elongated rectangular form; under the Flavians, they assume a lunate form, which little by little begins to close, until by the time of Commodus they become practically circular. From AD 123, under Hadrian, stamps were required to indicate the consular date, a practice that diminished over time until disappearing completely around 164.

Between the reigns of Marcus Aurelius and of Caracalla, all of the private brick factories ended up in the hands of the emperors; from that point forward, the state held exclusive control over the production of bricks. The use of brick stamps ended 70 to 80 years after the death of Caracalla, but was resumed by Diocletian.

7 *Opus vittatum*. A new type of facing was introduced at the beginning of the fourth century. It consisted of horizontal courses of bricks alternating with tufa blocks, also arranged in horizontal courses. This technique lasted throughout the fourth century and is typical in Rome during the reigns of Maxentius and Constantine.

THE MATERIALS: STONE

1 *Cappellaccio*. The granular, friable, dark gray tufa that comes from Rome itself. It was used almost exclusively during the archaic period (seventh to fifth century BC) for walls built in *opus quadratum*, particularly those whose blocks are of limited thickness (one foot, or 0.296 meters) and are worked with considerable care. The Temple of Jupiter Capitolinus, the oldest sections of the Servian Wall, and the archaic cisterns on the Palatine were built of this material.

2 *Grotta Oscura Tufa.* This semilithoid, porous, yellowish tufa was used in large quantities after the conquest of Veii (396 BC), since the quarries lay within the territory of this city. Examples of earlier use of this stone are not lacking, however, such as in the inscription below the Niger Lapis and the archaic temples of Sant'Omobono. This was the only tufa for which quarry marks were inscribed on the blocks. The dimensions of these blocks are almost double those of cappellaccio (2 feet, or 0.59 meters high). The working of the quarries ceased around or shortly before 100 BC, when Anio tufa began to be widely used. The following monuments make use of this stone: the inscribed stele below the Niger Lapis, the Republican walls of the fourth century, Temples C and A in Largo Argentina, Basilica Fulvia-Aemilia, Pons Aemilius, the Temple of Veiovis, the foundations of the Circular Temple of the Forum Boarium, and Pons Milvius.

3 *Fidenae Tufa.* Easily recognizable because of the inclusions of black scoriae, this tufa was probably used after 426 BC, the year when Fidenae was conquered. The quarries are near Castel Giubileo. The stone continued to be used up to the end of the second century BC, like Grotta Oscura tufa. The following monuments employed this stone in their construction: the supporting walls of the Palatine and Capitoline, the fourth-century Republican walls, Temple C and the second phase of Temple A in Largo Argentina, and the third Republican phase of the temples of Sant'Omobono.

4 *Monteverde Tufa.* This light-brown lithoid tufa, speckled with intrusions of variously colored scoriae, was not very fine. The quarries lay at the foot of the Janiculum and in Magliana. Regular use of this stone began during the second century BC.

5 *Anio Tufa.* A ruddy lithoid tufa that came from the quarries of Tor Cervara. Regular use of this stone began just before, though in architectural applications a little after, the middle of the second century BC (it is first documented in the Aqua Marcia, 144 BC). This is the tufa of preference at the end of the Republic and during the Empire. Other examples include Pons Milvius, the upper room of the Carcer, and the Temple of Mars Ultor.

6 *Peperino (Lapis Albanus).* A dark gray cinderlike lithoid tufa from the quarries near Marino that came into use as early as the Middle Republic (fourth/third century BC), but was employed primarily from the second century BC to the late Empire; it is, in fact, still used today. The following monuments used peperino in their construction: Aqua Marcia, the Tomb of the Scipios, the Temple of Magna Mater, the Tomb of Ser. Sulpicius Galba, the temples of the Forum Holitorium, the temple on Via delle Botteghe Oscure, the Tabularium, the Theater of Pompey, the large fire wall in the Forum of Augustus, the Temple of Mars Ultor, the Temple of Hadrian, and the Temple of Antoninus and Faustina.

7 *Sperone (Lapis Gabinus).* A lithoid tufa similar to peperino, but coarser and distinguished by a greater amount of scoriae. Sperone was used in the following monuments: the Aqua Marcia, Pons Aemilius, Pons Milvius, the outlet of the Cloaca Maxima, the Tabularium, Pons Fabricius, the Theater of Pompey, the tabernae in the Forum of Caesar, and the Forum of Augustus.

8 *Travertine (Lapis Tiburtinus).* A sedimentary limestone from quarries near Tivoli that is still used today. Use of this stone began during the second century BC,

with architectural applications at the end of the same century. Travertine was used primarily in Roman buildings of the Late Republic and Empire. Suffice it to mention the Theater of Marcellus and the Colosseum.

THE MATERIALS: MARBLES AND HARD STONES

1 *Pentelic Marble.* A fine-grained white marble from quarries on the eastern side of Mount Pentelicus, located about 15 kilometers northeast of Athens.

2 *Parian Marble.* A large-grained white marble from quarries in the northeastern part of the island of Paros in the Cyclades. In antiquity this marble was mostly used for statues.

3 *Luna (Luni) Marble.* The fine-grained marble from Carrara, whose quarries were first opened during the reign of Caesar but fully exploited only in the Augustan period. Under Tiberius the quarries became part of the Imperial domain.

4 *Proconnesian Marble.* The large-grained off-white bluish marble from the island of Proconnesus in the Sea of Marmara that was used in Rome from the second century AD.

5 *Pavonazzetto (Marmor Synnadicum* or *Phrygium).* A brecciated marble with white limestone pebbles in a violet base that came from Docimium, near Synnada in Asia Minor.

6 *Cipollino (Marmor Carystium).* A marble with parallel streaks varying from greenish-white to dark green that comes from the quarries near Carystos at the southeastern tip of Euboea in Greece.

7 *Rosso Antico.* A deep red marble that comes from the quarries of Taenarum (Cape Matapan in the Peloponnesus).

8 *Giallo Antico (Marmor Numidicum).* A fine-grained marble characterized by an intense yellow color with deep yellow or deep red veins. It came from the quarries of Chemtou in Tunisia (ancient Numidia).

9 *Portasanta (Marmor Chium).* A brecciated marble with spots and veins whose color varies from red to blood-red in a dark base, which ranges from gray to a soft pink, that came from the quarries of Chios in the eastern Aegean.

10 *Africano* (probably to be identified with *Marmor Luculleum).* A brecciated marble with spots and veins of several intense colors that came from Teos in Asia Minor, from where it was introduced to Rome by Lucullus (whence the name).

11 *Gray Granite.* Granite from *Mons Claudianus* in Egypt.

12 *Obelisk Granite.* Red or rose granite from Syene (present-day Aswan in Egypt).

13 *Red Porphyry (Lapis Porphyrites).* A very hard stone, violet-red in color, speckled with small white intrusions, from Upper Egypt (the area around the Red Sea).

14 *Green Porphyry* or *Serpentine (Lapis Lacedaemonicus).* A dark-green porphyry with light-green crystals that came from the vicinity of Sparta in the Peloponnesus.

15 *Verde Antico.* A green brecciated marble with light-gray, white, black, and dark-green inclusions that came from Thessaly (around Larissa).

GENERAL BIBLIOGRAPHY

The list below is a greatly abridged version of the full bibliography, which is available at www.ucpress.edu/coarelli/.

ROME

Balbi De Caro, S., and C. Moccheggiani, eds. *Tevere: Archeologia e commercio*. Rome 1987.

Boatwright, M. T. *Hadrian and the City of Rome*. Princeton 1987.

Claridge, A. *Rome: An Oxford Archeological Guide*. Oxford 1998.

Coarelli, F. *Roma sepolta*. Rome 1984.

Fagiolo, M. *Roma antica*. Lecce 1991.

Guide rionali di Roma. Rome 1967–.

Jordan, H., and Ch. Hülsen. *Topographie der Stadt Rom im Althertum*, I: 1–3; II. Berlin 1878–1907.

Kaiser Augustus und die verlorene Republik, exhibition catalogue. Mainz 1988.

Kolb, F. *Rom. Die Geschichte der Stadt in der Antike*. Munich 1995.

Le Gall, J. *Le Tibre, fleuve de Rome, dans l'antiquité*. Paris 1952.

Lugli, G. *I monumenti antichi di Roma e suburbio* 1–3 and supp. Rome 1931–40.

———. *Roma antica: Il centro monumentale*. Rome 1946.

Nash, E. *Pictorial Dictionary of Ancient Rome*. London 1968.

Palombi, D. "Roma." *Enciclopedia Oraziana*. Rome 1996–98.

Platner, S. B., and T. Ashby. *A Topographical Dictionary of Ancient Rome*. London 1929.

Richardson, L., Jr. *A New Topographical Dictionary of Ancient Rome*. Baltimore 1992.
"Roma." *Enciclopedia dell'Arte Antica, Classica e Orientale* 2, supp. 4 (1996): 784–996.
Steinby, E. M., ed. *Lexicon Topographicum Urbis Romae*, 5 vols. Rome 1991–99.

Christian Rome

Krautheimer, R. *Rome: Profile of a City*. Princeton 1980.
Krautheimer, R., et al. *Corpus Basilicarum Christianarum Romae*, 5 vols. Vatican City 1937–75.
Pietri, Ch. *Roma Christiana*. Bibliothèque des Écoles Françaises d'Athènes et de Rome 224. Rome 1976.

Literary and Epigraphic Sources

Dudley, D. R. *Urbs Roma: A Source Book of Classical Texts on the City*. Aberdeen 1967.
Kardos, M.-J. *Lieux et lumières de Rome chez Cicéron*. Paris 1997.
Lugli, G. *Fontes ad topographiam veteris urbis Romae pertinentes*. 7 vols. Rome 1952–69.
Neumaister, C. *Das antike Rom: Ein literarische Stadtführer*. Munich 1991.
Nordh, A. *Libellus de regionibus urbis Romae*. Lund 1949.
Valentini, R., and G. Zucchetti. *Codice topografico della città di Roma*. 4 vols. Rome 1940–53.

Architecture and Urbanism

Boëthius, A., and J. B. Ward Perkins. *Etruscan and Roman Architecture*. Harmondsworth 1970.
Capponi, S., and B. Mengozzi. *I vigiles dei Cesari: L'organizzazione antincendio nell'antica Roma*. Rome 1993.
Castagnoli, F. *Roma antica: Profilo urbanistico*. Rome 1978.
———. *Topografia e urbanistica di Roma antica*. Bologna 1969.
Crema, L. *L'architettura romana*. Turin 1959.
De Fine Licht, K., ed. *Città e architettura nella Roma imperiale*. Analecta Romana Instituti Danici, supp. 10. Odense, Denmark, 1983.
Delbrück, R. *Hellenistische Bauten in Latium*. Strasbourg 1907–12.
Desnier, J.-C. "*Omina* et *realia*: Naissance de l'Urbs Sacra Séverienne (193–204 ap. J.-C.)." *Mélanges de l'École Française de Rome: Antiquité* 105 (1993): 547–620.
Favro, D. *The Urban Image of Augustan Rome*. Rome 1996.
Gatti, G. *Topografia ed edilizia di Roma antica*. Rome 1989.
Gros, P. *L'architecture romaine*, vol. 1. Paris, 1996.
———. *Architettura e società nell'Italia romana*. Rome 1987.
Gros, P., and M. Torelli. *Storia dell'urbanistica: Il mondo romano*. Rome and Bari 1988.
Guilhembet, J.-P. "La densité des domus et des insulae dans les XIV Régions de Rome selon les Régionnaires: Représentations cartographiques." *Mélanges de l'École Française de Rome: Antiquité* 108 (1996): 7–26.
Hirschfeld, O. *Die kaiserlichen Verwaltungsbeamten*. Berlin 1905.
Homo, L. *Rome impériale et l'urbanisme dans l'antiquité*. Paris 1951.

La Rome impériale: Démographie et logistique. Actes de la table ronde, Rome, 25 mars 1994. Collection de l'Ecole Française de Rome 230. Rome 1997.

L'Urbs: Espace urbain et histoire (Ier siècle av. J.-C.–IIIe siècle ap. J.-C.): Actes du colloque international organisé par le Centre national de la recherche scientifique et l'École Française de Rome (Rome, 8–12 mai 1985). Collection de l'École Française de Rome 98. Rome 1987.

MacDonald, W. L. *The Architecture of the Roman Empire.* 2 vols. New Haven and London, 1982 and 1986.

Rainbird, J. S. "The Fire Stations of Imperial Rome." *Papers of the British School at Rome* 54 (1986): 147 ff.

Robinson, O. F. *Ancient Rome: City Planning and Administration.* London 1992.

Sablayrolles, R. *Libertinus miles: Les cohortes de vigils.* Collection de l'École Française de Rome 224. 1996.

Stambaugh, J. E. *The Ancient Roman City.* Baltimore 1988.

ENVIRONS OF ROME

Ashby, T. "The Classical Topography of the Roman Campagna." *Papers of the British School at Rome* 1 (1902): 125–38; 3 (1906): 1–212; 4 (1907): 4–159.

———. *The Roman Campagna in Classical Times.* 2nd ed. London 1970.

Carandini, A. *Schiavi in Italia,* 339 ff. Rome 1988.

Coarelli, F. "L'Urbs e il suburbio." In *Società romana e impero tardoantico* 2: 1 ff. Rome and Bari 1986.

Enciclopedia dell'Arte Antica, Classica e Orientale 2, supp. 4 (1996): 981 ff.

Lanciani, R. *Wanderings in the Roman Campagna.* Boston 1909.

Misurare la terra: Centuriazione e coloni nel mondo romano. Città, agricoltura, commercio: materiali da Roma e dal Suburbio. Modena 1985.

Nibby, A. *Viaggio antiquario ne' contorni di Roma.* Rome 1819.

———. *Analisi storico-topografica-antiquaria della carta dei dintorni di Roma,* 1–3. Rome 1837 (2nd ed. 1848).

Quilici, L. "Inventario e localizzazione dei beni culturali archeologici nel territorio del comune di Roma." *Urbanistica* 54–55 (1969): 1–20, 82–108.

Tomassetti, G. *La campagna romana,* 1–4. Rome 1910–26.

Torelli, M., and F. Zevi. "Roma (Principali monumenti del suburbio)." *Enciclopedia dell'Arte Antica, Classica e Orientale* 6 (1965): 872–99.

Geographical

Almagià, R. *Lazio.* Le regioni d'Italia 11. Turin 1966.

Protohistory of Latium

Acanfora, M. O., ed. *Civiltà del Lazio primitivo,* exhibition catalogue. Rome 1976.

Gierow, P. G. *The Iron Age Culture of Latium.* 2 vols. Lund 1964–66.

Medieval Period

Toubert, P. *Les structures du Latium medieval*. 2 vols. Rome 1973.

Maps and Plans

Frutaz, A. *Le carte del Lazio*. 3 vols. Rome 1972.

Christian Rome

Brandenburg, H. *Roms frühchristliche Basiliken des 4. Jahrhunderts*. Munich 1979.
Krautheimer, R., et al. *Corpus basilicarum Christianarum Romae*. 5 vols. Rome 1937–75.
Marucchi, O. *Le catacombe romane*. Rome 1933.
Nestori, A. *Repertorio topografico delle pitture delle catacombe romane*. Vatican City 1975.
Pergola, P. *Le catacombe romane*. Rome 1997.
Pietri, C. *Roma Christiana*. 2 vols. Rome 1976.
Reekmans, L. "L'implantation monumentale chrétienne dans la zone suburbaine de Rome du IVe au IXe siècle." *Rivista di Archeologia Cristiana* 44 (1968): 173–207.
Stevenson, J. *The Catacombs*. London 1978.
Testini, P. *Le catacombe e gli antichi cimiteri sotterranei in Roma*. Bologna 1966.
Wilpert, G. *Roma sotterranea: Le pitture delle catacombe romane*. Rome 1903.

Roman Roads

Radke, G. "Viae publicae Romanae." In *Pauly-Wissowa: Pauly's Real-Encyclopädie der Klassichen Altertumswissenschaft*, ed. G. Wissowa (Stuttgart 1894–), supp. 13 (1973): cols. 1477–1666.
Wiseman, P. "Roman Republican Road Building." *Papers of the British School at Rome* 308 (1970): 122–52.

ILLUSTRATION SOURCES

The illustrations in this volume have been adapted from Filippo Coarelli's three books *Roma* (1995 and 2003), *Dintorni di Roma* (1993), and *Italia Centrale* (1985). These books include illustrations based on the following sources, which are attributed by the author name at the end of the caption.

Ashby, T., and G. Lugli. "La villa dei Flavi Cristiani ad duas lauros." *Atti della Pontificia Accademia Romana di Archeologia: Memorie* 2 (1928): 158–92.

Astolfi, E., E. Guidobaldi, and A. Pronti. "Horrea Agrippiana." *Archeologia Classica* 30 (1978): 31–106.

Bauer, H. "Der Urplan des Forum Transitorium." In *Bathron: Beitrage für H. Drerup*, 41–57. Saarbrücken 1988.

———. "Il Foro Transitorio e il Tempio di Giano." *Atti della Pontificia Accademia Romana di Archeologia: Rendiconti* 49 (1976–77): 117–50.

Becatti, G. *Scavi di Ostia, 4: I mosaici e i pavimenti marmorei.* Rome 1961.

Calza, G. *La necropoli del Porto di Roma nell'Isola Sacra.* Rome 1940.

Canina, L. *Descrizione dell'antico Tuscolo.* Rome 1941.

Deichmann, F. W., and A. Tschira. "Das Mausoleum der Kaiserin Helena und die Basilika der Heiligen Marcellinus und Petrus." *Jahrbuch des Instituts* 72 (1957): 44–110.

Fasolo, F., and G. Gullini. *Il santuario della Fortuna Primigenia a Palestrina.* Rome 1956.

Ferrua, A. *Le pitture della nuova catacomba di via Latina.* Vatican City 1960.

Frutaz, A. P. *Il complesso monumentale di S. Agnese.* 3rd ed. Vatican City 1976.

Gatti, G. "Il Mausoleo di Augusto. Studio di ricostruzione." *Capitolium* 10 (1934): 457–64.

———. "Scoperta di una Basilica Christiana presso S. Lorenzo fuori le Mura." *Capitolium* 11 (1957): 16 ff.

Giuliani, C. F. *Tibur 1.* Forma Italiae. Rome 1970.

Guidobaldi, F. *Il complesso archeologico di San Clemente: Risultati degli scavi più recenti e riesame dei resti architettonici.* Rome 1978.

Kähler, H. "Das Fortunaheiligtum von Palestrina-Praeneste." *Annales Universitatis Saraviensis, philosophie-lettres* 7, nos. 3/4 (1958): 189–240.

Lugli, G. "Scavo dell'Albanum di Pompeo." *Notizie degli Scavi di Antichità* 1946: 60–83.

Marucchi, O. *Le catacombe romane.* Rome 1933.

Meiggs, R. *Roman Ostia.* 2nd ed. Oxford 1973.

Meneghini, R. "L'architettura del Foro di Traiano attraverso i ritrovamenti archeologici più recenti." *Mitteilungen des Deutsches Archäologischen Institut, Römische Abteilung* 105 (1998): 127–48.

Pensabene, P. "Il tempio della Vittoria sul Palatino." *Bollettino di Archeologia* 11–12 (1991): 11–51.

Quilici, L. *La via Prenestina: I suoi monumenti, i suoi paesaggi.* Rome 1977.

———. *La via latina da Roma a Castel Savelli.* Rome 1978.

———. *Urbanistica ed architettura dell'antica Praeneste: Atti del [primo] Convegno di studi archeologici sull'antica Praeneste.* Palestrina 1989.

Quilici, L., and S. Quilici Gigli. *Antemnae.* Rome 1978.

Rakob, F., and W. D. Heilmeyer. *Der Rundtempel am Tiber in Rom.* Mainz 1973.

Rickman, G. *Roman Granaries and Store Buildings.* Cambridge 1971.

Testini, P. *Le catacombe e gli antichi cimiteri sotterranei in Roma.* Bologna 1966.

Töbelmann, F. *Der Bogen von Malborghetto.* Heidelberg 1915.

Tortorici, E. *Castra Albana.* Forma Italiae. Rome 1974.

Ucelli, G. *Le navi di Nemi.* Rome 1950.

van Deman, E. B. *The Atrium Vestae.* Washington, D.C. 1909.

Zanker, P. *Forum Augustum.* Tübingen 1968.

INDEX

For monuments and places found in the environs of Rome, the location is given in SMALL CAPITALS.

Compositor:	Humanist Typesetting & Graphics
Text:	10/12 Baskerville
Display:	Syntax
Indexer:	Andrew Christenson
Printer/Binder:	KHL Printing